The All-American Girls Professional Baseball League Record Book

ALSO BY W. C. MADDEN

*The Women of the All-American Girls
Professional Baseball League:
A Biographical Dictionary*

The All-American Girls Professional Baseball League Record Book

Comprehensive Hitting, Fielding and Pitching Statistics

by
W. C. MADDEN

McFarland & Company, Inc., Publishers
Jefferson, North Carolina, and London

Cover photograph: Fort Wayne's Helen Callaghan led the league in
hits, total bases and doubles in 1945, and tied for the batting and
home run titles.

Library of Congress Cataloguing-in-Publication Data

Madden, W. C.
 The All-American Girls Professional Baseball League record
book : comprehensive hitting, fielding and pitching statistics / by
W. C. Madden.
 p. cm.
 Includes index.
 ISBN 0-7864-0597-X (illustrated case binding : 50# alkaline paper)
 1. All-American Girls Professional Baseball League Statistics.
 I. All-American Girls Professional Baseball League. II. Title.
GV875.A56M334 2000
796.357'64'0973 — dc21 99-37844

British Library Cataloguing-in-Publication data are available

Manufactured in the United States of America

McFarland & Company, Inc., Publishers
 Box 611, Jefferson, North Carolina 28640
 www.mcfarlandpub.com

Acknowledgments

This book was made possible through the assistance received from the All-American Girls Professional Baseball League Players Association, the Northern Indiana Historical Society, the National Baseball Hall of Fame and other supporters. Many thanks to former players for all their help and support, particularly Gertie Dunn, Dottie Kamenshek and Helen Hannah. And to my wife for allowing me the free time to bury myself in this project.

As a member of the Society for American Baseball Research, I hope my work in this area will be helpful in preserving the history of this all-but-forgotten league whose history was resurrected in recent years. This book hopes to capture the league's statistics, so the league will never be forgotten. I hope you find this information helpful in learning more about the league and its players.

Contents

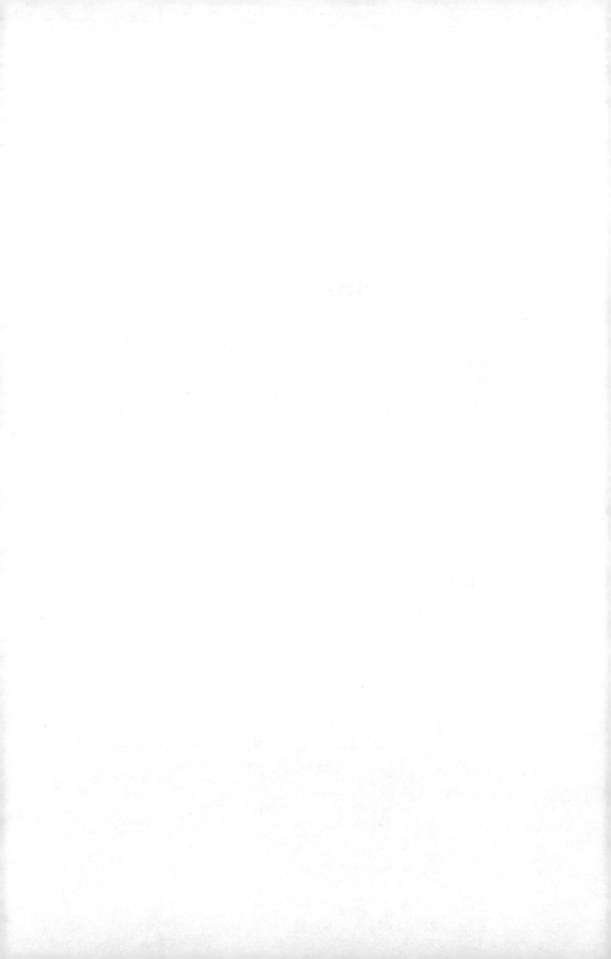

Introduction

For a dozen years during the 1940s and 1950s more than 600 women played professional baseball in the All-American Girls Professional Baseball League. They were paid much more than a normal job could have paid them for a game that most readily admit they would have played for free.

Many of the women of the league were superb athletes and had excelled at many sports, particularly softball, before they joined the league. They attained some records unequaled by their male counterparts. Sophie Kurys swiped 201 bases in one season (the Major League record is 156 set by Harry Stovey in 1888). Joanne Winter hurled 63 consecutive scoreless innings (the ML record is 59 by Orel Hershiser in 1988) for six shutouts in a row (the ML record is six by Don Drysdale in 1968). Joanne Weaver is the last professional player to break .400 in a season with a .429 in 1954 (Ted Williams hit .407 in 1953). Jean Faut compiled a 20–2 record one summer for a .910 winning percentage (the ML record is .886 held by Lefty Grove in 1931). However, comparing AAGPBL statistics with the Major Leagues is like comparing baseball with football — two different sports. The women's game was held on a much smaller scale: shorter base paths, shorter pitching distance, smaller fields, and so on.

The statistics reveal low hitting marks for the first five years of the league. This was the "dead-ball" era of the league, which was due in part to the use of a larger ball and to underhand pitching. Hitting over .300 or knocking a home run was considered quite an achievement. Many of the early parks had no fences in the outfield, so homers were hit only when a player could hit it over an outfielder's head. Few home runs were hit.

Overhand pitching and a smaller ball improved hitting over the last half of the league. In later years, fences were built and moved in to allow more homers and provide more excitement in the sport. The last year of the league saw a dramatic rise in the number of home runs.

The women were not as good at fielding as their Major League counterparts. Hardly a game would go by without several errors being committed. But there were some good fielders among the players and they could turn double and triple plays.

Most players came from the United States or Canada. A few Cuban players were signed after the league held spring training on that tropical island. A couple of players even came from Great Britain. However, the league was never integrated like its Major League counterparts. A few teams held tryouts for African Americans in Cuba and the United States, but none were ever signed. There was no restriction to signing a "black" player. According to South Bend Blue Sox Manager Karl Winsch, who held tryouts for all races, they just "weren't good enough." He attributed that to their lack of experience, not to their race.

The league and players attained recognition for their achievements in 1988 from the National Baseball Hall of Fame in Cooperstown, New York. The Hall of Fame inducted the entire league. The AAGPBL does not want the Hall of Fame to induct individual players. In 1992, the movie *A League of Their Own* was released. It told the league's story to the country. Several books were published soon after the movie, informing the world about the league of women professionals. The renaissance of recognition of the league has come at a time when many of the players have reached retirement age or have passed on.

The AAGPBL Record Book contains a brief history of the league, the rosters of the All-Star teams, the pitching champions, the batting champions, playoff records, individual pitching records, individual hitting records, individual fielding records, team records, players' records and pitchers' records.

This book documents all of the league statistics, many of which have been compiled for the first time and never previously published. The league kept accurate records on individual performances during the first six years of its existence, but after 1948 the exploits of its players fell by the wayside. However, batting averages, pitching statistics and fielding records were kept throughout its existence. Playoff records were not compiled by the league, so that information was obtained from box scores published in newspapers. This book sets the records straight and provides a permanent testament to the accomplishments of the players.

EXPLANATION OF RECORDS AND STATISTICS

Team Records

Statistics for total bases, base on balls, strikeouts, runs and fielding were not kept for all years; therefore, they are not included in the team statistics. Only those statistics that were kept on all teams in all years are listed for comparison.

Player Records

The league stopped compiling individual achievements after 1948, so individual accomplishments are complete only through 1948.

Playoffs

The league first adopted the Scholarship Series as its playoff format in 1943. The series was so named because the team winning the championship would earn a $1,000 scholarship to donate to a local high school graduate for a bachelor of science degree in physical

education. The league would pay $500 of the scholarship and the other $500 would come from the two teams out of the gate receipts they earned in the playoffs. The season was split and the winner of the first half would face the winner of the second half.

The Scholarship Series format lasted two seasons. In 1945, the league moved to a Shaughnessy format. Named for Dan Shaughnessy, the first-place team at the end of the regular season would face the third-place team and the second-place team would play the fourth-place team. The winners of the first round would meet for the championship. This format was used until the league ended play in 1954.

Playoff statistics were not kept by the league or published by the Home Town News Bureau. The playoff statistics in this book were gathered by obtaining the box scores of all playoff games at the different public libraries in the cities where the teams played; however, box scores do not reveal everything that transpired in a game, such as complete fielding information, bases on balls and strikeouts from hitters.

All-Star Teams

The list of players on the rosters are first selections as provided by the AAGPBL Player's Association. There were no All-Star teams from 1943 to 1945. Managers began selecting All-Stars in 1946. The All-Star team would play the best team in the league in an exhibition game. No record of those games could be found.

Individual Statistics

Player statistics were compiled mainly from the Howe News Bureau yearly releases. Some information was gathered from team brochures, the players and box scores from newspapers.

Players are listed by the name they played under according to information provided by the AAGPBL Player's Association. Nicknames are in quotation marks. Other names by which a player may have been known are in parentheses after the name.

Some of the players listed may not have played an official game in the league, but they signed a contract to play in the league, which the Player's Association considers as grounds for being recognized as a league player. When known, the birth date, birthplace and death date are listed.

Players and pitchers are listed separately. If a woman was strictly a pitcher, then hitting statistics are listed under Pitchers. If the pitcher also played other positions, those statistics are listed under Players.

Legend for players: BR = bats right; BL = bats left; BB = bats both; TR = throws right; TL = throws left. *Hitting:* Positions, 1B = first base, 2B = second base, 3B = third base, SS = shortstop, OF = outfielder, P = pitcher, C = catcher; G = Games; BA = Batting Average; AB = At Bats; H = Hits; 2B = Two-base hits; 3B = Three-base hits; HR = Home Runs; TB = Total Bases; SB = Stolen Bases; R = Runs; RBI = Runs Batted In. *Fielding:* G = Games; PO = Putouts; A = Assists; E = Errors; DP = Double Plays; FA = Fielding Average.

Legend for pitchers: *Pitching:* Positions, P = pitcher, RP = relief pitcher; W-L = Wins-Losses; Pct. = Winning Percentage; ERA = Earned Run Average; G = Games; IP = Innings Pitched; H = Hits; R = Runs Allowed; ER = Earned Runs Allowed; BB = Base on Balls; SO = Strikeouts. Hitting: AB = At Bats; H = Hits; AB = Batting Average. *Fielding:* G = Games; PO = Putouts; A = Assists; E = Errors; DP = Double Plays; FA = Fielding Average.

Statistics in *italic **boldface*** represent league highs for the season or career.

Statistics in *italic* represent play on the Player Development Tour with the Chicago Colleens or Springfield Sallies in 1949 and 1950. These statistics are not included in the player's career statistics.

Team abbreviations: BC = Battle Creek Belles; Chic = Chicago Colleens; FW = Fort Wayne; GR = Grand Rapids Chicks; Kal = Kalamazoo Lassies; Ken = Kenosha Comets; Mpls = Minneapolis Millerettes; Mil = Milwaukee Chicks; Mus = Muskegon Lassies or Belles; Peo = Peoria Redwings; Rac = Racine Belles; Roc = Rockford Peaches; SB = South Bend Blue Sox; Spr = Springfield.

The Stars of the League

ALL-STAR TEAMS

For the first three seasons, the league did not have an official All-Star team. In 1946, the eight managers of the league voted for a team of All-Stars as a result of achievements and performances during the season. In the voting, 53 different players received some recognition. All-Stars were selected in successive seasons and the All-Star players would play the best team in the league in an exhibition game.

1943–45

No All-Star teams

1946

1B-Dorothy Kamenshek, Rockford
2B-Sophie Kurys, Racine
3B-Madeline English, Racine
SS-Senaida Wirth, South Bend
OF-Merle Keagle, Grand Rapids
OF-Elizabeth Mahon, South Bend
OF-Thelma Eisen, Peoria
 P-Connie Wisniewski, Grand Rapids
 P-Joanne Winter, Racine
 P-Carolyn Morris, Rockford
 P-Anna May Hutchinson, Racine
 C-Mary Baker, South Bend
 C-Ruth Lessing, Grand Rapids

1947

1B-Dorothy Kamenshek, Rockford
2B-Sophie Kurys, Racine
3B-Mary Reynolds, Peoria
SS-Dorothy Harrell, Rockford
OF-Audrey Wagner, Kenosha
OF-Edythe Perlick, Racine
OF-Jo Lenard, Rockford

 P-Mildred Earp, Grand Rapids
 P-Anna May Hutchinson, Racine
 P-Dorothy Mueller, Peoria
 P-Ruth Lessing, Grand Rapids

1948

1B-Dorothy Kamenshek, Rockford
2B-Sophie Kurys, Racine
3B-Madeline English, Racine
SS-Dorothy Harrell, Rockford
OF-Audrey Wagner, Kenosha
OF-Connie Wisniewski, Grand Rapids
OF-Edythe Perlick, Racine
 P-Alice Haylett, Grand Rapids
 P-Joanne Winter, Racine
 P-Lois Florreich, Rockford
 C-Ruth Lessing, Grand Rapids

1949

1B-Dorothy Kamenshek, Rockford
2B-Sophie Kurys, Racine
3B-Madeline English, Racine
SS-Dorothy Harrell, Rockford
OF-Elizabeth Mahon, South Bend
OF-Doris Sams, Muskegon
OF-Connie Wisniewski, Grand Rapids

P-Lois Florreich, Rockford
P-Jean Faut, South Bend
P-Louise Erickson, Rockford
C-Ruth Richard, Rockford

1950

1B-Dorothy Kamenshek, Rockford
2B-Evelyn Wawryshyn, Fort Wayne
3B-Fern Shollenberger, Kenosha
SS-Dorothy Harrell, Rockford
OF-Betty Wagoner, South Bend
OF-Doris Satterfield, Grand Rapids
OF-Doris Sams, Kalamazoo
 P-Lois Florreich, Rockford
 P-Jean Faut, South Bend
 P-Maxine Kline, Fort Wayne
 C-Ruth Richard, Rockford

1951

1B-Dorothy Kamenshek, Rockford
2B-Charlene Pryer, South Bend
3B-Fern Shollenberger, Kenosha
SS-Alice Pollitt, Racine
OF-Eleanor Callow, Rockford
OF-Doris Sams, Kalamazoo
OF-Connie Wisniewski, Grand Rapids
 P-Jean Faut, South Bend
 P-Maxine Kline, Fort Wayne
 P-Rose Gacioch, Rockford
 C-Ruth Richard, Rockford

1952

1B-Betty Foss, Fort Wayne
2B-Joan Berger, Rockford
3B-Fern Shollenberger, Kenosha
SS-Dorothy Schroeder, Fort Wayne

OF-Eleanor Callow, Rockford
OF-Doris Sams, Kalamazoo
OF-Joanne Weaver, Fort Wayne
 P-Maxine Kline, Fort Wayne
 P-Rose Gacioch, Rockford
 P-Gloria Cordes, Racine
 P-Jean Cione, Battle Creek
 C-Ruth Richard, Rockford

1953

1B-Betty Foss, Fort Wayne
2B-Jean Geissinger, Fort Wayne
3B-Katie Horstman, Fort Wayne
SS-Dorothy Schroeder, Kalamazoo
OF-Doris Satterfield, Grand Rapids
OF-Joyce Ricketts, Grand Rapids
OF-Joanne Weaver, Fort Wayne
 P-Jean Faut, South Bend
 P-Maxine Kline, Fort Wayne
 P-Earlene Risinger, Grand Rapids
 P-Eleanor Moore, Grand Rapids
 C-Ruth Richard, Rockford

1954

1B-June Peppas, Kalamazoo
2B-Jean Geissinger, Fort Wayne
3B-Fern Shollenberger, Kalamazoo
SS-Dorothy Schroeder, Kalamazoo
OF-Eleanor Callow, Rockford
OF-Joyce Ricketts, Grand Rapids
OF-Joanne Weaver, Fort Wayne
 P-Maxine Kline, Fort Wayne
 P-Gloria Cordes, Kalamazoo
 P-Nancy Warren, Kalamazoo
 P-Janet Rumsey, South Bend
 C-Ruth Richard, Rockford

PLAYERS OF THE YEAR

1945-Connie Wisniewski, Grand Rapids
1946-Sophie Kurys, Racine
1947-Doris Sams, Muskegon
1948-Audrey Wagner, Kenosha
1949-Doris Sams, Muskegon

1950-Alma Ziegler, Grand Rapids
1951-Jean Faut, South Bend
1952-Betty Foss, Fort Wayne
1953-Jean Faut, South Bend
1954-Joanne Weaver, Fort Wayne

PITCHING CHAMPIONS

1943-Helen Nicol, Kenosha, 1.81 ERA
1944-Helen Nicol, Kenosha, 0.93 ERA
1945-Connie Wisniewski, Grand Rapids, 0.81 ERA
1946-Connie Wisniewski, Grand Rapids, 0.96 ERA
1947-Mildred Earp, Grand Rapids, 0.68 ERA
1948-Alice Haylett, Grand Rapids, 0.77 ERA

1949-Lois Florreich, Rockford, 0.67 ERA
1950-Jean Faut, South Bend, 1.12 ERA
1951-Alma Ziegler, Grand Rapids, 1.26 ERA
1952-Jean Faut, South Bend, 0.93 ERA
1953-Jean Faut, South Bend, 1.51 ERA
1954-Janet Rumsey, South Bend, 2.18 ERA

Batting Champions

1943-Gladys Davis, Rockford, .332 BA
1944-Betsy Jochum, South Bend, .296 BA
1945-Helen Callaghan, Fort Wayne, .199 BA
1946-Dorothy Kamenshek, Rockford, .316 BA
1947-Dorothy Kamenshek, Rockford, .306 BA
1948-Audrey Wagner, Kenosha, .312 BA

1949-Doris Sams, Muskegon, .279 BA
1950-Betty Foss, Fort Wayne, .346 BA
1951-Betty Foss, Fort Wayne, .368 BA
1952-Joanne Weaver, Fort Wayne, .344 BA
1953-Joanne Weaver, Fort Wayne, .346 BA
1954-Joanne Weaver, Fort Wayne, .429 BA

Dream Team

The National Baseball Hall of Fame unveiled a permanent exhibit of league memorabilia in October 1988. However, no individual players have ever been inducted into the Hall of Fame. The AAGPBL Player's Association would rather the league be recognized than any individual players. If a Hall of Fame would have been created for the league, the following players would likely be considered:

First Base

• Dorothy Kamenshek was selected on seven All-Star teams. "Kammie" played ten seasons in the league and twice won the league's batting crown. She is the league's career leader in hits (1,090), putouts (10,440) and double plays (360). She ranks second in at-bats (3,736) and runs scored (667). Remarkably, she struck out only 81 times in her career.

• Betty Foss was Player of the Year in 1952 and set many marks during her five-year career in the league. She led the league in hitting in her first season with a .346 average. Nineteen fifty-two was banner year for Foss as she led the league in runs (81), hits (137), doubles (26), triples (17) and RBI (74); she was selected to the All-Star team, too. She continued to lead the league in several categories the following season and was again named to the All-Star team. Her .342 career batting average is second only to her sister Joanne.

Second Base

• Sophie Kurys was a four-time All-Star second baseman. She was known for her speed and swiped a phenomenal 1,114 bases during her nine-year career in the league. She was so good at stealing bases that in one season she was successful 201 times in 203 attempts. "Flint Flash" also set the all-time record for runs scored (688).

• Jean Geissinger was selected twice to the All-Star team and led the league in RBI for two years in helping the Fort Wayne Daisies to two pennants. The excellent fielding infielder was second in hitting in 1954 with a .377 average.

Shortstop

• Dorothy Schroeder was the only player to play in all 12 seasons of the league. The three-time All-Star set career records for games played (1,249), RBI (431), at-bats (4,129), walks (696) and strikeouts (566). She ranks second in hits (870) and third in home runs (42). "Dottie" was the best fielding shortstop three times in her 12 seasons.

• Dorothy Harrell was a four-time All-Star and one of the lifetime leaders in put outs

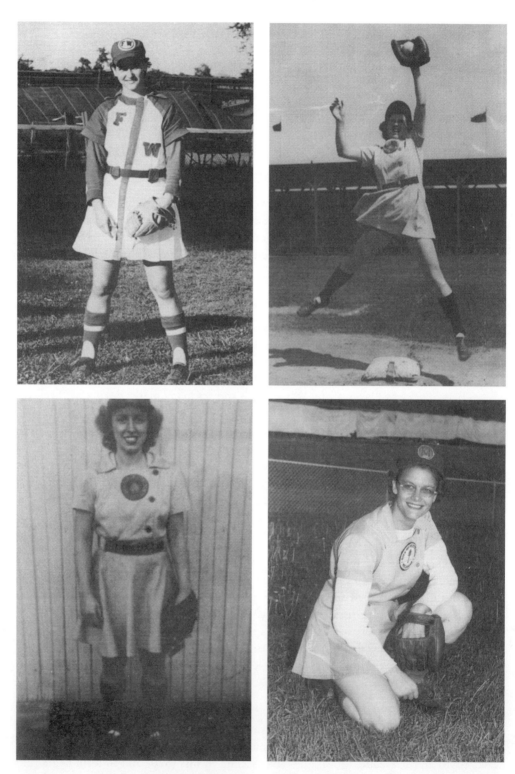

Top left: Jean Geissinger. *Top right:* Maddy English. *Bottom left:* Edythe Perlick. *Bottom right:* Doris Sams.

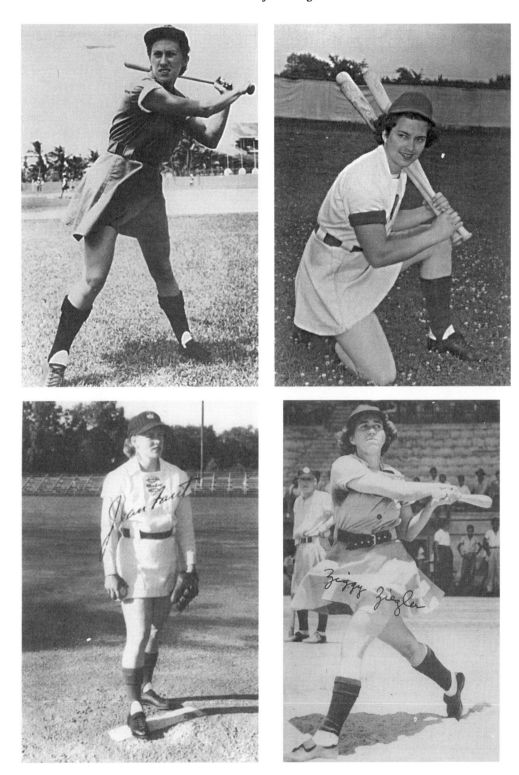

Top left: Dottie Kamenshek. *Top right:* Betty Foss. *Bottom left:* Jean Faut. *Bottom right:* Ziggy Ziegler.

and assists at shortstop. She led her Rockford team in RBI for three seasons in a row and helping the Peaches capture a championship.

Third Base

• Fern Shollenberger was named to four All-Star teams as a result of her fielding expertise. "Shelly" led third baseman for three years in a row in fielding.
• Madeline English was an excellent fielder and was picked to the All-Star team three times. "Maddy" stole seven bases in one game to tie a league record.

Outfield

• Eleanor Callow was the Babe Ruth of the AAGPBL as she hit more home runs (55) and triples (60) than any player in league history. She was picked for three All-Star teams during her seven years in the league. Besides hitting, she was a great fielder and led all outfielders in fielding in 1952.
• Eleanor Dapkus was named to the first All-Star team. She led the league in home runs (10) during the first year of the league. "Slugger" led the league in extra-base hits (19) in her second season and tied for the lead in triples (9) in 1946. She played for seven years and ended up as one of the career leaders in home runs (30).
• Edythe Perlick was one of the first girls signed to the league and she turned out to be quite a player. She was picked for the All-Star team three times. She led the league in several hitting categories during the early years of the league. She ended her eight-year career with 18 home runs, one of the best in league history.
• Doris Sams was twice named Player of the Year and five times named to the All-Star team. Primarily an outfielder, Sams also pitched for several years (64–47 record) and once had a perfect game on the mound. The prolific hitter won the batting crown (.279) in 1949 and once led the league in homers (12), in 1952.
• Audrey Wagner was selected as the Player of the Year in 1948 and twice made the All-Star team. Wagner, one of the original players in the league, led the league in several power categories year after year and hit over .300 twice during her seven years in the league. Her 55 career triples is second best in league history.
• Joanne Weaver was the best hitter in league history with the highest career average (.359) and highest season average (.429). Her 29 home runs in 1954 set a single-season record. Her prolific hitting led to her selection as Player of the Year in 1954 and three All-Star teams in her five seasons.

Pitcher

• Jean Faut was named as Player of the Year after tossing a perfect game in 1951, ending the season with a 1.33 ERA and leading her team to a league championship. The four-time All-Star set a single season record for best winning percentage in 1952 with a 20–2 record. She ended up the league with the second most career wins (140).
• Lois Florreich played on three consecutive All-Star teams and was the 1949 pitching champion. Her 0.67 ERA in 1949 was the lowest single season ERA in league history. In her last season, she compiled a 20–8 record and led the league in strikeouts (171).

• Rose Gacioch began the league in the field, but when overhand pitching was introduced she was moved to the mound to find her full potential. She twice was named as an All-Star pitcher. "Rosie" once hurled a no-hitter and tied for the league lead in wins (20) in 1952.

• Maxine Kline was a four-time All-Star who helped her team to three straight pennants. During her seven seasons, she pitched two no-hitters and led the league in several categories during the swan-song season of the league.

• Helen Nicol was the Cy Young of the AAGPBL as she compiled the most wins (163) and pitched the most games (313) and innings (2,382) of any pitcher. She was one of the few pitchers who made the successful transition from underhand to overhand pitching. "Nicki" was the pitching champion of the league the first two years of its existence.

• Dorothy Wiltse was the underhand strikeout queen as she set the single season record for K's (293). Her best seasons came when there was no All-Star team. She had the most shutouts (17) in 1945 with 17. Her 117–76 career record was among the best in the league.

Top: D. Schroeder. *Bottom left:* Joanne Weaver. *Bottom right:* Dorothy Wiltsie.

• Joanne Winter was twice an All-Star and once threw 63 consecutive scoreless innings, which resulted in six straight shutouts. Her best season came in 1946 when she compiled a 33–10 record in leading her team to a championship. Her 133 career wins ranks her third among pitchers.

• Connie Wisniewski was a Player of the Year and five-time All-Star as a pitcher and an outfielder. She began her eight-year career primarily as a pitcher and later became strictly an outfielder when the league moved to overhand pitching. "Iron Woman" earned her nickname in her second season by winning 32 games and throwing 391 innings. Her ERA was below 1.00 two seasons in a row. She ended up with the best career winning percentage (107–48) among pitchers. When she switched to the outfield, she became one of the best hitters in the league and led the league in homers (7) one season.

• Alma Ziegler began as a fielder and was moved to the mound, which proved to be her best position. She was Player of the Year in 1950 when she went 19–7. "Ziggy" led the league in ERA (1.26) the following season. She ended up playing the second most games in league history.

Individual Records

The league kept accurate records on individual players' performances through the 1948 season. After that date, no attention was paid to game performances, so the following game records are from 1943 to 1948.

INDIVIDUAL PITCHING RECORDS

Games

Most Games Pitched, Season
51-Anna May Hutchison, Racine, 1946

Most Games Pitched, Career
313-Helen Nicol

Wins

Most Wins, Season
33-Joanne Winter, Racine, 1946; Connie Wis-
 newski, Grand Rapids, 1946

Most Wins, Career
163-Helen Nicol

Most Consecutive Games Won
13-Helen Nicol, Kenosha, 1943

Losses

Most Losses, Season
23-Annabelle Lee, Peoria, 1946; Joanne Winter,
 Racine, 1944

Most Losses, Career
118-Helen Nicol

Most Consecutive Games Lost
10-Catherine Bennett, Kenosha and South Bend,
 1943

Innings Pitched

Most Innings Pitched, Game
22-Eleanor Dapkus, Racine, 1947; Jean Faut, South
 Bend, 1947

Most Innings Pitched, Season
391-Connie Wisniewski, Grand Rapids,1945

Most Innings Pitched, Career
2382-Helen Nicol

Winning Percentage

Best Winning Percentage, Season
(10 decisions)
.909 (20-2)-Jean Faut, South Bend, 1952
Bend, 1951

Best Winning Percentage, Career
(50 decisions)
.690 (107-48)-Connie Wisniewski

Earned Run Average

Best ERA, Season (200 innings)
0.67-Lois Florreich, Rockford, 1949

Best ERA, Career (50 games)
1.23-Jean Faut

Runs

Most Runs Allowed, Game
19-Martha Walker, Racine, June 19, 1943

Most Runs Allowed, Season
172-Joanne Winter, Racine, 1944

Most Runs Allowed, Career
822-Joanne Winter

Most Earned Runs Allowed, Season
104-Mary Nesbitt, Racine, 1944

Most Earned Runs Allowed, Career
499-Helen Nicol

Hits

Most Hits Allowed, Game
19-Olive Little, Rockford, June 18, 1945

Most Hits Allowed, Season
283-Josephine Kabick, Grand Rapids/Kenosha, 1946

Most Hits Allowed, Career
1579-Helen Nicol

Hit Batters

Hit Batters, Season
44-Dottie Wiltse, Minneapolis, 1944

Hit Batters, Career
121-Dottie Wiltse

Strikeouts

Most Strikeouts in Game
16-Dottie Wiltse, Ft. Wayne, June 7, 1946

Most Strikeouts, Season
293-Dottie Wiltse, Fort Wayne, 1945

Most Strikeouts, Career
1,076-Helen Nicol

Bases on Balls

Most Bases on Balls, Game
21-Martha Walker, Racine, June 19, 1943

Most Bases on Balls, Season
236-Audrey Haine, Fort Wayne/Grand Rapids, 1946

Most Bases on Balls, Career
959-Doris Barr

At-Bats

Most At-Bats Allowed, Season
1367-Connie Wisnewski, Grand Rapids, 1945

Most At-Bats Allowed, Career
7537-Helen Nicol

Wild Pitches

Wild Pitches, Season
38-Doris Barr, South Bend, Racine, 1945

Wild Pitches, Career
120-Doris Barr

Balks

*Balks, Season
6-Nelda Bird, South Bend, 1945; Mary Rini, Kenosha, 1945; Ruby Stephens, South Bend, 1947

*Balks, Career
8-Annabelle Lee

*No records for 1943, 1948

Sacrifices

Most Sacrifices Allowed, Season
53-Charlotte Armstrong, South Bend, 1945

Most Sacrifices Allowed, Career
246-Helen Nicol

Complete Games

Complete Games, Season
40-Helen Fox, Kenosha, 1945; Connie Wisniewski, Grand Rapids, 1946

Shutouts

Most Shutouts, Season
17-Dottie Wiltse, Fort Wayne, 1945; Joanne Winter, Racine, 1946

Most Consecutive Shutout Games
6-Joanne Winter, Racine, 1946: Aug. 17 vs Muskegon (9 innings); Aug. 19 vs. Peoria (9 innings); Aug. 21 vs. Peoria (7 innings; Aug. 24 vs. Muskegon (9 innings); Aug. 26 vs. Fort Wayne (9 innings); Aug. 28 vs. South Bend (9 innings).

Perfect Games

Most Perfect Games, Season
1-Jean Faut, South Bend, 1951 and 1953; Annabelle Lee, Minneapolis, 1944; Carolyn Morris, Rockford, 1945; Doris Sams, Muskegon, 1947

Most Perfect Games, Career
2-Jean Faut

Other Records

Most No-Hitters, Season
2-Olive Little, Rockford, 1943; Dorothy Wiltse, Ft. Wayne, 1945

Most No-Hitters, Career
3-Jean Cione, Rockford, Kenosha, Battle Creek, Rockford, 1947-54; Olive Little, Rockford, 1943-46; Betty Luna, Rockford, South Bend, Chicago, Ft. Wayne, 1944-49

Most Consecutive Scoreless Innings
63-Joanne Winter, Racine, 1946

INDIVIDUAL HITTING RECORDS

Games

Most Games Played, Regular Season
128-Rita Briggs, Rockford/Chicago, 1948

Most Games Played, Career
1,249-Dorothy Schroeder

Batting Average

Highest Batting Average, Season
.429-Joanne Weaver, Fort Wayne, 1954

Highest Batting Average Career (1,000 or more at-
bats)
.359-Joanne Weaver

At-Bats

Most At-Bats, Season
472-Vivian Kellogg, Fort Wayne, 1948

Most At-Bats, Career
4,129-Dorothy Schroeder

Scoring Records

Most Runs Scored, Game
5-Sophie Kurys, Racine, June 13, 1946

Most Runs Scored, Season
117-Sophie Kurys, Racine, 1946

Most Runs Scored, Career
688-Sophie Kurys

Most Consecutive Games Scoring Runs
11-Shirley Jameson, Kenosha, May 30-June 13,
1943 (22 runs)

Runs Batted In

Most Runs Batted In, Game
9-Margaret Villa, Kenosha, June 9, 1946

Most Runs Batted In, Season
91-Jean Geissinger, Fort Wayne, 1954

Most Runs Batted In, Career
431-Dorothy Schroeder

Bases on Balls

Most Bases on Balls, Game
5-Irene Hickson, Racine, June 13, 1946

Most Bases on Balls, Season
93-Sophie Kurys, Racine, 1946

Most Bases on Balls, Career
696-Dorothy Schroeder

Strikeouts

Most Strikeouts, Game
4-By many players

Most Strikeouts, Season
79-Thelda Marshall, South Bend, 1947

Most Strikeouts, Career
566-Dorothy Schroeder

Hits

Most Base Hits, Game
6-Dorothy Wind, Racine, Aug. 28, 1943

Most Base Hits, Season
144-Betty Foss, Fort Wayne, 1953

Most Base Hits, Career
1090-Dorothy Kamenshek

Longest Hitting Streak
13-Mildred Warwick, Rockford, June 20-27, 1943;
Elizabeth Mahon, South Bend, July 27-Aug.
9, 1945

Most Two-base Hits, Game
2-By many players

Most Two-base Hits, Season
34-Betty Foss, Fort Wayne, 1951

Most Two-base Hits, Career
117-Betty Foss

Most Three-base Hits, Game
3-Lois Florreich, South Bend, July 1, 1945

Most Three-base Hits, Season
17-Betty Foss, Fort Wayne, 1952

Most Three-base Hits, Career
60-Eleanor Callow

Most Home Runs, Game
2-By many players

Most Home Runs, Season
29-Joanne Weaver, Fort Wayne, 1954

Most Home Runs, Career
55-Eleanor Callow

Total Bases

Most Total Bases, Game
11-Margaret Villa, Kenosha, June 9, 1946

Most Total Advanced Bases, Game
23-Margaret Villa, Kenosha, June 9, 1946

Sacrifices

Most Sacrifice Hits, Game
3-Clara Schillace, Racine, July 7, 1943; Dorothy
Maguire, Grand Rapids, June19, 1945; Mar-
garet Danhauser, Racine, Aug. 13, 1945

Most Sacrifice Hits, Season
39-Sara Reeser, Muskegon, 1947

Stolen Bases

Most Stolen Bases, Game
7-Shirley Jameson, Kenosha, July 2, 1944; Lois

Florreich, South Bend, July 24, 1944; Betsy Jochum, South Bend, Aug. 2, 1944; Sophie Kurys, Racine, Sept. 3, 1944; Madeline English, Racine, May 21, 1947.

Most Stolen Bases, Season
201-Sophie Kurys, Racine, 1946

Most Stolen Bases, Career
1,114-Sophie Kurys

Most Consecutive Games Stealing Bases
18-Shirley Jameson, Kenosha, June 14-26, 1943

Other Records

Most Consecutive Games with No Strikeouts
57-Marge Stefani, South Bend, June 30-Aug. 22, 1943

INDIVIDUAL FIELDING RECORDS

Fielding records based on pitchers throwing in 20 games and fielders playing in 50 games a season. Career marks based on players with a minimum of six seasons.

First Base

Best Fielding Average, Season
.995-D. Kamenshek, Rockford, 1949

Best Fielding Average, Career
.982-D. Kamenshek, Rockford
.982-M. Danhauser, Racine
.982-B. Whiting, Milwaukee, Grand Rapids, Fort Wayne, Chicago, South Bend, Kalamazoo, Battle Creek

Second Base

Best Fielding Average, Season
.973-S. Kurys, Racine, Battle Creek

Best Fielding Average, Career
.957-S. Kurys, Racine, Battle Creek

Third Base

Best Fielding Average, Season
.965-E. Petras, Battle Creek, 1952

Best Fielding Average, Career
.942-F. Shollenberger, Kenosha, Kalamazoo

Shortstop

Best Fielding Average, Season
.972-A. Fischer, Muskegon, 1949

Best Fielding Average, Career
.945-L. Paire, Minneapolis, Fort Wayne, Racine, Grand Rapids, Fort Wayne

Outfield

Best Fielding Average, Season
1.000-B. Wagoner, Muskegon, South Bend, 1948

Best Fielding Average, Career
.971-D. Satterfield, Grand Rapids

Catcher

Best Fielding Average, Season
.986-M. Rountree, Fort Wayne, Grand Rapids, 1952

Best Fielding Average, Career
.973-R. Lessing, Minneapolis, Fort Wayne, Grand Rapids

Pitcher

Best Fielding Average, Season
1.000-L. Faralla, South Bend, 1951
1.000-M. Kline, Fort Wayne, 1953
1.000-J. Marlowe, Kalamazoo, 1952
1.000-M. Reynolds, Peoria, 1950
1.000-E. Roth, Kalamazoo, 1953
1.000-N. Warren, Kalamzoo, 1954

Best Fielding Average, Career
.972-M. Kline, Fort Wayne

Season Records

1943

Four teams with 64 players competed in 108 games and drew 176,000 fans during the inaugural season of the AAGPBL.

The league began with a 12-inch softball, but incorporated baseball rules. Pitchers threw an underhand fastball with a whirlwind delivery. The strong pitching led to depressed batting averages as the league hit just .230 on the season overall. The top individual pitching performance on the season was Olive Little's no-hitter, the first in league history. Helen Nicol, who won 13 consecutive games at one stretch, turned in a 31–8 performance with a 1.81 ERA. Only 72 home runs were hit during the year due to the strong pitching and fields with no fences. Just two players — Gladys Davis (.332) and Charlotte Smith (.316) — broke the .300 mark for the season.

The success that first year assured the league would continue for another season.

	G	AB	R	H	2B	3B	HR	SH	SB	LOB	Pct.
Racine	108	3510	611	865	65	50	24	122	480	626	.246
Rockford	108	3595	481	814	51	41	12	81	285	700	.226
South Bend	108	3578	539	806	73	40	14	79	475	748	.225
Kenosha	108	3603	550	794	54	59	22	110	352	647	.220

FINAL STANDINGS

Composite standings

	Won	Lost	Pct.	GB
Racine	59	49	.546	—
South Bend	58	50	.546	1
Kenosha	56	52	.519	3
Rockford	43	65	.398	16

(Note: Racine won first half with 34-20 record; Kenosha won second half with 33-21 record.)

Racine, W-59 L-49

POS	Player	G	AB	BA	HR	RBI	PO	A	E	DP
1B	M. Danhauser	61	162	.167	0	21	543	14	15	10
2B	S. Kurys	89	383	.271	3	59	190	167	36	10
SS	D. Wind	88	321	.255	2	44	129	356	79	10
3B	M. English	89	359	.220	0	23	162	259	89	15
OF	E. Dapkus	88	309	.220	10	43	94	19	11	4
OF	E. Perlick	84	310	.268	1	42	138	7	12	2
OF	C. Schillace	102	350	.251	1	38	150	16	19	1
C	D. Maguire	63	219	.269	0	33	162	28	21	9
1B	*D. Hunter	74	254	.224	1	28	736	15	21	16
U	C. Smith	53	149	.316	0	18	51	36	17	3
C	I. Hickson	58	193	.280	1	24	165	44	18	3

*Season split between Kenosha/Racine

		G	IP	W	L	ERA
P	J. Winter	29	200	11	11	2.57
P	M. Nesbitt	47	308	26	13	2.63
P	A. Thompson	32	223	11	15	3.51
P	G. Marks	29	166	11	9	4.03

South Bend, 58-50

POS	Player	G	AB	BA	HR	RBI	PO	A	E	DP
1B	J. Hagemann	108	373	.225	1	45	1122	35	21	39
2B	M. Stefani	99	397	.249	4	55	314	265	38	24
SS	D. Schroeder	98	298	.188	1	31	185	270	38	18
3B	L. Florreich	79	351	.231	4	43	143	192	57	13
OF	J. D'Angelo	104	358	.221	0	21	543	14	15	10
OF	M. Holle	79	332	.190	0	21	145	56	14	2
OF	B. Jochum	101	439	.273	1	35	118	17	9	4
C	M. Baker	66	73	.250	1	31	299	72	20	7
3B	B. Chester	17	58	.190	0	5	25	31	17	1
C	L. MacLean	47	228	.206	0	22	187	26	10	6

		G	IP	W	L	ERA
P	M. Berger	47	306	25	13	1.91
P	D. Barr	32	254	15	13	2.90
P	R. Born	11	67	4	5	3.59
P	*C. Bennett	15	189	8	13	3.81
P	**M. Coben	21	193	4	16	4.71

*Split season between South Bend and Kenosha.
**Split season between South Bend and Rockford.

Kenosha, 56-52

POS	Player	G	AB	BA	HR	RBI	PO	A	E	DP
1B	J. O'Hara	92	337	.187	0	28	818	20	33	18
2B	M. Lester	94	319	.210	0	31	190	124	31	11
SS	P. Pirok	88	333	.234	0	33	191	198	49	10
3B	A. Harnett	98	387	.271	6	69	214	268	59	11
OF	S. Jameson	105	399	.271	4	32	210	11	7	3
OF	P. Koehn	48	353	.238	4	52	213	47	23	8
OF	A. Wagner	66	257	.230	4	43	59	4	5	1
C	H. Westerman	81	263	.183	0	21	395	60	21	8

POS	Player	G	AB	BA	HR	RBI	PO	A	E	DP
1B	*D. Hunter	74	254	.224	1	28	736	15	21	16
OF	D. Michelson	43	161	.199	0	29	34	3	4	0
U	**E. McCreary	16	231	.251	1	36	57	8	4	1
C	K. Heim	25	77	.117	0	6	115	16	5	1

*Split season between Kenosha and Racine.
**Split season between Kenosha and Rockford.

		G	IP	W	L	ERA
P	H. Nicol	47	348	31	8	1.81
P	E. Harney	45	304	19	19	2.93
P	J. O'Hara	3	14	1	0	3.21
P	A. Wagner	5	30	1	2	3.65
P	*C. Bennett	31	189	8	13	3.81
P	**C. Cook	15	203	6	17	4.42
P	M. Nearing	5	19	0	1	7.43

*Split season between Kenosha and South Bend.
**Split season between Kenosha and and Rockford.

Rockford, 43-65

POS	Player	G	AB	BA	HR	RBI	PO	A	E	DP
1B	D. Kamenshek	89	395	.271	3	39	864	16	32	23
2B	M. Deegan	17	97	.206	0	17	48	37	8	3
SS	G. Davis	77	349	.332	4	58	183	279	64	14
3B	M. Warwick	88	354	.263	1	30	173	316	64	11
OF	E. Burmeister	43	377	.191	0	41	152	184	41	7
OF	B. Fritz	98	348	.210	0	43	152	17	9	4
OF	B. Moczynski	59	208	.173	1	27	75	7	4	0
C	H. Nelson	70	214	.210	0	20	204	49	19	7
SS	I. Ruhnke	19	285	.253	1	36	41	38	20	2
OF	B. Melin	42	146	.158	2	4	27	4	3	1
C	D. Green	48	128	.164	0	4	162	15	8	2
U	*E. McCreary	16	231	.251	1	36	57	8	4	1

*Split season between Rockford and Kenosha.

		G	IP	W	L	ERA
P	O. Little	44	288	21	15	2.56
P	M. Peters	39	270	12	19	3.10
P	M. Pratt	24	150	5	11	3.93
P	*C. Cook	30	203	6	17	4.42
P	**M. Coben	21	193	4	16	4.71

*Split season between Rockford and Kenosha.
**Split season between South Bend and Rockford.

BATTING AND BASE RUNNING LEADERS

Batting Average *(Played at least 54 games)*

G. Davis, Roc	.332	D. Kamenshek, Roc	.271
M. Nesbitt, Rac	.280	S. Kurys, Rac	.271
I. Hickson, Rac	.280	D. Maguire, Rac	.269
B. Jochum, SB	.273	D. Barr, SB	.269
S. Jameson, Ken	.271	E. Perlick, Rac	.268

Home Runs

E. Dapkus, Rac	110
A. Harnett, Ken	6
G. Davis, Roc	4
S. Jameson, Ken	4
M. Stefani, SB	4
P. Koehn, Ken	4
L. Florreich, SB	4
A. Wagner, Ken.	4
D. Kamenshek, Roc	3
S. Kurys, Rac	3

Total Bases

G. Davis, Roc	155
A. Harnett, Ken	153
B. Jochum, SB	149
S. Jameson, Ken	146
M. Stefani, SB	139
S. Kurys, Rac	135
D. Kamenshek, Roc	128
P. Koehn, Ken	117
M. Warwick, Roc	115
L. Florreich, SB	114

RBI

A. Harnett, Ken	69
S. Kurys, Rac	59
G. Davis, Roc	58
M. Stefani, SB	55
P. Koehn, Ken	52
J. Hagemann, SB	45
D. Wind, Rac	44
L. Florreich, SB	43
B. Fritz, Roc	43
E. Dapkus, Rac	42
E. Perlick, Rac	42

Stolen Bases

S. Jameson, Ken.	126
M. Stefani, SB	90
M. English, Rac	75
I. Hickson, Rac	68
B. Jochum, SB	66
L. Florreich, SB	57
E. Perlick, Rac	55
C. Smith, Rac	54

G. Davis, Roc	53
M. Baker, SB	46

Hits

B. Jochum, SB	120
G. Davis, Roc	116
S. Jameson, Ken	108
D. Kamenshek, Roc	107
A. Harnett, Ken	105
S. Kurys, Rac	104
M. Stefani, SB	99
M. Warwick, Roc	93
C. Schillace, Rac	88
J. Hagemann, SB	85

Runs Scored

S. Jameson, Ken	111
M. Stefani, SB	87
G. Davis. Roc	78
B. Jochum, SB	70
M. English, Rac	69
C. Schillace, Rac	65
J. D'Angelo, SB	62
I. Hickson, Rac	62
M. Warwick, Roc	62
S. Kurys, Rac	60

Doubles

B. Jochum, SB	12
A. Harnett, Ken	10
J. Hagemann, SB	10
E. Perlick, Rac	10
P. Koehn, Ken	9
L. Florreich, SB	9
E. Burmeister, Roc	8
S. Kurys, Rac	8

Triples

M. Stefani, SB	11
G. Davis, Roc	10
A. Wagner, Ken	10
S. Jameson, Ken	10
A. Harnett, Ken	10
B. Jochum, SB	7
E. Burmeister, Roc	7
S. Kurys, Rac	7
M. Warwick, Roc	7
D. Wind, Rac	7

PITCHING LEADERS

Earned Run Average

H. Nicol, Ken	1.81		D. Barr, SB	2.90
M. Berger, SB	1.91		E. Harney, Ken	2.93
A. Little, Roc	2.56		M. Peters, Roc	3.10
J. Winter, Rac	2.57		A. Thompson, Rac	3.51
M. Nesbitt, Rac	2.63		R. Born, SB	3.59

Wins

H. Nicol, Ken	31
M. Nesbitt, Rac	26
M. Berger, SB	25
A. Little, Roc	21
E. Harney, Ken	19
D. Barr, SB	15
M. Peters, Roc	11
J. Winter, Rac	11
G. Marks, Rac	11

Winning Percentage

H. Nicol, Ken	.795
M. Nesbitt, Rac	.667
M. Berger, SB	.658
A. Little, Roc	.583
G. Marks, Rac	.550
D. Barr, SB	.536

Strikeouts

H. Nicol, Ken	220
A. Little, Roc	151
M. Berger, SB	112
E. Harney, Ken	102

Complete Games

H. Nicol, Ken	33
E. Harney, Ken	30
M. Berger, SB	29
M. Nesbitt, Rac	29
A. Little, Roc	28
M. Peters, Roc	24
D. Barr, SB	22

Shutouts

H. Nicol, Ken	8
A. Little, Roc	8
M. Nesbitt, Rac	6
C. Bennett, Ken/SB	3

Innings Pitched

H. Nicol, Ken	348
M. Nesbitt, Rac	308
M. Berger, SB	306
E. Harney, Ken	304
A. Little, Roc	288
M. Peters, Roc	270
D. Barr, SB	254
A. Thompson, Rac	223

1944

The league expanded in its second year of existence. Milwaukee and Minneapolis were added to the original four-team league. The number of games in the games also increased to 118.

Attendance also increased to 260,000 fans, a 49 percent raise. However, crowds were so sparse in Minneapolis that the team was put on the road most of the season. The ball was decreased in size to 11½ inches. The base paths were lengthened to 68 feet. Batting averages plummeted to about .200 as pitchers continued to dominate the league. Helen Nicol turned in a 0.98 ERA on the season to lead all pitchers. Minneapolis' Annabelle Lee pitched the first perfect game in the history of the league against Kenosha. Six no-hitters were thrown during the year. No batters surpassed .300 on the year.

	G	AB	R	H	2B	3B	HR	SH	SB	LOB	Pct.
Milwaukee	115	3498	492	725	39	30	12	82	730	693	.207
Rockford	113	3600	412	739	49	42	4	82	458	761	.205
Minneapolis	117	3711	434	742	47	31	12	66	446	774	.200
Racine	117	3603	494	716	47	24	10	97	612	775	.199
Kenosha	116	3666	450	722	52	30	12	58	441	723	.197
South Bend	116	3603	410	694	28	24	7	114	625	817	.193

First Half Standings

	Won	Lost	Pct.	GB
Kenosha	36	23	.610	—
South Bend	33	25	.569	2½
Milwaukee	30	26	.536	4½
Racine	28	32	.467	8½

	Won	Lost	Pct.	GB
Rockford	24	32	.429	10½
Minneapolis	23	36	.390	13

Second Half Standings

	Won	Lost	Pct	GB
Milwaukee	40	19	.678	—
South Bend	31	27	.534	8½
Rockford	29	28	.509	10
Kenosha	26	31	.456	13
Racine	25	32	.439	14
Minneapolis	22	36	.379	17½

Final Standings

	Won	Lost	Pct	GB
Milwaukee	70	45	.609	—
South Bend	64	52	.552	6½
Kenosha	62	54	.534	8½
Rockford	53	60	.469	16
Racine	53	64	.453	18
Minneapolis	45	72	.385	26½

Milwaukee, 70-45

POS	Player	G	AB	BA	HR	RBI	PO	A	E	DP
1B	B. Whiting	71	371	.202	0	34	779	26	37	26
2B	A. Ziegler	115	324	.191	0	25	361	212	27	27
SS	M. Keagle	54	406	.264	7	47	165	59	52	13
3B	D. Tetzlaff	102	345	.212	3	42	164	317	50	12
OF	*V. Panos	113	403	.263	0	31	203	19	5	5
OF	T. Eisen	107	392	.204	1	41	169	14	8	2
OF	M. Keagle	56	406	.264	7	47	165	59	52	13
C	D. Maguire	108	361	.191	1	29	310	117	47	9

*Split season between Milwaukee and South Bend.

POS	Player	G	AB	BA	HR	RBI	PO	A	E	DP
1B	D. Klosowski	20	72	.222	0	12	225	7	5	13
SS	E. Petras	25	82	.092	0	8	39	62	15	1
3B	V. Anderson	10	34	.147	0	1	22	22	7	1
U	*G. Davis	82	277	.246	1	34	102	94	29	7
U	E. Stevenson	29	74	.162	0	5	27	11	2	3
U	**K. Blumetta	27	82	.110	0	7	154	6	4	7
OF	***M. Kazmierczak	13	31	.032	0	2	5	0	1	0
OF	****J. Figlo	11	34	.059	0	3	11	0	4	0
OF	O. Grant	19	73	.147	0	6	17	0	1	0
OF	S. Schulze	15	44	.182	0	2	14	2	2	1

*Split season between Milwaukee and Rockford.
**Split season between Milwaukee and Minneapolis.
***Split season between Milwaukee, Racine and Kenosha.
****Split season between Milwaukee and Racine.

		G	IP	W	L	ERA
P	C. Wisniewski	36	291	23	10	2.23
P	J. Kabick	45	366	26	19	2.66

		G	IP	W	L	ERA
P	A. Thompson	33	222	15	12	2.88
P	S. Wronski	13	53	4	2	3.06
P	*C. Cook	9	45	2	2	3.40

*Split season between Milwaukee and Kenosha.

South Bend, 64-52

POS	Player	G	AB	BA	HR	RBI	PO	A	E	DP
1B	J. Hagemann	116	365	.142	0	28	1167	37	22	31
2B	M. Stefani	116	400	.218	0	46	296	228	40	26
SS	D. Schroeder	116	328	.180	1	24	153	310	65	31
3B	L. Florreich	91	366	.178	1	25	178	211	37	16
OF	R. Gacioch	73	348	.161	0	37	124	87	9	6
OF	L. Surkowski	97	335	.212	3	29	135	19	5	4
OF	B. Jochum	112	433	.296	1	35	118	17	9	4
C	M. Baker	107	373	.236	0	41	437	101	32	6
OF	*V. Panos	113	403	.263	0	31	203	19	5	5
OF	J. D'Angelo	40	141	.149	0	38	56	5	0	1
U	**L. Dwojak	28	174	.201	0	19	52	24	7	0
C	L. MacLean	15	174	.075	0	22	187	26	10	6

*Split season between South Bend and Milwaukee.
**Split season between South Bend and Minneapolis.

		G	IP	W	L	ERA
P	C. Armstrong	39	321	21	15	1.51
P	M. Berger	41	315	21	17	1.57
P	C. Bennett	34	229	14	9	2.04
P	D. Barr	29	148	8	11	2.98

Kenosha, 62-54

POS	Player	G	AB	BA	HR	RBI	PO	A	E	DP
1B	G. Ganote	86	338	.133	0	11	819	8	10	14
2B	*E. Mahon	86	341	.211	3	38	186	134	21	12
SS	P. Pirok	112	404	.233	0	38	241	259	62	13
3B	A. Harnett	84	351	.248	1	45	188	260	44	4
OF	P. Koehn	92	428	.213	4	52	213	47	23	8
OF	S. Jameson	85	288	.253	2	23	156	17	8	3
OF	A. Wagner	88	317	.189	0	26	103	16	9	2
C	L. Colacito	81	268	.179	1	22	317	44	17	3

*Split season between Kenosha and Minneapolis.

POS	Player	G	AB	BA	HR	RBI	PO	A	E	DP
U	J. O'Hara	95	321	.153	1	26	90	53	33	10
OF	R. Folder	56	207	.261	1	24	43	9	2	2
OF	*M. Kazmierczak	13	31	.032	0	5	49	77	20	12
C	K. Heim	31	105	.181	1	10	114	24	9	0

*Split season between Kenosha, South Bend and Milwaukee.

		G	IP	W	L	ERA
P	H. Nicol	32	243	17	11	0.93
P	E. Harney	34	262	18	14	2.23
P	*M. Pratt	41	303	21	15	2.50
P	G. Ganote	12	91	4	6	3.26

		G	IP	W	L	ERA
P	**C. Cook	9	45	2	2	3.40
P	R. Folder	14	73	2	7	5.67

*Split season between Kenosha and Rockford .
**Split season between Kenosha and Milwaukee.

Rockford, 53-60

POS	Player	G	AB	BA	HR	RBI	PO	A	E	DP
1B	D. Kamenshek	113	447	.257	1	23	1215	39	31	32
2B	M. Deegan	96	353	.232	1	39	227	153	12	20
SS	D. Harrell	92	322	.177	0	14	184	224	48	15
3B	M. Warwick	97	342	.208	1	37	188	237	48	13
OF	J. Lenard	97	356	.211	0	34	128	8	5	2
OF	D. Nelson	99	373	.231	1	23	181	9	12	3
OF	E. Burmeister	42	194	.211	0	19	60	45	11	1
C	D. Green	98	290	.145	0	20	366	93	18	10
U	*G. Davis	60	277	.246	1	34	102	94	29	7
U	**I. Ruhnke	88	296	.193	0	26	124	60	29	6
OF	***M. Wigiser	72	273	.212	2	38	78	16	16	4
C	L. Daetweiller	19	76	.079	0	8	38	7	12	0

*Split season between Rockford and Milwaukee.
**Split season between Rockford and Minneapolis.
***Split season between Rockford and Minneapolis.

		G	IP	W	L	ERA
P	C. Morris	44	343	23	18	2.15
P	*M. Pratt	41	207	21	15	2.61
P	B. Luna	27	207	12	13	2.61
P	A. Applegren	36	250	16	15	2.77
P	M. Peters	9	70	1	5	3.34
P	**M. Jones	28	175	6	12	3.33
P	***E. Farrow	19	99	1	12	5.61

*Split season between Rockford and Kenosha.
**Split season between Rockford and Minneapolis.
***Split season between Rockford and Minneapolis.

Racine, 53-64

POS	Player	G	AB	BA	HR	RBI	PO	A	E	DP
1B	M. Danhauser	109	329	.149	0	34	1182	23	38	27
2B	S. Kurys	116	394	.244	1	60	355	188	28	20
SS	D. Wind	56	208	.240	0	19	98	141	24	13
3B	M. English	86	371	.121	0	21	201	350	63	10
OF	E. Perlick	116	423	.229	2	63	206	15	11	5
OF	C. Schillace	111	374	.209	0	30	146	20	13	4
OF	E. Dapkus	103	362	.273	5	56	70	11	7	1
C	I. Hickson	83	325	.145	0	9	186	98	16	9
3B	*J. Dusanko	58	246	.167	0	16	123	150	38	10
OF	**M. Kazmierczak	13	31	.032	0	2	5	0	1	0
U	C. Smith	42	204	.186	0	15	107	94	35	7
C	R. Knezovich	17	41	.146	0	2	29	16	2	1
C	A. Hutchison	43	115	.191	0	9	79	30	21	2
C	***E. Frank	15	46	.109	0	2	53	10	6	2

*Split season between Racine and Minneapolis.
**Split season between Racine, Milwaukee and Kenosha.
***Split season between Racine and Minneapolis.

		G	IP	W	L	ERA
P	M. Nesbitt	45	343	23	17	2.73
P	J. Jacobs	31	230	9	16	2.82
P	J. Winter	40	310	15	23	2.96
P	D. Ortman	15	99	6	8	3.36

Minneapolis, 45-72

POS	Player	G	AB	BA	HR	RBI	PO	A	E	DP
1B	V. Kellogg	97	382	.202	3	46	850	17	23	23
2B	A. Kissel	101	360	.189	1	19	261	182	37	20
SS	B. Trezza	63	194	.108	2	16	113	132	20	4
3B	M. Callaghan	47	154	.182	0	10	69	95	11	5
OF	F. Dancer	86	329	.274	2	48	118	17	6	4
OF	H. Callaghan	109	397	.287	3	17	130	4	10	1
OF	*M. Wigiser	72	273	.212	2	38	78	16	16	4

*Split season between Minneapolis and Rockford.

POS	Player	G	AB	BA	HR	RBI	PO	A	E	DP
U	*C. Blumetta	33	82	.110	0	7	154	6	4	7
U	L. Paire	58	220	.241	0	20	132	125	22	10
U	**L. Dwojak	39	174	.201	0	19	52	24	7	0
U	***I. Ruhnke	86	296	.193	0	26	124	60	29	6
C	L. Borg	23	83	.133	0	2	157	12	10	1
C	****E. Frank	15	46	.109	0	2	53	10	6	2
C	R. Lessing	57	198	.177	0	11	290	60	15	8

*Split season between Minneapolis and Milwaukee.
**Split season between Minneapolis and South Bend.
***Split season between Minneapolis and Rockford.
****Split season between Minneapolis and Racine.

		G	IP	W	L	ERA
P	D. Wiltse	38	297	20	16	1.88
P	A. Lee	29	211	11	14	2.43
P	*D. Jones	28	175	6	12	3.70
P	A. Haine	34	230	8	20	4.85
P	**E. Farrow	19	99	1	12	5.64

*Split season betweeen Minneapolis and Rockford.
**Split season between Minneapolis and Rockford.

BATTING AND BASE RUNNING LEADERS

Batting Average

B. Jochum, SB	.296
H. Callaghan, Mpls	.287
F. Dancer, Mpls	.274
E. Dapkus, Rac	.273
M. Keagle, Mil	.264
V. Panos, SB, Mil	.263
R. Folder, Ken	.261
D. Kamenshek, Roc	.257
S. Jameson, Ken	.253
A. Harnett, Ken	.248

Home Runs

M. Keagle, Mil	7
E. Dapkus, Rac	5
H. Callaghan, Mpls	3
D. Tetzlaff, Mil	3
L. Surkowski, SB	3
V. Kellogg, Mpls	3

Total Bases

M. Keagle, Mil	145
B. Jochum, SB	141
H. Callaghan, Mpls	136

D. Kamenshek, Roc	136
E. Dapkus, Rac	132
A. Harnett, Ken	114
E. Perlick, Rac	114
S. Kurys, Rac	112
P. Koehn, Ken	112
F. Dancer, Mpls	112

RBI

E. Perlick, Rac	63
S. Kurys, Rac	60
E. Dapkus, Rac	56
F. Dancer, Mpls	48
M. Keagle, Mil	47
M. Stefani, SB	46
V. Kellogg, Mpls	46
A. Harnett, Ken	45
P. Koehn, Ken	42
D. Tetzlaff, Mil	42

Stolen Bases

S. Kurys, Rac	166
V. Panos, SB, Mil	141
B. Jochum, SB	127
M. Keagle, Mil	122
S. Jameson, Ken	119
L. Florreich, SB	113
H. Callaghan, Mpls	112
D. Tetzlaff, Mil	101

Hits

B. Jochum, SB	128
D. Kamenshek, Roc	115
H. Callaghan, Mpls	114
M. Keagle, Mil	107
V. Panos, SB, Mil	106
E. Dapkus, Rac	99

E. Perlick, Rac	97
S. Kurys, Rac	96
P. Pirok, Ken	94
P. Koehn, Ken	91

Runs Scored

S. Kurys, Rac	87
V. Panos, SB, Mil	84
H. Callaghan, Mpls	81
P. Pirok, Ken	73
B. Jochum, SB	72
M. Keagle, Mil	72
C. Schillace, Rac	65
S. Jameson, Ken	64
P. Koehn, Ken	62
D. Tetzlaff, Mil	62

Doubles

E. Dapkus, Rac	10
P. Pirok, Ken	10
D. Kamenshek, Roc	8
A. Harnett, Ken	8
L. Paire, Mpls	8
J. Lenard, Roc	8
V. Kellogg, Mpls	8
S. Kurys, Rac	7
L. Colacito, Ken	7
M. Keagle, Mil	7
E. Perlick, Rac	7
L. Surkowski, SB	7

Triples

J. Lenard, Roc	10
A. Harnett, Ken	8
V. Kellogg, Mpls	7
L. Florreich, SB	6
P. Koehn, Ken	6

PITCHING LEADERS

Earned Run Average

H. Nicol, Ken	0.93
C. Armstrong, SB	1.51
M. Berger, SB	1.57
D. Wiltse, Mpls	1.88
C. Bennett, SB	2.04

C. Morris, Roc	2.15
C. Wisniewski, Mil	2.23
E. Harney, Ken	2.23
A. Lee, Mpls	2.43
M. Pratt, Roc, Ken	2.50

1945

The 1945 season began with same amount of teams as the year before, but Milwaukee was moved to Grand Rapids, Michigan and Minneapolis was replaced by the Fort Wayne Daisies. This was due to the poor attendance figures the year before. The move was a wise one as attendance soared to 450,000. Close races for the playoff spots also helped boost the crowds.

Pitchers continued to dominate the league, although the rubber was moved back two feet to 42. A record eight no-hitters were recorded during the season. Rockford's Carolyn Morris hurled a perfect game against Fort Wayne. South Bend's Betty Luna hurled four consecutive shutouts at one stretch during the season. Connie Wisniewski's .081 ERA was the best in the league, as were her 32 victories. Mary Crews (.319) was the only hitter to break .300. Just 38 homers were hit during the season.

	G	AB	R	H	2B	3B	HR	SH	SB	LOB	Pct.
South Bend	110	3320	349	708	65	42	3	93	193	731	.213
Rockford	111	3490	421	713	76	25	7	134	278	641	.204
Fort Wayne	112	3388	376	639	59	17	11	156	241	714	.189
Racine	110	3347	331	604	36	20	7	123	325	701	.180
Grand Rapids	110	3399	333	603	57	18	2	141	276	704	.177
Kenosha	111	3327	262	553	34	26	8	102	265	620	.166

Final Standings

	Won	Lost	Pct.	GB
Rockford	67	43	.609	—
Fort Wayne	62	47	.569	4½
Grand Rapids	60	50	.545	7
Racine	40	50	.455	17
South Bend	40	60	.450	22
Kenosha	41	69	.372	26½

Rockford, 67-43

POS	Player	G	AB	BA	HR	RBI	PO	A	E	DP
1B	D. Kamenshek	108	419	.274	0	26	1022	27	30	27
2B	M. Deegan	101	346	.208	1	34	215	156	30	15
SS	D. Harrell	92	310	.239	0	27	200	221	38	18
3B	H. Filarski	99	324	.173	0	25	171	208	49	7
OF	J. Lenard	95	330	.170	0	24	140	10	1	2
OF	M. Wigiser	83	309	.250	2	35	156	8	6	1
OF	R. Gacioch	103	374	.211	0	44	156	31	8	0
C	K. Rohrer	76	327	.239	2	26	396	106	21	10
3B	D. Ferguson	11	84	.131	0	4	20	24	6	0
OF	I. Kotowicz	47	154	.154	0	12	72	0	2	0
OF	J. Cione	14	45	.093	0	1	19	0	1	0
C	D. Green	44	117	.145	0	5	148	20	6	0

		G	IP	W	L	ERA
P	C. Morris	42	333	28	12	1.08
P	O. Little	34	295	22	11	1.68
P	*B. Carveth	21	138	4	11	2.28
P	A. Applegren	29	214	13	11	2.44
P	A. Fischer	16	98	4	7	3.77

*Split season between Rockford and Fort Wayne.

Fort Wayne, 62-47

POS	Player	G	AB	BA	HR	RBI	PO	A	E	DP
1B	V. Kellogg	103	383	.214	1	38	915	23	21	25
2B	I. Ruhnke	67	290	.155	0	16	161	120	31	13
SS	L. Paire	110	392	.196	0	39	205	226	39	9
3B	M. Callaghan	99	280	.196	1	17	176	238	40	10
OF	H. Callaghan	111	408	.299	3	29	210	11	11	4

POS	Player	G	AB	BA	HR	RBI	PO	A	E	DP
OF	F. Dancer	89	343	.195	3	29	147	15	11	4
OF	P. O'Brien	77	282	.216	1	23	236	10	14	5
C	R. Lessing	110	342	.123	1	31	634	83	13	8
2B	*B. Trezza	83	276	.112	0	16	161	124	10	12
OF	L. Jackson	59	188	.122	1	12	69	7	3	2

*Split seasons between Fort Wayne and South Bend.

		G	IP	W	L	ERA
P	D. Wiltse	46	345	29	10	0.83
P	A. Lee	31	243	13	16	1.56
P	*B. Carveth	21	138	4	11	2.28
P	A. Haine	32	223	16	10	2.46
P	M. Marsh	3	17	0	2	3.19
P	**A. Zurowski	4	12	0	1	5.89

*Split season between Fort Wayne and Rockford.
**Split season between Fort Wayne and Racine.

Grand Rapids, 60-50

POS	Player	G	AB	BA	HR	RBI	PO	A	E	DP
1B	B. Whiting	92	358	.176	0	14	1132	16	19	36
2B	A. Ziegler	103	365	.140	0	15	254	213	26	24
SS	E. Petras	110	359	.162	0	29	216	267	43	27
3B	D. Tetzlaff	110	378	.190	0	24	169	368	64	18
OF	T. Shively	106	372	.196	1	23	234	9	8	2
OF	T. Eisen	107	392	.240	1	34	220	14	10	4
OF	E. Wicken	87	319	.188	0	28	103	12	6	0
C	D. Maguire	96	327	.159	0	20	245	77	27	8
1B	C. Blumetta	19	67	.104	0	0	107	6	8	10
OF	P. Francisco	12	39	.154	0	1	9	2	0	1
OF	M. Wenzell	19	93	.172	0	11	23	4	1	0

		G	IP	W	L	ERA
P	C. Wisniewski	46	391	32	11	0.81
P	J. Kabick	35	292	16	18	1.85
P	A. Thompson	34	260	11	19	1.90
P	C. Blumetta	4	18	1	2	6.00

Racine, 40-50

POS	Player	G	AB	BA	HR	RBI	PO	A	E	DP
1B	M. Danhauser	110	335	.093	0	10	1140	30	15	34
2B	S. Kurys	105	347	.239	1	15	284	168	15	25
SS	B. Emry	84	180	.143	0	29	133	159	17	3
3B	M. English	98	349	.155	0	16	183	228	52	16
OF	E. Dapkus	100	345	.229	0	37	73	13	1	3
OF	C. Schillace	105	357	.185	1	26	182	12	7	3
OF	E. Perlick	107	389	.213	2	41	220	14	12	5
C	I. Hickson	96	318	.173	0	21	311	92	29	8
C	A. Hutchison	20	55	.127	0	9	40	12	3	2

		G	IP	W	L	ERA
P	*D. Barr	31	252	22	11	1.71
P	M. Crews	37	284	16	19	1.87
P	J. Winter	34	256	7	22	2.53
P	J. Jacobs	21	125	7	9	2.86

		G	IP	W	L	ERA
P	**A. Zurowski	4	12	0	1	5.89
P	F. Ferguson	1	11	0	0	4.90

*Split season between South Bend and Racine.
**Split season between Racine and Fort Wayne.

South Bend, 40-60

POS	Player	G	AB	BA	HR	RBI	PO	A	E	DP
1B	G. Ganote	62	287	.133	0	11	819	8	10	14
2B	M. Stefani	58	337	.231	1	39	514	127	19	14
SS	*D. Schroeder	94	312	.192	2	19	154	232	51	15
3B	*P. Koehn	72	408	.233	1	43	161	188	35	5
OF	E. Mahon	79	260	.246	0	21	78	12	4	0
OF	B. Jochum	101	388	.237	1	36	162	13	8	0
OF	L. Surkowski	102	349	.209	3	29	135	19	5	4
C	B. Baker	110	394	.236	0	21	508	69	23	5

*Split season between South Bend and Kenosha.

POS	Player	G	AB	BA	HR	RBI	PO	A	E	DP
1B	D. Klosowski	19	65	.169	0	4	225	7	5	13
2B	*B. Trezza	83	276	.112	0	16	161	124	10	12
SS	**L. Stone	17	50	.040	0	2	20	37	16	1
OF	***L. Florreich	28	217	.180	0	23	79	71	16	6
OF	A. Surkowski	18	39	.103	0	1	11	2	3	1
C	K. Sopkovic	10	15	.067	0	1	8	1	1	0

*Split season between South Bend and Fort Wayne.
**Split season between South Bend and Kenosha.
***Split season between South Bend and Racine.

		G	IP	W	L	ERA
P	B. Luna	30	230	14	15	1.53
P	*D. Barr	31	252	20	8	1.71
P	C. Armstrong	46	355	18	22	1.98
P	**P. Koehn	7	52	2	4	1.90
P	N. Bird	31	223	13	17	2.70
P	G. Ganote	10	53	2	2	4.42

*Split season between South Bend and Racine.
**Split season between South Bend and Kenosha.

Kenosha, 41-69

S	Player	G	AB	BA	HR	RBI	PO	A	E	DP
1B	J. Hagemann	95	273	.117	0	9	931	22	16	23
2B	E. Fabac	105	356	.199	0	14	175	154	27	16
SS	*P. Pirok	106	355	.163	0	29	172	284	49	14
3B	K. Shinen	90	333	.168	1	20	167	271	49	11
OF	S. Jameson	91	307	.189	1	5	169	18	4	2
OF	A. Wagner	101	343	.198	2	26	93	23	8	1
OF	J. O'Hara	63	247	.150	0	16	236	10	14	5
C	A. Harnett	69	322	.202	0	25	316	112	25	5

*Split season between Kenosha and South Bend.

S	Player	G	AB	BA	HR	RBI	PO	A	E	DP
SS	*D. Schroeder	94	312	.192	2	19	154	232	51	15
OF	D. Shinen	25	83	.145	0	5	19	2	1	0
C	L. Colacito	52	177	.141	1	6	253	21	5	6

*Split season between Kenosha and South Bend.

		G	IP	W	L	ERA
P	H. Fox	46	357	24	19	1.34
P	E. Harney	43	301	14	22	2.60
P	M. Rini	23	112	2	12	3.62
P	M. Pratt	27	158	1	16	3.99

BATTING AND BASE RUNNING LEADERS

Batting Average

M. Crews, Rac	.319
H. Callaghan, FW	.299
D. Kamenshek, Roc	.274
M. Wigiser, Roc	.249
E. Mahon, SB	.246
T. Eisen, GR	.240
S. Kurys, Rac	.239
K. Rohrer, Roc	.239
D. Harrell, Roc	.239
B. Jochum, SB	.237

Home Runs

H. Callaghan, FW	3
F. Dancer, FW	3
M. Wigiser, Roc	2
K. Rohrer, Roc	2
D. Harrell, Roc	2
E. Perlick, Rac	2
A. Wagner, Ken	2
D. Schroeder, SB, Ken	2

Total Bases

H. Callaghan, FW	156
D. Kamenshek, Roc	130
T. Eisen, GR	115
B. Jochum, SB	110
M. Stefani, SB	110
M. Baker, SB	109
P. Koehn, Ken, SB	109
V. Kellogg, FW	107
E. Perlick, Rac	107

RBI

R. Gacioch, Roc	44
P. Koehn, Ken, SB	43
E. Perlick, Rac	41
M. Stefani, SB	39
L. Paire, FW	39
V. Kellogg, FW	38

E. Dapkus, Rac	37
B. Jochum, SB	36
M. Wigiser, Roc	35

Stolen Bases

S. Kurys, Rac	115
H. Callaghan, FW	92
D. Kamenshek, Roc	60
S. Jameson, Ken	58
T. Shively, GR	46
E. Perlick, Rac	44
P. O'Brien, FW	43
T. Eisen, GR	41
B. Fabac, Ken	41

Hits

H. Callaghan, FW	122
D. Kamenshek, Roc	115
P. Koehn, Ken, SB	95
T. Eisen, GR	94
M. Baker, SB	93
B. Jochum, SB	92
S. Kurys, Rac	83
E. Perlick, Rac	83
V. Kellogg, FW	82

Runs Scored

D. Kamenshek, Roc	80
H. Callaghan, FW	77
S. Kurys, Rac	73
M. Baker, SB	49
E. Perlick, Rac	47
M. Deegan, Roc	47
F. Dancer, FW	44
H. Filarski, Roc	44
T. Eisen, GR	44

Doubles

H. Callaghan, FW	17
T. Eisen, GR	16

M. Stefani, SB	13		
D. Kamenshek, Roc	11		
V. Kellogg, FW	10		
M. Deegan, Roc	9		
D. Tetzlaff, GR	9		
M. Wigiser, Roc	8		
K. Rohrer, Roc	8		
L. Surkowski, SB	8		
R. Gacioch, Roc	8		

Triples

A. Wagner, Ken	9
G. Ganote, SB	8
M. Stefani, SB	8
E. Perlick, Rac	7
V. Kellogg, FW	6
L. Florreich, SB, Ken	6

PITCHING LEADERS

Earned Run Average

C. Wisniewski, GR	0.81
D. Wiltse, FW	0.83
C. Morris, Roc	1.08
H. Fox, Ken	1.34
B. Luna, SB	1.53
A. Lee, FW	1.56
A. Little, Roc	1.68
D. Barr, SB, Rac	1.71
J. Kabick, GR	1.85
M. Crews, Rac	1.87

Wins

C. Wisniewski, GR	32
D. Wiltse, FW	29
C. Morris, Roc	28
N. Fox, Ken	24
A. Little, Roc	22
D. Barr, SB, Rac	20
C. Armstrong, SB	18
A. Haine, FW	16
J. Kabick, GR	16
M. Crews, Rac	16

Winning Percentage

C. Wisniewski, GR	.744
D. Wiltse, FW	.744
D. Barr, SB, Rac	.714
C. Morris, Roc	.700
A. Little, Roc	.667
A. Haine, FW	.615
N. Fox, Ken	.558
A. Applegren, Roc	.542

Strikeouts

D. Wiltse, FW	293
N. Fox, Ken	220
A. Little, Roc	142
N. Bird, SB	128
C. Morris, Roc	119
D. Barr, SB, Rac	104
A. Applegren, Roc	101

Innings Pitched

C. Wisniewski, GR	391
N. Fox, Ken	357
C. Armstrong, SB	355
D. Wiltse, FW	345
C. Morris, Roc	333
E. Harney, Ken	301

1946

Many changes occurred in the league during 1946. Expansion brought two more teams to the league: the Peoria Redwings and Muskegon Lassies. The ball was reduced to 11 inches in circumference, the base paths were lengthened to 72 feet and sidearm pitching was introduced. The league was moving more toward baseball.

The year was great for many hitters. Racine's Anna May Hutchison threw the only nine-inning no-hitter of the season. Other no-hitters were recorded by South Bend's Betty Luna, Rockford's Carolyn Morris and Muskegon's Irene Applegren. Hutchison also set two individual all-time records: most innings pitched in a game (19 against Peoria) and most games pitched in a season (51). Racine's Joanne Winter set a record when she threw 63 consecutive scoreless innings. Connie Wisniewski had the lowest ERA for the season (0.96). Wis-

niewski and Winter notched 33 wins during the season, the best ever in AAGPBL history. Dottie Collins set the mark for most strikeouts in a season with 294.

Great pitching meant poor hitting. Dottie Kamenshek was the only hitter to hit above .300 for the season. Racine set a club record when it scored 26 runs against Grand Rapids.

	G	*AB*	*R*	*H*	*2B*	*3B*	*HR*	*SH*	*SB*	*LOB*	*Pct.*
South Bend	112	3458	504	761	47	35	8	126	599	756	.220
Grand Rapids	112	3446	470	726	80	14	6	169	436	772	.213
Rockford	112	3419	409	726	48	36	7	170	365	678	.212
Racine	113	3566	507	752	41	48	19	108	525	785	.211
Kenosha	112	3468	373	707	48	29	12	118	354	779	.204
Muskegon	112	3446	413	688	57	26	3	105	347	756	.200
Fort Wayne	112	3390	374	623	57	28	5	111	346	732	.184
Peoria	113	3421	316	620	34	29	2	93	323	725	.181

FINAL STANDINGS

	Won	*Lost*	*Pct.*	*GB*
Racine	74	38	.661	—
Grand Rapids	71	41	.634	3
South Bend	70	42	.625	4
Rockford	60	52	.536	14
Fort Wayne	52	60	.464	22
Muskegon	46	66	.411	28
Kenosha	42	70	.375	32
Peoria	33	79	.295	41

Racine, 74-38

POS	*Player*	*G*	*AB*	*BA*	*HR*	*RBI*	*PO*	*A*	*E*	*DP*
1B	M. Danhauser	113	387	.196	2	41	1123	29	21	29
2B	S. Kurys	113	392	.286	3	33	295	239	15	26
SS	B. Trezza	67	422	.175	0	43	209	269	60	20
3B	M. English	75	257	.214	1	21	124	202	30	14
OF	C. Schillace	98	310	.161	0	18	144	8	4	1
OF	E. Dapkus	112	403	.253	8	57	117	10	4	5
OF	E. Perlick	112	431	.230	4	56	198	11	10	2
C	L. Paire	64	383	.238	0	59	377	117	31	14
C	I. Hickson	46	147	.187	1	12	183	44	9	4

		G	*IP*	*W*	*L*	*ERA*
P	J. Winter	46	349	33	10	1.19
P	A. Hutchison	51	288	26	14	1.62
P	B. Emry	15	91	7	4	2.15
P	D. Barr	21	119	6	9	3.83
P	R. Stephens	7	34	2	1	—

Grand Rapids, 71-41

POS	*Player*	*G*	*AB*	*BA*	*HR*	*RBI*	*PO*	*A*	*E*	*DP*
1B	B. Whiting	112	374	.179	0	24	1142	29	13	50
2B	A. Ziegler	101	344	.151	0	27	267	196	25	38
SS	D. Tetzlaff	112	382	.199	1	34	178	264	60	18

POS	Player	G	AB	BA	HR	RBI	PO	A	E	DP
3B	E. Petras	112	355	.192	0	34	246	354	31	22
OF	T. Shively	111	409	.247	1	45	213	15	7	5
OF	P. Gianfrancisco	98	342	.225	2	53	79	16	4	5
OF	M. Keagle	105	409	.284	2	59	177	23	15	4
C	R. Lessing	112	367	.215	1	35	472	141	22	16
2B	V. Whitman	14	45	.133	0	2	12	12	1	2
SS	*E. Adams	18	86	.140	0	1	12	22	8	1
OF	*E. Wingrove	35	110	.209	0	7	37	3	4	0
OF	**B. Wicken	27	88	.159	0	6	29	5	1	0

*Split season between Grand Rapids and Fort Wayne.
**Split season between Muskegon and Grand Rapids.

		G	IP	W	L	ERA
P	C. Wisniewski	48	366	33	9	0.96
P	M. Keagle	6	51	3	2	1.94
P	*J. Kabick	40	324	19	19	2.39
P	A. Haylett	38	297	17	21	2.97
P	**A. Haine	30	208	14	11	4.02

*Split season between Grand Rapids and Kenosha.
**Split season between Grand Rapids and Fort Wayne.
Chaperone: Dorothy Hunter

South Bend, 70-42

POS	Player	G	AB	BA	HR	RBI	PO	A	E	DP
1B	I. Voyce	104	329	.210	2	43	1163	32	39	26
2B	M. Stefani	112	370	.224	1	53	327	216	34	28
SS	S. Wirth	107	372	.245	0	27	122	198	22	11
3B	J. Faut	90	344	.177	0	40	150	349	60	13
OF	B. Jochum	109	400	.250	2	63	201	12	6	3
OF	D. Junior	98	322	.186	0	22	173	7	6	0
OF	E. Mahon	112	399	.176	1	72	133	15	6	2
C	M. Baker	84	325	.286	0	31	413	82	18	10
3B	P. Pirok	21	71	.197	0	2	29	85	3	2
OF	*L. Surkowski	77	256	.200	1	28	121	3	4	1
C	D. Naum	22	72	.194	0	8	49	26	2	0
C	**J. Hill	18	57	.123	0	3	41	9	5	1

*Split season between South Bend and Rockford.
**Split season between South Bend and Fort Wayne.

		G	IP	W	L	ERA
P	J. Faut	12	81	8	3	1.32
P	B. Luna	41	298	23	13	2.30
P	P. Koehn	39	309	22	15	2.48
P	A. Thompson	31	202	15	6	2.90
P	L. Lucky	8	54	2	4	3.44
P	M. Denton	3	13	0	1	—

Rockford, 60-52

POS	Player	G	AB	BA	HR	RBI	PO	A	E	DP
1B	D. Kamenshek	107	408	.316	1	22	1019	15	16	45
2B	M. Holgerson	43	158	.190	0	7	66	48	5	6
SS	D. Harrell	88	301	.213	0	26	146	237	39	20
3B	H. Filarski	70	231	.182	1	23	233	202	32	13

POS	Player	G	AB	BA	HR	RBI	PO	A	E	DP
OF	*L. Surkowski	77	256	.200	1	28	121	3	4	1
OF	R. Gacioch	107	405	.262	1	57	147	30	9	4
OF	N. Meier	101	374	.249	1	49	165	8	10	2
C	D. Green	76	206	.116	0	13	413	68	21	4

*Split season between Rockford and South Bend.

POS	Player	G	AB	BA	HR	RBI	PO	A	E	DP
OF	M. Wigiser	34	118	.203	0	15	37	5	2	0
OF	B. Yahr	23	76	.171	0	8	31	1	4	0
C	R. Heafner	44	128	.141	0	8	202	30	11	4
U	*D. Ferguson	50	235	.183	0	15	138	131	23	10
U	**V. Abbott	52	169	.178	0	5	52	107	20	10
U	M. Deegan	60	272	.213	2	25	109	72	13	6

*Split season between Rockford and Peoria.
**Split season between Rockford, Kenosha and Peoria.

		G	IP	W	L	ERA
P	C. Morris	48	356	29	13	1.42
P	M. Deegan	21	139	10	5	2.40
P	A. Little	34	247	14	17	2.51
P	M. Pratt	14	69	1	7	4.83
P	D. Moon	15	63	2	6	6.89
P	R. Gacioch	4	34	2	2	—
P	M. Holgerson	5	33	2	2	—

Fort Wayne, 52-60

POS	Player	G	AB	BA	HR	RBI	PO	A	E	DP
1B	V. Kellogg	89	324	.191	0	31	802	33	18	15
2B	I. Ruhnke	61	389	.193	1	50	159	87	19	3
SS	M. Pieper	80	289	.173	1	24	161	183	43	14
3B	M. Callaghan	111	340	.188	1	11	236	290	52	21
OF	F. Dancer	72	368	.250	1	43	307	8	12	11
OF	H. Callaghan	112	399	.213	1	26	249	20	23	3
OF	I. Kotowicz	37	121	.190	0	7	31	3	3	1
C	K. Vonderau	98	289	.149	0	30	452	70	27	8
SS	*E. Adams	18	86	.140	0	1	12	22	8	1
C	K. Beare	24	45	.111	0	0	61	10	4	2
OF	A. Tognatti	19	45	.204	0	3	15	5	1	2
OF	*E. Wingrove	35	110	.209	0	7	37	3	4	0
U	A. DeCambra	70	314	.185	0	11	113	103	20	7

*Split season between Fort Wayne and Grand Rapids.

		G	IP	W	L	ERA
P	F. Dancer	21	148	10	9	1.93
P	D. Collins	49	357	22	20	2.32
P	A. DeCambra	16	354	7	5	2.81
P	*E. Harney	33	966	10	20	2.93
P	**A. Haine	30	208	14	11	4.02
P	B. Podolski	2	17	1	1	—
P	L. Arnold	6	40	2	4	—
P	M. Moraty	6	28	0	2	—

Muskegon, 46-66

POS	Player	G	AB	BA	HR	RBI	PO	A	E	DP
1B	S. Reeser	110	382	.207	1	39	1213	31	13	31
2B	*E. Wawryshyn	62	235	.217	0	18	125	103	21	8
SS	D. Stolze	61	273	.194	0	34	145	125	42	11
3B	A. Johnson	112	383	.163	0	31	174	277	35	17
OF	C. Pryer	108	381	.202	0	18	234	17	8	3
OF	D. Cook	78	231	.156	0	14	95	15	6	2
OF	J. Lenard	82	273	.187	0	82	128	11	7	4
C	D. Maguire	101	340	.218	1	47	378	100	39	13

*Split season between Muskegon and Kenosha.

POS	Player	G	AB	BA	HR	RBI	PO	A	E	DP
OF	*B. Wicken	27	88	.159	0	6	29	5	1	0
2B	**J. Overleese	53	174	.178	0	15	120	96	15	16
2B	D. Montgomery	17	53	.208	0	2	29	20	5	4
C	N. Metrolis	15	32	.188	0	1	47	10	4	1
U	G. Davis	46	193	.202	0	31	68	119	22	8
U	N. Warren	27	116	.155	0	3	42	45	12	3

*Split season between Muskegon and Grand Rapids.
**Split season between Muskegon and Peoria.

		G	IP	W	L	ERA
P	E. Bergmann	35	263	15	16	2.05
P	N. Warren	11	85	4	6	2.12
P	A. Fischer	29	224	11	16	2.77
P	A. Applegren	28	197	8	18	2.79
P	D. Sams	25	169	8	9	3.78

Kenosha, 42-70

POS	Player	G	AB	BA	HR	RBI	PO	A	E	DP
1B	A. Hohlmayer	110	372	.223	0	33	1186	36	25	34
2B	F. Shollenberger	90	342	.225	0	24	126	155	13	15
SS	D. Schroeder	110	334	.168	0	14	237	298	50	18
3B	M. Carey	74	310	.152	0	20	119	258	37	15
OF	S. Jameson	104	374	.198	1	9	163	11	7	1
OF	A. Wagner	109	392	.281	9	53	174	14	11	3
OF	J. O'Hara	44	168	.149	0	10	73	159	8	3
C	M. Villa	97	355	.197	3	33	423	59	21	5
OF	L. Hickey	17	61	.213	0	3	11	1	2	0
OF	J. Anderson	21	75	.173	0	2	10	1	1	0
C	A. Harnett	16	58	.224	0	3	55	13	5	2
U	*V. Abbott	52	169	.178	0	5	52	107	20	10

*Split season between Rockford, Kenosha and Peoria.

		G	IP	W	L	ERA
P	N. Fox	33	231	15	17	2.09
P	*J. Kabick	40	324	19	19	2.39
P	L. Florreich	33	244	9	16	2.40
P	T. Kobuczewski	21	123	3	9	2.71
P	**E. Harney	33	255	10	20	2.93
P	J. Anderson	10	36	0	6	—

*Split season between Kenosha and Grand Rapids.
**Split season between Kenosha and Fort Wayne.

Peoria, 33-79

POS	Player	G	AB	BA	HR	RBI	PO	A	E	DP
1B	J. Cione	100	343	.172	0	23	1027	36	32	33
2B	*J. Overleese	53	174	.178	0	15	120	96	15	16
SS	R. Meyer	103	339	.168	0	19	218	235	60	20
3B	T. Donahue	57	274	.153	0	14	146	163	26	14
OF	T. Eisen	91	363	.256	2	30	155	5	4	0
OF	M. Wood	83	269	.193	0	13	160	13	15	2
OF	H. Machado	69	252	.183	0	14	81	6	7	0
C	M. Rountree	86	291	.216	0	41	308	74	24	7

*Split season between Peoria and Muskegon.

OF	N. Stoll	53	164	.140	0	14	77	8	5	3
OF	M. Lawson	24	57	.105	0	1	27	3	2	1
OF	L. Florreich	31	231	.234	0	21	37	4	1	1
OF	P. Crawley	19	81	.086	0	4	19	7	3	1
2B	L. Faralla	41	138	.181	0	13	70	64	10	4
U	*D. Ferguson	50	235	.183	0	15	138	131	23	10
U	**V. Abbott	52	169	.178	0	5	52	107	20	10

*Split season between Peoria and Rockford.
**Split season between Rockford, Kenosha and Peoria.

		G	IP	W	L	ERA
P	C. Blumetta	26	209	11	12	1.71
P	J. Jacobs	23	164	6	12	2.13
P	M. Reynolds	13	91	3	9	2.37
P	A. Lee	37	266	12	23	2.74
P	E. Tucker	22	125	1	12	3.38
P	M. Bryson	14	71	0	8	5.32
P	F. Lovett	1	7	0	1	—
P	L. Faralla	2	4	0	1	—

BATTING AND BASE RUNNING LEADERS

Batting Average

D. Kamenshek, Roc	.316
S. Kurys, Rac	.286
M. Baker, SB	.286
M. Keagle, GR	.284
A. Wagner, Ken	.281
E. Mahon, SB	.276
R. Gacioch, Roc	.262
I. Applegren, Mus	.258
T. Eisen, Peo	.256

Home Runs

A. Wagner, Ken	9
E. Dapkus, Rac	8
E. Perlick, Rac	4
M. Villa, Ken	3
S. Kurys, Rac	3

Total Bases

A. Wagner, Ken	162
E. Dapkus, Rac	150
M. Keagle, GR	145
S. Kurys, Rac	143
D. Kamenshek, Roc	141
R. Gacioch, Roc	141
E. Mahon, SB	134
B. Jochum, SB	127
T. Shively, GR	121
T. Eisen, Peo	120

RBI

E. Mahon, SB	72
B. Jochum, SB	63
L. Paire, Rac	59
M. Keagle, GR	59
R. Gacioch, Roc	57
E. Dapkus, Rac	57

E. Perlick, Rac	56
P. Gianfrancisco, GR	53
M. Stefani, SB	53
A. Wagner, Ken	53

Stolen Bases

S. Kurys, Rac	201
T. Eisen, Peo	128
E. Mahon, SB	114
H. Callaghan, FW	114
D. Kamenshek, Roc	109
M. Keagle, GR	107
S. Jameson, Ken	98
S. Wirth, SB	89

Hits

D. Kamenshek, Roc	129
M. Keagle, GR	116
S. Kurys, Rac	112
A. Wagner, Ken	110
E. Mahon, SB	110
R. Gacioch, Roc	106
E. Dapkus, Rac	102
T. Shively, GR	101
B. Jochum, SB	100

Runs Scored

S. Kurys, Rac	117
E. Mahon, SB	90
D. Kamenshek, Roc	78

T. Shively, GR	78
E. Perlick, Rac	72
M. Stefani, SB	70
M. Callaghan, FW	70
M. Keagle, GR	69
T. Eisen, Peo	68

Doubles

M. Keagle, GR	15
A. Wagner, Ken	15
R. Gacioch, Roc	14
F. Dancer, FW	11
L. Paire, Rac	10
A. Hohlmayer, Ken	10
R. Lessing, GR	10
H. Callaghan, FW	10
T. Shively, GR	9
P. Gianfrancisco	9

Triples

R. Gacioch, Roc	9
T. Eisen, Peo	9
E. Dapkus, Rac	9
E. Perlick, Rac	8
B. Trezza, Rac	8
M. Stefani, SB	8
B. Jochum, SB	7
L. Florreich, Ken	7
E. Mahon, SB	7

PITCHING LEADERS

Earned Run Average

C. Wisniewski, GR	0.96
J. Winter, Rac	1.19
J. Faut, SB	1.32
C. Morris, Roc	1.42
A. Hutchison, Rac	1.62
C. Blumetta, Peo	1.71
F. Dancer, FW	1.93
M. Keagle, GR	1.94
E. Bergmann, Mus	2.05
N. Fox, Ken	2.09

Wins

C. Wisniewski, GR	33
J. Winter, Rac	33
C. Morris, Roc	29
A. Hutchison, Rac	26
B. Luna, SB	23
D. Collins, FW	22
P. Koehn, SB	22
J. Kabick, GR, Ken	19
A. Haylett, GR	17

Winning Percentage

C. Wisniewski, GR	.786
J. Winter, Rac	.767
J. Faut, SB	.727
C. Morris, Roc	.690
M. Deegan, Roc	.667
R. Stephens, Rac	.667
A. Hutchison, Rac	.650
B. Luna, SB	.639
B. Emry, Rac	.636

Strikeouts

D. Collins, FW	294
C. Morris, Roc	240
J. Winter, Rac	183
K. Blumetta, Peo	137
N. Fox, Ken	137
A. Haine, FW, GR	120
A. Haylett, GR	113

Innings Pitched

C. Wisniewski, GR	366

D. Collins, FW	357	B. Luna, SB	298
C. Morris, Roc	356	A. Haylett, GR	297
J. Winter, Rac	349	A. Hutchinson, Rac	288
J. Kabick, GR, Ken	324	A. Lee, Peo	266
P. Koehn, SB	309		

1947

Nearly a million fans came out to watch the eight AAGPBL teams play during the 112-game season. Attendance records were set in Muskegon, Peoria and Racine. Spring training was held in Havana, Cuba, for two weeks. Hundreds of Cubans watched them practice and nearly 55,000 attended a round-robin tournament that was held at the end of training. Racine won the tournament and received a trophy from Esther Williams.

The underhand delivery was replaced by sidearm throwing, which allowed the hitter more of an advantage. Still, Mildred Earp of Grand Rapids set a new league record with the lowest ERA on record (0.68). Muskegon's Doris Sams pitched the third perfect game in league history. Five no-hitters were recorded during the season by Racine's Doris Barr, Rockford's Marge Holgerson, Kenosha's Jean Cione, Muskegon's Erma Bergman and Betty Luna of Rockford.

Rockford's Dottie Kamenshek repeated the batting crown with a .306 average, while Audrey Wagner of Kenosha finished one percentage point behind her.

Three teams — Muskegon, Racine and Grand Rapids — fought over the regular season championship until Muskegon nailed down the victory with two days remaining on the schedule.

	G	AB	R	H	2B	3B	HR	SH	SB	LOB	Pct.
Muskegon	112	3505	340	781	60	17	4	166	408	770	.223
Peoria	113	3520	361	764	69	31	8	112	214	748	.217
Kenosha	112	3407	334	677	55	40	12	106	278	645	.199
Rockford	112	3346	291	661	46	29	10	141	305	588	.198
South Bend	113	3479	335	671	60	40	3	146	312	679	.193
Grand Rapids	112	3427	312	656	65	24	2	179	291	732	.191
Racine	112	3565	366	646	54	25	9	104	446	688	.181
Fort Wayne	112	3389	294	595	60	25	8	91	291	690	.176

FINAL STANDINGS

	Won	Lost	Pct	GB
Muskegon	69	43	.616	—
Grand Rapids	64	46	.582	4
Racine	65	47	.580	4
South Bend	57	54	.514	11½
Peoria	54	57	.487	14½
Rockford	48	63	.432	19½
Fort Wayne	44	66	.400	24
Kenosha	43	69	.384	26

Muskegon, 69-43

POS	Player	G	AB	BA	HR	RBI	PO	A	E	DP
1B	S. Reeser	110	398	.231	0	21	1213	31	12	31
2B	D. Stolze	102	383	.217	0	22	255	231	28	18
SS	A. Fischer	112	361	.202	0	35	217	311	58	22
3B	A. Johnson	112	345	.165	2	22	117	254	23	10
OF	C. Pryer	108	422	.249	1	20	204	15	1	2
OF	J. Lenard	110	391	.261	0	38	152	11	3	2
OF	D. Sams	91	346	.280	0	41	124	31	10	5
C	D. Maguire	72	232	.216	0	24	269	63	21	6
U	E. Wawryshyn	36	93	.237	0	7	35	22	3	0
OF	D. Cook	22	134	.172	0	7	23	4	1	2
C	K. Vonderau	43	148	.196	0	9	169	24	5	5

		G	IP	W	L	ERA
P	D. Sams	19	138	11	4	0.98
P	A. Applegren	27	220	16	10	1.06
P	N. Warren	31	223	17	11	1.13
P	D. Cook	25	178	14	8	1.42
P	E. Bergman	27	207	11	10	1.74
P	A. Little	1	1	0	0	—

Racine, 65-47

POS	Player	G	AB	BA	HR	RBI	PO	A	E	DP
1B	M. Danhauser	112	364	.124	1	20	1056	63	14	22
2B	S. Kurys	112	432	.229	2	19	322	215	18	14
SS	L. Paire	112	430	.226	0	50	190	266	49	12
3B	M. English	103	335	.131	1	30	172	232	37	14
OF	E. Dapkus	110	398	.216	2	41	134	16	2	3
OF	E. Perlick	112	436	.239	2	39	237	3	5	0
OF	B. Trezza	99	433	.157	1	36	218	45	7	7
C	I. Hickson	100	309	.152	0	21	497	71	14	6
C	N. Metrolis	18	47	.149	0	2	72	0	5	2
OF	S. Lonetto	16	61	.115	0	0	17	1	1	0

		G	IP	W	L	ERA
P	A. Hutchison	44	360	27	13	1.38
P	J. Winter	38	297	22	13	2.06
P	D. Barr	30	219	14	12	2.26
P	E. Dapkus	5	55	0	3	2.45
P	J. Jacobs	13	71	2	6	2.92

Grand Rapids, 65-47

POS	Player	G	AB	BA	HR	RBI	PO	A	E	DP
1B	I. Voyce	113	383	.214	1	45	1269	22	15	43
2B	A. Ziegler	112	388	.183	0	8	284	241	15	33
SS	E. Petras	112	394	.175	0	25	255	356	38	29
3B	D. Tetzlaff	89	285	.179	0	18	136	233	25	14
OF	T. Shively	102	369	.206	1	27	176	10	4	3
OF	N. Stoll	71	203	.163	0	12	107	12	3	3
OF	E. Wingrove	77	353	.169	0	15	87	13	3	2
C	R. Lessing	111	396	.205	0	42	473	141	22	16
3B	C. Barnett	28	78	.115	0	4	39	62	11	0

POS	Player	G	AB	BA	HR	RBI	PO	A	E	DP
OF	R. Richard	39	147	.177	0	7	46	2	4	0
OF	C. Wisniewski	22	189	.291	0	24	32	2	3	0
OF	P. Gianfrancisco	32	98	.163	0	5	24	3	3	1

		G	IP	W	L	ERA
P	M. Earp	35	280	20	8	.068
P	A. Haylett	31	258	19	11	1.95
P	C. Wisniewski	32	264	16	14	2.15
P	*A. Lee	24	165	9	11	2.24
P	*A. Haine	28	199	13	12	2.89
P	**B. Tucker	16	92	0	12	3.72
P	D. Satterfield	1	2	0	0	—
P	R. Richard	3	7	0	0	—

*Split season between Grand Rapids and Peoria.
**Split season between Grand Rapids and Fort Wayne.

South Bend, 57-54

POS	Player	G	AB	BA	HR	RBI	PO	A	E	DP
1B	T. Marshall	112	362	.141	0	31	1304	37	42	45
2B	M. Stefani	86	337	.237	2	38	253	243	19	26
SS	P. Pirok	68	400	.193	0	17	199	395	44	26
3B	D. Brumfield	32	103	.117	0	4	42	85	18	3
OF	D. Junior	90	248	.133	0	14	157	9	3	1
OF	B. Jochum	105	402	.211	0	42	161	11	8	1
OF	E. Mahon	82	199	.234	0	23	78	9	5	2
C	M. Baker	102	369	.217	0	20	383	86	14	7
SS	S. Wirth	47	229	.227	0	5	122	198	22	11
3B	I. Crigler	20	81	.086	0	4	19	7	3	1
OF	J. Kelley	23	107	.178	0	13	43	3	6	0
OF	E. Mahoney	45	147	.204	1	13	47	2	5	1

		G	IP	W	L	ERA
P	J. Faut	44	298	19	13	1.15
P	R. Williams	25	180	12	8	1.70
P	P. Koehn	34	265	16	16	2.17
P	R. Stephens	31	194	9	15	2.88
P	J. Bittner	8	35	1	2	1.54
P	P. Pirok	3	8	0	0	—
P	V. Thompson	1	1	0	0	—

Peoria, 55-57

POS	Player	G	AB	BA	HR	RBI	PO	A	E	DP
1B	M. Wisham	110	399	.261	3	43	1091	18	18	29
2B	*A. DeCambra	79	307	.186	0	12	173	138	16	17
SS	R. Meyer	66	257	.226	1	30	106	143	42	4
3B	M. Reynolds	93	400	.245	1	42	186	217	28	15
OF	A. Harnett	100	414	.203	0	29	221	7	8	1
OF	*F. Dancer	101	380	.237	2	26	186	21	8	1
OF	*T. Eisen	111	425	.216	3	26	207	20	9	6
C	J. Hill	87	251	.227	0	19	304	65	24	8

*Split season between Peoria and Fort Wayne.

POS	Player	G	AB	BA	HR	RBI	PO	A	E	DP
2B	S. Smith	36	171	.152	0	6	79	60	9	5
SS	M. Carey	50	194	.180	0	0	106	114	23	8

POS	Player	G	AB	BA	HR	RBI	PO	A	E	DP
3B	*H. Filarski	43	227	.185	0	12	92	144	23	8
3B	**M. Wenzell	14	72	.097	-	-	21	27	9	2
C	T. Donahue	39	115	.165	0	4	139	21	10	2
OF	J. DeNoble	11	28	.107	0	0	12	0	1	0
OF	E. Callow	41	143	.245	0	14	34	6	2	1
OF	D. Wilson	64	230	.217	0	23	44	7	8	0

*Split season between Peoria and Kenosha.
**Split season between Peoria and Fort Wayne.

		G	IP	W	L	ERA
P	D. Mueller	48	312	21	13	1.41
P	*A. Lee	24	165	9	11	2.24
P	*A. Haine	28	199	13	12	2.89
P	J. Kabick	31	231	13	16	2.34
P	**K. Blumetta	27	193	9	14	2.80
P	R. Meyer	13	75	3	6	3.12
P	**A. DeCambra	14	70	4	3	4.24
P	F. Dancer	4	26	1	2	4.17
P	M. Reynolds	3	17	0	3	2.66
P	A. Harnett	1	1	0	0	—

*Split season between Peoria and Grand Rapids.
**Split season between Peoria and Fort Wayne.

Rockford, 48-63

POS	Player	G	AB	BA	HR	RBI	PO	A	E	DP
1B	D. Kamenshek	101	366	.306	6	32	1157	34	15	26
2B	C. Doyle	46	166	.169	0	7	74	97	9	7
SS	D. Harrell	98	351	.202	1	41	206	275	49	19
3B	M. Wegman	96	297	.175	1	10	126	252	51	11
OF	R. Briggs	56	270	.215	1	15	150	23	8	5
OF	R. Gacioch	100	338	.257	1	31	127	31	7	3
OF	D. Ferguson	60	367	.166	0	20	178	95	16	11
C	J. Romatowski	80	220	.123	0	6	332	58	17	10
1B	*J. Cione	20	163	.166	1	11	202	3	7	3
2B	I. Sanvitis	19	67	.164	0	2	39	28	4	3
C	D. Green	14	26	.115	0	1	40	10	2	3
OF	L. Fisher	38	129	.116	0	9	47	6	4	2
OF	**N. Meier	91	308	.153	1	18	136	3	7	0

*Split season between Rockford and Kenosha.
**Split season between Rockford and Fort Wayne.

		G	IP	W	L	ERA
P	*J. Cione	37	271	19	14	1.30
P	B. Luna	29	234	11	14	1.65
P	L. Florreich	35	257	13	19	1.68
P	*M. Deegan	21	133	8	9	2.30
P	L. Fisher	13	69	4	4	2.35
P	M. Holgerson	27	201	9	15	2.42
P	*H. Fox	26	175	6	16	2.62
P	**B. Tucker	16	92	0	12	3.72
P	M. Pratt	4	27	0	2	6.33
P	R. Gacioch	1	4	0	0	—

*Split season between Rockford and Kenosha.
**Split season between Rockford, Fort Wayne and Grand Rapids.

Fort Wayne, 45-67

POS	Player	G	AB	BA	HR	RBI	PO	A	E	DP
1B	V. Kellogg	97	358	.206	0	23	754	36	16	21
2B	M. Callaghan	64	324	.201	1	23	228	172	40	19
SS	*M. Pieper	109	369	.225	5	38	245	247	61	10
3B	V. Abbott	56	269	.141	1	15	135	132	31	6
OF	B. Whiting	95	356	.157	1	31	270	11	7	7
OF	H. Machado	90	301	.223	0	23	180	8	10	2
OF	**N. Meier	91	308	.153	1	18	136	3	7	0
C	R. Heafner	65	198	.172	0	14	292	64	13	6

*Split season between Fort Wayne and Kenosha
**Split season between Fort Wayne and Rockford.

POS	Player	G	AB	BA	HR	RBI	PO	A	E	DP
2B	*A. DeCambra	79	307	.186	0	12	173	138	16	17
OF	*F. Dancer	101	380	.237	2	26	186	21	8	1
OF	*T. Eisen	111	425	.216	3	26	207	20	9	6
SS	**K. Schroeder	100	344	.172	0	19	215	231	44	10
C	M. Rountree	47	148	.209	0	9	243	43	15	7

*Split season between Fort Wayne and Peoria.
**Split season between Fort Wayne and Kenosha.

		G	IP	W	L	ERA
P	D. Collins	40	292	20	14	1.33
P	L. Faralla	22	123	3	12	1.98
P	*T. Kobuczewski	30	208	11	15	2.42
P	*I. Kotowicz	23	162	8	10	2.61
P	**K. Blumetta	27	193	9	14	2.80
P	***B. Tucker	16	92	0	12	3.72
P	E. Harney	17	107	2	10	3.79
P	**A. DeCambra	14	70	4	3	4.24

*Split season between Fort Wayne and Kenosha.
**Split season between Fort Wayne and Peoria.
***Split season between Fort Wayne, Rockford and Grand Rapids.

Kenosha, 43-69

POS	Player	G	AB	BA	HR	RBI	PO	A	E	DP
1B	A. Hohlmayer	76	298	.208	0	24	847	20	30	17
2B	E. Fabac	81	294	.133	1	18	131	175	14	10
SS	*D. Schroeder	100	344	.172	0	19	215	231	44	10
3B	F. Shollenberger	54	273	.165	0	10	91	170	13	6
OF	A. Wagner	107	390	.305	7	53	140	9	4	4
OF	M. Wood	69	211	.128	0	6	110	10	6	3
OF	M. Villa	54	353	.201	1	30	238	81	17	4
C	D. Naum	80	232	.207	0	9	287	56	20	11

*Split season between Kenosha and Fort Wayne.

POS	Player	G	AB	BA	HR	RBI	PO	A	E	DP
SS	*M. Pieper	109	369	.225	5	38	245	247	61	10
3B	**H. Filarski	43	227	.185	0	12	92	144	23	8
2B	***M. Deegan	23	131	.214	0	8	47	36	8	1
1B	***J. Cione	20	163	.166	1	11	202	3	7	3
1B	J. O'Hara	22	110	.173	0	19	244	10	10	3
OF	M. Kruckel	12	60	.067	0	3	4	3	2	1
OF	***C. Lobrovich	77	258	.209	0	21	69	7	6	0

*Split season between Kenosha and Fort Wayne
**Split season between Kenosha and Peoria.
***Split season between Kenosha and Rockford.

		G	IP	W	L	ERA
P	*J. Cione	37	271	19	14	1.30
P	A. Hohlmayer	16	129	7	6	1.88
P	*M. Deegan	21	133	8	9	2.30
P	**T. Kobuczewski	30	208	11	15	2.42
P	**I. Kotowicz	23	162	8	10	2.61
P	*H. Fox	26	175	6	16	2.62
P	J. O'Hara	21	118	6	8	3.51
P	M. Denton	23	112	1	10	3.54
P	A. Wagner	2	5	0	0	—

*Split season between Kenosha and Rockford.
**Split season between Kenosha and Fort Wayne.

Batting and Base Running Leaders

Batting Average

D. Kamenshek, Roc	.306
A. Wagner, Ken	.305
C. Wisniewski, GR	.291
D. Sams, Mus	.280
J. Lenard, Mus	.261
M. Wisham, Peo	.261
R. Gacioch, Roc	.257
C. Pryer, Mus	.249
M. Reynolds, Peo	.245
E. Perlick, Rac	.239

Home Runs

A. Wagner, Ken	7
D. Kamenshek, Roc	6
M. Pieper, FW, Ken	5
T. Eisen, Peo, FW	3
M. Wisham, Peo	3

Total Bases

A. Wagner, Ken	183
D. Kamenshek, Roc	156
M. Wisham, Peo	144
E. Perlick, Rac	133
M. Reynolds, Peo	128
S. Kurys, Rac	125
D. Sams, Mus	116
C. Pryer, Mus	115
J. Lenard, Mus	114
L. Paire, Rac	111

RBI

A. Wagner, Ken	53
L. Paire, Rac	50
I. Voyce, GR	45
M. Wisham, Peo	43
B. Jochum, SB	42
R. Lessing, GR	42
D. Harrell, Roc	41
D. Sams, Mus	41
E. Dapkus, Rac	41

Stolen Bases

S. Kurys, Rac	142
J. Lenard, Mus	83
E. Perlick, Rac	83
C. Pryer, Mus	76
F. Dancer, FW, Peo	71
D. Ferguson, Roc	71
B. Trezza, Rac	66
D. Kamenshek, Roc	66
D. Stolze, Mus	65
A. Ziegler, GR	62

Hits

A. Wagner, Ken	119
D. Kamenshek, Roc	112
C. Pryer, Mus	105
E. Perlick, Rac	104
M. Wisham, Peo	104
J. Lenard, Mus	102
S. Kurys, Rac	99
M. Reynolds, Peo	98
D. Sams, Mus	97
L. Paire, Rac	97

Runs scored

S. Kurys, Rac	81
E. Perlick, Rac	62
J. Lenard, Mus	58
A. Ziegler, GR	55
M. Baker, SB	54
D. Kamenshek, Roc	52
C. Pryer, Mus	51
P. Pirok, SB	51
F. Dancer, FW, Peo	51

Doubles

A. Wagner, Ken	25
M. Reynolds, Peo	17
L. Paire, Rac	14
B. Jochum, SB	11
F. Dancer, FW, Peo	11
E. Perlick, Rac	11
M. Pieper, FW, Ken	11
D. Kamenshek, Roc	10
J. Lenard, Mus	10

V. Kellogg, FW	10
T. Marshall, SB	10

Triples

M. Wisham, Peo	11
A. Wagner, Ken	9
D. Kamenshek, Roc	8
E. Mahon, SB	8
M. Mahoney, SB	7
A. Hohlmayer, Ken	6

PITCHING LEADERS

Earned Run Average

M. Earp, GR	0.68
D. Sams, Mus	0.98
I. Applegren, Mus	1.06
N. Warren, Mus	1.13
J. Faut, SB	1.15
J. Cione, Roc, Ken	1.30
D. Collins, FW	1.33
A. Hutchison, Rac	1.38
D. Mueller, Peo	1.41
D. Cook, Mus	1.42

Wins

A. Hutchison, Rac	27
J. Winter, Rac	22
D. Collins, FW	20
M. Earp, GR	20
J. Cione, Roc, Ken	19
A. Haylett, GR	19
J. Faut, SB	19
N. Warren, Mus	17

Winning Percentage

D. Sams, Mus	.733
M. Earp, GR	.714
A. Hutchison, Rac	.675
D. Cook, Mus	.636
A. Haylett, GR	.633

J. Winter, Rac	.629
D. Mueller, Peo	.618
N. Warren, Mus	.615
J. Faut, SB	.607
R. Williams, SB	.600

Strikeouts

D. Collins, FW	244
M. Earp, GR	192
J. Winter, Rac	121
A. Hutchison, Rac	120
D. Mueller, Peo	112
K. Blumetta, Peo, FW	105
J. Cione, Roc, Ken	98
J. Faut, SB	97
D. Barr, Rac	96
N. Warren, Mus	93

Innings Pitched

A. Hutchison, Rac	360
D. Mueller, Peo	312
J. Faut, SB	298
J. Winter, Rac	297
D. Collins, FW	292
M. Earp, GR	280
J. Cione, Roc, Ken	271
P. Koehn, SB	265
C. Wisniewski, GR	264

1948

The AAGPBL reached its zenith as it expanded to ten teams and attendance neared the million milestone again. Two new teams opened in Chicago and Springfield, Illinois. Spring training was held in Opa-Locka, Florida, in April.

The Springfield franchise failed to reach the attendance desired and became a traveling team. The league office took over managing the team. Several Cuban players broke into the league as a result of holding spring training there the year before. Players represented 27 different states in the United States and many provinces from Canada. A total of 21 players had been in the league for all six years of its existence.

The league continued to move more toward traditional baseball as full overhand pitching was adopted, which brought about the curveball, drop pitch, change of pace and other wizardry. The rubber was moved back to 50 feet and the distance between bases stayed at 72 feet. The ball was made yet smaller at 10⅜ inches. Pitching still outweighed hitting in the league as evidenced by Grand Rapid's Alice Haylett's 0.77 ERA. She and Racine's Eleanor Dapkus threw 10 shutouts apiece. Only Kenosha's Audrey Wagner broke the .300 batting average mark (.312).

The season began poorly for the 1947 champion Muskegon Lassies as they found themselves in the cellar. However, a late charge in August sparked by a 13-game winning streak put them back in contention and they finished second in the East behind Grand Rapids. In the West, Racine, Rockford and Peoria all took the league lead at one time or another, but Racine finished on top, the third time in six years.

	G	AB	R	H	2B	3B	HR	SH	SB	LOB	Pct.
South Bend	127	3915	410	840	45	31	3	159	227	881	.215
Grand Rapids	126	3901	460	820	87	26	14	173	312	869	.210
Muskegon	125	3845	472	806	56	30	6	189	370	826	.210
Rockford	126	3960	450	822	66	45	11	137	312	856	.208
Peoria	126	3875	485	783	78	34	11	164	357	862	.202
Fort Wayne	126	3853	397	732	39	47	5	187	330	902	.190
Racine	126	3906	453	737	67	41	14	113	487	816	.189
Kenosha	127	3935	411	737	58	40	10	127	295	828	.187
Springfield	125	3785	342	703	50	40	3	79	314	807	.186
Chicago	126	3730	346	672	58	30	6	171	334	753	.180

Eastern Division

	Won	Lost	Pct	GB
Grand Rapids	77	48	.616	—
Muskegon	67	58	.536	5
South Bend	57	69	.452	20½
Fort Wayne	53	73	.421	24½
Chicago	47	77	.379	29½

Western Division

	Won	Lost	Pct	GB
Racine	77	49	.611	—
Rockford	75	50	.600	1½
Peoria	71	55	.563	6
Kenosha	62	64	.492	15
Springfield	41	84	.328	35½

Grand Rapids, 77-48

POS	Player	G	AB	BA	HR	RBI	PO	A	E	DP
1B	I. Voyce	125	436	.227	1	52	1400	42	16	60
2B	A. Ziegler	114	454	.170	1	33	287	240	34	46
SS	*E. Petras	108	349	.218	0	32	293	71	36	42
3B	L. Paire	114	377	.186	0	27	166	355	44	21
OF	D. Satterfield	125	452	.246	1	61	234	21	6	5
OF	M. Keagle	105	423	.251	3	27	156	18	7	5
OF	C. Wisniewski	124	439	.289	7	66	95	18	10	6
C	R. Lessing	125	417	.206	0	33	556	115	17	12

*Split season between Grand Rapids and Chicago.

POS	Player	G	AB	BA	HR	RBI	PO	A	E	DP
2B	A. Foss	16	49	.122	0	5	35	26	7	2
SS	*M. Olinger	121	408	.167	2	28	217	345	86	31
3B	D. Petryna	17	61	.115	0	2	27	26	6	1
OF	H. Smith	18	52	.192	0	2	13	3	0	0
OF	L. Fisher	19	143	.161	0	7	29	2	2	0

* Split season between Grand Rapids and Chicago.

		G	IP	W	L	ERA
P	A. Haylett	32	269	25	5	.077
P	A. Ziegler	18	119	9	6	1.21
P	M. Earp	34	282	15	14	1.31
P	C. Wisniewski	8	62	3	4	2.47
P	L. Fisher	32	230	16	11	2.82
P	M. Keagle	10	51	4	3	3.67
P	F. Janssen	11	61	4	4	3.98
P	I. Voyce	4	21	1	1	3.43

Racine, 77-49

POS	Player	G	AB	BA	HR	RBI	PO	A	E	DP
1B	M. Danhauser	125	390	.167	0	38	1274	39	20	27
2B	S. Kurys	124	444	.252	3	22	284	232	27	20
SS	B. Trezza	126	469	.181	1	27	199	322	58	12
3B	M. English	121	400	.160	0	24	207	342	40	19
OF	E. Dapkus	81	411	.202	4	46	76	8	1	0
OF	P. Gianfrancisco	113	398	.204	4	35	89	8	4	1
OF	E. Perlick	111	415	.243	2	51	185	9	9	0
C	I. Hickson	97	287	.164	0	16	632	80	25	4
OF	*P. Koehn	52	256	.160	0	21	46	0	2	0
OF	G. Bureker	22	53	.140	0	2	8	1	0	1
OF	**J. Hasham	14	73	.178	0	7	15	0	20	0
U	***J. Hill	83	252	.187	0	28	295	36	8	2
C	****J. Romatowski	83	242	.211	0	27	313	99	9	11

*Split season between Racine, South Bend and Peoria.
**Split season between Racine and Muskegon.
***Split season between Racine and Chicago.
****Split season between Racine and Peoria.

		G	IP	W	L	ERA
P	J. Winter	38	329	25	12	1.18
P	E. Dapkus	39	297	24	9	1.55
P	*P. Koehn	21	128	6	8	3.02
P	G. Vincent	15	59	5	2	3.66
P	A. Hutchison	14	76	3	6	3.67
P	L. Erickson	3	11	1	0	5.74

*Split season between Racine, South Bend and Peoria.

Rockford, 75-50

POS	Player	G	AB	BA	HR	RBI	PO	A	E	DP
1B	D. Kamenshek	124	448	.186	2	35	1316	28	23	42
2B	M. Stefani	102	317	.196	0	25	217	225	30	20
SS	D. Harrell	116	414	.251	1	58	236	328	40	24
3B	A. Pollitt	102	376	.189	0	31	195	250	39	17
OF	R. Gacioch	100	426	.239	1	44	105	25	4	2

POS	Player	G	AB	BA	HR	RBI	PO	A	E	DP
OF	D. Ferguson	123	419	.153	0	16	185	19	9	3
OF	*R. Briggs	107	425	.200	0	37	252	47	17	10
C	R. Richard	94	363	.168	1	35	518	113	23	3

*Split season between Rockford and Chicago.

POS	Player	G	AB	BA	HR	RBI	PO	A	E	DP
U	B. Warfel	54	193	.166	1	15	76	90	23	10
OF	*E. Callow	107	387	.251	6	52	144	10	10	3
OF	**M. Alspaugh	46	135	.185	0	9	44	9	3	2
C	J. Lovell	36	151	.219	0	8	154	29	12	1

*Split season between Rockford and Chicago.
**Split season between Rockford and Fort Wayne.

		G	IP	W	L	ERA
P	L. Florreich	36	282	22	10	1.18
P	M. Holgerson	37	277	16	15	1.92
P	R. Gacioch	21	175	14	5	2.21
P	H. Fox	32	252	17	13	2.61
P	J. Lovell	9	54	3	4	4.00
P	M. Moore	8	45	2	3	4.00
P	B. Warfel	6	17	1	0	1.06

Peoria, 71-55

POS	Player	G	AB	BA	HR	RBI	PO	A	E	DP
1B	M. Wisham	126	438	.292	3	58	1317	37	25	39
2B	A. DeCambra	121	392	.189	0	30	272	221	19	25
SS	R. Meyer	121	457	.232	2	68	214	315	62	21
3B	M. Carey	118	428	.178	0	49	203	297	42	18
OF	F. Dancer	120	459	.237	6	34	216	18	8	4
OF	M. Reynolds	95	390	.213	0	43	88	30	8	5
OF	G. Ruiz	52	126	.095	0	8	60	3	4	2
C	T. Donahue	44	174	.098	0	18	199	29	13	7
OF	E. Roth	10	17	.235	0	2	5	1	2	0
OF	*T. Shively	75	263	.156	0	14	158	8	3	1
OF	**P. Koehn	52	256	.160	0	21	46	0	2	0
OF	*N. Meier	127	450	.222	0	47	228	5	17	2
U	***J. Hill	89	252	.187	0	28	295	36	8	2
C	*K. Vonderau	79	264	.174	0	11	343	62	30	8

*Split season between Peoria and Chicago.
**Split season between Peoria, South Bend and Racine.
***Split season between Peoria and Racine.

		G	IP	W	L	ERA
P	D. Mueller	32	267	21	9	1.11
P	*J. Hasham	10	63	0	6	2.14
P	M. Reynolds	18	135	9	6	2.27
P	E. Roth	39	225	18	15	2.38
P	A. Haine	33	228	17	14	2.92
P	**P. Koehn	21	128	6	8	3.02
P	***L. Gallegos	16	73	2	6	5.79

*Split season between Peoria and Muskegon.
**Split season between Peoria, South Bend and Racine.
***Split season between Peoria and South Bend.

Muskegon, 67-58

/POS	Player	G	AB	BA	HR	RBI	PO	A	E	DP
1B	S. Reeser	110	372	.223	0	28	1073	27	16	45
2B	D. Stolze	106	467	.242	0	29	327	208	32	26
SS	A. Fischer	89	353	.252	0	36	165	232	36	11
3B	*A. Johnson	105	373	.155	1	38	174	339	37	23
OF	C. Pryer	112	408	.262	1	29	184	13	7	2
OF	D. Sams	85	409	.257	3	59	97	13	6	2
OF	J. Lenard	120	421	.211	0	56	188	7	16	2
C	D. Chapman	124	373	.155	1	30	549	34	11	12

*Split season between Ft. Wayne and Muskegon.

/POS	Player	G	AB	BA	HR	RBI	PO	A	E	DP
1B	A. Applegren	16	133	.173	0	8	193	8	1	3
2B	*A. Foss	16	49	.122	0	5	35	26	7	2
U	D. Pearson	80	233	.150	0	12	101	119	30	7
OF	S. Lonetto	23	109	.183	1	4	18	3	1	0
OF	**J. Hasham	14	73	.173	0	7	15	0	2	0
OF	***B. Wagoner	82	248	.278	0	11	79	3	0	0
OF	****D. Cook	18	81	.123	0	6	20	7	0	0
C	G. George	14	13	.154	0	2	19	2	0	0

*Split season between Muskegon and Grand Rapids.
**Split season between Muskegon and Peoria.
***Split season between Muskegon and South Bend.
****Split season between Muskegon, Chicago and Fort Wayne.

		G	IP	W	L	ERA
P	*N. Warren	23	161	12	5	1.45
P	A. Fischer	21	129	9	7	1.47
P	D. Sams	32	268	18	10	1.54
P	**M. Kruckel	19	120	9	4	1.65
P	I. Applegren	29	210	15	12	1.76
P	J. Hasham	10	63	0	6	2.14
P	J. Bittner	21	152	9	9	2.55
P	S. Lonetto	17	97	3	9	2.78
P	***H. Walulik	17	91	2	6	3.07
P	****D. Cook	0	116	4	9	4.03

*Split season between Muskegon and Chicago.
**Split season between Muskegon and South Bend.
***Split season between Muskegon and Fort Wayne.
****Split season between Muskegon, Chicago and Fort Wayne.

Kenosha, 62-64

POS	Player	G	AB	BA	HR	RBI	PO	A	E	DP
1B	A. Hohlmayer	69	243	.144	1	17	778	10	11	12
2B	E. Fabac	123	445	.191	0	15	242	252	19	17
SS	M. Villa	103	405	.190	1	31	213	296	50	17
3B	F. Shollenberger	127	466	.210	0	17	204	401	39	24
OF	A. Wagner	117	417	.312	4	56	193	17	7	2
OF	*J. Smith	104	310	.168	1	22	135	8	12	1
OF	C. Jewett	117	430	.216	3	35	102	17	12	3
C	D. Naum	104	311	.174	0	9	393	104	16	12

*Split season between Kenosha and Ft. Wayne.

POS	Player	G	AB	BA	HR	RBI	PO	A	E	DP
1B	J. Cione	30	173	.168	1	14	346	5	6	7
3B	*M. Pieper	74	369	.190	0	37	128	176	39	6

POS	Player	G	AB	BA	HR	RBI	PO	A	E	DP
C	M. Redman	30	121	.099	0	4	94	20	4	2
U	D. Brumfield	87	261	.142	0	17	480	47	13	8

*Split season between Kenosha and Chicago.

		G	IP	W	L	ERA
P	B. Goldsmith	31	245	14	14	1.62
P	J. Cione	31	229	12	13	1.85
P	*R. Stephens	36	241	20	11	1.87
P	*M. Deegan	29	237	12	15	2.13
P	A. Hohlmayer	13	80	4	4	2.36
P	B. Rotvig	30	209	11	16	2.81
P	J. O'Hara	20	104	4	6	3.20

*Split season between Kenosha and Springfield.

South Bend, 57-69

POS	Player	G	AB	BA	HR	RBI	PO	A	E	DP
1B	*T. Marshall	125	392	.140	0	31	1304	37	42	45
2B	H. Filarski	23	324	.179	0	29	128	161	27	43
SS	S. Wirth	102	399	.241	0	26	224	352	23	21
3B	P. Pirok	111	413	.219	0	19	174	312	36	18
OF	E. Mahon	117	422	.258	2	65	190	35	9	3
OF	B. Jochum	72	339	.195	1	33	77	9	3	1
OF	**D. Junior	89	248	.125	0	15	125	11	6	2
C	B. Baker	49	324	.179	0	29	128	161	27	43

*Split season between South Bend and Chicago.
**Split season between South Bend and Springfield.

POS	Player	G	AB	BA	HR	RBI	PO	A	E	DP
OF	*B. Wagoner	82	257	.230	0	11	79	3	0	0
OF	**E. Mahoney	45	107	.140	0	1	49	3	2	1
OF	***P. Koehn	52	256	.160	0	21	46	0	2	0
OF	J. Krick	31	131	.191	1	9	9	2	1	0
OF	A. Mayer	32	90	.211	0	13	13	0	2	0
OF	L. Faralla	18	169	.225	0	16	10	0	3	0
C	****B. Whiting	29	338	.183	1	20	1210	68	25	33
C	*****S. Stovroff	77	279	.158	0	20	346	90	30	5
C	N. Metrolis	12	25	.160	0	2	37	6	3	1

*Split season between South Bend and Muskegon.
**Split season between South Bend and Fort Wayne.
***Split season between South Bend, Racine and Peoria.
****Split season between South Bend and Chicago.
*****Split season between South Bend and Springfield.

		G	IP	W	L	ERA
P	J. Faut	34	250	16	11	1.44
P	B. Jochum	29	215	14	13	1.51
P	*M. Kruckel	19	120	9	4	1.65
P	L. Faralla	34	267	10	20	1.99
P	R. Williams	23	160	10	10	2.25
P	P. Koehn	21	128	6	8	3.02
P	L. Arnold	20	82	4	4	4.06
P	J. Krick	13	59	2	6	4.12
P	**L. Gallegos	16	73	2	6	5.79

*Split season between South Bend and Muskegon.
**Split season between South Bend and Peoria.

Fort Wayne, 53-73

POS	Player	G	AB	BA	HR	RBI	PO	A	E	DP
1B	V. Kellogg	126	472	.248	0	43	1257	49	35	60
2B	M. Callaghan	112	391	.187	0	27	241	174	24	36
SS	D. Schroeder	125	418	.170	0	43	275	317	59	35
3B	*A. Johnson	105	373	.155	1	39	174	339	37	23
OF	T. Eisen	121	464	.220	1	30	227	25	10	7
OF	L. DelMonico	63	226	.186	0	20	87	6	9	2
OF	W. Briggs	62	193	.228	1	15	51	3	7	0
C	M. Rountree	79	251	.163	0	18	387	99	26	14

*Split season between Fort Wayne and Muskegon.

POS	Player	G	AB	BA	HR	RBI	PO	A	E	DP
2B	M. Wegman	14	86	.093	0	6	26	18	2	3
3B	*D. Tetzlaff	121	392	.191	0	27	203	288	47	22
OF	**D. Cook	18	81	.123	0	6	20	7	0	0
OF	***E. Mahoney	56	107	.140	0	1	49	3	2	1
OF	****M. Alspaugh	46	135	.185	0	9	44	9	3	2
OF	H. Callaghan	51	178	.191	0	13	93	4	7	1
OF	*****J. Smith	104	310	.168	1	22	135	8	12	1
C	R. Heafner	50	146	.171	0	7	188	41	14	9

*Split season between Fort Wayne and Chicago.
**Split season between Fort Wayne, Chicago and Muskegon.
***Split season between Fort Wayne and South Bend.
****Split season between Fort Wayne and Rockford.
*****Split season between Fort Wayne and Kenosha.

		G	IP	W	L	ERA
P	D. Collins	34	267	10	20	1.99
P	C. Blumetta	30	238	14	13	2.16
P	A. Lee	27	208	10	14	2.25
P	M. Kline	24	161	8	13	2.58
P	*H. Walulik	17	91	2	6	3.07
P	**D. Cook	20	116	4	9	4.03
P	J. Peppas	16	113	4	12	4.62
P	***B. Georges	10	48	0	4	5.63
P	D. Schroder	2	17	0	2	3.19
P	R. Haefner	2	2	0	1	13.51
P	M. Wegman	3	11	0	0	6.56
P	T. Eisen	1	7	0	0	5.15

*Split season between Fort Wayne and Muskegon.
**Split season between Fort Wayne, Chicago and Muskegon.
***Split season between Fort Wayne and Chicago.

Chicago, 47-77

POS	Player	G	AB	BA	HR	RBI	PO	A	E	DP
1B	*B. Whiting	97	338	.183	1	20	1210	68	25	33
2B	C. Barnett	106	448	.165	1	19	248	211	29	39
SS	**M. Olinger	121	408	.167	2	28	217	345	86	31
3B	***D. Tetzlaff	121	392	.191	0	27	203	288	47	22
OF	****T. Shively	75	263	.156	0	14	158	9	3	1
OF	*****E. Callow	107	387	.251	6	52	144	10	10	3
OF	B. Luna	57	257	.237	1	26	56	5	6	2
C	****K. Vonderau	79	264	.174	0	11	343	62	30	8

*Split season between Chicago and South Bend.
**Split season between Chicago and Grand Rapids.

***Split season between Chicago and Fort Wayne.
****Split season between Chicago and Peoria.
*****Split season between Chicago and Rockford.

POS	Player	G	AB	BA	HR	RBI	PO	A	E	DP
1B	*T. Marshall	125	392	.140	0	17	1303	24	38	50
U	E. Albright	65	142	.141	0	4	90	114	20	8
SS	**E. Petras	108	349	.218	0	32	293	71	36	42
3B	***M. Pieper	74	369	.190	0	37	128	176	39	6
OF	****D. Cook	18	81	.123	0	6	20	7	0	0
OF	J. Kelley	32	145	.138	0	6	77	13	7	3
OF	*****R. Briggs	107	425	.200	0	37	252	47	17	10
OF	******N. Meier	127	450	.222	0	47	228	5	17	2
OF	D. Reid	48	115	.139	0	4	51	8	7	1
OF	D. Healy	12	41	.122	0	7	16	0	3	0
C	******J. Romatowski	83	242	.211	0	27	313	99	9	11

*Split season between Chicago and South Bend.
**Split season between Chicago and Grand Rapids.
***Split season between Chicago and Kenosha.
****Split season between Chicago, Muskegon and Fort Wayne.
*****Split season between Chicago and Rockford.
******Split season between Chicago and Racine.

		G	IP	W	L	ERA
P	*N. Warren	23	161	12	5	1.45
P	B. Luna	25	171	12	9	1.95
P	M. Perez	32	240	10	17	2.55
P	B. Tucker	33	238	11	17	2.68
P	K. Kotowicz	37	298	18	17	2.71
P	M. Marrero	29	211	4	21	3.75
P	**D. Cook	20	116	4	9	4.03
P	***B. Georges	10	48	0	4	5.63
P	E. Albright	4	22	0	4	2.46
P	M. Pieper	4	15	0	1	2.40

*Split season between Chcago and Muskegon.
**Split season between Chicago, Muskegon and Fort Wayne.
***Split season between Chicago and Fort Wayne.

Springfield, 41-84

POS	Player	G	AB	BA	HR	RBI	PO	A	E	DP
1B	M. Meacham	95	289	.180	0	10	984	32	26	20
2B	E. Wawryshyn	118	435	.262	0	30	275	239	41	23
SS	J. Schofield	76	440	.236	2	49	496	242	67	17
3B	D. Neal	97	406	.153	0	28	155	246	47	14
OF	N. Stoll	116	413	.191	0	18	191	25	8	5
OF	B. Barbaze	76	223	.193	0	16	104	5	11	1
OF	M. Wenzell	48	346	.168	1	19	141	136	45	9
C	J. Gutz	70	223	.152	0	8	171	71	21	5
OF	*D. Junior	89	248	.125	0	15	125	11	6	2
OF	J. Emerson	37	110	.182	0	5	27	3	3	0
OF	D. Barr	27	174	.230	0	10	16	2	4	1
C	*S. Stovroff	77	279	.158	0	20	346	90	30	5
C	D. Whalen	49	111	.153	0	5	187	28	24	1

*Split season between Springfield and South Bend.

		G	IP	W	L	ERA
P	*R. Stephens	36	241	20	11	1.87
P	*M. Deegan	29	237	12	15	2.13
P	D. Barr	30	208	7	19	2.68
P	E. Bergman	32	236	9	19	3.05
P	E. Risinger	22	129	3	8	3.35
P	J. Marlowe	31	236	7	22	3.66
P	J. Schofield	1	1	0	1	36.36
P	V. Bell	1	8	0	0	7.88

*Split season between Springfield and Kenosha.

BATTING AND BASE RUNNING LEADERS

Batting Average *(Played at least 54 games)*

A. Wagner, Ken	.312
M. Wisham, Peo	.292
C. Wisniewski, GR	.289
D. Kamenshek, Roc	.289
B. Wagoner, Mus	.278
E. Wawryshyn, Spr	.262
C. Pryer, Mus	.262
E. Mahon, SB	.258
D. Sams, Mus	.257
S. Kurys, Rac	.252

Home Runs

C. Wisniewski, GR	7
E. Callow, Chic/Roc	6
F. Dancer, Peo	6
A. Wagner, Ken	4
P. Gianfrancisco, Rac	4
E. Dapkus, Rac	4
M. Wisham, Peo	3
D. Sams, Mus	3
S. Kurys, Rac	3
M. Keagle, GR	3
C. Jewett, Ken	3

Total Bases

A. Wagner, Ken	186
M. Wisham, Peo	185
C. Wisniewski, GR	172
D. Kamenshek, Roc	152
V. Kellogg, FW	144
S. Kurys, Rac	143
D. Satterfield, GR	136
E. Mahon, SB	135
D. Sams, Rac	134
E. Wawryshyn, Spr	126

RBI

R. Meyer, Peo	68
C. Wisniewski, GR	66
E. Mahon, SB	65

D. Satterfield, GR	61
D. Sams, Mus	59
D. Harrell, Roc	58
M. Wisham, Peo	58
J. Lenard, Mus	56
A. Wagner, Ken	56

Stolen Bases

S. Kurys, Rac	172
F. Dancer, Peo	102
D. Kamenshek, Roc	94
T. Eisen, FW	88
M. Keagle, GR	85
E. Perlick, Rac	82
E. Petras, GR/Chi	86
D. Ferguson, Roc	73
D. Stolze, Mus	67
E. Wawryshyn, Spr	66

Hits

A. Wagner, Ken	130
D. Kamenshek, Roc	128
M. Wisham, Peo	128
C. Wisniewski, GR	127
V. Kellogg, FW	117
E. Wawryshyn, Spr	114
D. Stolze, Mus	113
S. Kurys, Rac	112
D. Satterfield, GR	111

Runs Scored

S. Kurys, Rac	97
F. Dancer, Peo	89
D. Kamenshek, Roc	89
M. Keagle, GR	75
D. Ferguson, Roc	73
J. Lenard, Mus	70
A. Wagner, Ken	70
C. Wisniewski, GR	70
C. Pryer, Mus	70
M. Wisham, Peo	69

Doubles

M. Wisham, Peo	24
C. Wisniewski, GR	20
A. Wagner, Ken	16
E. Mahon, SB	12
S. Kurys, Rac	12
J. Schofield, Spr	12
P. Francisco, Rac	11
M. Keagle, GR	11
E. Perlick, Rac	11
R. Gacioch, Roc	11

Triples

E. Callow, Chi/Roc	15
A. Wagner, Ken	14
M. Wisham, Peo	12
J. Schofield, Spr	9
V. Kellogg, FW	9
M. Villa, Ken	8
R. Briggs, Roc/Chi	7
D. Tetzlaff, Chi/FW	7
D. Sams, Mus	7
D. Harrell, Roc	7

PITCHING LEADERS

Earned Run Average

A. Haylett, GR	0.77
D. Mueller, Peo	1.11
J. Winter, Rac	1.18
L. Florreich, Roc	1.18
A. Ziegler, GR	1.21
M. Earp, GR	1.31
J. Faut, SB	1.44
N. Warren, Mus/Chi	1.45
A. Fischer, Mus	1.47
B. Jochum, SB	1.51

Wins

A. Haylett, GR	25
J. Winter, Rac	25
E. Dapkus, Rac	24
L. Florreich, Roc	22
D. Mueller, Peo	21
R. Stephens, Spr/Ken	20
E. Roth, Peo	18
I. Kotowicz, Chi	18
D. Sams, Mus	18

Winning Percentage

A. Haylett, GR	.833
R. Gacioch, Roc	.737
E. Dapkus, Rac	.727
N. Warren, Mus/Chi	.706
D. Mueller, Peo	.700
M. Kruckel, SB/Mus	.692
L. Florreich, Roc	.688
J. Winter, Rac	.676
R. Stephens, Spr/Ken	.645
D. Sams, Mus	.643

Strikeouts

J. Winter, Rac	248
L. Florreich, Roc	231
I. Kotowicz, Chi	197
M. Holgerson, Roc	194
E. Dapkus, Rac	191
D. Mueller, Peo	181
M. Earp, GR	166
J. Faut, SB	165
I. Applegren, Mus	129

Innings Pitched

J. Winter, Rac	329
E. Dapkus, Rac	297
I. Kotowicz, Chi	296
E. Roth, Peo	291
L. Florreich, Roc	282
M. Earp, GR	282
M. Holgerson, Roc	277
A. Haylett, GR	269
D. Sams, Mus	268
D. Mueller, Peo	267
L. Faralla, SB	267

1949

The beginning of the end for the AAGPBL came in 1949. The two teams that had been added in 1948 — the Chicago Colleens and Springfield Sallies — were turned into player development teams to train and recruit new players. The league had lost some talent for two seasons because it had drifted away from softball and underhand pitching.

The move toward baseball continued as the ball shrunk to 10 inches in circumference and the pitching mound was pushed back to 55 feet. Pitchers still had the upper hand as

no hitter could reach the .300 mark all season. Rockford's Lois Florreich (0.67) and Helen Fox (0.98) gave up less than one earned run per game.

	G	AB	R	H	2B	3B	HR	SH	SB	LOB	Pct.
South Bend	113	3403	441	736	54	13	1	237	402	805	.216
Grand Rapids	113	3509	361	719	56	26	6	160	169	827	.205
Fort Wayne	110	3400	339	687	59	24	7	186	231	778	.202
Kenosha	111	3434	376	690	54	31	5	159	330	666	.201
Rockford	112	3506	341	686	45	28	3	170	298	726	.196
Muskegon	114	3529	291	688	38	12	1	174	262	776	.195
Racine	111	3393	323	618	37	33	5	164	370	730	.182
Peoria	110	3286	269	585	44	19	1	147	136	738	.178

Final Standings

	Won	Lost	Pct	GB
South Bend	75	36	.676	—
Rockford	75	36	.676	—
Grand Rapids	57	54	.514	18
Kenosha	58	55	.505	19
Fort Wayne	52	57	.477	23
Muskegon	46	66	.411	29½
Racine	45	65	.409	29½
Peoria	36	73	.330	39

South Bend, 75-36-2

POS	Player	G	AB	BA	HR	RBI	PO	A	E	DP
1B	B. Whiting	93	254	.193	0	40	972	44	14	34
2B	M. Baker	88	408	.216	0	25	584	154	33	38
SS	S. Wirth	113	389	.229	1	40	231	359	36	33
3B	H. Filarski	92	290	.201	0	26	136	294	36	16
OF	E. Mahon	106	396	.245	0	60	178	9	3	5
OF	B. Wagoner	113	382	.230	0	26	106	11	3	2
OF	N. Stoll	99	341	.232	0	28	153	8	6	3
C	S. Stovroff	75	199	.191	0	12	252	72	9	4
3B	M. Callaghan	26	160	.169	0	16	101	114	19	11
U	R. Briggs	45	221	.222	0	21	156	51	9	2
*C	N. Metrolis	14	27	.148	0	3	26	3	2	0

*Split season between South Bend and Peoria.

		G	IP	W	L	ERA
P	J. Faut	34	261	24	8	1.10
P	L. Faralla	34	245	19	9	1.36
P	R. Williams	25	170	10	6	1.64
P	J. Hasham	23	169	12	8	2.02
P	L. Arnold	16	91	3	2	2.27
P	G. Vincent	11	36	3	2	3.50
P	J. Krick	5	25	2	1	1.44

Rockford, 75-36-1

POS	Player	G	AB	BA	HR	RBI	PO	A	E	DP
1B	D. Kamenshek	107	385	.255	0	25	1184	37	6	43
2B	C. Barnett	104	359	.159	0	13	240	188	20	36
SS	D. Doyle	111	431	.220	0	50	243	333	41	30
3B	A. Pollitt	106	385	.210	0	27	198	301	39	11

POS	Player	G	AB	BA	HR	RBI	PO	A	E	DP
OF	E. Callow	104	387	.227	2	36	206	17	3	2
OF	R. Gacioch	71	281	.203	0	34	63	13	4	1
OF	D. Key	94	346	.179	0	20	161	6	9	4
C	R. Richard	83	265	.170	1	20	387	63	13	4
*U	J. Kelley	21	117	.162	0	5	77	17	8	2
**OF	M. Alspaugh	53	162	.210	0	53	60	1	2	0
C	J. Lovell	26	64	.156	0	4	125	18	6	4

*Split season between Rockford and Peoria.
*Split season between Rockford and Muskegon.

		G	IP	W	L	ERA
P	L. Florreich	29	269	22	7	0.67
P	H. Fox	26	212	13	8	0.98
P	L. Erickson	25	216	17	6	1.54
P	R. Gacioch	14	91	9	2	1.68
*P	M. Silvestri	17	132	5	10	1.70
P	B. Werfel	14	79	5	5	2.96
*P	I. Applegren	20	131	5	12	3.09
*P	A. Foss	3	6			

*Split season between Rockford and Muskegon.

Grand Rapids, 57-54-2, Johnny Rawlings

POS	Player	G	AB	BA	HR	RBI	PO	A	E	DP
1B	I. Voyce	113	374	.257	3	53	871	49	25	37
2B	A. Ziegler	111	370	.181	0	18	278	218	17	33
SS	M. Olinger	113	432	.213	1	18	202	272	50	16
3B	D. Neal	58	178	.079	0	11	84	137	24	5
OF	D. Satterfield	113	421	.259	2	58	203	5	6	2
OF	D. Reid	99	307	.160	0	23	177	11	13	1
OF	C. Wisniewski	112	406	.178	0	32	13	10	9	1
C	L. Paire	80	371	.205	0	37	407	179	23	15
C	R. Lessing	40	120	.233	0	9	172	32	7	5
3B	C. Smith	30	98	.184	0	4	45	81	11	8
OF	M. Beschoner	23	85	.165	0	4	28	1	4	0

		G	IP	W	L	ERA
P	M. Earp	27	216	14	10	1.83
P	A. Haylett	27	220	9	10	1.88
P	L. Fisher	25	161	13	11	2.18
P	E. Risinger	30	234	15	12	2.35
P	J. Bittner	26	131	4	10	3.44
P	A. Ziegler	5	31	2	1	1.16

Kenosha, 56-55

POS	Player	G	AB	BA	HR	RBI	PO	A	E	DP
1B	D. Brumfield	77	274	.212	0	26	870	26	8	34
2B	M. Villa	111	387	.204	0	36	250	205	23	26
SS	E. Petras	111	376	.196	0	17	259	332	36	29
3B	F. Shollenberger	111	370	.178	1	18	178	333	24	20
OF	H. Candaele	106	374	.251	0	32	141	4	4	0
OF	A. Wagner	97	348	.233	3	40	152	7	8	2
OF	J. Marlowe	73	305	.220	1	17	102	9	9	3
C	D. Naum	79	172	.157	0	13	251	59	10	8
1B	J. Cione	34	245	.220	0	27	352	10	6	7

POS	Player	G	AB	BA	HR	RBI	PO	A	E	DP
*OF	C. Jewett	76	247	.206	0	15	84	5	13	0
OF	J. Holderness	12	48	.167	0	8	9	1	1	0
C	M. Redman	66	134	.149	0	3	168	54	5	1

*Split season between Kenosha and Peoria.

		G	IP	W	L	ERA
P	R. Stephens	32	195	13	9	1.30
P	J. Cione	32	223	15	10	1.57
P	B. Rotvig	32	209	11	15	2.33
P	J. Marlowe	17	108	7	7	2.67
P	B. Goldsmith	29	179	8	11	3.17
P	J. O'Hara	11	60	2	3	4.65

Fort Wayne, 52-57-1

POS	Player	G	AB	BA	HR	RBI	PO	A	E	DP
1B	V. Kellogg	107	397	.247	1	34	1124	30	23	38
2B	E. Wawryshyn	109	391	.251	0	34	244	169	15	22
SS	D. Schroeder	104	346	.208	0	31	230	282	55	19
3B	D. Allen	97	300	.143	0	18	151	276	43	11
OF	T. Eisen	109	424	.184	3	18	216	13	8	8
OF	B. Luna	81	320	.197	1	26	156	5	8	0
OF	W. Briggs	109	362	.202	1	23	100	11	6	4
C	M. Rountree	65	182	.225	0	16	271	57	8	1
*1B	J. Peppas	24	121	.116	0	7	210	7	7	3
*OF	M. Wenzell	53	220	.182	0	13	79	25	10	1
*OF	M. Pieper	54	221	.163	0	14	41	7	3	2
OF	J. Smith	18	67	.149	1	11	25	1	3	2
C	R. Heafner	50	146	.171	0	7	188	41	14	9

*Split season between Fort Wayne and Racine.

		G	IP	W	L	ERA
P	M. Deegan	28	234	16	11	1.77
P	M. Kline	28	229	14	11	1.93
P	D. Cook	22	153	9	9	1.94
P	C. Blumetta	27	217	9	16	1.99
*P	J. Peppas	12	68	3	4	2.25
*P	P. Koehn	22	126	2	11	3.43
P	B. Luna	10	67	2	6	3.90
P	J. Smith	3	8	0	1	3.38

*Split season between Fort Wayne and Racine.

Muskegon, 46-66-2

POS	Player	G	AB	BA	HR	RBI	PO	A	E	DP
1B	A. Hohlmayer	97	310	.177	0	18	1097	33	19	27
2B	C. Pryer	44	277	.235	1	10	157	74	19	17
SS	A. Fischer	91	384	.198	0	47	187	271	23	15
*3B	J. Schofield	106	378	.228	0	27	147	332	46	11
*OF	J. Lenard	110	383	.206	0	29	182	12	7	3
**OF	N. Meier	101	354	.234	0	32	138	10	7	2
OF	D. Sams	85	408	.279	0	35	152	12	4	2
*C	K. Vonderau	83	252	.175	0	13	321	109	26	10

*Split season between Muskegon and Peoria.
**Split season between Muskegon and Racine.

POS	Player	G	AB	BA	HR	RBI	PO	A	E	DP
U	D. Tetzlaff	54	274	.161	0	16	114	173	35	14
*U	D. Stolze	111	399	.163	0	29	361	52	15	9
**OF	M. Alspaugh	53	162	.210	0	53	60	1	2	0
OF	T. McKinley	35	101	.099	0	4	38	3	2	2
OF	M. Kruckel	31	119	.193	0	8	35	3	0	0
OF	M. Wegman	10	165	.139	0	8	79	76	12	7
OF	S. Lonetto	17	56	.089	0	1	15	4	1	1
OF	D. Chapman	10	67	.148	0	2	9	1	1	0
C	J. Gutz	39	121	.132	0	9	136	44	12	5

*Split season between Muskegon and Racine.
**Split season between Muskegon and Rockford.

		G	IP	W	L	ERA
P	D. Sams	28	211	15	10	1.58
*P	M. Silvestri	17	132	5	10	1.70
P	A. Fischer	25	157	10	7	1.78
P	A. Hutchison	25	161	8	12	2.35
P	D. Barr	27	191	8	13	2.40
P	M. Kruckel	15	85	1	7	2.75
P	B. Allard	19	59	2	2	2.75
*P	I. Applegren	20	131	5	12	3.09
P	A. Hohlmayer	7	22	0	1	1.23
*P	A. Foss	3	6			
P	S. Lonetto	3	12			

*Split season between Muskegon and Rockford.

Racine, 45-65-1

POS	Player	G	AB	BA	HR	RBI	PO	A	E	DP
1B	M. Danhauser	98	290	.110	0	12	1091	45	19	30
2B	S. Kurys	111	416	.245	2	26	288	195	19	27
SS	B. Trezza	110	387	.196	1	27	220	380	55	23
3B	M. English	111	364	.168	0	21	211	357	47	17
OF	E. Perlick	99	364	.255	2	41	194	6	6	2
OF	N. Meier	101	354	.234	0	32	138	10	7	2
OF	M. Wenzell	53	220	.182	0	13	79	25	10	1
C	I. Hickson	81	210	.129	0	8	296	96	13	9
C	J. Hill	45	121	.190	0	12	117	24	7	2
OF	I. Dapkus	21	155	.226	0	16	23	2	1	0
*OF	M. Pieper	54	221	.163	0	14	41	7	3	2
*OF	J. Peppas	12	121	.116	0	7	210	7	7	3
U	R. Briggs	45	221	.222	0	21	156	51	9	2
**U	D. Stolze	111	399	.163	0	29	361	52	15	9

*Split season between Racine and Fort Wayne.
**Split season between Racine and Muskegon.

		G	IP	W	L	ERA
P	E. Bergmann	32	225	11	14	2.08
P	J. Winter	32	228	11	13	2.17
P	I. Dapkus	27	208	12	11	2.25
*P	J. Peppas	12	68	3	4	2.25
P	I. Kotowicz	25	190	8	13	2.32
*P	P. Koehn	22	126	2	11	3.43

*Split season between Racine and Fort Wayne.

Peoria, 36-73-1

POS	Player	G	AB	BA	HR	RBI	PO	A	E	DP
1B	T. Shively	85	347	.187	0	21	1116	49	35	26
2B	A. DeCambra	101	352	.205	0	26	206	210	28	24
SS	R. Moellering	82	332	.190	0	23	158	250	47	15
3B	M. Carey	67	330	.164	1	22	140	215	36	11
OF	Ei. Roth	89	322	.161	0	13	98	1	6	0
*OF	J. Lenard	110	383	.206	0	29	182	12	7	3
OF	M. Reynolds	69	344	.198	0	29	127	43	9	4
C	K. Vonderau	83	252	.175	0	13	321	109	26	10

*Split season between Peoria and Muskegon.

1B	I. Kerwin	15	73	.137	0	1	166	7	6	6
SS	D. Pearson	14	74	.216	0	4	25	39	9	1
*3B	J. Schofield	106	378	.228	0	27	147	332	46	11
C	N. Metrolis	14	27	.148	0	3	26	3	2	0
C	W. Baumgartner	14								
**U	J. Kelley	21	117	.162	0	5	77	17	8	2
OF	J. Emerson	16	49	.122	0	0	13	2	1	0
***OF	C. Jewett	76	247	.206	0	15	84	5	13	0

*Split season between Peoria and Muskegon.
**Split season between Peoria and Rockford.
***Split season between Peoria and Kenosha.

		G	IP	W	L	ERA
P	D. Mueller	26	219	7	16	1.89
P	A. Lee	21	161	5	14	2.18
P	B. Tucker	16	118	4	8	2.67
P	M. Reynolds	12	93	6	6	2.90
P	E. Roth	24	151	4	12	2.92
P	N. Warren	27	192	10	16	3.00

BATTING AND BASE RUNNING LEADERS

Batting Average

D. Sams, Mus	.279
C. Wisniewski, GR	.278
D. Satterfield, GR	.259
I. Voyce, GR	.257
D. Kamenshek, Roc	.255
E. Perlick, Rac	.255
E. Wawryshyn, FW	.251
H. Candaele, Ken	.251
V. Kellogg, FW	.247
S. Kurys, Rac	.245

Home Runs

T. Eisen, FW	3
I. Voyce, GR	3
A. Wagner, Ken	3
D. Satterfield, GR	2
E. Perlick, Rac	2
S. Kurys, Rac	2
E. Callow, Roc	2

Total Bases

D. Satterfield, GR	153
C. Wisniewski, GR	140
E. Perlick, Rac	120
E. Mahon, SB	119
E. Callow, Roc	119
V. Kellogg, FW	117
S. Kurys, Rac	117
D. Kamenshek, Roc	114
H. Candaele, Ken	113

RBI

E. Mahon, SB	60
D. Satterfield, GR	58
D. Doyle, Roc	50
I. Voyce, GR	53
A. Fischer, Mus	47
E. Perlick, Rac	41
R. Lessing, GR	40
B. Whiting, SB	40

S. Wirth, SB	40		E. Mahon, SB	62
L. Paire, GR	37		S. Wirth, SB	62
E. Callow, Roc	36		E. Petras, Ken	59
			T. Eisen, FW	59
			B. Wagoner, SB	58
			M. Baker, SB	58
			A. Ziegler, GR	58

Stolen Bases

S. Kurys, Rac	137
E. Petras, Ken	73
D. Kamenshek, Roc	69
M. Baker, SB	68
C. Pryer, Mus	68
E. Mahon, SB	66
S. Wirth, SB	66
H. Candaele, Ken	65
E. Wawryshyn, FW	64
B. Wagoner, SB	64

Doubles

D. Satterfield, GR	22
E. Mahon, SB	16
C. Wisniewski, GR	13
M. Olinger, GR	11
V. Kellogg, FW	10
H. Candaele, Ken	9
E. Wawryshyn, FW	8
D. Kamenshek, Roc	8
M. Reynolds, Peo	8
R. Moellering, Peo	8
A. Wagner, Ken	8

Hits

D. Sams, Mus	114
C. Wisniewski, GR	113
D. Satterfield, GR	109
S. Kurys, Rac	102
D. Kamenshek, Roc	98
V. Kellogg, FW	98
E. Wawryshyn, FW	98
E. Mahon, SB	97
I. Voyce, GR	96
D. Doyle, Roc	95

Triples

E. Callow, Roc	11
E. Perlick, Rac	9
D. Satterfield, GR	8
B. Trezza, Rac	8
C. Wisniewski, GR	7
J. Cione, Ken	7
E. Wawryshyn, FW	6
H. Candaele, Ken	5
M. English, Rac	5
D. Doyle, Roc	5
W. Briggs, FW	5

Runs Scored

S. Kurys, Rac	70
C. Wisniewski, GR	64
D. Kamenshek, Roc	62

PITCHING LEADERS

Earned Run Average

L. Florreich, Roc	0.67
H. Fox, Roc	0.98
J. Faut, SB	1.10
L. Faralla, SB	1.36
R. Stephens, Ken	1.38
L. Erickson, Roc	1.54
J. Cione, Ken	1.57
D. Sams, Mus	1.58
R. Williams, SB	1.64
R. Gacioch, Roc	1.68

D. Sams, Mus	15
M. Earp, GR	14
M. Kline, FW	14

Winning Percentage

R. Gacioich, Roc	.818
L. Florreich, Roc	.750
J. Faut, SB	.750
L. Erickson, Roc	.739
L. Arnold, SB	.714
L. Faralla, SB	.679
A. Ziegler, GR	.667
J. Krick, SB	.667
R. Williams, SB	.625
H. Fox, Roc	.619

Wins

J. Faut, SB	24
L. Florreich, Roc	22
L. Faralla, SB	19
L. Erickson, Roc	17
M. Deegan, FW	16
E. Risinger, GR	15
J. Cione, Ken	15

Strikeouts

L. Florreich, Roc	210

M. Earp, GR	143
J. Faut, SB	120
E. Risinger, GR	116
D. Mueller, Peo	114
C. Blumetta, FW	102
B. Rotvig, Ken	97
A. Fisher, Mus	86
M. Deegan, FW	82
D. Sams, Mus	81

L. Florreich, Roc	9
L. Erickson, Roc	8
L. Faralla, SB	7
H. Fox, Roc	7
M. Deegan, FW	6
D. Sams, Mus	6
J. Cione, Ken	5
N. Warren, Peo	5
R. Stephens, Ken	5

Complete Games

L. Florreich, Roc	26
M. Deegan, FW	26
J. Faut, SB	25
M. Earp, GR	24
D. Mueller, Peo	24
L. Faralla, SB	24
J. Winter, Rac	23
J. Cione, Ken	22

Innings Pitched

L. Florreich, Roc	269
J. Faut, SB	261
L. Faralla, SB	245
M. Deegan, FW	234
E. Risinger, GR	234
M. Kline, FW	229
J. Winter, Rac	228
E. Bergmann, Rac	225
J. Cione, Ken	223
A. Haylett, GR	220

Shutouts

J. Faut, SB	12

1950

Attendance continued to decline, and halfway through the season the Muskegon Lassies were forced to move to Kalamazoo to survive. The Racine Belles called it quits at the end of the season. That franchise was moved to Battle Creek.

Hitters finally began to get the advantage over pitching as evidenced by eight hitters hitting over .300 on the season. Fort Wayne's Betty Foss led hitters with a .346 mark. The league still had some good hurlers, but not as good as in previous years. Being the only women's league with overhand pitching, it was difficult for the league to find any experienced players. Pitchers had to be taught how to throw overhand effectively. Jean Faut of South Bend was the most effective pitcher with a 1.12 ERA.

	G	AB	R	H	2B	3B	HR	SH	SB	LOB	Pct.
Fort Wayne	107	3533	508	880	133	16	21	78	306	822	.249
Rockford	111	3634	430	873	88	51	18	90	225	765	.240
Kenosha	112	3617	446	844	86	34	8	135	243	803	.233
South Bend	111	3511	426	806	86	20	4	149	265	842	.230
Racine	110	3474	456	779	74	38	22	177	309	827	.224
Grand Rapids	113	3495	423	767	86	20	9	179	188	783	.219
*Kalamazoo	111	3513	364	766	106	18	11	113	189	836	.218
Peoria	109	3418	377	723	87	25	11	93	192	789	.212

*Franchise began the season in Muskegon.

Final Standings

	Won	Lost	Pct	GB
Rockford	67	44	.604	—
Fort Wayne	62	43	.590	2
Kenosha	63	46	.578	3
Grand Rapids	59	53	.527	8½
South Bend	55	55	.500	11½

	Won	Lost	Pct	GB
Racine	50	59	.459	16
Peoria	44	63	.411	21
Kalamazoo	36	73	.330	30

Rockford, 67-44

POS	Player	G	AB	BA	HR	RBI	PO	A	E	DP
1B	D. Kamenshek	92	341	.334	0	50	951	27	17	40
2B	C. Barnett	88	331	.221	0	29	198	196	24	29
SS	D. Doyle	106	431	.276	3	63	217	321	41	34
3B	A. Pollitt	63	240	.279	3	37	98	135	22	17
OF	M. Mansfield	77	208	.139	0	9	100	9	2	0
OF	D. Key	96	364	.234	0	27	185	22	5	3
OF	E. Callow	109	409	.259	7	56	180	14	14	3
C	R. Richard	94	315	.251	1	28	403	79	14	5
1B	A. Applegren	17	134	.224	0	12	182	3	8	13
U	H. Waddell	53	149	.094	0	12	38	55	20	5
U	J. Kelley	49	217	.226	2	21	74	84	16	3
*OF	R. Gacioch	18	156	.263	0	18	17	2	1	0
*OF	S. Palesch	10	25	.040	0	2	4	2	1	0
C	M. Jones	30	69	.203	0	6	106	17	6	1

*Split season between Rockford and Grand Rapids.

		G	IP	W	L	ERA
P	L. Florreich	32	252	20	8	1.18
P	H. Fox	28	218	14	12	1.98
P	L. Erickson	27	221	16	10	2.52
*P	R. Gacioch	23	162	7	9	3.56
P	A. Applegren	21	132	9	10	3.75
P	E. Scheer	18	71	3	1	5.58
P	J. Kelley	7	9	0	1	9.00
P	D. Key	1	1			

*Split season between Rockford and Grand Rapids.

Fort Wayne, 62-43-2

POS	Player	G	AB	BA	HR	RBI	PO	A	E	DP
1B	V. Kellogg	107	397	.229	3	49	1142	34	22	58
2B	E. Wawryshyn	104	399	.311	1	50	226	203	22	34
SS	D. Schroeder	107	371	.210	5	58	241	319	59	35
3B	B. Foss	94	361	.346	5	61	110	217	47	11
OF	W. Briggs	107	396	.275	3	38	126	12	4	1
OF	T. Eisen	106	432	.238	0	19	217	12	11	5
*OF	B. Luna	100	376	.237	2	50	194	19	14	6
C	K. Vonderau	90	295	.193	0	25	331	109	19	13

*Split season between Fort Wayne and Kalamazoo.

POS	Player	G	AB	BA	HR	RBI	PO	A	E	DP
3B	H. Ketola	20	61	.131	0	9	20	48	8	6
*OF	N. Meier	90	326	.261	1	36	137	6	12	0
*OF	B. Luna	100	376	.237	2	42	194	19	14	6
C	M. Rountree	23	63	.206	0	23	79	31	4	4

*Split season between Fort Wayne and Kalamazoo.

		G	IP	W	L	ERA
P	M. Deegan	29	220	16	9	2.17
P	C. Blumetta	23	170	9	12	2.33

		G	IP	W	L	ERA
P	M. Kline	33	266	23	9	2.44
P	D. Collins	26	169	13	8	3.46
P	R. Matlack	14	61	0	4	3.54
P	B. Foss	2	1	0	0	54.05
P	L. Wood	2	2			
P	D. Schroeder	1	2			
P	J. Weaver	1	1			

Kenosha, 64-46-2

POS	Player	G	AB	BA	HR	RBI	PO	A	E	DP
1B	D. Brumfield	108	409	.264	1	37	1210	34	15	69
2B	M. Villa	75	332	.256	0	38	283	159	20	36
SS	E. Petras	104	381	.231	0	23	199	290	22	32
3B	F. Shollenberger	112	417	.254	0	31	152	321	27	18
OF	J. Lenard	110	389	.260	1	51	165	8	8	1
OF	J. Buckley	66	222	.207	2	22	73	8	11	3
*OF	J. Holderness	57	175	.149	0	10	51	5	5	3
C	J. Gutz	112	365	.203	1	27	439	123	22	14

*Split season between Kenosha and Grand Rapids.

POS	Player	G	AB	BA	HR	RBI	PO	A	E	DP
OF	J. Cione	40	268	.250	1	37	67	4	2	2
*OF	M. Pieper	29	304	.207	3	27	639	21	18	21
OF	J. Marlowe	11	109	.211	1	17	11	0	1	0
OF	M. Bevis	46	165	.212	1	13	43	3	6	2
OF	M. Rommelaire	27	80	.188	0	7	19	1	3	1
U	D. Naum	50	191	.209	0	11	104	90	9	15

*Split season between Kenosha and Peoria.

		G	IP	W	L	ERA
P	D. Naum	19	94	6	4	2.39
P	J. Marlowe	25	201	12	12	2.42
P	R. Stephens	29	211	15	9	2.73
P	J. Cione	32	243	18	10	2.96
P	B. Goldsmith	27	198	12	9	3.68
P	M. Bevis	7	29	1	2	6.83

Grand Rapids, 59-53-1

POS	Player	G	AB	BA	HR	RBI	PO	A	E	DP
1B	I. Voyce	113	380	.292	3	66	1261	28	17	36
2B	A. Ziegler	87	322	.174	0	23	216	176	25	25
SS	M. Olinger	113	396	.225	1	21	200	328	38	24
3B	M. Wegman	60	286	.234	0	27	118	181	27	11
OF	D. Satterfield	113	432	.278	4	54	231	10	6	3
OF	D. Reid	107	392	.199	0	28	179	12	17	1
OF	P. Koehn	45	166	.157	0	11	33	11	4	2
C	L. Paire	107	370	.249	1	70	415	98	11	8
3B	D. Niemiec	47	147	.170	0	4	50	108	25	0
3B	M. Redman	20	77	.130	0	5	65	52	5	2
OF	L. Barker	31	64	.125	0	3	16	1	1	0
*OF	J. Holderness	57	175	.149	0	10	51	5	5	3
*OF	R. Gacioch	18	156	.263	0	18	17	2	1	0
*OF	S. Palesch	10	25	.040	0	2	4	2	1	0

*Split season between Rockford and Grand Rapids.
*Split season between Kenosha and Grand Rapids.

		G	IP	W	L	ERA
P	A. Ziegler	35	235	19	7	1.38
*P	M. Silvestri	33	230	14	12	2.00
P	E. Risinger	31	231	14	13	2.38
P	M. Earp	12	82	5	6	2.52
**P	R. Gacioch	23	162	7	9	3.56
***P	L. Faralla	28	170	8	10	3.12
P	J. Bittner	20	119	5	10	5.60
P	D. Cook	4	18	0	2	10.00
P	J. Tysver	1	8	0	1	10.41
P	L. Paire	1	7			
P	P. Koehn	1	6			

*Split season between Grand Rapids and Muskegon.
*Split season between Rockford and Grand Rapids.
**Split season between Grand Rapids and Kalamazoo.

South Bend, 55-55-1

POS	Player	G	AB	BA	HR	RBI	PO	A	E	DP
*1B	A. Kotil	82	244	.205	0	21	177	20	19	33
*2B	C. Pryer	95	429	.269	0	50	276	188	27	28
SS	S. Wirth	105	384	.268	1	49	204	320	20	22
3B	H. Filarski	92	287	.209	0	26	106	215	33	12
OF	E. Mahon	67	256	.258	1	37	111	4	1	1
OF	B. Wagoner	101	388	.296	0	39	157	15	6	4
OF	N. Stoll	98	350	.271	1	50	165	18	11	3
C	S. Stovroff	79	228	.197	0	18	294	53	11	6

*Split season between South Bend and Muskegon.

POS	Player	G	AB	BA	HR	RBI	PO	A	E	DP
1B	J. Wiley	34	97	.134	0	7	307	10	13	8
*1B	B. Whiting	89	285	.207	1	25	875	32	16	35
OF	J. Faut	13	198	.217	0	26	20	5	2	1
**OF	M. Dailey	53	159	.138	0	10	57	3	5	2
C	J. Romatowski	45	134	.209	0	9	165	24	6	2
***C	M. Baumgardner	36	74	.176	0	5	67	18	9	2
*U	M. Baker	58	349	.244	0	26	195	229	41	19

*Split season between South Bend and Kalamazoo.
**Split season between South Bend and Peoria.
***Split season between South Bend and Muskegon.

		G	IP	W	L	ERA
P	J. Faut	36	290	21	9	1.12
P	D. Mueller	27	221	16	9	2.48
P	*S. Kidd	26	141	1	10	2.94
P	G. Vincent	21	153	8	12	3.12
P	E. Roth	23	151	7	13	3.28
P	**R. Williams	19	121	5	10	3.57
P	B. Wagoner	4	24	0	3	4.14

*Split season between South Bend, Muskegon and Peoria.
**Split season between South Bend, Peoria and Kalamazoo.

Racine, 50-60

POS	Player	G	AB	BA	HR	RBI	PO	A	E	DP
1B	J. Peppas	102	395	.268	4	45	912	41	31	31
2B	S. Kurys	110	424	.307	7	42	330	203	28	27
SS	D. Pearson	70	400	.235	0	47	284	201	31	13
3B	M. English	110	382	.209	4	41	179	285	72	17

POS	Player	G	AB	BA	HR	RBI	PO	A	E	DP
OF	E. Perlick	110	409	.247	3	59	255	10	15	1
OF	B. Trezza	63	385	.231	1	35	250	127	38	14
OF	D. Shero	76	194	.093	0	9	74	5	6	2
C	R. Heafner	62	204	.211	0	17	207	61	6	3
OF	E. Dapkus	25	166	.187	1	21	22	0	1	0
OF	B. Stuhr	18	34	.088	0	1	18	2	3	0
OF	S. Danz	23	55	.145	0	1	18	0	4	0
*OF	M. Wenzell	55	184	.185	0	14	66	9	1	3
C	I. Hickson	30	64	.172	1	9	83	27	4	3
C	B. Berger	10	17	.176	0	1	18	2	5	0
*C	A. O'Dowd	34	106	.217	0	10	106	29	7	2

*Split season between Racine and Kalamazoo.

		G	IP	W	L	ERA
P	E. Dapkus	31	229	17	11	1.81
P	J. Winter	30	190	9	11	2.46
P	E. Bergmann	29	208	11	14	2.68
*P	G. Cordes	25	119	5	10	3.63
P	J. Peppas	11	67	4	4	4.57
P	I. Kotowicz	11	54	0	5	4.67
P	B. Hatzell	19	102	4	7	4.85
P	S. Kurys	1	2			

*Split season between Racine and Kalamazoo.

Peoria, 44-63-2

POS	Player	G	AB	BA	HR	RBI	PO	A	E	DP
1B	M. Wisham	48	162	.340	3	22	491	14	9	12
2B	D. Stolze	106	415	.243	1	32	269	182	21	23
SS	M. Russo	74	266	.132	0	23	139	245	42	11
3B	M. Carey	71	412	.235	0	24	136	306	57	13
OF	T. Shively	108	381	.192	1	36	231	10	10	1
OF	J. Hill	51	197	.254	0	19	101	5	7	1
OF	F. Dancer	49	193	.207	2	13	87	4	3	1
*1B	A. Hohlmayer	27	158	.241	2	28	284	8	7	11
**1B	M. Pieper	60	304	.207	3	27	639	21	18	21
*2B	A. DeCambra	66	213	.244	0	26	162	92	27	27
SS	M. Carey	39	412	.235	0	24	136	306	57	13
3B	M. Callaghan	30	70	.157	0	5	27	72	6	5
**OF	M. Pieper	29	304	.207	3	27	639	21	18	21
***OF	M. Dailey	53	159	.138	0	10	57	3	5	2
OF	M. Beschorner	41								

*Split season between Peoria and Kalamazoo.
**Split season between Kenosha and Peoria.
***Split season between South Bend and Peoria.

		G	IP	W	L	ERA
P	N. Warren	32	228	13	13	2.37
P	A. Lee	17	68	3	4	2.51
P	M. Reynolds	33	221	12	14	2.85
*P	S. Kidd	26	141	1	10	2.94
P	J. Hasham	32	226	8	19	3.38
**P	R. Williams	19	121	5	10	3.57
***P	F. Janssen	19	93	3	3	3.87
***P	A. Hohlmayer	24	139	7	10	4.01

		G	IP	W	L	ERA
P	J. Smith	4	5	2	0	1.80
****P	D. Barr	18	83	1	11	6.51
P	A. DeCambra	1	2			

*Split season between South Bend, Muskegon and Peoria.
**Split season between South Bend, Peoria and Kalamazoo.
***Split season between Peoria and Kalamazoo.

Kalamazoo, 36-73-2 (began season with franchise in Muskegon)

POS	Player	G	AB	BA	HR	RBI	PO	A	E	DP
*1B	B. Whiting	89	285	.207	1	25	875	32	16	35
*2B	A. DeCambra	66	213	.244	0	26	162	92	27	27
SS	B. Payne	91	299	.191	0	16	161	220	57	15
3B	Y. Castillo	96	207	.135	0	14	115	215	29	15
OF	E. Roth	106	386	.202	0	21	163	14	9	2
**OF	B. Luna	100	376	.237	2	42	194	19	14	6
**OF	N. Meier	90	326	.261	1	36	137	6	12	0

*Split season between Peoria and Kalamazoo.
**Split season between Kalamazoo and Fort Wayne.

POS	Player	G	AB	BA	HR	RBI	PO	A	E	DP
*1B	A. Kotil	82	244	.205	0	21	177	20	19	33
*1B	A. Hohlmayer	27	158	.241	2	28	284	8	7	11
1B	S. Reeser	10	25	.080	0	0	49	1	2	0
**2B	C. Pryer	95	429	.269	0	50	276	188	27	28
****OF	M. Wenzell	55	184	.185	0	14	66	9	1	3
U	H. Walulik	24	106	.160	0	6	42	30	6	3
**U	M. Baker	58	349	.244	0	26	195	229	41	19
***C	M. Baumgardner	36	74	.176	0	5	67	18	9	2

*Split season between Muskegon and South Bend.
**Split season between South Bend and Kalamazoo.
***Split season between South Bend and Muskegon.
****Split season between Kalamazoo and Racine.

		G	IP	W	L	ERA
*P	M. Silvestri	33	230	14	12	2.00
P	D. Sams	29	218	12	13	2.60
**P	S. Kidd	26	141	1	10	2.94
***P	L. Faralla	28	170	8	10	3.12
****P	R. Williams	19	121	5	10	3.57
*****P	G. Cordes	25	119	5	10	3.63
P	H. Walulik	15	57	2	4	3.63
P	M. Marerro	30	186	7	17	3.73
******P	F. Janssen	19	93	3	3	3.87
******P	A. Hohlmayer	24	139	7	10	4.01
******P	D. Barr	18	83	1	11	6.51

*Split season between South Bend and Muskegon.
**Split season between South Bend, Muskegon and Peoria.
***Split season between Grand Rapids and Kalamazoo.
****Split season between South Bend, Peoria and Kalamazoo.
*****Split season between Racine and Kalamazoo.
******Split season between Kalamazoo and Peoria.

BATTING AND BASE RUNNING LEADERS

Batting Average

B. Foss, FW	.346
D. Kamenshek, Roc	.334
E. Wawryshyn, FW	.311
S. Kurys, Rac	.307
D. Sams, Kal	.301
B. Wagoner, SB	.296
I. Voyce, GR	.292
A. Pollitt, Roc	.279
D. Satterfield, GR	.278
D. Doyle, Roc	.276

Home Runs

S. Kurys, Rac	7
E. Callow, Roc	7
B. Foss, FW	5
D. Schroeder, FW	5
M. English, Rac	4
D. Sams, Kal	4
D. Satterfield, GR	4
J. Peppas, Rac	4

Total Bases

S. Kurys, Rac	185
D. Satterfield, GR	164
D. Doyle, Roc	164
B. Foss, FW	162
I. Voyce, GR	144
E. Wawryshyn, FW	144
D. Brumfield, Ken	139
D. Kamenshek, Roc	134
B. Wagoner, SB	132

RBI

L. Paire, GR	70
I. Voyce, GR	66
D. Doyle, Roc	63
B. Foss, FW	61
E. Perlick, Rac	59
D. Schroeder, FW	58
E. Callow, Roc	56
D. Satterfield, GR	54
J. Peppas, Rac	52
J. Lenard, Ken	51

Stolen Bases

S. Kurys, Rac	120
T. Eisen, FW	75
C. Pryer, SB	75
S. Wirth, SB	67
E. Wawryshyn, FW	65
B. Foss, FW	64
E. Roth, Kal	64
M. English, Rac	61
J. Lenard, Ken	53
B. Trezza, Rac	53

Hits

S. Kurys, Rac	130
B. Foss, FW	125
E. Wawryshyn, FW	124
D. Satterfield, GR	120
D. Doyle. Roc	119
C. Pryer, SB	115
B. Wagoner, SB	115
D. Kamenshek, Roc	114
I. Voyce, GR	111
W. Briggs, FW	109

Runs Scored

S. Kurys, Rac	95
T. Eisen, FW	87
M. Olinger, GR	78
C. Pryer, SB	75
E. Wawryshyn, FW	71
W. Briggs, FW	69
D. Satterfield, GR	68
B. Foss, FW	64
E. Perlick, Rac	64
D. Kamenshek, Roc	64

Doubles

B. Foss, FW	24
S. Kurys, Rac	22
T. Eisen, FW	20
B. Luna, FW/Kal	18
D. Satterfield, GR	16
D. Doyle, Roc	16
L. Paire, GR	16
D. Schroeder, FW	15
B. Whiting, SB/Kal	15
D. Sams, Kal	15

Triples

E. Callow, Roc	11
D. Doyle, Roc	10
D. Satterfield, GR	8
A. Pollitt, Roc	7
D. Brumfield, Ken	7
E. Perlick, Rac	7
R. Richard, Roc	6
M. English, Rac	6
H. Filarski, SB	6
S. Kurys, Rac	6

PITCHING LEADERS

Earned Run Average

J. Faut, SB	1.12
L. Florreich, Roc	1.18
A. Ziegler, GR	1.38
E. Dapkus, Rac	1.81
H. Fox, Roc	1.98
M. Silvestri, GR	2.00
M. Deegan, FW	2.17
C. Blumetta, FW	2.33
N. Warren, Peo	2.37
E. Risinger, GR	2.38

Strikeouts

L. Florreich, Roc	171
J. Faut, SB	118
E. Dapkus, Rac	112
D. Sams, Kal	109
M. Reynolds, Peo	106
M. Silvestri, GR	101
E. Risinger, GR	90
D. Mueller, SB	90
L. Erickson, Roc	88
M. Kline, FW	87

Wins

M. Kline, FW	23
J. Faut, SB	21
L. Florreich, Roc	20
A. Ziegler, GR	19
J. Cione, Ken	18
E. Dapkus, Rac	17
D. Mueller, SB	16
L. Erickson, Roc	16
M. Silvestri, GR	16
R. Stephens, Ken	15

Complete Games

J. Faut, SB	29
L. Florreich, Roc	28
J. Cione, Ken	25
A. Ziegler, GR	24
M. Deegan, FW	24
L. Erickson, Roc	23
D. Sams, Kal	22
D. Mueller, SB	22

Winning Percentage

J. Smith	1.000
E. Scheer	.750
A. Ziegler, GR	.731
M. Kline, FW	.719
L. Florreich, Roc	.714
J. Faut, SB	.700
J. Cione, Ken	.643
M. Deegan, FW	.640
D. Mueller, SB	.640
D. Collins, FW	.619

Innings Pitched

J. Faut, SB	290
M. Kline, FW	266
L. Florreich, Roc	252
J. Cione, Ken	243
A. Ziegler, GR	235
E. Risinger, GR	231
M. Silvestri, GR	230
E. Dapkus, Rac	229
N. Warren, Peo	228
J. Hasham, Peo	226

1951

With the management organization gone, spring training was left up to the individual teams. Also, the traveling teams were disbanded. The Racine franchise was moved to Battle Creek, Michigan, which still left the league with eight teams. No changes were made to the game, so the league was status quo with the previous season. Attendance continued to decline at a slow pace, but no figures are available.

Fort Wayne's Betty Foss led all hitters for the second year in a row with the highest batting average yet in the league with a .368. Rose Gacioch was the only pitcher to gain 20 victories for the season.

	G	AB	R	H	2B	3B	HR	SH	SB	LOB	Pct.
South Bend	111	3409	572	864	98	27	4	189	407	769	.253
Rockford	107	3408	527	832	80	46	11	145	320	764	.244
Fort Wayne	104	3382	523	826	134	12	15	83	317	816	.244

	G	AB	R	H	2B	3B	HR	SH	SB	LOB	Pct.
Grand Rapids	107	3332	428	768	73	33	5	125	166	787	.230
Peoria	106	3324	438	746	92	19	4	171	211	797	.224
Kalamazoo	110	3305	346	682	90	15	2	162	156	776	.207
Kenosha	106	3189	333	651	78	17	3	136	164	734	.204
Battle Creek	109	3320	325	617	59	16	1	107	144	765	.186

First Half Standings

	Won	Lost	Pct.	GB
Grand Rapids	39	13	.750	—
Fort Wayne	34	17	.667	4½
South Bend	36	22	.621	6
Rockford	31	25	.553	10
Peoria	28	25	.528	11½
Kenosha	20	34	.370	20
Kalamazoo	13	34	.276	23½
Battle Creek	11	44	.200	29½

Second Half Standings

	Won	Lost	Pct	GB
South Bend	38	14	.731	—
Rockford	33	16	.673	3½
Fort Wayne	33	19	.635	5
Grand Rapids	32	22	.593	7
Peoria	20	31	.392	17½
Battle Creek	19	35	.352	20
Kenosha	16	33	.327	20½
Kalamazoo	15	38	.283	23½

South Bend, 75-36

POS	Player	G	AB	BA	HR	RBI	PO	A	E	DP
1B	J. Wiley	71	181	.221	0	13	595	27	15	20
2B	C. Pryer	108	426	.312	0	32	306	216	30	30
SS	S. Wirth	105	347	.274	0	54	186	290	33	23
3B	A. Bleiler	50	168	.202	0	21	46	130	11	4
OF	B. Wagoner	110	375	.272	0	41	137	20	3	2
OF	N. Stoll	101	347	.268	0	47	151	13	4	2
OF	E. Mahon	104	364	.269	1	41	178	8	6	2
C	S. Stovroff	99	304	.266	0	54	461	95	12	4
1B	D. Mueller	59	229	.236	0	30	491	15	19	21
*SS	G. Dunn	45	151	.185	0	10	76	115	18	9
3B	B. Hoffman	41	137	.212	0	11	46	71	23	5
3B	J. Faut	29	178	.258	2	28	35	74	5	1
*OF	M. Dailey	60	155	.187	0	6	106	3	4	0
C	M. Baumgardner	24	44	.205	0	3	52	14	6	1

*Split season between South Bend and Battle Creek.
**Split season between South Bend, Peoria and Battle Creek.

		G	IP	W	L	ERA
P	J. Faut	23	190	15	7	1.33
P	D. Mueller	13	104	10	2	1.56
P	L. Faralla	22	170	15	4	1.85
P	Vincent	23	171	13	9	2.42
*P	S. Kidd	19	136	11	7	2.51

		G	IP	W	L	ERA
*P	J. Rumsey	19	107	4	8	2.52
P	L. Arnold	20	117	10	2	2.62
P	M. Froming	1	1			
P	B. Wagoner	1	1			

*Split season between South Bend and Battle Creek.

Grand Rapids, 71-36

POS	Player	G	AB	BA	HR	RBI	PO	A	E	DP
1B	I. Voyce	106	372	.285	2	49	1056	28	18	45
2B	A. Ziegler	84	340	.171	0	35	206	163	21	25
SS	M. Olinger	106	396	.225	1	21	200	328	38	24
3B	R. Youngberg	98	338	.201	0	31	120	220	30	16
OF	D. Satterfield	105	401	.279	2	62	193	3	8	0
OF	C. Wisniewski	105	386	.326	0	42	117	16	16	1
OF	D. Reid	67	212	.127	0	5	99	7	5	1
C	L. Paire	80	261	.264	1	56	312	67	10	6
*2B	D. Niemiec	17	65	.092	0	6	28	20	4	12
*OF	E. Gascon	26	87	.184	0	4	51	2	2	1
*OF	J. Holderness	16	61	.148	0	10	19	1	1	1
C	M. Redman	25	96	.104	0	8	110	21	4	1

*Split season between Grand Rapids and Battle Creek.

		G	IP	W	L	ERA
P	A. Ziegler	22	171	14	8	1.26
P	M. Silvestri	25	200	16	6	1.53
P	E. Risinger	24	177	9	9	2.14
P	M. Studnicka	23	164	15	5	2.33
P	G. Schweigert	14	76	4	6	2.72
P	J. Bittner	23	183	15	8	2.95

Fort Wayne, 68-35-1

POS	Player	G	AB	BA	HR	RBI	PO	A	E	DP
1B	B. Foss	89	342	.368	4	58	932	23	36	31
2B	E. Wawryshyn	104	390	.277	0	54	251	212	29	32
SS	D. Schroeder	85	285	.200	4	45	167	241	27	22
3B	Joan Weaver	53	163	.276	1	21	39	3	5	2
OF	W. Briggs	87	106	.275	1	43	289	17	7	8
OF	T. Eisen	104	399	.195	0	21	224	11	8	5
*OF	C. Horstman	31	117	.256	1	13	33	2	2	1
C	K. Vonderau	74	249	.221	0	32	284	66	20	9

*Split season between Fort Wayne and Kenosha.

SS	J. Geissinger	19	67	.194	2	7	37	39	11	4
*3B	B. McKenna	57	159	.151	0	14	62	121	19	6
OF	Jean Weaver	33	312	.247	2	31	121	116	19	9
OF	N. Meier	21	75	.240	0	14	37	2	3	0
C	M. Rountree	41	98	.255	0	9	121	41	7	4

*Split season between Fort Wayne, Battle Creek and Peoria.

		G	IP	W	L	ERA
P	M. Kline	24	194	18	4	1.95
P	P. Scott	26	190	15	7	2.13
P	M. Marrero	29	213	17	8	2.24

		G	IP	W	L	ERA
*P	F. Janssen	26	145	6	10	2.67
**P	E. Moore	29	176	6	14	2.86
***P	N. Warren	27	188	10	10	2.20
***P	M. Deegan	17	110	4	9	3.44
****P	K. Horstman	6	23	3	0	2.35
*****P	I. Alvarez	13	34	2	0	3.71
P	Joan Weaver	1	2			

*Split season between Fort Wayne, Peoria, Battle Creek and Kalamazoo.
**Split season between Fort Wayne and Kalamazoo.
***Split season between Fort Wayne and Peoria.
****Split season between Fort Wayne and Kenosha.
*****Split season between Fort Wayne and Battle Creek.

Rockford, 65-41-1

POS	Player	G	AB	BA	HR	RBI	PO	A	E	DP
1B	D. Kamenshek	97	339	.345	0	34	1044	38	13	54
*2B	H. Waddell	41	217	.147	0	17	109	111	47	16
SS	A. Pollitt	105	405	.299	4	45	181	277	47	33
3B	J. Kelley	102	380	.224	2	52	159	235	42	22
OF	E. Callow	104	380	.326	4	84	205	11	3	5
OF	D. Key	106	370	.216	1	27	190	17	8	5
OF	L. Hlavaty	47	127	.189	0	5	32	6	2	1
C	R. Richard	99	368	.277	0	60	377	129	20	16

*Split season between Rockford and Battle Creek.

POS	Player	G	AB	BA	HR	RBI	PO	A	E	DP
*1B	S. Luhtala	20	96	.167	0	5	152	4	9	3
U	J. Berger	18	155	.194	0	15	72	29	6	6
**U	B. Payne	49	294	.173	0	33	186	203	58	28
OF	B. Thompson	18	49	.204	0	3	13	5	1	2
OF	M. Mansfield	11	102	.127	0	9	13	5	3	1
***C	M. Jones	56	139	.173	0	6	139	52	31	3

*Split season between Rockford and Battle Creek.
**Split season between Rockford, Kalamazoo and Battle Creek.
***Split season between Rockford and Battle Creek.

		G	IP	W	L	ERA
P	R. Gacioch	29	231	20	7	1.68
P	H. Fox	28	214	18	7	2.57
P	M. Mansfield	30	202	16	8	2.85
P	A. Daniels	10	66	4	3	3.82
P	A. Applegren	15	94	4	10	4.21
P	J. Kelley	6	29	1	1	2.80
P	M. Jurgensmeier	9	26	1	1	7.96
P	J. Tysver	9	32	0	2	9.28
P	D. Key	2	9	0	2	10.00
P	S. Burkovich	3	2			
P	M. Kerrigan	1	1			

Peoria, 48-56-2

POS	Player	G	AB	BA	HR	RBI	PO	A	E	DP
1B	J. Westerman	102	355	.242	0	50	991	35	20	46
2B	M. Carey	95	374	.176	1	22	245	168	37	28
SS	M. Russo	106	368	.247	2	51	212	291	45	25
*3B	M. Callaghan	105	339	.236	0	34	138	318	32	23
OF	J. Smith	82	305	.233	0	30	182	14	4	2

POS	Player	G	AB	BA	HR	RBI	PO	A	E	DP
OF	D. Stolze	92	404	.223	0	27	233	27	12	9
OF	M. McCarty	70	207	.169	0	24	83	9	9	4
C	R. Briggs	106	363	.275	0	44	342	106	22	20

*Split season between Peoria and Battle Creek.

POS	Player	G	AB	BA	HR	RBI	PO	A	E	DP
*3B	B. McKenna	57	159	.151	0	14	62	121	19	6
**OF	M. Dailey	60	155	.187	0	6	106	3	4	0
***3B	J. Krick	60	267	.210	0	21	70	155	29	9
OF	G. Guest	15	42	.119	0	2	15	2	0	1
***OF	E. Keys	88	316	.212	0	23	129	13	9	1
***U	M. Pieper	69	244	.254	1	29	113	50	17	2

*Split season between Fort Wayne, Battle Creek and Peoria.
**Split season between South Bend, Peoria and Battle Creek.
***Split season between Peoria and Battle Creek.

		G	IP	W	L	ERA
P	A. Hohlmayer	29	209	15	11	2.02
*P	F. Janssen	26	145	6	10	2.67
**P	N. Warren	27	188	10	10	2.20
P	J. Smith	18	111	7	7	2.92
P	J. Hasham	30	218	13	15	3.10
**P	M. Deegan	17	110	4	9	3.44
***P	J. Krick	19	107	2	7	4.12
P	L. Mandella	17	80	3	4	4.28
***P	B. Hatzell	20	105	1	14	5.66
P	M. Dailey	3	15	1	0	6.02
P	M. Pieper	3	13	1	1	11.81
P	F. Ziemak	2	9	0	1	6.00

*Split season between Fort Wayne, Peoria, Battle Creek and Kalamazoo.
**Split season between Fort Wayne and Peoria.
***Split season between Peoria and Battle Creek.

Kenosha, 37-69

POS	Player	G	AB	BA	HR	RBI	PO	A	E	DP
1B	D. Brumfield	44	216	.273	0	27	535	52	7	28
2B	B. Parks	25	72	.083	0	2	35	30	13	3
SS	D. Naum	57	331	.181	0	13	175	189	28	19
3B	F. Shollenberger	104	382	.254	0	21	132	306	30	18
OF	J. Lenard	100	333	.225	0	32	133	13	6	5
OF	J. Buckley	87	288	.198	1	31	134	16	17	4
OF	H. Nordquist	82	240	.158	1	12	75	21	11	6
*C	J. Lovell	70	278	.216	2	31	288	39	11	7

*Split season between Kenosha and Kalamazoo.

POS	Player	G	AB	BA	HR	RBI	PO	A	E	DP
*OF	C. Horstman	31	117	.256	1	13	33	2	2	1
OF	J. Jaykowski	19	42	.214	0	5	14	0	0	0
C	J. Mattson	22	51	.098	0	3	67	9	4	1
C	I. Hickson	11	23	.217	0	5	35	9	2	1
C	E. Taylor	25	114	.193	0	10	80	18	9	0
U	J. Marlowe	26	178	.174	0	16	170	18	7	10
**U	Y. Castillo	83	192	.120	0	9	128	187	21	20
U	J. Cione	67	292	.243	1	34	414	22	16	13

*Split season between Fort Wayne and Kenosha.
**Split season between Kenosha and Kalamazoo.

		G	IP	W	L	ERA
P	D. Naum	12	79	5	4	1.14
P	J. Marlowe	28	211	12	15	2.52
P	B. Rotvig	20	133	6	10	2.57
P	R. Stephens	15	86	3	8	3.77
P	J. Cione	18	127	5	9	3.90
P	L. Wood	24	165	3	16	4.75
*P	J. Lovell	8	48	0	6	5.25
**P	K. Horstman	6	23	3	0	2.35
P	J. Jaykowski	10	30	1	3	7.82
P	A. Hutchinson	4	24	1	2	4.89

*Split season between Kenosha and Kalamazoo.
**Split season between Fort Wayne and Kenosha.

Kalamazoo, 33-75-2

POS	Player	G	AB	BA	HR	RBI	PO	A	E	DP
*1B	B. Whiting	94	269	.190	0	28	942	35	14	39
*2B	M. Wenzell	108	381	.213	0	41	252	248	51	29
SS	J. Geisinger	19	67	.194	2	7	37	39	11	4
*3B	B. Cornett	39	114	.132	0	6	32	78	18	2
OF	D. Sams	97	356	.306	2	33	203	15	9	2
OF	B. Francis	96	325	.231	0	20	159	15	11	2
OF	E. Roth	62	207	.251	0	62	90	7	9	3
C	J. Romatowski	63	304	.194	0	21	217	126	25	12

*Split season between Kalamazoo and Battle Creek.

POS	Player	G	AB	BA	HR	RBI	PO	A	E	DP
*1B	J. Peppas	96	382	.285	1	35	937	54	24	39
*SS	D. Pearson	100	346	.150	0	37	213	270	54	26
OF	Doris Cook	10	32	.094	0	4	12	1	0	0
U	T. Rukavina	14	87	.115	0	2	31	25	14	0
U	J. Moffett	98	151	.219	0	14	64	3	2	1
OF	J. Sindelar	31	73	.123	0	2	25	1	2	0
**C	J. Lovell	70	278	.216	2	31	288	39	11	7
***U	Y. Castillo	83	192	.120	0	9	128	187	21	20
****U	B. Payne	49	294	.173	0	33	186	203	58	28

*Split season between Kalamazoo and Battle Creek.
**Split season between Kenosha and Kalamazoo.
***Split season between Kenosha and Kalamazoo.
****Split season between Rockford, Kalamazoo and Battle Creek.

		G	IP	W	L	ERA
P	R. Williams	25	156	10	11	1.96
*P	F. Janssen	26	145	6	10	2.67
P	K. Blumetta	24	151	8	11	2.74
**P	E. Moore	29	176	6	14	2.86
***P	J. Lovell	8	48	0	6	5.25
****P	G. Cordes	26	179	3	15	3.52
P	E. Roth	30	137	5	9	4.01
****P	J. Peppas	11	57	1	7	4.58
****P	A. Allen	24	100	3	10	6.21
P	Doris Cook	8	22	0	1	5.74
P	D. Becker	3	3			
P	B. Payne	1	2			

*Split season between Fort Wayne, Peoria, Battle Creek and Kalamazoo.
**Split season between Fort Wayne and Kalamazoo.
***Split season between Kenosha and Kalamazoo.
****Split season between Kalamazoo and Battle Creek.

Battle Creek, 30-79

POS	Player	G	AB	BA	HR	RBI	PO	A	E	DP
*1B	J. Peppas	96	382	.285	1	35	937	54	24	39
**2B	B. Payne	49	294	.173	0	33	186	203	58	28
*SS	D. Pearson	100	346	.150	0	37	213	270	54	26
***3B	B. McKenna	57	159	.151	0	14	62	121	19	6
OF	Donna Cook	84	358	.187	0	17	149	11	8	1
****OF	M. Dailey	60	155	.187	0	6	106	3	4	0
*****OF	E. Keys	88	316	.212	0	23	129	13	9	1

*Split season between Battle Creek and Kalamazoo.
**Split season between Rockford, Kalamazoo and Battle Creek.
***Split season between Fort Wayne, Battle Creek and Peoria.
****Split season between Battle Creek and South Bend.
*****Split season between Battle Creek and Peoria.

POS	Player	G	AB	BA	HR	RBI	PO	A	E	DP
*1B	S. Luhtala	20	96	.167	0	5	152	4	9	3
**1B	B. Whiting	94	269	.190	0	28	942	35	14	39
**2B	M. Wenzell	108	381	.213	0	41	252	248	51	29
2B	F. Battaglia	19	60	.167	0	4	38	21	5	5
***2B	D. Niemiec	17	65	.092	0	6	28	20	4	12
****SS	G. Dunn	45	151	.185	0	10	76	115	18	9
**3B	B. Cornett	39	114	.132	0	6	32	78	18	2
*****3B	M. Callaghan	105	339	.236	0	34	138	318	32	23
*****3B	J. Krick	60	267	.210	0	21	70	155	29	9
OF	D. Shero	12	40	.100	0	4	15	2	3	0
******C	M. Jones	56	139	.173	0	6	139	52	31	3
C	A. O'Dowd	21	68	.132	0	5	61	25	9	3
*****U	M. Pieper	69	244	.254	1	29	113	50	17	2

*Split season between Rockford and Battle Creek.
**Split season between Battle Creek and Kalamazoo.
***Split season between Battle Creek and Grand Rapids.
****Split season between Battle Creek and South Bend.
*****Split season between Battle Creek and Peoria.
******Split season between Rockford and Battle Creek.

POS	Player	G	IP	W	L	ERA
*P	F. Janssen	26	145	6	10	2.67
**P	S. Kidd	19	136	11	7	2.51
**P	J. Rumsey	19	107	4	8	2.52
P	M. Perez	32	237	13	16	3.00
***P	I. Alvarez	13	34	2	0	3.71
P	E. Bergmann	27	280	7	18	3.92
****P	J. Krick	19	107	2	7	4.12
P	Donna Cook	17	78	1	7	4.58
****P	B. Hatzell	20	105	1	14	5.66
*****P	G. Cordes	26	179	3	15	3.52
*****P	J. Peppas	11	57	1	7	4.58
*****P	A. Allen	24	100	3	10	6.21
P	F. Vukovich	5	16	0	3	5.08
P	B. Cornett	2	8	0	1	11.26
P	J. Young	2	3			
P	P. Brown	1	2			

*Split season between Fort Wayne, Peoria, Battle Creek and Kalamazoo.
**Split season between South Bend and Battle Creek.
***Split season between Fort Wayne and Battle Creek.
****Split season between Battle Creek and Peoria.
*****Split season between Battle Creek and Kalamazoo.

BATTING AND BASE RUNNING LEADERS

Batting Average

B. Foss, FW	.368
D. Kamenshek, Roc	.345
C. Wisniewski, GR	.326
E. Callow, Roc	.326
C. Pryer, SB	.312
D. Sams, Kal	.306
A. Pollitt, Roc	.299
J. Peppas, BC, Kal	.285
I. Voyce, GR	.285
D. Satterfield, GR	.279

Home Runs

B. Foss, FW	4
E. Callow, Roc	4
A. Pollitt, Roc	4
D. Schroeder	3
D. Sams, Kal	2
I. Voyce, GR	2
D. Satterfield, GR	2
J. Faut, SB	2
M. Russo, Peo	2
J. Weaver, FW	2
J. Kelley, Roc	2
J. Geissinger	2

Total Bases

B. Foss, FW	176
E. Callow, Roc	172
C. Wisniewski, GR	159
A. Pollitt, Roc	158
D. Satterfield, GR	148
D. Kamenshek, Roc	147
C. Pryer, SB	147
I. Voyce, GR	136
D. Sams, Kal	135
J. Peppas, BC, Kal	131

RBI

E. Callow, Roc	84
E. Mahon, SB	68
D. Satterfield, GR	62
R. Richard, Roc	60
B. Foss, FW	58
L. Paire, GR	56
S. Stovroff, SB	54
E. Wawryshyn, FW	54
S. Wirth, SB	54
M. Russo, Peo	51

Stolen Bases

C. Pryer, SB	129
D. Key, Roc	91
T. Eisen, FW	88

S. Wirth, SB	69
D. Kamenshek, Roc	63
A. Pollitt, Roc	61
B. Foss, FW	60
E. Mahon, SB	53
B. Wagoner, SB	50
E. Wawryshyn, FW	50

Hits

C. Pryer, SB	133
B. Foss, FW	126
C. Wisniewski, GR	126
E. Callow, Roc	124
A. Pollitt, Roc	121
D. Kamenshek, Roc	117
D. Satterfield, GR	112
J. Peppas, BC, Kal	109
D. Sams, Kal	109
E. Wawryshyn, FW	108

Runs Scored

C. Pryer, SB	106
D. Key, Roc	91
D. Kamenshek, Roc	90
T. Eisen, FW	88
A. Pollitt, Roc	88
M. Olinger, GR	82
C. Wisniewski, GR	78
B. Foss, FW	77
S. Wirth, SB	77
B. Wagoner, SB	77

Doubles

B. Foss, FW	34
S. Stovroff, SB	19
T. Eisen, FW	17
E. Callow, Roc	16
M. Pieper, Peo, BC	16
D. Sams, Kal	16
J. Stoll, SB	15
C. Wisniewski, GR	15
D. Brumfield, Ken	14
E. Mahon, SB	14
I. Voyce, GR	14

Triples

E. Callow, Roc	10
K. Kamenshek, Roc	9
A. Pollitt, Roc	9
D. Satterfield, GR	9
C. Wisniewski, GR	9
M. Wenzell, Kal, BC	7

J. Kelley, Roc	6	D. Pearson, BC, Kal	5
E. Mahon, SB	5	B. Payne, Kal, BC, Roc	5
I. Voyce, GR	5		

PITCHING LEADERS

Earned Run Average

D. Naum, Ken	1.14	H. Rotvig, Ken	93
A. Ziegler, GR	1.26	M. Marrero, FW	87
J. Faut, SB	1.33	N. Warren, Peo	79
M. Silvestri, GR	1.53	M. Studnicka, GR	72
D. Mueller, SB	1.56	G. Cordes, BC, Kal	70
R. Gacioch, Roc	1.68		
L. Faralla, SB	1.85	**Complete Games**	
M. Kline, FW	1.95	M. Perez, BC	26
R. Williams, Kal	1.96	R. Gacioch, Roc	25
A. Hohlmayer, Peo	2.02	H. Fox, Roc	23
		A. Ziegler, GR	22
Wins		A. Hohlmayer, Peo	22
R. Gacoich, Roc	20	M. Silvestri, GR	21
M. Kline, FW	18	J. Marlowe, Ken	21
H. Fox, Roc	18	E. Bergmann, BC	20
M. Marrero, FW	17	J. Faut, SB	20
M. Silvestri, GR	16	M. Kline, FW	20
M. Mansfield, Roc	16	M. Marrero, FW	20
J. Faut, SB	15		
L. Faralla, SB	15	**Shutouts**	
A. Hohlmayer, Peo	15	R. Gacioch, Roc	9
P. Scott, FW	15	A. Ziegler, GR	8
M. Studnicka, GR	15	J. Faut, SB	7
J. Bittner, GR	15	A. Hohlmayer, Peo	6
		M. Silvestri, GR	5
Winning Percentage		M. Kline, FW	5
K. Horstman, FW, Ken	1.000	L. Faralla, SB	4
I. Alvarez, FW, BC	1.000	R. Williams, Kal	4
M. Dailey, Peo	1.000	M. Studnicka, GR	4
L. Arnold, SB	.833	J. Bittner, GR	4
D. Mueller, SB	.833		
L. Faralla, SB	.789	**Innings Pitched**	
M. Studnicka, GR	.750	M. Perez, BC	237
R. Gacioch, Roc	.741	R. Gacioch, Roc	231
M. Silvestri, GR	.727	J. Hasham, Peo	218
		H. Fox, Roc	214
Strikeouts		M. Marrero, FW	213
J. Faut, SB	135	J. Marlowe, Ken	211
M. Silvestri, GR	123	A. Hohlmayer, Peo	209
M. Mansfield, Roc	121	M. Mansfield, Roc	202
J. Marlowe	116	E. Bergman, BC	200
J. Vincent, SB	113	M. Silvestri, GR	200

1952

With Kenosha and Peoria folding after the 1951 season, the league was left with six teams. Some players were seeing the beginning of the end and made their move as well to

other leagues or retirement. Little else changed from the previous year; there was a continued decline in attendance.

South Bend's Jean Faut compiled a record-breaking 20–2 record along with a 0.93 ERA. Six hitters broke .300 with Fort Wayne's Jo Weaver leading the pack with a .344 average.

	G	AB	R	H	2B	3B	HR	SH	SB	LOB	Pct.
Fort Wayne	109	3641	501	936	127	46	21	147	169	849	.257
South Bend	109	3426	469	851	128	20	5	178	262	861	.248
Rockford	109	3535	411	832	85	35	21	143	224	710	.235
Grand Rapids	109	3463	382	812	86	30	15	151	191	766	.234
Kalamazoo	109	3490	322	779	91	9	16	148	94	809	.223
Battle Creek	111	3366	362	709	92	21	6	70	163	754	.211

Final Standings

	Won	Lost	Pct	GB
Fort Wayne	67	42	.613	—
South Bend	64	43	.587	3
Rockford	54	54	.500	12½
Grand Rapids	50	60	.455	17½
Kalamazoo	49	60	.450	18
Battle Creek	43	67	.344	24

Fort Wayne, 67-42

POS	Player	G	AB	BA	HR	RBI	PO	A	E	DP
1B	B. Foss	106	414	.331	4	74	1232	32	33	60
2B	D. Brumfield	85	293	.218	1	23	173	200	28	30
SS	D. Schroeder	101	392	.245	6	43	184	295	39	38
3B	C. Horstman	69	312	.250	2	36	91	166	26	11
OF	W. Briggs	105	385	.275	1	43	289	17	7	8
OF	T. Eisen	105	399	.195	0	21	224	11	8	5
OF	Jo Weaver	81	314	.344	3	50	110	19	16	4
C	K. Vonderau	66	219	.210	1	20	213	46	8	6
3B	Jean Weaver	48	160	.225	0	19	56	98	20	6
*OF	N. Meier	48	163	.252	0	11	56	3	6	3
**C	L. Paire	61	200	.230	0	0	222	39	6	2
**C	M. Rountree	65	178	.202	0	5	235	41	4	3
**U	J. Geissinger	111	407	.280	5	56	187	139	35	15

*Split season between Fort Wayne and Battle Creek.
**Split season between Fort Wayne and Grand Rapids.

		G	IP	W	L	ERA
P	M. Kline	28	238	19	7	1.93
P	P. Scott	26	202	17	7	2.05
P	N. Warren	27	219	17	7	2.14
P	C. Horstman	10	65	5	2	2.35
*P	E. Moore	28	143	6	12	3.08
*P	J. Bittner	25	178	11	12	3.34
P	D. Vanderlip	10	39	0	4	3.93
P	Jean Weaver	5	14	0	2	12.90
P	L. Paire	3	3			
P	Jo Weaver	1	1			

*Split season between Fort Wayne and Grand Rapids.

South Bend, 64-44-1

POS	Player	G	AB	BA	HR	RBI	PO	A	E	DP
1B	J. Westerman	81	264	.277	0	36	865	34	23	22
2B	C. Pryer	79	293	.239	0	18	No Record			
SS	G. Dunn	93	326	.236	0	21	165	288	45	17
3B	B. Hoffmann	45	134	.172	1	11	40	95	12	5
OF	J. Lenard	101	351	.259	0	47	156	6	6	0
OF	N. Stoll	84	316	.301	1	60	157	7	8	2
OF	B. Wagoner	91	353	.295	0	27	105	10	7	2
C	S. Stovroff	92	296	.250	1	39	392	78	20	8
1B	D. Mueller	27	152	.250	5	21	252	11	9	14
*U	M. Wenzell	88	259	.216	0	20	183	107	24	21
SS	A. Bleiler	16	50	.180	0	6	32	42	8	0
3B	J. Faut	39	230	.291	0	32	44	119	13	8
*3B	R. Montalbano	12	32	.188	0	7	11	12	9	1
OF	E. Mahon	55	166	.229	0	16	58	6	3	1
*OF	M. Froning	12	25	.080	0	1	17	0	3	0
C	M. Baumgartner	34	50	.100	0	0	89	15	5	0

*Split season between South Bend and Battle Creek.

		G	IP	W	L	ERA
P	J. Faut	23	184	20	2	.909
P	D. Mueller	12	104	5	7	1.82
P	G. Kidd	23	189	13	7	2.00
P	J. Rumsey	26	178	9	10	2.22
P	G. Mooney	24	160	8	8	2.36
P	L. Arnold	16	76	4	8	3.43
P	B. Wagoner	9	55	5	2	4.25

Rockford, 55-54

POS	Player	G	AB	BA	HR	RBI	PO	A	E	DP
1B	I. Applegren	104	364	.253	1	29	1093	45	21	42
2B	J. Berger	109	382	.251	1	33	No record			
SS	D. Doyle	92	362	.229	2	27	188	209	41	19
3B	A. Deschaine	93	418	.270	1	34	158	46	13	4
OF	E. Callow	105	400	.253	8	49	236	12	8	3
OF	D. Key	108	354	.243	1	41	217	24	14	3
OF	J. Buckley	92	317	.196	1	35	131	11	13	2
C	R. Richard	103	394	.284	3	46	344	84	15	6
3B	J. Kelley	14	122	.180	0	15	18	35	7	1
*OF	M. Mansfield	10	83	.133	0	4	9	1	0	0

*Split season between Rockford and Battle Creek.

		G	IP	W	L	ERA
P	R. Gacioch	31	259	20	10	1.88
*P	M. Jinright	33	208	11	12	2.34
P	H. Fox	15	132	8	7	2.80
P	J. Kelley	27	209	12	11	2.89
P	H. Nordquist	17	86	3	7	4.50
*P	M. Mansfield	24	122	3	14	4.94
P	D. Lee	5	26	1	2	6.94
P	E. Callow	3	11	0	1	5.74
P	M. Deegan	1	8	0	1	3.38
P	R. Reis	3	4	0	1	25.00
P	I. Applegren	1	1			
P	D. Jogerst	1	1			
P	J. Berger	1	1			

*Split season between Rockford and Battle Creek.

Grand Rapids, 49-60

POS	Player	G	AB	BA	HR	RBI	PO	A	E	DP
1B	I. Voyce	107	390	.295	10	54	1052	34	13	46
2B	D. Stolze	46	308	.240	0	19	171	99	18	15
SS	M. Olinger	47	173	.202	0	10	81	139	27	9
B	R. Youngberg	85	287	.167	0	24	87	182	21	11
OF	D. Satterfield	102	386	.285	0	51	209	14	8	3
OF	C. Wisniewski	103	360	.267	0	25	120	17	15	3
OF	J. Smith	46	194	.196	1	18	97	6	5	2
*C	L. Paire	61	200	.230	0	18	222	38	6	2

*Split season between Grand Rapids and Fort Wayne.

		G	AB	BA	HR	RBI	PO	A	E	DP
2B	J. Krick	21	117	.162	0	6	17	34	5	0
OF	J. Jaykowski	15	41	.024	0	0	27	1	0	1
C	M. Redman	37	114	.219	0	4	130	44	8	5
*C	M. Rountree	65	178	.202	0	5	235	41	4	3
U	A. Ziegler	85	249	.197	0	16	192	196	35	30
*U	J. Geissinger	111	407	.280	5	56	187	139	35	15

*Split season between Grand Rapids and Fort Wayne.

		G	IP	W	L	ERA
*P	E. Moore	28	143	6	12	3.08
*P	J. Bittner	25	178	11	12	3.34
P	E. Risinger	27	192	10	15	2.34
P	M. Silvestri	24	168	14	9	2.36
P	A. Ziegler	12	72	3	4	2.50
P	M. Studnika	28	185	11	12	2.53
P	J. Krick	21	117	2	7	2.69
P	J. Smith	14	48	1	2	5.44

*Split season between Fort Wayne and Grand Rapids.

Kalamazoo, 49-60

POS	Player	G	AB	BA	HR	RBI	PO	A	E	DP
1B	J. Peppas	108	412	.262	0	36	1082	39	40	43
2B	M. Baker	84	366	.208	0	17	245	196	21	25
SS	D. Naum	62	237	.152	0	6	101	146	26	10
3B	F. Shollenberger	86	316	.228	0	86	130	264	21	13
OF	D. Sams	109	408	.314	12	57	231	15	8	6
OF	B. Francis	98	329	.210	0	14	130	16	6	3
OF	Doris Cook	55	152	.118	0	6	101	6	5	0
C	J. Romatowski	65	224	.223	0	18	237	38	13	3
*2B	N. Mudge	46	153	.150	0	4	132	76	17	13
SS	D. Pearson	44	138	.203	0	11	69	114	26	4
U	M. Carey	55	196	.209	0	2	101	34	8	8
OF	J. Schatz	13	43	.186	0	13	27	1	1	0
OF	A. Allen	44	161	.161	0	10	81	3	9	0
C	J. Lovell	42	142	.246	1	12	133	26	7	1
*OF	J. Moffet	42	151	.219	0	14	64	3	2	1

*Split season between Kalamazoo and Battle Creek.

		G	IP	W	L	ERA
P	G. Cordes	24	213	16	8	1.44
P	R. Williams	23	174	10	12	2.48
P	K. Blumetta	21	170	8	11	2.54
P	E. Roth	19	70	2	6	2.83

		G	IP	W	L	ERA
P	J. Marlowe	21	172	10	11	3.24
P	A. Allen	12	66	1	7	6.00
P	D. Sams	1	3	0	1	30.03

Battle Creek, 43-67-1

POS	Player	G	AB	BA	HR	RBI	PO	A	E	DP
1B	B. Whiting	104	342	.231	0	28	944	33	16	43
2B	J. Marlowe	35	86	.291	3	12	No record			
SS	M. Russo	100	320	.222	1	28	193	286	37	26
3B	E. Petras	92	322	.233	0	18	183	260	15	12
OF	R. Middleton	79	160	.138	0	10	157	7	8	2
OF	J. Cione	78	320	.275	0	32	189	5	10	0
OF	M. Pieper	62	304	.253	4	47	87	4	7	0
C	R. Briggs	111	384	.185	1	29	301	96	23	8
2B	M. Moore	42	88	.148	0	0	No record			
SS	S. Kurys	17	66	.318	3	22	284	232	27	20
3B	B. McKenna	11	26	.077	0	0	7	28	3	1
*3B	R. Montalbano	12	32	.188	0	7	11	12	9	1
*OF	M. Froning	12	25	.080	0	1	17	0	3	0
**2B	N. Mudge	46	153	.150	0	4	132	76	17	13
**OF	J. Moffet	42	151	.219	0	14	64	3	2	1
***OF	M. Mansfield	10	83	.133	0	4	9	1	0	0
OF	Donna Cook	60	152	.118	0	6	101	6	5	0
OF	N. Leduc	10	59	.169	0	2	4	0	2	0
OF	J. Hasham	20	158	.222	0	21	16	2	0	1
*U	M. Wenzell	88	259	.216	0	20	183	107	24	21

*Split season between South Bend and Battle Creek.
**Split season between Battle Creek and Kalamazoo.
***Split season between Rockford and Battle Creek.

		G	IP	W	L	ERA
P	M. Jones	17	128	9	7	1.69
*P	M. Jinright	33	208	11	12	2.34
P	J. Hasham	33	222	12	14	2.51
P	G. Schweigerdt	28	180	10	10	2.95
P	N. Leduc	19	81	3	4	3.11
P	J. Cione	9	50	2	5	3.24
P	M. Marrero	23	138	4	14	3.59
P	F. Janssen	5	18	0	1	5.00
*P	M. Mansfield	24	122	3	14	4.94
P	Waggott	1	1			

*Split season between Rockford and Battle Creek.

BATTING AND BASE RUNNING LEADERS

Batting Average

J. Weaver, FW	.344
B. Foss, FW	.331
D. Sams, Kal	.314
N. Stoll, SB	.301
I. Voyce, GR	.295
B. Wagoner, SB	.295
J. Faut, SB	.291
D. Satterfield, GR	.285
R. Richard, Roc	.284
J. Geissinger, FW, GR	.280

Home Runs

D. Sams, Kal	12
I. Voyce, GR	10

E. Callow, Roc	8	**Hits**		
D. Schroeder, FW	6	B. Foss, FW	137	
J. Geissinger, FW, GR	5	D. Sams, Kal	128	
B. Foss, FW	4	I. Voyce, GR	115	
M. Pieper, BC	4	J. Geissinger, FW, GR	114	
J. Weaver, FW	3	A. Deschaine, Roc	113	
J. Marlowe, Kal	3	R. Richard, Roc	112	
R. Richard, Roc	3	D. Satterfield, GR	110	
W. Briggs, FW	3	T. Eisen, FW	110	
		J. Peppas, Kal	108	
		J. Weaver, FW	108	

Total Bases

B. Foss, FW	209	**Runs Scored**	
D. Sams, Kal	195	B. Foss, FW	81
I. Voyce, GR	167	T. Eisen, FW	77
J. Geissinger, FW, GR	155	D. Schroeder, FW	67
E. Callow, Roc	151	C. Wisniewski, GR	64
R. Richard, Roc	145	B. Wagoner, SB	64
D. Satterfield, GR	138	J. Weaver, FW	58
J. Weaver, FW	137	I. Voyce, GR	57
A. Deschaine, Roc	136	E. Callow, Roc	56
W. Briggs, FW	135	J. Berger, Roc	54
		J. Lenard, SB	49

RBI

B. Foss, FW	74	**Doubles**	
N. Stoll, SB	60	B. Foss, FW	26
D. Sams, Kal	57	D. Sams, Kal	25
J. Geissinger, FW, GR	56	J. Cione, BC	17
I. Voyce, GR	54	I. Voyce, GR	16
D. Satterfield, GR	51	J. Geissinger, FW, GR	16
J. Weaver, FW	50	W. Briggs, FW	16
W. Briggs, FW	50	J. Lenard, SB	15
E. Callow, Roc	49	G. Dunn, SB	15
M. Pieper, BC	47	Several Others	14

Stolen Bases

C. Pryer, SB	59	**Triples**	
B. Foss, FW	56	B. Foss, FW	17
T. Eisen, FW	54	M. Pieper, BC	8
J. Lenard, SB	47	D. Sattefield, GR	7
D. Key, Roc	46	A. Deschaine, Roc	6
T. Petras, BC	42	E. Callow, Roc	6
B. Wagoner, SB	40	J. Berger, Roc	6
D. Satterfield, GR	40	C. Horstman, FW	5
E. Callow, Roc	39	D. Schroeder, FW	5
A. Deschaine, Roc	35	R. Richard, Roc	5
C. Wisniewski, GR	35	J. Geissinger, FW, GR	5
		J. Weaver, FW	5

PITCHING LEADERS

Earned Run Average

J. Faut, SB	0.93	M. Kline, FW	1.93
G. Cordes, Kal	1.44	G. Kidd, SB	2.00
M. Jones, BC	1.69	P. Scott, FW	2.13
D. Mueller, SB	1.82	N. Warren, FW	2.14
R. Gacioch, Roc	1.88	J. Rumsey, SB	2.22

Wins

J. Faut, SB	20
R. Gacioch, Roc	20
M. Kline, FW	19
N. Warren, FW	17
P. Scott, FW	17
G. Cordes, Kal	16
M. Silvestri, GR	14
G. Kidd, SB	13
J. Kelley, Roc	12
J. Hasham, BC	12

Winning Percentage

J. Faut, SB	.909
M. Kline, FW	.731
C. Horstman, FW	.714
N. Warren, FW	.708
P. Scott, FW	.708
G. Cordes, Kal	.667
R. Gacioch, Roc	.667
G. Kidd, SB	.650
M. Silvestri, GR	.609
M. Jones, BC	.563

Strikeouts

J. Faut, SB	114
N. Warren, FW	91
G. Cordes, Kal	84
E. Risinger, GR	82
M. Silvestri, GR	78

J. Kelley, Roc	73
M. Studnicka, GR	70
M. Kline, FW	70
G. Mooney, SB	65
G. Kidd, SB	64

Games

M. Jinright, BC, Roc	33
R. Gacioch, Roc	31
M. Kline, FW	28
M. Studnicka, GR	28
G. Schweigerdt, BC	28
M. Moore, FW, GR	28
N. Warren, FW	27
P. Scott, FW	26
E. Risinger, GR	27
J. Rumsey, SB	26

Innings Pitched

R. Gacioch, Roc	259
M. Kline, FW	238
J. Hasham, BC	222
N. Warren, FW	219
G. Cordes, Kal	213
M. Jinright, BC, Roc	208
P. Scott, FW	202
E. Risinger, GR	192
M. Studnicka, GR	185
J. Faut, SB	184

1953

The continued decline in attendance forced the league to make some changes to make the game more exciting. The length of the base paths was moved up to 75 feet and another foot was added to the pitching distance, making it 56 feet. However, these changes had little effect other than raising batting averages and ERAs a little.

Jean Faut of South Bend led the league in ERA (1.51) for the third year in a row. Joanne Weaver of Fort Wayne repeated the batting crown, too, with a .346 average.

	G	AB	R	H	2B	3B	HR	SH	SB	LOB	Pct.
Fort Wayne	113	3746	598	990	136	44	39	116	313	842	.264
Rockford	110	3584	396	848	95	27	14	137	169	782	.237
Grand Rapids	114	3540	485	833	104	22	15	201	279	877	.235
Kalamazoo	111	3603	410	825	88	11	15	179	82	891	.229
South Bend	112	3568	391	783	91	8	4	137	185	898	.219
Muskegon	112	3481	359	711	70	22	10	113	162	818	.204

Final Standings

	Won	Lost	Pct	GB
Fort Wayne	69	41	.627	—
Grand Rapids	65	45	.591	4

	Won	Lost	Pct	GB
Kalamazoo	50	50	.541	9½
Rockford	52	58	.473	17
South Bend	45	65	.409	24
Muskegon	39	70	.358	29½

Fort Wayne, 69-41-3

POS	Player	G	AB	BA	HR	RBI	PO	A	E	DP
1B	B. Foss	58	449	.321	5	65	656	35	20	36
2B	J. Geissinger	104	397	.295	8	81	250	211	23	37
SS	J. Havlish	94	344	.189	0	22	395	256	50	23
3B	C. Horstman	49	329	.292	4	46	68	155	18	13
OF	W. Briggs	107	404	.257	9	59	208	12	9	3
OF	Jo Weaver	102	410	.346	5	76	213	5	11	0
OF	A. Blaski	39	162	.198	2	14	60	5	3	0
C	R. Briggs	73	234	.231	0	22	279	56	11	5
1B	D. Brumfield	49	211	.332	2	26	481	9	6	21
U	M. Taylor	12	160	.238	4	19	150	3	7	6
3B	S. Crites	42	132	.129	0	11	41	92	11	5
C	L. Paire	46	160	.263	0	24	158	30	4	4

		G	IP	W	L	ERA
P	C. Horstman	17	124	11	5	2.32
P	J. Bittner	30	209	16	7	2.45
P	M. Kline	31	246	16	14	2.49
P	Jean Weaver	20	92	7	1	2.64
P	D. Vanderlip	14	50	2	2	2.88
P	P. Scott	32	238	16	12	3.06
P	L. Paire	3	11	1	0	1.29

Grand Rapids, 65-45-4

POS	Player	G	AB	BA	HR	RBI	PO	A	E	DP
1B	I. Voyce	111	383	.269	6	60	1073	36	13	42
2B	A. Zeigler	65	250	.168	0	18	183	173	20	20
SS	M. Olinger	99	365	.365	0	20	181	243	57	20
3B	B. Wanless	84	306	.248	3	35	118	185	25	12
OF	D. Satterfield	112	404	.295	0	79	254	12	8	1
OF	J. Ricketts	114	417	.288	5	71	141	22	11	4
OF	J. Smith	114	401	.227	1	23	208	18	11	3
C	M. Jenkins	63	203	.207	0	13	244	32	8	5
2B	D. Moore	43	156	.199	0	18	77	75	16	11
C	M. Redman	61	199	.186	0	19	264	48	8	2
*U	R. Youngberg	70	234	.222	0	18	75	169	21	7

*Split season between Grand Rapids, Muskegon and South Bend.

		G	IP	W	L	ERA
P	E. Risinger	30	231	15	10	1.75
P	E. Moore	30	221	17	7	2.00
P	M. Studnicka	27	176	12	13	2.56
P	D. Mueller	28	182	12	7	2.67
P	A. Ziegler	17	116	8	4	3.03
P	J. Descombes	7	17	0	1	7.45
P	J. Krick	3	7	0	1	3.90
*P	B. Gates	16	55	1	3	6.71

*Split season between Grand Rapids and South Bend.

Kalamazoo, 59-50-2

POS	Player	G	AB	BA	HR	RBI	PO	A	E	DP
1B	J. Peppas	108	417	.271	0	33	1170	42	24	51
2B	T. Rukavina	65	269	.178	1	21	184	118	26	11
SS	D. Schroeder	110	389	.285	6	39	253	343	40	29
3B	F. Shollenberger	107	388	.193	0	23	125	286	30	17
OF	N. Stoll	108	396	.308	3	65	222	21	9	2
OF	B. Francis	53	212	.226	0	23	88	8	7	0
OF	J. Sindelar	79	246	.224	2	14	109	9	6	0
C	J. Romatowski	70	263	.217	0	21	252	70	9	9
2B	A. Armato	23	26	.077	0	2	25	21	7	1
OF	D. Sams	45	173	.312	1	21	100	8	0	3
OF	I. Alvarez	38	123	.195	0	12	30	1	7	0
C	J. Lovell	46	193	.202	2	20	148	35	11	6
*OF	Doris Cook	27	66	.167	0	4	34	0	2	0
**2B	M. Carey	90	311	.174	0	17	200	187	31	30

*Split season between Kalmazoo and South Bend.
**Split season between Rockford, Kalamazoo and Muskegon.

		G	IP	W	L	ERA
P	G. Cordes	29	218	13	11	1.98
P	K. Blumetta	23	164	10	9	1.98
P	R. Williams	22	153	8	12	2.12
P	D. Naum	25	198	14	7	2.18
P	E. Rolth	25	82	4	2	2.30
P	A. Allen	24	158	10	9	3.70
*P	Doris Cook	9	30	0	2	8.41

*Split season between Kalamazoo and South Bend.

Rockford, 52-58

POS	Player	G	AB	BA	HR	RBI	PO	A	E	DP
1B	D. Kamenshek	55	188	.193	0	18	618	22	9	28
2B	J. Kelley	31	219	.256	1	22	229	62	19	11
SS	J. Berger	103	368	.247	1	28	196	366	68	32
3B	A. Deschaine	71	314	.315	0	39	125	143	40	16
OF	E. Callow	99	386	.303	8	58	182	12	10	1
OF	D. Key	101	400	.208	0	21	215	124	11	5
OF	S. Sands	67	234	.214	0	15	106	16	12	3
C	R. Richard	91								
1B	J. Wiley	20	102	.206	0	5	184	11	6	13
U	R. Gacioch	26	179	.285	2	18	96	3	4	2
2B	D. Lee	18	145	.152	0	2	52	48	9	8
2B	S. Parsons	10	51	.078	0	3	16	27	4	4
U	C. Habben	37	242	.194	0	18	80	69	27	5
OF	M. Mansfield	11	124	.177	0	11	8	0	1	0
*2B	M. Carey	90	311	.174	0	17	200	187	31	30

*Split season between Rockford, Kalamazoo and Muskegon.

		G	IP	W	L	ERA
P	A. Lee	26	193	12	10	2.24
P	M. Jinright	34	220	12	14	2.25
P	R. Gacioch	29	229	15	12	2.67
P	M. Mansfield	24	188	10	12	2.82
P	H. Nordquist	12	46	1	4	3.91

		G	IP	W	L	ERA
P	J. Kelley	13	63	2	5	4.86
P	E. Callow	1	4	0	1	4.55
P	D. Key	1	2			
P	J. Wiley	1	1			
P	S. Parsons	1	2			

South Bend, 45-65-2

POS	Player	G	AB	BA	HR	RBI	PO	A	E	DP
1B	A. Applegren	76	277	.242	0	24	860	30	14	28
2B	D. Pearson	68	297	.185	0	29	151	185	22	18
SS	G. Dunn	107	438	.179	0	36	184	335	43	18
3B	J. Faut	60	316	.275	4	38	75	162	22	11
OF	B. Wagoner	81	352	.239	0	32	142	11	7	1
OF	J. Lenard	64	193	.192	0	15	95	4	5	0
OF	M. Froning	111	375	.108	0	26	127	14	11	1
C	M. Baumgartner	88	262	.187	0	22	366	69	25	5
1B	G. Kidd	11	198	.187	0	17	118	8	4	4
1B	A. Garman	21	65	.154	0	7	195	7	7	6
*2B	R. Montalbano	13	63	.238	0	2	24	26	5	2
2B	J. Ogden	28	87	.253	0	5	56	34	13	2
**U	R. Youngberg	70	234	.222	0	18	75	169	21	7
***OF	Doris Cook	27	66	.167	0	4	34	0	2	0
U	M. Wenzell	34	96	.177	0	10	40	28	7	3
OF	J. Matuzewski	28	99	.162	0	2	32	1	5	0
C	L. Youngen	37	101	.188	0	9	111	19	6	5

*Split season between South Bend and Muskegon.
**Split season between Grand Rapids, Muskegon and South Bend.
***Split season between Kalamazoo and South Bend.

		G	IP	W	L	ERA
P	J. Faut	29	226	17	11	1.51
P	G. Kidd	31	258	13	15	2.37
P	J. Rumsey	35	249	11	19	2.42
P	B. Wagoner	19	149	4	13	3.02
P	Donna Cook	7	16	0	2	12.99
*P	B. Gates	16	55	1	3	6.71
**P	Doris Cook	9	30	0	2	8.41
P	M. Graham	6	8			

*Split season between Grand Rapids and South Bend.
**Split season between Kalamazoo and South Bend.

Muskegon, 39-70-3

POS	Player	G	AB	BA	HR	RBI	PO	A	E	DP
1B	J. Cione	94	356	.244	0	41	917	35	17	43
2B	N. Mudge	99	337	.157	1	12	234	197	30	35
SS	M. Russo	112	402	.226	2	29	220	330	49	33
3B	B. McKenna	92	293	.215	0	28	132	235	35	11
OF	N. Meier	111	406	.229	1	27	209	10	11	10
OF	M. Pieper	89	314	.229	3	38	112	26	12	4
OF	B. Sowers	65	166	.205	1	15	89	1	12	0
C	K. Vonderau	101	321	.202	0	29	331	77	23	7
U	C. Ballengall	58	188	.181	1	13	281	10	11	11
*2B	M. Carey	90	311	.174	0	17	200	187	31	30
OF	R. Middleton	33	72	.125	0	2	48	2	2	0

POS	Player	G	AB	BA	HR	RBI	PO	A	E	DP
**OF	Donna Cook	43	131	.198	0	10	65	3	4	0
***U	R. Youngberg	70	234	.222	0	18	75	169	21	7
OF	N. Leduc	29	90	.144	0	4	32	2	3	1

*Split season between Rockford, Kalamazoo and Muskegon.
**Split season between Muskgon and South Bend.
***Split season between Grand Rapids, Muskegon and South Bend.

		G	IP	W	L	ERA
P	M. Jones	30	218	14	11	2.56
P	N. Warren	28	200	6	17	2.70
P	M. Baker	28	188	7	12	3.21
P	J. Hasham	31	206	8	19	3.71
P	N. Leduc	24	97	3	9	5.10
P	B. Gates	16	55	1	3	6.71
P	J. Cione	1	5	1	0	5.40
P	M. Marrero	8	26	0	2	7.29
P	M. Pieper	1	5			

Batting and Base Running Leaders

Batting Average

Jo Weaver, FW	.346
D. Brumfield, FW	.332
B. Foss, FW	.321
A. Deschaine, Roc	.315
N. Stoll, Kal	.308
E. Callow, Roc	.303
D. Satterfiled, GR	.295
J. Geissinger, FW	.295
C. Horstman, FW	.292
J. Ricketts, GR	.288

Home Runs

W. Briggs, FW	9
J. Geissinger, FW	8
E. Callow, Roc	8
I. Voyce, GR	6
D. Schroeder, Kal	6
J. Ricketts, GR	5
Jo Weaver, FW	5
B. Foss, FW	5
C. Horstman, FW	4

Total Bases

B. Foss, FW	195
Jo Weaver, FW	187
J. Geissinger, FW	182
E. Callow, Roc	172
J. Ricketts, GR	164
W. Briggs, FW	155
N. Stoll, Kal	149
D. Satterfield	143
G. Dunn, SB	141
D. Schroeder, Kal	141

RBI

J. Geissinger, FW	81
D. Satterfield, GR	79
Jo Weaver, FW	76
J. Ricketts, GR	71
B. Foss, FW	65
N. Stoll, Kal	65
I. Voyce, GR	60
W. Briggs, FW	59
E. Callow, Roc	58
R. Richard, Roc	48

Stolen Bases

B. Foss, FW	80
J. Smith, GR	73
J. Weaver, FW	70
M. Olinger, GR	56
B. Wanless, GR	48
M. Russo, Mus	45
D. Satterfield, GR	40
E. Callow, Roc	37
W. Briggs, FW	33
M. Froning, SB	32

Hits

B. Foss, FW	144
Jo Weaver, FW	142
N. Stoll, Kal	122
G. Dunn, SB	122
J. Ricketts, GR	120
D. Satterfield, GR	119
E. Callow, Roc	117
J. Geissinger, FW	117
J. Peppas, Kal	113

Runs Scored

B. Foss, FW	99	J. Smith, GR	20
J. Smith, GR	86	J. Ricketts, GR	19
Jo Weaver, FW	79	N. Stoll, Kal	18
D. Schroeder, Kal	76	Jo Weaver, FW	18
W. Briggs, FW	75	G. Dunn, SB	17
M. Olinger, GR	67	D. Satterfield, GR	16
M. Russo, Mus	65	J. Cione, Mus	15
E. Callow, Roc	58		
D. Satterfield, GR	58	**Triples**	
J. Berger, Roc	56	J. Geissinger, FW	10
D. Key, Roc	56	M. Russo, Mus	9
		B. Foss, FW	8
Doubles		C. Horstman, FW	7
		Jo Weaver, FW	6
E. Callow, Roc	23	R. Gacioch, Roc	6
J. Geissinger, FW	21	A. Deschaine, Roc	5
B. Foss, FW	20	J. Ricketts, GR	5

PITCHING LEADERS

Earned Run Average

J. Faut, SB	1.51	M. Mansfield, Roc	143
E. Risinger, GR	1.75	E. Risinger, GR	121
G. Cordes, Kal	1.98	E. Moore, GR	119
K. Blumetta, Kal	1.98	G. Cordes, Kal	106
E. Moore, GR	2.00	N. Warren, Mus	100
R. Williams, Kal	2.12	M. Jones, Mus	86
D. Naum, Kal	2.18	J. Rumsey, SB	86
A. Lee, Roc	2.24	D. Mueller, GR	82
M. Jinright, Roc	2.25		
E. Roth, Kal	2.30	**Complete Games**	
		M. Kline, FW	26
Wins		G. Kidd, SB	25
J. Faut, SB	17	J. Faut, SB	24
E. Moore, GR	17	P. Scott, FW	24
J. Bittner, FW	16	R. Gacioch, Roc	23
M. Kline, FW	16	E. Risinger, GR	22
P. Scott, FW	16	M. Jones, Mus	22
R. Gacioch, Roc	15	G. Cordes, Kal	20
E. Risinger, GR	15	E. Moore, GR	20
M. Jones, Mus	14	M. Jinright, Roc	20
D. Naum, Kal	14	J. Hasham, Mus	20

Winning Percentage

L. Paire, FW	1.000	**Shutouts**	
J. Cione, Mus	1.000	M. Kline, FW	7
Jean Weaver, FW	.875	G. Cordes, Kal	6
E. Moore, GR	.708	J. Faut, SB	5
J. Bittner, FW	.696	P. Scott, FW	4
C. Horstman, FW	.688	J. Bittner, FW	4
E. Roth, Kal	.667	J. Rumsey, SB	4
A. Ziegler, GR	.667	Several with three	
D. Mueller, GR	.632		

Strikeouts

		Innings Pitched	
		G. Kidd, SB	258
		J. Rumsey, SB	249
J. Faut, SB	143	M. Kline, FW	246

P. Scott, FW	238	E. Moore, GR	221
E. Risinger, GR	231	M. Jinright, Roc	220
R. Gacioch, Roc	229	G. Cordes, Kal	218
J. Faut, SB	226		

1954

With Muskegon dropping out of the league, the AAGPBL was left with five franchises, the lowest since its opening year. This resulted in the league's most drastic changes yet, making the game much like Major League baseball. The ball was reduced to the same size (9 inches) as the majors, as was the pitching distance (60 feet). Ten feet was added to the base paths, five feet short of the major leagues. But the change that made the most difference was the shortening of the fences to make the home run more feasible than any time in the past. The result was that the home run output tripled! The game was certainly more exciting with more runs being scored than in previous years.

Fort Wayne's Joanne Weaver led the league again in hitting, but this time she broke the .400 barrier with a .429 average. Not since Ted Williams of the Boston Red Sox had someone broken .400, and nobody has done it since. She also knocked out a record 29 home runs. Teammate Jean Geissinger did almost as well with 26 homers on the season. The Fort Wayne team averaged a record .292 on the year. Pitching took a pounding, and the best pitcher, Janet Rumsey of South Bend, could not give up fewer than two runs a game (2.18). The best pitching streak for the year was turned in by Gloria Cordes of Kalamazoo, who pitched three successive shutouts in 34 consecutive scoreless innings.

	G	AB	R	H	2B	3B	HR	SH	SB	LOB	Pct.
Fort Wayne	94	2790	552	815	98	12	102	78	168	677	.292
Kalamazoo	98	2918	482	781	60	2	109	102	82	753	.268
South Bend	93	2725	418	718	92	7	70	105	133	643	.263
Grand Rapids	93	2653	483	698	72	13	67	89	79	722	.263
Rockford	92	2735	352	694	80	6	60	99	103	643	.254

Final Standings

	Won	Lost	Pct	GB
Fort Wayne	53	40	.570	—
South Bend	58	43	.527	4
Grand Rapids	46	45	.505	6
Kalamazoo	48	49	.495	7
Rockford	37	55	.402	15½

Fort Wayne, 54-40

POS	Player	G	AB	BA	HR	RBI	PO	A	E	DP
1B	B. Foss	82	332	.352	14	54	708	23	15	56
2B	J. Geissinger	93	313	.377	2	91	197	197	36	50
SS	J. Havlish	90	276	.254	4	36	143	237	32	37
3B	C. Horstman	42	299	.328	16	55	115	88	17	3
OF	A. Blaski	45	144	.257	3	17	55	5	3	0
OF	Jo Weaver	93	333	.429	29	87	190	13	11	4
OF	N. LeDuc	23	118	.246	2	15	30	1	0	0
C	R. Briggs	65	230	.213	3	33	234	25	4	1
1B	P. Roy	12	38	.079	0	2	95	2	5	1

POS	Player	G	AB	BA	HR	RBI	PO	A	E	DP
U	M. Weddle	62	241	.216	2	21	52	77	20	11
3B	S. Wierman	10	28	.179	0	0	13	24	4	2
OF	V. Carver	19	75	.173	0	7	15	0	1	0
*OF	L. Youngen	44	208	.284	1	35	143	18	3	4
**OF	I. Alvarez	21	66	.191	0	2	22	0	0	0

*Split season between Fort Wayne and South Bend.
**Split season with Grand Rapids and Fort Wayne.

		G	IP	W	L	ERA
P	C. Horstman	16	101	10	4	2.85
P	M. Kline	28	181	18	7	3.23
P	M. Weddle	15	47	3	1	3.83
P	M. Jones	22	131	8	8	4.26
P	N. LeDuc	24	125	9	10	6.05
P	V. Carver	17	80	5	7	8.78
P	B. Gates	3	2	0	1	18.00
*P	M. Baker	22	129	5	11	4.81
P	J. Geissinger	5	10			

*Split season between Fort Wayne and South Bend.

South Bend, 48-44-1

POS	Player	G	AB	BA	HR	RBI	PO	A	E	DP
1B	G. Kidd	37	172	.238	5	32	287	8	2	25
2B	M. Carey	83	252	.210	0	17	221	155	26	38
SS	G. Dunn	92	311	.299	6	38	132	290	34	33
3B	B. Wanless	86	321	.274	15	47	89	175	44	10
OF	W. Briggs	92	317	.300	25	73	126	2	4	0
OF	B. Francis	90	300	.350	8	58	143	8	6	0
OF	M. Froning	81	251	.231	3	19	95	20	8	2
C	M. Baumgartner	81	226	.186	4	19	291	55	10	8
1B	B. Wagoner	35	150	.320	0	15	296	12	9	19
OF	H. Nordquist	19	113	.310	3	16	13	1	2	2
U	M. Drinkwater	39	95	.147	0	4	233	27	16	14
*OF	L. Youngen	44	208	.284	1	35	143	18	3	4

*Split season between Fort Wayne and South Bend.

		G	IP	W	L	ERA
P	J. Rumsey	25	169	15	6	2.18
P	D. Vanderlip	19	120	11	6	2.40
P	G. Kidd	18	133	9	6	2.91
P	B. Wagoner	9	58	4	4	4.66
P	H. Nordquist	15	77	2	9	7.05
P	G. Mooney	3	21	1	1	5.58
P	M. Froning	5	12	1	2	6.02
*P	M. Baker	22	129	5	11	4.81
**P	L. Clapp	3	5			
P	J. McCormick	1	4			

*Split season between Fort Wayne and South Bend.
**Split season between South Bend and Grand Rapids.

Grand Rapids, 46-45-2

POS	Player	G	AB	BA	HR	RBI	PO	A	E	DP
1B	D. Moore	92	321	.239	3	39	844	30	11	53

POS	Player	G	AB	BA	HR	RBI	PO	A	E	DP
2B	A. Ziegler	72	215	.200	2	21	169	162	26	29
SS	D. Pearson	83	272	.327	18	83	128	193	29	30
3B	R. Youngberg	85	282	.269	8	50	99	194	25	14
OF	J. Smith	92	309	.252	3	56	169	15	6	2
OF	J. Ricketts	92	290	.317	15	72	112	24	5	4
OF	B. Sowers	69	197	.284	3	34	113	9	9	1
C	M. Redman	52	177	.249	2	20	186	59	6	6
*OF	I. Alvarez	21	66	.191	0	2	22	0	0	0
OF	R. Stevenson	23	82	.232	3	7	18	2	3	0
C	M. Jenkins	50	132	.182	1	18	102	31	9	6
**U	A. Gosbee	34	85	.153	0	7	67	77	10	16

*Split season with Grand Rapids and Fort Wayne.
**Split season with Grand Rapids and Rockford.

		G	IP	W	L	ERA
P	E. Moore	24	163	14	7	3.31
P	A. Ziegler	17	95	5	4	3.98
P	E. Risinger	23	153	7	13	4.06
P	J. Descombes	22	117	10	8	5.00
P	J. Bittner	24	119	5	11	5.07
*P	J. Hasham	20	60	5	7	7.05
P	R. Youngberg	1	6			
**P	L. Clapp	3	5			

*Split season between Grand Rapids and Rockford.
**Split season between South Bend and Grand Rapids.

Kalamazoo, 48-49-1

POS	Player	G	AB	BA	HR	RBI	PO	A	E	DP
1B	J. Peppas	94	366	.333	16	49	758	20	17	46
2B	N. Mudge	98	353	.232	7	22	264	213	30	37
SS	D. Schroeder	98	312	.304	17	65	185	238	44	35
3B	F. Shollenberger	95	332	.268	8	58	108	210	33	16
OF	C. Habben	95	308	.276	15	46	164	16	12	1
OF	C. Ballengall	89	285	.242	17	40	138	6	11	2
OF	J. Romatowski	38	225	.258	6	26	140	24	8	1
C	J. Lovell	70	259	.286	21	69	214	33	14	5
OF	M. Taylor	32	87	.176	0	9	26	2	6	0
OF	N. Stoll	34	106	.302	0	18	66	7	1	2

		G	IP	W	L	ERA
P	E. Roth	24	146	5	12	3.14
P	J. Peppas	13	65	6	4	3.32
P	G. Cordes	24	145	12	7	4.59
P	N. Warren	26	151	12	9	4.65
P	J. Marlowe	23	147	8	12	4.78
P	K. Blumetta	19	83	5	5	5.86
P	C. Habben	2	4			
P	J. Lovell	1	1			

Rockford, 37-55

POS	Player	G	AB	BA	HR	RBI	PO	A	E	DP
1B	J. Cione	67	242	.256	4	27	559	23	7	45
2B	R. Gacioch	28	217	.304	13	45	180	60	13	17

POS	Player	G	AB	BA	HR	RBI	PO	A	E	DP
SS	M. Russo	88	284	.313	10	35	164	272	25	43
3B	J. Berger	59	289	.280	2	22	106	147	22	22
OF	S. Sands	54	180	.206	1	14	63	11	2	3
OF	D. Key	77	277	.253	0	8	127	6	5	1
OF	E. Callow	85	273	.326	20	58	129	5	10	1
C	R. Richard	89	325	.298	7	43	280	61	17	2
1B	M. Mansfield	14	106	.151	1	6	113	6	4	8
2B	D. Lee	14	101	.168	0	7	30	19	3	2
2B	W. Dokish	24	44	.113	0	2	50	28	11	6
OF	Donna Cook	53	152	.217	2	11	64	13	2	0
U	J. Kaufman	24	97	.134	0	5	49	77	20	12
**U	A. Gosbee	34	85	.153	0	7	67	77	10	16

**Split season with Grand Rapids and Rockford.

		G	IP	W	L	ERA
P	M. Mansfield	14	99	5	8	3.27
P	M. Jinright	24	164	11	11	3.73
P	D. Lee	22	152	10	10	3.91
P	R. Gacioch	22	152	7	15	4.68
P	J. Cione	10	52	4	4	5.02
P	S. Parsons	17	52	0	2	5.88
*P	J. Hasham	20	60	5	7	7.05
P	Donna Cook	4	7			

*Split season between Grand Rapids and Rockford.

BATTING AND BASE RUNNING LEADERS

Batting Average

Jo Weaver, FW	.429
J. Geissinger, FW	.377
E. Moore, GR	.375
B. Foss, FW	.352
B. Francis, SB	.350
J. Peppas, Kal	.333
C. Horstman, FW	.327
D. Pearson, GR	.326
J. Ricketts, GR	.317

Home Runs

Jo Weaver, FW	29
J. Geissinger, FW	26
W. Briggs, SB	25
J. Lovell, Kal	21
E. Callow, Roc	20
D. Pearson, GR	18
D. Schroeder, Kal	17
C. Ballengall, Kal	17
C. Horstman, FW	16
J. Peppas, Kal	16

Total Bases

Jo Weaver	254
J. Geissinger, FW	217
W. Briggs, SB	179

J. Peppas, Kal	174
B. Foss, FW	172
C. Horstman, FW	163
E. Callow, Roc	160
J. Ricketts, GR	159
B. Wanless, SB	150
D. Pearson, GR	148

RBI

J. Geissinger, FW	91
Jo Weaver, FW	87
W. Briggs, SB	73
J. Ricketts, GR	72
J. Lovell, Kal	69
D. Schroeder, Kal	65
F. Shollenberger, Kal	58
B. Francis, SB	58
E. Callow, Roc	58
D. Pearson, GR	57

Stolen Bases

Jo Weaver, FW	79
B. Foss, FW	34
N. Mudge, Kal	33
J. Smith, GR	28
M. Froning, SB	26

B. Wanless, SB	26	M. Russo, Roc	67
G. Dunn, SB	25	G. Dunn, SB	59
E. Callow, Roc	23		
J. Berger, Roc	19	**Doubles**	
M. Russo, Roc	17	J. Geissinger, FW	17
J. Geissinger, FW	17	Jo Weaver, FW	16
		J. Smith, GR	14
Hits		J. Ricketts, GR	14
Jo Weaver, FW	143	G. Dunn, SB	14
J. Peppas, Kal	122	B. Foss, FW	13
J. Geissinger, FW	118	B. Francis, SB	13
B. Foss, FW	117	C. Horstman, FW	13
C. Horstman, FW	98	B. Wanless, SB	13
R. Richard, Roc	97	J. Havlish, FW	13
W. Briggs, SB	95	N. Mudge, Kal	13
D. Schroeder, Kal	95		
G. Dunn, SB	93	**Triples**	
J. Ricketts, GR	92	E. Moore, GR	5
		Jo Weaver, FW	4
Runs Scored		J. Ricketts, GR	4
Jo Weaver, FW	109	M. Weddle, FW	2
B. Foss, FW	80	A. Blaski, FW	2
J. Geissinger, FW	78	J. Berger, Roc	2
B. Wanless, SB	75	M. Russo, Roc	2
J. Peppas, Kal	75	C. Horstman, FW	2
W. Briggs, SB	69	B. Francis, SB	2
C. Horstman, FW	68	J. Geissinger, FW	2
D. Pearson, GR	68		

PITCHING LEADERS

Earned Run Average		M. Kline, FW	.720
J. Rumsey, SB	2.18	J. Rumsey, SB	.714
D. Vanderlip, SB	2.40	C. Horstman, FW	.714
C. Horstman, FW	2.85	E. Moore, GR	.667
G. Kidd, SB	2.91	D. Vanderlip, SB	.647
E. Roth, Kal	3.14	G. Kidd, SB	.600
M. Kline, FW	3.23	J. Peppas, Kal	.600
M. Mansfield, Roc	3.27		
E. Moore, GR	3.31	**Strikeouts**	
J. Peppas, Kal	3.32	A. Lee, Roc	94
M. Jinright, Roc	3.73	M. Kline, FW	91
		J. Rumsey, SB	89
Wins		G. Cordes, Kal	86
M. Kline, FW	18	J. Descombes, GR	63
J. Rumsey, SB	15	N. Warren, Kal	63
E. Moore, GR	14	M. Jones, FW	59
G. Cordes, Kal	12	E. Moore, GR	53
N. Warren, Kal	12	M. Mansfield, Roc	52
D. Vanderlip, SB	11	G. Kidd, SB	50
M. Jinright, Roc	11		
C. Horstman, FW	10	**Complete Games**	
A. Lee, FW	10	J. Rumsey, SB	21
J. Descombes, GR	10	E. Moore, GR	21
		A. Lee, Roc	20
Winning Percentage		M. Kline, FW	19
M. Weddle, FW	.750		

N. Warren, Kal	18
R. Gacioch, Roc	17
J. Marlowe, Kal	15
M. Jinright, Roc	15
Several with 14	

Shutouts

M. Kline, FW	6
J. Rumsey, SB	5
D. Vanderlip, SB	4
A. Lee, Roc	4
G. Cordes, Kal	4
Several with 3	

Innings Pitched

M. Kline, FW	181
J. Rumsey, SB	169
M. Jinright, Roc	164
E. Moore, GR	163
E. Risinger, GR	153
R. Gacioch, Roc	152
A. Lee, Roc	152
N. Warren, Kal	151
J. Marlowe, Kal	147
E. Roth, Kal	146

Season Records

Most Wins

77 — Grand Rapids and Racine, 1948

Most Losses

84 — Springfield, 1948

Best Winning Percentage

.611, Racine, 1946

Worst Winning Percentage

.295 — Peoria, 1946

Most Games Played

127 — South Bend and Kenosha, 1948

Most Games Behind

41 — Peoria, 1946

Most Runs

611 — Racine, 1943

Best Batting Average

.292 — Fort Wayne, 1954

Most Hits

936 — Fort Wayne, 1952

Most At Bats

3960 — Rockford, 1948

Most Sacrifice Hits

237 — South Bend, 1949

Most Doubles

136 — Fort Wayne, 1953

Most Triples

51 — Rockford, 1950

Most Home Runs

109 — Kalamazoo, 1954

Most Stolen Bases

730 — Milwaukee, 1944

Most Left on Base

902 — Fort Wayne, 1948

Club Records, One Game*

Most Runs Scored, One Club

26 — Racine vs. Grand Rapids, June 13, 1946

Most Hits

19 — Kenosha vs. Rockford, June 11, 1943; South
 Bend vs. Rockford, June 18, 1945

Most Doubles

8 — Rockford vs. Racine, June 22, 1945

Most Triples

4 — Racine vs. Rockford, July 8, 1943

***No records kept after 1948.**

Most Home Runs

3 — Racine vs. Rockford, July 8, 1943; Minneapolis vs. Milwaukee, July 2, 1944; Minneapolis vs. Kenosha, July 29, 1944

Most Stolen Bases

24 — Racine vs. Minneapolis, June 7, 1944

Most Bases on Balls

23 — South Bend vs. Racine, June 19, 1943

Most Strikeouts

16 — Peoria vs. Fort Wayne, June 7, 1946

Most Left on Bases

17 — South Bend vs. Minneapolis, July 31, 1944

Most Errors

12 — Rockford vs. Racine, Aug. 17, 1943

Most Consecutive Games Won

13 — Grand Rapids, 1946; Muskegon, 1948

Most Consecutive Games Lost

10 — Kenosha, June 16-24, 1945

Most Double Plays

4 — South Bend vs. Kenosha, June 22, 1945; Racine vs. Grand Rapids, July 16, 1945

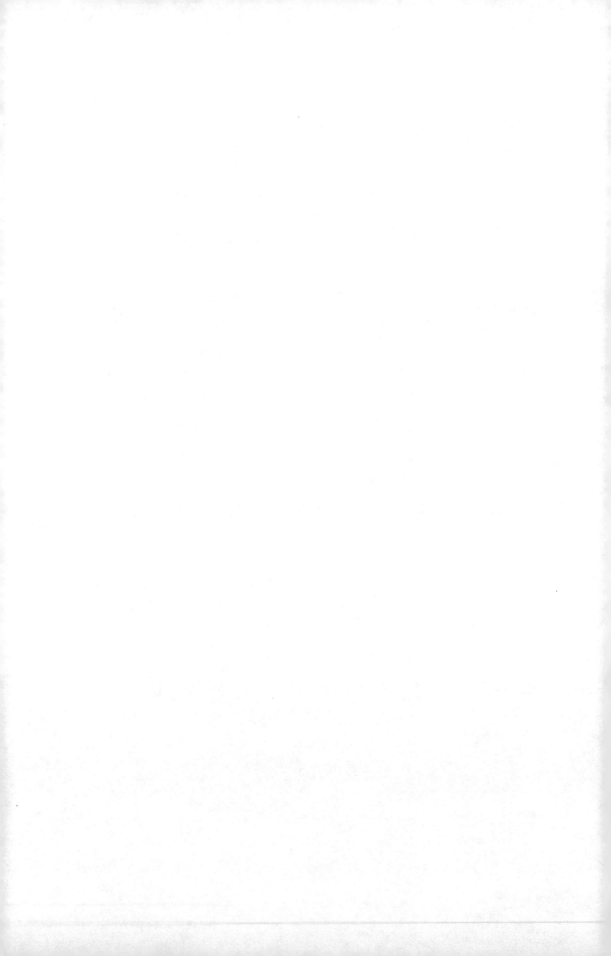

IV

Playoff Records

THE 1943 SCHOLARSHIP SERIES

The first AAGPBL Scholarship Series pitted first-half winner Racine Belles against the Kenosha Comets, second-half champs. The series opened at Lakefront Park in Kenosha. Racine swept both games and wrapped up the sweep at their own Horlick Field to claim the championship. Helen Nicol claimed two of the victories by limiting the Comets to five runs over two games. Irene Hickson led the Belles hitters with a .417 average in the three games. Racine received 60 percent of the gate receipts with the remaining going to Kenosha. The league would have received the receipts from Games 4 and 5 if they had been played.

The championship won the city of Racine a $1,000 scholarship to give to a student to attend the University of Wisconsin on a physical education program. The city also received a championship flag to fly and a bronze plaque. Each member of the Racine Belles was awarded a solid gold bar pin at the conclusion of the 1943 Series.

Championship Round (Best of five)

Racine vs. Kenosha

Game 1: Racine 6, Kenosha 2
Game 2: Racine 7, Kenosha 4
Game 3: Racine 6, Kenosha 3
Racine wins championship 3 games to 0.

Game 1 — September 3 — Racine 6, Kenosha 2

				R	H	E	DP
Racine	001	200	201	6	12	1	1
Kenosha	001	000	010	2	7	3	0

Winning Pitcher: M. Nesbitt; *Losing Pitcher:* H. Nicol. *Umpires:* Gembler and Porter.
Highlights: Racine overcame the pitching of Helen Nicol, who had a 9-3 record against Racine during the regular season. Racine's Irene Hickson garnered three hits and Sophie Kurys tripled to lead the Belles to victory.

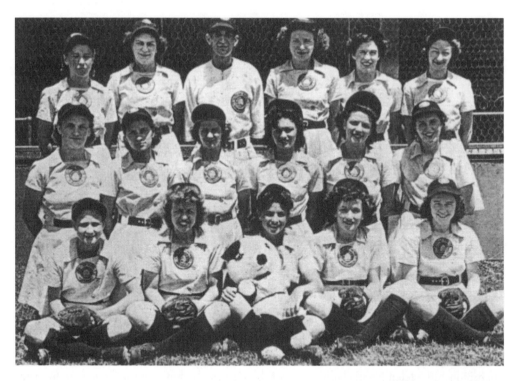

Members of the 1943 Racine Belles playoff championship team were (front row from left) Irene Hickson, Edythe Perlick, Clara Schillace, Annabelle Thompson, Madeline English, (second row from left) Eleanor Dapkus, Sophie Kurys, Dorothy Wind, Gloria Marks, Dorothy Maguire, Margaret Danhauser (back from left) Charlotte Smith, Joanne Winter, Manager Johnny Gottselig, Mary Nesbit, Dorothy Hunter and Chaperone Marie Anderson.

Game 2 — September 4 — Racine 7, Kenosha 4

				R	H	E	DP
Racine	000	141	001	7	7	2	1
Kenosha	000	100	300	4	9	6	0

> *Winning Pitcher:* J. Winter; *Losing Pitcher:* E. Harney. *Umpires:* Porter and Gembler.
> *Highlights:* Although outhit, Racine made their hits count for runs. Joanne Winter held off Kenosha with curves and drops until the rain came in the third inning and rendered those pitches ineffective. Winter ran into trouble in the eighth, so Mary Nesbitt was called in to save the game.

Game 3 — September 5 — Racine 6, Kenosha 3

				R	H	E	DP
Kenosha	100	002	000	3	8	2	0
Racine	201	000	03x	6	6	1	0

> *Winning Pitcher:* H. Nicol; *Losing Pitcher:* M. Nesbitt. *Umpires:* Porter and Gembler
> *Highlights:* Eleanor Dapkus singled with the bases loaded in the eighth inning to score two runs and secure the victory for Racine.

Composite Averages

Racine Pitching Records

	IP	W	L	H	BB	SO	B	WP	HB	R	ER	ERA
M. Nesbitt	21	2	0	16	7	3	0	2	1	5	5	2.14

	IP	W	L	H	BB	SO	B	WP	HB	R	ER	ERA
J. Winter	6	1	0	8	2	0	0	0	0	4	3	4.50
Totals	27	3	0	24	9	3	0	2	1	9	8	2.66

Racine Batting Records

	AB	R	H	S	2B	3B	HR	RBI	Pct.	SB	PO	A	E	FA
I. Hickson	12	1	5	2	2	0	0	5	.417	2	9	3	0	1.000
C. Schillace	8	3	3	3	0	0	0	2	.375	1	9	0	0	1.000
M. Nesbitt	9	2	3	0	1	0	0	0	.333	1	2	4	0	1.000
J. Winter	3	1	1	0	0	0	0	0	.333	0	1	2	0	1.000
M. English	13	5	4	0	0	0	0	1	.308	2	4	12	3	.843
S. Kurys	10	3	2	1	0	1	0	2	.200	2	14	3	0	1.000
E. Perlick	11	1	2	0	0	0	0	0	.182	4	3	0	0	1.000
E. Dapkus	11	1	2	1	0	0	0	3	.182	0	4	1	0	1.000
D. Wind	12	1	2	0	0	0	0	1	.167	1	18	10	3	.903
M. Danhauser	12	1	1	0	0	0	0	1	.083	0	17	1	0	1.000
Totals	101	19	25	7	3	1	0	14	.248	13	81	36	6	.951

Kenosha Pitching Records

	IP	W	L	H	BB	SO	B	WP	HB	R	ER	ERA
E. Harney	8	0	1	6	2	0	0	1	0	6	4	4.50
H. Nicol	17	0	2	18	6	1	0	1	0	12	8	4.50
C. Cook	1	0	0	1	0	0	0	0	0	0	0	0.00
Totals	26	0	3	25	8	1	0	2	0	19	12	4.16

Kenosha Batting Records

	AB	R	H	S	2B	3B	HR	RBI	Pct.	SB	PO	A	E	FA
S. Jameson	13	3	4	0	0	0	0	1	.308	9	7	0	0	1.000
A. Wagner	10	1	3	0	0	1	0	2	.300	0	2	0	1	.667
P. Koehn	14	2	4	0	1	0	0	0	.286	0	7	0	0	1.000
P. Pirok	13	1	3	0	1	0	0	2	.231	1	9	8	3	.850
M. Lester	13	0	3	0	0	0	0	1	.231	1	8	7	1	.938
K. Heim	10	1	2	1	0	0	0	0	.200	3	11	2	0	1.000
J. O'Hara	11	0	2	0	0	0	0	0	.182	0	28	1	1	.967
A. Harnett	12	1	2	0	0	0	0	1	.167	0	4	9	3	.813
E. Harney	3	0	0	0	0	0	0	0	.000	0	0	0	2	.000
E. McCreary	1	0	0	0	0	0	0	0	.000	0	0	0	0	1.000
H. Nicol	8	0	1	0	0	0	0	0	.125	0	4	5	0	1.000
C. Cook	0	0	0	0	0	0	0	0	.000	0	0	1	0	1.000
Totals	108	9	24	1	2	1	0	7	.222	14	80	33	11	.911

THE 1944 SCHOLARSHIP SERIES

This Scholarship Series featured the first-half champion Kenosha against the second-half–winning Milwaukee Chicks. All games were played at Borchert Field in Kenosha, because the Milwaukee field was being used by the Brewers, a minor league team. The series was extended to best four of seven games and it took all seven games for Milwaukee to be declared the champion.

Milwaukee's Connie Wisniewski won a series-record four games. She shutout the Comets in the final game to give the Chicks the championship. Although outhit, Milwaukee runners made up the difference by stealing 39 bases, a series record.

Championship Round (Best of seven):

Game 1: Kenosha vs. Milwaukee

Game 1: Kenosha 4, Milwaukee 2
Game 2: Kenosha 4, Milwaukee 1
Game 3: Milwaukee 7, Kenosha 0
Game 4: Milwaukee 7, Kenosha 1
Game 5: Kenosha 9, Milwaukee 0
Game 6: Milwaukee 2, Kenosha 1
Game 7: Milwaukee 3, Kenosha 0
Milwaukee wins championship 4 games to 3.

Game 1: Kenosha 4, Milwaukee 2

				R	H	E	DP
Milwaukee	101	000	000	2	11	6	0
Kenosha	100	020	01x	4	6	2	0

Winning Pitcher: H. Nicol; *Losing Pitcher:* C. Wisniewski. *Umpires:* Kober and Green. A: 1,520.
Highlights: Helen Nicol scattered 11 hits and scored a run in winning the opener over the Chicks.

Game 2: Kenosha 4, Milwaukee 1

				R	H	E	DP
Kenosha	001	101	010	4	8	4	0
Milwaukee	100	000	000	0	4	0	0

Winning Pitcher: M. Pratt; *Losing Pitcher:* J. Kabick. *Umpires:* Green and Kober. A: 1,779.
Highlights: Ann Harnett homered and Mary Pratt gave up only one run to lead the Comets over the Chicks and take 2-0 lead in the series.

Game 3: Milwaukee 7, Kenosha 0

				R	H	E	DP
Milwaukee	040	010	020	7	10	0	0
Kenosha	000	000	000	0	5	5	1

Winning Pitcher: C. Wisniewski; *Losing Pitcher:* H. Nicol. *Umpires:* Kober and Green.
Highlights: Connie Wisniewski revenged a Game 1 loss as she shutout the Comets.

Game 4: Milwaukee 7, Kenosha 1

				R	H	E	DP
Kenosha	000	100	000	1	4	6	0
Milwaukee	000	101	41x	7	7	4	1

Winning Pitcher: C. Wisniewski; *Losing Pitcher:* M. Pratt. *Umpires:* Green and Kober. A: 1,144.
Highlights: Rain delays allowed Connie Wisniewski to pitch again for the Chicks and win again as well in limiting the Comets to one run to tie the series.

Game 5: Kenosha 9, Milwaukee 0

Winning Pitcher: H. Nicol; *Losing Pitcher:* J. Kabick
Highlights: Helen Nicol shutout the Chicks to put the Comets back in the lead in the series.

Game 6: Milwaukee 2, Kenosha 1

					R	H	E	DP	
Kenosha	000	000	000	0	1	1	3	5	0
Milwaukee	000	000	000	0	2	2	2	2	0

Winning Pitcher: C. Wisniewski; *Losing Pitcher:* H. Nicol. *Umpires:* Green and Kober. *Highlights:* Connie Wisniewski won her third game of the series as her team came back in the bottom of the 11th inning on Kenosha miscues to win the game.

Game 7: Milwaukee 3, Kenosha 0

				R	H	E	DP
Milwaukee	000	000	201	3	4	0	0
Kenosha	000	000	000	0	3	7	0

Winning Pitcher: C. Wisniewski; *Losing Pitcher:* H. Nicol. *Umpires:* Kober and Green. A: 3,166.

Composite Averages

Milwaukee Pitching Records

	IP	W	L	H	BB	SO	B	WP	HB	R	ER	ERA
C. Wisniewski	45	4	1	21	2	7	0	0	0	6	2	0.40
J. Kabick	9	0	2	12	2	2	0	0	0	10	7	7.00
V. Thompson	9	0	0	0	0	0	0	0	1	2	3	3.00
Totals	63	4	3	33	4	9	0	0	1	18	12	1.71

Milwaukee Batting Records

	AB	R	H	S	2B	3B	HR	RBI	Pct.	SB	PO	A	E	FA
G. Davis	27	3	9	2	0	0	0	3	.333	8	19	10	3	.906
M. Keagle	30	6	9	0	1	0	0	2	.300	9	7	0	3	.700
T. Eisen	28	3	7	1	1	0	1	2	.250	8	10	0	2	.833
V. Panos	28	5	6	2	0	0	0	0	.214	7	13	1	0	1.000
D. Maguire	24	1	3	1	0	0	0	2	.125	3	17	5	1	.957
A. Ziegler	20	1	2	2	1	0	0	1	.100	2	22	17	0	1.000
B. Whiting	22	1	2	2	0	0	0	1	.090	1	88	1	4	.989
D. Tetzlaff	26	1	2	2	0	0	0	2	.077	1	9	28	3	.925
C. Wisniewski	18	1	1	0	0	0	0	1	.055	0	1	26	0	1.000
J. Kabick	3	0	0	0	0	0	0	0	.000	0	2	2	0	1.000
V. Thompson	1	0	0	0	0	0	0	0	.000	0	0	1	0	1.000
E. Stevenson	1	0	0	0	0	0	0	0	.000	0	0	0	0	1.000
Totals	228	22	41	12	3	0	1	14	.129	39	189	91	16	.946

Kenosha Pitching Records

	IP	W	L	H	BB	SO	B	WP	HB	R	ER	ERA
H. Nicol	33	2	3	26	9	15	0	0	0	9	4	1.09
M. Pratt	31	1	1	13	4	2	0	0	2	10	4	1.16
Totals	64	3	4	39	13	17	0	0	2	19	8	1.13

Kenosha Batting Records

	AB	R	H	S	2B	3B	HR	RBI	Pct.	SB	PO	A	E	FA
P. Pirok	27	2	8	0	1	0	0	1	.296	0	12	10	8	.733
H. Nicol	11	4	0	0	1	0	0	2	.364	0	2	10	0	1.000
G. Ganote	29	2	7	0	0	0	0	1	.241	0	68	5	13	.849
P. Koehn	26	1	4	0	1	0	0	1	.154	0	22	1	0	1.000
A. Wagner	26	3	4	0	1	1	0	0	.154	0	4	0	0	1.000
L. Colacito	13	1	2	0	1	0	0	0	.154	0	20	4	3	.889
E. Harnett	28	3	4	0	1	0	1	3	.143	0	29	17	4	.920
S. Jameson	27	4	3	0	1	0	0	2	.111	2	10	2	2	.857
E. Mahon	22	1	2	1	0	0	0	2	.091	2	18	12	1	.968
J. O'Hara	11	0	1	0	0	0	0	0	.091	0	6	6	2	.857

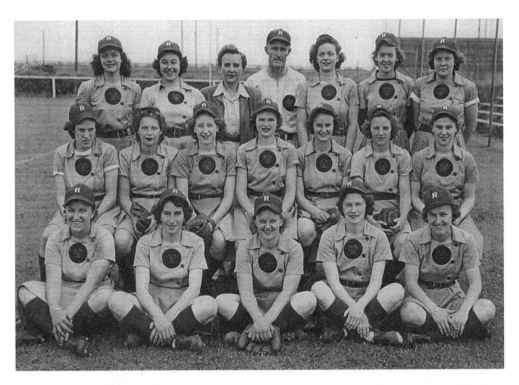

Members of the 1945 Rockford Peaches playoff championship team were (front row from left) Rose Gacioch, Dorothy Ferguson, Helen Filarski, Olive Little, Josephine Lenard, (second row from left) Dorothy Kamenshek, Kay Rohrer, Dorothy Harrell, Dorothy Green, Betty Carveth, Irene Applegren, Irene Kotowicz, (back row from left) Carolyn Morris, Margaret Wigiser, Chaperone Marie Timme, Manager Bill Allington, Mildred Deegan, Alva Jo Fischer and Jean Cione.

	AB	R	H	S	2B	3B	HR	RBI	Pct.	SB	PO	A	E	FA
R. Folder	1	0	0	0	0	0	0	0	.000	0	0	0	0	1.000
M. Pratt	11	0	1	0	0	0	0	0	.091	0	0	12	1	.923
Totals	232	19	36	1	6	2	1	12	.155	5	189	103	34	.896

1945
CHAMPIONSHIP SERIES

The split season was dropped in favor of a longer playoff schedule with the Shaughnessy format: the one seed versus three, and two versus four, with the winners facing each other in the finals. Rockford won the regular season and faced Grand Rapids, while second place Fort Wayne took on Racine. Rockford and Fort Wayne ended up facing each other in the finals, with Rockford proving that finishing first during the regular season was no fluke.

The Peaches also proved the adage that in a short series, good pitching and fielding was more important than hitting. Carolyn Morris won six games for the Peaches during the playoffs.

First Round (Best of five)

Fort Wayne vs. Racine

Game 1: Fort Wayne 6, Racine 1
Game 2: Fort Wayne 8, Racine 2
Game 3: Racine 5, Fort Wayne 4
Game 4: Fort Wayne 10, Racine 3
Fort Wayne wins series 3 games to 1

Game 1: Fort Wayne 6, Racine 1

				R	H	E	DP
Racine	000	000	100	1	2	3	0
Fort Wayne	000	310	20x	6	8	2	0

Winning Pitcher: D. Wiltse; *Losing Pitcher:* D. Barr. *Umpires:* Ward and Zoss. *Time:* 1:38.
Highlights: Fort Wayne's Dottie Wiltse struck out a series record 10 hitters on her way to a two-hitter to stop Racine.

Game 2: Fort Wayne 8, Racine 2

				R	H	E	DP
Racine	000	000	002	2	4	2	1
Fort Wayne	400	000	04x	8	8	4	1

Winning Pitcher: A. Lee; *Losing Pitcher:* M. Crews. *Umpires:* Ward and Zoss. A: 2,400.
Highlights: Faye Dancer pounded a home run and knocked in a series record four runs to push Fort Wayne past Racine. Annabelle Lee held the Belles to four hits.

Game 3: Racine 5, Fort Wayne 4

				R	H	E	DP		
Fort Wayne	000	300	001	0	0	4	5	5	0
Racine	200	000	002	0	1	5	7	3	0

Winning Pitcher: D. Barr; *Losing Pitcher:* B. Carveth. *Umpires:* Rome and Chapman. A: 1,713
Highlights: Janet Jacobs blasted a home run in the bottom of the ninth to take the game into extra innings and consequently lead the Belles to a victory in the 11th inning.

Game 4: Fort Wayne 10, Racine 3

				R	H	E	DP
Fort Wayne	210	142	000	10	12	1	0
Racine	001	002	000	3	6	4	2

Winning Pitcher: D. Wiltse; *Losing Pitcher:* M. Crews. *Umpires:* Chapman and Rome. Time: 1:36.
Highlights: Fort Wayne launched a 12-hit barrage and Dottie Wiltse pitched another gem to win the series over Racine.

Composite Averages

Racine Pitching Records

	IP	W	L	H	BB	SO	B	WP	HB	R	ER	ERA
D. Barr	19	1	1	13	9	9	0	2	1	10	5	2.37
M. Crews	12	0	2	13	7	1	1	1	0	12	12	9.00
J. Winter	5	0	0	7	1	0	0	3	0	6	1	1.80
Totals	36	1	3	33	17	10	1	6	1	28	18	4.50

Racine Hitting Records

	AB	R	H	S	2B	3B	HR	RBI	Pct.	SB	PO	*A	E	FA
S. Kurys	16	1	4	0	0	2	0	1	.250	5	12	0	0	1.000
C. Schillace	15	0	0	0	0	0	0	0	.000	0	10	0	0	1.000
I. Hickson	16	4	3	0	0	0	0	0	.188	1	20	0	0	1.000
E. Perlick	13	3	1	0	0	0	0	0	.077	0	12	0	0	1.000
J. Jacobs	15	1	3	0	0	0	1	4	.200	0	22	0	0	1.000
M. English	16	0	3	0	0	0	0	0	.188	0	14	0	4	.778
B. Emry	15	1	1	0	0	0	0	1	.067	0	4	0	0	1.000
F. Danhauser	11	0	1	0	0	0	0	1	.091	0	23	0	0	1.000
D. Barr	8	0	0	0	0	0	0	0	.000	0	3	0	3	.500
M. Crews	10	0	3	0	0	1	0	3	.300	0	20	0	0	1.000
J. Winter	2	0	0	0	0	0	0	0	.000	0	3	0	0	1.000
Totals	137	10	19	0	0	3	1	10	.139	6	147	0	7	.955

Fort Wayne Pitching Records

	IP	W	L	H	BB	SO	B	WP	HB	R	ER	ERA
D. Wiltse	9	2	0	8	3	16	0	0	0	4	1	1.00
A. Lee	9	1	0	4	3	4	0	0	0	2	2	2.00
B. Carveth	11	0	1	7	3	2	0	0	0	5	4	3.27
Totals	29	3	1	19	9	22	0	0	0	11	7	2.17

Fort Wayne Hitting Records

	AB	R	H	S	2B	3B	HR	RBI	Pct.	SB	PO	*A	E	FA
H. Callaghan	15	2	2	1	0	0	0	0	.133	2	10	0	0	1.000
M. Callaghan	10	4	1	0	0	0	0	0	.100	1	15	0	3	.834
P. O'Brien	13	4	7	0	1	0	0	2	.538	2	9	0	1	.900
V. Kellogg	13	5	7	1	1	1	0	2	.538	1	46	0	0	1.000
L. Paire	13	5	4	1	0	1	0	4	.308	1	19	0	2	.905
I. Ruhnke	13	2	3	0	0	0	0	0	.231	0	9	0	1	.900
F. Dancer	13	4	4	0	1	0	2	8	.308	0	2	0	0	1.000
R. Lessing	14	1	2	0	0	0	0	3	.143	0	20	0	0	1.000
D. Wiltse	7	0	2	0	1	0	0	1	.000	0	7	0	0	1.000
A. Lee	3	0	0	0	0	0	0	0	.000	0	3	0	0	1.000
J. O'Hara	1	1	0	0	0	0	0	0	.000	0	1	0	0	1.000
A. Johnson	2	1	0	0	0	0	0	0	.000	0	2	0	2	.500
Y. Teillett	2	0	0	0	0	0	0	0	.000	0	0	0	0	1.000
B. Carveth	3	0	0	0	0	0	0	0	.000	0	3	0	0	1.000
Totals	122	29	32	3	4	2	2	20	.262	7	146	0	9	.942

*No assists available in box scores.

First Round (Best of five)

Rockford vs. Grand Rapids

Game 1: Rockford 1, Grand Rapids 0
Game 2: Rockford 4, Grand Rapids 3
Game 3: Grand Rapids 1, Rockford 0
Game 4: Rockford 2, Grand Rapids 0
Rockford wins series 3 games to 1

Game 1: Rockford 1, Grand Rapids 0

				R	H	E	DP
Grand Rapids	000	000	000	0	4	0	1
Rockford	000	001	00x	1	5	1	0

Winning Pitcher: C. Morris; *Losing Pitcher:* C. Wisniewski. *Umpires:* Giacinti and Chapman. Time 1:20.

Highlights: Carolyn Morris recorded a shutout of the Chicks allowing only four hits.

Game 2: Rockford 4, Grand Rapids 3

				R	H	E	DP
Grand Rapids	000	000	300	3	7	3	0
Rockford	101	001	10x	4	6	1	0

Winning Pitcher: C. Morris; *Losing Pitcher:* J. Kabick. *Umpires:* Zoss and Fryback. A: 3,200.

Highlights: Margaret Wigiser knocked in two runs and Dottie Kamenshek scored two runs to lead the Peaches to a second straight victory.

Game 3: Grand Rapids 1, Rockford 0

				R	H	E	DP
Rockford	000	000	000	0	1	1	1
Grand Rapids	000	001	00x	1	3	1	0

Winning Pitcher: C. Wisniewski; *Losing Pitcher:* A. Applegren. *Umpires:* Ward and Zoss. Time: 1:15.

Highlights: Connie Wisniewski allowed only one hit to whip the Peaches.

Game 4: Rockford 2, Grand Rapids 0

				R	H	E	DP
Rockford	000	100	010	2	5	0	0
Grand Rapids	000	000	000	0	6	3	0

Winning Pitcher: C. Morris; *Losing Pitcher:* C. Wisniewski. *Umpires:* Chapman and Giacinti. 1:30.

Carolyn Morris again shutout the Peaches to record her third victory of the series, a series record. Rockford wins series 3 games to 2

Grand Rapids Pitching Records

	IP	W	L	H	BB	SO	B	WP	HB	R	ER	ERA
C. Wisniewski	26	1	2	11	5	0	0	0	0	3	2	0.69
J. Kabick	8	0	1	6	2	0	0	0	0	4	1	1.13
Totals	34	1	3	17	7	0	0	0	0	7	3	0.80

Grand Rapids Hitting Records

	AB	R	H	S	2B	3B	HR	RBI	Pct.	SB	PO	A	E	FA
D. Tetzlaff	14	0	2	0	0	0	0	0	.143	1	5	16	2	.913
B. Whiting	16	0	1	0	0	0	0	0	.063	0	52	0	2	.963
T. Shively	13	0	1	0	0	0	0	0	.077	1	8	0	0	1.000
T. Eisen	14	2	5	0	1	0	0	0	.357	1	6	0	0	1.000
E. Wicken	15	1	4	0	0	0	0	0	.267	0	4	1	0	1.000
D. Maguire	15	0	4	0	1	0	0	2	.267	1	7	5	0	1.000
A. Ziegler	11	0	2	1	0	0	0	0	.182	0	9	4	3	.812
P. Gianfrancisco	2	0	0	0	0	0	0	0	.000	0	0	0	0	1.000
E. Petras	8	0	0	1	0	0	0	0	.000	0	11	17	2	.933
M. Wenzell	1	0	0	0	0	0	0	0	.000	2	1	0	0	1.000
C. Wisniewski	7	0	0	0	0	0	0	0	.000	0	0	14	0	1.000
J. Kabick	3	0	0	0	0	0	0	0	.000	0	0	0	1	.000
Totals	119	3	19	2	2	0	0	2	.160	6	103	57	8	.952

Rockford Pitching Records

	IP	W	L	H	BB	SO	B	WP	HB	R	ER	ERA
C. Morris	20	3	0	11	4	17	1	0	0	0	0	0.00
O. Little	7	0	0	6	2	6	0	1	0	3	1	1.29
A. Applegren	8	0	1	3	6	0	1	0	0	1	1	1.13
Totals	35	3	1	20	12	23	2	1	0	4	2	0.51

Rockford Hitting Records

	AB	R	H	S	2B	3B	HR	RBI	Pct.	SB	PO	A	E	FA
D. Kamenshek	14	2	5	0	0	1	0	0	.357	0	32	1	0	1.000
J. Lenard	11	2	1	3	1	0	0	1	.091	0	2	0	0	1.000
M. Wigiser	12	2	2	0	0	0	0	2	.167	0	5	0	0	1.000
R. Gacioch	13	1	2	1	0	0	0	1	.154	0	8	1	0	1.000
K. Rohrer	12	0	2	1	0	0	0	0	.167	1	29	2	1	.969
M. Deegan	12	0	1	1	0	0	0	1	.083	0	11	7	0	1.000
D. Harrell	13	0	1	0	0	0	0	1	.077	0	6	5	1	.917
H. Filarski	14	0	2	0	0	0	0	0	.143	0	8	9	1	.945
C. Morris	7	0	1	0	0	0	0	0	.143	0	4	3	0	1.000
O. Little	3	0	0	0	0	0	0	0	.000	0	1	3	0	1.000
A. Applegren	3	0	0	0	0	0	0	0	.000	0	0	5	0	1.000
Totals	114	7	17	6	1	1	0	6	.149	1	106	36	3	.979

Championship Round (Best of seven)

Rockford vs. Fort Wayne

Game 1: Rockford 2, Fort Wayne 1
Game 2: Rockford 3, Fort Wayne 2
Game 3: Rockford 3, Fort Wayne 1
Game 4: Fort Wayne 2, Rockford 0
Game 5: Rockford 3, Fort Wayne 2
Rockford wins championship 4 games to 1.

Game 1: Rockford 2, Fort Wayne 1

				R	H	E	DP
Fort Wayne	000	000	010	1	3	1	0
Rockford	001	100	00x	2	4	10	0

Winning Pitcher: O. Little; *Losing Pitcher:* D. Wiltse. *Umpires:* Ward, Chapman and Giacinti. A: 2,311. Time: 1:42.
Highlights: Olive Little and Dottie Wiltse each recorded a series record of 10 strikeouts, but Little allowed only one run to spell the difference. Kay Rohrer's triple proved to be the winning RBI.

Game 2: Rockford 3, Fort Wayne 2

						R	H	E	DP
Fort Wayne	000	000	020	0	0	2	3	3	0
Rockford	002	000	000	0	1	3	7	0	0

Winning Pitcher: C. Morris; *Losing Pitcher:* A. Lee. *Umpires:* Zoss, Ward, Chapman and Giacinti. A: 1,711. Time: 1:45.
Highlights: Mildred Deegan's home run in the bottom of the 11th ended an extra-inning affair and gave the Peaches a 2-0 advantage in the series.

Game 3: Rockford 3, Fort Wayne 1

				R	H	E	DP
Fort Wayne	000	010	000	1	5	4	0

				R	H	E	DP
Rockford	030	000	00x	3	7	1	0

Winning Pitcher: C. Morris; *Losing Pitcher:* A. Haine. *Umpires:* Giacinti, Zoss, Ward and Chapman. A: 2,818. Time: 1:50.

Highlights: Carolyn Morris recorded her second straight win over the Daisies as she allowed only one run.

Game 4: Fort Wayne 2, Rockford 0

				R	H	E	DP
Rockford	000	000	000	0	4	1	0
Fort Wayne	100	100	00x	2	7	1	0

Winning Pitcher: C. Wiltse: *Losing Pitcher:* O. Little. *Umpires:* Chapman, Ward, Zoss and Rome. Time: 1:20.

Highlights: Olive Little shutout the Peaches on four hits, while Faye Dancer knocked in a run and scored one herself to account for the two runs.

Game 5: Rockford 3, Fort Wayne 2

				R	H	E	DP
Rockford	001	002	000	3	7	3	0
Fort Wayne	000	001	010	2	7	3	0

Winning Pitcher: C. Morris; *Losing Pitcher:* A. Lee. *Umpires:* Zoss, Chapman and Rome. Time: 1:20.

Highlights: Carolyn Morris recorded her sixth win in the playoffs and Mildred Deegan pounded her second home run of the series to pace the Peaches.

Composite Averages

Fort Wayne Pitching Records

	IP	W	L	H	BB	SO	B	WP	HB	R	ER	ERA
D. Wiltse	20	1	1	10	2	18	0	1	0	2	2	0.90
A. Lee	17	0	2	12	6	1	0	0	0	5	5	2.65
A. Haine	8	0	1	7	5	5	0	0	0	3	2	2.25
Totals	45	1	4	29	13	24	0	1	0	10	9	1.80

Fort Wayne Hitting Records

	AB	R	H	S	2B	3B	HR	RBI	Pct.	SB	PO	A	E	FA
H. Callaghan	15	1	6	0	1	0	0	1	.400	5	14	1	2	.882
M. Callaghan	21	0	2	1	1	0	0	0	.095	0	11	10	4	.840
P. O'Brien	19	2	3	0	0	0	0	2	.158	3	8	0	0	1.000
V. Kellogg	20	0	3	0	0	0	0	2	.150	0	36	0	0	1.000
L. Paire	16	0	2	0	0	0	0	0	.125	0	12	5	2	.895
I. Ruhnke	18	1	3	0	0	0	0	1	.167	0	6	6	3	.800
F. Dancer	14	2	4	0	0	0	0	1	.286	0	14	0	0	1.000
R. Lessing	14	0	1	0	0	0	0	0	.071	1	27	2	1	1.000
D. Wiltse	6	0	0	0	0	0	0	0	.000	0	1	4	0	1.000
A. Lee	6	1	1	0	0	0	0	0	.167	0	1	2	0	1.000
A. Haine	4	0	1	0	0	0	0	0	.250	1	0	4	2	1.000
Y. Teillet	0	0	0	0	0	0	0	0	.000	0	1	0	0	1.000
Totals	153	7	26	1	2	0	0	7	.170	10	131	34	14	.922

Rockford Pitching Records

	IP	W	L	H	BB	SO	B	WP	HB	R	ER	ERA
O. Little	16	1	1	10	3	13	0	0	0	3	3	1.69

	IP	W	L	H	BB	SO	B	WP	HB	R	ER	ERA
A. Fischer	3	0	0	0	3	3	0	0	0	0	0	0.00
A. Applegren	8	0	0	5	3	0	0	0	0	2	1	1.13
C. Morris	19	3	0	12	6	7	0	1	1	3	2	0.95
Totals	46	4	1	27	15	23	0	1	1	8	6	1.17

Rockford Hitting Records

	AB	R	H	S	2B	3B	HR	RBI	Pct.	SB	PO	A	E	FA
D. Kamenshek	21	1	6	0	0	0	0	2	.285	1	52	1	0	1.000
J. Lenard	19	0	2	0	0	0	0	0	.105	2	7	0	0	1.000
M. Wigiser	20	2	5	0	1	0	0	2	.250	0	7	0	0	1.000
R. Gacioch	19	0	3	0	0	0	0	0	.158	0	5	0	0	1.000
K. Rohrer	13	3	3	0	0	2	0	1	.231	1	29	1	0	1.000
M. Deegan	17	2	2	1	0	0	2	2	.118	0	7	6	1	.929
D. Harrell	16	1	4	0	0	0	0	0	.250	3	14	11	1	.962
H. Filarski	14	2	3	0	0	0	0	3	.214	0	5	14	0	1.000
O. Little	4	0	0	1	0	0	0	0	.000	0	2	6	0	1.000
D. Ferguson	3	0	0	0	0	0	0	0	.000	0	4	2	1	.857
D. Green	3	0	0	0	0	0	0	0	.000	1	0	0	0	1.000
A. Fischer	1	0	0	0	0	0	0	0	.000	0	0	1	0	1.000
C. Morris	9	1	2	0	0	0	0	0	.000	0	0	4	2	.667
A. Applegren	2	1	1	0	0	0	0	0	.000	0	0	2	0	1.000
Totals	161	13	31	2	1	2	1	10	.193	8	132	48	5	.973

1946 CHAMPIONSHIP SERIES

For the second consecutive year, the league champion also won the Shaughnessy playoffs. The Racine Belles beat the defending champion Rockford Peaches in six games to take the championship. The leading pitcher for Racine was Jo Winter, who won four games and loss only one during the entire playoffs, including a 16-inning affair in the last game of the playoffs. Anna May Hutchison outdid Winter in long games as she won a 17-inning contest against South Bend in the opening round of the playoffs. Racine's Sophie Kury stole a record 18 bases in the playoffs and stroked 16 hits.

1st Round (Best of five):

Racine vs. South Bend

Game 1: Racine 3, South Bend 2
Game 2: South Bend 13, Racine 2
Game 3: Racine 7, South Bend 2
Game 4: Racine 10, South Bend 2
Racine wins series 3 games to 1.

Game 1: Racine 3, South Bend 2

							R	H	E	DP
South Bend	000	000	011	0 0 0	0 0 0	0 0	2	6	4	2
Racine	000	002	000	0 0 0	0 0 0	0 1	3	9	3	0

Winning Pitcher: A. Hutchison; *Losing Pitcher:* J. Faut. *Umpires:* Chapman, Loew and Remo. Time: 3:14.
Highlights: Anna May Hutchison and Jean Faut battled a record 17 innings before Maddy English knocked in the winning run for the Belles and give Hutchison the win.

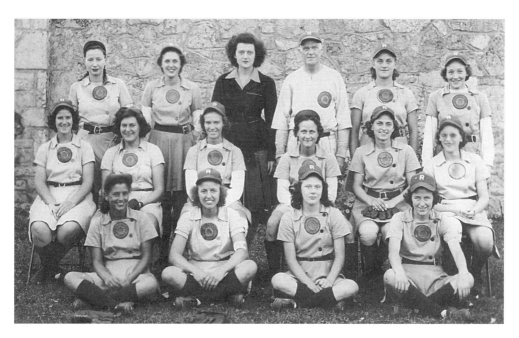

Members of the 1946 Racine Belles playoff championship team were (front row from left) Clara Schillace, Edythe Perlick, Janet Jacobs, Madeline English, (second row from left) Anna May Hutchison, Joanne Winter, Betty Emry, Irene Hickson, Sophie Kurys, Jane Jacobs, (back row from left) Marie Nesbitt, Marnie Danhauser, Chaperone Mary Wilson, Manager Leo Murphy, Eleanor Dapkus and Doris Barr.

Game 2: South Bend 13, Racine 2

				R	H	E	DP
South Bend	200	330	011	13	14	1	1
Racine	200	000	000	2	4	4	1

Winning Pitcher: B. Luna; Losing Pitcher J. Winter. *Umpires:* Ward, Johnson and Batwinski. A: 3,743. Time: 2:04.

Highlights: Marge Stefani knocked in three runs as the Blue Sox pasted the Belles with a record amount of runs for a series game.

Game 3: Racine 7, South Bend 2

				R	H	E	DP
Racine	330	000	001	7	11	2	2
South Bend	100	000	000	1	2	1	1

Winning Pitcher: A. Hutchison; *Losing Pitcher:* J. Faut. *Umpires:* Batwinski, Ward and Johnson. Time: 1:42.

Highlights: A home run by Edythe Perlick was all that was needed by the Belles as Anna May Hutchison held the Blue Sox to two hits.

Game 4: Racine 10, South Bend 2

				R	H	E	DP
Racine	300	211	120	10	10	3	0
South Bend	100	010	000	2	3	6	1

Winning Pitcher: J. Winter; *Losing Pitcher:* B. Luna. *Umpires:* Johnson, Batwinski and Ward. Time: 1:50.

Highlights: The Belles launched a 10-hit, 10-run attack and Joanne Winter limited the Blue Sox to three hits.

Composite Averages for Series

South Bend Pitching Records

	IP	W	L	H	BB	SO	B	WP	HB	R	ER	ERA
J. Faut	24	0	2	15	2	7	0	0	1	4	3	1.13
B. Luna	18	1	1	14	3	7	0	1	1	12	3	1.50
P. Koehn	2	0	0	5	0	0	0	0	0	5	4	18.00
Totals	44	1	4	34	5	14	0	1	2	21	10	2.05

South Bend Hitting Records

	AB	R	H	S	2B	3B	HR	RBI	Pct.	SB	PO	A	E	FA
M. Baker	21	6	4	0	0	0	0	1	.190	5	13	5	1	.947
M. Stefani	18	2	4	0	0	0	0	4	.222	1	14	8	3	.880
P. Pirok	19	2	4	0	0	1	0	0	.211	3	6	4	3	.770
E. Mahon	20	2	3	0	0	0	0	2	.150	0	6	0	0	1.000
S. Wirth	9	3	1	1	0	0	0	1	.111	1	5	14	1	.950
I. Voyce	14	2	2	0	0	0	0	1	.143	1	38	3	1	.976
D. Junior	16	4	2	1	0	0	0	0	.125	0	13	1	1	.933
D. Naum	15	4	4	1	0	0	0	1	.267	2	3	2	0	1.000
J. Romatowski	1	0	0	0	0	0	0	0	.000	0	0	0	0	1.000
J. Faut	8	0	0	0	0	0	0	0	.000	0	3	10	1	.929
B. Luna	8	2	1	0	0	0	0	0	.125	1	0	2	1	.667
P. Koehn	0	0	0	0	0	0	0	0	.000	0	0	3	0	1.000
Totals	149	27	25	3	0	1	0	10	.168	14	101	52	12	.927

Racine Pitching Records

	IP	W	L	H	BB	SO	B	WP	HB	R	ER	ERA
A. Hutchison	26	2	0	8	5	6	0	0	1	3	2	0.69
J. Winter	13	1	1	8	3	4	0	1	0	10	7	4.86
B. Emry	3	0	0	3	2	0	0	0	0	3	0	0.00
D. Barr	2	0	0	3	3	0	0	1	0	2	2	9.01
Totals	44	3	1	22	13	10	0	2	1	18	11	2.25

Racine Hitting Records

	AB	R	H	S	2B	3B	HR	RBI	Pct.	SB	PO	A	E	FA
S. Kurys	20	7	9	0	1	0	0	0	.450	9	9	11	1	.952
B. Trezza	18	2	1	0	0	1	0	2	.056	1	11	6	2	.895
L. Paire	14	3	4	1	0	0	0	1	.286	3	11	3	0	1.000
E. Perlick	19	2	3	0	0	0	1	1	.158	0	6	0	0	1.000
E. Dapkus	18	3	2	0	0	1	0	0	.111	1	2	0	0	1.000
M. English	17	2	6	0	2	0	0	2	.353	3	2	13	3	.833
M. Danhauser	16	1	4	0	0	0	0	0	.250	2	56	0	0	1.000
T. Walmsley	1	0	0	0	0	0	0	0	.000	0	0	0	0	1.000
C. Schillace	17	2	2	0	0	1	0	1	.118	0	5	0	0	1.000
J. Winter	4	0	0	0	0	0	0	1	.000	1	0	4	0	1.000
B. Emry	1	0	1	0	0	0	0	0	.000	0	0	0	0	1.000
A. Hutchison	8	1	0	1	0	0	0	0	.000	0	3	5	2	.800
Totals	153	22	32	2	3	3	1	8	.209	20	105	42	8	.948

First Round

Rockford vs. Grand Rapids

Game 1: Rockford 4, Grand Rapids 3
Game 2: Rockford 2, Grand Rapids 0
Game 3: Grand Rapids 3, Rockford 0
Game 4: Grand Rapids 2, Rockford 1
Game 5: Rockford 2, Grand Rapids 0
Rockford wins series 3 games to 2.

Game 1: Rockford 4, Grand Rapids 3

				R	H	E	DP
Rockford	100	000	003	4	6	0	1
Grand Rapids	001	000	011	3	6	4	0

Winning Pitcher: M. Deegan; *Losing Pitcher:* C. Wisniewski
Highlights: Snookie Harrell knocked in the game winning run with a double as Grand Rapids allowed two other runs with four errors.

Game 2: Rockford 2, Grand Rapids 0

				R	H	E	DP
Rockford	000	010	100	2	7	2	0
Grand Rapids	000	000	000	0	4	2	0

Winning Pitcher: C. Morris; *Losing Pitcher:* A. Haylett
Highlights: Carolyn Morris shutout the Chicks on four hits, while Dottie Kamenshek knocked in the only run needed.

Game 3: Grand Rapids 3, Rockford 0

				R	H	E	DP
Grand Rapids	000	012	000	3	10	1	2
Rockford	000	000	000	0	7	5	0

Winning Pitcher: C. Wisniewski; *Losing Pitcher:* A. Little
Highlights: Connie Wisniewski allowed seven hits, but no runs to give the Chicks their first victory in the series.

Game 4: Grand Rapids 2, Rockford 1

				R	H	E	DP
Grand Rapids	010	000	000	1	2	4	1
Rockford	001	000	000	0	1	9	1

Winning Pitcher: A. Haylett; *Losing Pitcher:* C. Morris
Highlights: Connie Wisniewski picked up a save in a courageous relief performance to perserve the win in the 10th inning.

Game 5: Rockford 2, Grand Rapids 0

				R	H	E	DP
Grand Rapids	000	000	000	0	3	2	0
Rockford	000	001	01x	2	7	0	0

Winning Pitcher: M. Deegan; *Losing Pitcher:* C. Wisniewski
Highlights: Mildred Deegan blanked the Chicks to give the Peaches the win and the series. Dottie Kamenshek tripled, stole a base and knocked in a RBI for Rockford.

Composite Average

Grand Rapids Pitching Records

	IP	W	L	H	BB	SO	B	WP	HB	R	ER	ERA
C. Wisniewski	26	1	2	21	0	6	0	0	0	6	5	1.73
A. Haylett	18	1	1	15	7	3	1	1	1	3	2	1.00
Totals	44	2	3	36	7	9	1	1	1	9	7	1.43

Grand Rapids Hitting Records

	AB	R	H	S	2B	3B	HR	RBI	Pct.	SB	PO	A	E	FA
T. Shively	21	0	6	0	1	0	0	2	.286	2	7	1	0	1.000
D. Tetzlaff	16	0	2	0	0	0	0	0	.125	4	9	11	1	.952
P. Keagle	20	1	2	0	0	0	0	0	.100	2	6	0	0	1.000
R. Lessing	18	1	1	0	0	0	0	0	.056	0	18	4	2	.917
P. Gianfrancisco	17	1	4	0	0	0	0	0	.235	1	5	0	0	1.000
E. Petras	15	1	3	0	0	0	0	0	.200	1	11	23	1	.972
A. Ziegler	17	0	0	1	0	0	0	2	,000	0	17	16	3	.917
B. Whiting	18	2	3	0	1	2	0	1	.167	0	59	2	0	1.000
C. Wisniewski	9	2	5	1	0	1	1	2	.556	0	0	10	2	.835
A. Haylett	6	0	1	0	0	0	0	1	.167	0	3	6	1	.900
E. Wingrove	2	0	0	0	0	0	0	0	.000	0	0	0	0	1.000
Totals	159	8	27	2	2	3	1	8	.170	10	157	73	10	.968

Rockford Pitching Records

	IP	W	L	H	BB	SO	B	WP	HB	R	ER	ERA
M. Deegan	17	2	0	9	3	9	0	1	1	3	3	1.59
C. Morris	20	1	1	14	4	13	0	0	0	2	2	0.90
O. Little	8	0	1	9	2	1	0	0	0	3	3	3.38
M. Holgerson	1	0	0	1	0	0	0	0	0	0	0	0.00
Totals	46	3	2	33	9	23	0	1	1	8	8	1.57

Rockford Hitting Records

	AB	R	H	S	2B	3B	HR	RBI	Pct.	SB	PO	A	E	FA
D. Kamenshek	21	2	8	0	1	1	0	3	.381	3	57	1	1	.983
S. Ferguson	19	1	4	0	0	0	0	0	.211	1	13	11	0	1.000
R. Gacioch	18	0	3	0	0	0	0	0	.167	0	4	0	0	1.000
N. Meier	20	1	3	0	0	0	0	0	.150	1	9	0	0	1.000
D. Harrell	18	1	4	1	0	0	0	1	.222	0	7	9	2	.890
L. Surkowski	13	2	2	0	0	0	0	2	.154	0	5	0	0	1.000
V. Abbott	14	0	4	1	0	0	0	0	.286	1	10	9	3	.864
D. Green	12	1	1	1	0	0	0	0	.083	0	30	9	0	1.000
M. Deegan	9	1	2	0	0	0	0	0	.222	0	0	11	0	1.000
C. Morris	8	0	4	0	0	0	0	0	.500	1	3	5	0	1.000
O. Little	2	0	0	0	0	0	0	0	.000	0	0	0	0	1.000
H. Filarski	2	0	0	0	0	0	0	0	.000	0	0	0	0	1.000
M. Holgerson	0	0	0	0	0	0	0	0	.000	0	0	0	1	.000
Totals	156	9	35	3	1	1	0	6	.224	7	138	55	7	.965

Championship Round (Best of seven):

Racine vs. Rockford

Game 1: Racine 6, Rockford 3
Game 2: Racine 2, Rockford 1
Game 3: Rockford 2, Racine 1
Game 4: Racine 4, Rockford 1

Game 5: Rockford 1, Racine 0
Game 6: Racine 1, Rockford 0
Racine wins championship 4 games to 2.

Game 1: Racine 6, Rockford 3

				R	H	E	DP
Rockford	100	000	200	3	7	2	1
Racine	100	002	30x	6	9	1	0

Winning Pitcher: A. Hutchison; *Losing Pitcher:* O. Little. *Umpires:* Ward, Johnson, Chapman and Giacinti. A: 2,928.
Highlights: Eleanor Dapkus' three hits, including a triple, and two RBIs paced the Belles to a win.

Game 2: Racine 2, Rockford 1

				R	H	E	DP
Rockford	001	000	000	1	3	0	0
Racine	000	000	002	2	4	1	0

Winning Pitcher: J. Winter: *Losing Pitcher:* C. Morris. *Umpires:* Johnson, Chapman and Giacinti. A: 1,697. Time: 1:40.
Highlights: Edythe Perlick singled in two runs in the bottom of the ninth to give the Belles a slim victory over the Peaches and take a 2-0 lead in the series.

Game 3: Rockford 2, Racine 1

				R	H	E	DP
Racine	000	010	000	1	3	1	0
Rockford	000	020	00x	2	3	4	0

Winning Pitcher: M. Deegan; *Losing Pitcher:* A. Hutchison. *Umpires:* Chapman, Giacinti, Ward and Johnson. A: 3,261. Time: 1:20.
Highlights: Mildred Deegan pitched the Peaches back into the series by allowing only one run.

Game 4: Racine 4, Rockford 1

				R	H	E	DP
Racine	100	002	001	4	7	1	0
Rockford	000	001	000	1	2	1	0

Winning Pitcher: J. Winter; *Losing Pitcher:* C. Morris
Edthe Perlick's home run and Joanne Winter's two-hit performance gave the Belles the win.

Game 5: Rockford 1, Racine 0

				R	H	E	DP
Racine	000	000	000	0	5	2	2
Rockford	100	000	00x	1	5	2	0

Winning Pitcher: M. Deegan; *Losing Pitcher:* A. Hutchison. *Umpires:* Ward, Johnson, Chapman and Giacinti. Time: 1:36. A: 4,490.
Mildren Deegan pitched a superlative game to give the Belles a 3-2 advantage in the series.

Game 6: Racine 1, Rockford 0

							R	H	E	DP	
Rockford	000	000	000	0 0 0	0 0 0		0	0	13	1	0
Racine	000	000	000	0 0 0	0 0 0		1	1	5	2	0

Winning Pitcher: J. Winter; *Losing Pitcher:* M. Deegan. *Umpires:* Johnson, Chapman, Giacinti and Ward. A: 5,550. Time: 2:40.

Joanne Winter allowed 13 hits over 16 innings, but gave up no runs to shut down the Peaches and win the series for the Belles.

Composite Average for Series

Rockford Pitching Records

	IP	W	L	H	BB	SO	B	WP	HB	R	ER	ERA
O. Little	8	0	1	9	4	3	0	1	0	6	6	6.76
C. Morris	26	0	2	13	8	15	0	0	1	6	5	1.73
M. Deegan	22	2	1	11	7	12	0	0	0	2	2	0.82
Totals	56	2	4	33	19	30	0	1	1	14	13	2.09

Rockford Hitting Records

	AB	R	H	S	2B	3B	HR	RBI	Pct.	SB	PO	A	E	FA
D. Kamenshek	25	2	6	0	0	0	0	0	.240	4	61	2	1	.984
S. Ferguson	21	1	4	2	0	0	0	0	.190	3	16	9	2	.926
L. Surkowski	21	1	1	3	0	0	0	1	.048	1	9	1	1	.909
N. Meier	23	1	4	0	0	0	0	0	.174	1	8	2	0	1.000
D. Harrell	22	3	7	2	1	0	0	2	.318	0	10	10	2	.955
R. Gacioch	22	1	4	1	0	2	0	0	.182	0	10	1	0	1.000
T. Abbott	22	0	1	0	0	0	0	1	.148	3	8	14	4	.846
D. Green	21	0	2	0	0	0	0	1	.095	1	39	4	0	1.000
O. Little	3	1	0	0	0	0	0	1	.000	0	0	0	0	1.000
C. Morris	9	0	1	0	0	0	0	0	.111	0	0	5	0	1.000
M. Deegan	8	0	1	0	0	1	0	0	.125	0	4	7	0	1.000
Totals	188	10	31	8	1	3	0	6	.165	13	173	55	10	.958

Racine Pitching Records

	IP	W	L	H	BB	SO	B	WP	HB	R	ER	ERA
A. Hutchison	26	1	2	15	2	8	0	0	0	6	5	1.73
J. Winter	32	3	0	18	9	6	0	1	1	2	2	0.56
Totals	58	4	2	33	11	14	0	1	1	8	7	1.09

Racine Hitting Records

	AB	R	H	S	2B	3B	HR	RBI	Pct.	SB	PO	A	E	FA
S. Kurys	23	4	7	0	0	1	0	0	.304	9	10	13	0	1.000
B. Trezza	25	3	4	0	0	0	0	2	.160	4	13	19	3	.914
L. Paire	21	0	3	0	0	0	0	4	.143	2	27	3	0	1.000
E. Perlick	25	2	4	0	0	1	1	4	.160	5	14	2	0	1.000
E. Dapkus	20	3	5	0	0	1	0	2	.250	0	4	0	1	.800
M. English	22	1	3	2	0	0	1	2	.136	0	19	20	3	.929
M. Danhauser	23	0	1	0	0	0	0	0	.043	1	74	1	1	.987
C. Schillace	15	0	2	0	0	0	0	0	.133	0	4	0	0	1.000
A. Hutchison	7	1	1	1	0	0	0	0	.143	1	3	6	0	1.000
J. Winter	10	0	0	0	0	0	0	0	.000	0	1	16	1	.945
B. Emry	5	0	0	0	0	0	0	0	.000	0	0	0	0	1.000
Totals	196	14	30	3	0	3	2	14	.153	22	169	80	9	.965

1947 CHAMPIONSHIP SERIES

The third time is said to be a charm, but that situation didn't occur in the 1947 Shaughnessy Playoffs as regular season champion Muskegon was eliminated in the first round by

Members of the 1947 Grand Rapids Chicks playoff championship team were (front row from left) Beverly Leach, Charlene Barnett, Dorothy Stoll, Phil Francisco, Twila Shively, Ernestine Petras, Dorothy Montgomery, Alma Ziegler, (back row from left) Manager Johnny Rawlings, Ruth Lessing, Alice Haylett, Elsie Wingrove, Audrey Haine, Connie Wisniewski, Mildred Earp, Inez Voyce, Doris Tetzlaff, Ruth Richard and Chaperone Dorothy Hunter.

a veteran playoff Racine team. Anna May Hutchison was credited with all three victories for Racine in the first-round playoffs.

Grand Rapids also had a tough time against South Bend in the other first-round matchup. Connie Wisniewski was a one woman wrecking crew by pitching a win, stealing home for a win in another game and hitting .318 in the series.

The championship playoffs were a tight battle as evidenced by the first three games, which all went to extra innings. Grand Rapids took a 3-1 advantage in the series and looked to take it all, but the Belles won the next two games to send the series to a seventh game. The top pitchers for each team faced each other in the final: Mildred Earp for Grand Rapids and Hutchison for Racine. The Chicks concocted a run in the seventh inning without a hit and that was all they needed for the championship.

1st Round (Best of five)

Grand Rapids vs. South Bend

Game 1: Grand Rapids 3, South Bend 2
Game 2: South Bend 8, Grand Rapids 7
Game 3: Grand Rapids 6, South Bend 1
Game 4: South Bend 1, Grand Rapids 0
Game 5: Grand Rapids 6, South Bend 1
Grand Rapids win series 3 games to 2

Game 1: Grand Rapids 3, South Bend 2

				R	H	E	DP
South Bend	001	010	000	2	5	2	0
Grand Rapids	030	000	00x	3	6	3	0

Winning Pitcher: M. Earp; *Losing Pitcher:* J. Faut.
Highlights: Mildred Earp held the Blue Sox to two runs, while her team scored three runs in one inning to give her a lead she wouldn't relinquish.

Game 2: South Bend 8, Grand Rapids 7

				R	H	E	DP
South Bend	060	200	000	8	7	4	1
Grand Rapids	000	001	114	7	10	4	1

Winning Pitcher R. Williams; *Losing Pitcher:* A. Haylett. A: 4,500
Highlights: Betsy Jochum knocked in two runs and scored once to give the Blue Sox a 8-0 lead that was preserved in the ninth by Jean Faut.

Game 3: Grand Rapids 6, South Bend 1

				R	H	E	DP
Grand Rapids	510	000	000	6	7	0	1
South Bend	000	100	000	1	9	2	0

Winning Pitcher: C. Wisniewski; *Losing Pitcher:* P. Koehn. A: 4,341.
Highlights: The Chicks staked Connie Wisniewski to a 5-0 lead in the first inning, which is all she needed to top the Sox.

Game 4: South Bend 1, Grand Rapids 0

				R	H	E	DP
Grand Rapids	000	000	000	0	2	0	0
South Bend	000	100	00x	1	4	0	0

Winning Pitcher: J. Faut; *Losing Pitcher:* M. Earp.
Highlights: Jean Faut shutout the Chicks with a two-hitter.

Game 5: Grand Rapids 6, South Bend 1

				R	H	E	DP
Grand Rapids	010	000	050	6	6	1	0
South Bend	010	000	000	1	6	4	0

Winning Pitcher: A. Haylett; *Losing Pitcher:* R. Williams.
Highlights: A 1-1 game was broken open in the eighth inning when the Chicks scored five runs with Jeep Stoll knocking in two runs.

Composite Averages

South Bend Pitching Records

	IP	W	L	H	BB	SO	B	WP	HB	R	ER	ERA
J. Faut	19	1	1	12	6	6	0	0	0	7	5	2.37
R. Williams	14	1	1	11	5	2	1	1	0	5	3	1.93
P. Koehn	11	0	1	9	9	1	0	0	0	10	8	6.55
Totals	44	2	3	32	20	9	1	1	0	22	16	3.27

South Bend Hitting Records

	AB	R	H	S	2B	3B	HR	RBI	Pct.	SB	PO	A	E	FA
M. Baker	18	3	8	1	0	0	0	0	.444	2	4	3	0	1.000
P. Pirok	19	1	3	1	0	0	0	1	.158	1	4	6	1	.909
M. Stefani	22	1	3	0	0	0	0	1	.136	0	5	6	0	1.000
E. Mahon	14	2	3	0	1	0	0	0	.214	0	3	0	0	1.000
J. Faut	8	0	1	0	0	0	0	0	.125	1	0	7	2	.778
B. Jochum	17	1	4	1	0	0	0	2	.235	1	2	0	0	1.000
T. Marshall	18	2	3	1	1	0	0	0	.167	0	24	1	1	.965
I. Crigler	13	1	2	2	0	0	0	2	.153	0	3	4	1	.875
D. Junior	14	2	3	0	0	0	0	1	.214	2	2	0	1	.667
P. Koehn	5	0	2	0	0	0	0	0	.400	0	0	1	0	1.000

	AB	R	H	S	2B	3B	HR	RBI	Pct.	SB	PO	A	E	FA
R. Williams	4	0	0	1	0	0	0	0	.000	0	1	2	0	1.000
J. Kelley	1	0	0	0	0	0	0	0	.000	0	0	0	0	1.000
Totals	153	13	32	7	2	0	0	7	.209	7	48	30	6	.929

Grand Rapids Pitching Records

	IP	W	L	H	BB	SO	B	WP	HB	R	ER	ERA
M. Earp	16	1	1	9	1	9	1	0	0	3	2	1.13
A. Haylett	11	1	1	8	2	3	0	0	0	5	3	2.45
A. Lee	6	0	0	5	3	2	0	0	0	4	2	3.00
E. Tucker	2	0	0	0	0	0	0	0	0	0	0	0.00
C. Wisniewski	9	1	0	9	3	2	0	0	0	1	1	1.00
Totals	44	3	2	31	9	16	1	0	0	13	8	1.64

Grand Rapids Hitting Records

	AB	R	H	S	2B	3B	HR	RBI	Pct.	SB	PO	A	E	FA
A. Ziegler	17	1	3	0	0	0	0	1	.176	2	3	5	0	1.000
E. Petras	20	4	3	0	0	1	0	1	.150	1	0	3	1	.750
C. Wisniewski	22	2	7	0	0	0	0	1	.318	1	2	0	0	1.000
I. Voyce	19	4	2	1	0	0	0	2	.105	3	30	0	0	1.000
R. Lessing	18	2	4	1	0	0	0	1	.222	0	8	3	0	1.000
T. Shively	17	3	4	0	0	0	0	2	.235	2	1	0	0	1.000
N. Stoll	17	2	4	1	0	0	0	4	.235	0	4	0	0	1.000
D. Tetzlaff	15	2	5	0	0	0	0	1	.333	0	6	5	5	.688
M. Earp	4	0	0	1	0	0	0	1	.000	0	0	7	0	1.000
A. Lee	2	0	0	0	0	0	0	0	.000	0	0	2	0	1.000
D. Satterfield	3	0	0	0	0	0	0	0	.000	0	0	0	0	1.000
E. Tucker	1	0	1	0	0	0	0	0	.000	0	0	0	0	1.000
R. Richard	1	0	0	0	0	0	0	0	.000	0	0	0	0	1.000
C. Barnett	0	1	0	0	0	0	0	0	.000	1	0	0	0	1.000
E. Wingrove	3	0	0	0	0	0	0	0	.000	0	0	0	0	1.000
A. Haylett	4	0	1	0	1	0	0	3	.250	0	0	1	2	.333
Totals	163	21	34	4	1	1	0	17	.209	10	54	25	8	.908

NOTE: Fielding statistics only available on two games.

First Round (best of five)

Muskegon vs. Racine

Game 1: Racine 4, Muskegon 0
Game 2: Racine 7, Muskegon 3
Game 3: Muskegon 7, Racine 1
Game 4: Racine 2, Muskegon 1
Racine wins series 3 games to 1

Game 1: Racine 4, Muskegon 0

				R	H	E	DP
Racine	000	022	000	4	10	0	0
Muskegon	000	000	000	0	2	3	0

Winning Pitcher: A. Hutchison; *Losing Pitcher:* A. Applegren. *Umpires:* Johnson, Batwinski and Loew. *Time:* 1:42.

Highlights: Anna May Hutchinson blanked the Lassies with a two-hit performance. Betty Trezza knocked in two runs for the Belles.

Game 2: Racine 7, Muskegon 3

				R	H	E	DP
Racine	200	000	050	7	4	2	1
Muskegon	000	101	001	3	9	8	0

Winning Pitcher: J. Winter; *Losing Pitcher:* D. Sams. *Umpires:* Loew, Johnson and Batwinski. T: 2:14.
Highlights: A series record eight errors by the Lassies allowed the Belles to win despite being out-hit.

Game 3: Muskegon 7, Racine 1

				R	H	E	DP
Muskegon	220	021	000	7	6	2	0
Racine	000	000	010	1	2	4	0

Winning Pitcher: N. Warren; *Losing Pitcher:* D. Barr. *Umpires:* Batwinski, Johnson and Loew. A: 2,333. Time: 1: 30
Highlights: Jo Lenard tripled and knocked in two runs to give the Belles a 7-0 lead. Nancy Warren allowed only two hits and a meaningless run.

Game 4: Racine 2, Muskegon 1

				R	H	E	DP
Muskegon	001	000	000	1	7	1	0
Racine	001	000	001	2	6	0	0

Winning Pitcher: A. Hutchison; *Losing Pitcher:* D. Sams. *Umpires:* Batwinski, Johnson and Loew. Time: 1:50.
Highlights: Anna May Hutchison garnered her second victory of the series when she held the Belles to only a run.

Composite Averages

Muskegon Pitching Records

	IP	W	L	H	BB	SO	B	WP	HB	R	ER	ERA
A. Applegren	5	0	1	6	3	2	0	0	0	2	2	3.60
N. Warren	11	1	0	6	6	1	0	1	0	3	3	2.45
D. Sams	18	0	2	9	8	5	0	0	0	9	6	3.00
Totals	34	1	3	21	17	8	0	1	0	14	11	2.92

Muskegon Hitting Records

	AB	R	H	S	2B	3B	HR	RBI	Pct.	SB	*PO A E
C. Pryer	15	1	2	1	0	0	0	1	.133	3	
S. Reeser	19	3	3	0	0	0	0	0	.158	3	
D. Stolze	15	1	2	1	0	0	0	1	.133	3	
J. Lenard	14	0	5	1	0	1	0	2	.357	5	
D. Sams	15	1	4	1	1	0	0	1	.267	1	
A. Fischer	11	1	1	0	1	0	0	0	.090	0	
D. Maguire	13	2	2	0	1	0	0	0	.154	2	
A. Johnson	10	1	2	1	0	0	0	1	.200	3	
A. Applegren	1	0	0	0	0	0	0	0	.000	0	
E. Wawryshyn	4	1	1	0	0	0	0	0	.250	0	
D. Cook	8	0	2	0	0	0	0	2	.250	1	
N. Warren	5	0	0	0	0	0	0	1	.000	0	
Totals	130	11	24	5	3	1	0	9	.185	21	

Racine Pitching Records

	IP	W	L	H	BB	SO	B	WP	HB	R	ER	ERA
A. Hutchison	20	2	0	12	3	3	0	0	0	2	1	0.45
J. Winter	7	1	0	6	6	2	0	0	0	6	4	5.15
D. Barr	6	0	1	5	2	3	0	1	0	7	5	7.51
E. Dapkus	3	0	0	3	0	0	0	0	0	0	0	0.00
Totals	36	3	1	26	11	8	0	1	0	15	10	2.50

Racine Hitting Records

	AB	R	H	S	2B	3B	HR	RBI	Pct.	SB	*PO A E
S. Kurys	16	3	4	0	1	0	0	1	.250	4	
B. Trezza	17	1	1	0	0	0	0	2	.059	1	
L. Paire	16	2	5	0	0	0	0	1	.313	0	
E. Perlick	17	2	4	0	0	0	0	1	.235	1	
E. Dapkus	13	2	0	4	0	0	0	0	.000	0	
M. English	15	1	2	1	0	0	0	1	.133	0	
I. Hickson	12	2	2	2	0	0	0	3	.167	1	
M. Danhauser	9	1	3	1	0	0	0	2	.333	1	
A. Hutchison	11	0	0	3	0	0	0	0	.000	0	
J. Winter	1	0	0	0	0	0	0	0	.000	0	
D. Barr	1	0	0	0	0	0	0	0	.000	0	
S. Lonetto	2	0	0	0	0	0	0	0	.000	0	
Totals	130	14	21	11	1	0	0	11	.162	8	

*No fielding statistics available in box scores.

Championship Round:

Grand Rapids vs. Racine

Game 1: Racine 2, Grand Rapids 0
Game 2: Grand Rapids 3, Racine 2
Game 3: Grand Rapids 2, Racine 1
Game 4: Grand Rapids 3, Racine 0
Game 5: Racine 3, Grand Rapids 2
Game 6: Racine 4, Grand Rapids 3
Game 7: Grand Rapids 1, Racine 0
Championship: Grand Rapids

Game 1: Racine 2, Grand Rapids 0

							R	H	E	DP
Racine	000	000	000	0	2	2	5	2		1
Grand Rapids	000	000	000	0	0	0	4	0		0

Winning Pitcher: A. Hutchison; *Losing Pitcher:* M. Earp. A: 4,684.
Highlights: Mildred Earp retired the first 21 Chicks; however, Anna May Hutchison pitched and hit her way to victory.

Game 2: Grand Rapids 3, Racine 2

							R	H	E	DP
Racine	000	101	000	0	0	0	2	7	1	0
Grand Rapids	000	000	020	0	0	1	3	5	1	0

Winning Pitcher: C. Wisniewski; *Losing Pitcher* A. Hutchison. A: 4,200.
Highlights: Connie Wisniewski tied up the series as she limited the Belles to two runs. Gabby Ziegler drove in the winning run with a perfect bunt.

Game 3: Grand Rapids 2, Racine 1

				R	H	E	DP	
Racine	000	000	100	0	1	4	0	0
Grand Rapids	000	010	000	1	2	9	4	0

Winning Pitcher: A. Haylett; *Losing Pitcher:* A. Hutchison.
Highlights: Alice Haylett gave up only a run, while Tenny Petras hit two doubles, knocked in a run and scored a run.

Game 4: Grand Rapids 3, Racine 0

				R	H	E	DP
Grand Rapids	020	000	100	3	5	1	0
Racine	000	000	00x	0	2	1	0

Winning Pitcher: M. Earp; *Losing Pitcher:* J. Winter.
Highlights: Mildred Earp allowed only two hits in her shutout of the Belles.

Game 5: Racine 3, Grand Rapids 2

				R	H	E	DP
Grand Rapids	001	010	000	2	5	1	0
Racine	300	000	00x	3	2	1	0

Winning Pitcher: A. Hutchison; *Losing Pitcher:* C. Wisniewski.
Highlights: Tenny Petras homered in the first inning to account for all the runs the Belles would need as Anna May Hutchison gave up only two runs.

Game 6: Racine 4, Grand Rapids 3

				R	H	E	DP
Grand Rapids	020	000	001	3	3	4	0
Racine	001	100	011	4	9	3	0

Winning Pitcher: J. Winter; *Losing Pitcher:* A. Haylett
Highlights: Four errors contributed to the Chicks downfall and Alice Haylett balked in the winning run.

Game 7: Grand Rapids 1, Racine 0

				R	H	E	DP
Grand Rapids	000	000	100	1	5	0	0
Racine	000	000	000	0	4	1	0

Winning Pitcher: Earp; *Losing Pitcher:* A. Hutchison. A: 3,300.
Highlights: Mildred Earp hurled a brilliant shutout and knocked in the winning run to win the series.

Composite Averages

Racine Pitching Records

	IP	W	L	H	BB	SO	B	WP	HB	R	ER	ERA
A. Hutchison	42	2	3	27	16	16	0	1	0	6	6	1.29
J. Winter	22	1	1	9	19	10	0	0	0	6	4	1.64
D. Barr	4	0	0	0	5	4	0	0	0	2	2	4.50
Totals	68	3	4	36	40	30	0	1	0	14	12	1.59

Racine Hitting Records

	AB	R	H	S	2B	3B	HR	RBI	Pct.	SB	PO	A	E	FA
S. Kurys	30	1	4	0	0	0	0	0	.133	4	31	16	2	.959

	AB	R	H	S	2B	3B	HR	RBI	Pct.	SB	PO	A	E	FA
B. Trezza	28	1	3	1	0	0	0	1	.107	1	11	1	0	1.000
L. Paire	27	1	6	1	0	0	0	0	.222	0	6	15	3	.875
E. Perlick	27	2	8	2	1	0	1	3	.296	3	18	0	0	1.000
E. Dapkus	24	1	2	1	0	0	0	0	.083	0	6	0	0	1.000
M. English	28	2	4	1	1	0	0	1	.143	0	15	17	1	.970
I. Hickson	23	1	1	0	0	0	0	1	.043	1	45	11	0	1.000
M. Danhauser	24	2	4	0	0	0	0	1	.167	0	59	7	1	.985
A. Hutchison	13	0	0	4	0	0	0	0	.000	0	2	9	0	1.000
J. Winter	5	1	2	0	0	0	0	0	.400	0	0	4	0	1.000
D. Barr	1	0	0	0	0	0	0	1	.000	0	2	1	0	1.000
S. Lonetto	0	0	0	0	0	0	0	0	.000	0	0	0	0	1.000
Totals	230	12	34	10	2	0	1	8	.148	9	195	81	7	.975

Grand Rapids Pitching Records

	IP	W	L	H	BB	SO	B	WP	HB	R	ER	ERA
M. Earp	29	2	1	11	4	10	0	0	1	2	2	0.62
C. Wisniewski	20	1	1	9	6	1	0	0	0	5	5	2.25
A. Haylett	19	1	1	14	3	8	0	0	1	4	3	1.42
Totals	68	4	3	34	13	19	0	0	2	11	10	1.32

Grand Rapids Hitting Records

	AB	R	H	S	2B	3B	HR	RBI	Pct.	SB	PO	A	E	FA
A. Ziegler	25	4	4	0	0	0	0	1	.160	4	14	15	0	1.000
E. Petras	28	1	6	4	2	0	1	2	.214	6	13	20	2	.943
C. Wisniewski	30	0	8	0	1	1	0	3	.267	3	6	11	1	.945
I. Voyce	28	0	3	0	0	0	0	2	.107	2	95	0	3	.969
R. Lessing	24	1	3	0	1	0	0	0	.125	6	30	5	0	1.000
T. Shively	24	3	4	0	0	0	0	0	.167	8	11	0	0	1.000
N. Stoll	22	3	2	2	0	0	0	1	.091	3	11	0	1	.917
D. Tetzlaff	24	2	3	1	1	0	0	1	.125	3	10	24	3	.919
M. Earp	9	0	1	1	0	0	0	1	.111	0	4	10	0	1.000
E. Wingrove	8	0	1	0	0	0	0	2	.125	1	2	0	0	1.000
A. Haylett	8	0	1	0	0	0	0	1	.125	0	3	4	0	1.000
R. Richard	1	0	0	0	0	0	0	0	.000	0	0	0	0	1.000
Totals	231	14	36	8	5	1	1	14	.156	36	199	89	10	.964

1948 CHAMPIONSHIP PLAYOFFS

The fact of two divisions resulted in the Shaughnessy Playoffs' adding another round of playoffs to decide the league championship. Grand Rapids and Racine had won their respective divisions. Racine swept Peoria in the first round of the playoffs in the Western Division. On the other hand, Grand Rapids had to go the full five games of their first round to eliminate South Bend. Meanwhile, Fort Wayne upset Muskegon and Rockford swept by Kenosha. Lois Florreich recorded a one-hit shutout for Rockford.

In the divisional playoffs, both division championships were upset. That left third-place Rockford facing eighth-place Fort Wayne for the championship. The Peaches never gave the Daisies a chance at another upset as Rockford jumped out to a three-game lead and won the series four games to one. Helen Fox won two of the games. Dorothy Harrell hit .412 on the series to lead Rockford in hitting.

Members of the 1948 Rockford Peaches playoff championship team were (front row from left) Dottie Ferguson, Melba Alspaugh, Manager Bill Allington, Chaperone Dottie Green, Charlene Barnett, Amy Applegren, (second row from left) Ruth Richard, Alice Pollitt, Jean Lovell, Jackie Kelley, Lou Erickson, Betty Warfel, Helen Fox, (third row from left) Dottie Kamenshek, Dorothy Harrell, Eleanor Callow, Rose Gacioch and Doris Neal.

1st Round (Best of five)

Racine vs. Peoria

Game 1: Racine 6, Peoria 4
Game 2: Racine 5, Peoria 3
Game 3: Racine 2, Peoria 1
Racine wins series 3 games to 0

Game 1: Racine 6, Peoria 4

				R	H	E	DP
Racine	020	000	301	6	12	4	0
Peoria	400	000	000	4	6	4	0

Winning Pitcher: J. Winter; Losing Pitcher D. Mueller. *Umpires:* Batwinski and Koehnlein. A: 2,665. Time: 2:00.
Highlights: Edythe Perlick's two hits, two runs and three stolen bases helped the Belles get past the Redwings in a comeback win. Joanne Winter gave up four runs in the first, but settled down after that to preserve the victory.

Game 2: Racine 5, Peoria 3

				R	H	E	DP
Peoria	101	000	001	3	4	2	0
Racine	100	004	00x	5	6	5	0

Winning Pitcher: E. Roth; *Losing Pitcher:* E. Dapkus.
Highlights: Edythe Perlick knocked in two runs, while Betty Trezza stole three bases in leading the Belles to their second straight win.

Game 3: Racine 2, Peoria 1

				R	H	E	DP		
Peoria	000	010	000	0	0	1	8	3	1
Racine	000	100	000	0	1	2	6	1	0

Winning Pitcher: I. Kotowicz; *Losing Pitcher:* D. Mueller. Time: 2:17.
Highlights: Irene Kotowicz allowed one run to give her Belles a sweep of the series.

Composite Averages

Peoria Pitching Records

	IP	W	L	H	BB	SO	B	WP	HB	R	ER	ERA
D. Mueller	20	0	2	18	6	0	0	1	1	8	6	2.70
E. Roth	9	0	1	6	2	0	0	0	0	5	5	5.00
Totals	29	0	3	24	8	0	0	1	0	13	11	3.42

Peoria Hitting Records

	AB	R	H	S	2B	3B	HR	RBI	Pct.	SB	PO	A	E	FA
F. Dancer	13	2	3	0	0	1	0	0	.231	0	0	0	1	.000
A. DeCambra	13	2	2	2	0	0	0	0	.154	1	6	0	0	1.000
G. Wisham	12	1	4	1	1	0	0	3	.333	1	11	0	1	.917
M. Reynolds	10	1	3	0	0	1	0	1	.300	0	1	0	1	.500
N. Meyer	1	0	0	0	0	0	0	0	.000	0	0	0	0	1.000
Ei. Roth	5	1	0	1	0	0	0	0	.000	0	3	0	0	1.000
K. Vonderau	12	0	1	1	0	0	0	1	.083	0	2	0	0	1.000
M. Carey	12	0	2	0	0	0	0	0	.167	0	5	0	0	1.000
T. Donohue	9	0	0	0	0	0	0	0	.000	0	5	0	0	1.000
J. Hasham	4	0	1	0	0	0	0	0	.250	0	1	0	0	1.000
E. Roth	9	1	2	0	0	0	0	0	.222	0	3	0	0	1.000
D. Mueller	7	0	0	1	0	0	0	0	.000	0	6	0	0	1.000
Totals	107	8	18	6	1	2	0	5	.168	2	43	0	3	.935

Racine Pitching Records

	IP	W	L	H	BB	SO	B	WP	HB	R	ER	ERA
J. Winter	9	1	0	6	4	0	0	0	0	4	4	4.00
E. Dapkus	8	1	0	4	1	4	0	0	0	3	1	1.13
I. Kotowicz	11	1	0	8	0	0	0	0	2	1	1	0.82
Totals	28	3	0	18	5	4	0	0	2	8	6	1.93

Racine Hitting Records

	AB	R	H	S	2B	3B	HR	RBI	Pct.	SB	PO	A	E	FA
S. Kurys	12	1	2	0	0	0	0	1	.167	2	4	0	0	1.000
B. Trezza	15	2	4	0	1	0	0	0	.267	3	5	0	0	1.000
P. Gianfrancisco	11	2	3	0	0	0	0	1	.273	0	0	0	0	1.000
E. Perlick	13	3	5	0	1	0	0	2	.385	4	1	0	0	1.000
E. Dapkus	12	1	2	0	0	0	0	1	.167	0	1	0	1	.500
M. English	10	2	2	1	0	0	0	0	.200	0	10	0	0	1.000
I. Hickson	9	1	2	1	0	0	0	2	.222	0	12	0	0	1.000
M. Danhauser	11	0	3	0	0	0	0	1	.273	0	10	0	0	1.000
J. Winter	3	0	0	1	0	0	0	1	.000	0	0	0	0	1.000
P. Koehn	3	0	0	0	0	0	0	1	.000	0	0	0	0	1.000

	AB	R	H	S	2B	3B	HR	RBI	Pct.	SB	PO	A	E	FA
I. Kotowicz	4	0	1	0	0	0	0	0	.250	0	2	0	0	1.000
J. Hill	1	0	0	0	0	0	0	0	.000	0	4	0	0	1.000
G. Vincent	0	1	0	0	0	0	0	0	.000	0	0	0	0	1.000
Totals	104	11	24	0	3	2	0	10	.231	9	49	0	1	.980

*Fielding statistics not available for games 1 and 2.

1st Round (Best of five)

Rockford vs. Kensoha

Game 1: Rockford 6, Kenosha 0
Game 2: Rockford 3, Kenosha 2
Game 3: Rockford 4, Kenosha 0
Rockford win 3 games to 0

Game 1: Rockford 6, Kenosha 0

				R	H	E	DP
Kenosha	000	000	000	0	0	1	0
Rockford	240	000	00x	6	8	1	0

Winning Pitcher: L. Florreich; *Losing Pitcher:* B. Goldsmith. *Umpires:* Gembler and Giacinti. A: 2,143. Time: 1:37.
Highlights: Lois Florreich recorded the first no-hitter in series history against the Comets.

Game 2: Rockford 3, Kenosha 2

				R	H	E	DP
Rockford	000	002	001	3	6	5	0
Kenosha	020	000	000	2	2	3	0

Winning Pitcher: H. Fox; *Losing Pitcher:* Stephens. *Umpires:* Remo and Gembler. A: 1,455.
Highlights: Helen Fox held the Comets to two hits and two runs as the Peaches pulled off a comeback win.

Game 3: Rockford 4, Kenosha 0

				R	H	E	DP
Kenosha	000	000	000	0	0	0	0
Rockford	300	010	00x	4	10	0	1

Winning Pitcher: M. Holgerson; *Losing Pitcher:* A. Hohlmayer. *Umpires:* Gembler and Giacinti. A: 3,875. Time: 1:36.
Highlights: Marge Holgerson recorded a second no-hitter against the Comets, while Dorothy Harrell went 4-for-4 with two runs scored.

Composite Averages

Kenosha Pitching Records

	IP	W	L	H	BB	SO	B	WP	HB	R	ER	ERA
B. Goldsmith	5	0	1	8	4	3	0	1	0	6	6	10.81
J. O'Hara	6	0	0	0	0	1	0	0	0	0	0	0.00
B. Rotvig	1	0	1	4	0	0	0	1	1	3	3	27.03
A. Hohlmayer	7	0	0	6	2	2	0	0	0	1	1	1.29
R. Stephens	6	0	1	6	3	1	0	0	0	2	2	3.00
Totals	25	0	3	24	6	3	2	1	1	3	12	4.33

Kenosha Hitting Records

	AB	R	H	S	2B	3B	HR	RBI	Pct.	SB	PO	A	E	FA
B. Fabac	10	0	0	1	0	0	0	0	.000	0	5	9	0	1.000
D. Naum	11	0	0	0	0	0	0	0	.000	0	8	0	0	1.000
M. Villa	11	0	0	0	0	0	0	0	.000	0	3	4	1	.875
A. Wagner	9	1	1	0	1	0	0	0	.111	1	6	0	0	1.000
F. Shollenberger	8	1	1	0	0	0	0	0	.125	1	5	8	1	.929
C. Jewett	10	0	0	0	0	0	0	0	.000	0	4	1	0	1.000
A. Hohlmayer	6	0	0	0	0	0	0	0	.000	0	22	0	0	1.000
J. Cione	3	0	0	0	0	0	0	0	.000	0	11	0	0	1.000
M. Redman	2	0	0	0	0	0	0	0	.000	0	3	0	0	1.000
D. Brumfield	6	0	0	0	0	0	0	0	.000	0	3	0	0	1.000
B. Goldsmith	1	0	0	1	0	0	0	0	.000	0	0	0	0	1.000
J. O'Hara	2	0	0	0	0	0	0	0	.000	0	1	2	1	.750
B. Rotvig	0	0	0	0	0	0	0	0	.000	0	0	0	0	1.000
A. Hohlmayer	2	0	0	0	0	0	0	0	.000	0	0	0	0	1.000
R. Stephens	1	0	0	0	0	0	0	0	.000	0	0	1	0	1.000
B. Goldsmith	0	0	0	0	0	0	0	0	.000	0	0	0	1	.000
Totals	82	2	2	2	1	0	0	0	.037	2	71	25	4	.960

Rockford Pitching Records

	IP	W	L	H	BB	SO	B	WP	HB	R	ER	ERA
L. Florreich	9	1	0	0	2	7	0	0	0	0	0	0.00
M. Holgerson	9	1	0	0	6	8	0	0	0	0	0	0.00
H. Fox	9	1	0	2	0	0	0	0	0	2	0	0.00
Totals	27	3	0	2	0	0	0	0	0	2	0	0.00

Rockford Hitting Records

	AB	R	H	S	2B	3B	HR	RBI	Pct.	SB	PO	A	E	FA
D. Ferguson	13	0	2	0	0	0	0	2	.154	1	5	0	0	1.000
D. Kamenshek	10	3	2	0	0	0	0	1	.200	0	32	1	0	1.000
D. Harrell	11	4	6	0	1	0	0	1	.545	1	4	8	1	.923
E. Callow	12	1	2	0	0	0	0	3	.167	0	2	0	0	1.000
R. Gacioch	12	1	5	0	1	1	0	3	.417	0	9	0	0	1.000
M. Stefani	9	0	2	0	0	0	0	1	.222	0	10	10	1	.952
A. Pollitt	13	1	3	0	0	0	0	0	.231	0	1	3	1	.800
R. Richard	8	1	3	0	0	0	0	0	.375	2	17	2	0	1.000
L. Florreich	3	1	0	0	0	0	0	0	.000	0	0	2	0	1.000
M. Holgerson	4	0	0	0	0	0	0	0	.000	0	1	1	0	1.000
B. Warfel	0	0	0	0	0	0	0	0	.000	0	0	0	0	1.000
J. Lovell	3	0	1	0	0	0	0	0	.333	0	0	1	2	.333
H. Fox	3	0	0	0	0	0	0	1	.000	0	0	4	1	.800
M. Alspaugh	0	1	0	0	0	0	0	0	.000	0	0	0	0	1.000
Totals	64	13	26	0	2	0	0	12	.406	4	81	32	6	.950

1st Round (Best of five)

Grand Rapids vs. South Bend

Game 1: South Bend 3, Grand Rapids 2
Game 2: Grand Rapids 3, South Bend 2
Game 3: South Bend 2, Grand Rapids 1
Game 4: Grand Rapids 1, South Bend 0
Game 5: Grand Rapids 3, South Bend 0
Grand Rapids won 3 games to 2

Game 1: South Bend 3, Grand Rapids 2

								R	H	E	DP
Grand Rapids	010	000	010	0 0 0	0 0 0	0 0 0	0 0	2	8	5	0
South Bend	000	020	000	0 0 0	0 0 0	0 0 0	0 1	3	11	0	0

Winning Pitcher: J. Faut; *Losing Pitcher:* A. Haylett
Highlights: Jean Faut dueled Alice Haylett in the longest game in playoff history. Faut gained the win as the Blue Sox scored in the 20th inning.

Game 2: Grand Rapids 3, South Bend 2

						R	H	E	DP
Grand Rapids	000	100	100	0	1	3	10	1	1
South Bend	000	110	000	0	0	2	9	1	0

Winning Pitcher: M. Earp; *Losing Pitcher:* B. Jochum
Highlights: Mildred Earp single-handedly whipped the Blue Sox with her two-run performance and a game-winning single in the eleventh.

Game 3: South Bend 2, Grand Rapids 1

				R	H	E	DP
South Bend	000	001	100	2	4	0	0
Grand Rapids	000	100	000	1	4	0	2

Winning Pitcher: L. Faralla; Losing Pitcher A. Ziegler
Highlights: Lillian Faralla held the Chicks to a run, while Pinky Pirok tripled and knocked in an RBI for the Blue Sox.

Game 4: Grand Rapids 1, South Bend 0

					R	H	E	DP
South Bend	000	000	000 000 000	0	6	1	0	
Grand Rapids	000	000	000 000 000	1	4	0	0	

Winning Pitcher: A. Haylett; *Losing Pitcher:* J. Faut. Time: 2:15.
Highlights: In a rematch of Game 1, Alice Haylett dueled Jean Faut. This time Haylett won the extra-inning affair on a shutout.

Game 5: Grand Rapids 3, South Bend 0

				R	H	E	DP
South Bend	000	000	000	0	1	1	0
Grand Rapids	100	101	00x	3	5	0	0

Winning Pitcher: M. Earp; *Losing Pitcher:* L. Faralla. *Umpires:* Loew, Ringenberg, Zoss and Ward. Time: 1:30.
Highlights: Mildred Earp blanked the Blue Sox with a one-hitter.

Composite Averages

South Bend Pitching Records

	IP	W	L	H	BB	SO	B	WP	HB	R	ER	ERA
J. Faut	35	1	1	10	15	22	0	0	0	3	3	0.77
B. Jochum	16	0	2	15	3	8	0	0	0	5	5	2.82
L. Faralla	12	1	0	9	1	3	0	0	1	2	2	1.50
Totals	63	2	3	34	9	33	0	0	1	10	10	1.43

South Bend Hitting Records

	AB	R	H	S	2B	3B	HR	RBI	Pct.	SB	PO	A	E	FA
B. Baker	26	1	8	1	0	0	0	1	.308	1	18	17	0	1.000
H. Filarski	21	0	2	0	1	0	0	0	.095	1	4	0	0	1.000
S. Wirth	26	0	4	1	1	0	0	0	.154	1	9	25	1	.972
E. Mahon	25	0	4	0	1	0	0	1	.160	1	11	1	0	1.000
B. Jochum	15	0	2	0	0	0	0	0	.133	3	3	11	0	1.000
P. Pirok	22	0	2	0	0	0	0	0	.091	0	16	20	0	1.000
J. Faut	14	0	1	0	0	0	0	0	.071	0	5	19	0	1.000
B. Whiting	21	1	2	0	1	0	0	0	.095	1	81	3	1	.988
S. Stovroff	22	3	5	1	0	0	0	1	.227	1	28	8	1	.973
L. Faralla	4	1	0	0	0	0	0	0	.000	0	0	0	0	1.000
B. Wagoner	17	0	1	1	0	0	0	0	.059	0	6	0	0	1.000
Totals	213	7	30	4	4	0	0	3	.141	9	181	104	3	.990

Grand Rapids Pitching Records

	IP	W	L	H	BB	SO	B	WP	HB	R	ER	ERA
A. Haylett	35	1	1	17	8	26	0	0	2	3	1	0.26
M. Earp	20	2	0	10	2	17	0	0	0	2	2	0.90
A. Ziegler	9	0	1	4	2	6	0	0	1	2	2	2.00
Totals	64	3	2	31	12	49	0	0	3	7	5	0.70

Grand Rapids Hitting Records

	AB	R	H	S	2B	3B	HR	RBI	Pct.	SB	PO	A	E	FA
M. Olinger	28	0	3	0	1	0	0	0	.107	0	15	23	4	.905
A. Ziegler	26	1	1	0	0	0	0	0	.038	1	4	18	2	.917
C. Wisniewski	22	0	5	0	1	0	0	1	.227	1	5	0	0	1.000
I. Voyce	23	2	6	0	0	0	0	0	.261	0	82	1	0	1.000
D. Satterfield	22	2	4	1	0	0	0	0	.182	1	8	1	0	1.000
R. Lessing	21	1	4	1	0	1	0	1	.190	1	58	8	0	1.000
L. Paire	23	1	4	1	0	0	0	1	.174	0	9	23	3	.914
L. Fisher	20	0	0	2	0	0	0	0	.000	0	5	0	0	1.000
A. Haylett	12	0	0	0	0	0	0	0	.000	0	1	15	1	.941
M. Earp	8	0	2	0	0	0	0	2	.250	0	2	6	0	1.000
B. Petryna	3	0	0	0	0	0	0	0	.000	0	2	1	0	1.000
Totals	208	7	28	5	2	1	0	5	.135	4	197	96	10	.967

1st Round (Best of five)

Fort Wayne vs. Muskegon

Game 1: Muskegon 4, Fort Wayne 0
Game 2: Fort Wayne 5, Muskegon 3
Game 3: Fort Wayne 6, Muskegon 3
Game 4: Fort Wayne 4, Muskegon 0
Fort Wayne won 3 games to 1

Game 1: Muskegon 4, Fort Wayne 0

				R	H	E	DP
Fort Wayne	000	000	000	0	4	3	0
Muskegon	000	031	00x	4	3	0	0

Winning Pitcher: A. Applegren; *Losing Pitcher:* K. Blumetta.
Highlights: Kay Blumetta shutout the Daisies and her teammates scored four runs on three miscues.

Game 2: Fort Wayne 5, Muskegon 3

				R	H	E	DP
Fort Wayne	021	000	200	5	5	1	0
Muskegon	300	000	000	3	6	2	1

 Winning Pitcher: A. Lee; *Losing Pitcher:* A. Fischer
 Highlights: Vivian Kellogg singled twice, knocked in a run and scored once to help the Daisies to a comeback-from-behind win.

Game 3: Fort Wayne 6, Muskegon 3

				R	H	E	DP
Muskegon	000	030	000	3	4	2	0
Fort Wayne	011	400	00x	6	6	2	1

 Winning Pitcher: D. Cook; *Losing Pitcher:* D. Sams. *Umpires:* Zoss and Ward. Time: 1:45.
 Highlights: A home run by Margaret Callaghan and triples by Vivian Kellogg, Doris Cook and Thelma Eisen pushed the Daisies past the Lassies.

Game 4: Fort Wayne 4, Muskegon 0

				R	H	E	DP
Muskegon	000	000	000	0	4	2	0
Fort Wayne	003	100	00x	4	5	3	1

 Winning Pitcher: K. Blumetta; *Losing Pitcher:* A. Applegren. *Umpires:* Ward and Zoss. Time: 2:05.
 Highlights: Kay Blumetta tossed a shutout to give the Daisies the series.

Composite Averages

Muskegon Pitching Records

	IP	W	L	H	BB	SO	B	WP	HB	R	ER	ERA
A. Applegren	17	1	1	9	9	13	0	0	2	4	3	1.59
D. Sams	7	0	1	6	7	3	0	0	1	9	6	7.72
S. Lonetto	6	0	0	2	0	0	0	0	0	0	0	0.00
A. Fischer	6	0	1	5	5	1	0	0	0	2	1	1.50
Totals	36	1	3	22	21	17	0	0	3	15	10	2.50

Muskegon Hitting Records

	AB	R	H	S	2B	3B	HR	RBI	Pct.	SB	PO	A	E	FA
C. Pryer	9	1	0	0	0	0	0	0	.000	2	8	0	0	1.000
S. Reeser	13	1	4	1	0	0	0	0	.308	1	40	0	1	.976
D. Stolze	15	1	2	0	0	0	0	1	.133	2	9	6	1	.938
D. Sams	13	0	2	0	0	0	0	0	.154	0	3	4	0	1.000
A. Fischer	15	1	4	0	0	1	0	1	.267	0	2	10	0	1.000
J. Lenard	15	1	3	1	0	1	0	4	.200	1	11	1	0	1.000
A. Johnson	12	1	1	0	0	0	0	0	.083	1	5	14	2	.905
D. Chapman	12	0	0	1	0	0	0	0	.000	0	20	3	2	.920
A. Applegren	7	1	1	0	0	0	0	0	.143	0	0	6	0	1.000
S. Lonetto	6	0	0	0	0	0	0	0	.000	0	3	0	0	1.000
D. Pearson	3	0	0	0	0	0	0	0	.000	0	1	0	0	1.000
Totals	120	7	17	3	0	2	0	6	.142	7	103	44	6	.961

Fort Wayne Pitching Records

	IP	W	L	H	BB	SO	B	WP	HB	R	ER	ERA
K. Blumetta	18	1	1	7	7	6	0	0	2	0	0	0.00
A. Lee	9	1	0	6	3	3	0	0	0	3	3	3.00
D. Cook	6	1	0	4	12	7	0	0	0	3	3	4.50

	IP	W	L	H	BB	SO	B	WP	HB	R	ER	ERA
M. Kline	3	0	0	0	0	1	0	0	2	0	0	0.00
Totals	36	3	1	17	22	17	0	0	4	6	6	1.50

Fort Wayne Hitting Records

	AB	R	H	S	2B	3B	HR	RBI	Pct.	SB	PO	A	E	FA
T. Eisen	14	2	3	1	0	1	0	1	.214	4	4	1	0	1.000
M. Callaghan	15	3	2	1	0	0	1	2	.133	0	9	0	1	.900
W. Briggs	11	1	2	1	0	0	0	1	.181	1	1	0	0	1.000
V. Kellogg	15	3	4	0	0	1	0	0	.267	0	31	0	1	.969
D. Schroeder	10	2	0	0	0	0	0	0	.000	0	9	15	2	.923
E. Mahoney	4	0	1	0	0	0	0	0	.250	0	1	0	1	.500
D. Tetzlaff	13	1	1	0	0	0	0	1	.077	0	11	17	2	.933
J. Smith	8	0	1	1	0	0	0	1	.125	2	5	0	1	.833
M. Rountree	8	2	3	0	0	0	0	0	.375	0	16	2	0	1.000
K. Blumetta	3	0	1	1	0	0	0	0	.333	0	3	10	0	1.000
R. Heafner	1	1	0	0	0	0	0	0	.000	1	4	1	0	1.000
A. Lee	4	0	1	0	0	0	0	0	.250	0	1	3	0	1.000
D. Cook	2	1	1	0	0	1	0	2	.500	0	0	0	1	.000
M. Kline	1	0	0	0	0	0	0	0	.000	0	0	0	0	1.000
Totals	109	16	20	5	0	3	1	8	.183	8	95	49	9	.941

2nd Round (Best of five)

Grand Rapids vs. Fort Wayne

Game 1: Fort Wayne 4, Grand Rapids 0
Game 2: Fort Wayne 1, Grand Rapids 0
Game 3: Fort Wayne 6, Grand Rapids 0
Ft. Wayne win series 3 games to 0

Game 1: Fort Wayne 4, Grand Rapids 0

				R	H	E	DP	
Fort Wayne	100	000	100	2	4	6	1	0
Grand Rapids	002	000	000	0	2	6	4	0

Winning Pitcher: M. Kline; *Losing Pitcher:* A. Ziegler.
Highlights: Dottie Schroeder knocked in two RBI with her two hits to lead the Daisies over the Chicks in ten innings, as Maxine Kline picked up the win in relief.

Game 2: Fort Wayne 1, Grand Rapids 0

				R	H	E	DP
Fort Wayne	000	000	100	1	5	0	0
Grand Rapids	000	000	000	0	2	1	0

Winning Pitcher: M. Kline; *Losing Pitcher:* A. Haylett.
Highlights: Maxine Kline picked up her second victory of the series as she blanked the Chicks on two hits.

Game 3: Fort Wayne 6, Grand Rapids 0

				R	H	E	DP
Grand Rapids	000	000	000	0	2	2	0
Fort Wayne	031	002	00x	6	10	3	0

Winning Pitcher: A. Lee; *Losing Pitcher:* M. Earp
Highlights: Annabelle Lee shutout the Chicks again and Ruby Heafner added all the firepower needed with two hits and two RBI.

Composite Averages

Grand Rapids Pittching Records

	IP	W	L	H	BB	SO	B	WP	HB	R	ER	ERA
A. Ziegler	10	0	1	6	0	1	0	0	0	4	2	1.82
A. Haylett	9	0	1	5	5	4	0	0	0	1	0	0.00
M. Earp	6	0	1	8	3	1	0	0	0	6	6	9.01
L. Fisher	2	0	0	2	1	1	0	0	0	0	0	0.00
Totals	27	0	3	21	9	7	0	0	0	11	8	2.67

Grand Rapids Hitting Records

	AB	R	H	S	2B	3B	HR	RBI	Pct.	SB	PO	A	E	FA
M. Olinger	11	1	1	0	0	0	0	0	.091	0	6	14	4	.833
A. Ziegler	12	0	2	0	0	0	0	0	.167	1	6	7	0	1.000
C. Wisniewski	11	0	2	0	0	0	0	1	.182	0	2	0	0	1.000
D. Satterfield	11	0	0	0	0	0	0	1	.000	0	3	1	0	1.000
I. Voyce	9	0	2	0	1	0	0	0	.222	0	42	1	0	1.000
R. Lessing	7	0	0	2	0	0	0	0	.000	0	13	2	1	.938
P. Paire	10	0	2	0	0	0	0	0	.200	0	2	9	1	.917
L. Fisher	7	0	0	0	0	0	0	0	.000	0	6	0	0	1.000
B. Petryna	2	1	0	0	0	0	0	0	.000	0	0	5	0	1.000
A. Haylett	3	0	1	0	0	0	0	0	.000	0	1	7	0	1.000
H. Smith	3	0	0	0	0	0	0	0	.000	0	0	0	0	1.000
M. Earp	2	0	0	0	0	0	0	0	.000	0	0	1	1	.500
Totals	69	2	10	2	1	0	0	2	.145	1	81	47	7	.968

Fort Wayne Pitching Records

	IP	W	L	H	BB	SO	B	WP	HB	R	ER	ERA
M. Kline	12	2	0	4	2	4	0	0	0	0	0	0.00
D. Cook	7	0	0	4	6	4	0	0	0	2	2	2.57
A. Lee	9	1	0	2	2	4	0	0	0	0	0	0.00
Totals	28	3	0	10	10	12	0	0	0	2	2	0.64

Fort Wayne Hitting Records

	AB	R	H	S	2B	3B	HR	RBI	Pct.	SB	PO	A	E	FA
T. Eisen	14	1	3	0	0	0	0	1	.214	0	5	0	1	.833
M. Callaghan	14	1	3	0	0	0	0	0	.214	1	8	3	1	.917
D. Schroeder	13	2	2	0	0	0	0	2	.154	1	5	3	0	1.000
V. Kellogg	14	0	1	0	0	0	0	2	.071	0	32	1	0	1.000
W. Briggs	11	1	2	0	0	0	0	1	.182	0	5	0	0	1.000
J. Smith	10	2	0	0	0	0	0	0	.000	3	4	0	0	1.000
D. Tetzlaff	10	1	0	0	0	0	0	0	.000	0	6	10	1	.941
M. Rountree	6	0	2	1	0	0	0	0	.333	1	11	4	0	1.000
D. Cook	3	0	0	0	0	0	0	0	.000	0	1	1	1	.667
M. Kline	4	0	1	0	0	0	0	0	.000	0	1	2	0	1.000
R. Heafner	4	2	2	0	0	0	0	0	.500	2	6	1	0	1.000
A. Lee	4	1	1	0	0	0	0	0	.250	0	0	1	0	1.000
Totals	94	11	17	1	0	0	0	6	.181	8	84	26	4	.965

2nd Round (Best of five)

Rockford vs. Racine

Game 1: Rockford 2, Racine 0
Game 2: Rockford 3, Racine 1
Game 3: Rockford 1, Racine 0
Rockford won 3 games to 0

Game 1: Rockford 2, Racine 0

				R	H	E	DP
Racine	000	000	000	0	1	1	0
Rockford	000	000	20x	2	3	2	0

Winning Pitcher: L. Florreich; *Losing Pitcher:* J. Winter. *Umpires:* Giacinti, Koehnline and Batwinski. A: 4,249.
Highlights: Lois Florreich handcuffed the Belles with a one-hitter as the Peaches rallied for two runs in the seventh inning on RBIs by Eleanor Callow and Rose Gacioch.

Game 2: Rockford 3, Racine 1

				R	H	E	DP
Racine	100	000	000	1	6	0	0
Rockford	000	001	02x	3	5	0	0

Winning Pitcher: H. Fox; *Losing Pitcher:* E. Dapkus. *Umpires:* Koehnline, Batwinski and Giacinti. A: 3,703. Time: 1:37.
Highlights: Helen Fox held the Belles to a solo run, while Eleanor Callow cleaned up with three RBI.

Game 3: Rockford 1, Racine 0

				R	H	E	DP
Rockford	000	010	000	1	5	1	0
Racine	000	000	000	0	2	1	1

Winning Pitcher: M. Holgerson; *Losing Pitcher:* I. Kotowicz. A: 1,800. Time: 1:38.
Highlights: Marge Holgerson continued the Peaches' pitching domination in the series as she shutout the Belles for the sweep.

Composite Averages

Racine Pitching Records

	IP	W	L	H	BB	SO	B	WP	HB	R	ER	ERA
J. Winter	8	0	1	3	0	5	0	0	0.	2	2	2.25
E. Dapkus	8	0	1	5	4	7	0	0	0	3	3	3.38
I. Kotowicz	9	0	1	5	1	3	0	0	1	1	1	1.00
Totals	25	0	3	13	5	15	0	0	1	6	6	2.16

Racine Hitting Records

	AB	R	H	S	2B	3B	HR	RBI	Pct.	SB	PO	A	E	FA
G. Vincent	8	0	0	0	0	0	0	0	.000	0	1	1	0	1.000
B. Trezza	12	0	1	0	0	0	0	0	.000	0	3	1	0	1.000
P. Gianfrancisco	9	1	3	0	1	1	0	0	.333	2	1	0	0	1.000
E. Perlick	12	0	3	0	0	0	0	1	.250	0	4	0	1	.800
E. Dapkus	12	0	1	0	0	0	0	0	.083	0	3	7	0	1.000
M. English	8	0	0	0	0	0	0	0	.000	0	3	3	0	1.000
I. Hickson	6	0	0	0	0	0	0	0	.000	0	13	4	0	1.000
M. Danhauser	8	0	0	0	0	0	0	0	.000	0	19	1	0	1.000
S. Kurys	4	0	0	0	0	0	0	0	.000	0	2	2	0	1.000
J. Winter	1	0	0	0	0	0	0	0	.000	0	0	0	0	1.000
P. Koehn	1	0	0	0	0	0	0	0	.000	0	2	0	0	1.000
J. Hill	1	0	0	0	0	0	0	0	.000	0	0	1	0	1.000
I. Kotowicz	3	1	0	0	0	0	0	0	.000	0	0	0	0	1.000
Totals	85	2	8	0	1	1	0	1	.094	0	51	20	1	.986

Rockford Pitching Records

	IP	W	L	H	BB	SO	B	WP	HB	R	ER	ERA
L. Florreich	9	1	0	1	3	8	0	0	0	0	0	0.00
H. Fox	9	1	0	6	2	1	0	0	0	1	1	1.00
M. Holgerson	9	1	0	2	3	5	0	0	0	0	0	0.00
Totals	27	1	0	9	8	14	0	0	0	1	1	0.33

Rockford Hitting Records

	AB	R	H	S	2B	3B	HR	RBI	Pct.	SB	PO	A	E	FA
D. Ferguson	8	1	1	0	0	0	0	0	.125	3	2	0	0	1.000
D. Kamenshek	9	3	3	0	0	0	0	0	.333	1	23	0	0	1.000
D. Harrell	11	0	0	0	0	0	0	0	.000	0	9	8	1	.945
E. Callow	11	1	5	0	0	0	0	4	.455	1	1	1	0	1.000
R. Gacioch	9	0	2	0	0	0	0	1	.222	0	4	0	0	1.000
M. Stefani	8	0	1	0	0	0	0	0	.125	1	2	6	0	1.000
A. Pollitt	9	1	1	0	0	0	0	0	.111	0	1	6	0	1.000
R. Richard	8	0	0	1	0	0	0	0	.000	0	8	0	0	1.000
J. Lovell	3	0	0	0	0	0	0	0	.000	0	1	0	0	1.000
L. Florreich	3	0	0	0	0	0	0	0	.000	0	0	0	0	1.000
H. Fox	3	0	0	0	0	0	0	0	.000	0	2	1	0	1.000
M. Holgerson	2	0	0	1	0	0	0	1	.000	0	1	3	0	1.000
Totals	81	6	13	2	0	0	0	6	.160	6	55	25	1	.987

NOTE: No fielding statistics available for Game 1.

Championship Round (Best of seven)

Rockford vs. Fort Wayne

Game 1: Rockford 1, Fort Wayne 0
Game 2: Rockford 2, Fort Wayne 2
Game 3: Rockford 10, Fort Wayne 0
Game 4: Fort Wayne 4, Rockford 2
Game 5: Rockford 4, Fort Wayne 2
Championship: Rockford

Game 1: Rockford 1, Fort Wayne 0

				R	H	E	DP
Fort Wayne	000	000	000	0	2	1	0
Rockford	000	100	00x	1	4	0	0

Winning Pitcher: L. Florreich; *Losing Pitcher:* K. Blumetta. *Umpires:* Ward, Giacinti, Loew and Ringenberg. Time: 1:16.
Highlights: Lois Florreich blanked the Daisies, who scored their only run on a triple by Mary Richard.

Game 2: Rockford 2, Fort Wayne 2

				R	H	E	DP
Fort Wayne	100	000	010	2	6	2	1
Rockford	100	101	00X	3	5	1	0

Winning Pitcher: H. Fox; *Losing Pitcher:* D. Cook. *Umpires:* Giacinti, Loew, Ringenberg and Ward. Time: 1:38.
Highlights: Dottie Ferguson went 3-for-3 and knocked in two runs to lead the Peaches past the Daisies.

Game 3: Rockford 10, Fort Wayne 0

				R	H	E	DP
Fort Wayne	000	000	000	0	2	1	0
Rockford	450	000	001	10	11	0	0

Winning Pitcher: M. Holgerson; *Losing Pitcher:* A. Lee. *Umpires:* Loew, Zeagranti, Ringenberg and Ward. A: 4,295.
Highlights: Marge Holgerson pitched a marvelous two-hitter, while her team racked up ten runs for its third straight win.

Game 4: Fort Wayne 4, Rockford 2

				R	H	E	DP
Rockford	000	000	020	2	5	2	0
Fort Wayne	000	120	10x	4	3	5	1

Winning Pitcher: K. Blumetta; *Losing Pitcher:* L. Forreich. *Umpires:* Ward, Loew, Ringenberg and Giacinti. Time: 1:45.
Highlights: Kay Blumetta starved off a sweep of the series with a win.

Game 5: Rockford 4, Fort Wayne 2

				R	H	E	DP
Rockford	000	400	000	4	8	3	1
Fort Wayne	100	000	001	2	7	2	0

Winning Pitcher: H. Fox; *Losing Pitcher:* M. Kline. *Umpires:* Ward, Loew, Giacinti and Ringenberg.
Highlights: Helen Fox held the Daisies to two runs to win the series.

Composite Averages

Fort Wayne Pitching Records

	IP	W	L	H	BB	SO	B	WP	HB	R	ER	ERA
K. Blumetta	17	1	1	9	5	4	0	0	1	3	1	0.53
D. Cook	8	0	1	5	8	2	0	0	0	3	2	2.25
A. Lee	6	0	1	11	3	2	0	0	0	8	8	12.01
M. Kline	11	0	1	8	4	0	0	0	1	6	4	3.27
Totals	42	0	4	33	20	8	0	0	2	20	15	3.22

Fort Wayne Hitting Records

	AB	R	H	S	2B	3B	HR	RBI	Pct.	SB	PO	A	E	FA
T. Eisen	19	2	6	0	0	0	0	2	.316	0	3	0	0	1.000
M. Callaghan	18	1	2	0	0	0	0	0	.111	1	3	6	0	1.000
D. Schroeder	19	1	2	0	0	0	0	0	.105	2	4	8	4	.750
V. Kellogg	18	0	4	0	0	0	0	1	.222	0	28	0	0	1.000
W. Briggs	20	0	4	0	0	0	0	1	.200	1	5	0	0	1.000
J. Smith	14	1	0	1	0	0	0	0	.000	0	2	0	1	.667
D. Tetzlaff	12	1	0	0	0	0	0	0	.000	0	2	6	2	.800
M. Rountree	9	2	1	1	0	0	0	0	.111	0	5	1	0	1.000
K. Blumetta	6	0	0	0	0	0	0	0	.000	0	2	3	0	1.000
M. Mahoney	1	0	0	0	0	0	0	0	.000	0	0	0	0	1.000
D. Cook	4	0	0	0	0	0	0	0	.000	0	0	0	0	1.000
R. Heafner	3	0	0	0	0	0	0	0	.000	0	0	0	0	1.000
M. Kline	4	0	1	0	0	0	0	0	.000	0	0	1	0	1.000
A. Lee	2	0	0	0	0	0	0	0	.000	0	0	0	0	1.000
Totals	149	8	20	2	0	0	0	4	.134	4	54	25	7	.919

Rockford Pitching Records

	IP	W	L	H	BB	SO	B	WP	HB	R	ER	ERA
L. Florreich	17	1	1	5	5	13	0	1	0	4	1	0.53
H. Fox	18	2	0	13	1	3	0	0	0	4	2	1.00
M. Holgerson	9	1	0	2	4	7	0	0	0	0	0	0.00
Totals	44	4	1	20	10	23	0	1	0	8	3	0.61

Rockford Hitting Records

	AB	R	H	S	2B	3B	HR	RBI	Pct.	SB	PO	A	E	FA
D. Ferguson	19	3	6	0	0	0	0	2	.316	3	0	0	0	1.000
D. Kamenshek	18	6	6	0	1	0	0	0	.333	6	10	0	0	1.000
D. Harrell	17	4	7	0	1	0	0	3	.412	4	1	1	0	.833
E. Callow	18	2	4	0	0	0	0	3	.222	1	2	0	0	1.000
R. Gacioch	18	0	2	0	0	0	0	0	.111	0	0	0	0	1.000
M. Stefani	14	3	3	1	0	0	0	2	.214	1	0	1	0	1.000
A. Pollitt	15	1	3	3	1	0	0	2	.200	0	0	4	0	1.000
R. Richard	18	0	3	0	0	0	0	3	.167	0	10	0	1	.909
L. Florreich	11	0	0	0	0	0	0	0	.000	0	1	4	1	.833
J. Lovell	0	0	0	0	0	0	0	0	.000	0	0	0	0	1.000
H. Fox	2	1	0	1	0	0	0	0	.000	0	0	0	0	1.000
M. Holgerson	4	0	0	0	0	0	0	0	.000	0	0	0	0	1.000
Totals	154	20	34	5	3	0	0	15	.221	0	24	10	2	.945

NOTE: No fielding statistics available for Game 2 and 3.

1949 Championship Playoffs

The Shaughnessy Playoff format was altered for the eight-team league. In the first round, first place South Bend and second place Rockford received a bye; third place Grand Rapids played fifth place Fort Wayne; and fourth place Kenosha faced sixth place Muskegon.

Grand Rapids and Muskegon won their respective best-of-three series and faced each other in a best-of-five series. Meanwhile, South Bend played a best-of-seven series with Rockford, which Rockford swept. Grand Rapids and Rockford hooked up for a best-of-five series to determine the league championship, which was won by Rockford in four contests. Dottie Collins picked up two wins in the final series, including a shutout. Rockford's Thelma Eisen went 7-for-14 to lead all hitters with a .500 aveage.

1st Round (Best of three)

Muskegon vs. Kenosha
Game 1: Muskegon 3, Kenosha 0
Game 2: Muskegon 6, Kenosha 1
Muskegon wins series 2 games to 0

Game 1: Muskegon 3, Kenosha 0

				R	H	E	DP
Kenosha	000	000	000	0	4	0	1
Muskegon	010	000	20x	3	5	3	1

Winning Pitcher: A. Fischer; *Losing Pitcher:* Rotvig. *Umpires:* Remo and Fust. *Time:* 1:43.
Highlights: Alva Jo Fisher blanked the Comets with a four-hitter.

Members of the 1949 Rockford Peaches playoff championship team were (front row from left) Jean Lovell, Helen Fox, Dottie Harrell, Dottie Kamenshek, Dottie Ferguson, Marge Holgerson, (second row from left) Alice Pollitt, Eleanor Callow, Rose Gacioch, Ruth Richard, Betty Warfel, Lois Florreich, (third row from left) Manager Bill Allington, Marge Stefani, Mary Moore, Melba Alspaugh and Chaperone Dottie Green.

Game 2: Muskegon 6, Kenosha 1

				R	H	E	DP
Muskegon	001	030	020	6	7	3	0
Kenosha	000	000	001	1	4	1	0

Winning Pitcher: D. Sams; *Losing Pitcher:* J. Cione. *Umpires:* Fust and Remo. A: 784.
Highlights: Doris Sams put the clamps to the Comets by allowing a single meaningless run in the ninth inning.

Composite Averages

Kenosha Pitching Records

	IP	W	L	H	BB	SO	B	WP	HB	R	ER	ERA
B. Rotvig	6	0	1	5	7	4	0	0	1	3	3	4.50
B. Goldsmith	2	0	0	0	0	3	0	0	0	0	0	0.00
J. Cione	8	0	1	7	7	3	0	0	0	6	2	2.25
R. Stephens	1	0	0	0	0	0	0	0	0	0	0	0.00
Totals	17	0	2	12	14	10	0	0	1	9	5	2.65

Kenosha Hitting Records

	AB	R	H	S	2B	3B	HR	RBI	Pct.	SB	*PO	A	E	FA
E. Petras	7	0	1	0	0	0	0	0	.143	1				
H. Candaele	5	1	0	0	0	0	0	0	.000	1				
M. Villa	7	0	2	0	0	0	0	0	.286	0				
A. Wagner	7	0	1	0	0	0	0	0	.143	0				
D. Brumfield	6	0	3	0	0	0	0	0	.500	0				

	AB	R	H	S	2B	3B	HR	RBI	Pct.	SB	*PO A E FA
J. Marlowe	7	0	0	0	0	0	0	0	.000	0	
F. Shollenberger	6	0	1	1	0	0	0	0	.167	0	
D. Naum	3	0	0	0	0	0	0	0	.000	0	
B. Rotvig	3	0	0	0	0	0	0	0	.000	0	
B. Goldsmith	0	0	0	0	0	0	0	0	.000	0	
R. Stephens	0	0	0	0	0	0	0	0	.000	0	
M. Holgerson	1	0	0	0	0	0	0	0	.000	0	
M. Redman	1	0	0	0	0	0	0	0	.000	0	
J. Cione	3	0	0	0	0	0	0	0	.000	0	
Totals	56	1	8	1	0	0	0	0	.143	2	

Muskegon Pitching Records

	IP	W	L	H	BB	SO	B	WP	HB	R	ER	ERA
A. Fischer	9	1	0	4	3	9	0	0	0	0	0	0.00
D. Sams	9	1	0	4	6	2	0	0	0	1	0	0.00
Totals	18	2	0	8	9	11	0	0	0	1	0	0.00

Muskegon Hitting Records

	AB	R	H	S	2B	3B	HR	RBI	Pct.	SB	*PO A E FA
D. Tetzlaff	7	1	1	0	0	0	0	0	.143	1	
A. Fischer	5	2	1	1	0	0	0	0	.200	0	
D. Sams	7	2	2	0	0	0	0	0	.286	0	
J. Schofield	9	0	1	0	0	0	0	0	.111	0	
N. Meier	7	1	1	0	0	0	0	1	.143	1	
A. Hohlmayer	5	0	2	0	0	0	0	1	.400	0	
M. Wegman	5	1	2	2	0	0	0	0	.400	1	
T. McKinley	7	0	1	0	0	0	0	1	.143	2	
K. Vonderau	6	2	1	0	0	0	0	0	.167	0	
Totals	58	9	12	3	0	0	0	3	.207	0	

*No fielding statistics available in box scores.

1st Round (Best of three)

Grand Rapids vs. Fort Wayne
Game 1: Grand Rapids 3, Fort Wayne 2
Game 2: Fort Wayne 5, Grand Rapids 4
Game 3: Grand Rapids 7, Fort Wayne 3
Grand Rapids wins series 2 games to 1

Game 1: Grand Rapids 3, Fort Wayne 2

				R	H	E	DP
Fort Wayne	000	100	100	2	8	2	0
Grand Rapids	000	000	003	3	7	2	0

Winning Pitcher: A. Ziegler; *Losing Pitcher:* M. Kline. *Umpires:* Ward, Ringesberg and Zoss. A: 1,059. Time: 2:00.
Highlights: The Chicks rallied in the bottom of the ninth on two errors by the Daisies.

Game 2: Fort Wayne 5, Grand Rapids 4

				R	H	E	DP	
Grand Rapids	002	002	000	0	4	5	2	0
Fort Wayne	100	000	201	1	5	7	3	1

Winning Pitcher: M. Deegan; *Losing Pitcher:* A. Haylett. *Umpires:* Ringenberg, Ward and Zoss. A: 1,488. Time: 2:45.
Highlights: Wilma Briggs went 3-for-4 and knocked in a series record five runs for the Daisies.

Game 3: Grand Rapids 7, Fort Wayne 3

				R	**H**	**E**	**DP**
Grand Rapids	100	001	203	7	7	1	1
Fort Wayne	020	000	010	3	6	3	2

Winning Pitcher: M. Earp; *Losing Pitcher:* M. Deegan. *Umpires:* Zoss, Ward and Ringenberg. A: 2,082. Time: 2:10.

Highlights: Connie Wisniewski tripled and knocked in two decisive runs for the Chicks.

Composite Averages

Fort Wayne Pitching Records

	IP	**W**	**L**	**H**	**BB**	**SO**	**B**	**WP**	**HB**	**R**	**ER**	**ERA**
M. Kline	10	0	1	7	2	1	0	0	0	4	1	0.90
M. Deegan	18	1	1	14	8	2	0	0	0	8	6	3.00
D. Cook	1	0	0	0	5	0	0	0	0	1	1	9.01
Totals	29	1	2	21	15	3	0	0	0	13	8	2.48

Fort Wayne Hitting Records

	AB	**R**	**H**	**S**	**2B**	**3B**	**HR**	**RBI**	**Pct.**	**SB**	**PO**	**A**	**E**	**FA**
T. Eisen	12	0	1	0	0	0	0	1	.083	0	6	1	0	1.000
E. Wawryshyn	14	2	2	1	0	1	0	0	.143	3	4	3	0	1.000
B. Luna	11	1	1	0	0	0	0	0	.091	1	3	1	0	1.000
D. Schroeder	11	2	4	0	0	0	0	1	.364	1	7	6	2	.867
V. Kellogg	9	1	3	0	0	0	0	1	.333	0	22	2	1	.960
W. Briggs	9	1	4	0	0	1	0	5	.444	0	3	0	0	1.000
M. Rountree	11	1	3	0	0	0	0	2	.273	1	7	2	1	.900
A. Allen	9	0	0	0	0	0	0	0	.000	0	2	6	1	.889
M. Kline	4	0	1	1	0	0	0	0	.250	0	0	2	0	1.000
M. Deegan	7	0	1	0	0	0	0	0	.143	0	1	6	1	.875
J. Smith	1	1	0	0	0	0	0	0	.000	0	0	0	0	1.000
D. Cook	0	0	0	0	0	0	0	0	.000	0	0	0	0	1.000
Totals	98	9	20	2	0	2	0	10	.204	6	55	29	6	.933

Grand Rapids Pitching Records

	IP	**W**	**L**	**H**	**BB**	**SO**	**B**	**WP**	**HB**	**R**	**ER**	**ERA**
A. Ziegler	9	1	0	8	4	2	0	0	0	2	1	1.00
L. Fisher	6	0	0	4	9	2	0	0	1	3	3	4.50
A. Haylett	4	0	1	3	5	3	0	0	1	2	2	4.50
M. Earp	9	1	0	6	6	6	0	0	0	3	3	3.00
Totals	28	2	1	21	24	13	0	0	2	10	9	2.89

Grand Rapids Hittting Records

	AB	**R**	**H**	**S**	**2B**	**3B**	**HR**	**RBI**	**Pct.**	**SB**	**PO**	**A**	**E**	**FA**
C. Smith	4	0	0	0	0	0	0	0	.000	0	0	0	0	1.000
M. Olinger	12	2	1	1	0	0	0	0	.083	1	2	1	0	1.000
C. Wisniewski	12	1	3	0	0	1	0	4	.250	2	0	0	0	1.000
I. Voyce	13	1	1	0	0	0	0	1	.077	0	10	0	0	1.000
D. Satterfield	10	3	1	0	0	0	0	0	.100	1	2	0	0	1.000
E. Paire	9	3	2	0	0	0	0	1	.222	0	1	6	1	.875
R. Lessing	11	0	4	0	0	0	0	1	.364	1	7	2	0	1.000
D. Reid	10	0	3	0	0	0	0	1	.300	0	2	3	0	1.000
A. Ziegler	12	3	3	0	0	0	0	1	.250	0	4	1	0	1.000
L. Fisher	3	1	1	0	0	0	0	0	.333	0	1	1	0	1.000
A. Haylett	1	0	0	0	0	0	0	0	.000	0	0	1	1	.500

	AB	R	H	S	2B	3B	HR	RBI	Pct.	SB	PO	A	E	FA
M. Earp	3	0	0	1	0	0	0	0	.000	0	0	0	0	1.000
Totals	100	13	19	2	0	0	0	9	.190	0	29	16	2	.958

NOTE: No fielding statistics available for Game 1.

2nd Round (Best of five)

Grand Rapids vs. Muskegon
Game 1: Grand Rapids 7, Muskegon 4
Game 2: Grand Rapids 7, Muskgon 6
Game 3: Grand Rapids 6, Muskegon 3
Grand Rapids wins series 3 games to 0

Game 1: Grand Rapids 7, Muskegon 4

				R	H	E	DP
Muskegon	200	000	002	4	8	4	0
Grand Rapids	000	002	50x	7	9	1	0

Winning Pitcher: A. Ziegler; *Losing Pitcher:* A. Hutchison. A: 1,170
Highlights: The Chicks crushed the Lassies with a five-run seventh inning that was sparked by Doris Satterfield's two RBI.

Game 2: Grand Rapids 7, Muskegon 6

				R	H	E	DP	
Muskegon	310	000	200	0	6	10	1	1
Grand Rapids	000	060	000	1	7	8	1	0

Winning Pitcher: E. Risinger; *Losing Pitcher:* D. Sams.
Highlights: The Chicks came from behind and Earlene Risinger held the Lassies down in relief to pick up the win.

Game 3: Grand Rapids 6, Muskegon 3

				R	H	E	DP
Grand Rapids	101	310	000	6	8	0	0
Muskegon	000	100	200	3	7	8	0

Winning Pitcher: M. Earp; *Losing Pitcher:* D. Barr. *Umpires:* Koehnlien, Prat, Ward and Ringenberg. Time: 1:30.
Highlights: Mildred Earp had two hits, scored a run and held the Lassies to three runs to win it all for the Chicks.

Composite Averages

Muskegon Pitching Records

	IP	W	L	H	BB	SO	B	WP	HB	R	ER	ERA
A. Fischer	13	0	0	12	5	6	0	0	0	6	4	2.77
A. Hutchison	1	0	1	3	2	0	0	0	0	5	3	27.27
D. Barr	4	0	1	5	4	1	0	0	0	2	1	2.25
D. Sams	9	0	1	5	8	2	0	0	0	7	7	7.00
Totals	27	0	3	25	19	9	0	0	0	20	15	5.00

Muskegon Hitting Records

	AB	R	H	S	2B	3B	HR	RBI	Pct.	SB	PO	A	E	FA
D. Tetzlaff	9	1	4	1	0	0	0	2	.444	1	1	0	0	1.000
A. Fischer	12	0	2	0	0	0	0	0	.167	0	2	3	0	1.000
A. Hutchison	0	0	0	0	0	0	0	0	.000	0	0	0	0	1.000

	AB	R	H	S	2B	3B	HR	RBI	Pct.	SB	PO	A	E	FA
D. Barr	3	0	0	0	0	0	0	0	.000	0	0	0	0	1.000
D. Sams	11	2	2	1	0	0	0	0	.182	0	0	4	0	1.000
J. Schofield	13	2	3	0	0	0	0	0	.231	0	3	3	0	1.000
N. Meier	10	3	4	1	0	0	0	2	.400	3	0	0	0	1.000
A. Hohlmayer	11	0	1	0	0	0	0	1	.091	0	12	0	0	1.000
M. Wegman	13	1	4	0	0	0	0	1	.308	0	5	4	0	1.000
T. McKinley	9	2	3	0	0	0	0	0	.333	0	3	0	0	1.000
K. Vonderau	9	1	1	1	0	0	0	1	.111	0	2	0	1	.667
J. Gutz	2	1	0	0	0	0	0	0	.000	0	0	0	0	1.000
Totals	102	13	24	4	0	0	0	7	.235	0	28	14	1	.977

Grand Rapids Pitching Records

	IP	W	L	H	BB	SO	B	WP	HB	R	ER	ERA
A. Ziegler	9	1	0	8	2	2	0	0	1	4	4	4.00
L. Fisher	6	0	0	8	1	0	0	0	0	6	4	6.01
E. Risinger	4	1	0	2	2	2	0	0	0	0	0	0.00
M. Earp	9	1	0	7	3	6	0	0	0	3	2	2.00
Totals	28	3	0	25	8	10	0	0	1	13	10	3.22

Grand Rapids Hitting Records

	AB	R	H	S	2B	3B	HR	RBI	Pct.	SB	PO	A	E	FA
C. Smith	8	2	3	0	0	0	0	2	.273	0	0	0	0	1.000
M. Olinger	6	1	2	0	0	0	0	0	.250	0	1	3	0	1.000
C. Wisniewski	8	1	3	1	0	1	0	0	.375	1	0	0	0	1.000
I. Voyce	12	1	1	0	0	0	0	1	.083	0	16	1	0	1.000
D. Satterfield	14	1	2	0	0	0	0	2	.143	0	4	0	0	1.000
L. Paire	11	2	4	0	0	0	0	2	.364	1	1	0	0	1.000
R. Lessing	12	2	2	1	0	0	0	1	.167	0	3	3	1	.857
D. Reid	11	1	0	0	0	0	0	1	.000	1	1	0	0	1.000
A. Ziegler	13	1	4	0	0	0	0	2	.308	0	4	1	0	1.000
L. Fisher	3	0	1	0	0	0	0	0	.333	0	0	1	0	1.000
E. Risinger	2	0	1	0	0	0	0	0	.500	0	0	1	0	1.000
M. Earp	5	1	2	0	0	0	0	0	.000	0	0	0	0	1.000
Totals	105	13	25	2	0	1	0	11	.238	3	30	10	1	.968

NOTE: No fielding statistics available for Game 1 and Game 3.

2nd Round (Best of seven)

South Bend vs. Rockford
Game 1: Rockford 5, South Bend 1
Game 2: Rockford 2, South Bend 0
Game 3: Rockford 2, South Bend 1
Game 4: Rockford 2, South Bend 0
Rockford wins series 4 games to 0

Game 1: Rockford 5, South Bend 1

				R	H	E	DP
Rockford	003	110	000	5	5	2	0
South Bend	000	001	000	1	5	2	1

Winning Pitcher: H. Fox; *Losing Pitcher:* J. Faut. *Umpires:* Koehnlein, Platt and Schalk. A: 2,279. Time: 2:05.
Highlights: Backed by a 5-0 lead, Helen Fox held the Blue Sox to a run.

Game 2: Rockford 2, South Bend 0

				R	H	E	DP
Rockford	000	100	010	2	5	2	0
South Bend	000	000	000	0	2	1	0

> *Winning Pitcher:* L. Florreich; *Losing Pitcher:* R. Williams. *Umpires:* Platt, Schalk and Koehnlein. A: 2,966. Time: 2:40.
> *Highlights:* Lois Florreich shut out the Blue Sox on a two-hitter.

Game 3: Rockford 2, South Bend 1

				R	H	E	DP
South Bend	000	000	100	1	3	0	0
Rockford	000	020	00x	2	4	2	1

> *Winning Pitcher:* R. Gacioch; *Losing Pitcher:* L. Faralla. *Umpires:* Schalk, Koehnlein and Piet. A: 3,597. Time: 1:28.
> *Highlights:* Rose Gacioch held the Blue Sox to a run as Ruth Richard knocked in two runs with a triple.

Game 4: Rockford 2, South Bend 0

				R	H	E	DP
South Bend	000	000	000	0	2	1	1
Rockford	000	000	001	1	4	3	1

> *Winning Pitcher:* L. Erickson; *Losing Pitcher:* J. Faut. *Umpires:* Koehnlein, Piet and Schalk. A: 4,185. Time: 1:33.
> *Highlights:* Rockford scored on an error in the bottom of the ninth to end the series.

Composite Averages

South Bend Pitching Records

	IP	W	L	H	BB	SO	B	WP	HB	R	ER	ERA
L. Faralla	8	0	1	4	1	1	0	0	0	2	2	2.25
R. Williams	8	0	1	5	1	4	0	0	0	2	2	2.25
L. Arnold	5	0	0	0	1	1	0	0	0	0	0	0.00
J. Faut	14	0	2	9	5	3	0	0	0	6	4	2.58
Totals	35	0	4	18	8	9	0	0	0	10	8	2.06

South Bend Hitting Records

	AB	R	H	S	2B	3B	HR	RBI	Pct.	SB	PO	A	E	FA
B. Wagoner	14	0	3	0	0	0	0	0	.214	0	4	0	0	1.000
B. Baker	14	0	1	1	0	0	0	0	.071	1	8	11	1	.950
S. Wirth	13	1	1	0	0	0	0	0	.077	1	3	12	1	.938
N. Stoll	13	1	2	0	0	0	0	0	.154	1	7	0	0	1.000
E. Mahon	14	0	1	0	0	0	0	0	.071	1	8	0	0	1.000
B. Whiting	12	0	1	0	0	0	0	0	.083	1	52	1	3	.982
G. Vincent	0	0	0	0	0	0	0	0	.000	0	2	3	0	1.000
H. Filarski	5	0	0	0	0	0	0	0	.000	0	1	2	1	.750
J. Faut	7	0	1	0	1	0	0	0	.143	0	0	4	0	1.000
S. Stovroff	7	0	1	0	0	0	0	0	.143	0	14	7	0	1.000
L. Faralla	3	0	2	0	0	0	0	1	.667	0	2	6	0	1.000
R. Williams	3	0	0	0	0	0	0	0	.000	0	0	0	0	1.000
M. Callaghan	3	0	0	0	0	0	0	0	.000	0	2	7	0	1.000
L. Arnold	1	0	0	0	0	0	0	0	.000	0	0	0	0	1.000
W. Briggs	1	0	0	0	0	0	0	0	.000	0	0	0	0	1.000
G. Hasham	0	0	0	0	0	0	0	1	.000	0	0	0	0	1.000
Totals	110	2	13	1	1	0	0	2	.118	0	103	53	6	.963

Rockford Pitching Records

	IP	W	L	H	BB	SO	B	WP	HB	R	ER	ERA
R. Gacioch	7	1	0	3	5	1	0	0	0	1	1	1.29
H. Fox	11	1	0	5	5	4	0	0	0	1	1	0.82
L. Florreich	9	1	0	2	6	2	0	0	0	0	0	0.00
L. Erickson	9	1	0	2	2	0	0	0	2	0	0	0.00
Totals	36	4	0	12	18	7	0	0	2	2	2	0.50

Rockford Hitting Records

	AB	R	H	S	2B	3B	HR	RBI	Pct.	SB	PO	A	E	FA
D. Kamenshek	12	1	0	0	0	0	0	1	.000	0	41	1	0	1.000
D. Key	14	2	1	0	0	0	0	1	.071	0	6	0	0	1.000
D. Doyle	13	0	2	0	0	0	0	0	.154	1	14	10	3	.890
E. Callow	13	1	3	1	1	0	0	1	.231	1	9	0	0	1.000
R. Gacioch	1	0	0	1	0	0	0	0	.000	0	0	3	0	1.000
H. Fox	5	1	1	0	0	0	0	1	.200	0	0	2	0	1.000
A. Pollitt	14	1	5	0	2	0	0	1	.357	0	3	10	1	.929
C. Barnett	12	2	2	0	0	0	0	1	.167	0	10	5	0	1.000
R. Richard	13	0	1	0	0	0	0	2	.077	0	15	5	2	.909
M. Alspaugh	14	1	3	1	0	0	0	0	.214	0	5	2	0	1.000
L. Florreich	2	1	0	0	0	0	0	0	.000	0	1	2	1	.750
L. Erickson	3	0	0	0	0	0	0	0	.000	0	1	3	0	.750
Totals	113	10	18	3	3	0	0	8	.159	2	105	43	7	.955

Final Round (Best of five)

Grand Rapids vs. Rockford
Game 1: Grand Rapids 8, Rockford 2
Game 2: Rockford 7, Grand Rapids 1
Game 3: Rockford 5, Grand Rapids 2
Game 4: Rockford 2, Grand Rapids 2
Rockford wins championship 3 games to 1

Game 1: Grand Rapids 8, Rockford 2

				R	H	E	DP
Rockford	020	000	000	2	8	4	0
Grand Rapids	004	020	20x	8	6	0	1

Winning Pitcher: A. Ziegler; *Losing Pitcher:* L. Florreich. A: 2,032. Time: 1:45.
Highlights: Connie Wisniewski cleared the bases with a double to knock in three runs, which was all the Chicks needed for the win.

Game 2: Rockford 7, Grand Rapids 1

				R	H	E	DP
Rockford	103	102	000	7	9	2	0
Grand Rapids	000	001	000	1	5	3	0

Winning Pitcher: H. Fox; *Losing Pitcher:* L. Fisher. A: 2,316. Time: 1:50.
Highlights: Snookie Doyle hit three singles to knock in three runs, while Nicky Fox held the Peaches to a single run.

Game 3: Rockford 5, Grand Rapids 2

				R	H	E	DP
Grand Rapids	000	000	020	2	6	3	1
Rockford	000	032	00x	5	7	2	2

Winning Pitcher: L. Erickson; *Losing Pitcher:* M. Earp. *Umpires:* Koehnlein, Piet, Ward and Ringenberg. A: 2,579. Time: 1:19.

Game 4: Rockford 2, Grand Rapids 1

				R	H	E	DP
Grand Rapids	010	000	000	1	4	4	0
Rockford	001	000	001	2	9	2	1

Winning Pitcher: R. Gacioch; *Losing Pitcher:* A. Ziegler. *Umpires:* Piet, Ward, Ringenberg and Koehnlein. A: 1,581. Time: 1:36.

Highlights: Dottie Key's game-winning RBI in the bottom of the ninth won the game and series for the Peaches. Rose Gacioch allowed only one run by the Chicks for her second win of the series.

Composite Averages

Grand Rapids Pitching Records

	IP	W	L	H	BB	SO	B	WP	HB	R	ER	ERA
A. Ziegler	18	1	1	17	4	1	0	0	0	4	3	1.50
L. Fisher	4	0	1	5	5	3	0	3	0	5	3	6.76
J. Bittner	4	0	0	3	3	2	0	0	0	2	1	2.27
A. Haylett	2	0	0	1	0	1	0	0	0	0	0	0.00
M. Earp	7	0	1	7	2	1	0	0	0	5	4	5.15
Totals	35	1	3	33	14	8	0	3	0	16	11	2.84

Grand Rapids Hitting Records

	AB	R	H	S	2B	3B	HR	RBI	Pct.	SB	PO	A	E	FA
D. Reid	13	1	2	0	0	0	0	1	.154	0	2	0	2	.500
A. Ziegler	13	3	2	0	0	0	0	0	.154	1	8	18	1	.963
C. Wisniewski	16	3	4	0	1	0	0	3	.250	1	4	0	0	1.000
I. Voyce	14	2	4	0	0	0	0	0	.286	0	47	1	2	.960
D. Satterfield	14	2	6	1	0	1	0	4	.429	0	12	3	2	.882
P. Paire	10	0	1	0	0	0	0	1	.100	0	4	6	2	.833
R. Lessing	12	1	1	0	0	0	0	0	.083	0	17	2	0	1.000
C. Smith	12	0	3	0	0	0	0	0	.250	0	6	9	0	1.000
M. Beschoner	6	0	0	1	0	0	0	0	.000	0	4	0	0	1.000
L. Fisher	2	0	0	0	0	0	0	0	.000	0	0	1	1	.500
A. Haylett	2	0	0	0	0	0	0	0	.000	0	0	1	0	1.000
M. Earp	2	0	0	0	0	0	0	0	.000	0	0	3	1	.750
Totals	116	12	23	2	1	1	0	9	.198	2	104	44	11	.938

Rockford Pitching Records

	IP	W	L	H	BB	SO	B	WP	HB	R	ER	ERA
L. Florreich	5	0	1	3	6	6	0	0	0	6	5	9.01
R. Gacioch	11	1	0	7	4	3	0	1	0	3	2	1.64
A. Applegren	1	0	0	0	1	2	0	0	0	0	0	0.00
H. Fox	9	1	0	5	8	4	0	0	1	1	0	0.00
L. Erickson	9	1	0	6	2	1	0	0	0	2	2	2.00
Totals	35	3	1	21	21	16	0	1	1	12	9	2.32

Rockford Hitting Records

	AB	R	H	S	2B	3B	HR	RBI	Pct.	SB	PO	A	E	FA
D. Kamenshek	12	2	2	1	0	0	0	1	.167	2	45	0	0	1.000
D. Key	14	4	4	2	0	0	0	3	.286	5	7	1	2	.700
C. Doyle	17	1	4	0	0	0	0	3	.235	0	9	10	3	.864

	AB	R	H	S	2B	3B	HR	RBI	Pct.	SB	PO	A	E	FA
E. Callow	16	2	6	0	0	0	0	1	.375	0	5	1	0	1.000
A. Pollitt	17	1	4	0	0	0	0	1	.235	0	2	9	1	.917
C. Barnett	15	0	4	1	0	0	0	0	.267	0	10	6	1	.941
R. Richard	16	2	3	0	0	0	0	3	.186	0	19	5	2	.923
L. Florreich	1	0	0	0	0	0	0	0	.000	0	0	0	0	1.000
R. Gacioch	1	0	0	0	0	0	0	0	.000	0	2	3	1	1.000
M. Alspaugh	11	2	3	0	2	0	0	1	.273	1	4	0	0	1.000
J. Kelley	1	0	0	0	0	0	0	0	.000	0	0	0	0	1.000
H. Fox	5	0	1	0	0	0	0	0	.200	0	1	2	0	1.000
L. Erickson	3	1	0	0	0	0	0	0	.000	0	0	5	0	1.000
A. Applegren	0	0	0	0	0	0	0	0	.000	0	0	1	0	1.000
Totals	129	15	31	4	2	0	0	13	.240	8	104	53	10	.940

1950 CHAMPIONSHIP PLAYOFFS

The league returned to the Shaughnessy Playoff format with the top four teams going to the postseason. In the first round best-of-five series, first place Rockford faced third place Kenosha and second place Fort Wayne played fourth place Grand Rapids. No surprises occurred as Rockford and Fort Wayne beat their opponents in four games. After losing the first game, Rockford pitchers held Kenosha to five runs over three games. The Peaches' Dorothy Doyle hit .500 and added two triples during the series. Fort Wayne was led by Dottie Collins, who gave up a total of three runs in two games to earn two victories. She was helped by Thelma Eisen's .500 batting average.

In the final best-of-seven series, Rockford and Fort Wayne battled like two heavyweights going the full 15 rounds. After some close games early, the last two contests were blowouts with Fort Wayne winning the sixth game 8–0, and Rockford taking the finale 11–0 to win the championship. Had it not been for Helen Fox, the Peaches would have likely lost to the Daisies. Fox won three games, including a shutout in Game 7 for the championship. The best hitter for the Peaches was Dottie Kamenshek with a .440 average.

1st Round (Best of five)

Grand Rapids vs. Fort Wayne
Game 1: Fort Wayne 4, Grand Rapids 0
Game 2: Grand Rapids 4, Fort Wayne 3
Game 3: Fort Wayne 6, Grand Rapids 5
Game 4: Fort Wayne 14, Grand Rapids 3
Fort Wayne wins series 3 games to 1

Game 1: Fort Wayne 4, Grand Rapids 0

				R	H	E	DP
Grand Rapids	000	000	000	0	6	1	1
Fort Wayne	000	200	02x	4	9	1	1

Winning Pitcher: D. Collins; *Losing Pitcher:* M. Earp. *Umpires:* Ward, Ringenberg and Van Eennenaam. Time: 2:05.
Highlights: Dottie Collins scattered six hits in shutting out the Chicks.

Members of the 1950 Rockford Peaches playoff championship team were (front row from left) Marilyn Jones, Dorothy Key, Amy Applegren, Ruth Richard, Charlene Barnett, Rose Gacoich, Helen Fox, (second row from left) Marie Mansfield, Eleanor Callow, Helen Waddell, Edna Scheer, Dottie Kamenshek, Alice Pollitt, Lois Florreich, Lou Erickson, Jackie Kelley, Dottie Ferguson, Chaperone Dottie Green and Business Manager Mr. Laudahl.

Game 2: Grand Rapids 4, Fort Wayne 3

				10	11	R	H	E	DP
Grand Rapids	300	000	000	0	1	4	8	0	2
Fort Wayne	020	100	000	0	0	3	6	5	1

Winning Pitcher: E. Risinger; *Losing Pitcher:* M. Kline. *Umpires:* Van Eennenaam, Ward and Ringenberg. Time: 2:09.
Highlights: The Chicks scored two unearned runs on five Daisy errors to over come Fort Wayne and even the series.

Game 3: Fort Wayne 6, Grand Rapids 5

				R	H	E	DP
Fort Wayne	000	130	110	6	9	3	1
Grand Rapids	000	020	003	5	3	5	0

Winning Pitcher: M. Deegan; *Losing Pitcher:* A. Ziegler
Highlights: Betty Foss hit a home run and knocked in two runs to lead the Daisies to a close win.

Game 4: Fort Wayne 14, Grand Rapids 3

				R	H	E	DP
Fort Wayne	150	023	200	14	14	1	0
Grand Rapids	300	000	000	3	4	3	1

Winning Pitcher: D. Collins; Losing Pitcher E. Risinger.
Highlights: The Daisies scored a series record 14 runs in routing the Chicks and taking the series. Dottie Collins earned her second victory of the series.

Grand Rapids Pitching Records

	IP	W	L	H	BB	SO	B	WP	HB	R	ER	ERA
M. Earp	13	0	1	13	7	3	0	0	0	9	9	6.25
M. Silvestri	7	0	0	5	9	1	0	0	2	3	3	3.86
E. Risinger	8	1	1	7	8	5	0	0	0	6	5	5.63
A. Ziegler	9	0	1	9	6	5	0	0	0	6	5	5.00
Totals	37	1	3	34	30	14	0	0	2	24	22	5.35

Grand Rapids Hitting Records

	AB	R	H	S	2B	3B	HR	RBI	Pct.	SB	PO	A	E	FA
D. Reid	15	4	6	1	0	0	0	0	.400	2	4	0	1	.800
M. Wegman	13	1	2	3	0	0	0	1	.154	1	4	5	1	.900
D. Satterfield	17	2	3	0	1	0	0	2	.176	0	6	0	2	.750
I. Voyce	14	1	1	0	0	0	0	2	.071	2	31	1	0	1.000
L. Paire	14	1	2	1	0	0	0	0	.143	0	19	1	0	1.000
M. Olinger	15	0	2	0	0	0	0	1	.133	0	5	7	1	.923
J. Holderness	15	0	1	0	0	0	0	0	.067	0	4	1	0	1.000
A. Ziegler	14	1	2	1	0	0	0	0	.143	0	8	7	1	.938
M. Earp	5	0	0	0	0	0	0	0	.000	0	1	5	0	1.000
M. Redman	4	1	1	0	0	0	0	0	.250	0	1	8	0	1.000
M. Silvestri	5	0	0	0	0	0	0	0	.000	0	0	3	0	1.000
E. Risinger	2	1	0	0	0	0	0	0	.000	0	1	2	0	1.000
D. Niemic	0	1	0	0	0	0	0	0	.000	0	0	0	0	1.000
Totals	133	13	20	6	1	0	0	6	.150	0	84	40	6	.954

Fort Wayne Pitching Records

	IP	W	L	H	BB	SO	B	WP	HB	R	ER	ERA
D. Collins	18	2	0	9	7	11	0	0	1	3	1	0.50
M. Kline	10	0	1	8	3	2	0	0	0	4	2	1.80
M. Deegan	9	1	0	3	8	0	0	0	0	5	3	3.00
Totals	37	3	1	20	18	13	0	0	1	12	6	1.94

Fort Wayne Hitting Records

	AB	R	H	S	2B	3B	HR	RBI	Pct.	SB	PO	A	E	FA
T. Eisen	14	3	7	1	2	0	0	2	.500	6	4	0	0	1.000
W. Briggs	13	5	3	1	0	0	0	1	.231	0	10	2	1	.923
E. Wawryshyn	18	2	2	1	1	0	0	2	.111	0	5	10	0	1.000
B. Foss	13	5	5	0	0	0	1	2	.385	3	2	7	0	1.000
N. Meier	14	1	4	1	0	0	0	4	.286	1	6	0	0	1.000
D. Schroeder	14	3	2	0	2	0	0	4	.143	0	9	11	5	.800
V. Kellogg	17	0	4	0	0	0	0	3	.235	0	38	1	0	1.000
K. Vonderau	8	2	1	2	0	0	0	2	.125	1	9	4	1	.929
D. Collins	7	4	1	0	0	0	0	1	.143	0	0	4	0	1.000
M. Kline	4	0	1	0	0	0	0	0	.250	0	2	7	1	.900
M. Deegan	3	1	1	0	0	0	0	0	.333	0	2	1	1	.750
H. Ketola	0	0	0	0	0	0	0	0	.000	0	0	0	0	1.000
R. Matlack	1	0	1	0	0	0	0	0	1.000	0	0	0	0	1.000
M. Rountree	5	1	1	0	0	0	0	0	.200	0	0	0	0	1.000
Totals	131	27	33	6	5	0	1	21	.252	0	87	47	9	.937

NOTE: No fielding statistics for Game 4.

1st Round (Best of five)

Rockford vs. Kenosha
Game 1: Kenosha 5, Rockford 1
Game 2: Rockford 5, Kenosha 2
Game 3: Rockford 8, Kenosha 3
Game 4: Rockford 5, Kenosha 1
Rockford wins series 3 games to 1

Game 1: Kenosha 5, Rockford 1

				R	H	E	DP
Kenosha	000	004	001	5	9	0	0
Rockford	100	000	000	1	4	2	1

Winning Pitcher: R. Gacioch; *Losing Pitcher:* J. Cione. *Umpires:* Piet, Schalk and Barteil. Time: 1:31. A: 1,309.
Highlights: Jean Cione tripled in three runs and held the Peaches to a run to do it all for the Comets.

Game 2: Rockford 5, Kenosha 2

				R	H	E	DP
Kenosha	000	100	001	2	5	1	0
Rockford	000	001	40x	5	11	3	0

Winning Pitcher: H. Fox; *Losing Pitcher:* R. Stephens. *Umpires:* Shalk, Barteil and Piet. Time: 1:48. A: 2,061.
Highlights: The game was close until the eighth inning when Marilyn Jones singled in two runs to seal the victory. Helen Fox scattered five hits for the win.

Game 3: Rockford 8, Kenosha 2

				R	H	E	DP
Rockford	001	016	000	8	13	2	3
Kenosha	100	002	000	3	4	1	1

Winning Pitcher: L. Erickson; *Losing Pitcher:* J. Marlowe. *Umpires:* Barteil, Piet and Schalk. Time: 2:18. A: 1,909.
Highlights: Rockford exploded for eight runs and Louise Erickson cruised to an easy win.

Game 4: Rockford 5, Kenosha 1

				R	H	E	DP
Rockford	000	103	100	5	4	1	1
Kenosha	010	000	000	1	6	2	1

Winning Pitcher: L. Florreich; *Losing Pitcher:* J. Cione. Time: 1:40. A: 1,011.
Highlights: Charlene Barnett tripled in the winning runs for the Peaches, and Lois Florreich held the Comets to a single run.

Kenosha Pitching Records

	IP	W	L	H	BB	SO	B	WP	HB	R	ER	ERA
J. Cione	9	1	0	4	2	3	0	0	0	1	1	1.00
R. Stephens	11	0	1	11	5	1	1	0	1	5	5	4.10
J. Marlowe	5	0	1	9	1	1	0	0	1	6	6	10.81
D. Naum	4	0	0	5	3	0	0	0	0	2	2	4.50
J. Cione	7	0	1	4	7	2	0	0	0	5	4	5.19
Totals	36	1	3	33	18	7	1	0	2	19	18	4.50

Kenosha Hitting Records

	AB	R	H	S	2B	3B	HR	RBI	Pct.	SB	PO	A	E	FA
E. Petras	15	2	4	0	1	0	0	1	.267	0	10	3	0	1.000
F. Shollenberger	15	2	3	0	0	0	0	1	.200	0	7	8	1	.938
J. Lenard	13	1	1	1	0	0	0	0	.077	0	13	1	0	1.000
M. Villa	14	1	0	0	0	0	0	1	.000	0	3	12	0	1.000
J. Cione	16	1	3	0	0	1	0	4	.188	0	4	8	1	.923
D. Brumfield	13	1	2	0	0	1	0	0	.154	2	51	2	0	1.000
J. Gutz	13	2	5	0	0	0	0	2	.385	0	14	2	0	1.000
D. Naum	8	0	3	0	0	0	0	0	.375	1	2	2	0	1.000
J. Marlowe	2	0	0	0	0	0	0	0	.000	0	0	3	0	1.000
J. Buckley	10	1	4	0	0	1	0	1	.400	0	6	1	0	1.000
R. Stephens	3	0	0	0	0	0	0	0	.000	0	0	5	1	.833
M. Bevis	2	0	0	0	0	0	0	0	.000	0	0	0	0	1.000
Totals	122	11	25	1	1	3	0	10	.205	0	110	47	3	.981

Rockford Pitching Records

	IP	W	L	H	BB	SO	B	WP	HB	R	ER	ERA
R. Gacioch	9	0	1	9	2	0	0	0	0	5	5	5.00
H. Fox	9	1	0	5	4	4	0	1	0	2	1	1.00
L. Erickson	9	1	0	4	4	2	0	0	0	3	3	3.00
L. Florreich	9	1	0	6	2	4	0	0	2	1	1	1.00
Totals	36	3	1	24	12	10	0	1	2	11	10	2.50

Rockford Hitting Records

	AB	R	H	S	2B	3B	HR	RBI	Pct.	SB	PO	A	E	FA
D. Kamenshek	15	4	2	0	0	0	0	1	.133	1	49	2	1	.981
D. Doyle	16	2	8	3	0	2	0	4	.500	1	7	14	5	.808
L. Florreich	3	0	1	0	0	0	0	0	.333	1	0	0	0	1.000
J. Kelley	11	2	1	0	0	0	0	1	.091	0	6	16	0	1.000
R. Gacioch	14	3	3	0	0	0	0	2	.214	0	4	1	0	1.000
C. Barnett	11	2	5	2	0	0	0	3	.455	0	10	8	2	.900
E. Callow	13	1	1	0	1	0	0	1	.077	0	8	0	1	.890
M. Jones	15	1	4	0	1	0	0	4	.267	0	12	4	0	1.000
H. Fox	3	0	2	0	0	0	0	0	.666	0	0	6	0	1.000
D. Key	13	3	3	0	0	0	0	0	.231	2	8	0	0	1.000
L. Erickson	5	1	2	0	0	0	0	1	.400	0	0	4	0	1.000
L. Florreich	4	0	0	0	0	0	0	0	.000	0	2	2	0	1.000
Totals	123	19	32	5	2	2	0	17	.260	0	106	57	9	.948

Final Round (Best of seven)

Game 1: Rockford 3, Fort Wayne 1
Game 2: Rockford 7, Fort Wayne 2
Game 3: Fort Wayne 7, Rockford 3
Game 4: Fort Wayne 5, Rockford 3
Game 5: Rockford 4, Fort Wayne 3
Game 6: Fort Wayne 8, Rockford 0
Game 7: Rockford 11, Fort Wayne 0
Rockford wins championship 4 games to 3

Game 1: Rockford 3, Fort Wayne 1

				R	H	E	DP
Fort Wayne	100	000	000	1	4	1	1
Rockford	001	010	01x	3	15	1	0

Winning Pitcher: H. Fox; *Losing Pitcher* M. Kline. *Umpires:* Ward, Piet, Ringenberger and Schalk. Time: 1:31. A: 2,598.

Highlights: Helen Fox limited Fort Wayne to a run, while her team knocked out 15 hits, yet scored only three runs.

Game 2: Rockford 7, Fort Wayne 2

				R	H	E	DP
Fort Wayne	101	000	000	2	5	2	2
Rockford	070	000	000	7	9	1	0

Winning Pitcher: L. Erickson; *Losing Pitcher:* M. Deegan. *Umpires:* Piet, Ringenberger, Schalk and Ward. Time: 1:45. A: 2,397.

Highlights: The Peaches decided the game in the second inning with a seven-run outburst, and Louis Erickson limited the Daisies to two runs.

Game 3: Fort Wayne 7, Rockford 3

				R	H	E	DP
Rockford	000	030	0	3	3	2	1
Fort Wayne	010	410	1	7	7	1	2

Winning Pitcher: D. Collins; *Losing Pitcher:* L. Florreich.

Highlights: The Daisies led the rain-shortened game the whole way as Dottie Collins had only one poor inning where she allowed three runs.

Game 4: Fort Wayne 5, Rockford 3

				R	H	E	DP
Rockford	100	020	000	3	3	1	0
Fort Wayne	000	002	30x	5	5	0	1

Winning Pitcher: M. Kline; *Losing Pitcher:* H. Fox. A: 1,200.

Highlights: Sally Meier's double scored three runs and was the blow that beat the Peaches.

Game 5: Rockford 4, Fort Wayne 3

				R	H	E	DP
Rockford	002	000	000	2	4	4	1
Fort Wayne	000	011	000	1	3	3	0

Winning Pitcher: H. Fox; *Losing Pitcher:* D. Collins. A: 1,800.

Highlights: Snookie Doyle stole home on a double steal to give the Peaches the slim victory.

Game 6: Fort Wayne 8, Rockford 0

				R	H	E	DP
Fort Wayne	104	010	002	8	9	4	1
Rockford	000	000	000	0	8	1	0

Winning Pitcher: M. Kline; *Losing Pitcher:* L. Erickson. *Umpires:* Piet, Ringenberger, Schalk and Ward. Time: 1:34. A: 3,383.

Highlights: Maxine Kline gave up eight hits but no runs as her teammates scored eight runs to tie up the series.

Game 7: Rockford 11, Fort Wayne 0

				R	H	E	DP
Fort Wayne	000	000	000	0	11	4	1
Rockford	221	401	01x	11	11	1	0

Winning Pitcher: H. Fox; *Losing Pitcher:* M. Deegan. *Umpires:* Ringenberg, Schalk, Ward and Piet. Time: 1:45. A: 3,233.

Highlights: Dottie Kamenshek homer, tripled and scored five times to lead the Peaches, while Helen Fox allowed 11 hits but no runs to win the series.

Fort Wayne Pitching Records

	IP	W	L	H	BB	SO	B	WP	HB	R	ER	ERA
M. Kline	26	2	1	28	3	8	0	0	0	6	6	2.14
M. Deegan	8	0	2	15	7	0	0	0	2	13	12	13.64
F. Janssen	11	0	0	7	2	2	0	0	1	3	2	1.67
D. Collins	15	1	1	11	8	4	0	1	1	9	6	3.60
Totals	60	3	4	61	20	14	0	1	4	32	26	3.90

Fort Wayne Hitting Records

	AB	R	H	S	2B	3B	HR	RBI	Pct.	SB	PO	A	E	FA
T. Eisen	27	3	4	1	0	1	0	0	.148	6	6	1	0	1.000
W. Briggs	27	6	9	1	0	0	0	1	.333	1	6	1	0	1.000
E. Wawryshyn	25	5	13	3	3	0	0	3	.520	4	6	6	2	.857
B. Foss	26	5	10	0	4	0	1	6	.385	3	7	5	4	.750
N. Meier	27	0	8	1	2	0	0	3	.296	1	9	1	1	.909
D. Schroeder	14	3	3	0	1	0	0	1	.214	2	5	8	1	.929
V. Kellogg	26	1	7	0	2	0	0	0	.182	0	41	8	1	.980
K. Vonderau	16	0	2	0	1	0	0	0	.125	0	4	1	0	1.000
M. Rountree	5	0	0	0	0	0	0	0	.000	0	2	0	0	1.000
M. Deegan	2	1	0	0	0	0	0	0	.000	0	1	1	0	1.000
D. Collins	5	0	0	0	0	0	0	1	.000	0	0	2	0	1.000
M. Kline	9	2	1	0	0	0	0	0	.111	0	4	4	0	1.000
F. Janssen	5	0	0	0	0	0	0	0	.000	0	1	1	0	1.000
R. Matlack	2	0	0	0	0	0	0	0	.000	0	0	0	0	1.000
D. Tetzlaff	2	0	0	0	0	0	0	0	.000	1	0	1	0	1.000
H. Ketola	5	1	1	0	0	0	0	0	.200	0	1	5	2	.750
Totals	223	26	56	6	13	1	1	15	.251	18	93	45	11	.926

Rockford Pitcher Records

	IP	W	L	H	BB	SO	B	WP	HB	R	ER	ERA
H. Fox	31	3	1	21	7	6	0	0	1	7	4	1.16
L. Erickson	18	1	1	14	8	6	0	0	0	10	5	2.50
L. Florreich	5	0	1	6	4	2	0	0	0	6	4	7.27
A. Applegren	2	0	0	1	1	0	0	0	1	1	1	4.55
R. Gacioch	5	0	0	3	3	4	0	0	0	2	2	3.64
Totals	61	4	3	45	23	18	0	0	2	26	16	2.36

Rockford Hitting Records

	AB	R	H	S	2B	3B	HR	RBI	Pct.	SB	PO	A	E	FA
D. Kamenshek	25	9	11	2	0	1	1	3	.440	1	49	0	0	1.000
D. Doyle	29	3	8	2	1	0	0	5	.276	2	11	10	1	.955
J. Kelley	26	0	5	0	0	0	0	8	.192	2	7	11	0	1.000
R. Gacioch	21	2	8	0	1	0	0	3	.381	1	8	1	1	.900
C. Barnett	22	2	4	2	0	0	0	1	.182	0	8	12	0	1.000
E. Callow	25	5	8	0	2	0	0	2	.320	0	8	0	0	1.000
M. Jones	22	3	5	2	0	0	0	1	.227	2	13	3	1	.933
D. Key	22	4	7	1	0	1	0	3	.318	1	4	1	0	1.000
M. Mansfield	2	0	0	0	0	0	0	0	.000	0	0	0	0	1.000
L. Florriech	2	0	1	0	1	0	0	2	.500	0	0	0	0	1.000
H. Fox	12	2	4	0	0	0	0	0	.250	0	1	4	0	1.000
L. Erickson	6	1	0	0	0	0	0	1	.000	0	0	4	1	.800
A. Applegren	5	0	1	0	0	0	0	0	.200	0	0	0	0	1.000

	AB	R	H	S	2B	3B	HR	RBI	Pct.	SB	PO	A	E	FA
Totals	219	31	61	9	5	2	1	27	.278	0	109	46	4	.975

NOTE: No fielding statistics available for Game 3, 4 and 5

1951 Shaughnessy Playoffs

In the first round of the best-of-three series, first place South Bend took on third place Fort Wayne, while second place Grand Rapids faced fourth place Rockford. Jean Faut stopped Fort Wayne by allowing only one run in two games to give the Blue Sox the 2-1 series win. Betty Wagoner hit .667 for the Blue Sox. Rockford swept the favored Grand Rapids team, as Helen Fox threw a shutout and the Peaches won the other game in extra innings. Dottie Kamenshek and Eleanor Callow led the hit parade for Rockford.

Rockford gave South Bend a little trouble in the final best-of-seven series, but the Blue Sox proved they were the best team in the league by winning the series three games to two. Faut continued her winning ways and walked away with two victories. The Blue Sox got balanced hitting from many players who hit .275 in the series.

1st Round (Best of three)

Grand Rapids vs. Rockford
Game 1: Rockford 5, Grand Rapids 0
Game 2: Rockford 7, Grand Rapids 6
Rockford wins series 2 games to 0

Game 1: Rockford 5, Grand Rapids 0

				R	H	E	DP
Rockford	102	010	010	5	9	1	1
Grand Rapids	000	000	000	0	6	0	0

Winning Pitcher: H. Fox; *Losing Pitcher:* M. Silvestri. *Umpires:* Schalk and Block. Time: 1:55. *Highlights:* Helen Fox scattered six hits in shutting out the Chicks.

Game 2: Rockford 7, Grand Rapids 6

							R	H	E	DP
Grand Rapids	000	101	002	2	0	0	6	10	4	1
Rockford	000	000	130	2	0	1	7	11	2	1

Winning Pitcher: M. Mansfield; *Losing Pitcher:* A. Ziegler. *Umpires:* Bender and Barteil. A: 2,041. *Highlights:* Dottie Kamenshek rallied the Peaches to a comeback tie in the 10th inning, then caused Marie Mansfield to balk when she tried scoring in the 12th inning for the win.

Grand Rapids Pitching Records

	IP	W	L	H	BB	SO	B	WP	HB	R	ER	ERA
M. Silvestri	9	0	1	9	5	8	0	1	0	5	5	5.00
A. Ziegler	12	0	1	11	3	5	0	0	0	7	5	3.76
Totals	21	0	2	20	8	13	0	1	0	12	10	4.29

Grand Rapids Hitting Records

	AB	R	H	S	2B	3B	HR	RBI	Pct.	SB	PO	A	E	FA
M. Olinger	11	1	1	0	0	1	0	0	.091	0	4	5	0	1.000
C. Wisniewski	9	1	2	0	0	0	0	0	.222	0	0	0	0	1.000

	AB	R	H	S	2B	3B	HR	RBI	Pct.	SB	PO	A	E	FA
D. Satterfield	7	2	2	1	0	0	0	0	.286	1	2	1	0	1.000
I. Voyce	9	1	3	0	0	0	0	0	.333	0	30	0	0	1.000
L. Paire	7	0	2	0	0	0	0	0	.286	0	14	3	0	1.000
R. Youngberg	9	0	2	0	1	0	0	1	.444	0	3	6	1	.900
A. Ziegler	6	0	2	0	0	0	0	1	.333	0	5	11	1	.941
D. Reid	7	0	0	0	0	0	0	0	.000	0	1	0	0	1.000
M. Silvestri	7	1	2	0	0	0	0	0	.286	0	1	6	0	1.000
M. Redman	5	0	1	1	0	0	0	1	.200	0	2	4	0	1.000
Totals	77	6	17	2	1	1	0	3	.221	0	62	36	2	.980

Rockford Pitching Records

	IP	W	L	H	BB	SO	B	WP	HB	R	ER	ERA
H. Fox	9	1	0	6	5	1	0	0	0	0	0	0.00
R. Gacioch	9	0	0	7	6	2	0	0	0	6	3	3.00
M. Mansfield	3	1	0	3	0	2	0	0	0	0	0	0.00
Totals	21	2	0	16	11	5	0	0	0	6	3	1.29

Rockford Hitting Records

	AB	R	H	S	2B	3B	HR	RBI	Pct.	SB	PO	A	E	FA
D. Kamenshek	7	3	4	0	0	0	0	0	.571	2	26	0	0	1.000
A. Pollitt	10	4	3	1	0	0	0	0	.300	0	6	6	3	.800
R. Richard	10	2	3	1	0	1	0	1	.300	1	7	3	0	1.000
E. Callow	6	1	4	1	0	1	0	4	.667	1	8	0	0	1.000
J. Kelley	9	2	1	0	0	1	0	2	.111	1	2	6	0	1.000
N. Berger	8	0	3	2	1	0	0	3	.125	0	2	4	2	.750
B. Payne	5	0	0	0	0	0	0	0	.000	0	6	6	0	1.000
H. Fox	3	0	0	1	0	0	0	0	.000	0	0	0	0	1.000
D. Key	8	0	1	1	0	0	0	0	.000	0	4	0	0	1.000
A. Applegren	1	0	0	0	0	0	0	0	.000	0	2	0	0	1.000
R. Gacioch	4	0	1	0	0	0	0	0	.250	0	0	5	0	1.000
M. Mansfield	1	0	0	0	0	0	0	0	.000	0	0	3	0	1.000
Totals	71	12	20	7	1	3	0	10	.282	5	63	33	5	.951

1st Round (Best of three)

Fort Wayne vs. South Bend
Game 1: South Bend 2, Fort Wayne 1
Game 2: Fort Wayne 9, South Bend 1
Game 3: South Bend 2, Fort Wayne 1
South Bend wins series 2 games to 1

Game 1: South Bend 2, Fort Wayne 1

				R	H	E	DP
Fort Wayne	000	001	000	1	6	1	1
South Bend	010	010	00x	2	9	1	0

Winning Pitcher: J. Faut; Losing Pitcher M. Kline. *Umpires:* Gembler, Zoss and Sears. Time: 1:55.

Highlights: Jean Faut knocked in a run and held the Daisies to a run in winning the first game for the Blue Sox.

Game 2: Fort Wayne 9, South Bend 1

				R	H	E	DP
South Bend	100	000	000	1	5	6	1
Fort Wayne	300	040	11x	9	11	2	0

Winning Pitcher: P. Scott; *Losing Pitcher:* G. Vincent. *Umpires:* Koehnlein, Bender and Schalk. Time: 2:15.

Highlights: Dottie Schroeder knocked in three runs and Pat Scott held the Blue Sox to a single run to tie the series at a game apiece.

Game 3: South Bend 2, Fort Wayne 1

				R	H	E	DP	
South Bend	000	010	000	1	2	12	0	2
Fort Wayne	000	000	100	0	1	8	0	0

Winning Pitcher: J. Faut; *Losing Pitcher:* P. Scott. *Umpires:* Bender and Schalk. Time: 2:30.

Highlights: Jean Faut struck out nine and held the Daisies again to a single run to win her second game of the short series.

Fort Wayne Pitching Records

	IP	W	L	H	BB	SO	B	WP	HB	R	ER	ERA
M. Kline	16	0	1	15	4	3	0	0	0	3	3	1.69
N. Warren	2	0	0	2	3	1	0	0	0	1	1	4.50
P. Scott	9	1	1	5	9	2	0	0	0	1	1	1.00
Totals	27	1	2	22	16	6	0	0	0	5	5	1.66

Fort Wayne Hitting Records

	AB	R	H	S	2B	3B	HR	RBI	Pct.	SB	PO	A	E	FA
T. Eisen	10	4	3	1	1	0	0	0	.300	4	6	0	0	1.000
W. Briggs	10	1	3	1	1	0	0	1	.300	0	6	0	0	1.000
B. Foss	10	2	2	0	0	0	0	0	.200	0	21	2	0	1.000
Jo Weaver	10	1	5	1	0	0	0	3	.500	0	1	0	1	.500
Jean Weaver	9	2	3	3	1	0	0	1	.333	3	5	5	1	.909
E. Wawryshyn	9	1	2	2	0	0	0	0	.222	1	5	6	0	1.000
D. Schroeder	11	0	2	0	0	0	0	3	.182	1	4	10	1	.933
M. Rountree	8	0	1	1	0	0	0	0	.125	0	9	3	0	1.000
M. Kline	5	0	2	0	0	0	0	0	.400	0	0	5	0	1.000
N. Warren	0	0	0	0	0	0	0	0	.000	0	0	1	1	.500
P. Scott	5	0	1	0	0	0	0	0	.200	0	0	5	0	1.000
C. Horstman	2	0	1	0	1	0	0	1	.500	0	0	0	0	1.000
J. Giessinger	0	0	0	0	0	0	0	0	.000	0	0	0	0	1.000
Totals	89	11	25	9	4	0	0	9	.281	9	57	37	4	.959

South Bend Pitching Records

	IP	W	L	H	BB	SO	B	WP	HB	R	ER	ERA
J. Faut	18	2	0	14	7	15	0	1	0	2	2	1.00
G. Vincent	8	0	1	11	3	5	0	0	0	9	9	11.25
Totals	26	2	1	25	10	20	0	0	0	11	11	3.82

South Bend Hitting Records

	AB	R	H	S	2B	3B	HR	RBI	Pct.	SB	PO	A	E	FA
C. Pryer	8	1	4	0	1	0	0	0	.500	2	5	4	0	1.000
B. Wagoner	11	0	7	1	1	0	0	1	.636	0	4	0	0	1.000
S. Wirth	11	0	0	1	0	0	0	1	.000	0	6	5	1	.917
S. Stovroff	12	2	2	2	1	0	0	1	.167	0	14	3	2	.895
J. Stoll	8	0	1	2	0	0	0	0	.125	0	2	0	0	1.000
J. Faut	9	0	2	1	1	0	0	1	.222	0	0	8	1	.889
E. Mahon	12	1	4	0	1	0	0	0	.333	0	3	0	0	1.000
D. Mueller	8	0	1	1	0	0	0	1	.125	0	13	0	1	.929

	AB	R	H	S	2B	3B	HR	RBI	Pct.	SB	PO	A	E	FA
A. Bleiler	8	1	4	0	0	0	0	0	.500	0	1	1	0	1.000
J. Wiley	2	0	0	0	0	0	0	0	.000	0	5	0	0	1.000
G. Vincent	3	0	0	0	0	0	0	0	.000	0	0	4	3	.572
L. Faralla	1	0	0	0	0	0	0	0	.000	0	0	0	0	1.000
Totals	91	5	25	8	5	0	0	5	.275	2	53	17	5	.933

NOTE: No fielding statistics available for Game 1.

Final Round (Best of five)

South Bend vs. Rockford
Game 1: Rockford 5, South Bend 4
Game 2: Rockford 7, South Bend 1
Game 3: South Bend 3, Rockford 2
Game 4: South Bend 6, Rockford 3
Game 5: South Bend 10, Rockford 2
South Bend wins 3 games to 2

Game 1: Rockford 5, South Bend 4

				R	H	E	DP
South Bend	100	000	021	4	9	0	0
Rockford	000	001	40x	5	8	0	0

Winning Pitcher: H. Fox; *Losing Pitcher:* L. Faralla. Time: 1:35. A: 687
Highlights: Alice Pollitt knocked in two runs, and Rose Gacioch earned a save in giving the Peaches a close win over the Blue Sox.

Game 2: Rockford 7, South Bend 1

				R	H	E	DP
South Bend	000	100	000	1	6	3	0
Rockford	300	100	03x	7	9	1	0

Winning Pitcher: R. Gacioch; *Losing Pitcher:* S. Kidd. *Umpires:* Runser, Bender and Schalk. Time: 1:56. A: 1,083.
Highlights: Rose Gacioch homered and held the Blue Sox to a run to earn the win.

Game 3: South Bend 3, Rockford 2

				R	H	E	DP
Rockford	010	000	000	2	6	1	0
South Bend	003	000	00x	3	3	3	0

Winning Pitcher: J. Faut; *Losing Pitcher:* Mansfield. *Umpires:* Bender, Schalk and Sears. Time: 2:30. A: 1,905.
Highlights: The Blue Sox scored three unearned runs, and Jean Faut held the Peaches to two as the team narrowly survived a sweep of the series.

Game 4: South Bend 6, Rockford 3

			R	H	E	DP
Rockford	012	003	3	7	2	0
South Bend	002	103	6	11	2	0

Winning Pitcher: G. Vincent; *Losing Pitcher:* H. Fox. *Umpires:* Schalk, Bender and Sears. Time: 1:40. A: 1,500.
Highlights: The Blue Sox launched an 11-hit, six-run attack on the Peaches in a rain-shortened contest to tie up the series.

Game 5: South Bend 10, Rockford 2

				R	H	E	DP
Rockford	101	000	000	2	4	2	0
South Bend	511	100	02x	10	13	2	0

Winning Pitcher: J. Faut; *Losing Pitcher:* R. Gacioch. A: 2,268.
Highlights: Flu and a five-run outburst in the first inning doomed the Peaches. Jean Faut picked up the win in relief. The Blue Sox made one of the most remarkable comebacks in playoff history after being down 2 games to none. Seven players from the Peaches came down with the flu during the last three games of the playoffs. Dottie Kamenshek played the last series game with a temperature of 101.

Rockford Pitching Records

	IP	W	L	H	BB	SO	B	WP	HB	R	ER	ERA
H. Fox	15	1	1	20	7	6	0	0	1	10	7	4.22
R. Gacioch	17	1	1	10	10	6	0	0	1	11	7	3.72
M. Mansfield	8	0	1	3	13	4	0	1	0	3	0	0.00
Totals	40	2	3	33	30	16	0	1	2	24	14	3.15

Rockford Hitting Records

	AB	R	H	S	2B	3B	HR	RBI	Pct.	SB	PO	A	E	FA
D. Kamenshek	16	5	7	0	1	0	0	1	.438	2	49	2	0	1.000
A. Pollitt	20	3	5	0	2	0	0	3	.250	1	5	16	0	1.000
R. Richard	13	1	4	2	0	0	0	2	.308	0	16	6	2	.875
E. Callow	17	2	4	1	2	1	0	3	.235	1	8	0	0	1.000
J. Kelley	18	2	4	0	1	0	0	2	.222	1	8	7	3	.833
N. Berger	14	1	2	3	0	0	0	1	.143	0	11	13	0	1.000
A. Applegren	15	1	1	1	0	0	0	2	.067	1	4	0	1	.800
H. Fox	5	1	1	1	0	0	0	1	.200	0	0	5	0	1.000
D. Key	12	2	2	0	0	0	0	0	.167	0	11	0	0	1.000
R. Gacioch	8	1	2	0	0	0	0	1	.250	0	1	7	0	1.000
H. Waddell	3	0	1	0	0	0	0	0	.333	0	5	2	0	1.000
M. Mansfield	2	0	0	0	0	0	0	0	.000	0	0	4	0	1.000
Totals	143	19	33	8	6	1	0	16	.231	6	118	62	6	.968

South Bend Pitching Records

	IP	W	L	H	BB	SO	B	WP	HB	R	ER	ERA
L. Faralla	11	0	1	10	6	2	0	5	1	7	1	0.82
S. Kidd	1	0	1	3	2	1	0	0	0	3	3	27.27
L. Arnold	5	0	0	2	1	1	0	0	0	1	1	1.82
J. Rumsey	2	0	0	4	0	0	0	0	0	3	2	9.09
J. Faut	16	2	0	8	6	11	0	1	0	2	2	1.13
G. Vincent	6	1	0	7	0	3	0	1	0	3	3	4.50
Totals	41	3	2	34	9	18	0	7	1	19	12	2.64

South Bend Hitting Records

	AB	R	H	S	2B	3B	HR	RBI	Pct.	SB	PO	A	E	FA
C. Pryer	22	4	6	0	1	0	0	1	.273	2	16	13	3	.906
B. Wagoner	18	5	7	1	0	0	0	0	.389	0	4	0	0	1.000
S. Wirth	17	4	7	0	0	0	0	0	.412	0	6	9	1	.938
S. Stovroff	15	4	7	0	0	0	0	3	.467	2	27	3	0	1.000
N. Stoll	18	1	6	1	0	0	0	6	.333	1	4	1	1	.833
E. Mahon	13	3	3	0	1	0	0	2	.231	1	5	0	0	1.000
D. Mueller	11	1	1	0	0	0	0	0	.091	0	34	1	2	.946

	AB	*R*	*H*	*S*	*2B*	*3B*	*HR*	*RBI*	*Pct.*	*SB*	*PO*	*A*	*E*	*FA*
A. Bleiler	10	0	1	1	0	0	0	0	.100	0	4	11	0	1.000
L. Faralla	5	0	0	0	0	0	0	0	.000	0	0	7	0	1.000
J. Faut	10	1	3	0	1	0	0	2	.300	0	4	6	1	.909
L. Arnold	2	0	0	0	0	0	0	0	.000	0	0	4	0	1.000
G. Vincent	3	1	0	0	0	0	0	0	.000	0	0	3	0	1.000
J. Wiley	5	0	0	2	0	0	0	1	.000	0	8	3	0	1.000
S. Kidd	0	0	0	0	0	0	0	0	.000	0	0	1	0	1.000
Totals	149	24	41	5	3	0	0	15	.275	6	112	62	8	.956

1952 CHAMPIONSHIP PLAYOFFS

First place Fort Wayne faced third place Rockford in the best-of-three first round, while second place South Bend played fourth place Grand Rapids. After winning the first game in extra innings, Fort Wayne lost the next two games to get eliminated in the first round. Rockford outhit the stronger Daisies and shut them out in the last game. Meanwhile, South Bend, which went into the playoffs with only 12 players on the roster due to a late-season walkout, was having no problem getting by the Chicks and swept the series on strong pitching by Jean Faut and Sue Kidd.

The championship finals was reduced to a five-game series and it took all five games to decide the champion. After winning the first two games, Rockford looked to be headed to a championship, but South Bend protested the second game because Rockford had moved its fences in too much. The Blue Sox won the protest and the next game to tie the series instead of being behind. The tightly fought series went down to the last game. The Blue Sox relied on their ace pitcher, Jean Faut, to finish off the Peaches and win the championship for the second year in a row. Faut won two games in the final series to lead the Sox to victory.

1st Round (Best of three)
Rockford vs. Fort Wayne
Game 1: Fort Wayne 5, Rockford 4
Game 2: Rockford 4, Fort Wayne 3
Game 3: Rockford 4, Fort Wayne 0
Rockford wins series 2 games to 1

Game 1: Fort Wayne 5, Rockford 4

					R	*H*	*E*	*DP*
Rockford	100	003	000	0	4	9	3	0
Fort Wayne	030	010	000	1	5	8	1	0

Winning Pitcher: M. Kline; *Losing Pitcher:* M. Jinright.
Highlights: The Daisies pulled out a win in the bottom of the tenth despite two homers by the Peaches.

Game 2: Rockford 4, Fort Wayne 3

				R	*H*	*E*	*DP*
Fort Wayne	200	100	000	3	9	3	1
Rockford	102	010	00x	4	9	1	3

Winning Pitcher: R. Gacioch; *Losing Pitcher:* N. Warren. *Umpires:* Anderson, Barteil and Papich. Time: 1:46. A: 1,076.

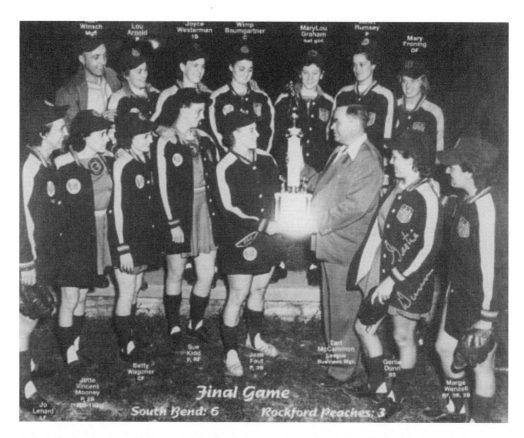

League business manager Earl McCammon presents the 1952 playoff championship trophy to the South Bend Blue Sox. The players were (front row from left) Jo Lenard, Jette Vincent Mooney, Betty Wagoner, Sue Kidd, Jean Faut, Gertie Dunn, Marge Wenzell (back row) Manager Karl Winsch, Lou Arnold, Joyce Westerman, Wimp Baumgartner, Mary Lou Graham, Janet Rumsey and Mary Froning.

Highlights: After a shaky first inning, Rose Gacioch held the Daisies to a run the rest of the way to tie the series.

Game 3: Rockford 6, Fort Wayne 0

				R	H	E	DP
Fort Wayne	000	000	000	0	6	0	2
Rockford	012	102	00x	6	10	2	0

Winning Pitcher: M. Jinright; *Losing Pitcher:* J. Bittner. *Umpires:* Barteil, Papich and Anderson. Time: 1:33. A: 2,236.

Highlights: M. Jinright scattered six hits in shutting down the Daisies, while being supported by Jean Buckley's 4-for-4, four RBI performance.

Fort Wayne Pitching Records

	IP	W	L	H	BB	SO	B	WP	HB	R	ER	ERA
M. Kline	10	1	0	9	5	1	0	0	0	4	4	3.64
N. Warren	9	0	1	9	0	3	0	0	0	4	4	4.00
J. Bittner	2	0	1	2	3	0	0	0	0	3	3	13.64
P. Scott	6	0	0	8	0	3	0	0	0	3	3	4.50
Totals	27	1	2	28	8	7	0	0	0	14	14	4.67

Fort Wayne Hitting Records

	AB	R	H	S	2B	3B	HR	RBI	Pct.	SB	PO	A	E	FA
T. Eisen	13	1	4	0	0	0	0	0	.308	6	4	0	0	1.000
W. Briggs	13	2	5	0	1	0	0	0	.385	0	8	0	1	.889
D. Schroeder	10	0	2	2	0	0	0	1	.200	0	6	11	0	1.000
B. Foss	10	1	3	0	0	0	0	1	.300	1	38	0	1	.974
Jo Weaver	13	2	3	0	1	0	0	0	.231	0	3	0	0	1.000
C. Horstman	11	1	1	0	1	0	0	1	.091	0	5	7	1	.923
Jean Weaver	13	1	5	0	1	0	0	2	.385	1	5	12	0	1.000
L. Paire	9	0	1	0	0	0	0	0	.111	0	6	0	0	1.000
M. Kline	4	0	0	0	0	0	0	0	.000	0	1	3	1	.800
N. Warren	3	0	0	0	0	0	0	0	.000	0	1	2	0	1.000
J. Bittner	1	0	0	0	0	0	0	0	.000	0	0	1	0	1.000
P. Scott	2	0	0	0	0	0	0	0	.000	0	1	2	0	1.000
Totals	102	8	24	2	4	0	0	5	.235	8	78	38	4	.967

Rockford Pitching Records

	IP	W	L	H	BB	SO	B	WP	HB	R	ER	ERA
M. Jinright	17	1	1	13	3	3	0	0	0	2	1	0.53
J. Kelley	1	0	0	1	3	1	0	0	0	3	2	18.18
R. Gacioch	9	1	0	9	1	1	0	0	0	3	2	2.00
Totals	27	2	1	23	7	5	0	0	0	8	5	1.67

Rockford Hitting Records

	AB	R	H	S	2B	3B	HR	RBI	Pct.	SB	PO	A	E	FA	
J. Berger	13	2	7	0	0	0	0	0	.538		4	6	8	0	1.000
R. Richard	11	2	1	1	0	0	0	0	.091		3	9	0	0	1.000
D. Doyle	12	1	2	1	0	0	0	1	.167		0	4	7	3	.786
E. Callow	12	2	6	0	0	0	1	3	.500		2	11	1	0	1.000
A. Deschaine	12	2	5	1	0	0	1	3	.417		2	3	6	2	.818
A. Applegren	9	2	0	2	0	0	0	0	.000		0	29	2	0	1.000
J. Buckley	12	2	6	0	1	0	2	1	.500		2	4	0	0	1.000
J. Kelley	1	0	0	0	0	0	0	0	.000		0	0	1	1	.500
M. Jinright	6	0	0	0	0	0	0	0	.000		0	1	3	0	1.000
D. Key	9	1	1	0	0	0	0	1	.111		2	11	0	1	.909
R. Gacioch	3	0	1	0	0	0	0	0	.333		0	2	3	0	1.000
Totals	100	14	29	5	1	0	4	9	.290		15	80	31	7	.941

1st Round (Best of three)

South Bend vs. Grand Rapids
Game 1: South Bend 2, Grand Rapids 1
Game 2: South Bend 6, Grand Rapids 1
South Bend wins 2 games to 0

Game 1: South Bend 2, Grand Rapids 1

				R	H	E	DP
Grand Rapids	000	000	001	1	3	4	0
South Bend	010	000	01x	2	5	1	0

Winning Pitcher: J. Faut; *Losing Pitcher:* A. Ziegler. *Umpires:* Meredith, Stover and Zoss. Time: 1:40.
Highlights: Jean Faut struck out nine Chicks en route to a one-run victory.

Game 2: South Bend 6, Grand Rapids 1

				R	H	E	DP
South Bend	102	001	200	6	2	3	1
Grand Rapids	000	010	000	1	6	2	0

Winning Pitcher: S. Kidd; *Losing Pitcher:* E. Risinger. *Umpires:* Block, Wierzbicki and Passage. Time: 1:55.

Highlights: The Blue Sox made the most of two hits and eight stolen bases by scoring three unearned runs, and Sue Kidd gave up only a run to the Chicks.

Grand Rapids Pitching

	IP	W	L	H	BB	SO	B	WP	HB	R	ER	ERA
A. Ziegler	8	0	1	5	3	4	0	0	0	2	1	1.14
E. Risinger	3	0	1	0	3	0	0	0	1	3	0	0.00
E. Moore	6	0	0	2	4	3	0	0	0	1	1	1.52
Totals	17	0	2	7	10	7	0	0	1	6	2	1.06

Grand Rapids Hitting

	AB	R	H	S	2B	3B	HR	RBI	Pct.	SB	PO	A	E	FA
D. Stolze	9	1	1	0	0	0	0	0	.111	1	3	1	1	.800
J. Smith	8	0	0	1	0	0	0	0	.000	1	6	0	0	1.000
I. Voyce	8	0	1	0	0	0	0	0	.125	0	26	1	1	.964
D. Satterfield	6	0	1	0	1	0	0	1	.167	0	4	0	0	1.000
J. Geissinger	7	0	1	0	0	0	0	0	.143	0	2	0	3	.400
C. Wisniewski	4	0	0	0	0	0	0	0	.000	0	0	0	0	1.000
R. Youngberg	3	0	0	0	0	0	0	0	.000	0	1	7	1	.778
M. Jenkins	6	1	1	0	0	0	0	0	.167	0	9	3	0	1.000
A. Ziegler	7	0	1	0	0	0	0	0	.143	0	2	7	0	1.000
E. Risinger	0	0	0	0	0	0	0	0	.000	0	0	4	0	1.000
E. Moore	3	0	0	0	0	0	0	0	.000	0	0	2	1	.667
Totals	61	2	6	1	1	0	0	1	.098	0	53	25	7	.918

South Bend Pitching

	IP	W	L	H	BB	SO	B	WP	HB	R	ER	ERA
J. Faut	9	1	0	3	0	9	0	0	0	1	1	1.00
S. Kidd	9	1	0	6	5	2	0	0	0	1	0	0.00
Totals	18	2	0	9	5	11	0	0	0	1	1	0.50

South Bend Hitting

	AB	R	H	S	2B	3B	HR	RBI	Pct.	SB	PO	A	E	FA
B. Wagoner	7	0	2	1	0	0	0	1	.285	1	7	0	0	1.000
G. Mooney	7	1	1	1	0	0	0	0	.143	3	4	3	1	.875
J. Lenard	7	3	0	0	0	0	0	0	.000	5	0	0	1	.000
H. Westerman	5	2	1	1	0	0	0	0	.200	0	26	2	0	1.000
J. Faut	5	1	1	2	0	0	0	0	.200	0	1	6	1	.875
S. Kidd	6	0	0	1	0	0	0	0	.000	0	0	3	0	1.000
G. Dunn	8	1	2	0	0	0	0	0	.250	0	2	7	2	.818
M. Wenzel	7	0	0	0	0	0	0	0	.000	0	1	2	0	1.000
W. Baumgartner	4	0	0	0	0	0	0	0	.000	0	13	0	0	1.000
Totals	56	8	7	6	0	0	0	1	.125	9	54	23	5	.939

Final Series (Best of five)

South Bend vs. Rockford
Game 1: Rockford 7, South Bend 3

Game 2: South Bend 5, Rockford 4
Game 3: Rockford 5, South Bend 4
Game 4: South Bend 2, Rockford 1
Game 5: South Bend 6, Rockford 3
South Bend wins championship 3 games to 2

Game 1 — Rockford 7, South Bend 3

				R	H	E	DP
South Bend	101	000	001	3	4	0	0
Rockford	020	111	20x	7	13	5	0

Winning Pitcher: J. Kelley; *Losing Pitcher:* J. Faut. Time: 2:13. A: 1,565.
Highlights: Eleanor Callow homered and knocked in two RBI to lead the Peaches to a rout of Blue Sox ace Jean Faut.

**Game 2 — South Bend 5, Rockford 4*

							R	H	E	DP
Rockford	000	000	022	0	0	0	4	12	5	1
South Bend	101	200	000	0	0	1	5	10	2	3

Winning Pitcher: J. Faut; *Losing Pitcher:* M. Mansfield. *Umpires:* Zoss, Meredith and Stover. Time: 2:35. A: 1,200 (estimated).
Highlights: Jean Faut came on in relief to hold the Peaches, while Sue Kidd singled home the winning run in the 12th inning.

*The original Game 2 was won 3-2 by Rockford, but was disallowed after a protest by South Bend. The protest occurred when the Peaches moved the right field fence to 21 feet short of the league's minimum distance.

Game 3: Rockford 5, South Bend 4

				R	H	E	DP
Rockford	011	120	000	5	9	3	4
South Bend	000	102	100	4	8	4	0

Winning Pitcher: J. Kelley; *Losing Pitcher:* G. Mooney.
Highlights: Jean Buckley squeezed in the winning run to edge the Blue Sox, and Jackie Kelley hung on for the win.

Game 4: South Bend 2, Rockford 1

				R	H	E	DP	
Rockford	000	010	000	0	1	9	2	0
South Bend	000	000	100	1	2	8	4	0

Winning Pitcher: J. Rumsey; *Losing Pitcher:* R. Gacioch. *Umpires:* Gradeless, Meredith and Zoss. Time: 2:00. A: 1,200.
Highlights: Joyce Westerman singled home the winning run in the 10tn inning, while Janet Rumsey held the Peaches to a single run.

Game 5: South Bend 6, Rockford 3

				R	H	E	DP
Rockford	000	100	002	3	8	3	1
South Bend	103	001	100	6	12	1	2

Winning Pitcher: J. Faut; Losing Pitcher M. Jinright. *Umpires:* Bartel, Papich, Cromwell and Anderson. T: 1:46. A: 2,700 (estimated).
Highlights: Jean Faut knocked in two RBI and held the Peaches to three runs to win the series.

Rockford Pitching Records

	IP	W	L	H	BB	SO	B	WP	HB	R	ER	ERA
J. Kelley	18	2	0	12	8	4	0	1	0	7	2	1.00
M. Mansfield	10	0	1	4	7	1	0	0	0	1	1	0.91
M. Jinright	14	0	1	10	1	0	0	0	0	10	6	3.87
R. Gacioch	10	0	1	8	2	1	0	0	0	2	2	1.82
Totals	52	2	3	34	18	6	1	0	0	20	11	1.91

Rockford Hitting Records

	AB	R	H	S	2B	3B	HR	RBI	Pct.	SB	PO	A	E	FA
J. Berger	22	0	4	0	1	0	0	4	.182	1	22	11	0	1.000
R. Richard	24	1	5	0	0	0	0	0	.208	0	22	3	3	.893
D. Doyle	21	2	6	1	0	1	0	0	.286	0	9	24	7	8.25
E. Callow	21	5	7	1	2	0	1	2	.333	6	5	2	2	.778
A. Deschaine	21	2	7	0	1	0	0	2	.333	2	4	19	1	.958
A. Applegren	17	4	6	1	1	0	0	3	.353	2	60	3	2	.969
J. Buckley	18	1	4	1	1	0	0	2	.222	1	8	0	2	.500
J. Kelley	10	3	5	1	1	1	0	2	.500	0	2	2	0	1.000
D. Key	20	1	8	0	1	0	0	2	.400	2	11	2	0	1.000
M. Jinright	3	0	0	0	0	0	0	0	.000	0	0	5	0	1.000
M. Mansfield	4	1	0	0	0	0	0	0	.000	0	2	4	1	.857
R. Gacioch	5	0	0	0	0	0	0	0	.000	0	0	3	0	1.000
Totals	186	20	52	5	8	2	1	17	.280	0	145	78	18	.925

South Bend Pitching Records

	IP	W	L	H	BB	SO	B	WP	HB	R	ER	ERA
J. Faut	20	2	1	25	7	8	0	1	0	12	12	5.41
L. Arnold	1	0	0	0	0	1	0	0	0	0	0	0.00
S. Kidd	8	0	0	8	0	1	0	0	0	2	2	2.25
G. Mooney	9	0	1	9	2	0	0	0	0	5	3	3.00
J. Rumsey	10	1	0	9	3	7	0	0	0	1	0	0.00
Totals	48	3	2	51	12	17	0	1	0	20	17	3.19

South Bend Hitting Records

	AB	R	H	S	2B	3B	HR	RBI	Pct.	SB	PO	A	E	FA
B. Wagoner	22	5	6	0	0	0	0	3	.273	1	8	2	1	.909
G. Mooney	22	5	5	0	2	0	0	1	.227	1	12	11	1	.958
J. Lenard	20	1	5	2	0	0	0	1	.250	3	6	1	0	1.000
J. Westerman	18	3	4	1	1	0	0	2	.222	0	67	4	3	.950
J. Faut	20	1	6	0	0	2	0	3	.300	1	8	22	0	1.000
L. Arnold	1	0	0	0	0	0	0	0	.000	0	3	5	0	1.000
G. Dunn	20	4	3	0	0	0	0	0	.150	0	10	21	1	.969
M. Wenzell	17	0	2	2	0	0	0	0	.118	2	6	10	2	.890
S. Kidd	16	1	4	2	1	0	0	1	.250	1	4	3	1	.875
W. Baumgartner	16	3	4	2	0	0	0	1	.250	0	23	4	2	.930
J. Rumsey	3	0	0	1	0	0	0	0	.000	0	0	2	0	1.000
Totals	175	23	39	10	4	2	0	12	.223	9	147	85	11	.953

1953 CHAMPIONSHIP PLAYOFFS

With the league reduced to six teams, four of the teams made the Shaughnessy Playoffs, which was reduced to a best of three series for both rounds. The days of long playoffs were

Members of the 1953 Grand Rapids Chicks playoff championship team were (front row from left) Jean Smith, Doris Satterfield, Marilyn Olinger, Jaynee Krick, Earlene Risinger, Mary Lou Studnicka, Inez Voyce, Alma Ziegler, (back row from left) Manager Woody English, Unknown, Delores Moore, Ellie Moore, Marie Ziegler, Joyce Ricketts, Marilyn Jenkins, Unknown and Chaperone Dottie Hunter.

long gone. First place Fort Wayne drew third place Kalamazoo in the first round, and second place Grand Rapids battled fourth place Rockford.

After the Daisies won the first game in extra innings, Lassie pitchers held off the powerful Fort Wayne sluggers and won the next two games to upset the season champion. June Peppas stroked five hits to lead Kalamazoo.

Grand Rapids looked to be headed for the same fate as Fort Wayne when they lost the first game. However, Beans Risinger pitched a shutout to lead the Chicks in the second playoff game. Then Grand Rapids pulled off a comeback in the last game to win the series.

In the final series, Grand Rapids swept the series as Risinger won the final game to earn her team the championship. Doris Satterfield and Joyce Ricketts had four hits to lead the Chicks.

1st Round: (Best of three)

Grand Rapids vs. Rockford
Game 1: Rockford 9, Grand Rapids 2
Game 2: Grand Rapids 2, Rockford 0
Game 3: Grand Rapids 4, Rockford 3
Grand Rapids wins series 2 games to 1

Game 1: Rockford 9, Grand Rapids 2

				R	H	E	DP
Grand Rapids	100	001	000	2	8	3	0
Rockford	000	040	05x	9	14	1	0

Winning Pitcher: R. Gacioch; *Losing Pitcher:* E. Moore. *Umpires:* Pratt and Kowalweski. A: 1,464. T: 2:08.
Highlights: The Peaches racked up 14 hits in pounding the Chicks, while Rose Gacioch gave up just two runs.

Game 2: Grand Rapids 2, Rockford 0

				R	H	E	DP
Rockford	000	000	000	0	6	1	2
Grand Rapids	000	000	11x	2	9	1	0

Winning Pitcher: E. Risinger; *Losing Pitcher:* M. Jinright. *Umpires:* Vanportfleit and Woudstra. Time: 1:48. A: 784.
Highlights: Earlene Risinger sprinkled six hits to shutout the Peaches.

Game 3: Grand Rapids 4, Rockford 3

				R	H	E	DP
Rockford	000	003	000	3	8	4	0
Grand Rapids	200	002	00x	4	7	1	0

Winning Pitcher: D. Mueller; *Losing Pitcher:* A. Lee. *Umpires:* VanPortfliet and Blok. A: 858.
Highlights: Dee Moore knocked in two runs, and Dottie Mueller held off the Peaches to send the Chicks into the finals.

Rockford Pitching Records

	IP	W	L	H	BB	SO	B	WP	HB	R	ER	ERA
R. Gacioch	9	1	0	8	3	4	0	0	1	2	1	1.00
M. Jinright	8	0	1	6	4	1	0	0	0	2	2	2.25
A. Lee	8	0	1	7	1	0	0	1	0	4	3	3.38
Totals	25	1	2	21	8	5	0	1	1	8	6	2.17

Rockford Hitting Records

	AB	R	H	S	2B	3B	HR	RBI	Pct.	SB	PO	A	E	FA
D. Key	11	2	4	1	0	0	0	0	.364	1	7	0	1	.875
J. Berger	11	3	4	1	0	0	0	2	.364	1	3	8	1	.917
E. Callow	10	2	5	2	0	0	1	3	.500	1	6	0	0	1.000
A. Deschaine	13	1	2	0	0	0	0	1	.154	1	2	4	1	.857
R. Richard	12	1	4	0	1	0	0	1	.250	0	7	1	0	1.000
D. Kamenshek	9	0	1	0	1	0	0	0	.111	0	28	0	1	.966
R. Gacioch	8	1	1	1	1	0	0	0	.125	0	3	4	0	1.000
M. Carey	11	1	6	1	1	0	0	1	.545	1	12	12	1	.960
S. Sands	5	1	1	0	0	0	0	0	.200	0	2	1	0	1.000
M Mansfield	2	0	0	1	0	0	0	0	.000	0	1	0	0	1.000
M. Jinright	2	0	0	0	0	0	0	0	.000	0	2	4	1	.857
A. Lee	3	0	0	0	0	0	0	0	.000	0	0	3	0	1.000
J. Kelley	1	0	0	0	0	0	0	0	.000	0	0	0	0	1.000
Totals	98	12	28	7	4	0	1	8	.286	5	73	37	6	.948

Grand Rapids Pitching Records

	IP	W	L	H	BB	SO	B	WP	HB	R	ER	ERA
E. Moore	5	0	1	7	1	2	0	0	0	4	3	5.41
M. Studnicka	3	0	0	7	1	1	0	0	0	5	4	12.01
E. Risinger	9	1	0	6	5	3	0	0	0	0	0	0.00
D. Mueller	9	1	0	8	3	2	0	0	0	3	3	3.00
Totals	26	2	1	28	10	8	0	0	0	12	10	3.47

Grand Rapids Hitting Records

	AB	R	H	S	2B	3B	HR	RBI	Pct.	SB	PO	S	E	FA
J. Smith	10	1	3	1	0	0	0	0	.300	1	6	1	0	1.000
A. Ziegler	11	2	1	1	0	0	0	1	.091	0	7	5	2	.857
D. Satterfield	12	1	4	0	1	0	0	1	.250	0	4	0	0	1.000
I. Voyce	12	5	0	0	0	0	0	0	.000	1	33	1	0	1.000
J. Ricketts	9	1	3	1	0	0	0	0	.333	0	2	1	1	.750
M. Jenkins	10	1	0	0	0	0	0	0	.000	0	10	2	0	1.000
R. Youngberg	10	0	3	0	0	0	0	0	.300	2	5	8	1	.929
D. Moore	11	0	3	0	0	0	0	3	.273	0	10	9	2	.905
E. Moore	1	0	0	0	0	0	0	0	.000	0	0	3	0	1.000
M. Studnicka	6	0	1	0	0	0	0	0	.167	0	0	2	0	1.000
D. Mueller	3	0	1	0	0	0	0	0	.333	0	0	3	0	1.000
E. Risinger	4	0	1	0	0	0	0	0	.250	0	1	4	0	1.000
Totals	95	11	19	3	1	0	0	5	.200	0	78	39	6	.952

1st Round: (Best of three)

Fort Wayne vs. Kalamazoo
Game 1: Fort Wayne 3, Kalamazoo 1
Game 2: Kalamazoo 2, Fort Wayne 1
Game 3: Kalamazoo 5, Fort Wayne 3
Kalamazoo wins series 2 games to 1

Game 1: Fort Wayne 3, Kalamazoo 1

							R	H	E	DP
Fort Wayne	010	000	000	0	0	2	3	7	5	0
Kalamazoo	010	000	000	0	0	0	1	3	0	0

Winning Pitcher: M. Kline; *Losing Pitcher:* G. Cordes. *Umpires:* Wendt and Hughes.
Highlights: Jo Weaver stole second and third base in the 12th inning before scoring the winning run, and Maxine Kline held the Lassies to a single run.

Game 2: Kalamazoo 2, Fort Wayne 1

						R	H	E	DP
Kalamazoo	000	000	001	1	2	13	2	0	
Fort Wayne	000	001	000	0	1	7	1	0	

Winning Pitcher: D. Naum; *Losing Pitcher:* C. Horstman. *Umpires:* Richendollar and Fryback.
Time: 2:15. .
Highlights: Jean Lovell singled in the winning run in the 10th inning, while Dottie Naum homered and held Fort Wayne to a single run.

Game 3: Kalamazoo 5, Fort Wayne 3

				R	H	E	DP
Kalamazoo	100	100	201	5	10	1	1
Fort Wayne	000	010	101	3	8	4	1

Winning Pitcher: K. Blumetta; *Losing Pitcher:* P. Scott. *Umpires:* Fryback and Ceccanese. Time: 1:45.

Highlights: Jean Lovell knocked in two runs and Terry Rukavina tripled in a run to lead the Lassies.

Fort Wayne Pitching Records

	IP	W	L	H	BB	SO	B	WP	HB	R	ER	ERA
M. Kline	12	1	0	3	5	6	0	0	1	1	1	0.75
C. Horstman	10	0	1	13	2	7	0	0	1	2	2	1.80
P. Scott	9	0	1	10	3	2	0	0	1	5	3	3.00
Totals	31	1	2	26	10	15	0	0	3	8	6	1.74

Fort Wayne Hitting Records

	AB	R	H	S	2B	3B	HR	RBI	Pct.	SB	PO	A	E	FA
D. Brumfield	14	0	3	1	1	0	0	0	.214	0	28	2	1	.968
W. Briggs	14	0	4	0	0	0	0	2	.285	1	8	2	0	1.000
C. Horstman	14	1	5	0	1	0	0	1	.357	0	4	8	4	.750
Jo Weaver	13	2	3	0	0	0	0	0	.231	5	10	1	0	1.000
J. Geissinger	11	1	3	0	0	0	0	0	.273	2	12	3	1	.938
R. Briggs	12	0	0	0	0	0	0	0	.000	0	18	2	1	.952
J. Havlish	8	1	2	0	0	0	0	0	.250	0	6	10	2	.890
M. Kline	3	0	1	0	0	0	0	1	.333	0	1	5	0	1.000
A. Blaski	7	0	0	0	0	0	0	0	.000	0	3	0	0	1.000
L. Paire	4	1	1	0	0	0	1	1	.250	0	3	1	1	.800
S. Crites	3	1	0	0	0	0	0	0	.000	1	1	1	0	1.000
P. Scott	4	0	1	0	0	0	0	0	.250	0	0	2	0	1.000
J. Bittner	0	1	0	0	0	0	0	0	.000	0	0	0	0	1.000
Jean Weaver	1	0	0	0	0	0	0	0	.000	0	0	0	0	1.000
Totals	108	8	23	1	2	0	1	5	.213	9	94	37	10	.929

Kalamazoo Pitching Records

	IP	W	L	H	BB	SO	B	WP	HB	R	ER	ERA
G. Cordes	12	0	1	7	4	6	0	0	0	3	3	2.26
D. Naum	10	1	0	7	3	1	0	0	0	1	1	0.90
K. Blumetta	9	1	0	8	4	3	0	0	0	3	2	2.00
Totals	31	2	1	22	11	10	0	0	0	7	6	1.74

Kalamazoo Hitting Records

	AB	R	H	S	2B	3B	HR	RBI	Pct.	SB	PO	A	E	FA
D. Schoreder	11	1	1	1	0	0	0	0	.091	1	4	10	1	.933
J. Peppas	13	1	5	1	0	0	0	0	.385	2	28	3	0	1.000
D. Sams	15	0	2	0	0	0	0	0	.133	1	6	0	0	1.000
N. Stoll	12	2	2	0	0	0	0	0	.167	2	3	1	0	1.000
B. Francis	11	1	0	2	0	0	0	0	.000	0	5	1	0	1.000
J. Romatowski	2	0	1	0	0	0	0	0	.500	1	5	2	0	1.000
F. Shollenberger	14	1	4	0	0	0	0	0	.286	2	5	6	1	.917
T. Rukavina	10	0	4	0	0	1	0	1	.400	0	6	3	0	1.000
G. Cordes	3	0	1	0	0	0	0	0	.333	0	0	3	0	1.000
B. Lovell	9	0	4	0	1	0	0	3	.444	0	2	1	0	1.000
J. Sindelar	0	0	0	0	0	0	0	0	.000	0	0	0	0	1.000
D. Naum	5	1	1	0	0	0	1	1	.200	0	0	1	0	1.000
A. Armato	0	0	0	0	0	0	0	0	.000	0	2	0	0	1.000
I. Alvarez	2	0	0	0	0	0	0	0	.000	0	0	0	0	1.000
K. Blumetta	3	1	1	1	0	0	0	0	.333	0	0	0	0	1.000
Totals	110	8	26	5	1	1	1	5	.236	9	66	31	2	.980

Final Round (Best of three)

Grand Rapids vs. Kalamazoo
Game 1: Grand Rapids 5, Kalamazoo 2
Game 2: Grand Rapids 4, Kalamazoo 3
Grand Rapids wins championship 2 games to 0

Game 1: Grand Rapids 5, Kalamazoo 2

				R	H	E	DP
Kalamazoo	010	100	000	2	7	2	1
Grand Rapids	101	300	00x	5	12	0	1

Winning Pitcher: M. Studnicka; *Losing Pitcher:* G. Cordes. *Umpires:* VanPortfliet and Blok. Time: 2:30.
Highlights: Joyce Ricketts knocked in two runs to lead the Chicks, while Mary Studnicka limited the Lassies to two runs.

Game 2: Grand Rapids 4, Kalamazoo 3

				R	H	E	DP
Grand Rapids	010	003	0	4	5	1	0
Kalamazoo	000	102	0	3	7	1	0

Winning Pitcher: E. Risinger; *Losing Pitcher:* D. Naum. *Umpires:* Hughes and Kott. A: 500.
Highlights: Earlene Risinger knocked in two runs and struck out nine to whip the Lassies for the league championship in a cold-weather shortened game.

Kalamazoo Pitching Records

	IP	W	L	H	BB	SO	B	WP	HB	R	ER	ERA
G. Cordes	3	0	1	8	2	0	0	0	0	5	4	6.76
R. Williams	5	0	0	3	2	0	0	0	0	0	0	0.00
D. Naum	7	0	1	5	3	6	0	0	0	4	4	5.15
Totals	15	0	2	16	7	6	0	0	0	9	8	4.82

Kalamazoo Hitting Records

	AB	R	H	S	2B	3B	HR	RBI	Pct.	SB	PO	A	E	FA
D. Schroeder	6	1	2	0	0	0	0	0	.333	0	2	5	0	1.000
J. Peppas	7	0	1	0	0	0	0	0	.143	0	11	2	0	1.000
D. Sams	8	1	3	0	0	0	1	1	.375	0	3	0	0	1.000
N. Stoll	6	1	3	0	0	0	0	0	.500	0	4	2	0	1.000
B. Francis	4	1	1	0	0	0	0	0	.250	0	8	0	1	.890
B. Lovell	7	0	2	0	0	0	0	1	.286	0	11	1	0	1.000
F. Shollenberger	7	1	3	0	0	1	0	1	.429	0	1	3	1	.800
T. Rukavina	6	0	2	0	1	0	0	1	.333	0	4	2	0	1.000
G. Cordes	2	0	0	0	0	0	0	0	.000	0	0	2	1	.667
R. Williams	0	0	0	0	0	0	0	0	.000	0	0	0	0	1.000
I. Alvarez	1	0	0	0	0	0	0	0	.000	0	0	0	0	1.000
D. Naum	3	0	0	0	0	0	0	0	.000	0	1	1	0	1.000
Totals	57	5	17	0	1	1	1	4	.298	0	45	18	3	.955

Grand Rapids Pitching Records

	IP	W	L	H	BB	SO	B	WP	HB	R	ER	ERA
M. Studnicka	8	1	0	7	5	7	0	0	0	2	2	2.27
E. Moore	1	0	0	1	0	1	0	0	0	0	0	0.00
E. Risinger	7	1	0	7	4	9	0	0	0	3	3	3.86
Totals	16	2	0	15	9	17	0	0	0	5	5	2.82

Grand Rapids Hitting Records

	AB	R	H	S	2B	3B	HR	RBI	Pct.	SB	PO	A	E	FA
J. Smith	8	2	1	0	1	0	0	0	.125	0	5	1	0	1.000
A. Ziegler	6	2	2	0	0	0	0	1	.333	0	2	3	0	1.000
D. Satterfield	8	1	4	0	0	0	0	1	.500	0	7	0	0	1.000
I. Voyce	6	1	2	0	1	0	0	1	.333	0	12	0	0	1.000
J. Ricketts	6	1	4	0	2	0	0	4	.667	0	0	1	1	.500
M. Jenkins	6	0	1	0	0	0	0	0	.167	0	15	3	0	1.000
R. Youngberg	5	0	1	0	0	0	0	0	.200	0	2	3	0	1.000
D. Moore	5	1	1	0	0	0	0	0	.200	0	3	0	0	1.000
M. Studnicka	2	1	0	0	0	0	0	0	.000	0	2	0	0	1.000
E. Moore	0	0	0	0	0	0	0	0	.000	0	0	0	0	1.000
E. Risinger	3	0	1	0	0	0	0	0	.500	0	0	3	0	1.000
Totals	55	9	17	0	4	0	0	7	.309	0	48	11	1	.983

1954 CHAMPIONSHIP PLAYOFFS

With five teams in the league, the only team not to make it to the playoffs was the last-place once powerful Rockford Peaches. Fort Wayne repeated the regular season title and faced third place Grand Rapids in the first round. Second place South Bend played fourth place Kalamazoo. The first round of the playoffs was again a best of three, but the finals were a best of five.

Fort Wayne lost a close battle the first game, losing it in the ninth inning. The Daisies were facing elimination in the second game, but the Chicks forfeited the game as well as the next to give the Fort Wayne the first round. When the league allowed Rockford's Ruth Richard to catch for the Daisies, the Grand Rapids players voted not to play. The dispute got so heated that Fort Wayne manager Bill Allington and Grand Rapids manager Woody English fought about it at home plate before the game.

Meanwhile, Kalamazoo lost the first game of the playoffs to South Bend before rebounding and taking the next two contests at home. The Lassies pounded out six home runs in the three games.

In the finals, Kalamazoo continued pounding the ball as it scored a record 17 runs in the first game to whip the Daisies. Then the Lassies almost folded and lost the next two games before winning the last two close contests. June Peppas starred for the Lassies as she won two games and knocked two homers.

1st Round (Best of three)
Fort Wayne vs. Grand Rapids
Game 1: Grand Rapids 8, Fort Wayne 7
Fort Wayne won Games 2 and 3 by forfeit

Game 1: Grand Rapids 8, Fort Wayne 7

				R	H	E	DP
FortWayne	000	210	040	7	12	2	1
Grand Rapids	000	004	211	8	10	2	1

Winning Pitcher: E. Moore; *Losing Pitcher:* C. Horstman. Time: 2:35.
Highlights: Eleanor Moore singled home the winning run in the bottom of the ninth after holding the Daisies in the top of the inning.

Members of the 1954 Kalamazoo Lassies playoff championship team were (front row from left) Jenny Romatowski, June Peppas, Elaine Roth, bat girl, Nancy Mudge, Fern Shollengerger, Jean Lovell, (back from left) Chaperone Bobbie Liebrich, Nancy Warren, Carol Habben, Nancy Taylor, Dorothy Schroeder, unknown, Gloria Cordes, Chris Ballingal, Jenny Marlowe, Nancy Stoll and Manager.

Game 2 and 3

Grand Rapids players voted not to play against Fort Wayne the last two games, because the league had allowed Ruth Richard, who had played for the Rockford Peaches during the regular season, to play on the Fort Wayne squad. Richard was a last-minute replacement for Rita Briggs, who was sidelined with a broken wrist. During a debate over the eligibility of Richard, the managers of the two teams, Bill Allington of the Daisies and Woody English of the Chicks, came to blows before a crowd of 1,612 spectators.

Grand Rapids Pitching Records

	IP	W	L	H	BB	SO	B	WP	HB	R	ER	ERA
E. Risinger	7	0	0	10	3	3	0	1	0	3	3	3.86
E. Moore	2	1	0	2	1	0	0	0	0	4	3	13.51
Totals	9	1	0	12	4	3	0	1	0	7	6	6.00

Grand Rapids Hitting Records

	AB	R	H	S	2B	3B	HR	RBI	Pct.	SB	*PO	A	E	FA
J. Smith	4	2	1	0	0	0	0	0	.250	1				
D. Pearson	3	1	1	0	1	0	0	1	.333	0				
J. Ricketts	4	1	1	1	0	0	1	2	.250	0				
B. Sowers	3	1	0	0	0	0	0	0	.000	0				
R. Youngberg	5	1	1	0	0	0	1	3	.200	0				
D. Moore	4	0	1	0	0	0	0	0	.250	0				
M. Redman	3	1	2	1	1	0	0	0	.667	0				

	AB	R	H	S	2B	3B	HR	RBI	Pct.	SB	*PO	A	E	FA
A. Zeigler	3	0	0	0	0	0	0	0	.000	0				
A. Gosbee	1	1	0	0	0	0	0	0	.000	0				
E. Risinger	3	0	1	0	0	0	0	0	.333	0				
E. Moore	2	0	2	0	0	0	0	1	1.000	0				
G. Hasham	0	0	0	0	0	0	0	0	.000	0				
Totals	35	8	10	2	2	0	2	7	.286	1				

Fort Wayne Pitching Records

	IP	W	L	H	BB	SO	B	WP	HB	R	ER	ERA
C. Horstman	9	0	1	10	7	6	0	0	0	8	7	7.00

Fort Wayne Hitting Records

	AB	R	H	S	2B	3B	HR	RBI	Pct.	SB	*PO	A	E	FA
M. Weddle	5	0	1	0	0	0	0	0	.200		0			
C. Horstman	3	1	1	0	0	0	0	0	.333		0			
J. Weaver	5	2	3	0	1	0	0	0	.600		1			
B. Foss	4	2	2	0	0	0	0	1	.500		0			
J. Geissinger	4	2	2	0	0	1	0	3	.500		0			
R. Richard	4	0	1	0	0	0	0	1	.250		0			
J. Havlish	2	0	2	1	0	0	0	0	1.00		0			
N. LeDuc	3	0	0	1	0	0	0	1	.000		0			
M. Kline	4	0	0	0	0	0	0	0	.000		0			
Totals	34	7	12	2	1	1	0	6	.353		1			

*No fielding statistics available.

1st Round (Best of three)

South Bend vs. Kalamazoo
Game 1: South Bend 6, Kalamazoo 3
Game 2: Kalamazoo 6, South Bend 3
Game 3: Kalamazoo 10, South Bend 7
Kalamazoo wins series 2 games to 0

Game 1: South Bend 6, Kalamazoo 3

				R	H	E	DP
Kalamazoo	000	201	000	3	8	3	0
South Bend	000	203	01x	6	10	2	0

Winning Pitcher: J. Rumsey; *Losing Pitcher:* G. Cordes. *Umpires:* Zoss, Batowski and Sears. Time: 2:30.
Highlights: The Blue Sox came from behind thanks to a two-run error to beat the Lassies.

Game 2: Kalamazoo 6, South Bend 3

				R	H	E	DP
South Bend	002	000	100	3	3	3	0
Kalamazoo	230	001	00x	6	9	0	0

Winning Pitcher: N. Warren; *Losing Pitcher:* S. Kidd. *Umpires:* Kott and Spurgeon.
Highlights: Nancy Warren pitched a three-hitter and June Peppas homered to knock in two runs for the Lassies to tie the series.

Game 3: Kalamazoo 10, South Bend 7

				R	H	E	DP
South Bend	003	013	000	7	7	2	2

			R	H	E	DP	
Kalamazoo	000	053	11x	10	13	8	0

			R	**H**	**E**	**DP**
Kalamazoo	000	053	11x 10	13	8	0

Winning Pitcher: E. Roth; *Losing Pitcher:* J. Rumsey. *Umpires:* Hughes and Spurgeon. Time: 3:04. A: 865.

Highlights: Kalamazoo came from behind twice and won on the strength of three home runs, a series record.

South Bend Pitching Records

	IP	W	L	H	BB	SO	B	WP	HB	R	ER	ERA
J. Rumsey	11	1	1	14	7	7	0	1	1	6	3	2.46
S. Kidd	1	0	1	3	2	2	0	0	0	5	4	36.04
D. Vanderlip	9	0	0	7	2	1	0	0	0	3	3	3.00
B. Wagoner	5	0	0	6	6	7	0	0	1	5	3	5.45
Totals	26	1	2	30	17	17	0	1	2	19	13	4.51

South Bend Hitting Records

	AB	R	H	S	2B	3B	HR	RBI	Pct.	SB	PO	A	E	FA
G. Dunn	11	3	3	0	0	0	0	3	.273	0	1	8	2	.819
B. Wanless	14	4	4	0	0	0	2	3	.286	1	5	11	1	.941
W. Briggs	8	1	1	0	0	0	0	0	.125	0	3	0	2	.600
B. Francis	9	2	2	0	0	0	0	0	.222	0	5	1	0	1.000
B. Wagoner	10	2	5	1	0	0	1	4	.500	0	25	2	1	.964
M. Froning	9	1	2	0	1	0	0	2	.222	1	2	1	0	1.000
L. Youngen	10	0	1	0	0	0	0	0	.100	0	21	4	0	1.000
M. Carey	10	0	1	0	0	0	0	0	.100	0	4	6	0	1.000
J. Rumsey	3	1	0	0	0	0	0	0	.000	0	0	7	0	1.000
S. Kidd	5	1	1	0	0	0	0	0	.200	0	8	0	0	1.000
D. Vanderlip	3	0	0	0	0	0	0	0	.000	0	1	0	0	1.000
H. Nordquist	2	0	0	0	0	0	0	0	.000	0	0	3	0	1.000
M. Drinkwater	1	0	0	0	0	0	0	0	.000	0	0	0	0	1.000
M. Baumgartner	1	0	0	0	0	0	0	0	.000	0	0	0	0	1.000
Totals	96	15	20	1	1	0	3	12	.208	2	75	43	6	.947

Kalamazoo Pitching Records

	IP	W	L	H	BB	SO	B	WP	HB	R	ER	ERA
G. Cordes	12	0	1	11	6	9	0	0	0	6	3	2.26
N. Warren	9	1	0	3	7	7	0	0	0	3	3	3.00
E. Roth	6	1	0	6	3	2	0	0	0	7	2	3.00
Totals	27	2	1	20	16	18	0	0	0	16	8	2.67

Kalamazoo Hitting Records

	AB	R	H	S	2B	3B	HR	RBI	Pct.	SB	PO	A	E	FA
N. Mudge	10	4	4	0	0	0	1	4	.400	0	7	5	1	.923
J. Peppas	8	1	1	0	0	0	1	2	.125	0	33	1	2	.945
C. Ballingal	11	4	5	0	0	0	1	3	.455	0	4	0	0	1.000
D. Schroeder	10	3	4	0	0	0	0	0	.400	0	8	12	5	.800
F. Shollenberger	11	0	4	0	0	0	1	0	.363	0	3	4	1	.875
J. Lovell	12	2	5	0	0	0	1	2	.417	0	18	2	1	.952
C. Habben	10	3	3	0	0	0	1	1	.300	0	1	0	1	.500
J. Romatowski	12	0	4	0	0	0	0	2	.333	0	7	1	0	1.000
G. Cordes	4	0	0	0	0	0	0	0	.000	0	0	6	0	1.000
M. Taylor	1	0	0	0	0	0	0	0	.000	0	0	0	0	1.000
N. Warren	3	1	0	0	0	0	0	0	.000	0	0	5	0	1.000
E. Roth	2	1	0	0	0	0	0	0	.000	0	0	1	0	1.000
Totals	94	19	30	0	0	0	6	14	.319	0	81	37	11	.915

Final Round (Best of five)

Fort Wayne vs. Kalamazoo
Game 1: Kalamazoo 17, Fort Wayne 9
Game 2: Fort Wayne 11, Kalamazoo 4
Game 3: Fort Wayne 8, Kalamazoo 7
Game 4: Kalamazoo 6, Fort Wayne 5
Game 5: Kalamazoo 8, Fort Wayne 5
Kalamazoo wins series 3 games to 2

Game 1: Kalamazoo 17, Fort Wayne 9

				R	H	E	DP
Fort Wayne	003	000	420	9	9	4	0
Kalamazoo	133	022	06x	17	13	7	1

Winning Pitcher: J. Peppas; *Losing Pitcher:* M. Kline. *Umpires:* Highes and Kott. A: 1,294. Time: 3:00.
Highlights: The Lassies pounded out a series record four home runs to trounce the Daisies in a score reminiscent of a football game.

Game 2: Fort Wayne 11, Kalamazoo 4

				R	H	E	DP
Fort Wayne	501	030	101	11	14	1	1
Kalamazoo	001	001	101	4	9	2	2

Winning Pitcher: M. Jones; *Losing Pitcher:* G. Cordes. *Umpires:* Kott and Spurgeon. A: 1,626. Time: 2:05.
Highlights: The Daisies hit a series-record five homers, and Marilyn Jones limited the Lassies to four runs in tieing up the series.

Game 3: Fort Wayne 8, Kalamazoo 7

				R	H	E	DP
Kalamazoo	000	310	300	7	8	0	0
Fort Wayne	000	330	20x	8	13	3	1

Winning Pitcher: Baker; *Losing Pitcher:* Nancy Warren. *Umpires:* Tielker, Slater and Ceccanese. Time: 2:20.
Highlights: Jo Weaver hit a double, triple and homer and drove in four runs to lead the Daisies over the Lassies and take a 2-1 lead in the series.

Game 4: Kalamazoo 6, Fort Wayne 5

				R	H	E	DP
Kalamazoo	100	001	040	6	12	4	0
Fort Wayne	300	001	100	5	9	1	1

Winning Pitcher: G. Cordes; *Losing Pitcher:* M. Kline. *Umpires:* Ceccanese, Slater and Tielker. T: 2:00.
Highlights: Chris Ballingal was ejected in the ninth inning, but her three hits, RBI and run scored led the Lassies to a close win over the Daisies.

Game 5: Kalamazoo 8, Fort Wayne 5

				R	H	E	DP
Kalamazoo	000	320	012	8	8	5	1
Fort Wayne	010	030	010	5	5	1	0

Winning Pitcher: J. Peppas; *Losing Pitcher:* M. Jones. *Umpires:* Slater, Tielker and Ceccanese. T: 2:45.

Highlights: June Peppas knocked in four runs and held off the Daisies to win the last championship of the All-American Girls Professional Baseball League.

Fort Wayne Pitching Records

	IP	W	L	H	BB	SO	B	WP	HB	R	ER	ERA
M. Kline	14	0	2	21	3	12	0	0	0	17	13	8.39
V. Carver	2	0	0	5	3	2	0	0	0	6	3	13.51
M. Jones	12	1	1	17	12	15	0	2	0	7	7	5.25
P. Baker	11	1	0	3	3	2	0	0	0	5	1	0.82
C. Horstman	6	0	0	6	4	2	0	0	0	7	4	6.01
Totals	45	2	3	52	25	33	0	2	0	42	28	5.60

Fort Wayne Hitting Records

	AB	R	H	S	2B	3B	HR	RBI	Pct.	SB	PO	A	E	FA
M. Weddle	19	5	4	0	0	0	0	0	.211	1	6	5	1	.917
C. Horstman	22	5	6	1	0	0	3	4	.273	1	2	2	0	1.000
Jo Weaver	23	10	8	0	1	1	3	7	.348	1	10	1	0	1.000
B. Foss	19	9	8	0	0	0	2	4	.421	3	30	2	3	.914
J. Geissinger	21	3	9	0	2	0	1	7	.429	0	13	6	0	1.000
R. Richard	18	6	4	2	0	0	0	0	.222	1	23	0	1	.958
J. Havlish	18	1	5	2	2	1	0	4	.278	0	7	8	3	.833
N. LeDuc	18	0	5	0	0	0	0	3	.278	1	8	1	0	1.000
M. Kline	12	1	1	0	0	0	0	0	0.83	0	2	2	1	.800
V. Carver	1	0	0	0	0	0	0	0	.000	0	0	2	0	1.000
M. Jones	3	0	0	0	0	0	0	0	.000	0	1	2	0	1.000
P. Baker	4	0	0	0	0	0	0	0	.000	0	0	1	0	1.000
Totals	178	40	50	5	5	2	9	29	.281	8	102	32	9	.937

Kalamazoo Pitching Records

	IP	W	L	H	BB	SO	B	WP	HB	R	ER	ERA
J. Peppas	16	2	0	12	15	12	0	0	1	12	5	2.82
N. Warren	8	0	0	14	2	2	0	0	0	8	5	5.63
G. Cordes	12	1	1	14	4	4	0	0	0	13	10	7.52
E. Roth	8	0	1	11	2	0	0	0	0	6	5	5.63
Totals	44	3	2	51	23	18	0	0	1	39	25	5.12

Kalamazoo Hitting Records

	AB	R	H	S	2B	3B	HR	RBI	Pct.	SB	PO	A	E	FA
N. Mudge	17	6	4	0	2	0	1	1	.235	1	5	10	4	.790
J. Peppas	15	4	6	1	1	0	2	3	.400	0	27	3	1	.968
N. Warren	2	1	0	1	0	0	0	0	.000	0	1	1	0	1.000
C. Ballingal	21	3	8	1	1	0	1	3	.381	0	5	0	0	1.000
D. Schroeder	17	6	6	1	1	0	2	2	.353	0	8	17	3	.893
F. Shollenberger	19	6	10	0	1	0	1	2	.526	0	7	11	3	.850
J. Lovell	17	3	6	0	0	0	0	1	.353	0	19	0	1	.950
C. Habben	12	2	3	1	0	0	1	0	.250	1	11	1	1	.923
J. Romatowski	13	1	3	1	0	0	0	2	.231	0	15	0	0	1.000
M. Taylor	5	1	1	0	0	0	0	0	.200	0	1	0	0	1.000
G. Cordes	5	0	0	0	0	0	0	0	.000	0	1	3	0	1.000
E. Roth	4	0	1	0	0	0	0	0	.000	0	1	1	0	1,000
Totals	147	33	48	6	6	0	8	14	.327	2	101	47	13	.920

NOTE: No fielding statistics available for Game 5.

Series Pitching Records

Most Playoff Years
7 — Maxine Kline, Fort Wayne

Most Wins, Career
13 — Helen Nicol, Kenosha, Rockford

Most Wins, Series
4 — Connie Wisniewski, Milwaukee, 1944

Most Losses, Career
7 — Jan Faut, South Bend; Maxine Kline, Fort
Wayne; Helen Nicol, Kenosha, Rockford

Most Strikeouts, Career
80 — Jean Faut, South Bend

Most Strikeouts, Series
22 — Jean Faut, South Bend, 1948

Most Strikeouts, 7-inning Game
9 — Earlene Risinger, Grand Rapids, 1953, vs.
Kalamazoo

Most Strikeouts, 9-inning Game
10 — D. Wiltse, Fort Wayne, 1945, vs. Racine;
D. Wiltse, Fort Wayne, 1945, vs. Rockford;
O. Little, Rockford, 1945, vs. Fort Wayne; M.
Jones, Fort Wayne, 1954, vs. Kalamazoo

Most Strikeouts, extra-inning game
16 — Alice Haylett, Grand Rapids, 1948, vs.
South Bend

Most Walks, Series
19 — Anna May Hutchison, Racine, 1947

Most Walks, 9-inning game
13 — Marie Mansfield, Rockford, 1951, vs.
South Bend

Most Walks, extra-inning game
10 — Jean Faut, South Bend, 1948, vs. Grand
Rapids

No-Hitters
L. Florreich, Rockford, 1948, vs. Kenosha
M. Holgerson, Rockdord, 1948, vs. Kenosha

One-Hitters
Connie Wisniewski, Grand Rapids, 1945, vs.
Rockford
Lois Florreich, Rockford, 1948, vs. Racine

Most Innings, Career
170 — Jean Faut, South Bend

Most Innings Pitched, Series
45 — Connie Wisniewski, Grand Rapids, 1944

Most Innings, Game
20 — Jean Faut, South Bend, 1948, vs. Grand
Rapids; Alice Haylett, Grand Rapids, 1948,
vs. South Bend

Most Wild Pitches, Series
5 — Lillian Faralla, South Bend, 1951

Most Wild Pitches, Game
3 — Jo Winter, Ft. Wayne, 1944, vs. Fort Wayne

Most Hits Batters, Series
Many with 2

Most Hit Batters, Game
2 — Louise Erickson, Rockford, 1949, vs. South
Bend; Lois Florreich, Rockford, 1950, vs.
Kenosha

Series Hitting Records

Highest Average, Series
.556 — Connie Wisniewski, Grand Rapids, 1946,
vs. Rockford

Most At Bats, Series
30 — C. Wisniewski, Grand Rapids, and S. Kurys,
Racine, 1947

Most At Bats, Game
9 — Bonnie Baker, South Bend, 1948

Most Doubles, Career
9 — Eleanor Callow, Peoria, Chicago, Rockford

Most Doubles, Series
4 — Betty Foss, Fort Wayne, 1950, vs. Rockford

Most Doubles, Game
2 — Many

Most Triples, Career
3 — Eleanor Callow, Peoria, Chicago, Rockford

Most Triples, Series
2 — Many

Most Triples, Game
2 — Dorothy Doyle, Rockford, 1950, vs. Kenosha;
Jean Faut, South Bend, 1952, vs. Rockford

Most Home Runs, Career
4 — Betty Foss, Fort Wayne

Most Home Runs, Series
3 — Betty Foss, Fort Wayne, 1954, vs. Kalamazoo; Joanne Weaver, Fort Wayne, 1954, vs. Kalamazoo

Most Home Runs, Game
2 — C. Horstman, Fort Wayne, 1954, vs. Kalamazoo

Most Hits, Career
46 — Dorothy Ferguson, Rockford, Peoria

Most Hits, Series
13 — Evie Wawryshyn, Fort Wayne, vs. Rockford, 1950

Most Hits, Game
5 — Dorothy Doyle, Rockford, 1950, vs. Kenosha

Most Stolen Bases, Game
5 — Sophie Kurys, Racine, 1946, vs. Rockford

Most Stolen Bases, Career
32 — Sophie Kurys, Racine, Battle Creek

Most Stolen Bases, Series
9 — S. Kurys, Racine, 1946, vs. Rockford

Most RBI, Career
32 — Eleanor Callow, Peoria, Chicago, Rockford

Most RBI, Series
8 — Faye Dancer, Fort Wayne, 1945, vs. Racine

Most RBI, Game
5 — Wilma Briggs, Fort Wayne, 1949, vs. Grand Rapids

Most Runs Scored, Career
42 — Dorothy Schroeder, South Bend, Kenosha, Fort Wayne, Kalamazoo

Most Runs Scored, Series
9 — Dottie Kamenshek, Rockford, 1950 vs. Fort Wayne

Most Runs Scored, Game
5 — Dottie Kamenshek, Rockford, vs. Fort Wayne

Most Sacrifices, Series
4 — Eleanor Dapkus, Racine, 1947, vs. Muskegon; Ernestine Petras, Grand Rapids, 1947, vs. Rockford

Most Sacrifices, Game
3 — Alice Polliett, Racine, 1948, vs. Fort Wayne

SERIES FIELDING RECORDS

Most Errors, Career
28 — Dorothy Schroeder, South Bend, Kenosha, Fort Wayne, Kalamazoo

Most Errors, Game
4 — Marilyn Olinger, Grand Rapids, 1948, vs. Fort Wayne

Most Errors, Series
7 — Snookie Doyle, Rockford, 1952, vs. South Bend

Most Putouts, Career
550 — Dottie Kamenshek, Rockford

Most Putouts, Series
95 — Inez Voyce, Grand Rapids, 1947, vs. Racine

Most Putouts, Game
24 — Margaret Danhauser, Racine, 1946, vs. South Bend

Most Assists, Career
110 — Doris Tetzlaff, Milwaukee, Grand Rapids, Chicago, Chicago, Fort Wayne, Muskegon

Most Assists, Series
28 — Doris Tetzlaff, Milwaukee, 1944, vs. Kenosha

Most Assists, Game
15 — Jean Faut, South Bend, 1948, vs. Grand Rapids

Most Individual Double Plays, Career
15 — Dorothy Schroeder, South Bend, Kenosha, Fort Wayne, Kalamazoo

Most Individual Double Plays, Game
6 — Amy Applegren, Rockford, 1952, vs. South Bend

Unassisted Double Plays
Betty Trezza, Racine, 1946, vs. South Bend
Inez Voyce, Grand Rapids, 1948, vs. South Bend
Dorothy Doyle, Rockford, 1949, vs. South Bend
Betty Foss, Fort Wayne, 1950, vs. Racine
Dorothy Mueller, South Bend, 1951, vs. Fort Wayne
Gertie Dunn, South Bend, 1952, vs. Rockford

SERIES TEAM RECORDS

Most Playoff Championships
4 — Rockford, 1945, 1948, 1949, 1950

Most Stolen Bases, Series
39 — Milwaukee, 1944

Longest Game, Innings
20 innings — Grand Rapids vs. South Bend, 1948

Longest Game, Time
3:14 — South Bend vs. Racine, 1946

Most At Bats, Series
232 — Kenosha, 1944, vs. Milwaukee

Most Hits, Series
61 — Rockford, 1950, vs. Fort Wayne

Most Hits, Game
19 — Kalamazoo, 1954, vs. Fort Wayne

Highest Batting Average, Series
.406 — Rockford, 1948, vs. Kenosha

Lowest Batting Average, Series
.037 — Kenosha, 1948

Highest Batting Average, Series
.406 — Rockford, 1948, vs. Kenosha

Lowest ERA, Series
0.00 — Rockford, 1948, vs. Kenosha; Muskegon, 1949, vs. Kenosha

Highest ERA, Series
7.00 — Fort Wayne, 1954, vs. Grand Rapids

Most Runs, Series
40 — Fort Wayne, 1954, vs. Kalamazoo

Most Runs, Game
17 — Kalamazoo, 1954, vs. Fort Wayne

Most Runs by Both Teams, Game
26 — Fort Wayne vs. Kalamazoo, 1954

Lowest Runs Allowed Series
1 — Muskegon, 1949, vs. Kenosha

Most RBI, Series
29 — Fort Wayne, 1954, vs. Kalamazoo

Most Doubles, Series
13 — Fort Wayne, 1950, vs. Rockford

Most Doubles, Game
3 — Rockford, 1952, vs. South Bend

Most Triples, Series
3 — Several

Most Home Runs, Series
9 — Fort Wayne, 1954, vs. Kalamazoo

Most Home Runs, Game
5 — Fort Wayne, 1954, vs. Kalamazoo

Most Home Runs by Both Teams, Series
17 — Kalamazoo vs. Fort Wayne, 1954

Most Sacrifices, Series
12 — Milwaukee, 1944, vs. Kenosha

Most Errors, Series
34 — Kenosha, 1944, vs. Milwaukee

Most Errors, Game
8 — Kalamazoo, 1954, vs. South Bend

Most Left on Base, Game
18 — Grand Rapids, 1947, vs. Racine

Most Double Plays, Game
4 — Rockford, 1952, vs. South Bend

OTHER RECORDS

Most Years in Playoffs
11 — Alma Ziegler, Milwaukee, Grand Rapids (each year she was in the league)

Most Years in League Without Playing in the Playoffs
8 — Marjorie Pieper, Fort Wayne, Kenosha, Chicago, Racine, Peoria, Battle Creek, Muskegon

V

Players' Statistics

All players' statistics were compiled from year-end news releases from Home News Bureau. The bureau usually did not include players who played in less than 10 games during the season, which is why no records are available on some players. Playoff records were gathered from box scores published in daily newspapers, which is why bases on balls and strikeouts are not available. Pitchers who played other positions on a regular basis are included in the player's records. (Car = career; Play = playoffs.)

Abbott, Velma (Born: 5/29/24, Regina, SK Canada; Died: Date Unknown BR, TR, 5'2", 110, U)

	Hitting											Fielding						
YEAR/TEAM	G	BA	AB	H	2B	3B	HR	SB	BB	SO	R	RBI	G	PO	A	E	DP	FA
'46/Ken, Peo,Roc	60	.178	169	30	0	2	0	15	11	1	15	5	52	52	107	20	10	.888
'47/FW	89	.141	269	38	2	2	1	18	27	28	27	15	81	135	132	31	6	.896
Car (2 yrs)	149	.155	438	68	2	4	1	33	38	43	42	20	133	187	239	51	16	.893
Play (1 yr)	11	.135	37	5	0	0	0	2	—	—	1	1	11	18	23	7	1	.854

Adams, Evelyn "Tommie" (Born: 11/16/23, Richmond, VA, BB, TR, 5'3", 110, SS)

	Hitting											Fielding						
YEAR/TEAM	G	BA	AB	H	2B	3B	HR	SB	BB	SO	R	RBI	G	PO	A	E	DP	FA
'46/FW, GR	39	.140	86	12	1	1	0	4	6	20	6	1	18	12	22	8	1	.810

Ahrndt (Proefrock), Ellen "Babe" (Born: 11/8/22, Racine, WI BR, TR, 5'4", 120, 2B)

	Hitting											Fielding	
YEAR/TEAM	G	BA	AB	H	2B	3B	HR	SB	BB	SO	R	RBI	
'45/SB	3	.000	3	0	—	—	—	—	—	—	—	—	No record

Albright, Eileen (Hometown: Wollaston, MA, 3B, 2B)
see Pitchers

	Hitting											Fielding						
YEAR/TEAM	G	BA	AB	H	2B	3B	HR	SB	BB	SO	R	RBI	G	PO	A	E	DP	FA
'48/Chic	65	.141	142	20	3	0	0	9	19	24	9	4	55	90	114	20	8	.911

Alderfer (Benner), Gertrude "Gert" (Born: 9/21/31, Telford, PA, BR, TR, 5'7", 155, 1B)

	Hitting												Fielding					
YEAR/TEAM	G	BA	AB	H	2B	3B	HR	SB	BB	SO	R	RBI	G	PO	A	E	DP	FA
'50/Chic-Spr	54	.236	212	50	3	3	1	9	22	24	38	24	No record					
'50/Kal	No record																	

Allen, Agnes "Aggie" (Born: 9/21/30, Alvord, IA, TR, BR, 5'3", 120, OF, P)

see Pitchers

	Hitting												Fielding					
YEAR/TEAM	G	BA	AB	H	2B	3B	HR	SB	BB	SO	R	RBI	G	PO	A	E	DP	FA
'49/FW	No record																	
'52/Kal	56	.161	161	26	6	0	0	6	6	13	15	10	44	81	3	9	0	.903
Play (1 yr)	3	.000	9	0	0	0	0	0	—	—	0	0	0	2	6	1	0	1.000

Alspaugh, Melba (Hometown: Wichita, KS; Died: 2/15/83, OF)

	Hitting												Fielding					
YEAR/TEAM	G	BA	AB	H	2B	3B	HR	SB	BB	SO	R	RBI	G	PO	A	E	DP	FA
'48/FW, Roc	51	.185	135	25	1	0	0	18	10	26	17	9	46	44	9	3	2	.946
'49/Roc, Mus	61	.210	162	34	0	0	0	22	19	20	24	10	53	60	1	2	0	.968
Car (2 yrs)	112	.199	297	59	1	0	0	40	29	46	41	19	99	104	10	5	2	.958
Play (1 yr)	8	.240	25	6	2	0	0	1	—	—	4	1	8	9	2	0	1	1.000

Alvarez, Isabel (Born: 10/31/33, Havana, Cuba, TL, BL, 5'3", 140, OF, P)

see Pitchers

	Hitting												Fielding					
YEAR/TEAM	G	BA	AB	H	2B	3B	HR	SB	BB	SO	R	RBI	G	PO	A	E	DP	FA
'53/Kal	53	.195	123	24	4	0	0	0	7	9	4	12	38	30	1	7	0	.816
'54/GR, FW	23	.191	68	13	2	0	0	3	2	5	6	2	21	22	0	0	0	1.000
Car (2 yrs)	76	.194	191	37	6	0	0	3	9	14	10	14	59	52	1	7	0	.883
Play (1 yr)	3	.000	3	0	0	0	0	0	—	—	0	0	0	—	—	—	—	—

Anderson (Perkin), Janet (Hometown: Bethune, SK, Canada, P, OF)

see Pitchers

	Hitting												Fielding					
YEAR/TEAM	G	BA	AB	H	2B	3B	HR	SB	BB	SO	R	RBI	G	PO	A	E	DP	FA
'46/Ken	36	.173	75	13	0	2	0	2	10	12	5	2	21	10	1	1	0	.952

Anderson (Sheriffs), Vivian "Andy" (Born: 4/21/21, Milwaukee, WI, BR, 5'2", 140, 3B)

	Hitting												Fielding					
YEAR/TEAM	G	BA	AB	H	2B	3B	HR	SB	BB	SO	R	RBI	G	PO	A	E	DP	FA
'44/Mil	11	.147	34	5	0	0	0	1	6	1	3	1	10	22	22	7	1	.863

Applegren, Amy Irene "Lefty" (Born: 11/16/26, Peoria, IL, BL, TL, 5'4", 125, 1B, P)

see Pitchers

	Hitting												Fielding					
YEAR/TEAM	G	BA	AB	H	2B	3B	HR	SB	BB	SO	R	RBI	G	PO	A	E	DP	FA
'48/Musk	49	.173	133	23	1	0	0	8	15	14	13	8	16	193	8	1	3	.995
'50/Roc	45	.224	134	30	2	2	0	5	8	4	18	12	17	182	3	8	13	.959
'52/Roc	105	.253	364	92	7	0	1	24	28	31	47	29	104	1093	45	21	42	.982
'53/SB	76	.242	277	67	5	1	0	24	21	17	24	24	76	860	30	14	28	.985
Car (4 yrs)	175	.233	908	212	15	3	1	61	72	66	102	73	123	2328	86	44	86	.982
Play (3 yrs)	15	.152	46	7	2	0	0	3	—	—	7	5	15	82	6	3	8	.961

Arbour (Parrott), Beatrice "Bea" (Born: 12/2/20, Somerset, MA, BR, 5'6", 129, SS)

	Hitting											Fielding						
YEAR/TEAM	G	BA	AB	H	2B	3B	HR	SB	BB	SO	R	RBI	G	PO	A	E	DP	FA
'47/Racine	1	.000	1	0	0	0	0	0	0	0	0	0	No record					

Armato, Angie "Lil Bonnie" (Born: 10/27/29, Rockford, IL, BR, TR, 5'2", 123, 2B)

	Hitting												Fielding					
YEAR/TEAM	G	BA	AB	H	2B	3B	HR	SB	BB	SO	R	RBI	G	PO	A	E	DP	FA
'53/Kal	27	.077	26	2	0	0	0	1	8	6	5	2	23	25	21	7	1	.868
Play (1 yr)	1	.000	0	0	0	0	0	0	—	—	0	0	1	2	0	0	0	1.000

Baker (George), Mary Geraldine "Bonnie" (Born: 7/10/18, Regina, SK, Canada, BR, TR, 5'5", 133, C, 2B)

	Hitting												Fielding					
YEAR/TEAM	G	BA	AB	H	2B	3B	HR	SB	BB	SO	R	RBI	G	PO	A	E	DP	FA
'43/SB	73	.250	256	64	7	2	1	46	24	6	45	31	66	299	72	20	7	.949
'44/SB	109	.236	373	88	1	4	0	92	49	20	48	41	107	437	101	32	6	.944
'45/SB	110	.236	394	93	6	5	0	35	49	17	49	21	110	508	69	23	5	.962
'46/SB	94	.286	325	93	4	2	0	94	61	19	63	31	96	413	82	18	10	.965
'47/SB	106	.217	369	80	5	1	0	58	40	32	54	20	102	383	86	14	7	.971
'48/SB	126	.233	468	109	3	4	0	56	56	33	62	29	132	527	157	35	16	.951
'49/SB	111	.216	408	88	4	2	0	68	50	38	58	25	114	584	154	33	38	.957
'50/SB, Kal	99	.244	349	85	7	0	0	37	37	23	43	26	110	195	229	41	19	.912
'52/Kal	102	.208	366	76	7	0	0	20	38	22	43	17	84	245	196	21	25	.955
Car (9 yrs)	930	.235	3308	776	44	20	1	506	404	210	465	244	921	3591	1146	236	213	.953
Play (4 yrs)	18	.253	79	20	2	0	0	6	—	—	8	1	18	43	36	2	4	.975

Ballingall, Chris (Born: 5/17/32, Ann Arbor, MI, BL, TR, 5'6", 145, 1B, OF, C)

	Hitting												Fielding					
YEAR/TEAM	G	BA	AB	H	2B	3B	HR	SB	BB	SO	R	RBI	G	PO	A	E	DP	FA
'53/Mus	72	.181	188	34	3	1	1	4	30	52	14	13	58	281	10	11	11	.964
'54/Kal	90	.242	285	69	6	0	17	0	53	56	54	40	89	138	6	11	2	.929
Car (2 yrs)	162	.218	473	103	9	1	18	4	83	108	68	53	167	454	25	26	13	.949
Play (1 yr)	8	.444	36	16	1	0	2	0	—	—	7	11	8	9	0	0	0	1.000

Barbaze, Barbara (Hometown: Toronto, ON, Canada, OF)

	Hitting												Fielding					
YEAR/TEAM	G	BA	AB	H	2B	3B	HR	SB	BB	SO	R	RBI	G	PO	A	E	DP	FA
'48/Spr	80	.193	223	43	2	0	0	23	24	29	19	16	76	104	5	11	1	.908

Barker, Lois Anna "Tommie" (Born: 4/7/23, Dover, NJ, BR, TR, 5'3", 130, OF, 3B)

	Hitting												Fielding					
YEAR/TEAM	G	BA	AB	H	2B	3B	HR	SB	BB	SO	R	RBI	G	PO	A	E	DP	FA
'50/GR	32	.125	64	8	0	0	0	0	6	15	4	3	31	16	1	1	0	.944

Barnett, Charlene "Barney" (Hometown: Elgin, IL; Died: Date Unknown, BR, 2B, 3B, SS)

	Hitting												Fielding					
YEAR/TEAM	G	BA	AB	H	2B	3B	HR	SB	BB	SO	R	RBI	G	PO	A	E	DP	FA
'47/GR	33	.115	78	9	0	0	0	0	3	10	7	4	28	39	62	11	0	.902
'48/Chic	126	.165	448	74	7	5	1	29	67	59	48	19	129	248	211	29	39	.941
'49/Roc	104	.159	359	57	6	0	0	30	42	37	30	13	104	240	188	20	36	.955
'50/Roc	92	.221	331	73	3	2	0	30	32	22	35	29	88	198	196	24	29	.943
Car (4 yrs)	355	.175	1216	213	16	7	1	89	144	128	120	85	349	725	657	84	104	.943
Play (3 yrs)	20	.250	60	15	0	0	0	1	—	—	7	7	19	38	29	4	4	.944

Barney, Edith "Little Red" (Born: 2/3/23, Bridgeport, CT, BR, TR, 5'6", 136, C)

	Hitting												Fielding					
YEAR/TEAM	G	BA	AB	H	2B	3B	HR	SB	BB	SO	R	RBI	G	PO	A	E	DP	FA
'48/GR	4	.000	4	0	—	—	—	—	—	—	—	—	No record					

Barringer, Patricia (Born: 9/14/24, New Carlisle, OH, BR, TR, 5'7", 145, 2B)

	Hitting												Fielding					
YEAR/TEAM	G	BA	AB	H	2B	3B	HR	SB	BB	SO	R	RBI	G	PO	A	E	DP	FA
'47/Mus	1	.000	1	0	—	—	—	—	—	—	—	—	No record					

Batikis, Annastasia "Stash" (Born: 5/15/27, Racine, WI, BL, TL, 4'11", 125, OF)

	Hitting												Fielding					
YEAR/TEAM	G	BA	AB	H	2B	3B	HR	SB	BB	SO	R	RBI	G	PO	A	E	DP	FA
'45/Rac	5	.000	11	0	0	0	0	0	0	0	0	0	No record					

Battaglia, Fern (Born: 1/6/31, Chicago, IL, BR, TR, 5'4", 120, 3B, 2B)

	Hitting												Fielding					
YEAR/TEAM	G	BA	AB	H	2B	3B	HR	SB	BB	SO	R	RBI	G	PO	A	E	DP	FA
'50/																		
Spr-Chic	67	.204	250	51	3	2	1	11	28	25	36	29	No record					
'51/BC	19	.167	60	10	1	0	0	4	6	8	5	4	19	38	21	5	5	.922

Baumgartner, Mary "Wimp" (Born: 9/13/30, Fort Wayne, IN, BR, TR, 5'5", 145, C)

	Hitting												Fielding					
YEAR/TEAM	G	BA	AB	H	2B	3B	HR	SB	BB	SO	R	RBI	G	PO	A	E	DP	FA
'49/																		
Chic-Spr	No record																	
'49/Peo	15	.091	22	2	1	0	0	0	1	9	1	0	14	25	8	4	0	.892
'50/SB, Kal	36	.176	74	13	2	0	0	3	9	22	5	5	36	67	18	9	2	.904
'51/SB	24	.205	44	9	0	0	0	1	6	5	2	3	24	52	14	6	1	.917
'52/SB	34	.100	50	5	0	0	0	2	20	15	7	0	34	89	15	5	0	.954
'53/SB	90	.187	262	49	8	0	0	6	38	48	26	22	88	366	69	25	5	.946
'54/SB	81	.186	226	42	5	1	4	12	42	33	26	19	81	291	55	10	8	.972
Car (6 yrs)	280	.177	678	120	16	1	4	24	116	132	67	49	277	890	179	59	16	.948
Play (2 yrs)	8	.190	21	4	0	0	0	0	—	—	3	1	7	36	4	2	1	.952

Bayse (Schuller), Betty (Hometown: Bisbee, AZ; Died: 1992, OF)

	Hitting												Fielding					
YEAR/TEAM	G	BA	AB	H	2B	3B	HR	SB	BB	SO	R	RBI	G	PO	A	E	DP	FA
'50/Spr-																		
Chic	49	.220	200	44	2	2	0	14	—	—	20	30	No record					

Beare, Kathryn "Katie" (Born: 11/7/17, Syracuse, NY; Died: 1/27/97, BR, TR, 5'7", 170, C)

	Hitting												Fielding					
YEAR/TEAM	G	BA	AB	H	2B	3B	HR	SB	BB	SO	R	RBI	G	PO	A	E	DP	FA
'46/FW	24	.111	45	5	0	0	0	0	6	3	1	0	24	61	10	4	2	.947

Bellman, Lois "Punky" (Hometown: Berwyn, IL, 2B)

	Hitting												Fielding					
YEAR/TEAM	G	BA	AB	H	2B	3B	HR	SB	BB	SO	R	RBI	G	PO	A	E	DP	FA
'49/																		
Chic-Spr	No record																	

Berger (Brown), Barbara Ann "Bergie" (Born: 12/6/30, Maywood, IL, BR, TR, 5'2", 115, C)

	Hitting											Fielding						
YEAR/TEAM	G	BA	AB	H	2B	3B	HR	SB	BB	SO	R	RBI	G	PO	A	E	DP	FA
'49/Chic	No record																	
'50/Rac	11	.176	17	3	0	0	0	1	1	3	2	1	10	18	2	5	0	.800

Berger (Knebl), Joan "Bergie" (Born: 10/9/33, Passaic, NJ, BR, TR, 5'4", 132 3B, 2B, SS, OF, P)

see Pitchers

	Hitting											Fielding						
YEAR/TEAM	G	BA	AB	H	2B	3B	HR	SB	BB	SO	R	RBI	G	PO	A	E	DP	FA
'51/Roc	48	.194	155	30	2	1	0	4	18	20	20	15	45	72	29	6	6	.944
'52/Roc	109	.251	382	96	5	6	1	24	39	34	54	33	No record					
'53/Roc	103	.247	368	91	8	3	1	31	44	16	56	28	103	196	366	68	32	.892
'54/Roc	85	.280	289	81	12	2	2	19	18	5	43	22	79	106	147	22	22	.920
Car (4 yrs)	345	.250	1194	298	27	12	4	78	119	75	173	98	227	374	542	96	60	.905
Play (3 yrs)	18	.299	67	20	1	0	0	3	—	—	6	9	18	44	40	0	1	1.000

Beschorner (Baskovich), Mary Lou "Bush" (Born: 9/18/29, Sandwich, IL, BR, 5'9", 145, OF)

	Hitting											Fielding						
YEAR/TEAM	G	BA	AB	H	2B	3B	HR	SB	BB	SO	R	RBI	G	PO	A	E	DP	FA
'49/GR	36	.165	85	14	2	1	0	3	2	19	5	4	23	28	1	4	0	.879
'50/Peo	49	.150	133	20	3	0	0	1	10	22	7	10	41	49	3	0	0	1.000
Car (2 yrs)	85	.156	218	34	5	1	0	4	12	41	12	14	64	77	4	4	0	.953
Play (1 yr)	2	.000	6	0	0	0	0	—	—	0	0	2	2	4	0	0	0	1.000

Bevis, Muriel (Born: 10/7/28, Corona, NY, TL, BL, OF, P)

see Pitchers

	Hitting											Fielding						
YEAR/TEAM	G	BA	AB	H	2B	3B	HR	SB	BB	SO	R	RBI	G	PO	A	E	DP	FA
'50/Ken	56	.212	165	35	4	2	1	4	5	38	13	13	46	43	3	6	2	.885
Play (1 yr)	2	.000	2	0	0	0	0	0	—	—	0	0	—	—	—	—	—	—

Blaski, Alice (Hometown: Wallingford, CT; Died: Date Unknown, BR, TR, OF)

	Hitting											Fielding						
YEAR/TEAM	G	BA	AB	H	2B	3B	HR	SB	BB	SO	R	RBI	G	PO	A	E	DP	FA
'53/FW	47	.198	162	32	1	2	2	22	24	16	33	14	39	60	5	3	0	.956
'54/FW	45	.257	144	37	4	2	3	1	34	18	35	17	45	55	5	3	0	.952
Car (2 yrs)	92	.225	306	69	5	4	5	23	58	34	68	31	84	115	10	6	0	.954
Play (1 yr)	2	.000	7	0	0	0	0	0	—	—	0	0	2	3	0	0	0	1.000

Bleiler (Thomas), Audrey (Born: 1/12/33, Philadelphia, PA; Died: 6/20/75 BR, TR, 5'7", 125, 3B, SS)

	Hitting											Fielding						
YEAR/TEAM	G	BA	AB	H	2B	3B	HR	SB	BB	SO	R	RBI	G	PO	A	E	DP	FA
'50/SB	23	.093	43	4	0	0	0	0	6	11	5	3	22	16	41	13	3	.814
'51/SB	64	.202	168	34	3	3	0	6	21	19	22	21	61	46	130	11	4	.941
'52/SB	16	.180	50	9	1	0	0	3	6	12	4	6	16	32	42	8	0	.902
Car (3 yrs)	103	.180	261	47	4	3	0	9	33	42	31	30	99	94	213	32	7	.906
Play (1 yr)	7	.286	21	6	0	0	0	0	—	—	1	0	7	5	14	0	0	1.000

Blumetta, Catherine "Kay" "Swish" (Born: 5/1/23, North Plainfield, NJ, BR, TR, 5'8", 150, OF, 1B, P)
see Pitchers

	Hitting												Fielding					
YEAR/TEAM	G	BA	AB	H	2B	3B	HR	SB	BB	SO	R	RBI	G	PO	A	E	DP	FA
'44/Mil, Mpls	33	.110	82	9	1	0	0	4	16	19	7	7	37	154	6	4	7	.976

Borg (Alpin), Lorraine "Borgie" (Born: 7/18/23, Minneapolis, MN, BR, TR, 5'9", 145, C)

	Hitting												Fielding					
YEAR/TEAM	G	BA	AB	H	2B	3B	HR	SB	BB	SO	R	RBI	G	PO	A	E	DP	FA
'44/Mpls	23	.133	83	11	0	0	0	2	7	5	7	2	23	157	12	10	1	.944

Boyce, Ethel (Born: 6/27/17, Vancouver, BC, Canada, BR, TR, 5'8", 130, OF, 1B, C)

	Hitting												Fielding					
YEAR/TEAM	G	BA	AB	H	2B	3B	HR	SB	BB	SO	R	RBI	G	PO	A	E	DP	FA
'46/Ken	5	.000	3	0	0	0	0	—	—	—	—	—	—	—	—	—	—	— —

Briggs, Rita "Maude" (Born: 9/6/24 Ayer, MA; Died: 9/6/94, BL, TR, 5'3", 120, C, OF)

	Hitting												Fielding					
YEAR/TEAM	G	BA	AB	H	2B	3B	HR	SB	BB	SO	R	RBI	G	PO	A	E	DP	FA
'47/Roc	79	.215	270	26	3	1	1	26	25	28	26	15	75	150	23	8	5	.956
'48/Roc, Chic	128	.200	425	85	6	7	0	43	47	38	39	37	129	252	47	17	10	.946
'49/SB, Rac, Peo	72	.222	221	49	1	0	0	22	16	16	23	21	67	156	51	9	2	.958
'50/Peo	104	.216	338	73	9	1	1	14	47	22	39	26	103	398	84	14	6	.972
'51/Peo	106	.275	363	100	6	1	0	29	55	9	57	44	106	342	114	22	20	.954
'52/BC	111	.185	384	71	8	0	1	20	37	14	36	29	111	301	96	23	8	.945
'53/FW	80	.231	234	54	6	0	0	19	45	6	28	22	73	279	56	11	5	.968
'54/FW	77	.213	230	49	3	0	3	13	46	12	26	33	65	234	25	4	1	.985
Car (8 yrs)	757	.206	2465	507	42	10	6	186	318	145	274	227	729	2112	496	108	57	.960
Play (2 yrs)	4	.000	13	0	0	0	0	0	—	—	0	0	3	18	2	1	1	.952

Briggs, Wilma "Willie" "Briggsie" (Born: 11/6/30, East Greenwich, RI, BL, TR, 5'4", 138, OF, 1B)

	Hitting												Fielding					
YEAR/TEAM	G	BA	AB	H	2B	3B	HR	SB	BB	SO	R	RBI	G	PO	A	E	DP	FA
'48/FW	67	.228	193	44	0	6	1	2	42	19	14	15	62	51	3	7	0	.885
'49/FW	109	.202	362	73	2	5	1	15	56	30	38	23	109	100	11	6	4	.949
'50/FW	107	.275	396	109	13	1	3	29	79	31	69	38	107	126	12	4	1	.972
'51/FW	102	.275	385	106	12	2	1	32	58	23	64	43	101	289	17	7	8	.978
'52/FW	105	.256	399	102	16	4	3	1	44	46	46	50	105	191	8	7	1	.966
'53/FW	109	.257	404	104	14	5	9	33	59	32	75	59	407	208	12	9	3	.961
'54/SB	92	.300	317	95	7	1	25	16	42	33	69	73	92	126	2	4	0	.970
Car (7 yrs)	691	.258	2456	633	64	24	43	128	380	214	375	301	683	1092	65	44	17	.963
Play (7 yrs)	38	.259	143	37	3	0	0	2	—	—	18	7	49	55	5	5	3	.923

Brody, Leola "Bubbles" (Hometown: Chicago, IL; Died: 12/14/97 U)

	Hitting												Fielding					
YEAR/TEAM	G	BA	AB	H	2B	3B	HR	SB	BB	SO	R	RBI	G	PO	A	E	DP	FA
'43/Rac	No record																	

Brumfield (White), Delores "Dolly" (Born: 5/26/32, Prichard, AL, BR, TR, 5'6", 125, 1B, 2B, 3B, OF)

YEAR/TEAM	Hitting											Fielding						
	G	BA	AB	H	2B	3B	HR	SB	BB	SO	R	RBI	G	PO	A	E	DP	FA
'47/SB	39	.117	103	12	0	0	0	6	15	15	8	4	32	42	85	18	3	.876
'48/Ken	86	.142	261	37	3	0	0	18	28	60	18	17	87	480	47	13	8	.976
'49/Ken	80	.212	274	58	4	3	0	20	30	26	27	26	77	870	26	8	34	.991
'50/Ken	108	.264	409	108	14	7	1	29	44	23	58	37	108	1210	34	15	69	.988
'51/Ken	66	.273	216	59	14	3	0	13	31	15	23	27	60	535	52	7	28	.988
'52/FW	88	.218	293	64	13	1	1	10	48	22	33	23	85	173	200	28	30	.930
'53/FW	66	.332	211	70	13	3	2	11	51	15	48	26	49	481	9	6	21	.988
Car (7 yrs)	533	.231	1767	408	61	17	4	107	247	176	215	160	498	3841	453	95	193	.978
Play (4 yrs)	11	.205	30	8	1	1	0	2	—	—	1	0	11	82	7	1	2	.989

Buckley, Jean "Buckets" (Born: 12/4/31, Boston, MA, BR, TR, 5'9", 145, OF)

YEAR/TEAM	Hitting											Fielding						
	G	BA	AB	H	2B	3B	HR	SB	BB	SO	R	RBI	G	PO	A	E	DP	FA
'50/Ken	71	.207	222	46	6	4	2	5	13	38	23	22	66	73	8	11	3	.880
'51/Ken	88	.198	288	57	6	1	1	14	31	50	23	31	87	134	16	17	4	.898
'52/Roc	96	.196	317	62	8	4	1	14	22	61	31	35	92	131	11	13	2	.916
Car (3 yrs)	255	.200	827	165	20	6	7	33	66	149	77	88	245	338	35	41	0	.901
Play (2 yrs)	12	.341	44	15	1	1	2	2	—	—	3	8	12	17	1	2	0	.900

Bureker, Geraldine (Born: 12/18/24, Portland, OR, BR, TR, 5'2", 125, OF)

YEAR/TEAM	Hitting											Fielding						
	G	BA	AB	H	2B	3B	HR	SB	BB	SO	R	RBI	G	PO	A	E	DP	FA
'48/Rac	28	.140	53	8	0	0	0	2	9	9	5	2	22	8	1	0	1	1.000

Burkovich, Shirley "Hustle" (Born: 2/4/33, Swissvale, PA, BR, TR, 5'8", 150, OF, P)
see Pitchers

YEAR/TEAM	Hitting											Fielding						
	G	BA	AB	H	2B	3B	HR	SB	BB	SO	R	RBI	G	PO	A	E	DP	FA
'50/Chic/Spr	20	.286	77	22	0	2	0	4	10	7	16	16	—	—	—	—	—	—
'51/Roc	17	.071	28	2	0	0	0	0	2	7	2	0	—	—	—	—	—	—

Burmeister (Dean), Elleen "Burmy" (Born: 11/30/24, Thiensville, WI; Died: 3/23/90, BL, TL, 5'5", 140, U)

YEAR/TEAM	Hitting											Fielding						
	G	BA	AB	H	2B	3B	HR	SB	BB	SO	R	RBI	G	PO	A	E	DP	FA
'43/Roc	105	.191	377	72	8	7	0	12	36	30	39	41	110	152	184	41	7	.891
'44/Roc	62	.211	194	41	2	4	0	15	26	16	18	19	57	60	45	11	1	.905
Car (2 yrs)	167	.198	571	113	101	11	0	27	62	46	57	60	167	212	229	52	8	.895

Calacurcio (Thomas), Aldine (Hometown: Rockford, IL, SS)

YEAR/TEAM	Hitting											Fielding						
	G	BA	AB	H	2B	3B	HR	SB	BB	SO	R	RBI	G	PO	A	E	DP	FA
'47/Roc	No record																	

Callaghan (Candaele, St. Aubin), Helen "Cally" (Born: 3/13/23, Vancouver, BC, Canada; Died: 12/8/92, BL, TL, 5'1", 115, OF)

YEAR/TEAM	Hitting											Fielding						
	G	BA	AB	H	2B	3B	HR	SB	BB	SO	R	RBI	G	PO	A	E	DP	FA
'44/Mpls	111	.287	397	114	5	4	3	112	73	39	81	17	109	130	4	10	1	.931
'45/FW	111	.299	408	122	17	4	3	92	52	34	77	29	111	210	11	11	4	.953

YEAR/TEAM	Hitting											Fielding						
	G	BA	AB	H	2B	3B	HR	SB	BB	SO	R	RBI	G	PO	A	E	DP	FA
'46/FW	112	.213	399	85	10	3	1	114	73	61	70	26	112	249	20	23	3	.921
'48/FW	54	.191	178	34	3	4	0	36	23	27	21	13	51	93	4	7	1	.933
'49/Ken	107	.251	374	94	9	5	0	65	50	59	50	32	106	141	4	4	0	.973
Car (5 yrs)	495	.256	1756	449	44	20	7	419	271	220	299	117	489	823	43	55	9	.940
Play (2 yrs)	12	.289	38	11	1	0	0	9	—	—	4	1	12	22	1	4	0	.852

Callaghan (Maxwell), Margaret (Born: 12/23/21, Vancouver, BC, Canada, BR, TR, 5'3", 112, 3B, 2B)

YEAR/TEAM	Hitting												Fielding					
	G	BA	AB	H	2B	3B	HR	SB	BB	SO	R	RBI	G	PO	A	E	DP	FA
'44/Mpls	47	.182	154	28	1	0	0	20	20	18	19	10	47	69	95	11	5	.937
'45/FW	99	.196	280	55	1	1	1	20	54	45	34	17	99	176	238	40	10	.912
'46/FW	111	.188	340	64	2	3	1	80	88	52	72	11	111	236	290	52	21	.910
'47/FW	104	.201	324	65	2	1	1	57	61	63	40	23	102	228	172	40	19	.909
'48/FW	112	.187	391	73	2	3	0	42	49	72	44	27	112	241	174	24	36	.945
'49/SB	62	.169	160	27	3	0	0	24	26	23	26	16	56	101	114	19	11	.919
'50/Peo	30	.157	70	11	1	0	0	14	20	8	5	5	30	27	72	6	5	.943
'51/Peo, BC	107	.236	339	80	6	1	0	26	53	38	40	34	105	138	318	32	23	.934
Car (8 yrs)	672	.196	2058	403	18	9	3	283	371	319	280	143	662	1218	1473	224	130	.923
Play (3 yrs)	25	.146	82	12	2	0	1	5	—	—	6	2	21	52	30	6	4	.932

Callow, Eleanor "Squirt" (Hometown: Winnipeg, MB, Canada; Died: Date Unknown, BB, TR, OF, P)
see Pitchers

YEAR/TEAM	Hitting												Fielding					
	G	BA	AB	H	2B	3B	HR	SB	BB	SO	R	RBI	G	PO	A	E	DP	FA
'47/Peo	51	.245	143	35	5	2	0	7	3	11	18	14	41	34	6	2	1	.952
'48/Chic, Roc	114	.251	387	97	6	15	6	19	23	38	43	52	107	144	10	10	3	.939
'49/Roc	105	.227	387	88	3	11	2	25	26	29	34	36	104	206	17	3	2	.987
'50/Roc	109	.259	409	105	12	11	7	24	33	29	47	56	109	180	14	14	3	.933
'51/Roc	106	.326	380	124	16	10	4	40	49	23	66	84	104	205	11	3	5	.986
'52/Roc	107	.253	400	101	14	6	8	39	42	25	56	49	105	236	12	8	3	.969
'53/Roc	100	.303	386	117	23	4	8	37	39	19	58	58	99	182	12	10	1	.951
'54/Roc	86	.326	273	89	9	1	20	23	50	18	59	58	85	129	5	10	1	.931
Car (8 yrs)	778	.273	2765	756	88	60	55	214	147	192	381	407	754	1316	87	60	19	.960
Play (5 yrs)	47	.322	171	55	9	3	3	11	—	—	24	32	171	75	5	4	1	.952

Carey, Mary "Pepper" (Born: 9/8/25, Detroit, MI; Died: 1977, BR, 5'3", 3B, 2B)

YEAR/TEAM	Hitting												Fielding					
	G	BA	AB	H	2B	3B	HR	SB	BB	SO	R	RBI	G	PO	A	E	DP	FA
'46/Ken	103	.152	310	47	3	0	0	42	17	38	32	20	95	119	258	37	15	.911
'47/Peo	67	.180	194	35	1	0	0	12	17	14	17	16	63	106	114	23	8	.904
'48/Peo	122	.178	428	76	6	3	0	37	50	53	49	29	118	203	297	42	18	.923
'49/Peo	97	.164	330	54	3	1	1	17	25	24	21	22	81	140	215	36	11	.908
'50/Peo	109	.235	412	97	12	2	0	37	45	40	54	24	110	136	306	57	13	.886
'51/Peo	102	.176	374	66	8	2	1	27	36	30	47	22	95	245	168	37	28	.918
'52/Kal	65	.209	196	41	1	0	0	5	18	15	23	2	55	101	34	8	8	.944
'53/Kal, Mus, Roc	91	.174	311	54	2	1	0	13	32	21	22	17	90	200	187	31	30	.926
'54/SB	84	.210	252	53	5	0	0	8	23	20	16	17	83	221	155	26	38	.906
Car (9 yrs)	596	.186	2807	523	41	9	2	198	263	255	281	169	734	1065	1761	307	169	.902
Play (3 yrs)	10	.464	28	13	2	0	0	1	—	—	1	2	9	16	18	3	2	.919

Castillo (Kinney), Ysora "Chico" (Born: 5/16/32, Havana, Cuba, BR, TR, 5'1", 117, 2B, 3B)

	Hitting												Fielding					
YEAR/TEAM	G	BA	AB	H	2B	3B	HR	SB	BB	SO	R	RBI	G	PO	A	E	DP	FA
'49/Chic	No record																	
'50/																		
Chic-Spr	No record																	
'50/Kal	96	.135	207	28	6	2	0	6	52	39	20	14	96	115	215	29	15	.919
'51/Kal, Ken	83	.120	192	23	1	0	0	2	50	31	18	9	83	128	187	21	20	.938
Car (2 yrs)	179	.128	399	51	7	2	0	8	102	70	38	23	179	243	402	50	35	.928

Chester, Bea (Hometown: Brooklyn, NY, BR, TR, 3B)

	Hitting												Fielding					
YEAR/TEAM	G	BA	AB	H	2B	3B	HR	SB	BB	SO	R	RBI	G	PO	A	E	DP	FA
'43/SB	18	.190	58	11	2	1	0	6	7	8	6	5	17	25	31	17	1	.767
'44/Roc	11	.214	42	9	0	1	0	1	6	8	4	4	–	–	–	–	–	–
Car (2 yrs)	29	.200	100	20	2	2	0	7	13	16	10	9	17	25	31	17	1	.767

Chiano, Clara "Gabby" (Born: 9/19/21, Dorchester, MA, BR, TR, 5', 108, U)

	Hitting												Fielding					
YEAR/TEAM	G	BA	AB	H	2B	3B	HR	SB	BB	SO	R	RBI	G	PO	A	E	DP	FA
'44/Rac	No record																	

Christ, Dorothy (Born: 9/19/25, La Porte, IN)

	Hitting												Fielding					
YEAR/TEAM	G	BA	AB	H	2B	3B	HR	SB	BB	SO	R	RBI	G	PO	A	E	DP	FA
'48/SB	1	.000	0	0	–	–	–	–	–	–	–	–	–	–	–	–	–	–

Cione, Jean "Cy" (Born: 6/23/28, Rockford, Ill., BL, TL, 5'8", 143, OF, 1B, P)
see Pitchers

	Hitting												Fielding					
YEAR/TEAM	G	BA	AB	H	2B	3B	HR	SB	BB	SO	R	RBI	G	PO	A	E	DP	FA
'45/Roc	20	.093	45	4	0	0	0	0	5	10	2	1	14	19	0	1	0	.950
'46/Peo	106	.172	343	59	2	5	0	24	42	53	32	23	100	1027	36	32	33	.971
'47/Roc,																		
Ken	65	.166	163	27	2	5	1	10	8	38	15	11	20	202	3	7	3	.967
'48/Ken	60	.168	173	29	3	4	1	5	20	55	14	14	30	346	5	6	7	.983
'49/Ken	84	.220	245	54	3	7	0	16	23	42	24	27	34	352	10	6	7	.984
'50/Ken	79	.250	268	67	7	3	1	10	17	39	29	37	40	67	4	2	2	.973
'51/Ken	80	.243	292	71	11	0	1	10	17	27	31	34	67	414	22	16	13	.965
'52/BC	94	.275	320	88	17	2	0	7	45	31	43	32	78	189	6	10	0	.951
'53/Mus	96	.244	356	87	15	1	0	4	32	34	27	41	94	917	35	17	43	.982
'54/Roc	74	.256	242	62	8	0	4	0	23	24	23	27	67	559	23	7	45	.988
Car (10 yrs)	758	.224	2447	548	67	27	8	86	232	299	240	247	544	4092	144	104	153	.976
Play (2 yrs)	5	.158	19	3	0	1	0	0	–	–	1	3	5	15	9	1	0	.960

Clark, Corrine (Born: 9/28/12, Yorkville, IL, TR, BR, U)

	Hitting												Fielding					
YEAR/TEAM	G	BA	AB	H	2B	3B	HR	SB	BB	SO	R	RBI	G	PO	A	E	DP	FA
'47/Peo	No record																	

Colacito (Appugliese), Lucille "Lou" (Born: 12/27/21, Florence, CO; Died: 1/30/98, BR, TR, 5'3", 120, C)

	Hitting											**Fielding**						
YEAR/TEAM	G	BA	AB	H	2B	3B	HR	SB	BB	SO	R	RBI	G	PO	A	E	DP	FA
'44/Ken	85	.179	268	48	7	0	1	21	24	28	23	22	81	317	44	17	3	.955
'45/Ken	68	.141	177	25	2	0	1	42	14	22	14	6	68	253	21	5	6	.981
Car (2 yrs)	153	.164	445	73	9	0	2	42	38	50	37	28	149	560	65	22	9	.966
Play (1 yr)	3	.154	13	2	0	0	0	0	0	0	1	0	3	20	4	3	1	.889

Cook, Donna "Cookie" (Born: 5/24/28, Muskegon, MI, BR, TL, 5'2", 121, OF, P)
see Pitchers

	Hitting											**Fielding**						
YEAR/TEAM	G	BA	AB	H	2B	3B	HR	SB	BB	SO	R	RBI	G	PO	A	E	DP	FA
'46/Mus	78	.156	231	36	2	3	0	4	20	16	18	14	78	95	15	6	2	.948
'47/Mus	48	.172	134	23	1	0	0	4	4	8	6	7	22	23	4	1	2	.964
'48/Mus, FW	41	.123	81	10	0	0	0	6	14	13	8	6	18	20	7	0	0	1.000
'51/BC	102	.187	358	67	6	1	0	11	20	18	18	17	84	149	11	8	1	.952
'52/BC	62	.246	207	51	5	3	0	13	9	16	27	11	60	152	10	8	5	.953
'53/Mus, SB	53	.198	131	26	2	0	0	6	14	5	12	10	43	65	3	4	0	.944
'54/Roc	55	.217	152	33	4	0	2	2	14	9	10	11	53	64	13	2	0	.875
Car (7 yrs)	439	.190	1294	246	20	7	2	46	95	85	99	76	358	568	63	29	10	.956
Play (1 yr)	3	.250	8	2	0	0	0	1	—	—	0	2	—	—	—	—	—	—

Cook, Doris "Little Cookie" (Born: 6/23/31, Muskegon, MI, BR, TR, 5'1", 130, OF, P)
see Pitchers

	Hitting											**Fielding**						
YEAR/TEAM	G	BA	AB	H	2B	3B	HR	SB	BB	SO	R	RBI	G	PO	A	E	DP	FA
'51/Kal	18	.094	32	3	0	0	0	1	8	5	5	4	10	12	1	0	0	1.000
'52/Kal	55	.118	152	18	1	0	0	0	13	20	10	6	55	101	6	5	0	.955
'53/Kal, SB	36	.167	66	11	0	0	0	0	8	8	4	4	27	34	0	2	0	.944
Car (3 yrs)	109	.128	250	32	1	0	0	1	29	33	19	14	82	147	7	7	0	.957

Cook, Dorothy (Hometown: St. Catherines, ON, Canada, U)

	Hitting											**Fielding**						
YEAR/TEAM	G	BA	AB	H	2B	3B	HR	SB	BB	SO	R	RBI	G	PO	A	E	DP	FA
'46/FW, Roc	14	.000	24	0	0	0	0	1	5	5	0	2	—	—	—	—	—	—

Cornett , Betty Jane "Curly" (Born: 11/24/32, Pittsburgh, PA, BR, TR, 5'5", 125, 3B, P)
see Pitchers

'50/Chic-Spr	66	.205	264	54	5	3	0	19	26	32	36	37	—	—	—	—	—	—
'51/BC, Kal	47	.132	114	15	2	0	0	7	18	30	10	6	39	32	78	18	2	.859

Courtney, Patricia (Born: 10/8/31, Everett, MA, BR, TR, 5'5", 125, 3B)

	Hitting											**Fielding**						
YEAR/TEAM	G	BA	AB	H	2B	3B	HR	SB	BB	SO	R	RBI	G	PO	A	E	DP	FA
'50/ Chic-Spr	44	.181	166	30	1	0	0	1	20	16	20	12	—	—	—	—	—	—
'50/GR	10	.059	17	1	0	0	0	0	3	8	3	0	—	—	—	—	—	—

Cramer, Peggy (Born: 6/22/37, Buchanan, MI, BR, TR, 5'4", 125, C)

	Hitting											**Fielding**						
YEAR/TEAM	G	BA	AB	H	2B	3B	HR	SB	BB	SO	R	RBI	G	PO	A	E	DP	FA
'54/SB	No record — played less than 10 games																	

Crawley, Pauline "Hedy" (Born: 9/11/24, Phoenix, AZ, BR, TR, 5'4", 145, OF)

	Hitting												Fielding					
YEAR/TEAM	G	BA	AB	H	2B	3B	HR	SB	BB	SO	R	RBI	G	PO	A	E	DP	FA
'46/Peo	20	.086	81	7	0	0	0	2	4	9	7	4	19	19	7	3	1	.897
'51/BC	105	.178	337	60	2	2	0	19	29	35	33	21	100	147	10	6	2	.963
Car (2 yrs)	125	.160	418	67	2	2	0	21	33	44	40	25	119	166	17	9	3	.953

Crigler, Idona (Hometown: California, BR, TR, 3B)

	Hitting												Fielding					
YEAR/TEAM	G	BA	AB	H	2B	3B	HR	SB	BB	SO	R	RBI	G	PO	A	E	DP	FA
'47/SB	20	.138	65	9	0	0	0	0	5	7	2	0	20	32	47	7	3	.919
Play (1 yr)	4	.154	13	2	0	0	0	0	—	—	1	2	5	3	4	2	0	.778

Crites, Shirley "Squirrely" (Born: 8/21/34, Cape Giradeau, MO; Died 12/28/90, TR, BR, 3B)

	Hitting												Fielding					
YEAR/TEAM	G	BA	AB	H	2B	3B	HR	SB	BB	SO	R	RBI	G	PO	A	E	DP	FA
'53/FW	47	.129	132	17	3	1	0	7	15	17	15	11	42	41	92	11	5	.924
Play (1 yr)	1	.000	3	0	0	0	0	0	—	—	1	0	1	1	0	0	0	1.000

Dabbs, Sarah Mavis (Born: 3/10/22, Largo, FL, BR, TR, 5'5", 130, OF)

	Hitting												Fielding					
YEAR/TEAM	G	BA	AB	H	2B	3B	HR	SB	BB	SO	R	RBI	G	PO	A	E	DP	FA
'47/FW	12	.091	22	2	0	0	0	1	2	1	0	1	—	—	—	—	—	—

Daetweiler, Louella "Daets" (Born: 4/30/18, Lynwood, CA, BR, TR, 5'3", 160, C)

	Hitting												Fielding					
YEAR/TEAM	G	BA	AB	H	2B	3B	HR	SB	BB	SO	R	RBI	G	PO	A	E	DP	FA
'44/Roc	33	.079	76	6	0	0	0	4	6	3	4	8	19	38	7	12	0	.789

Dailey, Mary (Hometown: Lexington, MA; Died: Date Unknown, OF, P)
see Pitchers

	Hitting												Fielding					
YEAR/TEAM	G	BA	AB	H	2B	3B	HR	SB	BB	SO	R	RBI	G	PO	A	E	DP	FA
'50/SB, Peo	54	.138	159	22	2	1	0	1	15	25	16	10	53	57	3	5	2	.923
'51/Peo, SB, BC60		.187	155	29	2	0	0	9	19	23	8	6	60	106	3	4		.965
Car (2 yrs)	114	.162	314	51	4	1	0	10	34	48	24	16	113	163	6	9	2	.950

Damaschke, Dorothy "DD" (Born: 8/26/17, Racine, WI, BR, TR, 5'3", 135, U)

	Hitting												Fielding					
YEAR/TEAM	G	BA	AB	H	2B	3B	HR	SB	BB	SO	R	RBI	G	PO	A	E	DP	FA
'45/Rac	1	.000	2	0	—	—	—	—	—	—	—	—	No record					

Dancer, Faye "Fanny" (Born: 4/24/25, Santa Monica, CA, BR, TR, 5'6", 145, OF, 1B, P)
see Pitchers

	Hitting												Fielding					
YEAR/TEAM	G	BA	AB	H	2B	3B	HR	SB	BB	SO	R	RBI	G	PO	A	E	DP	FA
'44/Mpls	96	.274	329	90	6	5	2	63	53	24	58	48	86	118	17	6	4	.957
'45/FW	108	.195	343	67	7	1	3	29	46	38	44	29	89	147	15	11	4	.936
'46/FW	110	.250	368	92	11	5	1	68	52	22	56	43	99	307	8	12	11	.963
'47/FW, Peo	106	.237	380	90	11	1	2	71	43	30	51	26	101	186	21	8	1	.963

Hitting / Fielding

YEAR/TEAM	G	BA	AB	H	2B	3B	HR	SB	BB	SO	R	RBI	G	PO	A	E	DP	FA
'48/Peo	122	.237	459	109	10	2	6	102	55	79	89	34	120	216	18	8	4	.967
'50/Peo	49	.207	193	40	8	0	2	19	12	30	25	13	49	87	4	3	1	.968
Car (6 yrs)	591	.236	2072	488	53	14	16	352	261	223	323	193	544	1061	83	48	25	.960
Play (2 yrs)	10	.265	34	9	0	1	1	0	—	—	9	6	8	12	1	0	0	1.000

D'Angelo, Josephine "Jo Jo" (Born: 11/23/24, Chicago, IL, BR, TR, 5', 135, OF)

YEAR/TEAM	G	BA	AB	H	2B	3B	HR	SB	BB	SO	R	RBI	G	PO	A	E	DP	FA
'43/SB	104	.221	358	79	9	2	2	53	55	3	62	38	104	148	22	11	7	.939
'44/SB	40	.149	141	21	0	0	0	9	12	8	11	9	40	56	5	0	1	1.000
Car (2 yrs)	144	.200	499	100	9	2	2	62	67	11	73	47	144	204	27	11	8	.955

Danhauser (Brown), Margaret Louise "Marnie" (Born: 6/9/21, Racine, WI; Died: Date Unknown, BR, TR, 1B)

YEAR/TEAM	G	BA	AB	H	2B	3B	HR	SB	BB	SO	R	RBI	G	PO	A	E	DP	FA
'43/Rac	61	.167	162	27	2	1	0	6	8	11	18	21	61	543	14	15	10	.974
'44/Rac	109	.149	329	49	0	0	0	27	35	16	34	34	109	1182	23	38	27	.969
'45/Rac	110	.093	335	31	0	0	0	12	20	20	25	10	110	1140	30	15	34	.987
'46/Rac	113	.196	387	76	3	3	2	20	31	21	35	41	113	1123	29	21	29	.982
'47/Rac	112	.124	364	45	0	0	1	15	27	28	21	20	112	1056	63	14	22	.988
'48/Rac	125	.167	390	65	10	6	0	9	32	48	24	38	125	1274	39	20	27	.985
'49/Rac	98	.110	290	32	1	0	0	5	13	45	10	12	98	1091	45	19	30	.984
Car (7 yrs)	728	.144	2257	325	16	10	3	94	166	189	167	176	728	7409	243	142	179	.982
Play (5 yrs)	33	.155	110	17	0	0	0	2	—	—	5	4	33	245	10	5	4	.981

Danz, Shirley (Born: 8/16/26, Oak Park, IL, BR, TR, 5'4", 130, SS, 2B, OF)

YEAR/TEAM	G	BA	AB	H	2B	3B	HR	SB	BB	SO	R	RBI	G	PO	A	E	DP	FA
'49/Chic	No record																	
'50/Rac	23	.145	55	8	0	0	0	1	4	18	4	1	23	18	0	4	0	.818

Dapkus (Wolf), Eleanor "Slugger" (Born: 12/5/23, Chicago, IL, BR, TR, 5'6", 160, OF, P)
see Pitchers

YEAR/TEAM	G	BA	AB	H	2B	3B	HR	SB	BB	SO	R	RBI	G	PO	A	E	DP	FA
'43/Rac	89	.220	309	68	6	5	10	25	30	16	38	43	88	94	19	11	4	.911
'44/Rac	103	.273	362	99	10	4	5	46	34	17	48	56	103	70	11	7	1	.920
'45/Rac	100	.229	345	79	9	2	0	21	46	21	26	37	100	73	13	1	3	.989
'46/Rac	112	.253	403	102	6	9	8	25	51	36	49	57	112	117	10	4	5	.969
'47/Rac	112	.216	398	86	7	5	2	16	35	59	25	41	110	134	16	2	3	.987
'48/Rac	116	.202	411	83	5	6	4	18	43	57	39	46	81	76	8	1	0	.988
'49/Rac	68	.226	155	35	3	1	0	1	16	18	11	16	21	23	2	1	0	.962
'50/Rac	75	.187	166	31	4	4	1	2	21	28	13	21	25	22	0	1	0	.957
Car (8 yrs)	775	.229	2549	583	50	36	30	154	276	252	275	317	640	609	79	28	16	.960
Play (4 yrs)	29	.130	108	14	0	2	0	2	—	—	10	8	29	20	2	3	1	.880

Davis, Gladys "Terry" (Born: 9/1/19, Toronto, ON, Canada, BR, TR, 5'5", 130, SS, OF, 2B)

YEAR/TEAM	G	BA	AB	H	2B	3B	HR	SB	BB	SO	R	RBI	G	PO	A	E	DP	FA
'43/Roc	102	.332	349	116	7	10	4	53	52	0	78	58	101	183	279	64	14	.878
'44/Roc, Mil	80	.246	277	68	4	1	1	63	38	24	42	34	60	102	94	29	7	.871
'46/Mus	58	.202	193	39	8	0	0	21	23	22	22	31	46	68	119	22	8	.895
Car (3 yrs)	240	.272	819	223	19	11	5	137	113	55	142	123	117	353	492	115	29	.880
Play (1 yr)	7	.333	27	9	0	0	0	8	1	4	3	3	7	19	10	3	1	.906

DeCambra, Alice "Moose" (Born: 8/18/21, Somerset, MA; Died: 6/19/88, BR, TR, 5'3", 126, SS, 2B, P)

see Pitchers

	Hitting											**Fielding**						
YEAR/TEAM	G	BA	AB	H	2B	3B	HR	SB	BB	SO	R	RBI	G	PO	A	E	DP	FA
'46/FW	101	.185	314	58	2	0	0	18	28	11	21	11	70	113	103	20	7	.915
'47/FW,																		
Peo	98	.186	307	57	3	0	0	24	17	16	35	12	79	173	138	16	17	.951
'48/Peo	121	.189	392	74	8	1	0	34	49	26	46	30	121	272	221	19	25	.963
'49/Peo	101	.205	352	72	4	3	0	24	25	18	32	26	101	206	210	28	24	.937
'50/Peo,																		
Kal	69	.244	213	52	12	2	0	7	19	5	18	26	66	162	92	27	27	.904
Car (5 yrs)	490	.198	1578	313	29	6	0	107	138	76	152	105	437	926	764	110	90	.939
Play (1 yr)	4	.214	14	3	0	0	0	1	—	—	1	0	2	—	—	1	—	—

DeCambra, Lillian (Born: 11/21/25, Somerset, MA, BR, TR, 5'2", 102 U)

	Hitting											**Fielding**						
YEAR/TEAM	G	BA	AB	H	2B	3B	HR	SB	BB	SO	R	RBI	G	PO	A	E	DP	FA
'47/FW	No record																	

Deegan, Mildred "Millie" (Born: 12/11/19, Brooklyn, NY, BR, TR, 5'7", 155, OF, 2B, P)

see Pitchers

	Hitting											**Fielding**						
YEAR/TEAM	G	BA	AB	H	2B	3B	HR	SB	BB	SO	R	RBI	G	PO	A	E	DP	FA
'43/Roc	29	.206	97	20	1	2	0	6	8	8	8	17	26	48	37	8	3	.914
'44/Roc	104	.232	353	82	5	5	1	47	38	19	45	39	96	227	153	12	20	.969
'45/Roc	102	.208	346	72	9	5	1	31	46	19	47	34	101	215	156	30	15	.925
'46/Roc	87	.213	272	31	6	5	2	11	23	12	31	25	60	109	72	13	6	.933
'47/Roc,																		
Ken	55	.214	131	28	4	5	0	4	8	8	14	8	23	47	36	8	1	.912
'48/Ken,																		
Spr	49	.210	124	26	6	1	0	0	9	9	6	11	—	—	—	—	—	—
'49/FW	41	.167	90	15	7	0	0	1	13	9	8	4	—	—	—	—	—	—
'50/FW	39	.309	94	29	8	1	1	0	11	10	10	12	—	—	—	—	—	—
'51/FW, Peo	27	.170	53	9	2	0	0	0	4	6	6	2	—	—	—	—	—	—
Car (9 yrs)	533	.217	1560	339	48	24	5	100	160	100	175	152	190	708	759	103	45	.925
Play (1 yr)	8	.120	25	3	0	0	1	0	—	—	1	3	8	17	8	1	1	.962

Deemer, Audrey (Hometown: Steubenville, OH, U)

	Hitting											**Fielding**						
YEAR/TEAM	G	BA	AB	H	2B	3B	HR	SB	BB	SO	R	RBI	G	PO	A	E	DP	FA
'50/																		
Chic-Spr	25	.129	85	9	0	1	0	6	11	16	14	8	—	—	—	—	—	—

Dennert (Hill), Pauline (Born: 4/8/26, Hart, MI, BR, TR, 5'4", 145, OF)

	Hitting											**Fielding**						
YEAR/TEAM	G	BA	AB	H	2B	3B	HR	SB	BB	SO	R	RBI	G	PO	A	E	DP	FA
'47/Mus	3	.000	4	0	—	—	—	—	—	—	—	—	—	—	—	—	—	—

DeNoble, Jerrie (Hometown: Oakland, CA, BR, TR, OF)

	Hitting											**Fielding**						
YEAR/TEAM	G	BA	AB	H	2B	3B	HR	SB	BB	SO	R	RBI	G	PO	A	E	DP	FA
'47/Peo	21	.107	28	3	1	0	0	4	3	11	3	0	11	12	0	1	0	.923

DeShone (Rockwell), Nancy (Born: 3/22/32, Osceola, IN, BL, TL, 5'3", 120, OF)

	Hitting												Fielding					
YEAR/TEAM	G	BA	AB	H	2B	3B	HR	SB	BB	SO	R	RBI	G	PO	A	E	DP	FA
'48/SB	1	.000	2	0	—	—	—	—	—	—	—	—	—	—	—	—	—	—

Dokish, Wanita "Lee" (Born: 4/6/36, Van Meter, PA, BB, TR, 5'5", 125, 3B, OF)

	Hitting												Fielding					
YEAR/TEAM	G	BA	AB	H	2B	3B	HR	SB	BB	SO	R	RBI	G	PO	A	E	DP	FA
'54/Roc	27	.113	44	5	0	0	0	0	10	14	5	2	24	50	28	11	6	.876

Donahue, Terry (Born: 8/22/25, Melaval, SK, Canada, BR, TR, 5'2", 125, C, U)

	Hitting												Fielding					
YEAR/TEAM	G	BA	AB	H	2B	3B	HR	SB	BB	SO	R	RBI	G	PO	A	E	DP	FA
'46/Peo	95	.153	274	42	0	1	0	28	32	38	29	14	85	146	163	26	14	.922
'47/Peo	49	.165	115	19	1	0	0	3	11	10	12	4	39	139	21	10	2	.941
'48/Peo	71	.098	174	17	1	1	0	7	32	31	17	18	65	199	29	13	7	.946
'49/Peo	72	.088	159	14	1	0	0	6	48	28	9	14	69	250	48	7	7	.977
Car (4 yrs)	287	.127	722	92	3	2	0	44	123	107	67	50	258	734	261	56	30	.947
Play (1 yr)	3	.000	9	0	0	0	0	0	—	—	0	0	2	3	5	0	0	1.000

Downs, Dorothea "Dottie" (Hometown: South Bend, IN; Died: Date Unknown, BR, TR, 1B)

	Hitting												Fielding					
YEAR/TEAM	G	BA	AB	H	2B	3B	HR	SB	BB	SO	R	RBI	G	PO	A	E	DP	FA
'45/SB	3	.000	5	0	—	—	—	—	—	—	—	—	No record					

Doyle (Childress), Cartha "Duckie" (Born: 10/12/29, Knoxville, TN, BR, TR, 5'5", 130, 2B)

	Hitting												Fielding					
YEAR/TEAM	G	BA	AB	H	2B	3B	HR	SB	BB	SO	R	RBI	G	PO	A	E	DP	FA
'47/Roc	59	.169	166	28	4	0	0	2	5	24	5	7	46	74	97	9	7	.950

Drinkwater (Simmons), Maxine "Max" (Born: 5/19/36, Camden, ME, BR, 5'5", 136, 1B, 2B)

	Hitting												Fielding					
YEAR/TEAM	G	BA	AB	H	2B	3B	HR	SB	BB	SO	R	RBI	G	PO	A	E	DP	FA
'54/SB	45	.147	95	14	0	0	0	1	12	22	8	4	39	233	27	16	14	.942
Play (1 yr)	1	.000	1	0	0	0	0	0	—	—	0	0	—	—	—	—	—	—

Dunn, Gertrude "Gerty" (Born: 9/30/33, Sharon Hill, PA, BR, TR, 5'2", 125, SS)

	Hitting												Fielding					
YEAR/TEAM	G	BA	AB	H	2B	3B	HR	SB	BB	SO	R	RBI	G	PO	A	E	DP	FA
'51/SB, BC	45	.185	151	28	3	1	0	6	27	9	14	10	39	76	115	18	9	.914
'52/SB	95	.236	326	77	15	2	0	13	31	14	35	21	93	165	288	45	17	.910
'53/SB	112	.179	438	122	17	1	0	26	33	13	46	36	107	184	335	43	18	.923
'54/SB	92	.299	311	93	14	1	6	25	47	10	59	38	92	132	290	34	33	.925
Car (4 yrs)	344	.261	1226	320	49	5	6	70	138	46	154	105	331	557	1028	140	77	.919
Play (2 yr)	10	.256	39	10	0	0	0	0	—	—	8	3	10	13	36	5	3	.907

Dusanko (Sabo), Julianna "Julie" (Born: 2/22/22, Leross, SK, Canada, BR, TR, 5'5", 122, 3B)

	Hitting												Fielding					
YEAR/TEAM	G	BA	AB	H	2B	3B	HR	SB	BB	SO	R	RBI	G	PO	A	E	DP	FA
'44/Mpls, Rac	76	.167	246	41	3	2	0	29	21	26	21	16	58	123	150	38	10	.878

Dwojak, Loretta (Born: 12/19/25, Chicago, IL, BR, TR, 5'5", 135, OF, 3B)

	Hitting											Fielding						
YEAR/TEAM	G	BA	AB	H	2B	3B	HR	SB	BB	SO	R	RBI	G	PO	A	E	DP	FA
'44/Mpls, SB	63	.201	174	35	4	2	0	18	18	17	19	19	39	52	24	7	0	.916

Eisen, Thelma "Tiby" (Born: 5/11/22, Los Angeles, CA, BR, TR, 5'4", 130, OF, P)
see Pitchers

	Hitting											Fielding						
YEAR/TEAM	G	BA	AB	H	2B	3B	HR	SB	BB	SO	R	RBI	G	PO	A	E	DP	FA
'44/Mil	107	.204	392	80	6	3	1	91	28	12	55	41	107	169	14	8	2	.958
'45/GR	103	.240	392	94	16	1	1	41	38	15	44	34	107	220	14	10	4	.959
'46/Peo	99	.256	363	93	3	9	2	128	52	10	68	30	91	155	5	4	0	.976
'47/Peo, FW	111	.216	425	92	5	1	3	1	52	26	49	26	111	207	20	9	6	.962
'48/FW	121	.220	464	102	5	4	1	88	29	25	67	30	119	227	25	10	7	.962
'49/FW	109	.184	424	78	7	0	3	57	36	31	59	18	109	216	13	8	8	.966
'50/FW	106	.238	432	103	20	3	0	75	55	27	87	19	106	217	12	11	5	.954
'51/FW	104	.195	399	78	17	1	0	88	73	14	88	21	104	224	11	8	5	.967
'52/FW	106	.265	415	110	6	1	0	54	35	17	77	22	105	222	10	17	1	.932
Car (9 yrs)	966	.224	3706	830	85	23	11	674	372	164	591	241	959	1857	124	93	38	.955
Play (7 yrs)	43	.270	163	44	4	1	1	31	—	—	20	7	22	53	3	5	0	.918

Emerson, June "Venus" (Born: 6/4/24, Moose Jaw, SK, Canada, BR, TR, 5'5", 135, OF)

	Hitting											Fielding						
YEAR/TEAM	G	BA	AB	H	2B	3B	HR	SB	BB	SO	R	RBI	G	PO	A	E	DP	FA
'48/Spr	47	.182	110	20	1	0	0	6	16	10	8	5	37	27	3	3	0	.909
'49/Peo	21	.122	49	6	1	0	0	1	15	6	3	0	16	13	2	1	0	.938
Car (2 yrs)	68	.164	159	26	2	0	0	7	31	16	11	5	53	40	5	4	0	.918

Emry, Betty (Born: 1/20/23; Died: 4/18/95, Manistique, MI, BR, TR, 5'4", 130, SS, P)

	Hitting											Fielding						
YEAR/TEAM	G	BA	AB	H	2B	3B	HR	SB	BB	SO	R	RBI	G	PO	A	E	DP	FA
'45/Rac	96	.143	280	40	1	0	0	5	26	28	13	29	84	133	159	17	3	.945
'46/Rac	36	.165	85	14	0	0	0	6	17	14	11	5	11	18	14	10	1	.762
Car (2 yrs)	132	.147	365	54	1	0	0	11	43	42	24	34	95	151	173	27	4	.923
Play (1 yr)	4	.067	15	1	0	0	0	0	—	—	1	1	4	4	0	0	0	1.000

English, Madeline "Maddy" (Born: 2/22/25, Everett, MA, BR, TR, 5'4", 130, 3B, SS, 2B)

	Hitting											Fielding						
YEAR/TEAM	G	BA	AB	H	2B	3B	HR	SB	BB	SO	R	RBI	G	PO	A	E	DP	FA
'43/Rac	101	.220	359	79	0	4	0	75	33	21	69	23	101	162	259	89	15	.826
'44/Rac	112	.121	371	45	2	3	0	65	61	37	50	21	112	201	350	63	10	.897
'45/Rac	99	.155	349	54	1	1	0	24	43	41	33	16	98	183	228	52	16	.888
'46/Rac	75	.214	257	55	1	1	1	39	24	19	21	21	75	124	202	30	14	.916
'47/Rac	103	.131	335	44	2	1	1	47	36	49	31	30	101	172	232	37	14	.916
'48/Rac	121	.160	400	64	4	6	0	60	49	72	41	24	121	207	342	40	19	.932
'49/Rac	111	.168	364	61	6	5	0	26	45	44	28	21	111	211	357	47	17	.924
'50/Rac	110	.209	382	80	10	6	4	61	65	32	60	41	110	179	285	72	17	.866
Car (8 yrs)	832	.171	2817	482	26	27	6	397	356	315	333	197	829	1439	2255	430	122	.896
Play (6 yrs)	38	.203	143	29	4	0	1	5	—	—	15	7	38	63	69	14	5	.898

Fabac (Bretting), Elizabeth "Betty" (Born: 4/6/22, Detroit, MI, BR, TR, 5'3", 115, 2B)

	Hitting											Fielding						
YEAR/TEAM	G	BA	AB	H	2B	3B	HR	SB	BB	SO	R	RBI	G	PO	A	E	DP	FA
'45/Ken	105	.199	356	71	2	2	0	41	43	31	41	14	105	175	154	27	16	.924

	Hitting												Fielding					
YEAR/TEAM	G	BA	AB	H	2B	3B	HR	SB	BB	SO	R	RBI	G	PO	A	E	DP	FA
'46/Ken	3	.286	7	2	—	—	—	—	—	—	—	—	No record					
'47/Ken	90	.133	294	39	0	0	1	40	33	25	32	18	81	131	175	14	10	.956
'48/Ken	123	.191	445	85	5	3	0	43	68	58	68	15	123	242	252	19	17	.963
Car (4 yrs)	321	.179	1102	197	7	5	1	124	144	114	141	47	309	548	581	60	43	.950
Play (1 yr)	3	.000	10	0	0	0	0	0	—	—	0	0	3	5	9	0	0	1.000

Faralla, Lillian "Lil" (Born: 6/29/24, Brooklyn, NY, BR, TR, 5'6", 160, 2B, OF, P)

	Hitting												Fielding					
YEAR/TEAM	G	BA	AB	H	2B	3B	HR	SB	BB	SO	R	RBI	G	PO	A	E	DP	FA
'46/Peo	55	.181	138	25	1	0	0	12	14	28	8	13	41	70	64	10	4	.931
'47/FW	32	.279	68	19	3	2	0	7	1	8	7	4	No record					
'48/SB	66	.225	169	38	3	0	0	2	14	23	5	16	18	10	0	3	0	.769
Car (3 yrs)	153	.219	375	82	7	2	0	21	29	59	20	33	59	80	64	13	4	.917

Faut (Winsch, Eastman), Jean (Born: 11/17/25, Greenville, PA, BR, TR, 5'4", 137, 3B, OF, P)

see Pitchers

	Hitting												Fielding					
YEAR/TEAM	G	BA	AB	H	2B	3B	HR	SB	BB	SO	R	RBI	G	PO	A	E	DP	FA
'46/SB	101	.177	344	61	2	2	2	38	58	21	37	40	90	150	349	60	13	.893
'50/SB	76	.217	198	43	7	2	0	15	31	12	23	26	13	20	5	2	1	.926
'51/SB	62	.258	178	46	6	0	2	9	23	11	29	28	29	35	74	5	1	.956
'52/SB	73	.291	230	67	12	0	0	15	27	11	30	32	39	44	119	13	8	.926
'53/SB	98	.275	316	87	11	1	4	17	49	10	33	38	60	75	162	22	11	.915
Car (5 yrs)	410	.240	1266	304	38	5	8	94	188	65	152	164	231	324	709	102	34	.910
Play (2 yrs)	7	.280	25	7	0	0	0	0	—	—	1	4	7	8	21	0	1	1.000

Ferguson (Key), Dorothy "Dottie" (Born: 2/17/23, Winnipeg, MB, Canada, BR, TR, 5'6", 125, 2B, 3B, OF, P)

	Hitting												Fielding					
YEAR/TEAM	G	BA	AB	H	2B	3B	HR	SB	BB	SO	R	RBI	G	PO	A	E	DP	FA
'45/Roc	37	.131	84	11	2	0	0	6	9	14	5	4	11	20	24	6	0	.880
'46/Peo, Roc	80	.183	235	43	0	2	0	39	42	27	43	15	74	138	131	23	10	.921
'47/Roc	112	.166	367	61	2	1	0	71	52	39	51	20	103	178	95	16	11	.915
'48/Roc	123	.153	419	64	6	0	0	73	76	62	73	16	123	185	19	9	3	.958
'49/Roc	103	.179	346	62	6	2	0	56	59	52	51	20	94	161	6	9	4	.949
'50/Roc	102	.234	364	85	5	4	0	36	43	34	61	27	96	185	22	5	3	.976
'51/Roc	107	.216	370	80	6	0	1	91	67	32	91	27	106	190	17	8	5	.963
'52/Roc	108	.243	354	86	8	4	1	46	38	27	54	41	108	217	24	14	3	.945
'53/Roc	101	.208	400	83	8	1	0	29	43	30	56	21	101	215	14	11	5	.954
'54/Roc	77	.253	277	70	6	0	0	14	26	16	35	8	77	127	6	5	1	.964
Car (10 yrs)	950	.201	3216	645	49	14	2	461	455	333	520	199	893	1616	358	106	45	.951
Play (8 yrs)	61	.225	204	46	2	1	0	18	—	—	22	9	61	101	23	7	3	.947

Figlo, Josephine "Phie" (Born: 4/9/23, Milltown, NJ, BR, TR, 5'3", 140, OF)

	Hitting												Fielding					
YEAR/TEAM	G	BA	AB	H	2B	3B	HR	SB	BB	SO	R	RBI	G	PO	A	E	DP	FA
'44/Rac, Mil	15	.059	34	2	1	0	0	4	4	13	7	3	11	11	0	4	0	.733

Filarski (Steffes), Helen "Fil" (Born: 5/11/24, Detroit, MI, BR, TR, 5'2", 125, 3B, 2B, OF)

	Hitting												Fielding					
YEAR/TEAM	G	BA	AB	H	2B	3B	HR	SB	BB	SO	R	RBI	G	PO	A	E	DP	FA
'45/Roc	99	.173	324	56	7	1	0	28	48	30	44	25	99	171	208	49	7	.886

	Hitting											Fielding						
YEAR/TEAM	G	BA	AB	H	2B	3B	HR	SB	BB	SO	R	RBI	G	PO	A	E	DP	FA
'46/Roc	77	.182	231	42	5	3	1	23	43	14	33	23	70	233	202	32	13	.932
'47/Peo, Ken	72	.185	227	42	3	1	0	14	35	21	22	12	56	92	144	23	8	.911
'48/SB	101	.179	324	58	1	1	0	18	48	29	29	29	104	128	161	27	43	.915
'49/SB	92	.207	290	60	3	3	0	19	30	28	31	26	92	136	294	36	16	.923
'50/SB	93	.209	287	60	6	6	0	13	44	15	30	26	92	106	215	33	12	.907
Car (6 yrs)	534	.189	1683	318	25	15	1	115	248	137	189	141	513	866	1224	300	99	.875
Play (4 yrs)	17	.125	56	7	1	0	0	1	—	—	2	3	16	18	25	2	0	.956

Fischer, Alva Jo "Tex" (Born: 8/23/26, San Antonio, TX; Died: Date Unknown, BR, TR, 5'9", 135, SS, P)

	Hitting											Fielding						
YEAR/TEAM	G	BA	AB	H	2B	3B	HR	SB	BB	SO	R	RBI	G	PO	A	E	DP	FA
'45/Roc	17	.182	33	6	0	0	0	0	6	7	3	2	No record					
'46/Mus	42	.309	97	30	5	1	0	1	11	7	11	11	No record					
'47/Mus	112	.202	361	73	7	3	0	28	31	23	22	35	112	217	311	58	22	.901
'48/Mus	107	.252	353	89	10	1	0	14	26	22	31	36	89	165	232	36	11	.917
'49/Mus	109	.198	384	76	2	1	0	22	33	30	24	47	91	187	271	23	15	.972
Car (5 yrs)	345	.216	1131	244	19	5	0	64	96	82	80	120	292	569	814	117	48	.922
Play (3 yrs)	13	.125	48	6	0	1	0	0	—	—	1	1	13	9	13	0	0	1.000

Fisher (Stevens), Lorraine (Born: 7/5/28, Detroit, MI, BR, TR, 5'6", 120, OF, P)
see Pitchers

	Hitting											Fielding						
YEAR/TEAM	G	BA	AB	H	2B	3B	HR	SB	BB	SO	R	RBI	G	PO	A	E	DP	FA
'47/Roc	51	.116	129	15	1	1	0	2	7	14	7	9	38	47	6	4	2	.930
'48/GR	54	.161	143	23	1	0	0	4	14	11	18	7	19	29	2	2	0	.939
'49/GR	26	.127	55	7	0	0	0	1	7	5	4	2	No record					
Car (3 yrs)	131	.138	327	45	2	1	0	7	28	30	29	18	57	76	8	6	2	.933
Play (1 yr)	7	.000	26	0	0	0	0	0	—	—	0	0	7	11	0	0	0	1.000

Florreich, Lois "Flash" (Born: 4/29/27, Webster Grove, MO; Died: 9/11/91, BR, TR, 5'5", 140, OF, 3B, P)
see Pitchers

	Hitting											Fielding						
YEAR/TEAM	G	BA	AB	H	2B	3B	HR	SB	BB	SO	R	RBI	G	PO	A	E	DP	FA
'43/SB	89	.231	351	81	9	6	4	57	27	62	61	43	81	143	192	57	13	.855
'44/SB	99	.178	366	65	4	6	1	113	54	50	49	25	91	178	211	37	16	.913
'45/SB, Ken	67	.180	217	39	4	6	0	30	19	24	28	23	55	79	71	16	6	.904
'46/Ken	78	.234	231	54	1	7	0	19	27	28	26	21	31	37	4	1	1	.976
Car (4 yrs)	333	.205	1165	239	18	25	5	219	127	164	164	112	258	437	378	111	36	.880
Play (1 yr)	1	.333	3	1	0	0	0	0	—	—	0	0	1	43	9	2	2	.963

Foss, Anita "Nita" (Born: 8/5/21, Providence, RI, BR, TR, 5'2", 118, U, P)
see Pitchers

	Hitting											Fielding						
YEAR/TEAM	G	BA	AB	H	2B	3B	HR	SB	BB	SO	R	RBI	G	PO	A	E	DP	FA
'48/Mus	25	.122	49	6	1	0	0	5	14	11	5	5	16	35	26	7	2	.897
'49/Roc, Mus	3	.000	2	0	—	—	—	—	—	—	—	—	No record					
Car (2 yrs)	28	.117	51	6	1	0	0	5	14	11	5	5	16	35	26	7	2	.897

Foss (Weaver), Betty (Born: 5/10/29, Metropolis, IL; Died: 2/8/98; BB, TR, 5'10", 180, 1B, OF, P)

see Pitchers

	Hitting												Fielding					
YEAR/TEAM	G	BA	AB	H	2B	3B	HR	SB	BB	SO	R	RBI	G	PO	A	E	DP	FA
'50/FW	96	.346	361	125	24	3	5	64	43	46	64	61	94	110	217	47	11	.874
'51/FW	94	.368	342	126	34	2	4	60	58	34	77	58	89	932	23	36	31	.964
'52/FW	106	.331	414	137	26	17	4	56	53	40	81	74	106	1232	32	33	60	.975
'53/FW	110	.321	449	144	20	8	5	80	28	35	99	65	113	656	35	20	36	.972
'54/FW	92	.352	332	117	13	0	14	34	27	21	80	54	93	708	23	15	56	.980
Car (5 yrs)	498	.342	1898	649	117	30	32	294	199	176	401	312	495	3638	330	151	194	.963
Play (4 yrs)	23	.367	82	30	2	0	4	6	—	—	23	9	23	98	16	4	4	.988

Francis, Betty "BF" (Born: 7/7/31, Maquoketa, IA, BR, TR, 5'4", 140, OF)

	Hitting												Fielding					
YEAR/TEAM	G	BA	AB	H	2B	3B	HR	SB	BB	SO	R	RBI	G	PO	A	E	DP	FA
'49/Mus	9	.043	23	1	—	—	—	—	—	—	—	—	No record					
'50/Kal	56	.256	129	33	2	1	1	5	17	12	15	10	42	48	8	8	2	.875
'51/Kal	97	.231	325	75	8	0	0	21	49	14	42	20	96	159	15	11	2	.941
'52/Kal	99	.210	329	69	8	0	0	4	42	18	20	14	98	130	16	6	3	.961
'53/Kal	78	.226	212	48	7	0	0	5	36	10	31	23	53	88	8	7	0	.932
'54/SB	90	.350	300	105	12	2	8	7	27	22	49	58	90	143	8	6	0	.962
Car (6 yrs)	429	.251	1318	331	38	3	9	42	185	76	157	125	379	438	55	38	7	.929
Play (2 yrs)	8	.125	24	3	0	0	0	0	—	—	4	0	8	19	2	1	1	.955

Frank (Dummerth), Edna "Frankie" (Born: 6/15/24, St. Louis, MO, BR, TR, 5'5", 128, C)

	Hitting												Fielding					
YEAR/TEAM	G	BA	AB	H	2B	3B	HR	SB	BB	SO	R	RBI	G	PO	A	E	DP	FA
'44/Mpls, Rac	16	.109	46	5	0	0	0	1	1	4	1	2	15	53	10	6	2	.913

Franks, Hermine (Born: 9/7/14, Ocanta, WI, 5'4", 120, U)

	Hitting												Fielding					
YEAR/TEAM	G	BA	AB	H	2B	3B	HR	SB	BB	SO	R	RBI	G	PO	A	E	DP	FA
'46/Ken	1	.000	1	0	—	—	—	—	—	—	—	—	No record					

Fritz, Betty Jane (Hometown: Oshkosh, WI; Died: Date unknown, BR, TR, 5'5", 130, OF)

	Hitting												Fielding					
YEAR/TEAM	G	BA	AB	H	2B	3B	HR	SB	BB	SO	R	RBI	G	PO	A	E	DP	FA
'43/Roc	98	.210	348	73	4	1	0	29	9	16	38	43	98	152	17	9	4	.949

Froning (O'Meara), Mary (Born: 8/26/34, Minster, OH, BR, TR, 5'3", 118, OF, P)

see Pitchers

	Hitting												Fielding					
YEAR/TEAM	G	BA	AB	H	2B	3B	HR	SB	BB	SO	R	RBI	G	PO	A	E	DP	FA
'51/SB	No record																	
'52/SB, BC	13	.080	25	2	0	0	0	0	1	5	1	1	12	17	0	3	0	.850
'53/SB	111	.108	375	78	8	0	0	32	46	49	50	26	111	127	14	11	1	.928
'54/SB	85	.231	251	58	10	0	3	26	15	29	44	19	81	95	20	8	2	.935
Car (4 yrs)	209	.212	651	138	18	0	3	58	62	73	95	56	204	239	34	22	3	.925
Play (1 yr)	3	.222	9	2	0	0	0	0	—	—	1	0	3	2	1	0	0	1.000

Gacioch, Rose "Rosie" (Born: 8/31/15, Wheeling, WV, BR, TR, 5'6", 160, OF, 1B, 2B, 3B, P)
see Pitchers

	Hitting											Fielding						
YEAR/TEAM	G	BA	AB	H	2B	3B	HR	SB	BB	SO	R	RBI	G	PO	A	E	DP	FA
'44/SB	98	.161	348	56	2	2	0	27	25	13	29	37	97	124	87	9	6	.959
'45/Roc	103	.211	374	79	8	2	0	25	17	23	34	44	103	156	31	8	0	.959
'46/Roc	111	.262	405	106	14	9	1	52	27	19	56	57	107	147	30	9	4	.954
'47/Roc	100	.257	338	87	5	3	1	31	25	20	23	31	100	127	31	7	3	.958
'48/Roc	121	.239	426	102	11	3	1	18	39	28	41	44	100	105	25	4	2	.970
'49/Roc	90	.203	281	57	3	2	0	3	25	15	19	34	71	63	13	4	1	.950
'50/Roc, GR	61	.263	156	41	5	2	0	2	12	8	9	18	18	17	2	1	0	.950
'53/Roc	75	.285	179	51	4	6	2	1	12	10	13	18	26	96	3	4	2	.961
'54/Roc	79	.304	217	66	8	1	13	5	8	10	27	45	41	180	60	13	17	.949
Car (10 yrs)	838	.237	2724	645	60	30	18	164	190	146	251	328	663	1011	282	59	35	.956
Play (5 yrs)	46	.222	158	35	3	2	0	1	—	—	9	11	46	49	9	1	2	.983

Galdonik, Barbara (Born: 10/26/34, Kenosha, WI, 5'5", 130, 3B)

	Hitting											Fielding						
YEAR/TEAM	G	BA	AB	H	2B	3B	HR	SB	BB	SO	R	RBI	G	PO	A	E	DP	FA
'51/BC	No record—played less than 10 games																	

Ganote (Weise), Gertrude "Lefty" (Born: 2/17/20, Louisville, KY, BL, TL, 5'4", 130, 1B, P)
see Pitchers

	Hitting											Fielding						
YEAR/TEAM	G	BA	AB	H	2B	3B	HR	SB	BB	SO	R	RBI	G	PO	A	E	DP	FA
'44/Ken	97	.133	338	45	3	2	0	24	41	60	35	11	86	819	8	10	14	.988
'45/SB	81	.192	287	55	5	8	0	9	24	32	26	19	78	602	15	15	13	.976
Car (2 yrs)	178	.160	625	100	8	10	0	33	66	92	61	30	164	1421	23	25	27	.983
Play (1 yr)	7	.241	29	7	0	0	0	0	0	5	2	1	7	68	5	13	0	.849

Garman (Hosted), Ann (Born: 3/11/33, Avilla, IN, 5'6", 140, 1B)

	Hitting											Fielding						
YEAR/TEAM	G	BA	AB	H	2B	3B	HR	SB	BB	SO	R	RBI	G	PO	A	E	DP	FA
'53/SB	21	.154	65	10	0	0	0	1	13	13	5	7	21	195	7	7	6	.967

Gascon, Eileen "Ginger" (Born: 12/1/31, Chicago, IL, BR, TR, 5'2", 115, 3B, OF)

	Hitting											Fielding						
YEAR/TEAM	G	BA	AB	H	2B	3B	HR	SB	BB	SO	R	RBI	G	PO	A	E	DP	FA
'51/GR, BC, Peo	27	.184	87	16	2	0	0	7	16	22	12	4	26	51	2	2	1	.964

Geissinger (Harding), Jean Louise "Dutch" (Born: 6/25/34, Huntingdon, PA, BR, TR, 5'6", 120, 2B, SS, OF, RP)
see Pitchers

	Hitting											Fielding						
YEAR/TEAM	G	BA	AB	H	2B	3B	HR	SB	BB	SO	R	RBI	G	PO	A	E	DP	FA
'51/FW	22	.194	67	13	1	0	2	0	4	14	8	7	19	37	39	11	4	.874
'52/FW, GR	108	.280	407	114	16	5	5	15	17	63	41	56	111	187	139	35	15	.903
'53/FW	105	.295	397	117	21	10	8	28	30	47	50	81	104	250	211	23	37	.952
'54/FW	93	.377	313	118	17	2	26	17	45	41	78	91	93	197	197	36	50	.916
Car (4 yrs)	328	.306	1184	362	65	17	41	60	96	165	177	235	130	67	1586	105	106	.923
Play (4 yrs)	12	.302	43	13	2	1	1	2	—	—	6	9	12	25	9	4	3	.895

George (McFaul), Genevieve "Gene" (Born: 9/22/27, Regina, SK, Canada, TR, BR, 5'3", 110, C)

	Hitting											Fielding						
YEAR/TEAM	G	BA	AB	H	2B	3B	HR	SB	BB	SO	R	RBI	G	PO	A	E	DP	FA
'48/Mus	15	.154	13	2	0	0	0	0	0	4	1	2	14	19	2	0	0	1.000

Gianfrancisco, Philomena Theresa "Phil" "Frisco" (Born: 4/20/23, Chicago, IL; Died: 1/18/92, BL, TR, 5'2", 134, OF)

	Hitting											Fielding						
YEAR/TEAM	G	BA	AB	H	2B	3B	HR	SB	BB	SO	R	RBI	G	PO	A	E	DP	FA
'45/GR	21	.154	39	6	1	0	0	1	9	6	6	1	12	9	2	0	1	1.000
'46/GR	98	.225	342	77	9	2	2	21	38	33	34	53	90	79	16	4	5	.960
'47/GR	32	.163	98	16	2	1	0	6	12	13	13	5	32	24	3	3	1	.900
'48/Rac	114	.204	398	81	11	2	4	45	47	36	34	35	113	89	8	4	1	.960
Car (4 yrs)	265	.205	877	180	23	5	6	73	106	88	87	94	255	201	29	11	8	.954
Play (3 yrs)	12	..256	39	10	0	1	0	3	—	—	4	1	10	5	0	0	0	1.000

Gilchrist, Jeanne (Born: 6/13/26, New Westminister, BC, Canada BR, TR, 5'5", 125, C)

	Hitting											Fielding						
YEAR/TEAM	G	BA	AB	H	2B	3B	HR	SB	BB	SO	R	RBI	G	PO	A	E	DP	FA
'46/Peo	3	.167	6	1	—	—	—	—	—	—	—	—	No record					

Gilmore (Hawton), June (Born: 6/13/22, Peoria, IL; Died: 1/6/80, 5'1", 110, OF)

	Hitting											Fielding						
YEAR/TEAM	G	BA	AB	H	2B	3B	HR	SB	BB	SO	R	RBI	G	PO	A	E	DP	FA
'44/Roc	No record																	

Glaser, Rose Mary "Hap" (Born: 10/22/21, Cincinnati, OH, 5'10", 145, U)

	Hitting											Fielding						
YEAR/TEAM	G	BA	AB	H	2B	3B	HR	SB	BB	SO	R	RBI	G	PO	A	E	DP	FA
'44/Ken	1	.000	3	0	—	—	—	—	—	—	—	—	No record					

Gosbee, Ann (Hometown: Essex, MA; Died: Date Unknown, SS, 2B)

	Hitting											Fielding						
YEAR/TEAM	G	BA	AB	H	2B	3B	HR	SB	BB	SO	R	RBI	G	PO	A	E	DP	FA
'53/GR	18	.091	33	3	0	0	0	0	3	6	5	0	13	22	10	5	1	.865
'54/Roc, GR	57	.153	85	13	0	0	0	1	22	5	17	7	46	67	77	10	16	.935
Car (2 yrs)	75	.136	118	16	0	0	0	1	25	11	22	7	59	89	87	15	17	.922
Play (1 yr)	1	.000	1	0	0	0	0	0	—	—	1	0	No record					

Grambo (Hundeby), Thelma (Born: 10/28/23, Domremy, SK, Canada, BR, TR, 5'7", 165, C)

	Hitting											Fielding						
YEAR/TEAM	G	BA	AB	H	2B	3B	HR	SB	BB	SO	R	RBI	G	PO	A	E	DP	FA
'46/GR	No record																	

Grant, Olga (Hometown: Calgary, AB, Canada, BL, TR, OF)

	Hitting											Fielding						
YEAR/TEAM	G	BA	AB	H	2B	3B	HR	SB	BB	SO	R	RBI	G	PO	A	E	DP	FA
'44/Mil	21	.147	73	18	1	0	0	9	7	6	6	6	19	17	0	1	0	.944

Green, Dorothy (Born: 4/30/21, Natick, MA, BR, TR, 5'10", 150, C)

	Hitting											Fielding						
YEAR/TEAM	G	BA	AB	H	2B	3B	HR	SB	BB	SO	R	RBI	G	PO	A	E	DP	FA
'43/Roc	48	.164	128	21	0	0	1	0	12	35	12	4	48	162	15	8	2	.957
'44/Roc	98	.145	290	42	3	3	0	23	45	49	33	20	98	366	93	18	10	.962
'45/Roc	44	.145	117	17	5	1	0	5	12	9	13	5	44	148	20	6	0	.966
'46/Roc	76	.116	206	24	1	2	0	16	32	31	14	13	76	413	68	21	4	.958
'47/Roc	14	.115	26	3	0	0	0	0	2	3	1	1	14	40	10	2	3	.962
Car (5 yrs)	280	.140	767	107	9	6	1	44	103	127	73	43	280	1129	151	55	19	.957
Play (2 yrs)	12	.088	34	3	0	0	0	0	—	—	1	0	12	73	11	0	1	1.000

Guest, Geraldine "Jerry" (Hough) (Hometown: Flint, MI Died: Date Unknown, OF)

	Hitting											Fielding						
YEAR/TEAM	G	BA	AB	H	2B	3B	HR	SB	BB	SO	R	RBI	G	PO	A	E	DP	FA
'51/Peo	26	.119	42	5	0	0	0	1	3	12	5	2	15	15	2	0	1	1.000

Gutz, Julie "Gutzie" (Born: 12/4/26, Storm Lake, IA, BR, TR, 5'5", 155, C, OF)

	Hitting											Fielding						
YEAR/TEAM	G	BA	AB	H	2B	3B	HR	SB	BB	SO	R	RBI	G	PO	A	E	DP	FA
'48/Spr	83	.152	223	34	0	3	0	4	14	35	11	8	83	171	71	21	5	.920
'49/Mus	40	.132	121	16	3	1	0	5	8	23	6	9	39	136	44	12	5	.938
'50/Ken	112	.203	365	74	10	1	1	5	41	36	45	27	112	439	123	22	14	.962
Car (3 yrs)	235	.175	709	124	13	5	1	14	63	94	62	44	234	846	238	55	24	.952
Play (2 yrs)	5	.267	15	4	0	0	0	0	—	—	2	2	5	16	2	0	1	1.000

Habben, Carol (Born: 5/15/33, Midland Park, NJ, Died: 1/11/97, BR, TR, 5'5", 135, OF, P)
see Pitchers

	Hitting											Fielding						
YEAR/TEAM	G	BA	AB	H	2B	3B	HR	SB	BB	SO	R	RBI	G	PO	A	E	DP	FA
'51/Roc	10	.038	26	1	0	0	0	0	1	7	1	1	No record					
'52/Roc	No record — played less than 10 games																	
'53/Roc	82	.194	242	47	5	1	0	5	14	41	18	18	67	80	69	27	5	.847
'54/Kal	98	.276	308	85	5	1	15	8	42	41	45	46	95	164	16	12	1	.938
Car (4 yrs)	190	.231	576	133	10	2	15	13	57	89	64	65	162	244	85	39	6	.894
Play (1 yr)	8	.231	26	6	0	0	1	1	—	—	5	6	8	12	1	4	0	.765

Hagemann (Hargraves), Johanna (Born: 12/17/18, Chicago, IL; Died: 2/84, BR, TR, 5'9", 155, 1B)

	Hitting											Fielding						
YEAR/TEAM	G	BA	AB	H	2B	3B	HR	SB	BB	SO	R	RBI	G	PO	A	E	DP	FA
'43/SB	108	.225	373	85	10	6	1	24	50	28	47	45	108	1122	35	21	39	.983
'44/SB	116	.142	365	52	2	0	0	23	52	39	24	28	116	1167	37	22	31	.982
'45/Ken	96	.117	273	32	2	2	0	11	26	20	8	9	95	931	22	16	23	.983
Car (3 yrs)	320	.167	1011	169	14	8	1	58	128	87	79	82	319	3220	94	59	93	.983

Haines, Martha "Marty" (Hometown: Covington, KY, U)

	Hitting											Fielding						
YEAR/TEAM	G	BA	AB	H	2B	3B	HR	SB	BB	SO	R	RBI	G	PO	A	E	DP	FA
'47/Ken	1	.000	1	0	—	—	—	—	—	—	—	—	No record					

Harnett, Ann (Born: 8/10/20, Chicago, IL; Died: Date unknown, BR, TR, 5'6", 139, 3B, C, OF, P)
see Pitchers

	Hitting											Fielding						
YEAR/TEAM	G	BA	AB	H	2B	3B	HR	SB	BB	SO	R	RBI	G	PO	A	E	DP	FA
'43/Ken	101	.271	387	105	10	10	6	15	19	7	54	69	101	214	268	59	11	.891

YEAR/TEAM	Hitting												Fielding					
	G	BA	AB	H	2B	3B	HR	SB	BB	SO	R	RBI	G	PO	A	E	DP	FA
'44/Ken	98	.248	351	87	8	8	1	18	23	9	41	45	95	188	260	44	4	.911
'45/Ken	99	.202	322	65	5	5	0	14	29	13	22	25	90	316	112	25	5	.945
'46/Ken	16	.224	58	13	3	1	0	5	2	6	4	3	16	55	13	5	2	.932
'47/Peo	110	.203	414	84	8	4	0	13	23	18	47	29	100	221	7	8	1	.966
Car (5 yrs)	314	.231	1532	354	34	28	7	65	96	53	168	171	402	994	660	141	23	.921
Play (2 yrs)	10	.150	40	6	1	0	1	0	—	—	4	4	10	32	27	6	0	.908

Harrell (Doyle), Dorothy "Snookie" (Born: 2/4/24, Los Angeles, CA, BR, TR, 5'4", 127, SS)

YEAR/TEAM	Hitting												Fielding					
	G	BA	AB	H	2B	3B	HR	SB	BB	SO	R	RBI	G	PO	A	E	DP	FA
'44/Roc	93	.177	322	57	4	2	0	18	22	10	24	14	92	184	224	48	15	.895
'45Roc	92	.239	310	74	6	5	2	24	28	8	36	27	92	200	221	38	18	.917
'46/Roc	88	.213	301	64	6	2	0	28	28	9	31	26	88	146	237	39	20	.908
'47/Roc	99	.202	351	71	6	5	1	34	24	18	31	41	98	206	275	49	19	.908
'48/Roc	116	.251	414	104	9	7	1	45	48	21	52	58	113	236	328	40	24	.934
'49/Roc	111	.220	431	95	3	5	0	39	25	7	40	50	111	243	333	41	30	.934
'50/Roc	107	.276	431	119	16	110	3	23	18	10	45	63	106	217	321	41	34	.929
'52/Roc	93	.229	362	83	6	1	2	18	13	12	40	27	92	188	209	41	19	.906
Car (8 yrs)	799	.228	2922	667	56	37	9	213	205	87	302	297	792	1620	2148	337	179	.918
Play (6 yrs)	58	.281	217	61	4	2	0	15	—	—	18	21	58	109	129	26	6	.902

Hasham, Josephine "Jo" (Hometown: Waltham, MA, BR, TL, OF, P)
see Pitchers

YEAR/TEAM	Hitting												Fielding					
	G	BA	AB	H	2B	3B	HR	SB	BB	SO	R	RBI	G	PO	A	E	DP	FA
'48/Mus, Peo, SB	34	.178	73	13	0	0	0	0	4	6	2	7	14	15	0	2	0	.882
'52/BC	81	.222	158	35	2	0	0	1	8	2	6	21	20	16	2	0	1	1.000
Car (2 yrs)	115	.208	231	48	2	0	0	1	12	9	8	28	34	31	2	2	1	.943
Play (3 yrs)	5	.250	4	1	0	0	0	0	—	—	0	0	No record					

Havlish, Jean "Grasshopper" (Born: 11/23/35, St. Paul, MN, BR, TR, 5'6", 130, SS, 3B)

YEAR/TEAM	Hitting												Fielding					
	G	BA	AB	H	2B	3B	HR	SB	BB	SO	R	RBI	G	PO	A	E	DP	FA
'51/Kal	No record — played less than 10 games																	
'52/FW	No record — played less than 10 games																	
'53/FW	104	.189	344	65	4	0	0	14	35	40	35	22	104	395	256	50	23	.929
'54/FW	89	.254	276	70	13	0	4	9	46	16	39	36	90	143	237	32	37	.922
Car (4 yrs)	193	.218	620	135	17	0	4	23	81	56	74	58	194	538	593	82	60	.932
Play (2 yrs)	9	.286	28	8	2	0	0	0	—	—	1	3	9	17	16	6	1	.971

Hay, Florence (Hometown: Chicago, IL, BR, TR, OF)

YEAR/TEAM	Hitting												Fielding					
	G	BA	AB	H	2B	3B	HR	SB	BB	SO	R	RBI	G	PO	A	E	DP	FA
'49/Chic	No record																	

Heafner, Ruby "Rebel" (Born: 3/5/24, Gastonia, NC, BR, TR, 5'6", 140, C, P)

YEAR/TEAM	Hitting												Fielding					
	G	BA	AB	H	2B	3B	HR	SB	BB	SO	R	RBI	G	PO	A	E	DP	FA
'46/Roc	47	.141	128	18	1	2	0	6	23	24	16	8	44	202	30	11	4	.955
'47/FW	65	.172	198	34	7	0	0	5	20	36	14	14	65	292	64	13	6	.965
'48/FW	50	.171	146	25	2	1	0	4	11	18	5	7	50	188	41	14	9	.942
'49/FW	50	.171	146	25	2	1	0	4	11	18	5	7	No record					
'50/Rac	65	.211	204	43	3	1	0	4	5	38	19	17	62	207	61	6	3	.978

YEAR/TEAM	G	BA	AB	H	2B	3B	HR	SB	BB	SO	R	RBI	G	PO	A	E	DP	FA
		Hitting											**Fielding**					
'51/BC	56	.205	127	26	3	0	0	6	33	15	20	3	54	141	47	8	2	.959
Car (6 yrs)	342	.178	959	171	17	4	0	28	124	154	83	57	275	1030	243	52	24	.961
Play (1 yr)	4	.250	8	2	0	0	0	0	—	—	3	2	2	10	2	0	0	1.000

Healy, Dorothy (OF)

YEAR/TEAM	G	BA	AB	H	2B	3B	HR	SB	BB	SO	R	RBI	G	PO	A	E	DP	FA
		Hitting											**Fielding**					
'48/Chic	12	.122	41	5	1	0	0	0	4	2	2	7	12	16	0	3	0	.842

Heim (McDaniel), Kay "Heime" (Born: 8/21/17, Athabaska, AB, Canada, BR, TR, 5'6", 125, C)

YEAR/TEAM	G	BA	AB	H	2B	3B	HR	SB	BB	SO	R	RBI	G	PO	A	E	DP	FA
		Hitting											**Fielding**					
'43/Ken	25	.117	77	9	0	1	0	6	3	6	8	6	25	115	16	5	1	.963
'44/Ken	33	.181	105	19	0	0	1	19	5	8	9	10	31	114	24	9	0	.939
Car (2 yrs)	58	.154	182	28	0	1	1	25	8	14	17	16	56	229	40	14	1	.951
Play (1 yr)	3	.200	10	2	0	0	0	3	—	—	1	0	3	6	2	0	0	1.000

Herring, Katherine "Katie" (Born: 7/11/33, Hedrick, OK, OF)

YEAR/TEAM	G	BA	AB	H	2B	3B	HR	SB	BB	SO	R	RBI	G	PO	A	E	DP	FA
		Hitting											**Fielding**					
'53/GR	No record																	

Hershey, Esther (Born: 1/5/28, Gap, PA, 5'5", 133, U)

YEAR/TEAM	G	BA	AB	H	2B	3B	HR	SB	BB	SO	R	RBI	G	PO	A	E	DP	FA
		Hitting											**Fielding**					
'48/SB	No record																	

Hickey, Lillian (Hometown: Vaucouver, BC, Canada; Died: Date Unknown, BR, TR, OF)

YEAR/TEAM	G	BA	AB	H	2B	3B	HR	SB	BB	SO	R	RBI	G	PO	A	E	DP	FA
		Hitting											**Fielding**					
'46/Ken	21	.213	61	13	0	0	0	1	1	13	3	3	17	11	1	2	0	.857

Hickson, Irene "Choo-Choo" "Tuffy" (Born: 8/14/21, Chattanooga, TN; Died: 11/25/95, BR, TR, 5'2", 116, C)

YEAR/TEAM	G	BA	AB	H	2B	3B	HR	SB	BB	SO	R	RBI	G	PO	A	E	DP	FA
		Hitting											**Fielding**					
'43/Rac	68	.280	193	54	4	4	1	68	34	16	62	24	58	165	44	18	3	.921
'44/Rac	85	.145	325	47	1	0	0	76	35	15	52	9	83	186	98	16	9	.947
'45/Rac	97	.173	318	55	5	1	0	39	43	33	36	21	96	311	92	29	8	.933
'46/Rac	46	.187	147	28	1	1	1	41	39	7	34	12	46	183	44	9	4	.962
'47/Rac	101	.152	309	47	6	2	0	49	42	23	34	21	100	497	71	14	6	.976
'48/Rac	97	.164	287	47	3	5	0	23	51	48	37	16	97	632	80	25	4	.966
'49/Rac	83	.129	210	27	3	1	0	16	42	24	23	8	81	296	96	13	9	.968
'50/Rac	33	.172	64	11	0	0	1	5	25	7	17	9	30	83	27	4	3	.965
'51/Ken	11	.217	23	5	0	0	0	2	5	0	1	5	11	35	9	2	1	.957
Car (9 yrs)	621	.171	1876	321	23	14	3	319	316	173	296	125	602	2388	561	130	47	.958
Play (4 yrs)	23	.163	80	13	2	0	0	5	—	—	9	11	23	91	16	2	3	.972

Hill (Westerman), Joyce (Born: 12/29/25, Kenosha, WI, BL, TR, 5'5", 150, C, 1B, OF)

YEAR/TEAM	G	BA	AB	H	2B	3B	HR	SB	BB	SO	R	RBI	G	PO	A	E	DP	FA
		Hitting											**Fielding**					
'45/GR	9	.111	18	2	—	—	—	—	—	—	—	—	No record					

	Hitting												Fielding					
YEAR/TEAM	G	BA	AB	H	2B	3B	HR	SB	BB	SO	R	RBI	G	PO	A	E	DP	FA
'46/SB, FW	21	.123	57	7	0	0	0	7	9	12	6	3	18	41	9	5	1	.909
'47/Peo	90	.227	251	57	5	2	0	16	36	26	24	19	87	304	65	24	8	.939
'48/Peo, Rac	89	.187	252	47	6	5	0	18	43	37	29	28	83	295	36	8	2	.976
'49/Rac	64	.190	121	23	1	2	0	4	32	12	16	12	45	117	24	7	2	.953
'50/Peo	70	.254	197	50	4	2	0	4	45	29	26	19	62	101	5	7	1	.951
'51/Peo	102	.242	355	86	13	3	0	20	68	19	51	50	102	991	35	20	46	.981
'52/SB	86	.277	264	73	5	0	0	12	59	14	39	36	81	865	34	23	22	.975
Car (8 yrs)	531	.277	1515	345	34	14	0	81	292	149	191	167	478	2714	208	94	82	.969
Play (2 yrs)	8	.208	24	5	0	0	0	0	—	—	2	5	8	94	6	2	3	.980

Hlavaty, Lillian (Hometown: Jessup, PA, OF)

	Hitting												Fielding					
YEAR/TEAM	G	BA	AB	H	2B	3B	HR	SB	BB	SO	R	RBI	G	PO	A	E	DP	FA
'51/Roc	47	.189	127	24	3	0	0	7	20	34	13	5	47	32	6	2	1	.950

Hoffman, Nadine (U)

	Hitting												Fielding					
YEAR/TEAM	G	BA	AB	H	2B	3B	HR	SB	BB	SO	R	RBI	G	PO	A	E	DP	FA
'46/Peo	2	.000	4	0	—	—	—	—	—	—	—	—	No record					

Hoffmann, Barbara (Born: 1/18/31, Bellville, IL, BR, TR, 5'6", 133, 3B, 2B)

	Hitting												Fielding					
YEAR/TEAM	G	BA	AB	H	2B	3B	HR	SB	BB	SO	R	RBI	G	PO	A	E	DP	FA
'51/SB	46	.212	137	29	2	3	0	9	25	20	20	11	41	46	71	23	5	.836
'52/SB	49	.172	134	23	3	1	1	3	20	30	11	11	45	40	95	12	5	.918
Car (2 yrs)	95	.192	271	52	5	4	1	12	45	50	31	22	86	86	166	35	10	.878

Hohlmayer (McNaughton), Alice (Born: 1/19/25, Springfield, OH, BR, TL, 5'6", 160, 1B, P)

see Pitchers

	Hitting												Fielding					
YEAR/TEAM	G	BA	AB	H	2B	3B	HR	SB	BB	SO	R	RBI	G	PO	A	E	DP	FA
'46/Ken	110	.223	372	83	10	6	0	21	24	63	24	33	110	1186	36	25	34	.980
'47/Ken	90	.208	298	62	7	6	0	8	22	47	24	24	76	847	20	30	17	.967
'48/Ken	81	.144	243	35	4	1	1	2	28	30	10	17	69	778	10	11	12	.986
'49/Mus	98	.177	310	55	3	1	0	10	39	23	13	18	97	1097	33	19	27	.983
'50/Kal, Peo	63	.241	158	38	5	0	2	28	27	19	6	28	27	284	8	7	11	.977
Car (5 yrs)	486	.203	1486	301	35	15	3	43	138	192	85	128	379	4192	107	92	101	.979
Play (2 yrs)	7	.136	22	3	0	0	0	1	—	—	0	3	6	34	0	0	2	1.000

Holda, Mary "Bucky" (Hometown: Mansfield, OH; Died: Date Unknown BR, TR, U)

	Hitting												Fielding					
YEAR/TEAM	G	BA	AB	H	2B	3B	HR	SB	BB	SO	R	RBI	G	PO	A	E	DP	FA
'43/SB	29	.205	73	15	0	0	0	8	4	11	9	6	19	30	31	5	2	.924

Holderness, Joan (Born: 3/17/33, Kenosha, WI, BR, TR, 5'10", 145, OF)

	Hitting												Fielding					
YEAR/TEAM	G	BA	AB	H	2B	3B	HR	SB	BB	SO	R	RBI	G	PO	A	E	DP	FA
'49/Ken	34	.167	48	8	0	0	0	1	2	8	2	8	12	9	1	1	0	.909
'50/Ken, GR	62	.149	175	26	1	1	0	3	20	10	10	10	57	51	5	5	3	.918
'51/GR, BC	23	.148	61	9	1	0	0	0	8	3	1	10	16	19	1	1	1	.952
Car (3 yrs)	119	.151	284	43	2	1	0	4	30	21	13	28	85	79	7	7	4	.925
Play (2 yrs)	5	.063	16	1	0	0	0	0	—	—	0	0	5	4	1	0	1	1.000

Holgerson (Silvestri), Margaret "Marge" (Born: 1/28/27, Mobile, AL; Died: 3/23/90, BR, TR, 2B, P)
see Pitchers

	Hitting												Fielding					
YEAR/TEAM	G	BA	AB	H	2B	3B	HR	SB	BB	SO	R	RBI	G	PO	A	E	DP	FA
'46/Roc	60	.190	158	17	0	0	0	21	4	1	17	7	43	66	48	5	6	.961

Holle, Mabel "Holly" (Born: 3/21/21, Jacksonville, IL, BR, TR, 5'7", 125, 3B, OF)

	Hitting												Fielding					
YEAR/TEAM	G	BA	AB	H	2B	3B	HR	SB	BB	SO	R	RBI	G	PO	A	E	DP	FA
'43/SB	90	.199	332	66	3	1	0	24	22	33	37	21	90	145	56	14	2	.942

Hood, Marjorie (Hometown: Bell Buckle, TN, OF)

	Hitting												Fielding					
YEAR/TEAM	G	BA	AB	H	2B	3B	HR	SB	BB	SO	R	RBI	G	PO	A	E	DP	FA
'43/Rac	No record																	

Hoover, Alice "Pee Wee" (Born: 10/27/28, Reading, PA, BR, TR, 4'11", 105, 2B, 3B)

	Hitting												Fielding					
YEAR/TEAM	G	BA	AB	H	2B	3B	HR	SB	BB	SO	R	RBI	G	PO	A	E	DP	FA
'48/FW	6	.000	4	0	—	—	—	—	—	—	—	—	No record					

Horstman, Catherine "Katie" (Born: 4/14/35, Minster, OH, BR, TR, 5'7", 150, C, OF, SS, 3B, P)
see Pitchers

	Hitting												Fielding					
YEAR/TEAM	G	BA	AB	H	2B	3B	HR	SB	BB	SO	R	RBI	G	PO	A	E	DP	FA
'51/FW, Ken	38	.256	117	30	6	0	1	3	6	18	13	13	31	33	2	2	1	.946
'52/FW	90	.250	312	78	11	5	2	3	28	20	36	36	69	91	166	26	11	.908
'53/FW	94	.292	329	96	12	7	4	14	37	13	47	46	69	68	155	18	13	.925
'54/FW	86	.328	299	98	13	2	16	8	33	10	68	55	76	115	88	17	3	.923
Car (4 yrs)	308	.286	1057	302	42	14	23	28	104	61	164	150	245	307	411	63	28	.919
Play (4 yrs)	12	.255	47	12	3	0	3	2	—	—	7	7	12	10	17	5	1	.844

Hosbein, Marion (Born: 1/29/37, Coloma, MI, BR, TR, 5'8", 138, OF)

	Hitting												Fielding					
YEAR/TEAM	G	BA	AB	H	2B	3B	HR	SB	BB	SO	R	RBI	G	PO	A	E	DP	FA
'54/SB	No record — played less than 10 games																	

Hunter, Dorothy "Dottie" (Born: 1/28/16, Winnipeg, MB, Canada, BR, TR, 5'6", 155, 1B)

	Hitting												Fielding					
YEAR/TEAM	G	BA	AB	H	2B	3B	HR	SB	BB	SO	R	RBI	G	PO	A	E	DP	FA
'43/Rac, Ken	82	.224	254	57	6	5	1	9	16	18	27	28	74	736	15	21	16	.973

Hutchison, Anna May "Hutch" (Born: 5/1/25, Louisville, KY; Died: 1/29/98; BR, TR, 5'7", 149, C, P)
see Pitchers

	Hitting												Fielding					
YEAR/TEAM	G	BA	AB	H	2B	3B	HR	SB	BB	SO	R	RBI	G	PO	A	E	DP	FA
'44/Rac	52	.191	115	22	2	0	0	1	2	11	7	9	43	79	30	21	2	.838
'45/Rac	24	.127	55	7	1	0	0	0	3	4	2	2	20	40	12	3	2	.945
Car (2 yrs)	76	.171	170	29	3	0	0	1	5	15	9	11	63	119	42	24	4	.870

Jackson, Lillian "Bird Dog" (Born: 8/4/19, Nashville, TN, BL, TL, 5'6", 125, OF)

YEAR/TEAM		Hitting												Fielding					
YEAR/TEAM	G	BA	AB	H	2B	3B	HR	SB	BB	SO	R	RBI	G	PO	A	E	DP	FA	
'43/Roc	No record																		
'44/Mpls	58	.201	179	36	1	2	0	24	13	11	23	19	49	41	6	8	0	.855	
'45/FW	62	.122	188	23	2	0	1	28	12	2	24	12	59	69	7	3	2	.962	
Car (3 yrs)	120	.161	367	59	3	2	1	52	25	13	57	31	108	110	13	11	2	.918	

Jacobs (Murk), Janet "Jay Jay" (Born: 10/31/28, Englewood, NJ, BB, TR, 5'4", 115, SS, OF)

YEAR/TEAM		Hitting												Fielding					
YEAR/TEAM	G	BA	AB	H	2B	3B	HR	SB	BB	SO	R	RBI	G	PO	A	E	DP	FA	
'45/Rac	21	.163	43	7	0	0	1	0	3	6	2	4	23	36	43	17	3	.823	
Playoffs	4	.200	15	3	0	0	1	0	—	—	1	3	4	22	0	0	2	1.000	

Jameson, Shirley (Born: 3/29/18, Maywood, IL; Died 12/29/93, BR, TL, 4'11", 105, OF)

YEAR/TEAM		Hitting												Fielding					
YEAR/TEAM	G	BA	AB	H	2B	3B	HR	SB	BB	SO	R	RBI	G	PO	A	E	DP	FA	
'43/Ken	105	.271	399	108	6	10	4	126	66	7	111	32	105	210	11	7	3	.969	
'44/Ken	85	.253	288	73	4	2	2	119	78	6	64	23	85	156	17	8	3	.956	
'45/Ken	91	.189	307	58	4	4	1	13	9	2	41	5	91	169	18	4	2	.979	
'46/Ken	104	.198	374	74	2	3	1	98	68	12	62	9	104	163	11	7	1	.961	
Car (4 yrs)	385	.229	1368	313	16	19	8	356	221	27	278	69	385	698	57	26	9	.967	
Play (2 yrs)	10	.175	40	7	1	0	0	´11	—	—	7	3	10	17	2	2	0	.905	

Jamieson, Janet "Jamie" (Born: 4/3/27, Minneapolis, MN, BR, TR, 5'3", 136, C)

YEAR/TEAM		Hitting												Fielding					
YEAR/TEAM	G	BA	AB	H	2B	3B	HR	SB	BB	SO	R	RBI	G	PO	A	E	DP	FA	
'48/SB	1	.000	1	0	—	—	—	—	—	—	—	—	No record						

Jaykowski, Joan (Hometown: Menosha, WI, OF, P)

see Pitchers

YEAR/TEAM		Hitting												Fielding					
YEAR/TEAM	G	BA	AB	H	2B	3B	HR	SB	BB	SO	R	RBI	G	PO	A	E	DP	FA	
'51/Ken	30	.214	42	9	0	0	0	2	9	12	5	5	19	14	0	0	0	1.000	
'52/GR	15	.024	41	1	0	0	0	0	5	7	2	0	15	27	1	0	1	1.000	
Car (2 yrs)	45	.120	83	10	0	0	0	2	14	19	7	5	34	41	1	0	1	1.000	

Jenkins, Marilyn "Jenks" (Born: 9/18/34, Grand Rapids, MI, BR, TR, 5'6", 140, C)

YEAR/TEAM		Hitting												Fielding					
YEAR/TEAM	G	BA	AB	H	2B	3B	HR	SB	BB	SO	R	RBI	G	PO	A	E	DP	FA	
'52/GR	19	.133	30	4	1	0	0	0	5	14	1	6	No record						
'53/GR	69	.207	203	42	4	2	0	9	22	25	17	13	63	244	32	8	5	.972	
'54/GR	54	.182	132	24	3	0	1	2	25	12	20	18	50	102	31	9	6	.937	
Car (3 yrs)	141	.192	365	70	8	2	1	11	50	43	38	33	113	346	63	17	11	.960	
Play (2 yrs)	7	.909	22	2	0	0	0	0	—	—	2	0	7	34	8	0	0	1.000	

Jewett (Beckett), Christine (Born: 8/3/26, England; Hometown: Regina, SK, Canada, BR, TR, 5'6", 145, OF)

YEAR/TEAM		Hitting												Fielding					
YEAR/TEAM	G	BA	AB	H	2B	3B	HR	SB	BB	SO	R	RBI	G	PO	A	E	DP	FA	
'48/Ken	117	.216	430	93	7	4	3	51	27	50	46	35	117	102	17	12	3	.908	
'49/Ken,																			
Peo	85	.206	247	51	0	0	0	17	16	23	24	15	76	84	5	13	0	.873	
Career	202	.213	677	144	7	4	3	68	43	73	70	50	193	186	22	25	3	.893	
Play (1 yr)	3	.000	10	0	0	0	0	0	—	—	0	0	2	4	1	0	0	1.000	

Jochum, Betsy "Sock'um" (Born: 2/8/21, Cincinnati, OH, BR, TR, 5'7", 140, OF, 1B, P)
see Pitchers

	Hitting											Fielding						
YEAR/TEAM	G	BA	AB	H	2B	3B	HR	SB	BB	SO	R	RBI	G	PO	A	E	DP	FA
'43/SB	101	.273	439	120	12	7	1	66	27	21	70	35	101	118	17	9	4	.940
'44/SB	112	.296	433	128	5	1	2	127	40	16	72	23	112	169	14	14	4	.929
'45/SB	110	.237	388	92	6	5	1	25	33	18	40	36	101	162	13	8	0	.956
'46/SB	110	.250	400	100	7	7	2	73	44	10	64	63	109	201	12	6	3	.973
'47/SB	105	.211	402	85	11	5	0	44	17	15	36	42	105	161	11	8	1	.956
'48/SB	107	.195	339	66	2	4	1	23	16	24	25	33	72	77	9	3	1	.966
Car (6 yrs)	645	.246	2401	591	43	29	7	285	117	104	307	232	600	888	76	48	13	.953
Play (2 yrs)	8	.188	32	6	0	1	0	4	—	—	1	2	8	7	11	0	0	1.000

Johnson (Noga), Arleene "Johnnie" (Born: 1/1/24, Regina, SK, Canada, BR, TR, 5'4", 137, 3B, SS)

	Hitting											Fielding						
YEAR/TEAM	G	BA	AB	H	2B	3B	HR	SB	BB	SO	R	RBI	G	PO	A	E	DP	FA
'45/FW	15	.222	18	4	0	1	0	0	1	7	2	0	No record					
'46/Mus	112	.163	383	64	5	6	0	38	35	67	35	31	112	174	277	35	17	.928
'47/Mus	112	.165	345	57	5	0	2	34	34	73	32	22	112	117	254	23	10	.942
'48/FW, Mus	115	.155	373	58	4	6	1	51	43	77	34	38	119	174	339	37	23	.933
Car (4 yrs)	354	.164	1110	183	14	13	3	123	113	224	103	91	343	465	870	95	50	.934
Play (3 yrs)	9	.120	25	3	0	0	0	4	—	—	3	2	9	7	14	4	0	.840

Jones, Doris (Born: 1924, Sellersburg, IN, BR, TR, 5'7", 125, OF)

	Hitting											Fielding						
YEAR/TEAM	G	BA	AB	H	2B	3B	HR	SB	BB	SO	R	RBI	G	PO	A	E	DP	FA
'45/SB	6	.000	15	0	—	—	—	—	—	—	—	—	No record					

Jones (Doxey), Marilyn "Jonesy" (Born: 4/5/27, Providence, RI, BR, TR, 5'5", 135, C, P)
see Pitchers

	Hitting											Fielding						
YEAR/TEAM	G	BA	AB	H	2B	3B	HR	SB	BB	SO	R	RBI	G	PO	A	E	DP	FA
'48/Ken	25	.040	50	2	0	0	0	0	5	11	4	2	No record					
'49/FW	3	.000	3	0	—	—	—	—	—	—	—	—	No record					
'50/Roc	31	.203	69	14	0	0	0	2	7	12	7	6	30	106	17	6	1	.954
'51/Roc, BC	58	.173	139	24	3	0	0	2	17	19	13	6	56	139	52	31	3	.860
Car (4 yrs)	117	.153	261	40	3	0	0	4	29	42	24	14	86	245	69	37	4	.895
Play (1 yr)	11	.243	37	9	0	0	0	1	—	—	3	3	11	25	7	3	0	.914

Junior, Daisy (Born: 7/10/20, Regina, SK, Canada, BR, TR, 5'6", 140, OF)

	Hitting											Fielding						
YEAR/TEAM	G	BA	AB	H	2B	3B	HR	SB	BB	SO	R	RBI	G	PO	A	E	DP	FA
'46/SB	99	.186	322	60	6	1	0	41	39	35	30	22	98	173	7	6	0	.968
'47/SB	90	.133	248	33	2	1	0	17	16	41	17	14	90	157	9	3	1	.982
'48/SB, Spr	98	.125	248	31	2	1	0	19	26	49	23	15	89	125	11	6	2	.958
'49/FW	9	.172	29	5	—	—	—	—	—	—	—	—	No record					
Car (4 yrs)	454	.152	847	129	10	3	0	77	81	125	70	51	277	455	27	15	3	.970
Play (2 yrs)	9	.156	32	5	0	0	0	2	—	—	5	1	9	10	1	2	1	.846

Kamenshek, Dorothy "Dottie" "Kammie" (Born: 12/21/25, Cincinnati, OH, BL, TL, 5'6", 136, 1B, OF)

	Hitting											Fielding						
YEAR/TEAM	G	BA	AB	H	2B	3B	HR	SB	BB	SO	R	RBI	G	PO	A	E	DP	FA
'43/Roc	101	.271	395	107	6	3	3	42	33	6	58	39	101	881	17	33	23	.965

YEAR/TEAM	G	BA	AB	H	2B	3B	HR	SB	BB	SO	R	RBI	G	PO	A	E	DP	FA
'44/Roc	113	.257	447	115	8	5	1	74	34	6	60	23	113	1215	39	31	32	.976
'45/Roc	109	.274	419	115	11	2	0	60	47	8	80	26	105	1055	27	30	27	.973
'46/Roc	107	.316	408	129	7	1	1	109	39	10	78	22	107	1019	15	16	45	.985
'47/Roc	101	.306	366	112	10	8	6	66	35	6	52	32	101	1157	34	15	26	.988
'48/Roc	124	.186	448	128	8	5	2	94	72	14	89	35	124	1316	28	23	42	.983
'49/Roc	111	.255	385	98	8	4	0	69	89	8	62	25	107	1184	37	6	43	.995
'50/Roc	94	.334	341	114	14	3	0	65	36	38	64	50	92	951	27	17	40	.983
'51/Roc	97	.345	339	117	12	9	0	63	80	7	90	34	97	1044	38	13	54	.988
'53/Roc Car	55	.193	188	55	5	1	0	15	27	7	34	18	55	618	22	9	28	.986
(10 yrs)	1012	.292	3736	1090	89	41	13	657	492	110	667	304	1005	104	40	284	193	.360 .982
Play (7 yrs)	60	.339	218	74	5	2	1	21	—	—	41	13	60	550	11	6	10	.990

Kaufman, Joan "Jo" (Born: 11/9/35, Rockford, IL, BR, TR, 5'4", 120, 2B, 3B)

YEAR/TEAM	G	BA	AB	H	2B	3B	HR	SB	BB	SO	R	RBI	G	PO	A	E	DP	FA
'54/Roc	43	.134	97	13	3	0	0	0	9	13	3	5	43	49	77	20	12	.863

Kazmierczak, Marie (Born: 2/14/20, South Milwaukee, WI, BR, TR, 5'4", 145, OF)

YEAR/TEAM	G	BA	AB	H	2B	3B	HR	SB	BB	SO	R	RBI	G	PO	A	E	DP	FA
'44/Ken, SB, Mil	16	.032	31	1	0	0	0	2	4	4	3	2	13	5	0	1	0	.833

Keagle, Merle "Pat" (Born: 3/21/23, Phoenix, Ariz.; Died: Date Unknown BR, TR, 5'2", 144, OF, P)

see Pitchers

YEAR/TEAM	G	BA	AB	H	2B	3B	HR	SB	BB	SO	R	RBI	G	PO	A	E	DP	FA
'44/Mil	109	.264	406	107	7	5	7	122	45	21	72	47	110	165	59	52	13	.812
'46/GR	112	.284	409	116	15	4	2	107	47	24	69	59	105	177	23	15	4	.930
'48/GR	116	.251	423	106	11	9	3	85	61	41	75	27	105	156	18	7	5	.961
Car (3 yrs)	337	.266	1238	329	33	18	12	314	153	86	216	133	310	498	200	34	22	.954
Play (2 yrs)	12	.220	50	11	1	0	0	11	2	2	7	2	12	13	0	3	0	.813

Keller, Rita (Born: 1/21/33, Kalamazoo, MI, 5'3", 115, TR, BR, SS)

YEAR/TEAM	G	BA	AB	H	2B	3B	HR	SB	BB	SO	R	RBI	G	PO	A	E	DP	FA
'51/Kal	No record—played less than 10 games																	

Kelley, Jacqueline "Scrounge" "Jackie" "Babe" (Born: 11/11/26, Lansing, MI; Died: 5/12/88, BR, TR, 5'7", 140, U, P)

see Pitchers

YEAR/TEAM	G	BA	AB	H	2B	3B	HR	SB	BB	SO	R	RBI	G	PO	A	E	DP	FA
'47/SB	44	.178	107	19	3	2	0	2	4	28	7	13	40	43	3	6	0	.885
'48/Chic	54	.138	145	20	1	2	0	5	11	27	7	6	47	77	13	7	3	.928
'49/Roc, Peo	41	.162	117	19	3	0	0	8	5	16	5	5	41	77	17	8	2	.922
'50/Roc	69	.226	217	49	7	3	2	13	22	25	31	21	61	74	84	16	3	.908
'51/Roc	107	.224	380	85	14	6	2	31	33	33	37	52	102	159	235	42	22	.947
'52/Roc	42	.180	122	22	5	4	0	3	13	17	12	15	14	18	35	7	1	.883
'53/Roc	69	.256	219	56	9	2	1	6	12	29	13	22	51	229	62	19	11	.939

			Hitting										Fielding					
YEAR/TEAM	G	BA	AB	H	2B	3B	HR	SB	BB	SO	R	RBI	G	PO	A	E	DP	FA
Car (7 yrs)	426	.207	1307	270	42	18	5	70	105	166	112	131	356	677	449	105	42	.918
Play (6 yrs)	26	.198	81	16	1	1	0	3	—	—	8	11	26	27	38	2	2	.970

Kellogg, Vivian (Born: 11/6/22, Jackson, MI, BR, TR, 5'7", 149, 1B, C)

			Hitting										Fielding					
YEAR/TEAM	G	BA	AB	H	2B	3B	HR	SB	BB	SO	R	RBI	G	PO	A	E	DP	FA
'44/Mpls	111	.202	382	77	8	7	3	13	16	16	20	46	97	850	17	23	23	.974
'45/FW	107	.214	383	82	10	6	1	6	14	17	31	38	103	915	23	21	25	.978
'46/FW	89	.191	324	62	6	5	0	8	18	15	25	31	89	802	33	18	15	.979
'47/FW, SB	101	.206	358	74	10	6	0	21	17	19	18	23	97	754	36	16	21	.980
'48/FW	126	.248	472	117	9	9	0	19	39	39	52	43	126	1257	49	35	60	.974
'49/FW	107	.247	397	98	10	3	1	10	29	24	26	34	107	1124	30	23	38	.980
'50/FW	107	.229	397	91	13	3	3	9	27	26	37	49	107	1142	34	22	58	.982
Car (7 yrs)	747	.221	2709	600	66	39	8	86	160	156	219	264	726	6844	222	158	240	.978
Play (4 yrs)	36	.232	138	32	4	2	0	1	—	—	12	11	31	279	11	3	11	.990

Kemmerer, Beatrice "Betty" (Born: 2/23/30, Center Valley, PA, BR, TR, 5'3", 145, C, SS)

			Hitting										Fielding					
YEAR/TEAM	G	BA	AB	H	2B	3B	HR	SB	BB	SO	R	RBI	G	PO	A	E	DP	FA
'50/FW, SB	No record — played less than 10 games																	
'51/SB	No record — played less than 10 games																	

Keppel, Evelyn (C)

			Hitting										Fielding					
YEAR/TEAM	G	BA	AB	H	2B	3B	HR	SB	BB	SO	R	RBI	G	PO	A	E	DP	FA
'47/SB	No record — played less than 10 games																	

Kerrar, Adeline "Addie" (Born: 8/31/24, Milwaukee, WI; Died: 7/4/95, BB, TR, 5'2", 130, SS, 3B, C)

			Hitting										Fielding					
YEAR/TEAM	G	BA	AB	H	2B	3B	HR	SB	BB	SO	R	RBI	G	PO	A	E	DP	FA
'44/Roc	8	.167	18	3	—	—	—	—	—	—	—	—	No record					

Kerwin, Irene "Pepper" (Born: 11/3/25, Peoria, IL, BR, TR, 5'7", 150, 1B, C)

			Hitting										Fielding					
YEAR/TEAM	G	BA	AB	H	2B	3B	HR	SB	BB	SO	R	RBI	G	PO	A	E	DP	FA
'49/Peo	27	.137	73	10	0	0	0	2	7	12	2	1	15	166	7	6	6	.966

Ketola (LaCamera), Helen (Born: 9/30/31, Quincy, MA, 5'4", 129, 3B)

			Hitting										Fielding					
YEAR/TEAM	G	BA	AB	H	2B	3B	HR	SB	BB	SO	R	RBI	G	PO	A	E	DP	FA
'50/FW	31	.131	61	8	0	0	0	0	11	14	8	9	20	20	48	8	6	.895
Play (1 yr)	4	.200	5	1	0	0	0	1	—	—	1	0	4	1	5	2	0	.750

Keyes, Erma "Erm" (Born: 8/1/26, Frazier, PA, BR, TR, 5'5", 135, OF)

			Hitting										Fielding					
YEAR/TEAM	G	BA	AB	H	2B	3B	HR	SB	BB	SO	R	RBI	G	PO	A	E	DP	FA
'51/BC, Peo	89	.212	316	67	0	0	0	7	20	23	23	23	88	129	13	9	1	.937

Kidd, Glenna "Sue" (Born: 9/2/33, Chowtaw, AR, BR, TR, 5'8", 165, 1B, P)
see Pitchers

			Hitting										Fielding					
YEAR/TEAM	G	BA	AB	H	2B	3B	HR	SB	BB	SO	R	RBI	G	PO	A	E	DP	FA
'53/SB	66	.187	198	37	4	0	0	1	12	16	17	17	11	118	8	4	4	.969

YEAR/TEAM	Hitting													Fielding					
	G	BA	AB	H	2B	3B	HR	SB	BB	SO	R	RBI		G	PO	A	E	DP	FA
'54/SB	60	.238	172	41	3	0	5	2	7	11	18	32		37	287	8	2	25	.993
Car (2 yrs)	126	.211	370	78	7	0	5	3	19	27	35	49		48	405	16	6	29	.986
Play (1 yr)	1	.250	4	1	0	0	0	0	—	—	1	0		1	8	0	1	2	.889

King, Nancy (Hometown: Chicago, IL, OF)

YEAR/TEAM	Hitting													Fielding					
	G	BA	AB	H	2B	3B	HR	SB	BB	SO	R	RBI		G	PO	A	E	DP	FA
'51/Ken	No record — less than 10 games																		

Kissel (Lafser), Audrey "Pigtails" "Kiss" (Born: 2/27/26, St. Louis, MO, BR, TR, 5'3", 120, 2B)

YEAR/TEAM	Hitting													Fielding					
	G	BA	AB	H	2B	3B	HR	SB	BB	SO	R	RBI		G	PO	A	E	DP	FA
'44/Mpls	102	.189	360	68	1	3	1	47	32	12	47	19		101	261	182	37	20	.923

Klosowski, Delores (Born: 4/28/23, Detroit, MI, BL, TL, 5'4", 134, 1B)

YEAR/TEAM	Hitting													Fielding					
	G	BA	AB	H	2B	3B	HR	SB	BB	SO	R	RBI		G	PO	A	E	DP	FA
'44/Mil	20	.222	72	16	1	0	0	10	7	6	6	12		20	225	7	5	13	.979
'45/SB	19	.169	65	11	1	0	0	0	5	9	2	4		17	165	9	10	6	.946
Car (2 yrs)	39	.197	137	27	2	0	0	10	12	15	8	16		37	390	16	15	19	.964

Klosowski, Theresa (U)

YEAR/TEAM	Hitting													Fielding					
	G	BA	AB	H	2B	3B	HR	SB	BB	SO	R	RBI		G	PO	A	E	DP	FA
'48/Mus	2	.000	3	0	—	—	—	—	—	—	—	—		No record					

Knezovich (Martz), Ruby (Born: 3/18/18, Hamilton, ON, Canada; Died: 8/1/95, BR, TR, 5'2", 130, C)

YEAR/TEAM	Hitting													Fielding					
	G	BA	AB	H	2B	3B	HR	SB	BB	SO	R	RBI		G	PO	A	E	DP	FA
'44/Rac	17	.146	41	6	0	0	0	1	3	3	4	2		17	29	16	2	1	.958

Koehn, Phyllis "Sugar" (Born: 9/15/22, Marshfield, WI, BR, TR, 5'5", 120, OF, P)
see Pitchers

YEAR/TEAM	Hitting													Fielding					
	G	BA	AB	H	2B	3B	HR	SB	BB	SO	R	RBI		G	PO	A	E	DP	FA
'43/Ken	95	.238	353	84	9	6	4	37	14	21	56	52		90	213	47	23	8	.874
'44/Ken	114	.213	428	91	6	6	1	50	15	13	62	42		115	204	23	13	3	.946
'45/Ken, SB	115	.233	408	95	5	3	1	15	24	19	32	43		108	161	188	35	5	.909
'48/SB, Peo, Rac	79	.160	256	41	6	2	0	9	14	39	22	21		52	46	0	2	0	.958
'50/GR	57	.157	166	26	3	0	0	3	11	18	11	11		45	33	11	4	2	.917
Car (5 yrs)	460	.209	1611	337	29	17	6	114	78	110	183	169		410	657	269	77	18	.923
Play (3 yrs)	13	.170	47	8	2	0	0	0	—	1	1	1		12	32	1	0	1	1.000

Kolanko, Mary Lou "Klinky" (Born: 5/16/32, Weirton, WV, BL, TL, 5'2", 124, OF)

YEAR/TEAM	Hitting													Fielding					
	G	BA	AB	H	2B	3B	HR	SB	BB	SO	R	RBI		G	PO	A	E	DP	FA
'50/ Chic/Spr	45	.285	172	49	1	2	0	24	35	13	36	20		No record					
'50/Peo	No record — played less than 10 games																		

Kotil, Arlene (Hometown: Chicago, IL, 1B)

YEAR/TEAM	G	BA	AB	H	2B	3B	HR	SB	BB	SO	R	RBI	G	PO	A	E	DP	FA
		Hitting											Fielding					
'50/Mus, SB	83	.205	244	50	5	1	0	10	30	64	21	21	82	177	20	19	33	.977
'51/SB	No record — less than 10 games																	

Kotowicz, Irene K. "Ike" (Born: 12/10/19, Chicago, IL, BR, TR, 5'5", 128, OF, P)
see Pitchers

YEAR/TEAM	G	BA	AB	H	2B	3B	HR	SB	BB	SO	R	RBI	G	PO	A	E	DP	FA
		Hitting											Fielding					
'45/Roc	52	.154	154	25	2	1	0	9	15	4	14	12	47	72	0	2	0	.973
'46/FW	37	.190	121	23	3	0	0	9	15	1	17	7	37	31	3	3	1	.919
Car (2 yrs)	89	.175	275	48	5	1	0	18	30	5	31	19	84	103	3	5	1	.955

Kovalchick (Roark), Helen "Dot" (Born: 12/31/25, Sagamore, PA, 5'2", 125, TR, BR, OF, 3B)

YEAR/TEAM	G	BA	AB	H	2B	3B	HR	SB	BB	SO	R	RBI	G	PO	A	E	DP	FA
		Hitting											Fielding					
'45/FW	No record																	

Krick, Jaynie "Red" (Born: 10/1/29, Auburn, IN, BR, TR, 5'11", 150, OF, 3B, P)
see Pitchers

YEAR/TEAM	G	BA	AB	H	2B	3B	HR	SB	BB	SO	R	RBI	G	PO	A	E	DP	FA
		Hitting											Fielding					
'48/Spr, SB	52	.191	131	25	2	0	0	1	15	26	13	9	31	9	2	1	0	.917
'51/BC, Peo	83	.210	267	56	6	1	0	2	22	44	20	21	60	70	155	29	9	.886
'52/GR	54	.162	117	19	0	1	0	0	8	17	13	6	21	17	34	5	0	.911
Car (3 yrs)	189	.194	515	100	8	2	0	3	45	87	46	36	112	96	191	35	9	.891

Kruckel, Marie "Kruck" (Born: 6/18/24, Bronx, NY, BR, TR, 5'4", 130, OF, P)
see Pitchers

YEAR/TEAM	G	BA	AB	H	2B	3B	HR	SB	BB	SO	R	RBI	G	PO	A	E	DP	FA
		Hitting											Fielding					
'46/SB	5	.000	9	0	—	—	—	—	—	—	—	—	No record					
'47/FW	23	.067	60	4	0	0	0	4	7	13	3	3	12	4	3	2	1	.778
'48/SB, Mus	22	.167	48	8	90	9	9	2	3	7	4	5	43	39	6	2	1	.958
'49/Mus	48	.193	119	23	1	1	0	1	32	15	9	8	31	35	3	0	0	1.000
Car (4 yrs)	98	.148	236	35	1	1	0	7	42	35	16	16	86	78	12	4	2	.958

Kunkel (Huff), Anna "Kunk" (Born: 3/18/32, Wescosville, PA, 5'2", 112, OF)

YEAR/TEAM	G	BA	AB	H	2B	3B	HR	SB	BB	SO	R	RBI	G	PO	A	E	DP	FA
		Hitting											Fielding					
'50/SB	No record — less than 10 games																	

Kurys, Sophie "Soph" "Flint Flash" (Born: 5/14/25, Flint, MI, TR, BR, 5'5", 115, 2B, OF, P)
see Pitchers

YEAR/TEAM	G	BA	AB	H	2B	3B	HR	SB	BB	SO	R	RBI	G	PO	A	E	DP	FA
		Hitting											Fielding					
'43/Rac	106	.271	383	104	8	7	3	44	28	21	60	59	92	197	167	36	10	.910
'44/Rac	116	.244	394	96	7	3	1	166	69	32	87	60	116	355	188	28	20	.951
'45/Rac	105	.239	347	83	6	2	1	115	69	27	73	15	105	284	168	15	25	.968

YEAR/TEAM	Hitting												Fielding					
	G	BA	AB	H	2B	3B	HR	SB	BB	SO	R	RBI	G	PO	A	E	DP	FA
'46/Rac	113	.286	392	112	5	6	3	201	93	31	117	33	113	295	239	15	26	.973
'47/Rac	112	.229	432	99	8	6	2	142	49	31	81	19	112	322	215	18	14	.968
'48/Rac	124	.252	444	112	12	5	3	172	81	21	97	22	124	284	232	27	20	.950
'49/Rac	111	.245	416	102	3	3	2	137	59	19	70	26	111	288	195	19	27	.962
'50/Rac	110	.307	424	130	22	6	7	120	68	18	95	42	110	330	203	28	27	.952
'52/BC	17	.318	66	21	0	1	0	17	6	4	8	3	17	52	34	4	4	.956
Car (9 yrs)	914	.260	3298	859	71	39	22	1114	522	204	688	278	900	2407	1641	190	173	.957
Play (5 yrs)	33	.252	127	32	3	4	0	32	—		20	6	30	77	46	4	2	.969

Lawson, Mary (Born: 8/15/24, Keyport, NJ; Died: 9/6/97, OF)

YEAR/TEAM	Hitting												Fielding					
	G	BA	AB	H	2B	3B	HR	SB	BB	SO	R	RBI	G	PO	A	E	DP	FA
'46/Peo	25	.105	57	6	2	0	0	1	1	3	3	1	24	27	3	2	1	.938

Leduc (Alverson), Noella "Pinky" (Born: 12/23/22, Graniteville, MA, BR, TR, 5'5", 130, OF, P)

see Pitchers

YEAR/TEAM	Hitting												Fielding					
	G	BA	AB	H	2B	3B	HR	SB	BB	SO	R	RBI	G	PO	A	E	DP	FA
'51/Peo	No record — less than 10 games																	
'52/BC	34	.169	59	10	3	0	0	1	2	12	3	2	10	4	0	2	0	.667
'53/Mus	59	.144	90	13	1	0	0	1	5	16	12	4	29	32	2	3	1	.979
'54/FW	51	.246	118	29	2	0	2	2	16	17	18	15	23	30	1	0	0	.969
Car (4 yrs)	144	.195	267	52	6	0	2	4	23	45	33	21	62	66	3	5	1	.933
Play (1 yr)	6	.238	21	5	0	0	0	1	—		0	4	6	6	0	1	0	.857

Lee (Harmon), Annabelle "Lefty" (Born: 1/22/22, Los Angeles, CA, BB, TL, 5'2", 120, 1B, P)

see Pitchers

YEAR/TEAM	Hitting												Fielding					
	G	BA	AB	H	2B	3B	HR	SB	BB	SO	R	RBI	G	PO	A	E	DP	FA
'44/Mpls	59	.179	147	25	2	0	0	9	20	4	15	9	18	149	4	4	2	.975

Lee (Dries), Dolores "Pickles" (Born: 4/21/35, Jersey City, NJ, TR, BR, 5'6", 130, 2B, P)

see Pitchers

YEAR/TEAM	Hitting												Fielding					
	G	BA	AB	H	2B	3B	HR	SB	BB	SO	R	RBI	G	PO	A	E	DP	FA
'52/Roc	No record — less than 10 games																	
'53/Roc	48	.152	145	22	0	2	0	8	5	18	13	2	18	52	48	9	8	.917
'54/Roc	45	.168	101	17	0	0	0	1	5	3	7	7	14	30	19	3	2	.942
Car (3 yrs)	93	.159	246	39	0	2	0	9	10	21	20	9	32	82	67	12	10	.926

Lenard, Jo "Bubblegum" (Born: 9/2/21, Chicago, IL, BR, TR, 5'4", 130, OF)

YEAR/TEAM	Hitting												Fielding					
	G	BA	AB	H	2B	3B	HR	SB	BB	SO	R	RBI	G	PO	A	E	DP	FA
'44/Roc	101	.211	356	75	8	10	0	68	40	11	52	34	97	128	8	5	2	.965
'45/Roc	95	.170	330	56	3	4	0	36	34	17	42	24	95	140	10	1	2	.993
'46/Mus	83	.187	273	51	5	2	0	60	50	19	34	25	82	128	11	7	4	.952
'47/Mus	111	.261	391	102	10	1	0	83	39	30	58	38	110	152	11	3	2	.982
'48/Mus	120	.211	421	89	10	6	0	64	50	57	70	56	120	188	7	16	2	.924
'49/Mus, Peo	110	.206	383	79	4	2	0	44	43	25	41	29	110	182	12	7	3	.965
'50/Ken	110	.260	389	101	9	4	1	53	59	19	52	51	110	165	8	8	1	.956
'51/Ken	100	.225	333	75	4	2	0	46	68	16	43	32	100	133	13	6	5	.961

	Hitting											Fielding						
YEAR/TEAM	G	BA	AB	H	2B	3B	HR	SB	BB	SO	R	RBI	G	PO	A	E	DP	FA
'52/SB	104	.259	351	91	15	0	0	47	59	24	49	47	101	156	6	6	0	.964
'53/SB	66	.192	193	37	5	0	0	19	39	16	24	15	64	95	4	5	0	.952
Car																		
(10 yrs)	1000	.221	3420	756	73	31	1	520	481	234	465	351	989	1467	90	64	21	.961
Play (6 yrs)	29	.172	99	17	2	2	0	11	—	—	7	4	29	37	3	1	1	.976

Leonard (Linehan), Rhoda "Nicky" (Hometown: Somerset, MA, BL, TR, 5'5", 115, 2B, OF)

	Hitting											Fielding						
YEAR/TEAM	G	BA	AB	H	2B	3B	HR	SB	BB	SO	R	RBI	G	PO	A	E	DP	FA
'46/FW	9	.095	21	2	—	—	—	—	—	—	—	—	No record					

Lequia (Barker), Joan "Joanie" (Born: 3/13/35, Negaunee, MI, 5'2", 120, BR, TR, 3B)

	Hitting											Fielding						
YEAR/TEAM	G	BA	AB	H	2B	3B	HR	SB	BB	SO	R	RBI	G	PO	A	E	DP	FA
'53/GR	No record — played in less than 10 games																	

Lessing, Ruth (Born: 8/15/25, San Antonio, TX, BR, TR, 5'5", 128 C)

	Hitting											Fielding						
YEAR/TEAM	G	BA	AB	H	2B	3B	HR	SB	BB	SO	R	RBI	G	PO	A	E	DP	FA
'44/Mpls	57	.177	198	35	1	0	0	22	16	14	13	11	57	290	60	15	8	.959
'45/FW	110	.123	342	42	2	2	1	13	41	50	32	31	109	634	83	13	8	.982
'46/GR	112	.215	367	79	10	1	1	20	38	52	43	35	112	472	141	22	16	.965
'47/GR	111	.205	396	81	9	2	0	19	32	26	24	42	111	473	88	13	7	.977
'48/GR	125	.206	417	86	7	2	0	22	56	36	43	33	125	556	115	17	12	.975
'49/GR	44	.233	120	28	2	0	0	2	21	9	9	9	40	172	32	7	5	.967
Car (6 yrs)	559	.191	1840	351	31	8	2	98	178	187	164	161	554	2597	519	87	56	.973
Play (4 yrs)	32	.083	109	15	0	1	0	1	—	—	6	9	32	169	19	8	1	.959

Lester, Mary Louise (Born: 1/19/21, Monterey, TN; Died: Date unknown, BR, TR, 5'3", 138, 2B)

	Hitting											Fielding						
YEAR/TEAM	G	BA	AB	H	2B	3B	HR	SB	BB	SO	R	RBI	G	PO	A	E	DP	FA
'43/Ken	94	.201	319	64	4	3	0	23	43	26	41	31	94	190	124	31	11	.910
'44/Ken	18	.000	26	0	0	0	0	2	7	3	2	2	No record					
Car (2 yrs)	112	.186	345	64	4	3	0	25	50	29	43	33	94	190	124	31	11	.910
Play (1 yr)	3	.231	13	3	0	0	0	1	—	—	0	1	3	7	7	1	0	.933

Liebrich, Barbara "Bobbie" (Born: 9/30/22, Providence, RI, BR, TR, 5'9", 145, 2B, 3B)

	Hitting											Fielding						
YEAR/TEAM	G	BA	AB	H	2B	3B	HR	SB	BB	SO	R	RBI	G	PO	A	E	DP	FA
'48/Roc	3	.250	4	1	—	—	—	—	—	—	—	—	No record					

Lionikas, Kay "Irene" (Hometown: New Brunswick, NJ; Died: Date Unknown, BR, TR, 2B)

	Hitting											Fielding						
YEAR/TEAM	G	BA	AB	H	2B	3B	HR	SB	BB	SO	R	RBI	G	PO	A	E	DP	FA
'48/GR, Peo	2	.000	4	0	—	—	—	—	—	—	—	—	No record					

Little, Alta (Born: 5/1/23, Gas City, IN, BR, TR, 5'10", 1B, P)
see Pitchers

	Hitting											Fielding						
YEAR/TEAM	G	BA	AB	H	2B	3B	HR	SB	BB	SO	R	RBI	G	PO	A	E	DP	FA
'48/FW	9	.135	37	5	—	—	—	—	—	—	—	—	No record					

Lobrovich, Claire (Hometown: Campbell, CA, BR, TR, OF)

	Hitting												Fielding					
YEAR/TEAM	G	BA	AB	H	2B	3B	HR	SB	BB	SO	R	RBI	G	PO	A	E	DP	FA
'47/Ken, Roc	81	.209	258	54	3	2	0	15	23	27	22	21	77	69	7	6	0	.927

Lonetto, Sarah "Tomato" (Born: 5/9/22, Detroit, MI, BR, TR, 5'3", 120, OF, P)
see Pitchers

	Hitting												Fielding					
YEAR/TEAM	G	BA	AB	H	2B	3B	HR	SB	BB	SO	R	RBI	G	PO	A	E	DP	FA
'47/Rac	22	.115	61	7	0	0	0	2	1	12	0	0	16	17	1	1	0	.947
'48/Mus	53	.183	109	20	2	1	1	4	18	14	21	4	23	18	3	1	0	.955
'49/Mus	27	.089	56	5	0	0	0	2	1	11	4	1	17	15	4	1	1	.950
Car (3 yrs)	102	.142	225	32	2	1	1	8	20	37	25	5	56	50	8	3	1	.951
Play (2 yrs)	2	.000	2	0	0	0	0	0	—	—	0	0	1	3	0	0	1	1.000

Lovell (Dowler), Jean "Grump" (Hometown: Conneaut, OH; Died: 1/1/92, C, P)
see Pitchers

	Hitting												Fielding					
YEAR/TEAM	G	BA	AB	H	2B	3B	HR	SB	BB	SO	R	RBI	G	PO	A	E	DP	FA
'48/Roc	52	.219	151	33	1	0	0	3	4	19	6	8	36	154	29	12	1	.931
'49/Roc	26	.156	64	10	2	0	0	1	8	8	5	4	26	125	18	6	4	.960
'50/Kal	94	.221	289	64	8	2	1	4	36	22	22	30	88	334	73	16	9	.962
'51/Kal, Ken	91	.216	278	60	14	2	0	2	36	27	27	31	70	288	39	11	7	.967
'52/Kal	55	.246	142	35	5	2	1	0	11	16	10	12	42	133	26	7	1	.958
'53/Kal	70	.202	193	39	4	0	2	1	20	16	18	20	46	148	35	11	6	.943
'54/Kal	82	.286	259	74	5	0	21	0	25	25	43	69	70	214	33	14	5	.946
Car (7 yrs)	470	.229	1376	315	39	6	25	11	140	131	174	174	378	1396	253	77	33	.955
Play (3 yrs)	15	.321	53	17	1	0	1	0	—	—	5	7	13	51	5	4	2	.933

Luhtala, Shirley (Hometown: Dekalb, IL, 1B)

	Hitting												Fielding					
YEAR/TEAM	G	BA	AB	H	2B	3B	HR	SB	BB	SO	R	RBI	G	PO	A	E	DP	FA
'50/Rac	No record — played in less than 10 games																	
'51/BC, Roc	30	.167	96	16	1	0	0	1	7	13	6	5	20	152	4	9	3	.945

Luna (Hill), Betty Jean (Born: 5/1/27, Dallas, TX, BR, TR, 5'5", 133, OF, P)
see Pitchers

	Hitting												Fielding					
YEAR/TEAM	G	BA	AB	H	2B	3B	HR	SB	BB	SO	R	RBI	G	PO	A	E	DP	FA
'48/Chic	97	.237	257	61	7	6	1	24	28	32	22	26	57	56	5	6	2	.910
'49/FW	95	.197	320	63	5	1	1	17	38	28	32	26	81	156	5	8	0	.953
'50/FW, Kal	104	.237	376	89	18	3	2	19	36	30	42	50	100	194	19	14	6	.938
Car (3 yrs)	296	.224	953	213	30	10	5	60	102	90	96	102	238	406	29	28	8	.964
Play (1 yr)	3	.091	11	1	0	0	0	0	—	—	1	0	3	3	1	0	1	1.000

Lyman (Kelly), Esther (Hometown: Peoria, IL:, Died: Date Unknown, C)

	Hitting												Fielding					
YEAR/TEAM	G	BA	AB	H	2B	3B	HR	SB	BB	SO	R	RBI	G	PO	A	E	DP	FA
'46/SB	No record																	

McCarty, Mary "Mick" (Born: 6/8/31, Flint, MI, 5'6", 180, OF)

	Hitting												Fielding					
YEAR/TEAM	G	BA	AB	H	2B	3B	HR	SB	BB	SO	R	RBI	G	PO	A	E	DP	FA
'51/Peo	72	.169	207	35	6	2	0	9	20	49	20	24	70	83	9	9	4	.911

McComb, Joanne "Jo" (Born: 3/1/33, Avonmore, PA, BR, TR, 5'7", 130, 1B)

	Hitting												Fielding					
YEAR/TEAM	G	BA	AB	H	2B	3B	HR	SB	BB	SO	R	RBI	G	PO	A	E	DP	FA
'50/																		
Chic/Spr	69	.141	242	34	1	0	0	9	37	43	32	19	No record					

McCreary, Ethel (Hometown: Regina, SK, Canada; Died: Date Unknown BR, TR, OF)

	Hitting												Fielding					
YEAR/TEAM	G	BA	AB	H	2B	3B	HR	SB	BB	SO	R	RBI	G	PO	A	E	DP	FA
'43/Ken	71	.251	231	58	6	1	1	11	18	7	29	36	49	57	8	4	1	.942
Play (1 yr)	1	.000	1	0	0	0	0	0	—	—	0	0	0	—	—	—	—	—

Machado (Van Sant), Helene "Chow" (Born: 4/17/26, Venice, CA, BR, TR, 5'11", 148, OF)

	Hitting												Fielding					
YEAR/TEAM	G	BA	AB	H	2B	3B	HR	SB	BB	SO	R	RBI	G	PO	A	E	DP	FA
'46/Peo	73	.183	252	46	7	1	0	6	11	9	13	14	69	81	6	7	0	.926
'47/FW	90	.223	301	67	6	3	0	27	24	23	26	23	90	180	8	10	2	.949
Car (2 yrs)	163	.204	553	113	13	4	0	33	35	32	39	37	159	261	14	17	2	.942

McKenna, Betty (Hometown: Lisbon, OH; Died: 2/24/92, 3B)

	Hitting												Fielding					
YEAR/TEAM	G	BA	AB	H	2B	3B	HR	SB	BB	SO	R	RBI	G	PO	A	E	DP	FA
'51/FW,																		
BC, Peo	61	.151	159	24	6	12	0	9	45	32	20	14	57	62	121	19	6	.906
'52/BC	11	.077	26	2	0	0	0	0	2	7	2	0	11	7	28	3	1	.921
'53/Mus	94	.215	293	63	8	1	0	16	48	38	31	28	92	132	235	35	11	.913
Car (3 yrs)	166	.186	478	89	14	2	0	25	95	77	53	42	160	201	384	57	18	.911

McKinley (Uselmann), Therese "Terry" (Born: 2/28/28, Chicago, IL, BR, TR, 5'6", 135, OF)

	Hitting												Fielding					
YEAR/TEAM	G	BA	AB	H	2B	3B	HR	SB	BB	SO	R	RBI	G	PO	A	E	DP	FA
'49/Mus	37	.099	101	10	0	0	0	7	9	18	10	4	35	38	3	2	2	.953
Play (1 yr)	5	.250	16	4	0	0	0	4	—	—	2	1	5	3	0	0	0	1.000

MacLean (Moore, Ross), Lucella "Frenchy" (Born: 1/3/21, Lloydminster, SK, Canada, BR, TR, 5'2", 135, C, OF)

	Hitting												Fielding					
YEAR/TEAM	G	BA	AB	H	2B	3B	HR	SB	BB	SO	R	RBI	G	PO	A	E	DP	FA
'43/SB	70	.206	228	47	4	1	0	44	22	9	30	22	64	187	26	10	6	.955
'44/SB	31	.075	174	13	0	0	0	18	6	8	4	3	15	56	10	4	2	.943
Car (2 yrs)	101	.149	402	60	4	1	0	62	28	17	34	25	79	243	36	14	8	.952

Maguire (Chapman, McAlpin), Dorothy "Mickey" (Born: 11/12/18, LaGrange, OH; Died: Date Unknown, BR, TR, 5'5", 145, C, OF)

	Hitting												Fielding					
YEAR/TEAM	G	BA	AB	H	2B	3B	HR	SB	BB	SO	R	RBI	G	PO	A	E	DP	FA
'43/Rac	70	.269	219	59	5	4	0	29	11	7	34	33	63	162	28	21	9	.900

YEAR/TEAM	Hitting												Fielding					
	G	BA	AB	H	2B	3B	HR	SB	BB	SO	R	RBI	G	PO	A	E	DP	FA
'44/Mil	109	.191	361	69	2	5	1	53	24	14	40	29	108	310	117	47	9	.901
'45/GR	99	.159	327	52	6	2	0	27	41	28	35	20	96	245	77	27	8	.923
'46/Mus	101	.218	340	74	7	4	1	57	47	18	42	47	101	378	100	39	13	.925
'47/Mus	75	.216	232	50	6	1	0	27	22	14	28	24	72	269	63	21	6	.941
'48/Mus	124	.155	373	58	3	0	1	47	56	58	40	30	124	549	139	34	11	.953
'49/Mus	17	.148	54	8	1	0	0	3	5	10	3	2	10	9	1	1	0	.909
Car (7 yrs)	595	.194	1906	370	30	16	3	243	206	149	222	185	574	1922	525	190	56	.928
Play (4 yrs)	19	.141	64	8	1	0	0	5	—	—	4	3	19	44	13	5	1	.919

Mahon, Elizabeth "Lib" (Born: 11/18/19, Greenville, SC, BR, TR, 5'7", 135, 2B, OF)

YEAR/TEAM	Hitting												Fielding					
	G	BA	AB	H	2B	3B	HR	SB	BB	SO	R	RBI	G	PO	A	E	DP	FA
'44/Mpls, Ken	107	.211	341	72	6	2	3	31	60	18	43	38	86	186	134	21	12	.938
'45/SB	80	.246	260	64	4	4	0	19	25	16	28	21	79	78	12	4	0	.957
'46/SB	112	.276	399	110	7	7	1	114	64	15	90	72	112	133	15	6	2	.961
'47/SB	83	.234	199	70	5	8	0	22	15	12	26	23	82	78	9	5	2	.946
'48/SB	117	.258	422	109	12	4	2	38	48	26	59	65	116	190	35	9	3	.962
'49/SB	106	.245	396	97	16	3	0	66	40	18	62	60	106	178	9	3	5	.984
'50/SB	69	.256	256	63	11	1	1	17	19	15	23	37	67	111	4	1	1	.991
'51/SB	104	.269	364	98	14	5	1	53	60	20	69	41	104	178	8	6	2	.969
'52/SB	59	.229	166	38	9	0	0	13	27	11	32	16	55	58	6	3	1	.955
Car (9 yrs)	837	.248	2903	721	84	34	8	364	358	150	432	400	807	1190	236	58	28	.961
Play (6 yrs)	33	.167	120	20	3	0	0	4	—	—	8	6	22	56	13	1	0	.986

Mahoney, Emily Marie "Red" (Born: 9/21/24, Houston, TX, BR, TR, 5'3", 135, OF)

YEAR/TEAM	Hitting												Fielding					
	G	BA	AB	H	2B	3B	HR	SB	BB	SO	R	RBI	G	PO	A	E	DP	FA
'47/SB	47	.204	147	30	3	7	1	13	6	23	14	13	45	47	2	5	1	.907
'48/SB, FW	56	.140	107	15	0	0	0	14	10	18	17	1	45	49	3	2	1	.963
Car (2 yrs)	103	.177	254	45	3	7	1	27	16	41	31	14	90	96	5	7	2	.935
Play (1 yr)	2	.200	5	1	0	0	0	0	—	—	0	0	1	1	0	1	0	.500

Malach (Webb), Kay (Born: 5/30/26, Knoxville, TN, 5'5", 135, BR, TR, U)

YEAR/TEAM	Hitting												Fielding					
	G	BA	AB	H	2B	3B	HR	SB	BB	SO	R	RBI	G	PO	A	E	DP	FA
'47/FW	1	.000	1	0	—	—	—	—	—	—	—	—	No record					

Mansfield (Kelley), Marie "Boston" (Born: 11/4/31, Jamaica Plain, MA, TR, BR, 5'7", 140, OF, P)

see Pitchers

YEAR/TEAM	Hitting												Fielding					
	G	BA	AB	H	2B	3B	HR	SB	BB	SO	R	RBI	G	PO	A	E	DP	FA
'50/Roc	77	.139	208	29	1	0	0	7	24	48	19	9	77	100	9	2	0	.982
'51/Roc	41	.127	102	13	1	0	0	7	24	48	19	9	11	13	5	3	1	.857
'52/BC, Roc	40	.133	83	11	2	0	0	0	5	14	3	4	10	9	1	0	0	1.000
'53/Roc	53	.177	124	22	3	1	0	1	13	30	11	11	11	8	0	1	0	.889
'54/Roc	42	.151	106	16	3	0	0	1	11	31	7	6	14	113	6	4	8	.967
Car (5 yrs)	153	.146	623	91	10	1	0	16	69	140	54	38	123	243	21	10	9	.961
Play (2 yrs)	2	.000	4	0	0	0	0	0	—	—	0	0	2	2	0	0	0	1.000

Marlowe (Malanowski), Jean "Mal" "Jeanie" (Born: 12/28/29, Scranton, PA, TR, BR, 5'6", 135, 1B, 2B, OF, P)

see Pitchers

YEAR/TEAM	G	BA	AB	H	2B	3B	HR	SB	BB	SO	R	RBI	G	PO	A	E	DP	FA
'49/Ken	98	.220	305	67	6	4	1	16	31	68	25	17	73	102	9	9	3	.925
'50/Ken	42	.211	109	23	1	1	1	4	10	24	11	17	11	11	0	1	0	.917
'51/Ken	66	.174	178	31	4	0	0	4	31	27	17	16	26	170	18	7	10	.964
'52/Kal	35	.291	86	25	4	0	3	2	10	9	12	12	No record					
Car (4 yrs)	157		678	146	15	5	5	26	82	128	65	62	110	283	27	17	13	.948
Play (2 yrs)	3	.000	9	0	0	0	0	0	—	—	0	0	3	0	3	0	0	1.000

Marshall, Theda "T" (Born: 4/24/25, Canton, SD, BR, TR, 5'7", 133, 1B)

YEAR/TEAM	G	BA	AB	H	2B	3B	HR	SB	BB	SO	R	RBI	G	PO	A	E	DP	FA
'47/SB	113	.141	362	51	10	5	0	27	24	79	27	31	112	1304	37	42	45	.970
'48/SB, Chic	125	.140	392	55	6	4	0	7	35	60	26	17	125	1303	24	38	50	.972
Car (2 yrs)	238	.141	754	106	16	9	0	34	59	139	53	48	237	2607	61	80	95	.971
Play (1 yr)	5	.166	18	3	1	0	0	0	—	—	2	0	5	24	1	2	1	.926

Mattson (Baumgart), Jacqueline (Born: 11/16/28, Waukegan, IL, BR, TR, 5'5", 100, C)

YEAR/TEAM	G	BA	AB	H	2B	3B	HR	SB	BB	SO	R	RBI	G	PO	A	E	DP	FA
'50/Chic/Spr	48	.200	175	35	4	0	0	2	21	25	17	18	No record					
'51/Ken	51	.098	51	5	0	0	0	1	7	7	6	3	22	67	9	4	1	.950

Maturzewski, Joan (Hometown: Milwaukee, WI, OF)

YEAR/TEAM	G	BA	AB	H	2B	3B	HR	SB	BB	SO	R	RBI	G	PO	A	E	DP	FA
'53/SB	28	.162	99	16	2	1	0	3	15	14	15	2	28	32	1	5	0	.868

Mayer, Alice (OF)

YEAR/TEAM	G	BA	AB	H	2B	3B	HR	SB	BB	SO	R	RBI	G	PO	A	E	DP	FA
'48/SB	37	.211	90	19	0	2	0	9	7	15	6	13	32	13	0	2	0	.867

Meacham, Mildred "Meach" (Born: 5/5/24, Charlotte, NC, BR, TR, 5'8", 160, 1B)

YEAR/TEAM	G	BA	AB	H	2B	3B	HR	SB	BB	SO	R	RBI	G	PO	A	E	DP	FA
'47/FW, Rac	2	.000	2	0	—	—	—	—	—	—	—	—	No record					
'48/Spr	95	.180	289	52	4	3	0	24	32	37	26	10	95	984	32	26	20	.975
Car (2 yrs)	97	.179	291	52	4	3	0	24	32	37	26	10	95	984	32	26	20	.975

Measner (Wildfong), Hazel (Hometown: Holdfast, SK, Canada, U)

YEAR/TEAM	G	BA	AB	H	2B	3B	HR	SB	BB	SO	R	RBI	G	PO	A	E	DP	FA
'46/Roc	1	.000	1	0	—	—	—	—	—	—	—	—	No record					

Meier, Naomi "Sally" (Born: 11/17/26, Fort Wayne, IN; Died: Date Unknown, BR, TR, 5'10", 148, OF)

YEAR/TEAM	G	BA	AB	H	2B	3B	HR	SB	BB	SO	R	RBI	G	PO	A	E	DP	FA
'46/Roc	103	.249	374	93	2	2	1	33	23	26	44	49	101	165	8	10	2	.945

YEAR/TEAM	G	BA	AB	H	2B	3B	HR	SB	BB	SO	R	RBI	G	PO	A	E	DP	FA
					Hitting									**Fielding**				
'47/Roc, FW	92	.153	308	47	3	2	1	16	25	38	27	18	91	136	3	7	0	.952
'48/Peo, Chic	127	.222	450	100	5	3	0	55	39	63	54	47	127	228	5	17	2	.932
'49/Rac, Mus	107	.234	354	83	3	3	0	29	44	43	30	32	101	138	10	7	2	.955
'50/Kal, FW	94	.261	326	85	5	0	1	34	32	40	41	36	90	137	6	12	0	.923
'51/FW	21	.240	75	18	3	0	0	8	8	8	12	14	21	37	2	3	0	.929
'52/FW, BC	55	.252	163	41	6	2	0	6	11	13	13	11	48	56	3	6	3	.908
'53/Mus	111	.229	406	93	6	2	1	25	37	46	44	27	111	209	10	11	0	.952
Car (8 yrs)	710	.258	2456	560	33	14	4	206	219	277	265	234	690	1106	47	73	9	.941
Play (3 yrs)	27	.208	101	21	1	0	0	6	—	—	7	7	27	32	3	1	0	.972

Melin, Berith (Hometown: Rockford, IL; Died: Date Unknown, BR, TR, OF)

YEAR/TEAM	G	BA	AB	H	2B	3B	HR	SB	BB	SO	R	RBI	G	PO	A	E	DP	FA
					Hitting									**Fielding**				
'43/Roc	56	.158	146	23	2	2	0	4	5	25	7	4	42	27	4	3	1	.912

Metrolis, Norma "Trolley" (Born: 12/5/25, Kettery, ME, BR, TR, 5'6", 135, C)

YEAR/TEAM	G	BA	AB	H	2B	3B	HR	SB	BB	SO	R	RBI	G	PO	A	E	DP	FA
					Hitting									**Fielding**				
'46/Mus	15	.188	32	6	0	0	0	2	2	2	2	1	15	47	10	4	1	.934
'47/Rac	18	.149	47	7	0	0	0	2	4	4	2	2	17	72	0	5	2	.935
'48/SB	12	.160	25	4	0	0	0	2	3	1	2	2	12	37	6	3	1	.935
'49/SB, Peo	15	.148	27	4	0	0	0	1	4	4	1	3	14	26	3	2	0	.935
'50/FW	No record — played less than 10 games																	
Car (5 yrs)	60	.160	131	21	0	0	0	7	13	11	7	8	58	182	19	14	4	.935

Meyer (Petrovic), Anna "Pee Wee" (Born: 11/17/28, Aurora, IL, BR, TR, 5'3", 105, SS)

YEAR/TEAM	G	BA	AB	H	2B	3B	HR	SB	BB	SO	R	RBI	G	PO	A	E	DP	FA
					Hitting									**Fielding**				
'44/Ken, Mpls	17	.107	28	3	0	0	0	3	5	7	3	1	No record					

Meyer (Moellering), Rita "Slats" (Born: 2/12/27, Florissant, MO, BR, TR, 5'10", 145, SS, P)
see Pitchers

YEAR/TEAM	G	BA	AB	H	2B	3B	HR	SB	BB	SO	R	RBI	G	PO	A	E	DP	FA
					Hitting									**Fielding**				
'46/Peo	103	.168	339	57	0	3	0	19	22	32	26	19	103	218	235	60	20	.883
'47/Peo	83	.226	257	58	4	2	1	5	13	16	18	30	66	106	143	42	4	.856
'48/Peo	122	.232	457	106	12	1	2	45	31	32	49	68	121	214	315	62	21	.895
'49/Peo	91	.190	332	63	8	1	0	7	17	16	28	23	82	158	250	47	15	.897
Car (4 yrs)	399	.205	1385	284	24	7	3	76	83	96	121	140	372	696	943	211	60	.886
Play (1 yr)	1	.000	1	0	0	0	0	0	—	—	0	0	1	0	0	0	0	1.000

Michelson, Darlene "Mickey" (Hometown: Kenosha, WI; Died: Date Unknown BR, TR, OF)

YEAR/TEAM	G	BA	AB	H	2B	3B	HR	SB	BB	SO	R	RBI	G	PO	A	E	DP	FA
					Hitting									**Fielding**				
'43/Ken	47	.199	161	32	1	2	0	10	19	18	20	29	43	34	3	4	0	.902
'45/SB	3	.250	4	1	—	—	—	—	—	—	—	—	No record					
Car (2 yrs)	50	.200	165	33	1	2	0	10	19	18	20	29	43	34	3	4	0	.902

Middleton (Gentry), Ruth (Born: 8/25/30, Winnipeg, MB, Canada, BR, TR, 5'2", 115, OF)

	Hitting											Fielding						
YEAR/TEAM	G	BA	AB	H	2B	3B	HR	SB	BB	SO	R	RBI	G	PO	A	E	DP	FA
'50/Chic/																		
Spr	73	.228	281	64	6	9	0	17	46	25	49	33	No record					
'51/BC	No record — played less than 10 games																	
'52/BC	86	.138	160	22	3	0	0	6	24	32	16	10	84	157	7	8	2	.953
'53/Mus	36	.125	72	9	0	0	0	2	7	9	9	2	33	48	2	2	0	.962
Car (3 yrs)	122	.134	232	31	3	0	0	8	31	41	25	12	117	205	9	10	2	.955

Miller, Pauline "Polly"

	Hitting											Fielding						
YEAR/TEAM	G	BA	AB	H	2B	3B	HR	SB	BB	SO	R	RBI	G	PO	A	E	DP	FA
'48/Ken	1	.000	0	0	—	—	—	—	—	—	—	—	No record					

Miller, Ruth (Hometown: Jacksonville, IL, C)

	Hitting											Fielding						
YEAR/TEAM	G	BA	AB	H	2B	3B	HR	SB	BB	SO	R	RBI	G	PO	A	E	DP	FA
'43/Roc	No record																	

Moczynski, Betty "Moe" (Born: 6/30/26, Milwaukee, WI, BR, TR, 5'3", 120, OF)

	Hitting											Fielding						
YEAR/TEAM	G	BA	AB	H	2B	3B	HR	SB	BB	SO	R	RBI	G	PO	A	E	DP	FA
'43/Roc	59	.173	208	36	1	2	1	13	17	13	15	27	59	75	7	4	0	.953

Moffett, Jane (Born: 7/2/30, Pirtman, NJ, BR, TR, 5'10", 151, 1B, OF, C)

	Hitting											Fielding						
YEAR/TEAM	G	BA	AB	H	2B	3B	HR	SB	BB	SO	R	RBI	G	PO	A	E	DP	FA
'49/Spr	No record																	
'50/																		
Chic/Spr	21	.162	74	12	1	0	0	7	7	12	11	9	No record					
'51/Kal	94	.205	312	64	11	1	0	23	33	38	35	23	98	262	25	21	11	.932
'52/Kal, BC	56	.219	151	33	2	3	0	8	124	15	13	14	42	64	3	2	1	.971
Car (2 yrs)	150	.210	463	97	13	4	0	31	47	53	48	37	140	326	38	23	11	.939

Montalbano, Rose "Monty" (Hometown: Staten Island, NY, 2B)

	Hitting											Fielding						
YEAR/TEAM	G	BA	AB	H	2B	3B	HR	SB	BB	SO	R	RBI	G	PO	A	E	DP	FA
'51/SB	No record — played less than 10 games																	
'52/BC, SB	12	.188	32	6	1	0	0	0	5	10	5	7	12	11	12	9	1	.719
'53/SB, Mus	26	.238	63	15	1	0	0	3	10	10	8	2	13	24	26	5	2	.909
Car (3 yrs)	38	.221	95	21	2	0	0	3	15	20	13	9	25	35	38	14	3	.839

Montgomery, Dorothy "Monty" (Born: 2/6/24, Ashville, NC, BL, TR, 5'3", 110, U)

	Hitting											Fielding						
YEAR/TEAM	G	BA	AB	H	2B	3B	HR	SB	BB	SO	R	RBI	G	PO	A	E	DP	FA
'46/Mus	26	.208	53	11	0	0	0	3	7	3	5	2	17	29	20	5	4	.908

Moore, Dolores "Dee" (Born: 10/27/32, Chicago, IL, BR, TR, 5'7", 153, 1B, 2B)

	Hitting											Fielding						
YEAR/TEAM	G	BA	AB	H	2B	3B	HR	SB	BB	SO	R	RBI	G	PO	A	E	DP	FA
'53/GR	56	.199	156	31	3	0	0	4	13	20	11	18	43	77	75	16	11	.905
'54/GR	93	.239	321	83	5	0	3	6	20	19	35	39	92	844	30	11	53	.988

YEAR/TEAM	Hitting G	BA	AB	H	2B	3B	HR	SB	BB	SO	R	RBI	Fielding G	PO	A	E	DP	FA
Car (2 yrs)	149	.239	477	114	8	0	3	10	33	39	46	57	135	921	105	27	64	.974
Play (2 yrs)	6	.238	21	5	0	0	0	0	—	—	1	4	6	13	8	2	0	.913

Moore, Mary Ann "Sis" (Born: 6/7/32, Detroit, MI, BR, TR, 5'5", 145, 2B)

YEAR/TEAM	Hitting G	BA	AB	H	2B	3B	HR	SB	BB	SO	R	RBI	Fielding G	PO	A	E	DP	FA
'50/																		
Chic/Spr	77	.253	297	75	4	4	3	20	61	40	65	48	No record					
'51/BC	No record — played less than 10 games																	
'52/BC	42148		88	13	1	0	0	5	20	31	11	0	No record					

Morrison (Gamberdella), Esther "Schmattze" (Born: 5/26/31, Chicago, IL, BR, TR, 5'1", 125, OF, C, P)

see Pitchers

YEAR/TEAM	Hitting G	BA	AB	H	2B	3B	HR	SB	BB	SO	R	RBI	Fielding G	PO	A	E	DP	FA
'50/																		
Chic/Spr	13	.204	59	12	0	1	0	0	—	—	11	9	No record					

Mudge (Cato), Nancy "Smudgie" (Born: 10/3/29, Bridgeport, NY, BR, TR, 5'2", 120, 2B)

YEAR/TEAM	Hitting G	BA	AB	H	2B	3B	HR	SB	BB	SO	R	RBI	Fielding G	PO	A	E	DP	FA
'49/FW	2	.000	0	0	—	—	—	—	—	—	—	—	No record					
'50/																		
Chic/Spr	40	.208	172	53	3	9	0	13	22	24	41	24	No record					
'51/Kal	85	.167	251	42	6	0	0	17	35	61	32	17	80	196	137	32	26	.912
'52/Kal, BC	61	.150	153	23	2	0	0	8	33	54	22	4	49	132	76	17	13	.924
'53/Mus	104	.157	337	53	4	3	1	39	68	66	58	12	99	234	197	30	35	.935
'54/Kal	98	.232	353	82	13	0	7	33	68	52	74	22	98	264	213	30	37	.941
Car (5 yrs)	350	.183	1094	200	25	3	8	97	204	233	186	55	326	826	623	109	111	.935
Play (1 yr)	8	.242	33	8	2	0	1	1	—	—	12	5	8	12	15	6	1	.818

Mueller (Bajda), Dorothy "Sporty" "Dottie" (Born: 12/25/25, Chevoit, OH; Died: 6/2/85, Br, TR, 5'11", 160, 1B, P)

see Pitchers

YEAR/TEAM	Hitting G	BA	AB	H	2B	3B	HR	SB	BB	SO	R	RBI	Fielding G	PO	A	E	DP	FA
'51/SB	75	.236	229	54	9	0	0	5	22	34	18	30	59	491	15	19	21	.964
'52/SB	47	.250	152	38	1	2	5	1	8	23	17	21	27	252	11	9	14	.967
Car (2 yrs)	122	.241	381	92	10	2	5	1	30	57	35	51	86	743	26	28	35	.965
Play (1 yr)	6	.105	19	2	0	0	0	0	—	—	1	1	6	47	1	2	2	.960

Murray, Margaret "Marge" (Hometown: Joliet, IL, C, OF)

YEAR/TEAM	Hitting G	BA	AB	H	2B	3B	HR	SB	BB	SO	R	RBI	Fielding G	PO	A	E	DP	FA
'48/Spr	No record																	
'49/Spr	No record																	

Naum (Parker), Dorothy "Dottie" (Born: 1/5/28, Dearborn, MI, BR, TR, 5'4", 112, C, 2B, SS, P)

see Pitchers

YEAR/TEAM	Hitting G	BA	AB	H	2B	3B	HR	SB	BB	SO	R	RBI	Fielding G	PO	A	E	DP	FA
'46/SB	31	.194	72	14	0	0	0	12	10	10	13	8	22	49	26	2	0	.974

	Hitting												**Fielding**					
YEAR/TEAM	*G*	*BA*	*AB*	*H*	*2B*	*3B*	*HR*	*SB*	*BB*	*SO*	*R*	*RBI*	*G*	*PO*	*A*	*E*	*DP*	*FA*
'47/Ken	83	.207	232	48	0	0	0	22	28	13	26	9	80	287	56	20	11	.945
'48/Ken	104	.174	311	54	2	0	0	31	39	16	23	9	104	393	104	16	12	.969
'49/Ken	81	.157	172	27	3	0	0	22	28	11	23	13	79	251	59	10	8	.969
'50/Ken	74	.209	191	40	4	1	0	10	21	12	25	11	50	104	90	9	15	.956
'51/Ken	103	.181	331	60	5	2	0	23	52	18	40	13	91	175	189	28	19	.929
'52/Kal	70	.152	237	36	2	0	0	7	39	11	24	6	62	101	146	26	10	.905
'53/Kal	32	.189	74	14	2	0	0	0	8	2	10	3	No record					
Car (8 yrs)	578	.181	1620	293	18	3	0	127	225	93	184	72	488	1360	670	111	75	.948
Play (4 yrs)	11	.151	33	5	0	0	0	1	—	—	3	2	11	11	4	0	2	1.000

Neal, Doris (Born: 8/30/28, Lincoln Park, MI, BR, TR, 5'4", 128, 3B, OF)

	Hitting												**Fielding**					
YEAR/TEAM	*G*	*BA*	*AB*	*H*	*2B*	*3B*	*HR*	*SB*	*BB*	*SO*	*R*	*RBI*	*G*	*PO*	*A*	*E*	*DP*	*FA*
'48/Spr	122	.153	406	62	5	6	0	23	47	62	27	28	125	155	246	47	14	.895
'49/GR	58	.079	178	14	2	0	0	4	25	19	11	11	58	84	137	24	5	.902
Car (2 yrs)	180	.130	584	76	7	6	0	27	72	81	38	39	1283	239	383	71	19	.898

Nelson, Doris "Dodie" (Born: 12/12/23, Des Moines, IA, BR, TR, 5'7", 136, OF)

	Hitting												**Fielding**					
YEAR/TEAM	*G*	*BA*	*AB*	*H*	*2B*	*3B*	*HR*	*SB*	*BB*	*SO*	*R*	*RBI*	*G*	*PO*	*A*	*E*	*DP*	*FA*
'44/Roc	99	.231	373	86	5	1	1	70	36	28	51	23	99	181	9	12	3	.941

Nelson (Sandiford), Helen "Nellie" (Born: 6/13/19, Logie Easter, Scotland; Died: 2/6/93 BR, TR, 5'1", 100, C)

	Hitting												**Fielding**					
YEAR/TEAM	*G*	*BA*	*AB*	*H*	*2B*	*3B*	*HR*	*SB*	*BB*	*SO*	*R*	*RBI*	*G*	*PO*	*A*	*E*	*DP*	*FA*
'43/Roc	83	.210	214	45	4	0	0	15	35	16	36	20	70	204	49	19	7	.930

Nelson, Mary "Nelly" (Born: 6/2/38, Angola, IN, TR, BR, 5'6", 105, U)

	Hitting												**Fielding**					
YEAR/TEAM	*G*	*BA*	*AB*	*H*	*2B*	*3B*	*HR*	*SB*	*BB*	*SO*	*R*	*RBI*	*G*	*PO*	*A*	*E*	*DP*	*FA*
'54/FW	No record — played less than 10 games																	

Nesbitt (Crews, Wisham), Mary "Choo-Choo" (Born: 2/1/25, Greenville, SC, BL, TL, 5'8", 155, 1B, OF, P)

see Pitchers

	Hitting												**Fielding**					
YEAR/TEAM	*G*	*BA*	*AB*	*H*	*2B*	*3B*	*HR*	*SB*	*BB*	*SO*	*R*	*RBI*	*G*	*PO*	*A*	*E*	*DP*	*FA*
'43/Rac	73	.280	186	52	7	4	2	27	27	20	7	34	29	21	31	3	3	.919
'47/Peo	110	.261	399	104	9	11	3	34	32	32	47	43	110	1091	18	18	29	.984
'48/Peo	126	.292	438	128	24	12	3	64	82	41	59	58	126	1317	37	25	39	.981
'50/Peo	49	.340	162	55	8	4	3	14	34	13	25	22	48	491	14	9	12	.982
Car (4 yrs)	247	.286	1185	339	43	31	11	139	264	106	138	157	313	2920	100	55	83	.982

Niemiec (Konwinski), Dolores "Dolly" (Born: 5/27/31, Chicago, IL, BR, TR, 5'4", 115, 1B, 3B)

	Hitting												**Fielding**					
YEAR/TEAM	*G*	*BA*	*AB*	*H*	*2B*	*3B*	*HR*	*SB*	*BB*	*SO*	*R*	*RBI*	*G*	*PO*	*A*	*E*	*DP*	*FA*
'50/GR	49	.170	147	25	3	0	0	1	12	24	12	4	47	50	108	25	0	.863
'51/GR, BC	29	.092	65	6	0	0	0	0	12	7	8	6	17	28	20	4	12	.923
Car (2 yrs)	78	.146	212	31	3	0	0	1	24	31	20	10	64	78	128	29	12	.877
Play (1 yr)	1	.000	0	0	0	0	0	0	—	—	1	0	No record					

Nordquist, Helen "Nordie" (Born: 3/23/32, Maiden, MA, BR, TR, 5'6", 160, OF, P)
see Pitchers

	Hitting												Fielding					
YEAR/TEAM	G	BA	AB	H	2B	3B	HR	SB	BB	SO	R	RBI	G	PO	A	E	DP	FA
'51/Ken	82	.158	240	38	7	4	1	7	22	40	23	12	82	75	21	11	6	.897
'54/SB	52	.310	113	35	7	0	3	2	16	16	14	16	19	13	1	2	2	.875
Car (2 yrs)	134	.207	353	73	14	4	4	9	38	56	37	24	101	88	22	13	8	.894
Play (1 yr)	2	.000	2	0	0	0	0	0	—	—	0	0	2	0	3	0	0	1.000

Norris, Donna (Hometown: Culver City, CA, U)

	Hitting												Fielding					
YEAR/TEAM	G	BA	AB	H	2B	3B	HR	SB	BB	SO	R	RBI	G	PO	A	E	DP	FA
'53/FW, SB	16	.083	36	3	1	0	0	0	1	13	3	2	No record					

O'Brien, Eileen (Born: 5/24/22, Chicago, IL, BR, TR, 5'4", 128, U)

	Hitting												Fielding					
YEAR/TEAM	G	BA	AB	H	2B	3B	HR	SB	BB	SO	R	RBI	G	PO	A	E	DP	FA
'46/Mus	5	.111	18	2	—	—	—	—	—	—	—	—	No record					

O'Brien (Cooke), Penny "Peanuts" (Born: 9/16/19, Edmonton, AB, Canada, BR, TR, 5'2", 120, OF, 1B)

	Hitting												Fielding					
YEAR/TEAM	G	BA	AB	H	2B	3B	HR	SB	BB	SO	R	RBI	G	PO	A	E	DP	FA
'45/FW	83	.216	282	61	0	0	1	43	16	46	34	23	82	236	10	14	5	.946
Play (1 yr)	10	.400	35	14	1	0	0	6	—	—	6	3	10	22	0	1	0	.957

O'Dowd, Anna Mae "Annie" (Born: 4/26/29, Chicago, IL, BR, TR, 5'9", 175, C)

	Hitting												Fielding					
YEAR/TEAM	G	BA	AB	H	2B	3B	HR	SB	BB	SO	R	RBI	G	PO	A	E	DP	FA
'49/Ken	3	.000	1	0	—	—	—	—	—	—	—	—	No record					
'50/ Chic/Spr	25	.313	96	30	1	1	0	1	3	6	11	20	No record					
'50/Kal, Rac	41	.217	106	23	2	0	0	15	31	7	6	10	34	106	29	7	2	.951
'51/BC	26	.132	68	9	1	0	0	0	7	8	7	5	21	61	25	9	3	.905
Car (3 yrs)	70	.183	175	32	3	0	0	15	38	15	13	15	55	167	54	16	5	.933

Ogden, Joanne (Born: 4/23/33, Johnson City, NY, BR, TR, 5'2", 124, 2B)

	Hitting												Fielding					
YEAR/TEAM	G	BA	AB	H	2B	3B	HR	SB	BB	SO	R	RBI	G	PO	A	E	DP	FA
'53/SB	42	.253	87	22	2	0	0	6	4	9	11	5	28	56	34	13	2	.874

O'Hara, Janice (Born: 11/30/18, Beardstown, IL BR, TR, 5'6", 122, U, P)
see Pitchers

	Hitting												Fielding					
YEAR/TEAM	G	BA	AB	H	2B	3B	HR	SB	BB	SO	R	RBI	G	PO	A	E	DP	FA
'43/Ken	97	.187	337	63	3	5	0	19	24	19	46	28	92	818	20	33	18	.962
'44/Ken	95	.153	321	49	3	0	1	37	30	16	31	26	95	90	53	33	10	.813
'45/Ken	88	.150	247	37	1	0	0	14	22	16	18	16	82	236	10	14	5	.946
'46/Ken	66	.149	168	25	2	0	0	6	8	18	15	10	54	73	159	8	3	.967
'47/Ken	51	.173	110	19	3	3	0	32	37	43	8	19	22	244	10	10	3	.962
Car (5 yrs)	397	.163	1183	193	12	8	1	108	121	102	118	99	345	1461	252	98	39	.946
Play (3 yrs)	7	.130	23	3	0	0	0	1	—	—	2	0	7	36	8	3	0	.936

Olinger, Marilyn (Born: 6/7/28, Sunbury, OH, BR, TR, 5'6", 140, SS)

YEAR/TEAM	G	BA	AB	H	2B	3B	HR	SB	BB	SO	R	RBI	G	PO	A	E	DP	FA
'48/Chic, GR	121	.167	408	68	6	2	2	22	36	51	34	28	121	217	345	86	31	.867
'49/GR	113	.213	432	92	11	1	1	21	43	25	51	18	113	202	272	50	16	.905
'50/GR	113	.225	396	89	7	1	1	35	58	25	78	21	113	200	328	38	24	.933
'51/GR	106	.267	401	107	3	2	0	49	46	9	82	18	106	189	281	61	25	.885
'52/GR	47	.202	173	35	1	1	0	14	18	1	22	10	47	81	139	27	9	.891
'53/GR	99	.241	365	88	6	0	0	56	54	16	67	20	99	181	243	57	20	.881
Car (6 yrs)	599	.220	2175	479	34	7	4	197	255	334	334	115	599	1070	1608	319	125	.894
Play (4 yrs)	20	.120	83	10	1	1	0	3	—	—	6	1	20	36	55	9	2	.910

Overleese, Joanne "Jo" (Born: 10/3/23, San Diego, CA, BR, TR, 2B)

YEAR/TEAM	G	BA	AB	H	2B	3B	HR	SB	BB	SO	R	RBI	G	PO	A	E	DP	FA
'46/Mus, Peo	54	.178	174	31	4	1	0	6	25	21	13	15	53	120	96	15	16	.936

Paire (Davis), Lavonne "Pepper" (Born: 5/29/24, Los Angeles, CA, BR, TR, 5'4", 138, C, SS, 3B, P)
see Pitchers

YEAR/TEAM	G	BA	AB	H	2B	3B	HR	SB	BB	SO	R	RBI	G	PO	A	E	DP	FA
'44/Mpls	60	.241	220	53	8	2	0	5	20	8	28	20	58	132	125	22	10	.906
'45/FW	111	.196	392	77	6	0	0	7	37	6	29	39	110	205	226	39	9	.917
'46/Rac	101	.238	383	91	10	4	0	13	33	15	31	59	102	377	117	31	14	.941
'47/Rac	112	.226	430	97	14	0	0	18	29	17	35	50	112	190	266	49	12	.903
'48/GR	114	.186	377	70	8	4	0	2	34	36	24	27	113	166	355	44	21	.922
'49/GR	110	.205	371	76	2	3	0	12	46	11	21	37	110	407	179	23	15	.962
'50/GR	110	.249	370	92	16	0	1	15	35	10	35	70	107	415	98	11	8	.979
'51/GR	81	.264	261	69	6	2	1	5	38	5	21	56	80	312	67	10	6	.974
'52/GR	67	.230	200	46	3	0	0	0	17	2	13	18	61	222	38	6	2	.977
'53/FW	60	.263	160	42	6	0	0	2	19	7	14	24	46	158	30	4	4	.979
Car (10 yrs)	926	.225	3164	713	79	15	2	79	308	117	251	400	899	2564	1501	239	101	.945
Play (9 yrs)	58	.198	212	42	2	1	1	3	—	—	17	17	58	137	79	21	3	.911

Palermo, Toni (Hometown: Forest Park, IL, BR, TR, SS)

YEAR/TEAM	G	BA	AB	H	2B	3B	HR	SB	BB	SO	R	RBI	G	PO	A	E	DP	FA
'50/ Chic/Spr	33	.205	117	24	0	0	0	14	39	13	30	8	No record					

Palesch, Shirley Ellen "Butch" (Born: 11/23/29, Chicago, IL, BR, TR, 5'4", 140, OF)

YEAR/TEAM	G	BA	AB	H	2B	3B	HR	SB	BB	SO	R	RBI	G	PO	A	E	DP	FA
'49/Rac	8	.032	31	1	—	—	—	—	—	—	—	—	No record					
'50/Roc, GR	10	.040	25	1	0	0	0	0	1	4	0	2	10	4	2	1	0	.857
Car (2 yrs)	18	.036	56	2	0	0	0	0	1	4	0	2	10	4	2	1	0	.857

Panos, Vickie (Born: 3/20/20, Edmonton, AB, Canada; Died: Date Unknown, BL, TR, 5'3", 120, OF)

YEAR/TEAM	G	BA	AB	H	2B	3B	HR	SB	BB	SO	R	RBI	G	PO	A	E	DP	FA
'44/SB, Mil	114	.263	403	106	1	0	0	141	66	25	84	31	113	203	19	5	5	.978
Play (1 yr)	7	.214	28	6	0	0	0	7	3	1	5	0	7	13	1	0	0	1.000

Parks (Young), Barbara (Born: 2/7/33, Brookline, MA, 5'7", 123, 2B)

	Hitting												Fielding					
YEAR/TEAM	G	BA	AB	H	2B	3B	HR	SB	BB	SO	R	RBI	G	PO	A	E	DP	FA
'50/ Chic/Spr	40	.212	151	32	6	1	0	2	13	15	16	24	No record					
'50/Ken	No record — played less than 10 games																	
'51/Ken	26	.083	72	6	0	0	0	1	4	13	4	2	25	35	30	13	3	.833

Parsons (Zipay), Sue (Born: 4/1/34, Medford, MA, BR, TR, 5'3", 115, U, P)
see Pitchers

	Hitting												Fielding					
YEAR/TEAM	G	BA	AB	H	2B	3B	HR	SB	BB	SO	R	RBI	G	PO	A	E	DP	FA
'53/Roc	19	.078	51	4	1	0	0	0	0	12	3	3	10	16	27	4	4	.915
'54/Roc	34	.055	55	3	1	0	0	0	3	11	3	1	No record					
Car (2 yrs)	53	.066	106	7	2	0	0	0	3	23	6	4	10	16	28	4	4	.915

Payne, Barbara "Bobbie" (Born: 9/18/32, Shreveport, LA, BR, TR, 5'7", 118, U, P)
see Pitchers

	Hitting												Fielding					
YEAR/TEAM	G	BA	AB	H	2B	3B	HR	SB	BB	SO	R	RBI	G	PO	A	E	DP	FA
'49/Spr	No record																	
'50/Kal	100	.191	299	57	8	1	0	6	20	45	19	16	103	161	220	57	15	.894
'51/Kal, BC, Roc	94	.173	294	51	4	5	0	11	42	57	39	33	92	186	203	58	28	.870
Car (2 yrs)	194	.182	593	108	12	6	0	17	62	92	57	49	195	347	424	115	43	.879
Play (1 yr)	2	.000	5	0	0	0	0	0	—	—	0	0	2	6	6	0	2	1.000

Pearson (Tesseine), Dolly "Buttons" (Born: 9/6/32, Pittsburgh, PA, BR, TR, 5'5", 125 U, P)
see Pitchers

	Hitting												Fielding					
YEAR/TEAM	G	BA	AB	H	2B	3B	HR	SB	BB	SO	R	RBI	G	PO	A	E	DP	FA
'48/Mus	82	.150	233	35	3	2	0	10	23	54	15	12	80	101	119	30	7	.88
'49/Peo	30	.216	74	16	3	1	0	1	11	10	4	4	14	25	39	9	1	.877
'50/Rac	110	.235	400	94	5	4	0	14	47	31	41	47	117	284	201	31	13	.940
'51/BC, Kal	100	.185	346	64	9	5	0	19	42	28	38	37	100	213	270	54	26	.889
'52/Kal	44	.203	138	28	3	1	0	5	17	5	11	11	44	69	114	26	4	.876
'53/SB	90	.185	297	55	8	1	0	11	69	25	38	29	80	151	185	22	18	.939
'54/GR	85	.327	272	89	5	0	18	10	70	30	68	57	83	128	193	29	30	.917
Car (7 yrs)	541	.216	1760	381	36	14	18	70	279	183	195	197	518	971	1121	201	99	.912
Play (2 yrs)	2	.167	6	1	1	0	0	0	—	—	1	2	1	1	0	0	0	1.000

Peppas, June (Born: 6/16/29, Kansas City, MO, BL, TL, 5'5", 145, OF, 2B, 1B, P)
see Pitchers

	Hitting												Fielding					
YEAR/TEAM	G	BA	AB	H	2B	3B	HR	SB	BB	SO	R	RBI	G	PO	A	E	DP	FA
'49/FW, Rac	50	.116	121	14	2	1	0	3	12	26	9	7	36	210	7	7	3	.969
'50/Rac	109	.268	395	106	11	5	4	8	45	39	34	45	102	912	41	31	31	.969
'51/BC, Kal	108	.285	382	109	11	4	1	26	48	36	46	35	96	937	54	24	39	.976
'52/Kal	108	.262	412	108	12	0	0	8	31	20	38	36	108	1082	39	40	43	.966
'53/Kal	108	.271	417	113	10	3	0	10	37	19	46	33	108	1170	42	24	51	.981
'54/Kal	98	.333	366	122	4	0	16	15	37	30	75	49	94	758	20	17	46	.979
Car (6 yrs)	581	.273	2093	572	50	13	21	70	210	170	248	205	544	5069	203	14	213	.974
Play (2 yrs)	13	.327	52	17	2	0	3	2	—	—	10	12	13	99	9	4	3	.964

Perlick (Keating), Edythe "Edie" (Born: 12/12/22, Chicago, IL, BR, TR, 5'3", 128, OF)

	Hitting											Fielding						
YEAR/TEAM	G	BA	AB	H	2B	3B	HR	SB	BB	SO	R	RBI	G	PO	A	E	DP	FA
'43/Rac	84	.268	310	83	10	4	1	55	22	10	56	42	84	138	7	12	2	.924
'44/Rac	116	.229	423	97	7	2	2	52	30	9	51	63	116	206	15	11	5	.953
'45/Rac	107	.213	389	83	4	7	2	44	25	14	47	41	107	220	14	12	5	.951
'46/Rac	112	.230	431	99	6	8	4	88	37	17	72	56	112	198	11	10	2	.954
'47/Rac	112	.239	436	104	11	6	2	83	21	19	62	39	112	237	3	5	0	.980
'48/Rac	111	.243	415	101	11	3	2	82	39	28	55	51	111	185	9	9	0	.956
'49/Rac	99	.255	364	93	3	9	2	44	33	18	38	41	99	194	6	6	2	.971
'50/Rac	110	.247	409	101	10	7	3	33	34	23	64	59	110	255	10	15	1	.946
Car (8 yrs)	851	.240	3177	761	62	46	18	481	241	138	445	392	851	1435	75	80	17	.950
Play (5 yrs)	33	.250	116	29	2	0	3	16	—	—	15	12	33	55	2	4	0	.934

Peterson (Fox), Betty Jean "Pete" (Born: 11/21/33, Wyanet, IL, BR, TR, 5'2", 125, C)

	Hitting											Fielding						
YEAR/TEAM	G	BA	AB	H	2B	3B	HR	SB	BB	SO	R	RBI	G	PO	A	E	DP	FA
'52/Roc				No record — played less than 10 games														
'53/Mus, Kal				No record — played less than 10 games														

Petras, Ernestine "Tenny" (Born: 10/22/24, Coaldale, PA, BR, TR, 5'5", 125, SS, 3B)

	Hitting											Fielding						
YEAR/TEAM	G	BA	AB	H	2B	3B	HR	SB	BB	SO	R	RBI	G	PO	A	E	DP	FA
'44/Mil	32	.098	82	8	1	0	0	10	7	5	7	8	25	39	62	15	1	.871
'45/GR	110	.162	359	58	3	3	0	31	22	38	32	29	110	216	267	43	27	.918
'46/GR	112	.192	355	68	5	1	0	53	31	27	38	34	112	246	354	31	22	.951
'47/GR	112	.175	394	69	6	3	0	51	29	31	45	25	112	255	356	38	29	.942
'48/GR, Chic	108	.218	349	76	7	0	0	86	53	32	59	32	108	293	71	36	42	.949
'49/Ken	111	.196	378	74	4	3	0	73	68	32	59	17	111	259	332	36	29	.943
'50/Ken	104	.231	381	88	8	4	0	52	59	38	57	23	104	199	290	22	32	.957
'51/Ken	53	.212	170	36	7	1	0	22	33	24	57	10	49	101	119	12	9	.948
'52/BC	92	.233	322	75	14	1	0	42	40	22	38	18	92	183	260	15	12	.965
Car (9 yrs)	834	.198	2790	552	55	16	0	420	342	249	359	196	823	1791	2411	249	203	.944
Play (5 yrs)	27	.179	95	17	3	1	0	11	—	—	8	4	27	45	71	7	2	.943

Petryna (Allen), Doreen Betty (Born: 11/26/30, Liberty, SK, Canada, BR, TR, 5'4", 140, 3B)

	Hitting											Fielding						
YEAR/TEAM	G	BA	AB	H	2B	3B	HR	SB	BB	SO	R	RBI	G	PO	A	E	DP	FA
'48/GR	25	.115	61	7	0	0	0	2	7	8	6	2	17	27	26	6	1	.898
'49/FW	97	.143	300	43	4	0	0	10	29	34	15	18	97	151	276	43	11	.909
Car (2 yrs)	122	.139	361	50	4	0	0	12	36	42	21	20	114	178	302	49	12	.907
Play (2 yrs)	5	.000	15	0	0	0	0	0	—	—	0	0	0	7	14	1	1	.955

Pieper, Marjorie "Peeps" "Marge" (Born: 8/2/22, Clinton, MI, BR, TR, 5'7", 140, OF, SS, 3B, P)

see Pitchers

	Hitting											Fielding						
YEAR/TEAM	G	BA	AB	H	2B	3B	HR	SB	BB	SO	R	RBI	G	PO	A	E	DP	FA
'46/FW	83	.173	289	50	8	4	1	14	18	18	22	24	80	161	183	43	14	.889
'47/FW, Ken	109	.225	369	83	11	5	5	31	34	30	33	38	109	245	247	61	10	.890
'48/Ken, Chic	107	.190	369	70	7	1	0	57	53	35	42	37	97	128	176	39	6	.886
'49/FW, Rac	69	.163	221	36	3	2	0	21	31	16	18	14	54	41	7	3	2	.941

YEAR/TEAM	Hitting G	BA	AB	H	2B	3B	HR	SB	BB	SO	R	RBI	Fielding G	PO	A	E	DP	FA
'50/Ken, Peo	91	.207	304	63	12	3	3	19	38	24	40	27	89	639	21	18	21	.973
'51/Peo, BC	76	.254	244	62	16	3	1	18	33	9	31	29	69	113	50	17	2	.905
'52/BC	91	.253	304	77	11	8	4	11	38	33	44	47	62	87	4	7	0	.929
'53/Mus	92	.229	314	72	8	4	3	10	41	26	26	38	99	112	26	12	4	.973
Car (8 yrs)	718	.213	2414	513	76	30	17	181	286	191	256	254	659	1526	714	200	59	.920

Pirok, Pauline "Pinky" (Born: 10/18/26, Chicago, IL, BR, TR, 5'2", 132, SS, 3B, P)
see Pitchers

YEAR/TEAM	Hitting G	BA	AB	H	2B	3B	HR	SB	BB	SO	R	RBI	Fielding G	PO	A	E	DP	FA
'43/Ken	88	.234	333	78	6	1	0	37	33	15	59	33	88	191	198	49	10	.888
'44/Ken	112	.233	404	94	10	3	0	75	46	11	73	38	112	241	259	62	13	.890
'45/Ken, SB	106	.163	355	58	5	2	0	27	48	0	18	29	106	172	284	49	14	.754
'46/SB	21	.197	71	14	0	0	0	15	5	7	5	2	21	29	85	3	2	.974
'47/SB	113	.193	400	77	6	4	0	53	24	21	51	17	115	199	395	44	26	.931
'48/SB	119	.219	413	90	5	4	0	16	32	51	37	19	111	174	312	36	18	.931
Car (6 yrs)	559	.208	1976	411	32	14	0	223	188	105	243	138	553	1006	1533	243	83	.913
Play (5 yrs)	24	.230	100	23	2	2	0	3	—	—	5	5	24	39	43	14	2	.854

Piskula, Grace (Born: 2/26/26, Milwaukee, WI, BR, TR, 5'7", 123, OF)
see Pitchers

YEAR/TEAM	Hitting G	BA	AB	H	2B	3B	HR	SB	BB	SO	R	RBI	Fielding G	PO	A	E	DP	FA
'44/Roc	No record																	

Pollitt (Deschaine), Alice "Al" "Rock" (Born: 7/19/29, Lansing, MI, BR, TR, 5'3", 150, SS, 3B, 2B)

YEAR/TEAM	Hitting G	BA	AB	H	2B	3B	HR	SB	BB	SO	R	RBI	Fielding G	PO	A	E	DP	FA
'47/Roc	18	.077	39	3	0	0	0	2	3	5	1	1	No record					
'48/Roc	116	.189	376	71	4	4	0	12	22	45	33	31	116	195	250	39	17	.919
'49/Roc	106	.210	385	81	5	4	0	30	17	32	23	27	106	198	301	39	11	.928
'50/Roc	65	.279	240	67	3	7	3	25	10	16	21	37	63	98	135	22	17	.914
'51/Roc	105	.299	405	121	7	9	4	61	36	50	88	45	105	181	277	47	33	.907
'52/Roc	108	.270	418	113	8	6	1	35	22	27	45	34	107	158	46	13	4	.940
'53/Roc	88	.315	314	99	14	5	0	16	29	9	39	39	83	125	143	40	16	.902
Car (7 yrs)	606	.255	2177	555	41	35	8	181	139	184	250	214	580	955	1252	200	98	.917
Play (5 yrs)	36	.265	136	36	5	0	0	5	—	—	17	10	36	27	82	10	6	.971

Pryer (Mayer), Charlene "Shorty" (Born: 9/24/21, Watsonville, CA, BR, TR, 5'1", 105, 2B, OF)

YEAR/TEAM	Hitting G	BA	AB	H	2B	3B	HR	SB	BB	SO	R	RBI	Fielding G	PO	A	E	DP	FA
'46/Mus	108	.202	381	77	9	0	0	45	51	33	64	18	108	234	17	8	3	.969
'47/Mus	108	.249	422	105	3	23	1	76	22	23	51	20	108	204	15	1	2	.995
'48/Mus	112	.262	408	107	5	3	1	58	56	41	70	29	112	184	13	7	2	.966
'49/Mus	76	.235	277	56	2	2	1	68	38	16	56	10	77	157	74	19	17	.924
'50/Mus, SB	112	.269	429	115	11	1	0	75	44	13	75	50	110	276	188	27	28	.945
'51/SB	109	.312	426	133	8	3	0	129	40	39	106	32	108	306	216	30	30	.946
'52/SB	79	.239	293	70	6	1	0	59	23	21	41	18	No record					
Car (7 yrs)	704	.255	2634	672	44	12	3	510	281	214	463	152	623	1361	523	92	82	.953
Play (3 yrs)	16	.188	64	12	2	0	0	7	—	—	5	2	12	24	17	8	2	.837

Redman, Magdalen "Mamie" (Born: 7/2/30, Waupun, WI, BR, TR, 5'5", 150, C, U)

	Hitting												Fielding					
YEAR/TEAM	G	BA	AB	H	2B	3B	HR	SB	BB	SO	R	RBI	G	PO	A	E	DP	FA
'48/Ken	49	.099	121	12	1	0	0	3	9	26	6	4	30	94	20	4	2	.966
'49/Ken	66	.149	134	20	1	0	0	2	27	16	15	3	66	168	54	5	1	.978
'50/GR	35	.130	77	10	1	0	0	4	1	11	7	5	34	65	52	5	2	.959
'51/GR	31	.104	96	10	1	0	0	1	14	7	3	8	25	110	21	4	1	.970
'52/GR	43	.219	114	25	1	0	0	2	16	14	7	4	37	130	44	8	5	.956
'53/GR	70	.186	199	27	4	0	0	1	33	15	13	19	61	264	48	8	2	.975
'54/GR	75	.249	177	44	6	2	2	0	55	12	39	20	67	186	49	6	6	.975
Car (7 yrs)	369	.172	918	158	15	2	2	10	162	101	90	63	320	1017	288	40	19	.970
Play (5 yrs)	6	.267	15	4	2	0	0	1	—	—	3	1	4	6	12	0	1	1.000

Reeser, Sara Louise (Born: 2/11/25, Columbus, OH, BL, TL, 5'4", 130, 1B)

	Hitting												Fielding					
YEAR/TEAM	G	BA	AB	H	2B	3B	HR	SB	BB	SO	R	RBI	G	PO	A	E	DP	FA
'46/Mus	110	.207	382	79	2	2	1	45	62	37	53	39	110	1120	41	27	32	.977
'47/Mus	110	.231	398	92	6	3	0	36	30	25	36	21	110	1213	31	13	31	.990
'48/Mus	110	.223	372	83	6	1	0	30	55	32	42	28	110	1073	27	16	45	.986
'50/Kal	12	.080	25	2	0	0	0	1	2	3	3	0	10	49	1	2	0	.962
Car (4 yrs)	342	.218	1177	256	14	6	1	112	149	97	134	88	340	3455	100	58	108	.984
Play (2 yrs)	8	.233	30	7	0	0	0	2	—	—	5	0	4	40	0	1	0	.976

Rehrer (Carteaux), Rita "Spud" (Born: 6/30/27, Fort Wayne, IN, 5'2", 130, C)

	Hitting												Fielding					
YEAR/TEAM	G	BA	AB	H	2B	3B	HR	SB	BB	SO	R	RBI	G	PO	A	E	DP	FA
'46/Peo	1	.000	3	0	—	—	—	—	—	—	—	—	No record					

Reid, Dorice "Dorrie" (Born: 2/26/29, Superior, WI, BR, TR, 5'4", 140, OF)

	Hitting												Fielding					
YEAR/TEAM	G	BA	AB	H	2B	3B	HR	SB	BB	SO	R	RBI	G	PO	A	E	DP	FA
'48/Chic	50	.139	115	16	1	1	0	6	12	36	3	4	48	51	8	7	1	.894
'49/GR	99	.160	307	49	3	1	0	16	38	32	23	23	99	177	11	13	1	.935
'50/GR	107	.199	392	78	6	3	0	36	60	43	59	28	107	179	12	17	1	.918
'51/GR	67	.127	212	27	1	0	0	11	20	34	23	5	67	99	7	5	1	.955
Car (4 yrs)	323	.166	1026	170	11	5	0	69	130	145	108	60	321	506	38	42	4	.928
Play (3 yrs)	16	.196	56	11	0	0	0	3	—	—	7	2	16	12	0	3	0	.800

Reynolds, Mary "Windy" (Born: 4/27/21, Gastonia, NC; Died: Date Unknown, BR, TR, 3B, OF, P)
see Pitchers

	Hitting												Fielding					
YEAR/TEAM	G	BA	AB	H	2B	3B	HR	SB	BB	SO	R	RBI	G	PO	A	E	DP	FA
'46/Peo	90	.232	254	59	5	4	0	9	35	23	18	28	54	100	143	21	7	.920
'47/Peo	113	.245	400	98	17	5	1	7	39	29	40	42	93	186	217	28	15	.935
'48/Peo	119	.213	390	83	7	4	0	11	67	60	42	43	108	88	30	8	5	.937
'49/Peo	104	.198	344	68	8	4	0	2	53	17	28	29	83	127	43	9	4	.950
Car (4 yrs)	426	.222	1388	308	27	17	1	29	194	129	128	142	338	501	433	66	31	.934
Play (1 yr)	4	.300	10	3	0	1	0	0	—	—	1	1	—	—	—	2	—	—

Richard, Ruth "Richie" (Born: 9/20/28, Argus, PA, BL, TR, 5'4", 134, C, OF, P)
see Pitchers

	Hitting												Fielding					
YEAR/TEAM	G	BA	AB	H	2B	3B	HR	SB	BB	SO	R	RBI	G	PO	A	E	DP	FA
'47/GR	47	.177	147	26	3	1	0	2	4	13	5	7	39	46	2	4	0	.923
'48/Roc	110	.168	363	61	9	5	1	11	25	24	30	35	106	518	113	23	3	.964
'49/Roc	84	.170	265	45	0	0	1	11	27	14	23	20	83	387	63	13	4	.972

YEAR/TEAM	G	BA	AB	H	2B	3B	HR	SB	BB	SO	R	RBI	G	PO	A	E	DP	FA
	Hitting												Fielding					
'50/Roc	95	.251	315	79	11	6	1	12	25	13	29	28	94	403	79	14	5	.972
'51/Roc	99	.277	368	102	7	3	0	6	18	19	34	60	99	377	129	20	16	.962
'52/Roc	106	.284	394	112	14	5	3	9	13	12	41	46	103	344	84	15	6	.966
'53/Roc	92	.252	341	86	11	0	2	7	15	9	33	48	91	313	74	28	5	.933
'54/Roc	92	.298	325	97	12	0	7	14	15	5	42	43	89	280	61	17	2	.953
Car (8 yrs)	725	.241	2518	608	67	20	15	72	142	109	237	287	704	2668	605	134	41	.961
Play (7 yrs)	44	.204	157	32	2	2	0	8	—	—	15	13	40	155	26	12	1	.938

Ricketts, Joyce "Rick" (Born: 4/25/33, Oquawka, IL; Died: 5/8/92, BL, TL, OF)

YEAR/TEAM	G	BA	AB	H	2B	3B	HR	SB	BB	SO	R	RBI	G	PO	A	E	DP	FA
	Hitting												Fielding					
'53/GR	114	.288	417	120	19	5	5	12	43	18	48	71	114	141	22	11	4	.937
'54/GR	93	.317	290	92	14	4	15	2	66	21	63	72	92	112	24	5	4	.965
Car (2 yrs)	207	.300	707	212	33	9	20	14	109	39	111	143	206	253	46	16	8	.949
Play (2 yrs)	6	.444	18	8	2	0	0	0	—	—	3	5	5	2	2	2	0	.667

Rohrer, Kay (Born: 6/29/22, Los Angeles, CA; Died: 3/17/62, BR, TR, 5'7", 139, C, SS)

YEAR/TEAM	G	BA	AB	H	2B	3B	HR	SB	BB	SO	R	RBI	G	PO	A	E	DP	FA
	Hitting												Fielding					
'45/Roc	100	.239	327	78	8	1	2	26	33	9	34	26	92	396	106	21	10	.960
Play (1 yr)	9	.185	27	5	0	1	0	3	—	—	3	0	9	63	3	1	0	.985

Romatowski, Jenny "Romey" (Born: 9/13/27, Wyandotte, MI, BR, TR, 5'4", 145, C, 3B, OF)

YEAR/TEAM	G	BA	AB	H	2B	3B	HR	SB	BB	SO	R	RBI	G	PO	A	E	DP	FA
	Hitting												Fielding					
'46/SB	10	.000	9	0	0	0	0	0	1	3	0	0	No record					
'47/Roc	80	.123	220	27	0	0	0	9	12	25	15	6	80	332	58	17	10	.958
'48/Rac, Chic	89	.211	242	51	4	0	0	8	28	29	15	27	83	313	99	9	11	.979
'49/Peo	5	.222	18	4	—	—	—	—	—	—	—	—	No record					
'50/SB	46	.209	134	28	2	0	0	1	12	11	11	9	45	165	24	6	2	.969
'51/Kal	89	.194	304	78	5	1	0	4	13	19	19	21	91	217	126	25	12	.932
'52/Kal	68	.223	224	50	5	0	0	3	8	15	13	18	65	237	38	13	3	.955
'53/Kal	80	.217	263	57	3	1	0	6	11	6	19	21	70	252	70	9	9	.973
'54/Kal	68	.258	225	58	2	1	6	0	12	6	23	26	69	140	24	8	1	.953
Car (9 yrs)	535	.204	1639	334	21	3	6	31	97	114	115	128	503	1656	439	87	48	.960
Play (3 yrs)	11	.277	36	10	0	0	0	1	—	—	3	6	10	29	3	0	0	1.000

Rommelaere (Manning), Martha (Born: 8/30/22, Deloraine, MN, Canada, BR, TR, 5'4", 120, OF)

YEAR/TEAM	G	BA	AB	H	2B	3B	HR	SB	BB	SO	R	RBI	G	PO	A	E	DP	FA
	Hitting												Fielding					
'50/Chic/Spr	38	.243	169	41	3	2	0	10	10	11	30	18	No record					
'50/Ken	30	.188	80	15	0	0	0	8	10	12	7	7	27	19	1	3	1	.870

Roth, Eilaine "I" (Born: 1/17/29, Michigan City, MI, BR, TR, 5'2", 115, OF)

YEAR/TEAM	G	BA	AB	H	2B	3B	HR	SB	BB	SO	R	RBI	G	PO	A	E	DP	FA
	Hitting												Fielding					
'48/Peo	16	.235	17	4	1	0	0	4	1	0	5	2	10	5	1	2	0	.750
'49/Peo	91	.161	322	52	2	0	0	16	34	21	32	13	89	98	1	6	0	.943
'50/Kal	107	.202	386	78	4	4	0	64	64	20	55	21	106	163	14	9	2	.952
'51/Kal	79	.251	207	52	5	3	0	16	22	16	24	16	62	90	7	9	3	.915
Car (4 yrs)	293	.200	932	186	12	7	0	100	121	57	116	52	267	356	23	26	5	.936
Play (1 yr)	3	.100	10	1	0	0	0	0	—	—	0	0	3	3	0	0	0	1.000

Rountree, Mary "Square Bush" (Born: 6/23/22, Miami, FL, BR, TR, 5'5", 125, C)

	Hitting												Fielding					
YEAR/TEAM	G	BA	AB	H	2B	3B	HR	SB	BB	SO	R	RBI	G	PO	A	E	DP	FA
'46/Peo	87	.216	291	63	1	2	0	27	41	21	22	41	86	308	74	24	7	.941
'47/FW	53	.209	148	31	2	3	0	12	13	7	10	9	47	243	43	15	7	.950
'48/FW	84	.163	251	41	3	0	0	20	40	20	19	18	79	387	99	26	14	.949
'49/FW	65	.225	182	41	2	0	0	16	29	14	12	16	65	271	57	8	1	.976
'50/FW	25	.206	63	13	1	0	0	0	5	5	12	9	23	79	31	4	4	.965
'51/FW	43	.255	98	25	3	0	0	9	20	9	16	9	41	121	41	7	4	.959
'52/FW, GR	65	.202	178	36	2	1	0	5	18	10	14	5	65	235	41	4	3	.986
Car (7 yrs)	422	.206	1211	250	14	6	0	89	166	86	105	107	406	1644	386	88	40	.959
Play (4 yrs)	19	.212	52	11	1	0	0	2	—	—	5	2	16	54	12	1	0	.985

Roy, Patricia (Born: 10/3/38, Goshen, IN, BR, TR, 5'10", 125, 1B, 3B)

	Hitting												Fielding					
YEAR/TEAM	G	BA	AB	H	2B	3B	HR	SB	BB	SO	R	RBI	G	PO	A	E	DP	FA
'54/FW	14	.079	38	3	0	0	0	0	0	9	0	2	12	95	2	5	1	.951

Roylance, Juanita (Hometown: Miami, FL, OF)

	Hitting												Fielding					
YEAR/TEAM	G	BA	AB	H	2B	3B	HR	SB	BB	SO	R	RBI	G	PO	A	E	DP	FA
'46/Mus	6	.067	15	1	—	—	—	—	—	—	—	—	No record					

Ruhnke (Sanvitis), Irene (Born: 3/30/20, Chicago, IL, BR, TR, 5'4", 130, OF, 2B, 3B)

	Hitting												Fielding					
YEAR/TEAM	G	BA	AB	H	2B	3B	HR	SB	BB	SO	R	RBI	G	PO	A	E	DP	FA
'43/Roc	77	.253	285	72	5	5	1	22	14	12	54	36	25	41	38	20	2	.798
'44/Roc, Mpls	90	.193	296	57	3	4	0	28	23	20	21	26	86	124	60	29	6	.864
'45/FW	90	.155	290	45	8	2	0	10	21	17	22	16	83	161	120	31	13	.901
'46/FW	107	.193	389	75	5	6	1	24	30	27	37	50	109	159	87	19	3	.928
'47/Roc	21	.164	67	11	1	1	0	3	3	4	3	2	19	39	28	4	3	.944
Car (5 yrs)	385	.196	1327	260	22	18	2	87	91	80	137	130	322	524	333	103	27	.893
Play (1 yr)	9	.176	34	6	0	0	0	0	—	—	3	1	9	18	6	3	1	.919

Ruiz, Gloria "Baby-Face" (Born: 6/25/28, Havana, Cuba, BR, TR, OF)

	Hitting												Fielding					
YEAR/TEAM	G	BA	AB	H	2B	3B	HR	SB	BB	SO	R	RBI	G	PO	A	E	DP	FA
'48/Peo	52	.095	126	12	0	0	0	10	19	26	8	8	50	60	3	4	2	.940
'49/Peo	No record																	

Rukavina, Terry (Born: 5/14/31, Middleton, OH, BR, TR, 5'7", 140, OF, 2B)

	Hitting												Fielding					
YEAR/TEAM	G	BA	AB	H	2B	3B	HR	SB	BB	SO	R	RBI	G	PO	A	E	DP	FA
'50/Chic/Spr	77	.273	304	83	10	4	4	18	33	32	48	71	No record					
'51/Kal	48	.115	87	10	0	0	0	1	4	15	3	2	44	31	25	14	0	.800
'53/Kal	99	.178	269	48	7	1	1	5	27	57	31	21	94	184	118	26	11	.921
Car (2 yrs)	147	.163	356	58	7	1	1	6	31	72	34	23	138	215	143	40	11	.900
Play (2 yrs)	5	.375	16	6	1	1	0	0	—	—	0	2	5	14	7	0	0	1.000

Russell, Betty (Born: 10/1/24, Globe, AZ, BR, TR, 5'6", 145, OF)

	Hitting												Fielding					
YEAR/TEAM	G	BA	AB	H	2B	3B	HR	SB	BB	SO	R	RBI	G	PO	A	E	DP	FA
'46/Rac	12	.143	28	4	1	0	0	0	0	3	0	1	No record					

Russo (Jones), Margaret (Born: 9/29/31, Milton, NY, BR, TR, 5'4", 130, SS, 3B)

	Hitting												Fielding					
YEAR/TEAM	G	BA	AB	H	2B	3B	HR	SB	BB	SO	R	RBI	G	PO	A	E	DP	FA
'50/Peo	93	.132	266	35	2	1	0	6	42	46	14	23	93	139	245	42	11	.901
'51/Peo	106	.247	368	91	6	4	2	22	44	27	66	51	106	212	291	45	25	.918
'52/BC	100	.222	320	71	13	3	1	14	52	21	39	28	100	193	286	37	26	.928
'53/Mus	112	.226	402	91	9	9	2	45	55	33	65	29	112	220	330	49	33	.918
'54/Roc	90	.313	284	89	9	2	10	17	58	20	67	35	88	164	272	25	43	.938
Car (4 yrs)	501	.230	1640	377	39	19	15	104	251	147	251	166	497	911	1424	202	138	.886

Sams, Doris "Sammy" (Born: 2/2/27, Knoxville, TN, BR, TR, 5'9", 145, OF, P)
see Pitchers'

	Hitting												Fielding					
YEAR/TEAM	G	BA	AB	H	2B	3B	HR	SB	BB	SO	R	RBI	G	PO	A	E	DP	FA
'46/Mus	42	.274	106	29	1	0	0	6	15	4	15	9	15	21	0	1	0	.955
'47/Mus	107	.280	346	97	9	5	0	40	28	33	31	41	91	124	31	10	6	.939
'48/Mus	117	.257	409	105	6	7	3	23	39	41	57	59	85	97	13	6	2	.948
'49/Mus	109	.279	408	114	6	1	0	29	12	39	35	35	85	152	12	4	2	.976
'50/Kal	94	.301	279	84	15	3	4	11	27	19	42	31	49	94	9	7	2	.936
'51/Kal	97	.306	356	109	16	2	2	19	29	21	40	33	97	203	15	9	2	.960
'52/Kal	109	.314	408	128	25	3	12	15	43	23	47	57	109	231	15	8	6	.969
'53/Kal	46	.312	173	54	4	2	1	11	21	14	23	21	45	100	8	0	3	1.000
Car (8 yrs)	721	.278	2485	690	82	23	22	154	214	194	290	286	576	1022	103	45	23	.962
Play (4 yrs)	16	.177	62	11	1	0	0	2	—	—	5	1	16	16	5	3	0	.875

Sands (Ferguson), Sarah Jane "Salty" (Born: 7/27/35, Orangeville, PA, BR, TR, 5'4", 120, C, OF)

	Hitting												Fielding					
YEAR/TEAM	G	BA	AB	H	2B	3B	HR	SB	BB	SO	R	RBI	G	PO	A	E	DP	FA
'53/Roc	76	.214	234	50	1	0	0	4	4	39	23	15	79	106	16	12	3	.910
'54/Roc	60	.206	180	37	4	0	1	5	9	9	14	14	54	63	11	2	3	.974
Car (2 yrs)	136	.210	414	87	5	0	1	9	13	48	37	29	133	169	27	14	6	.933
Play (1 yr)	2	.200	5	1	0	0	0	0	—	—	2	0	2	2	1	0	0	1.000

Satterfield, Doris (Hometown: North Belmont, NC; Died: Date Unknown, OF, P)
see Pitchers

	Hitting												Fielding					
YEAR/TEAM	G	BA	AB	H	2B	3B	HR	SB	BB	SO	R	RBI	G	PO	A	E	DP	FA
'47/GR	12	.048	21	1	0	0	0	0	2	4	1	1	No record					
'48/GR	125	.246	452	111	10	6	1	40	30	22	45	61	125	234	21	6	5	.977
'49/GR	113	.259	421	109	22	8	2	15	27	27	42	58	113	203	5	6	2	.972
'50/GR	113	.278	432	120	16	8	4	38	32	24	68	54	113	231	10	6	3	.976
'51/GR	105	.279	401	112	12	9	2	36	37	13	64	62	105	193	3	8	0	.961
'52/GR	103	.285	386	110	14	7	0	40	24	13	43	51	102	209	14	8	3	.965
'53/GR	112	.295	404	119	16	4	0	40	47	30	58	79	112	254	12	8	1	.971
Car (7 yrs)	683	.271	2517	682	90	42	9	209	199	121	321	365	670	1324	65	42	14	.971
Play (7 yrs)	33	.220	123	27	2	0	0	5	—	—	11	15	33	51	7	5	0	.921

Sawyer, Helen (Hometown: Buffalo, NY, C)

	Hitting												Fielding					
YEAR/TEAM	G	BA	AB	H	2B	3B	HR	SB	BB	SO	R	RBI	G	PO	A	E	DP	FA
'43/Roc	No record																	

Schachter, Blanche (Born: 9/20/26, Brooklyn, N.Y., BR, TR, 5'2", 125, C)

	Hitting												Fielding					
YEAR/TEAM	G	BA	AB	H	2B	3B	HR	SB	BB	SO	R	RBI	G	PO	A	E	DP	FA
'48/Ken	9	.040	25	1	—	—	—	—	—	—	—	—	No record					

Schallern, Ellen (Hometown: Miami, FL, BR, TR, F)

	Hitting											Fielding						
YEAR/TEAM	G	BA	AB	H	2B	3B	HR	SB	BB	SO	R	RBI	G	PO	A	E	DP	FA
'46/FW	No record																	

Schatz, Joan (Hometown: Winnipeg, MB, Canada, BR, TR, OF)

	Hitting												Fielding					
YEAR/TEAM	G	BA	AB	H	2B	3B	HR	SB	BB	SO	R	RBI	G	PO	A	E	DP	FA
'50/Chic/																		
Spr	77	.322	323	104	8	6	4	40	19	13	60	64	No record					
'52/Kal	13	.186	43	8	0	0	0	4	2	6	4	0	13	27	1	1	0	.966

Schenck. Audrey (Hometown: Chicago, IL, 3B)

	Hitting												Fielding					
YEAR/TEAM	G	BA	AB	H	2B	3B	HR	SB	BB	SO	R	RBI	G	PO	A	E	DP	FA
'50/Chic/Spr	2	.333	6	2	1	0	0	0	0	1	1	1	No record					

Schillace (Donahoe), Claire Joan (Born: 3/29/22, Melrose Park, IL, TL, BR, 5'3", 128, OF)

	Hitting												Fielding					
YEAR/TEAM	G	BA	AB	H	2B	3B	HR	SB	BB	SO	R	RBI	G	PO	A	E	DP	FA
'43/Rac	102	.251	350	88	7	3	1	40	50	18	65	38	102	150	16	19	1	.897
'44/Rac	112	.209	374	78	3	3	0	58	68	21	65	30	111	146	20	13	4	.927
'45/Rac	105	.185	357	66	3	4	1	34	61	27	31	26	105	182	12	7	3	.965
'46/Rac	98	.161	310	50	2	4	0	21	47	31	40	18	98	144	8	4	1	.974
Car (4 yrs)	417	.202	1391	282	15	14	2	153	226	92	201	112	416	622	56	43	9	.943
Play (3 yrs)	16	.145	55	8	0	1	0	1	—	—	5	3	16	27	0	0	0	1.000

Schmidt, Marilyn (Hometown: Hollywood, CA, TR, C)

	Hitting												Fielding					
YEAR/TEAM	G	BA	AB	H	2B	3B	HR	SB	BB	SO	R	RBI	G	PO	A	E	DP	FA
'52/Roc	No record — played less than 10 games																	

Schofield, June "Moneybags" (Hometown: Toronto, ON, Canada, BR, TR, SS, 3B, P)
see Pitchers

	Hitting												Fielding					
YEAR/TEAM	G	BA	AB	H	2B	3B	HR	SB	BB	SO	R	RBI	G	PO	A	E	DP	FA
'48/Spr	125	.236	440	104	12	9	2	29	46	44	22	49	134	496	242	67	17	.917
'49/Peo,																		
Mus	109	.228	378	86	7	3	0	9	47	39	27	27	106	147	332	46	11	.912
Car (2 yrs)	234	.232	818	190	19	12	2	38	93	83	49	76	240	643	574	113	39	.915
Play (1 yr)	5	.182	22	4	0	0	0	0	—	—	2	1	5	3	3	1	1	.857

Schroeder, Dorothy "Dottie" (Born: 4/11/28, Champaign, IL; Died: 12/8/96, BR, TR, 5'7", 150, SS, P)
see Pitchers

	Hitting												Fielding					
YEAR/TEAM	G	BA	AB	H	2B	3B	HR	SB	BB	SO	R	RBI	G	PO	A	E	DP	FA
'43/SB	98	.188	298	56	4	2	1	39	56	51	44	31	98	185	270	38	18	.924
'44/SB	116	.180	328	59	1	2	1	70	58	50	50	24	116	153	310	65	31	.896
'45/SB, Ken	94	.192	312	60	2	1	2	38	44	62	33	19	94	154	232	51	15	.883
'46/Ken	110	.168	334	56	3	1	0	24	54	6	31	14	110	237	298	50	18	.915
'47/Ken,																		
FW	100	.172	344	40	4	3	0	32	37	43	40	19	100	215	231	44	10	.910

YEAR/TEAM	Hitting												Fielding					
	G	BA	AB	H	2B	3B	HR	SB	BB	SO	R	RBI	G	PO	A	E	DP	FA
'48/FW	125	.170	418	71	5	3	0	30	57	69	41	43	124	275	317	59	35	.909
'49/FW	104	.208	346	72	4	4	0	14	55	40	36	31	104	230	282	55	19	.903
'50/FW	107	.210	371	78	15	3	5	22	60	48	52	58	107	241	319	59	35	.905
'51/FW	85	.200	285	57	9	2	4	17	58	50	39	45	85	167	241	27	22	.938
'52/FW	102	.245	392	96	12	5	6	5	60	52	67	43	101	184	295	39	38	.925
'53/Kal	110	.285	389	111	12	0	6	10	80	54	76	39	110	253	343	40	29	.937
'54/Kal	98	.304	312	95	8	0	17	11	27	41	63	65	98	185	238	44	35	.914
Car (12 yrs)	1249	.211	4129	870	79	26	42	312	696	566	571	431	1247	2579	3376	571	315	.913
Play (7 yrs)	43	.227	154	35	4	0	2	6	—	—	42	14	43	66	116	28	15	.867

Schulze, Shirley (Hometown: Chicago, IL, BR, TR, OF)
see Pitchers

YEAR/TEAM	Hitting												Fielding					
	G	BA	AB	H	2B	3B	HR	SB	BB	SO	R	RBI	G	PO	A	E	DP	FA
'44/Mil	15	.182	44	8	0	0	0	7	6	4	5	2	15	14	2	2	1	.889

Shadic (Campbell), Lillian "Pete" (Born: 6/14/29, Chatham, NY, BR, TR, 5'5", 145, OF)

YEAR/TEAM	Hitting												Fielding					
	G	BA	AB	H	2B	3B	HR	SB	BB	SO	R	RBI	G	PO	A	E	DP	FA
'49/Spr	No record																	

Shafranis, Geraldine (Hometown: Chicago, IL, OF)

YEAR/TEAM	Hitting												Fielding					
	G	BA	AB	H	2B	3B	HR	SB	BB	SO	R	RBI	G	PO	A	E	DP	FA
'43/SB	No record																	

Shero (Witiuk), Doris "Baser" (Born: 5/22/29, Winnipeg, MN, Canada, BR, TR, 5'2", 115, OF)

YEAR/TEAM	Hitting												Fielding					
	G	BA	AB	H	2B	3B	HR	SB	BB	SO	R	RBI	G	PO	A	E	DP	FA
'50/Rac	83	.093	194	18	0	0	0	10	21	27	14	9	76	74	5	6	2	.929
'51/BC	14	.100	40	4	0	0	0	6	4	5	5	4	12	15	2	3	0	.850
Car (2 yrs)	97	.094	234	22	0	0	0	16	25	32	19	13	88	89	7	9	2	.914

Shinen, Dorothy (Hometown: Los Angeles, CA, OF)

YEAR/TEAM	Hitting												Fielding					
	G	BA	AB	H	2B	3B	HR	SB	BB	SO	R	RBI	G	PO	A	E	DP	FA
'45/Ken	36	.145	83	12	1	0	0	5	12	9	4	5	25	19	2	1	0	.955

Shinen (Volkov), Kay (Born: 12/9/21, Los Angeles, CA, BR, TR, 5'5", 125, 3B)

YEAR/TEAM	Hitting												Fielding					
	G	BA	AB	H	2B	3B	HR	SB	BB	SO	R	RBI	G	PO	A	E	DP	FA
'45/Ken	98	.168	333	56	3	4	1	18	25	14	23	20	90	167	271	49	11	.899

Shively, Twila "Twi" (Born: 3/20/22, Decatur, IL, BR, TR, 5'6", 128, 1B, OF)

YEAR/TEAM	Hitting												Fielding					
	G	BA	AB	H	2B	3B	HR	SB	BB	SO	R	RBI	G	PO	A	E	DP	FA
'45/GR	106	.196	372	73	7	2	1	46	41	53	42	23	106	234	9	8	2	.968
'46/GR	111	.247	409	101	9	4	1	75	56	37	78	45	111	213	15	7	5	.970
'47/GR	104	.206	369	76	9	2	1	51	30	51	42	27	102	176	10	4	3	.979
'48/Chic, Peo	75	.156	263	71	3	3	0	36	55	58	37	14	75	158	9	3	1	.982

YEAR/TEAM	Hitting												Fielding					
	G	BA	AB	H	2B	3B	HR	SB	BB	SO	R	RBI	G	PO	A	E	DP	FA
'49/Peo	109	.187	347	65	4	4	0	18	58	59	31	21	109	1116	49	35	26	.971
'50/Peo	109	.192	381	73	10	5	1	29	51	64	23	36	108	231	10	10	1	.960
Car (6 yrs)	614	.200	2141	429	42	20	4	255	291	322	274	166	611	2028	102	67	38	.970
Play (3 yrs)	20	.176	74	13	1	0	0	11	—	—	6	3	12	26	1	0	0	1.000

Shollenberger, Fern "Shelly" (Born: 5/18/23, Hamburg, PA; Died: 12/24/77, BR, TR, 5'4", 125, 3B)

YEAR/TEAM	Hitting												Fielding					
	G	BA	AB	H	2B	3B	HR	SB	BB	SO	R	RBI	G	PO	A	E	DP	FA
'46/Ken	94	.225	342	77	0	3	0	35	26	16	35	24	90	126	155	13	15	.956
'47/Ken	81	.165	273	45	3	1	0	18	15	13	19	10	72	91	170	13	6	.953
'48/Ken	127	.210	466	98	5	4	0	24	33	44	47	17	130	204	401	39	24	.939
'49/Ken	111	.178	370	66	7	2	1	32	32	26	32	18	111	178	333	24	20	.955
'50/Ken	112	.254	417	106	8	2	0	28	32	22	48	31	112	152	321	27	18	.946
'51/Ken	105	.254	382	97	11	1	0	21	41	16	48	21	104	132	306	30	18	.936
'52/Kal	86	.228	316	72	7	1	0	11	18	18	32	29	86	130	264	21	13	.949
'53/Kal	107	.193	388	75	12	3	0	6	34	15	42	23	107	125	286	30	17	.932
'54/Kal	95	.268	332	89	8	0	8	6	38	12	47	58	95	108	213	33	16	.906
Car (9 yrs)	918	.221	3286	725	61	17	9	167	237	155	350	231	907	1246	2449	230	147	.942
Play (5 yrs)	21	.289	83	24	1	1	1	2	—	—	10	6	21	26	40	8	0	.892

Siegfried, Delores (2B)

YEAR/TEAM	Hitting												Fielding					
	G	BA	AB	H	2B	3B	HR	SB	BB	SO	R	RBI	G	PO	A	E	DP	FA
'47/Mus	No record																	

Sindelar, Joan "Jo" (Born: 8/29/31, Chicago, IL, BR, TR, 5'7", 125, OF)

YEAR/TEAM	Hitting												Fielding					
	G	BA	AB	H	2B	3B	HR	SB	BB	SO	R	RBI	G	PO	A	E	DP	FA
'50/Chic/																		
Spr	72	.260	173	70	4	1	2	15	58	20	50	42	No record					
'50/Kal	No record — played less than 10 games																	
'51/Kal	45	.123	73	9	4	1	0	1	17	24	10	2	31	25	1	2	0	.929
'52/Kal	No record — played less than 10 games																	
'53/Kal	81	.224	246	55	4	0	2	3	27	40	25	14	79	109	9	6	0	.952
Car (4 yrs)	126	.201	319	64	8	1	2	4	44	64	35	16	110	134	10	8	0	.948
Play (1 yr)	1	.000	0	0	0	0	0	0	0	0	0	0	No record					

Smith, Charlotte (Born: 1919, Chattanooga, TN, BR, TR, 5'6", 130, 1B, SS, OF)

YEAR/TEAM	Hitting												Fielding					
	G	BA	AB	H	2B	3B	HR	SB	BB	SO	R	RBI	G	PO	A	E	DP	FA
'43/Rac	53	.316	149	47	1	0	0	54	12	6	36	18	31	51	36	17	3	.836
'44/Rac	77	.186	204	38	1	2	0	39	27	12	21	15	42	56	58	18	4	.864
Car (2 yrs)	130	.241	353	85	2	2	0	93	39	18	57	33	73	107	94	35	7	.852

Smith (McCulloch), Colleen "Smitty" (Hometown: Vancouver, BC, Canada, BR, TR, 5'6", 120, 3B)

YEAR/TEAM	Hitting												Fielding					
	G	BA	AB	H	2B	3B	HR	SB	BB	SO	R	RBI	G	PO	A	E	DP	FA
'49/GR	40	.184	98	18	1	0	0	3	7	11	7	4	30	45	81	11	8	.920
Play (1 yr)	7	.217	23	5	0	0	0	0	—	—	2	2	7	6	9	3	1	.833

Smith, Hazel (Born: 2/16/30, Chicago, IL, TR, BR, 5'5", 135, C)

	Hitting												Fielding					
YEAR/TEAM	G	BA	AB	H	2B	3B	HR	SB	BB	SO	R	RBI	G	PO	A	E	DP	FA
'51/BC	No record																	

Smith, Helen (U)

	Hitting												Fielding					
YEAR/TEAM	G	BA	AB	H	2B	3B	HR	SB	BB	SO	R	RBI	G	PO	A	E	DP	FA
'46/Roc	2	.500	6	3	—	—	—	—	—	—	—	—	No record					

Smith, Helen "Gig" (Born: 1/5/22, Richmond, Va., BR, TR, 5'6", 133, OF)

	Hitting												Fielding					
YEAR/TEAM	G	BA	AB	H	2B	3B	HR	SB	BB	SO	R	RBI	G	PO	A	E	DP	FA
'47/Ken	5	.125	8	1	—	—	—	—	—	—	—	—	No record					
'48/GR	22	.192	52	10	2	0	0	2	6	6	8	2	18	13	3	0	0	1.000
Car (2 yrs)	27	.183	60	11	2	0	0	2	6	6	8	2	18	13	3	0	0	1.000
Play (1 yr)	5	.200	15	3	0	0	0	0	—	—	0	0	1	6	9	0	1	1.000

Smith, Jean (Born: 5/9/28, Ann Arbor, Mich., BR, TR, 5'6", 128 OF, P)
See also under Pitchers' Statistics

	Hitting												Fielding					
YEAR/TEAM	G	BA	AB	H	2B	3B	HR	SB	BB	SO	R	RBI	G	PO	A	E	DP	FA
'48/Ken, FW	104	.168	310	52	5	5	1	15	55	58	36	22	104	135	8	12	1	.923
'49/FW	25	.149	67	10	2	2	1	7	17	14	10	11	18	25	1	3	2	.897
'50/Peo	89	.217	267	58	10	3	0	12	36	44	36	14	82	137	6	5	3	.966
'51/Peo	93	.233	305	71	10	2	0	38	45	17	50	30	82	182	14	4	2	.975
'52/GR	69	.196	194	38	6	1	1	21	21	11	28	18	46	97	6	5	2	.954
'53/GR	114	.227	401	91	20	5	1	73	71	27	86	23	114	208	18	11	3	.954
'54/GR	93	.252	309	78	0	9	3	28	88	17	74	56	92	169	15	6	2	.968
Car (7 yrs)	567	.215	1853	398	67	18	13	194	333	188	320	174	538	953	78	47	15	.987
Play (5 yrs)	21	.095	63	6	1	0	0	6	—	—	9	0	19	28	2	1	0	.968

Smith, Marjean (Hometown: Kalamazoo, MI, U)

	Hitting												Fielding					
YEAR/TEAM	G	BA	AB	H	2B	3B	HR	SB	BB	SO	R	RBI	G	PO	A	E	DP	FA
'48/GR	22	.192	52	10	2	0	0	2	6	6	8	2	No record					

Smith, Shirley (Born: 1/24/23, Toronto, CA, BR, TR, 5'3", 132 OF, 2B)

	Hitting												Fielding					
YEAR/TEAM	G	BA	AB	H	2B	3B	HR	SB	BB	SO	R	RBI	G	PO	A	E	DP	FA
'47/Peo	61	.152	171	26	1	0	0	8	21	19	14	6	48	79	60	9	5	.939

Sopkovic, Kay (Born: 6/23/24, Youngstown, OH, BR, TR, 5'5", U)

	Hitting												Fielding					
YEAR/TEAM	G	BA	AB	H	2B	3B	HR	SB	BB	SO	R	RBI	G	PO	A	E	DP	FA
'45/SB	12	.067	15	1	0	0	0	0	0	1	0	1	No record					

Sowers, Barbara (Born: 5/4/32, Livonia, MI, BR, TR, 5'6", 148, OF)

	Hitting												Fielding					
YEAR/TEAM	G	BA	AB	H	2B	3B	HR	SB	BB	SO	R	RBI	G	PO	A	E	DP	FA
'53/Mus	70	.205	166	34	3	1	1	5	21	28	16	15	65	89	1	12	0	.882
'54/GR	70	.284	197	56	8	1	3	7	57	26	35	34	69	113	9	9	1	.931

YEAR/TEAM	G	BA	AB	H	2B	3B	HR	SB	BB	SO	R	RBI	G	PO	A	E	DP	FA
Car (2 yrs)	140	.248	363	90	11	2	4	12	78	54	51	49	134	202	10	21	1	.910
Play (1 yr)	1	.000	3	0	0	0	0	0	—	—	1	0	No record					

Stahley, Adele "Rustie" (Born: 6/10/28, Schnecksville, PA, BR, TR, 5'4", 150, U)

Hitting / **Fielding**

YEAR/TEAM	G	BA	AB	H	2B	3B	HR	SB	BB	SO	R	RBI	G	PO	A	E	DP	FA
'47/FW	No record																	

Steck (Weise), Elma "El" (Born: 5/3/23, Columbus, OH, BL, TR, 5'4", 120, OF)

Hitting / **Fielding**

YEAR/TEAM	G	BA	AB	H	2B	3B	HR	SB	BB	SO	R	RBI	G	PO	A	E	DP	FA
'48/Peo	11	.059	17	1	0	0	0	1	3	7	1	1	No record					
'49/Roc	6	.063	16	1	—	—	—	—	—	—	—	—	No record					
Car (2 yrs)	17	.061	33	2	0	0	0	1	3	7	1	1	No record					

Steele, Joyce M. "Lucky" (Born: 12/25/35, Wyalusing, PA, BB, TL, 5'7", 125, 1B, OF)

Hitting / **Fielding**

YEAR/TEAM	G	BA	AB	H	2B	3B	HR	SB	BB	SO	R	RBI	G	PO	A	E	DP	FA
'53/Kal	9	.279	—	—	—	—	—	—	—	—	—	—	No record					

Stefani, Margaret (Born: 12/18/17, Croweburg, KS; Died: Date Unknown, BR, TR, 5'2", 130, 2B)

Hitting / **Fielding**

YEAR/TEAM	G	BA	AB	H	2B	3B	HR	SB	BB	SO	R	RBI	G	PO	A	E	DP	FA
'43/SB	107	.249	397	99	6	11	4	90	71	5	87	55	106	314	265	38	24	.938
'44/SB	116	.218	400	87	4	5	0	83	66	7	57	46	116	296	228	40	26	.929
'45/SB	105	.231	337	78	13	8	1	14	64	7	39	39	102	514	127	29	14	.979
'46/SB	112	.224	370	83	5	8	1	79	80	15	70	53	112	327	216	34	28	.941
'47/SB	99	.237	337	80	7	1	2	27	33	13	34	38	98	253	243	19	26	.963
'48/Roc	103	.196	317	62	6	4	0	8	52	18	30	25	102	217	225	30	20	.936
Car (6 yrs)	642	.227	2158	489	41	37	8	301	366	65	317	256	636	1921	1295	190	138	.944
Play (3 yrs)	20	.183	71	10	0	0	0	2	—	—	6	8	19	31	31	4	4	.939

Stevenson, Emily (Born: 7/26/25, Champaign, IL, BR, TR, 5'7", 160, OF, C)

Hitting / **Fielding**

YEAR/TEAM	G	BA	AB	H	2B	3B	HR	SB	BB	SO	R	RBI	G	PO	A	E	DP	FA
'44/Mil	32	.162	74	12	0	0	0	3	12	8	12	5	29	27	11	2	3	.950
Play (1 yr)	1	.000	1	0	0	0	0	0	—	—	0	0	No record					

Stevenson, Rosemary "Stevie" (Born: 6/2/36, Stalwart, MI, BL, TR, 5'7", 137, OF)

Hitting / **Fielding**

YEAR/TEAM	G	BA	AB	H	2B	3B	HR	SB	BB	SO	R	RBI	G	PO	A	E	DP	FA
'54/GR	32	.232	82	19	3	0	3	3	4	27	15	7	23	18	2	3	0	.870

Stocker (Bottazzi), Jeanette "Jan" (Born: 12/13/26, Allentown, PA, BR, TR, 5'5", 140, C)

Hitting / **Fielding**

YEAR/TEAM	G	BA	AB	H	2B	3B	HR	SB	BB	SO	R	RBI	G	PO	A	E	DP	FA
'46/Ken	3	.000	3	0	—	—	—	—	—	—	—	—	No record					

Stoll, Nancy "Jeep" (Born: 8/8/28, West Point, PA, BR, TR, 5'2", 135, OF)

	Hitting											Fielding						
YEAR/TEAM	G	BA	AB	H	2B	3B	HR	SB	BB	SO	R	RBI	G	PO	A	E	DP	FA
'46/Peo	58	.140	164	23	2	0	0	12	20	25	13	14	53	77	8	5	3	.944
'47/GR	71	.163	203	33	2	4	0	21	40	41	16	12	70	107	12	3	3	.975
'48/Spr	116	.191	413	79	8	3	0	55	59	33	61	18	116	191	25	8	5	.964
'49/SB	99	.232	341	79	3	1	0	42	49	17	50	28	99	153	8	6	3	.964
'50/SB	99	.271	350	95	14	2	1	17	44	13	40	50	98	165	18	11	3	.943
'51/SB	101	.268	347	93	15	2	0	26	51	20	46	47	101	151	13	4	2	.976
'52/SB	86	.301	316	95	23	3	1	21	40	17	45	60	84	157	7	8	2	.953
'53/Kal	110	.308	396	122	18	0	3	14	47	20	37	65	108	222	21	9	2	.964
'54/Kal	34	.302	106	32	3	0	0	8	17	3	11	18	34	66	7	1	2	.986
Car (9 yrs)	774	.247	2636	651	88	15	5	216	367	189	319	312	763	1289	119	55	25	.963
Play (4 yrs)	29	.191	94	18	0	0	0	6	—	—	8	2	29	30	4	4	0	.974

Stolze, Dorothy "Dottie" (Born: 5/1/23, Tacoma, WA, BR, TR, 5'4", 129, OF, 2B)

	Hitting											Fielding						
YEAR/TEAM	G	BA	AB	H	2B	3B	HR	SB	BB	SO	R	RBI	G	PO	A	E	DP	FA
'46/Mus	81	.194	273	53	4	1	0	33	31	15	31	34	81	145	125	42	11	.865
'47/Mus	103	.217	383	83	5	0	0	65	24	18	44	22	102	255	231	28	18	.946
'48/Mus	121	.242	467	113	2	3	0	67	26	29	62	29	124	327	208	32	26	.944
'49/Mus, Rac	108	.163	399	65	4	0	0	47	29	16	32	29	111	361	52	15	9	.965
'50/Peo	106	.243	415	101	8	4	1	28	27	18	44	32	106	269	182	21	23	.956
'51/Peo	105	.223	404	90	9	1	0	37	49	18	62	27	106	233	27	12	9	.956
'52/GR	81	.240	308	74	4	4	0	23	22	11	34	19	74	171	99	18	15	.938
Car (7 yrs)	705	.219	2649	579	36	13	1	300	208	125	309	192	704	1761	924	168	111	.941
Play (3 yrs)	10	.128	39	5	0	0	0	4	—	—	4	2	10	12	7	5	0	.792

Stone (Richards), Lucille "Lou" (Born: 12/25/25, Boston, MA, BR, TR, 5'4", 130, SS)

	Hitting											Fielding						
YEAR/TEAM	G	BA	AB	H	2B	3B	HR	SB	BB	SO	R	RBI	G	PO	A	E	DP	FA
'45/Rac, SB	19	.040	50	2	0	0	0	0	7	12	1	2	17	20	37	16	1	.781

Stovroff, Shirley "Shirt" "Stovie" (Born: 3/18/31, Madison, IL; Died: 12/16/94, BR, TR, 5'6", 120 C, OF)

	Hitting											Fielding						
YEAR/TEAM	G	BA	AB	H	2B	3B	HR	SB	BB	SO	R	RBI	G	PO	A	E	DP	FA
'48/Spr, SB	100	.158	279	44	0	0	0	8	46	46	13	20	98	346	90	30	5	.936
'49/SB	77	.191	199	38	4	1	0	8	29	33	22	12	75	252	72	9	4	.973
'50/SB	85	.197	228	45	6	0	0	7	25	35	20	18	79	294	53	11	6	.969
'51/SB	100	.266	304	81	19	0	0	25	56	33	37	54	99	461	95	12	4	.979
'52/SB	93	.250	296	74	10	2	1	8	75	23	46	39	92	392	78	20	8	.959
Car (5 yrs)	455	.216	1306	282	39	3	1	56	231	170	138	143	293	1745	388	82	27	.963
Play (3 yrs)	17	.268	56	15	1	0	0	2	—	—	7	5	17	83	21	7	1	.937

Stuhr (Thompson), Beverly (Born: 5/5/32, Rock Island, IL, BL, TR, 5'1", 115, OF)

	Hitting											Fielding						
YEAR/TEAM	G	BA	AB	H	2B	3B	HR	SB	BB	SO	R	RBI	G	PO	A	E	DP	FA
'49/Peo	8	.286	14	4	—	—	—	—	—	—	—	—	No record					
'50/Rac	19	.088	34	3	0	0	0	0	6	13	4	1	18	18	2	3	0	.870
Car (2 yrs)	27	.146	48	7	0	0	0	0	6	13	4	1	18	18	2	3	0	.870

Surkowski (Deyotte), Anne (Born: 2/22/23, Moose Jaw, SK, Canada, 5'3", 120, OF)

	Hitting											Fielding						
YEAR/TEAM	G	BA	AB	H	2B	3B	HR	SB	BB	SO	R	RBI	G	PO	A	E	DP	FA
'45/SB	21	.103	39	4	0	0	0	4	3	7	5	1	18	11	2	3	1	.867

Surkowski (Delmonico), Lena (Born: 10/26/25, Moose Jaw, SK, Canada, BR, TR, 5'5", 128, OF)

	Hitting											**Fielding**						
YEAR/TEAM	G	BA	AB	H	2B	3B	HR	SB	BB	SO	R	RBI	G	PO	A	E	DP	FA
'44/SB	100	.212	335	71	7	4	3	37	36	24	32	29	97	135	19	5	4	.969
'45/SB	106	.209	349	73	8	4	1	26	28	34	42	28	102	162	16	12	2	.940
'46/SB, Roc	82	.200	256	51	4	3	1	11	21	31	21	28	77	121	3	4	1	.969
'48/FW	63	.186	226	42	2	5	0	16	23	34	33	20	63	87	6	9	2	.912
Car (4 yrs)	351	.203	1166	237	21	16	5	98	108	93	128	85	339	505	44	30	9	.948
Play (3 yrs)	11	.105	38	4	0	0	0	1	—	—	2	2	11	15	1	1	0	.941

Sutherland, Shirley (Hometown: Rockford, IL, BR, TR, C)

	Hitting												**Fielding**					
YEAR/TEAM	G	BA	AB	H	2B	3B	HR	SB	BB	SO	R	RBI	G	PO	A	E	DP	FA
'50/Chic-Spr	39	.121	141	17	4	0	1	8	14	19	18	14	No record					
'51/BC, GR	No record — played less than 10 games																	

Swamp, Rella (Hometown: Appleton, WI, U)

	Hitting												**Fielding**					
YEAR/TEAM	G	BA	AB	H	2B	3B	HR	SB	BB	SO	R	RBI	G	PO	A	E	DP	FA
'43/Roc	No record																	

Swanagon, Mary Lou "Swannie" (Born: 1/30/27, Sikeston, MO, BR, TR, 5'5", 130, U)

	Hitting												**Fielding**					
YEAR/TEAM	G	BA	AB	H	2B	3B	HR	SB	BB	SO	R	RBI	G	PO	A	E	DP	FA
'46/GR	No record																	

Taylor, Eunice "Tuffy" (Born: 2/12/34, Kenosha, WI, BR, TR, 5'4", 140, C)

	Hitting												**Fielding**					
YEAR/TEAM	G	BA	AB	H	2B	3B	HR	SB	BB	SO	R	RBI	G	PO	A	E	DP	FA
'50/Chic/Spr	47	.175	188	33	3	2	1	0	1	19	20	15	No record					
'51/Ken	38	.193	114	22	1	1	0	1	4	11	5	10	25	80	18	9	0	.916

Taylor, Mary (Hometown: Long Beach, CA, BR, TR, OF, 1B)

	Hitting												**Fielding**					
YEAR/TEAM	G	BA	AB	H	2B	3B	HR	SB	BB	SO	R	RBI	G	PO	A	E	DP	FA
'53/FW	46	.238	160	38	4	0	4	9	12	25	30	19	45	150	3	7	6	.956
'54/Kal	33	.176	87	24	0	0	0	1	11	13	12	9	32	26	2	6	0	.824
Car (2 yrs)	79	.251	247	62	4	0	4	10	23	38	42	28	77	176	5	13	6	.933
Play (2 yrs)	4	.545	11	6	2	0	0	0	—	—	3	0	3	1	0	0	0	1.000

Teillet (Schick), Yolande "Yo" (Born: 9/28/27, St. Vital, MN, Canada, BR, TR, 5', 125, C, OF)

	Hitting												**Fielding**					
YEAR/TEAM	G	BA	AB	H	2B	3B	HR	SB	BB	SO	R	RBI	G	PO	A	E	DP	FA
'45/FW	10	.231	13	3	0	0	0	0	2	2	2	3	No record					
'46/GR	5	.167	6	1	—	—	—	—	—	—	—	—	No record					
'47/GR	2	.333	3	1	—	—	—	—	—	—	—	—	No record					
Car (3 yrs)	17	.227	22	5	0	0	0	0	2	2	2	3	No record					
Play (1 yr)	3	.000	2	0	0	0	0	0	—	—	0	0	3	2	1	0	0	1.000

Terkowski, Georgia (Hometown: Passaic, NY, U)

	Hitting												Fielding					
YEAR/TEAM	G	BA	AB	H	2B	3B	HR	SB	BB	SO	R	RBI	G	PO	A	E	DP	FA
'52/Roc	17	.171	35	6	1	1	0	5	1	13	6	3	No record					

Terry, Betty

	Hitting												Fielding					
YEAR/TEAM	G	BA	AB	H	2B	3B	HR	SB	BB	SO	R	RBI	G	PO	A	E	DP	FA
'46/Peo	8	.158	19	3	—	—	—	—	—	—	—	—	No record					

Tetzlaff, Doris "Tetz" (Born: 1/1/21, Watertown, WI; Died: 4/11/98; BR, TR, 5'5", 155, OF, 3B)

	Hitting												Fielding					
YEAR/TEAM	G	BA	AB	H	2B	3B	HR	SB	BB	SO	R	RBI	G	PO	A	E	DP	FA
'44/Mil	102	.212	345	73	3	4	3	101	47	32	62	42	102	164	317	50	12	.906
'45/GR	110	.190	378	72	9	2	0	37	82	51	43	24	110	169	368	64	18	.894
'46/GR	112	.199	382	76	4	0	1	57	74	46	57	34	112	178	264	60	18	.880
'47/GR	89	.179	285	51	4	2	0	31	46	22	27	18	89	136	233	25	14	.937
'48/Chic, FW	121	.191	392	75	5	7	0	30	82	74	44	27	121	203	288	47	22	.913
'49/Mus	91	.161	274	44	4	0	0	28	68	37	34	16	98	114	173	35	14	.891
'50/FW	No record — played less than 10 games																	
'52/FW	No record — played less than 10 games																	
Car (8 yrs)	625	.190	2056	391	29	15	4	284	399	262	267	161	530	964	1643	281	98	.903
Play (7 yrs)	45	.137	146	20	1	0	0	9	—	—	9	7	26	61	110	21	3	.891

Tezak (Papesh), Virginia May Rita "Ginny" (Born: 5/22/28, Joliet, IL, 5'6", 145, OF, 1B, P)

see Pitchers

	Hitting												Fielding					
YEAR/TEAM	G	BA	AB	H	2B	3B	HR	SB	BB	SO	R	RBI	G	PO	A	E	DP	FA
'48/Rac	4	.000	7	0	—	—	—	—	—	—	—	—	No record					

Thomas, Mava Lee "Tommy" (Born: 9/1/29, Ocala, FL, 5'2", 145, 3B, C)

	Hitting												Fielding					
YEAR/TEAM	G	BA	AB	H	2B	3B	HR	SB	BB	SO	R	RBI	G	PO	A	E	DP	FA
'51/FW	No record — played less than 10 games																	

Thompson, Barbara (Born: 2/24/34, Rockford, IL, BR, TR, 5'3", 135, OF)

	Hitting												Fielding					
YEAR/TEAM	G	BA	AB	H	2B	3B	HR	SB	BB	SO	R	RBI	G	PO	A	E	DP	FA
'51/Roc	18	.204	49	10	0	0	0	4	10	11	6	3	18	13	5	1	2	.947
'52/Roc	No record — played less than 10 games																	

Tognatti, Alice (OF)

	Hitting												Fielding					
YEAR/TEAM	G	BA	AB	H	2B	3B	HR	SB	BB	SO	R	RBI	G	PO	A	E	DP	FA
'46/FW	21	.067	45	3	0	0	0	2	5	24	2	1	19	21	1	1	0	.957

Torrison, Lorraine "Peggy" (Hometown: Minneapolis, MN; Died: Date Unknown, BR, TR, 3B)

	Hitting												Fielding					
YEAR/TEAM	G	BA	AB	H	2B	3B	HR	SB	BB	SO	R	RBI	G	PO	A	E	DP	FA
'44/Mpls	16	.167	54	9	0	1	0	1	9	8	7	5	10	22	22	7	1	.863

Travis (Visich), Gene "Dolph" (Born: 10/18/26, Mt. Vernon, NY, BL, TB, 5'5", 140, 1B, OF)

YEAR/TEAM	Hitting												Fielding					
	G	BA	AB	H	2B	3B	HR	SB	BB	SO	R	RBI	G	PO	A	E	DP	FA
'48/Roc	No record — played less than 10 games																	

Trezza, Betty "Moe" (Born: 8/4/25, Brooklyn, NY, BR, TR, 5'3", 125, SS, 3B, OF)

YEAR/TEAM	Hitting												Fielding					
	G	BA	AB	H	2B	3B	HR	SB	BB	SO	R	RBI	G	PO	A	E	DP	FA
'44/Mpls	64	.108	194	21	1	0	2	48	29	16	25	16	63	113	132	20	4	.925
'45/FW, SB	86	.112	276	31	2	0	0	14	36	36	28	16	83	161	124	10	12	.966
'46/Rac	111	.175	422	74	6	8	0	65	52	42	58	43	107	209	269	60	20	.888
'47/Rac	112	.157	433	68	4	3	1	66	27	36	51	36	114	218	45	7	7	.974
'48/Rac	126	.181	469	85	4	4	1	64	44	55	67	27	126	199	322	58	12	.902
'49/Rac	110	.196	387	76	6	8	1	53	53	34	47	27	110	220	380	55	23	.916
'50/Rac	108	.231	385	89	6	5	1	53	44	22	15	35	108	250	127	38	14	.909
Car (7 yrs)	717	.173	2566	444	29	28	6	363	285	241	331	191	684	1531	1533	258	113	.922
Play (3 yrs)	27	.148	115	17	1	1	0	10	—	—	9	8	27	42	30	6	3	.962

Tronnier, Ellen (Born: June 28, 1927, Cudahy, WI, BR, TR, 5'6", 135, OF)

YEAR/TEAM	Hitting												Fielding					
	G	BA	AB	H	2B	3B	HR	SB	BB	SO	R	RBI	G	PO	A	E	DP	FA
'43/SB	No record																	

Ventura (Manina), Virginia "Jean" (Born: 11/30/35. Garfield, NJ, BR, TR, 5'9", 165, 1B)

YEAR/TEAM	Hitting												Fielding					
	G	BA	AB	H	2B	3B	HR	SB	BB	SO	R	RBI	G	PO	A	E	DP	FA
'51/Roc	No record																	
'53/Roc	11	.074	27	2	0	0	0	0	2	8	1	0	No record					

Villa (Cryan), Margaret (Born: 12/21/24, Montabello, CA, BR, TR, 5'2", 115, C, OF, 3B, 2B)

YEAR/TEAM	Hitting												Fielding					
	G	BA	AB	H	2B	3B	HR	SB	BB	SO	R	RBI	G	PO	A	E	DP	FA
'46/Ken	108	.197	355	70	5	1	3	44	72	30	52	33	97	423	59	21	5	.958
'47/Ken	105	.201	353	71	3	6	1	36	52	32	45	30	207	238	81	17	4	.949
'48/Ken	119	.190	405	77	6	8	1	36	71	40	54	31	103	213	296	50	17	.911
'49/Ken	111	.204	387	79	6	3	0	54	65	29	53	36	111	250	205	23	26	.952
'50/Ken	94	.256	332	85	12	3	0	30	42	20	45	38	97	283	159	20	36	.957
Car (5 yrs)	537	.209	1832	382	32	21	5	200	302	151	249	168	615	1407	800	131	88	.944
Play (3 yrs)	9	.071	32	2	0	0	0	0	—	—	1	1	9	6	16	1	1	.957

Violetta (Kunkel), Karen (Hometown: Negaunee, MI, BR, TR, U)

YEAR/TEAM	Hitting												Fielding					
	G	BA	AB	H	2B	3B	HR	SB	BB	SO	R	RBI	G	PO	A	E	DP	FA
'53/GR	No record — played less than 10 games																	

Vonderau, Katheryn "Katie" (Born: 9/26/27, Fort Wayne, IN, BR, TR, 5'7", 155, C)

YEAR/TEAM	Hitting												Fielding					
	G	BA	AB	H	2B	3B	HR	SB	BB	SO	R	RBI	G	PO	A	E	DP	FA
'46/FW	98	.149	289	43	2	2	0	4	26	28	13	30	98	452	70	27	8	.951
'47/Mus	45	.196	148	29	3	0	0	5	5	8	9	9	43	169	24	5	5	.97
'48/Chic, Peo	82	.174	264	46	3	4	0	2	21	31	18	11	79	343	62	30	8	.931

YEAR/TEAM	Hitting												Fielding					
	G	BA	AB	H	2B	3B	HR	SB	BB	SO	R	RBI	G	PO	A	E	DP	FA
'49/Peo,																		
Mus	86	.175	252	44	4	1	0	4	28	37	19	13	85	321	109	26	10	.943
'50/FW	90	.193	295	57	4	0	0	4	29	44	23	25	90	331	109	19	13	.959
'51/FW	74	.221	249	55	12	0	0	1	26	29	24	32	74	284	66	20	9	.946
'52/FW	66	.210	219	46	8	2	1	1	13	20	20	20	66	213	46	8	6	.970
'53/Mus	101	.202	321	65	6	0	0	3	33	21	21	29	101	331	77	23	7	.947
Car (8 yrs)	642	.189	2038	385	42	9	1	46	129	184	147	169	636	2444	563	178	66	.944
Play (3 yrs)	15	.130	46	6	1	0	0	0	—	—	2	8	13	15	5	4	2	.833

Voyce, Inez "Lefty" "Hook" (Born: 8/16/24, Rathbun, IA, BL, TL, 5'6", 148, 1B, P)
see Pitchers

YEAR/TEAM	Hitting												Fielding					
	G	BA	AB	H	2B	3B	HR	SB	BB	SO	R	RBI	G	PO	A	E	DP	FA
'46/SB	104	.210	329	69	6	3	2	32	64	22	31	43	104	1163	32	39	26	.968
'47/GR	113	.214	383	82	5	4	1	19	30	15	27	45	113	1269	22	15	43	.989
'48/GR	126	.227	436	99	9	2	1	31	66	29	46	52	125	1400	42	16	60	.989
'49/GR	113	.257	374	96	6	0	3	22	67	9	51	53	113	871	49	25	37	.974
'50/GR	113	.292	380	111	14	5	3	13	72	23	53	66	113	1261	28	17	36	.987
'51/GR	106	.285	372	106	14	5	2	10	59	12	43	49	106	1056	28	18	45	.984
'52/GR	107	.295	390	115	16	3	10	19	47	14	57	54	107	1052	34	13	46	.988
'53/GR	112	.269	383	103	11	4	6	22	75	20	55	60	111	1073	36	13	42	.988
Car (8 yrs)	894	.256	3047	781	81	28	28	168	480	144	386	422	892	8093	271	156	335	.961
Play (8 yrs)	47	.171	181	31	4	0	0	8	—	—	14	11	47	500	10	8	10	.985

Waddell (Wyatt), Helen "Sis" (Born: 4/24/30, Lemayne, PA, BR, TR, 5'6", 115, OF)

YEAR/TEAM	Hitting												Fielding					
	G	BA	AB	H	2B	3B	HR	SB	BB	SO	R	RBI	G	PO	A	E	DP	FA
'50/Roc	54	.094	149	14	3	0	0	3	17	37	11	12	53	38	55	20	5	.823
'51/Roc, BC	69	.147	217	32	2	0	0	6	24	36	25	17	64	109	111	47	16	.824
Car (2 yrs)	123	.137	366	46	5	0	0	9	41	73	36	29	117	147	166	67	21	.824
Play (1 yr)	1	.333	3	1	0	0	0	0	—	—	0	0	1	5	2	0	0	1.000

Wagner, Audrey (Born: 12/27/27, Bensenville, IL, BR, TR, 5'7", 145, OF, P)
see Pitchers

YEAR/TEAM	Hitting												Fielding					
	G	BA	AB	H	2B	3B	HR	SB	BB	SO	R	RBI	G	PO	A	E	DP	FA
'43/Ken	73	.230	257	59	3	10	4	57	27	35	30	43	66	59	4	5	1	.926
'44/Ken	90	.189	317	60	5	4	0	24	23	28	34	26	88	103	16	9	2	.930
'45/Ken	101	.198	343	68	5	9	2	13	32	22	26	26	101	93	23	8	1	.935
'46/Ken	109	.281	392	110	15	5	9	37	40	29	53	53	108	174	14	11	3	.945
'47/Ken	107	.305	390	119	25	9	7	39	32	25	48	53	107	140	9	4	4	.974
'48/Ken	117	.312	417	130	16	14	4	53	56	31	70	56	117	193	17	7	2	.968
'49/Ken	97	.233	348	81	8	4	3	23	48	55	28	40	97	152	7	8	2	.952
Car (7 yrs)	694	.254	2464	627	77	55	29	246	258	225	289	297	684	914	90	52	15	.951
Play (4 yrs))	15	.163	49	8	1	1	0	0	—	—	4	2	15	13	0	2	0	.867

Wagoner, Betty "Waggy" (Born: 7/15/30, Lebanon, MO, BL, TL, 5'2", 110, OF, P)
see Pitchers

YEAR/TEAM	Hitting												Fielding					
	G	BA	AB	H	2B	3B	HR	SB	BB	SO	R	RBI	G	PO	A	E	DP	FA
'48/Mus, SB	84	.278	248	69	2	1	0	7	42	42	42	11	82	79	3	0	0	1.000
'49/SB,																		
Mus	114	.230	382	87	4	1	0	64	87	36	58	26	113	106	11	3	2	.925
'50/SB	106	.296	388	115	11	3	0	37	64	22	61	39	101	157	15	6	4	.966
'51/SB	110	.272	375	102	9	3	0	50	63	20	77	41	110	137	20	3	2	.981

	Hitting											Fielding						
YEAR/TEAM	G	BA	AB	H	2B	3B	HR	SB	BB	SO	R	RBI	G	PO	A	E	DP	FA
'52/SB	97	.295	353	104	7	4	0	40	64	16	64	27	91	105	10	7	2	.943
'53/SB	107	.239	352	84	9	2	0	19	63	5	42	32	81	142	11	7	1	.956
'54/SB	48	.320	150	48	12	0	0	4	10	4	23	15	35	296	12	9	19	.972
Car	666	.271	2248	609	54	14	0	221	403	145	367	191	613	1022	82	35	30	.969
Play	26	.326	95	31	1	0	1	3	—	—	12	8	26	58	4	2	0	.969

Walker, Nellie Jean (U)

	Hitting											Fielding						
YEAR/TEAM	G	BA	AB	H	2B	3B	HR	SB	BB	SO	R	RBI	G	PO	A	E	DP	FA
'45/SB	2	.000	2	0	—	—	—	—	—	—	—	—	No record					

Walmsley, Thelma (Born: 4/13/18, Sudbury, ON, Canada, BR, TR, 5'5", 122)

	Hitting											Fielding						
YEAR/TEAM	G	BA	AB	H	2B	3B	HR	SB	BB	SO	R	RBI	G	PO	A	E	DP	FA
'46/Rac	6	.000	16	0	—	—	—	—	—	—	—	—	No record					
Play (1 yr)	1	.000	1	0	—	—	—	—	—	—	—	—	No record					

Walulik (Kiely), Helen "Hensky" (Born: 5/3/29, Plainfield, NJ, BR, TR, 5'8", 121, OF, 2B)
see Pitchers

	Hitting											Fielding						
YEAR/TEAM	G	BA	AB	H	2B	3B	HR	SB	BB	SO	R	RBI	G	PO	A	E	DP	FA
'48/Mus, FW	18	.120	25	3	0	0	1	1	2	4	1	4	No record					
'50/Kal	49	.160	106	17	1	0	0	4	1	9	10	6	24	42	30	6	3	.923
Car	67	.153	131	20	1	0	1	5	3	13	11	10	24	42	30	6	3	.923

Wanless (Decker), Betty (Born: 8/28/28, Springfield, IL, BR, TR, 5'5", 134, 3B)

	Hitting											Fielding						
YEAR/TEAM	G	BA	AB	H	2B	3B	HR	SB	BB	SO	R	RBI	G	PO	A	E	DP	FA
'53/GR	85	.248	306	76	10	1	3	48	27	39	49	35	84	118	185	25	12	.924
'54/SB	86	.274	321	88	13	2	15	26	29	32	75	47	86	89	175	44	10	.857
Car (2 yrs)	171	.262	627	164	23	3	18	74	56	71	124	82	170	207	360	69	22	.892
Play (1 yr)	3	.286	14	4	0	0	2	1	—	—	4	2	3	5	11	1	1	.941

Warfel, Betty (Born: 5/15/26, Enola, PA; Died: 9/23/90, 5'8" U, P)

	Hitting											Fielding						
YEAR/TEAM	G	BA	AB	H	2B	3B	HR	SB	BB	SO	R	RBI	G	PO	A	E	DP	FA
'48/Roc	70	.166	193	32	3	0	1	10	21	37	16	15	54	76	90	23	10	.878

Warren, Nancy "Hank" (Born: 6/13/21, Springfield, OH, BR, TR, 5'5", 130, 2B, P)
see Pitchers

	Hitting											Fielding						
YEAR/TEAM	G	BA	AB	H	2B	3B	HR	SB	BB	SO	R	RBI	G	PO	A	E	DP	FA
'46/Mus	39	.155	116	18	1	2	0	3	15	14	12	3	27	42	45	12	3	.879

Warwick (McAuley), Mildred "Millie" (Born: 10/28/22, Regina, Sask., Canada, BR, TR, 5'2", 115, 3B)

	Hitting											Fielding						
YEAR/TEAM	G	BA	AB	H	2B	3B	HR	SB	BB	SO	R	RBI	G	PO	A	E	DP	FA
'43/Roc	92	.263	354	93	5	7	1	34	19	7	62	30	88	173	316	64	11	.884

	Hitting												Fielding					
YEAR/TEAM	G	BA	AB	H	2B	3B	HR	SB	BB	SO	R	RBI	G	PO	A	E	DP	FA
'44/Roc	97	.208	342	71	4	2	1	69	35	17	45	37	97	188	237	48	13	.891
Car (2 yrs)	189	.236	696	164	9	9	2	103	54	24	107	67	185	361	553	112	24	.891

Wawryshyn (Moroz), Evelyn "Evie" (Born: 11/11/24, Tyndall, MN, Canada, BR, TR, 5'3", 130, 2B)

	Hitting												Fielding					
YEAR/TEAM	G	BA	AB	H	2B	3B	HR	SB	BB	SO	R	RBI	G	PO	A	E	DP	FA
'46/Ken, Mus	73	.217	235	51	2	2	0	24	16	21	29	18	62	125	103	21	8	.916
'47/Mus	36	.237	93	22	2	2	0	4	7	7	10	7	24	35	22	3	0	.929
'48/Spr	118	.262	435	114	4	4	0	66	32	39	58	30	118	275	239	41	23	.926
'49/FW	109	.251	391	98	8	6	0	64	38	52	47	34	109	244	169	15	22	.965
'50/FW	104	.311	399	124	13	2	1	65	36	38	71	50	104	226	203	22	34	.951
'51/FW	104	.277	390	108	8	0	0	50	48	18	60	54	104	251	212	29	32	.941
Car (6 yrs)	544	.266	1943	275	37	16	1	273	177	175	275	193	521	1156	948	131	119	.941
Play (4 yrs)	19	.286	70	20	4	0	0	9	—	—	9	5	19	18	22	6	0	.876

Weaver, Jean (Born: 8/28/33, Metropolis, IL, BR, TR, 5'8", 138, 3B, OF, P)
see Pitchers

	Hitting												Fielding					
YEAR/TEAM	G	BA	AB	H	2B	3B	HR	SB	BB	SO	R	RBI	G	PO	A	E	DP	FA
'51/FW	87	.247	312	77	4	2	2	31	16	42	39	31	86	121	116	19	9	.926
'52/FW	55	.225	160	36	9	3	0	8	8	17	21	19	48	56	98	20	6	.885
Car (2 yrs)	142	.239	472	113	13	5	2	39	24	59	60	50	134	177	214	39	15	.909
Play (3 yrs)	7	.348	23	8	1	0	0	0	—	—	3	5	6	10	15	1	2	.962

Weaver , Joanne "The Little" (Metropolis, IL, BR, TR, 5'11", 142, OF)
see Pitchers

	Hitting												Fielding					
YEAR/TEAM	G	BA	AB	H	2B	3B	HR	SB	BB	SO	R	RBI	G	PO	A	E	DP	FA
'51/FW	48	.276	163	45	8	2	1	6	15	16	123	21	43	39	3	5	2	.894
'52/FW	84	.344	314	108	10	5	3	19	23	58	50	81	110	19	16	21	4	.890
'53/FW	104	.346	410	142	18	6	5	70	23	26	76	76	102	213	5	11	0	.952
'54/FW	93	.429	333	143	16	4	29	79	32	24	109	87	93	190	13	11	4	.949
Car (4 yrs)	329	.359	1220	438	52	17	38	174	93	89	226	234	319	552	40	43	10	.932
Play (4 yrs))	15	.328	64	21	3	0	3	7	—	—	11	7	15	22	2	1	0	.960

Weddle (Hines), Mary "Giggles" (Born: 4/26/34, Woodsfield, OH, BR, TR, 5'3", 118, 3B)
see Pitchers

	Hitting												Fielding					
YEAR/TEAM	G	BA	AB	H	2B	3B	HR	SB	BB	SO	R	RBI	G	PO	A	E	DP	FA
'54/FW	76	.216	241	52	6	2	2	5	38	37	38	21	62	52	77	20	11	.866
Play	6	.208	24	5	0	0	0	1	—	—	5	0	6	6	5	2	1	.846

Weeks, Rossey (Born: 9/7/24, Jacksonville, FL, BR, TR, 5'7", 155, C)

	Hitting												Fielding					
YEAR/TEAM	G	BA	AB	H	2B	3B	HR	SB	BB	SO	R	RBI	G	PO	A	E	DP	FA
'47/Roc	7	.059	17	1	—	—	—	—	—	—	—	—	No record					

Wegman, Marie "Blackie" (Born: 4/30/25, Cincinnati, OH, BR, TR, 5'7", 130, 3B, 2B, OF, P)

see Pitchers

	Hitting											**Fielding**						
YEAR/TEAM	G	BA	AB	H	2B	3B	HR	SB	BB	SO	R	RBI	G	PO	A	E	DP	FA
'47/Roc	101	.175	297	52	4	1	1	18	24	43	19	10	96	126	252	51	11	.881
'48/FW	36	.093	86	8	0	1	0	2	13	19	3	6	14	26	18	2	3	.957
'49/Mus	60	.139	165	23	1	0	0	9	22	26	12	8	46	79	76	12	7	.928
'50/GR	94	.234	286	67	9	1	0	22	43	31	26	27	91	118	181	27	11	.917
Car (4 yrs)	291	.180	834	150	14	3	1	51	102	119	60	51	247	349	527	92	32	.905
Play (2 yrs)	9	.258	31	8	0	0	0	2	—	—	3	1	7	9	9	2	2	.900

Weierman, Shirley Ann (Born: 6/27/38, Lima, OH, BR, TR, 5'6", 120, 3B)

	Hitting											**Fielding**						
YEAR/TEAM	G	BA	AB	H	2B	3B	HR	SB	BB	SO	R	RBI	G	PO	A	E	DP	FA
'53/FW	No record — played less than 10 games																	
'54/FW	11	.179	28	5	0	0	0	0	1	12	0	0	12	13	24	4	2	.902

Wenzell, Margaret "Marge" (Born: 5/21/25, Detroit, MI, BR, TR, 5'4", 118, OF, 2B, 3B)

	Hitting											**Fielding**						
YEAR/TEAM	G	BA	AB	H	2B	3B	HR	SB	BB	SO	R	RBI	G	PO	A	E	DP	FA
'45/GR	34	.172	93	16	2	1	0	6	19	15	10	11	19	23	4	1	0	.964
'46/Mus	8	.269	26	7	—	—	—	—	—	—	—	—	No record					
'47/Peo, FW	31	.097	72	7	1	0	0	11	14	13	4	0	14	21	27	9	2	.842
'48/Spr	104	.168	346	58	3	4	1	33	55	39	30	19	103	141	136	45	9	.860
'49/Rac, FW	70	.182	220	40	3	1	0	27	29	17	22	13	64	79	25	10	1	.912
'50/Kal, Rac	73	.185	184	34	0	1	0	14	31	21	28	14	56	66	9	1	3	.987
'51/Kal, BC	108	.213	381	81	10	7	0	25	53	36	43	41	108	252	248	51	29	.907
'52/BC, SB	84	.216	259	56	6	6	0	21	27	16	28	20	88	183	107	24	21	.924
'53/SB	45	.177	96	17	5	1	0	10	28	13	14	10	34	40	28	7	3	.907
Car (9 yrs)	557	.188	1677	316	30	24	1	156	248	156	179	118	486	805	584	148	68	.904
Play (2 yrs)	8	.080	25	2	0	0	0	3	—	—	0	0	8	8	12	2	0	.909

Westerman (Austin), Helen "Pee Wee" (Born: 9/10/26, Springfield, IL, BR, TR, 5'7", 118, C)

	Hitting											**Fielding**						
YEAR/TEAM	G	BA	AB	H	2B	3B	HR	SB	BB	SO	R	RBI	G	PO	A	E	DP	FA
'43/Ken	82	.183	263	48	3	1	0	20	15	14	36	21	81	395	60	21	8	.956
Play	1	0	0	0	0	0	0	0	—	—	0	—	1	0	0	0	0	1.000

Whalen, Dorothy "Dot" (Born: 6/22/23, Brooklyn, NY, BR, TR, 5'6", 140, C)

	Hitting											**Fielding**						
YEAR/TEAM	G	BA	AB	H	2B	3B	HR	SB	BB	SO	R	RBI	G	PO	A	E	DP	FA
'48/Spr	49	.153	111	17	2	0	0	11	14	13	9	5	49	187	28	24	1	.900

Whiting, Betty Jane (Born: 7/21/25, La Salle, MI; Died: Date Unknown, BR, 5'6", 147, 1B, OF, C)

	Hitting											**Fielding**						
YEAR/TEAM	G	BA	AB	H	2B	3B	HR	SB	BB	SO	R	RBI	G	PO	A	E	DP	FA
'44/Mil	114	.202	371	75	6	5	0	53	50	31	41	34	105	779	26	37	26	.956
'45/GR	103	.176	358	63	4	1	0	29	37	17	36	14	96	1132	16	19	36	.984

	Hitting												Fielding					
YEAR/TEAM	G	BA	AB	H	2B	3B	HR	SB	BB	SO	R	RBI	G	PO	A	E	DP	FA
'46/GR	112	.179	374	67	8	1	0	27	34	34	41	24	112	1142	29	13	50	.989
'47/FW	110	.157	356	56	6	1	1	31	34	30	31	19	115	270	11	7	7	.967
'48/Chic, SB	120	.183	338	62	6	5	1	17	67	55	33	20	116	1210	68	25	33	.981
'49/SB	93	.193	254	49	7	3	0	7	48	45	25	40	93	972	44	14	34	.986
'50/SB, Kal	92	.207	285	59	15	0	1	4	54	33	36	25	89	875	32	16	35	.983
'51/Kal, BC	95	.190	269	51	8	0	0	16	55	28	30	28	94	942	35	14	39	.986
'52/BC	104	.231	342	79	4	1	0	14	43	30	38	28	104	944	33	16	43	.984
Car (9 yrs)	943	.190	2947	561	64	17	3	198	422	303	311	232	924	8266	294	161	303	.982
Play (5 yrs)	25	.098	92	9	1	2	0	3	—	—	4	2	25	320	7	10	8	.970

Whiteman, Vera (Hometown: Battle Creek, MI, 2B)

	Hitting												Fielding					
YEAR/TEAM	G	BA	AB	H	2B	3B	HR	SB	BB	SO	R	RBI	G	PO	A	E	DP	FA
'46/GR	16	.133	45	6	0	0	0	3	6	9	6	2	14	12	12	1	2	.960

Whitney (Dearfield), Norma (Born: 5/29/28, McKeesport, PA, BR, TR, 5'2", 115, 2B)

	Hitting												Fielding					
YEAR/TEAM	G	BA	AB	H	2B	3B	HR	SB	BB	SO	R	RBI	G	PO	A	E	DP	FA
'49/Chic	No record																	
'50/SB	No record																	

Wicken (Berthaiume), Elizabeth Ann "Betty" "Wiggles" (Born: 5/26/27, Regina, SK, Canada, BL, TL, 5'2", 115, OF)

	Hitting												Fielding					
YEAR/TEAM	G	BA	AB	H	2B	3B	HR	SB	BB	SO	R	RBI	G	PO	A	E	DP	FA
'45/GR	89	.188	319	60	7	4	0	18	38	31	22	28	89	103	12	6	0	.950
'46/GR, Mus	28	.159	88	14	5	1	0	8	13	16	10	6	28	29	5	1	0	.971
Car (2 yrs)	117	.182	407	74	12	5	0	26	51	47	32	34	117	132	17	7	0	.955
Play (1 yr)	4	.267	15	4	0	0	0	0	—	—	1	0	4	4	1	0	0	1.000

Wigiser, Margaret "Wiggy" (Born: 12/17/24, Brooklyn, NY, BR, TR, 5'6", 160, OF)

	Hitting												Fielding					
YEAR/TEAM	G	BA	AB	H	2B	3B	HR	SB	BB	SO	R	RBI	G	PO	A	E	DP	FA
'44/Mpls, Roc	78	.212	273	58	1	4	2	29	26	25	30	38	72	78	16	16	4	.855
'45/Roc	86	.250	309	77	8	2	2	24	29	15	39	35	85	156	8	6	1	.965
'46/Roc	39	.203	118	24	1	2	0	12	8	5	11	15	34	37	5	2	0	.955
Car (3 yrs)	203	.227	700	159	10	8	4	65	63	45	80	88	189	271	29	24	5	.926
Play (1 yr)	9	.212	33	7	1	0	0	0	—	—	3	3	9	16	0	0	0	1.000

Wiley (Sears), Janet "Pee Wee" (Born: 10/12/23, South Bend, IN, BR, TR, 5'4", 112, 1B, P)

see Pitchers

	Hitting												Fielding					
YEAR/TEAM	G	BA	AB	H	2B	3B	HR	SB	BB	SO	R	RBI	G	PO	A	E	DP	FA
'50/Chic/Spr	19	.289	83	24	2	2	0	2	4	11	17	7	No record					
'50/SB	40	.134	97	13	1	1	0	1	12	28	5	7	34	307	10	13	8	.961
'51/SB	74	.221	181	40	3	1	0	3	16	26	21	13	71	595	27	15	20	.976
'52/SB	No record — played less than 10 games																	
'53/Roc	33	.206	102	21	1	0	0	3	3	15	5	5	20	184	11	6	13	.970
Car (4 yrs)	147	.221	380	84	5	2	0	7	31	69	31	25	127	1086	48	34	41	.971
Play (1 yr)	3	.000	7	0	0	0	0	0	—	—	0	0	2	22	3	0	1	1.000

Wilson, Dolores "Dodie" (Born: 12/17/28, Stockton, CA, BR, TL, 5'5", 142, OF)

	Hitting												Fielding					
YEAR/TEAM	G	BA	AB	H	2B	3B	HR	SB	BB	SO	R	RBI	G	PO	A	E	DP	FA
'47/Peo	79	.217	230	50	1	1	0	16	21	22	17	23	64	44	7	8	0	.864

Wilson, Verna (Hometown: Rochester, NY, U)

	Hitting												Fielding					
YEAR/TEAM	G	BA	AB	H	2B	3B	HR	SB	BB	SO	R	RBI	G	PO	A	E	DP	FA
'46/Roc	1	.000	1	0	—	—	—	—	—	—	—	—	No record					

Wind, Dorothy "Dottie" (Born: 1926, Chicago, IL, BR, TR, 5'6", 128, SS)

	Hitting												Fielding					
YEAR/TEAM	G	BA	AB	H	2B	3B	HR	SB	BB	SO	R	RBI	G	PO	A	E	DP	FA
'43/Rac	88	.255	321	82	4	7	2	36	18	15	56	44	88	129	356	79	10	.860
'44/Rac	56	.240	208	50	4	4	0	28	17	7	29	19	56	98	141	24	13	.909
Car (2 yrs)	144	.250	529	132	8	11	2	64	35	22	85	63	144	227	497	103	23	.876
Play (1 yr)	3	.167	12	2	0	0	0	1	—	—	1	1	3	3	18	10	3	.903

Wingrove (Earl), Elsie "Windy" (Born: 9/26/23, Zelma, SK, Canada, BR, TR, 5'6", 130, OF)

	Hitting												Fielding					
YEAR/TEAM	G	BA	AB	H	2B	3B	HR	SB	BB	SO	R	RBI	G	PO	A	E	DP	FA
'46/FW, GR	38	.209	110	23	2	1	0	5	5	17	10	7	35	37	3	4	0	.909
'47/GR	81	.169	353	64	7	1	0	19	20	40	30	15	77	87	13	3	2	.971
Car	119	.181	353	64	7	1	0	19	20	40	30	15	112	124	16	7	2	.952
Play	7	.077	13	1	0	0	0	1	—	—	0	2	7	2	0	0	0	1.000

Wirth, Senaida "Shoo-Shoo" (Born: 10/4/26, Tampa, FL; Died: Date Unknown, BR, TR, 5', 114, SS, 2B)

	Hitting												Fielding					
YEAR/TEAM	G	BA	AB	H	2B	3B	HR	SB	BB	SO	R	RBI	G	PO	A	E	DP	FA
'46/SB	107	.245	372	91	4	1	0	89	61	22	65	27	107	160	379	42	14	.928
'47/SB	73	.227	229	52	0	1	0	32	42	20	35	5	74	122	198	22	11	.936
'48/SB	113	.241	399	96	6	4	0	36	42	37	60	26	113	224	352	23	21	.962
'49/SB	113	.229	389	89	1	0	1	66	55	38	62	40	113	231	359	36	33	.942
'50/SB	105	.268	384	103	9	2	1	67	49	20	61	49	105	204	320	20	22	.946
'51/SB	105	.274	347	95	6	4	0	69	64	23	77	54	105	186	290	33	23	.935
Car (6 yrs)	616	.248	2120	526	26	12	2	359	313	160	360	201	617	1127	1898	186	124	.942
Play (4 yrs)	21	.165	85	14	0	0	0	3	—	—	7	2	21	29	64	5	1	.949

Wisniewski, Connie "Iron Woman" "Polish Rifle" (Born: 2/18/22, Detroit, MI; Died: 5/4/95, BL, TR, 5'8", 147, OF, P)

see Pitchers

	Hitting												Fielding					
YEAR/TEAM	G	BA	AB	H	2B	3B	HR	SB	BB	SO	R	RBI	G	PO	A	E	DP	FA
'47/GR	62	.291	189	55	9	4	0	10	26	12	19	24	22	32	2	3	0	.919
'48/GR	124	.289	439	127	20	2	7	60	68	30	70	66	118	95	18	10	6	.919
'49/GR	112	.178	406	113	12	7	0	41	56	27	64	32	112	113	10	9	1	.932
'51/GR	105	.326	386	126	15	9	0	22	48	31	78	42	105	117	16	6	1	.957
'52/GR	105	.267	360	96	14	3	0	35	55	33	64	25	103	120	17	15	3	.901
Car (5 yrs)	508	.290	1780	517	70	25	7	168	253	133	295	189	460	477	63	43	11	.926
Play (5 yrs)	34	.254	134	34	3	4	0	8	—	—	10	12	34	18	11	1	1	.967

Wohlwender (Fricker), Marion "Wooly" (Born: 3/13/22, Cincinnati, OH, BR, TR, 5'4",
125, C)

	Hitting												Fielding					
YEAR/TEAM	G	BA	AB	H	2B	3B	HR	SB	BB	SO	R	RBI	G	PO	A	E	DP	FA
'43/Ken	No record																	

Wood, Mary (Hometown: Lakewood, OH, BR, TR, OF)

	Hitting												Fielding					
YEAR/TEAM	G	BA	AB	H	2B	3B	HR	SB	BB	SO	R	RBI	G	PO	A	E	DP	FA
'46/Peo	88	.193	269	52	5	3	0	33	36	36	23	13	83	160	13	15	2	.920
'47/Ken	70	.128	211	27	1	0	0	26	28	41	13	6	69	110	10	6	3	.952
Car (2 yrs)	158	.165	480	79	6	3	0	59	64	77	36	19	152	270	23	21	5	.983

Wuethrich, Lorraine (Hometown: Milwaukee, WI; Died: 4/27/92, U)

	Hitting												Fielding					
YEAR/TEAM	G	BA	AB	H	2B	3B	HR	SB	BB	SO	R	RBI	G	PO	A	E	DP	FA
'43/ Roc	No record — played in less than 10 games																	
'44/Roc	No record — played in less than 10 games																	

Yahr, Betty (Born: 4/22/23, Ann Arbor, MI, BL, TR, OF)

	Hitting												Fielding					
YEAR/TEAM	G	BA	AB	H	2B	3B	HR	SB	BB	SO	R	RBI	G	PO	A	E	DP	FA
'45/Roc	22	.171	76	13	1	1	0	2	12	12	11	8	23	31	1	4	0	.889

Youngberg, Renae "Ray" (Born: 4/3/33, Waukegan, IL, BR, TR, 5'6", 150, 3B, P)
see Pitchers

	Hitting												Fielding					
YEAR/TEAM	G	BA	AB	H	2B	3B	HR	SB	BB	SO	R	RBI	G	PO	A	E	DP	FA
'49/Spr	No record																	
'51/GR	98	.201	338	68	7	2	0	5	18	33	26	31	98	120	220	30	16	.919
'52/GR	86	.167	287	48	8	2	0	12	24	20	27	24	85	87	182	21	11	.928
'53/GR, SB,																		
Mus	72	.222	234	52	7	0	0	6	39	9	24	18	70	75	169	21	7	.921
'54/GR	85	.269	282	76	6	1	8	13	43	17	50	50	85	99	194	25	14	.921
Car (4 yrs)	341	.214	1141	244	28	5	8	36	124	79	127	123	338	381	765	97	49	.922
Play (4 yrs)	10	.278	36	10	1	0	1	1	—	—	3	4	10	11	23	3	0	.919

Youngen, Lois (Born: 10/23/33, Westfield Center, OH, BR, TR, 5'3", 115 C, OF)

	Hitting												Fielding					
YEAR/TEAM	G	BA	AB	H	2B	3B	HR	SB	BB	SO	R	RBI	G	PO	A	E	DP	FA
'51/Ken,																		
FW	No record — played less than 10 games																	
'52/FW	11	.313	16	5	0	0	0	0	0	1	2	0	No record					
'53/SB	40	.188	101	19	1	0	0	1	19	7	10	9	37	111	19	6	5	.956
'54/FW, SB	65	.284	208	59	7	0	1	2	27	14	27	35	67	143	18	3	4	.986
Car (4 yrs)	116	.255	325	83	8	0	1	3	46	22	39	44	104	254	37	9	9	.970
Play (1 yr)	3	.100	10	1	0	0	0	0	—	—	0	0	3	21	2	0	0	1.000

Ziegler, Marie "Little Zip" (Born: 7/3/37, Belding, MI, BR, TR, 5'10", 155, OF)

	Hitting												Fielding					
YEAR/TEAM	G	BA	AB	H	2B	3B	HR	SB	BB	SO	R	RBI	G	PO	A	E	DP	FA
'53/GR	No record																	

Ziegler, Alma "Gabby" "Ziggy" (Born: 1/9/21, Chicago, IL, BR, TR, 5'3", 125, 2B, SS, P)
see Pitchers

	Hitting												**Fielding**					
YEAR/TEAM	G	BA	AB	H	2B	3B	HR	SB	BB	SO	R	RBI	G	PO	A	E	DP	FA
'44/Mil	115	.191	324	62	2	1	0	77	72	29	51	25	115	361	212	27	27	.955
'45/GR	103	.140	365	51	3	0	0	48	46	26	35	15	103	254	213	26	24	.947
'46/GR	101	.151	344	52	7	0	0	55	65	26	60	27	101	267	196	25	38	.949
'47/GR	112	.183	388	71	4	0	0	67	62	36	36	8	112	284	241	15	33	.972
'48/GR	126	.170	454	77	8	0	1	38	61	44	61	33	114	287	240	34	46	.939
'49/GR	113	.181	370	67	0	2	0	34	87	12	58	18	111	278	218	17	33	.967
'50/GR	111	.174	322	56	4	0	0	19	70	19	37	23	87	216	176	25	25	.940
'51/GR	106	.171	340	58	10	4	0	20	52	16	35	35	84	206	163	21	25	.946
'52/GR	85	.197	249	49	2	1	0	16	33	9	20	16	78	192	196	35	30	.917
'53/GR	96	.168	250	42	4	0	0	17	55	23	37	18	80	183	173	20	20	.947
'54/GR	86	.200	215	43	3	0	2	5	38	9	33	21	72	169	162	26	29	.927
Car (11 yrs)	1154	.173	3621	628	47	8	3	365	610	226	482	240	954	2731	1977	245	306	.951
Play (11 yrs)	54	.147	191	28	1	0	0	1	—	—	15	8	54	106	101	11	9	.950

Zonia, Vialat (Hometown: Havana, Cuba, U)

	Hitting												**Fielding**					
YEAR/TEAM	G	BA	AB	H	2B	3B	HR	SB	BB	SO	R	RBI	G	PO	A	E	DP	FA
'48/Spr	1	.000	1	0	—	—	—	—	—	—	—	—	No record					

Other Players

The *AAGPBL* Players' Association also recognized players who had contracts with the league, but may not have played a game during their career. These players were included on the Official Players Roster printed in 1997 and submitted to the National Baseball Hall of Fame, but no statistics are available on them other than what is listed below. The list also includes some players who were uncovered through original research, but not included on the roster.

Beck, Lottie, Hometown: Jackson, MI, '46/FW
Bookout, Phyllis, Hometown: Fort Wayne, IN, '53
Bucior, Florence, Hometown: Jackson, MI, '46
Bunton, Lorraine, '51
Burton, Patty, '50
Buszka, Arlene, Hometown: Detroit, MI, '53
Campbell, Georgia, Hometown: Syracuse, NY, '47/FW
Campbell, Janet, '51
Campbell, Jean, Hometown: Syracuse, NY, '47/FW
Campbell, Ruth, Hometown: Spartanburg, SC, '49
Carlson, Phyllis, Hometown: Chicago, IL, '49/Mus
Chartier, Donna, Hometown: Traverse City, MI, '53
Childress, Thelma, Hometown: Richmond, VA, '46/GR
Cooper, Bonnie, Hometown: Tremont, IL, '52/BC
Cramer, Dorothy, '51
Davis, '49
Delaby, Irene, Hometown:Villa Park, IL, '49
De Marco, '54/Kal
Dougal, Hometown: Muskegon, MI, '53/Mus
Dustrade, Beverly, Hometown: Beloit, WI, '49
Edwards, Geraldine, Hometown: Cleveland, OH, '51
Ewald, Esther, Hometown: Niles, IL, '53
Fenton, Peggy, Born: 10/12/27 Forest Park, IL, BL, TL, 5'6", 128, '52/SB, Mus
Fitzgerald, Meryle, Hometown: Rapid City, SD, '46

Flaherty, Mary, Hometown: Ozone Park, NY, '48
Fountain, Betty , Hometown: Rome, GA, '49/Spr
Friend, Peggy, Hometown: Topeka, KS, '49
Gasby, '53/GR
Gernert, Betty, '51
Gregory, '46
Gruno, Betty, Hometown: Monroe, MI, '46
Hackbarth, Violet, Hometown:Watertown, WI, '46
Hammond, Marlene, Kalamazoo, MI, '54
Hardin, Julia, Mason, GA, '46
Harrington, Doris, '52
Hayslip, Martha, Hometown: Statesboro, GA, '45/SB
Hines, Barbara, '51
Hough, G., '51/Peo
Houston, Arlene, '47
Janowski, Alice, Sherbrooke, Canada, '51
Janowsky, Loretta, Griffith, IN, '51
Johnson, Esther, Hometown: Georgetown, SC, '46
Kleinhams, Shirley, Hometown: Sheboygan Falls, WI, '48
Ladd, Jean, '51/Ken
Lake, Joyce, '53/Mus
Lang, Marge, Hometown: Cincinnati, OH, '43
Leach, Beverly, '47
McCloskey, Gloria, Hometown: Edina, MO, '53
McCloskey, Helen, '44

Marsh, Doris, Hometown: Elkhart, IN, '45
Martin, Pauline, Hometown: Columbus, OH, '46
Mason, Pat , Hometown: Cedar Rapids, IA, '53/GR
Mason, Ruth, Hometown: Moose Jaw, SK, Canada, '53
Maxwell, Bernadine, Hometown: Topeka, KS, '48
Messenger, Joyce, Hometown: Lansing, MI, '53
Meyer, Alice, Hometown: Chicago, IL, '48
Moss, Glenora, '43/Rac
Mueller, Dolores, Hometown: Chicago, IL, '49
Murray, Margaret, Hometown: Joliet, IL, '48
Mystrysak, Vivian, Hometown: Pittsburgh, PA, '49
Nahtyk, Elizabeth, '47
Nobrain, Sally , '47/SB
Nogay, '51/Kal
Normine, Cynthia, Hometown: Everett, MA, '50/Roc
O'Connor, Pat , Hometown: Kenosha, WI, '46/Ken
Pechulis, Katherine, Hometown: Urbardge, WA, BR, TR, '45/GR
Perkins, Joy, '53/SB
Reid, Donna, '54/Roc
Richardson, Marie, Hometown: Rumford, ME, '53
Rinaldi, Rosaline, Hometown: Irvington, N.J., '50
Rios, Georgiana, Hometown: Havana, Cuba, '48
Roach, Marian, Hometown: Chicago, IL, '46
Rogato, Grace, Hometown: Lynn, MA, '51
Sachetti, Toni, '54/FW

Salisbury, Shirley, Hometown: South Bend, IN, '53/SB
Sarazen, Dorothy, '50
Shastal (Kustra), Mary , Hometown: Winnipeg, MN, Canada, '44/Mil
Sheehan, Mary, Hometown: Charlestown, MA, '52
Sheffield, Lois, Hometown: Wellington, OH, '52
Shuman, Amy, Hometown: Mohrsville, PA, '46
Sieg, Norma. '51
Simpson, Louise, Hometown: Charlotte, NC, '44
Stageman, Donna, Hometown: Billings, MT, '46
Steuert, Beverly, Hometown: Maywood, NJ, '52
Stoyovich, Ruby, Hometown: Negaunee, MI, '53
Taylor, Norma, Hometown: Huntington, IN, '50
Terry, Betty, Hometown: Long Beach, CA, '46
Thatcher, '51/BC
Thomas, Erla, '44
Towers, Ina Dell, Hometown: Belmont, MI, '53
Walter, Mary, Hometown: Gatonia, NC, '46
Williams, Wilma, Hometown: Thomasville, MO, '53
Winkler, Alma, Hometown: Whitaker, PA, '49
Winn, Laverne, '50
Winslow, '53/SB
Wood, Trois, Hometown: Lima, OH '50
Wright, Sadie, Hometown: Greensboro, NC, '51/BC
Zaph, Clara, Hometown: Cincinnati, OH, '43

Pitchers' Statistics

Acker, Fredda (Hometown: Anderson, SC, P)

Pitching											Hitting			Fielding			
YEAR/TEAM	*W–L*	*PCT.*	*ERA*	*G*	*IP*	*H*	*R*	*ER*	*BB*	*SO*	*AB*	*H*	*BA*	*PO*	*A*	*E*	*PA*
'47/SB	No record																

Albright, Eileen (Hometown: Wollaston, MA, P, 2B, 3B)
 see Players

Pitching											Hitting			Fielding			
YEAR/TEAM	*W–L*	*PCT.*	*ERA*	*G*	*IP*	*H*	*R*	*ER*	*BB*	*SO*	*AB*	*H*	*BA*	*PO*	*A*	*E*	*PA*
'48/Chic	0-4	.000	2.46	4	22	17	11	6	19	10	See Players			No record			

Allard, Beatrice "Bea" (Born: 7/10/30, Muskegon, MI, TR, BR, 5'4", 130, P)

Pitching											Hitting			Fielding			
YEAR/TEAM	*W–L*	*PCT.*	*ERA*	*G*	*IP*	*H*	*R*	*ER*	*BB*	*SO*	*AB*	*H*	*BA*	*PO*	*A*	*E*	*PA*
'49/Mus	2-2	.500	2.75	19	59	48	26	18	49	15	20	4	.200	4	14	2	.900

Allen, Agnes "Aggie" (Born: 9/21/30, Alvord, IA, TR, BR, 5'3", 120, P, OF)
 see Players

Pitching											Hitting			Fielding			
YEAR/TEAM	*W–L*	*PCT.*	*ERA*	*G*	*IP*	*H*	*R*	*ER*	*BB*	*SO*	*AB*	*H*	*BA*	*PO*	*A*	*E*	*PA*
'49/Chic/FW	No Record																
'50/Spr	9-5	.643	—	15	—	—	—	—	—	—	58	10	.172	—	—	—	—
'51/Kal, BC	3-10	.231	6.21	24	100	86	94	69	126	51	36	6	.167	7	41	9	.842
'52/Kal	1-7	.125	6.00	12	66	74	56	44	57	33	See Players			2	42	1	.978
'53/Kal	10-9	.526	3.70	24	258	130	85	65	113	50	70	13	.186	10	68	5	.940
Car (3 yrs)	14-26	.350	4.87	60	324	290	235	178	296	134	106	19	.179	19	141	15	.914

Alvarez, Isabel (Born: 10/31/33, Havana Cuba, TL, BL, 5'3", 140, P, OF)
 see Players

Pitching											Hitting			Fielding			
YEAR/TEAM	*W–L*	*PCT.*	*ERA*	*G*	*IP*	*H*	*R*	*ER*	*BB*	*SO*	*AB*	*H*	*BA*	*PO*	*A*	*E*	*PA*
'50/Chic	6-6	.500	—	13	—	—	—	—	—	—	39	10	.256	—	—	—	—
'51/FW, BC	2-0	1.000	3.71	13	34	41	29	14	26	7	21	2	.095	0	11	1	.917

Anderson, Janet (Perkin) (Hometown: Bethune, SK, Canada, P, OF)
see Players

											Hitting			Fielding			
YEAR/TEAM	W–L	PCT.	ERA	G	IP	H	R	ER	BB	SO	AB	H	BA	PO	A	E	PA
'46/Ken	0-6	.000	—	10	36	45	49	—	30	8	See Players			3	17	2	.909

Applegren, Amy Irene "Lefty" (Born: 11/16/26, Peoria, IL, TL, BL, 5'4", 125, P, 1B)
see Players

											Hitting			Fielding			
YEAR/TEAM	W–L	PCT.	ERA	G	IP	H	R	ER	BB	SO	AB	H	BA	PO	A	E	PA
'44/Roc	16-15	.516	2.77	36	250	168	123	77	128	56	99	25	.253	26	81	12	.914
'45/Roc	13-11	.542	2.44	29	214	132	81	58	130	27	73	15	.205	14	101	6	.941
'46/Mus	8-18	.308	2.79	28	197	134	90	61	126	62	66	17	.258	20	69	3	.967
'47/Mus	16-10	.615	1.06	27	220	113	41	26	81	62	75	18	.240	24	66	4	.957
'48/Mus	15-12	.556	1.76	29	210	110	64	41	117	129	See Players			No record			
'49/Mus, Roc	5-12	.294	3.09	20	131	78	54	45	124	64	69	13	.188	4	52	10	.848
'50/Roc	9-10	.474	3.75	21	132	104	76	55	83	68	See Players			7	39	9	.836
'51/Roc	4-10	.286	4.21	15	94	66	57	44	91	33	73	15	12.05	12	41	2	.964
'52/Roc	—	—	—	1	3	—	—	—	—	—	See Players						
Car (9 yrs)	86-98	467	2.52	206	1451	905	586	407	880	501	455	103	.226	107	449	46	.971
Play (4 yrs)	1-3	.250	1.60	7	45	24	12	8	22	14	14	3	.214	0	5	0	1.000

Armstrong, Charlotte "Skipper" (Born: 6/17/24, Dallas, TX, TR, BR, 5'7", 145, P)

											Hitting			Fielding			
YEAR/TEAM	W–L	PCT.	ERA	G	IP	H	R	ER	BB	SO	AB	H	BA	PO	A	E	PA
'44/SB	21-15	.583	1.51	39	321	231	99	54	71	68	120	16	.133	17	132	6	.954
'45/SB	18-22	.450	1.98	46	355	280	137	78	83	91	129	21	.163	10	107	9	.940
Career	39-37	.513	1.76	85	676	511	236	132	154	159	249	37	.149	27	239	15	.947

Arnold, Lenna "Sis" (Born: 10/29/20, Fort Wayne, IN, TR, BR, 5'7", 135, P)

											Hitting			Fielding			
YEAR/TEAM	W–L	PCT.	ERA	G	IP	H	R	ER	BB	SO	AB	H	BA	PO	A	E	PA
'46/FW	2-4	.333	—	6	40	37	32	—	23	1	14	3	.214	—	—	—	—

Arnold, Louise "Lou" (Born: 5/11/23, Pawtucket, RI, TR, BR, 5'3", 125, P)

											Hitting			Fielding			
YEAR/TEAM	W–L	PCT.	ERA	G	IP	H	R	ER	BB	SO	AB	H	BA	PO	A	E	PA
'48/SB	4-4	.500	4.06	20	82	64	48	37	32	17	21	3	.143	No record			
'49/SB	3-2	.714	2.27	16	91	72	32	23	32	17	29	3	.103	6	36	2	.955
'51/SB	10-2	.833	2.62	20	117	106	54	34	35	28	35	5	.153	7	45	8	.867
'50/SB	No record																
'52/SB	4-8	.333	3.43	16	76	83	49	29	18	13	20	2	.100	4	29	4	.892
Car (5 yrs)	23-16	.590	3.02	72	366	325	183	123	117	75	1051_3		.124	17	110	14	.890
Play (3 yrs)	0-0	.000	0.00	4	11	2	0	0	2	3	4	0	.000	3	9	0	1.000

Arnold (Witzel), Norene "Blonde" (Born: 11/21/27, Oregon, IL; Died: 1/27/87, TR, BR, P)

											Hitting			Fielding			
YEAR/TEAM	W–L	PCT.	ERA	G	IP	H	R	ER	BB	SO	AB	H	BA	PO	A	E	PA
'49/Spr	No record																
'49/Mus	No record																

Baker (Wise), Phyllis (Born: 6/3/37, Marshall, MI TR, BR, 5'8", 155, P)

											Hitting			Fielding			
YEAR/TEAM	W–L	PCT.	ERA	G	IP	H	R	ER	BB	SO	AB	H	BA	PO	A	E	PA
'53/Mus	7-12	.368	3.21	28	188	161	84	67	88	36	79	14	.177	9	74	2	.976

Pitching										**Hitting**			**Fielding**				
YEAR/TEAM	W-L	PCT.	ERA	G	IP	H	R	ER	BB	SO	AB	H	BA	PO	A	E	PA
'54/SB, FW	5-11	.313	4.81	22	129	145	89	69	78	30	48	5	.104	11	47	6	.906
Car (2 yrs)	12-23	.342	3.86	50	317	306	173	136	166	66	127	19	.150	20	111	8	.946
Play (1 yr)	1-0	1.000	0.82	3	11	3	5	1	3	2	4	0	.000	0	1	0	1.000

Barnes (McCoy), Joyce (Born: 10/18/25, Hutchinson, KS, TR, BR, 5'8", 125, P)

Pitching										**Hitting**			**Fielding**				
YEAR/TEAM	W-L	PCT.	ERA	G	IP	H	R	ER	BB	SO	AB	H	BA	PO	A	E	PA
'43/Ken	No record																

Barr, Doris "Dodie" (Born: 8/26/21, Starbuck, MN, Canada, TL, BL, 5'6", 145, P, OF)
see Players

Pitching										**Hitting**			**Fielding**				
YEAR/TEAM	W-L	PCT.	ERA	G	IP	H	R	ER	BB	SO	AB	H	BA	PO	A	E	PA
'43/SB	15-13	.536	2.90	32	254	199	123	82	151	63	134	36	.269	27	74	5	.953
'44/SB	8-11	.421	2.98	29	148	72	61	49	141	62	55	7	.127	20	34	3	.947
'45/SB, Rac	20-8	.714	1.71	31	252	144	66	48	168	104	104	23	.221	44	46	5	.947
'46/Rac	6-9	.400	3.83	21	119	77	73	51	109	53	39	5	.128	17	33	5	.909
'47Rac	14-12	.538	2.26	30	219	144	78	55	91	96	60	10	.167	25	47	5	.935
'48/Spr	7-19	.269	2.68	30	208	150	104	62	113	116	174	40	.230	16	2	4	.818
'49/Mus	8-13	.381	2.40	27	191	141	82	51	108	53	70	5	.071	15	78	4	.959
'50/Peo, Kal	1-11	.083	6.51	18	83	94	73	60	78	25	41	10	.244	7	34	7	.854
Car (8 yrs)	79-96	.451	2.80	218	1474	1021	660	458	959	572	677	136	.275	155	346	34	.937
Play (4 yrs)	1-4	.200	3.26	8	47	31	27	17	2	15	13	0	.000	5	1	1	.857

Becker, Donna (Born: 8/6/32, Kenosha, WI, TR, BR, 5'7", 145, P)

Pitching										**Hitting**			**Fielding**				
YEAR/TEAM	W-L	PCT.	ERA	G	IP	H	R	ER	BB	SO	AB	H	BA	PO	A	E	PA
'51/Kal	—	—	—	3	3	—	—	—	—	—	No record			No record			

Bell, Virginia "Ginger" (Born: 7/30/27, Muskegon, MI; Died: 4/19/94, TR, BR, 5'3", 128, P)

Pitching										**Hitting**			**Fielding**				
YEAR/TEAM	W-L	PCT.	ERA	G	IP	H	R	ER	BB	SO	AB	H	BA	PO	A	E	PA
'48/Spr	0-0	.000	7.88	1	8	6	10	7	8	4	4	2	.500	No record			

Bennett, Catherine (Born: 9/4/20, Craven, SK, Canada, TR, BR, 5'5", 120, P)

Pitching										**Hitting**			**Fielding**				
YEAR/TEAM	W-L	PCT.	ERA	G	IP	H	R	ER	BB	SO	AB	H	BA	PO	A	E	PA
'43/Ken, SB	8-13	.381	3.81	31	189	179	140	80	69	53	77	16	.208	11	30	19	.683
'44/SB	14-9	.609	2.04	34	229	185	81	52	44	69	78	5	.051	11	42	11	.828
Car (2 yrs)	22-22	.500	2.84	65	418	364	221	132	113	122	155	21	.135	22	72	30	.758

Berger (Knebl), Joan "Bergie" (Born: 10/9/33, Passaic, NJ, TR, BR, 5'4", 132, P, 3B, 2B, SS, OF)
see Players

Pitching										**Hitting**			**Fielding**				
YEAR/TEAM	W-L	PCT.	ERA	G	IP	H	R	ER	BB	SO	AB	H	BA	PO	A	E	PA
'52/Roc	—	—	—	1	1	—	—	—	—	—	See Players			No record			

Berger, Margaret (Born: 12/24/21, Homestead, FL, TR, BR, 5'3", 129, P)

Pitching										**Hitting**			**Fielding**				
YEAR/TEAM	W-L	PCT.	ERA	G	IP	H	R	ER	BB	SO	AB	H	BA	PO	A	E	PA
'43/SB	25-13	.658	1.91	47	306	207	103	65	70	112	113	22	.195	21	116	10	.932

Pitching											Hitting			Fielding			
YEAR/TEAM	W-L	PCT.	ERA	G	IP	H	R	ER	BB	SO	AB	H	BA	PO	A	E	PA
'44/SB	21-17	.553	1.57	41	315	188	84	55	64	92	109	12	.110	23	42	15	.813
Car (2 yrs)	46-30	.605	1.74	88	621	395	187	120	134	203	222	34	.153	44	158	25	.890

Berger (Taylor), Norma "Bergie" (Born: 12/22/32, Maywood, IL, TR, BR, 5'3", 140, P)

Pitching											Hitting			Fielding			
YEAR/TEAM	W-L	PCT.	ERA	G	IP	H	R	ER	BB	SO	AB	H	BA	PO	A	E	PA
'50/Spr	8-8	.500	—	18	—	—	—	—	—	—	51	6	.118	No record			

Bergmann, Erma "Bergie" (Born: 6/18/24, St. Louis, MO, TR, BR, 5'7", 155, P, OF)

Pitching											Hitting			Fielding			
YEAR/TEAM	W-L	PCT.	ERA	G	IP	H	R	ER	BB	SO	AB	H	BA	PO	A	E	PA
'46/Mus	15-16	.484	2.05	35	263	195	119	ˉ60	94	62	141	35	.255	12	126	17	.902
'47/Mus	11-10	.524	1.74	27	207	137	74	40	71	47	76	14	.184	12	95	11	.907
'48/Spr	9-19	.321	3.05	32	236	190	127	80	85	77	87	11	.126	No record			
'49/Rac	11-14	.440	2.08	32	225	156	80	52	71	42	80	17	.213	13	67	12	.870
'50/Rac	11-14	.440	2.68	29	208	173	108	62	68	51	81	15	.185	9	46	6	.902
'51/BC	7-18	.180	3.92	27	200	195	119	87	73	59	87	18	.207	11	53	6	.914
Car (6 yrs)	64-91	.413	3.28	182	1046	1046	627	381	462	338	552	111	.201	57	387	53	.899

Bevis, Muriel (Born: 10/7/28, Corona, NY, TL, BL, P, OF)
see Players

Pitching											Hitting			Fielding			
YEAR/TEAM	W-L	PCT.	ERA	G	IP	H	R	ER	BB	SO	AB	H	BA	PO	A	E	PA
'50/Ken	1-2	.333	6.83	7	29	30	27	22	25	5	See Players			No record			

Bird (Phillips), Nelda "Birdie" (Born: 2/11/27, Hawthorne, CA, TL, BR, 5'1", 114, P, OF)

Pitching											Hitting			Fielding			
YEAR/TEAM	W-L	PCT.	ERA	G	IP	H	R	ER	BB	SO	AB	H	BA	PO	A	E	PA
'45/SB	13-17	.433	2.70	31	223	135	117	67	160	128	117	19	.162	13	55	13	.850

Bittner, Jaynne B. (Born: 3/17/26, Lebanon, PA, TL, BL, 5'9", 140, P)

Pitching											Hitting			Fielding			
YEAR/TEAM	W-L	PCT.	ERA	G	IP	H	R	ER	BB	SO	AB	H	BA	PO	A	E	PA
'47/SB	1-2	.333	1.54	8	35	35	15	6	8	8	16	3	.188	No record			
'48/Mus	9-9	.500	2.55	21	152	148	69	43	81	29	58	4	.069	No record			
'49/GR	4-10	.286	3.44	26	131	94	70	50	72	31	41	3	.073	13	39	3	.945
'50/GR	5-10	.333	5.60	20	119	136	96	74	77	55	40	5	.125	11	36	3	.940
'51/GR	15-8	.652	2.95	23	183	128	76	60	78	57	70	13	.186	7	72	5	.940
'52/GR, FW	11-12	.478	3.34	25	178	163	92	66	111	59	71	9	.127	9	67	4	.955
'53/FW	16-7	.696	2.45	30	209	149	89	57	128	75	74	12	.162	15	65	5	.941
'54/GR	5-11	.313	5.07	24	119	120	92	67	92	45	38	6	.158	7	36	2	.958
Car (8 yrs)	66-69	.489	3.38	177	1126	973	599	423	647	359	392	52	.132	62	315	22	.945
Play (2 yrs)	0-1	.000	9.00	2	3	2	3	3	3	0	1	0	.000	0	1	0	1.000

Blair, Maybelle (Born: 1/16/27, Inglewood, CA, TR, BR, 5'6", 150, P)

Pitching											Hitting			Fielding			
YEAR/TEAM	W-L	PCT.	ERA	G	IP	H	R	ER	BB	SO	AB	H	BA	PO	A	E	PA
'48/Peo	No record										1	0	.000	No record			

Blumetta, Catherine "Kay" "Swish" (Born: 5/1/23, North Plainfield, NJ, TR, BR, 5'8", 150 P, OF, 1B)
 see Players

YEAR/TEAM	W-L	PCT.	ERA	G	IP	H	R	ER	BB	SO	AB	H	BA	PO	A	E	PA
												Hitting		*Fielding*			
'45/GR	1-2	.333	6.00	4	18	15	21	12	25	2	67	7	.104	No record			
'46/Peo	11-12	.478	1.71	26	209	117	65	40	74	137	113	13	.115	15	56	13	.845
'47/Peo, FW	9-14	.375	2.80	27	193	706	79	60	69	105	62	10	.161	16	43	3	.952
'48/FW	14-13	.519	2.16	30	238	157	81	57	117	100	80	9	.113	No record			
'49/FW	9-16	.360	1.99	27	217	145	72	48	71	102	70	10	.143	16	85	9	.918
'50/FW	9-12	.429	2.33	23	170	135	76	44	103	63	55	5	.091	7	36	5	.918
'51/Kal	8-11	.421	2.74	24	151	114	59	46	62	65	61	9	.148	11	52	1	.984
'52/Kal	8-11	.421	2.54	21	170	138	71	48	55	54	55	11	.200	8	63	1	.986
'53/Kal	10-9	.526	1.98	23	164	149	58	36	52	29	59	8	.136	7	58	4	.942
'54/Kal	5-5	.500	5.86	19	83	107	77	54	51	16	36	11	.306	5	19	2	.923
Car (10 yrs)	84-105	.444	2.51	224	1613	1183	659	445	679	673	658	93	.141	85	412	38	.929
Play (2 yrs)	3-2	.600	0.63	5	43	24	6	3	16	13	12	2	.166	5	17	0	1.000

Born, Ruth (Born: 8/8/25, Bay City, MI, TR, BR, 5'3", 125, P)

YEAR/TEAM	W-L	PCT.	ERA	G	IP	H	R	ER	BB	SO	AB	H	BA	PO	A	E	PA
												Hitting		*Fielding*			
'43/SB	4-5	.444	3.59	11	67	61	47	27	47	6	18	2	.111	5	15	2	.909

Brown, Patricia "Pat" (Born: 4/23/31, Boston, MA, TR, BR, 5'5", 135, P)

YEAR/TEAM	W-L	PCT.	ERA	G	IP	H	R	ER	BB	SO	AB	H	BA	PO	A	E	PA
												Hitting		*Fielding*			
'50/Chic	9-9	.500	—	22	—	—	—	—	—	—	57	17	.298	No record			
'51/BC	—	—	—	1	2	—	—	—	—	—	No record			No record			

Bryson, Marion (Los Angeles, CA, P)

YEAR/TEAM	W-L	PCT.	ERA	G	IP	H	R	ER	BB	SO	AB	H	BA	PO	A	E	PA
												Hitting		*Fielding*			
'46/Peo	0-8	.000	5.32	14	71	74	60	42	36	11	18	2	.111	3	38	7	.854

Burkovich, Shirley "Hustle" (Born: 2/4/33, Swissvale, PA, TR, BR, 5'8", 150, P, U)
 see Players

YEAR/TEAM	W-L	PCT.	ERA	G	IP	H	R	ER	BB	SO	AB	H	BA	PO	A	E	PA
												Hitting		*Fielding*			
'51/Roc	—	—	—	3	2	—	—	—	—	—	See Players			No record			

Butcher (Marsh), Mary "Butch" (Born: 10/12/27, Berne, IN, TR, BR, 5'7", 170, P)

YEAR/TEAM	W-L	PCT.	ERA	G	IP	H	R	ER	BB	SO	AB	H	BA	PO	A	E	PA
												Hitting		*Fielding*			
'45/FW	0-2	.000	3.19	3	17	18	10	6	8	2	No record			No record			
'46/GR	—	—	—	1	—	—	—	—	—	—	No record			No record			
Car (2 yrs)	0-2	.000	3.19	4	17	18	10	6	8	2	No record			No record			

Callow, Eleanor "Squirt" (Hometown: Winnipeg, MN, Canada, Died: Date Unknown, TR, BB, P, OF)
 see Players

YEAR/TEAM	W-L	PCT.	ERA	G	IP	H	R	ER	BB	SO	AB	H	BA	PO	A	E	PA
												Hitting		*Fielding*			
'52/Roc	0-1	.000	5.74	3	11	11	8	7	15	3	See Players			No record			

Pitching **Hitting** **Fielding**

YEAR/TEAM	W-L	PCT.	ERA	G	IP	H	R	ER	BB	SO	AB	H	BA	PO	A	E	PA
'53/Roc	0-1	.000	4.55	1	4	5	4	2	3	0	See Players			No record			
Car (2 yrs)	0-2	.000	5.42	4	15	16	12	9	18	3	See Players			No record			

Carver, Virgina (Born: 1933, New Brighton, PA, P, OF)

Pitching **Hitting** **Fielding**

YEAR/TEAM	W-L	PCT.	ERA	G	IP	H	R	ER	BB	SO	AB	H	BA	PO	A	E	PA
'53/SB	No record																
'54/FW	5-7	.417	8.78	17	80	102	91	78	70	12	75	13	.173	2	14	2	.875
Play (1 yr)	0-0	.000	13.51	1	2	4	6	3	3	2	1	0	.000	0	2	0	1.000

Carveth, Betty (Hometown: Edmonton, AB, Canada, P)

Pitching **Hitting** **Fielding**

YEAR/TEAM	W-L	PCT.	ERA	G	IP	H	R	ER	BB	SO	AB	H	BA	PO	A	E	PA
'45/Roc, FW	4-11	.267	2.28	21	138	116	57	35	47	24	47	7	.149	6	63	9	.885
Play (1 yr)	0-1	.000	3.27	1	11	7	5	4	3	2	3	0	.000	3	0	0	1.000

Cindric, Ann "Cindy" (Born: 9/5/22, Muse, PA, 5'6", 135, P)

Pitching **Hitting** **Fielding**

YEAR/TEAM	W-L	PCT.	ERA	G	IP	H	R	ER	BB	SO	AB	H	BA	PO	A	E	PA
'48/Mus	No record									25	1	.040	No record				
'49/Spr	No record																
'50/Chic-Spr	3-2	.600	—	5	—	—	—	—	—	—	13	3	.231	No record			

Cione, Jean "Cy" (Born: 6/23/28, Rockford, IL, TL, BL, 5'8", 143, P, OF, 1B)
see Players

Pitching **Hitting** **Fielding**

YEAR/TEAM	W-L	PCT.	ERA	G	IP	H	R	ER	BB	SO	AB	H	BA	PO	A	E	PA
'47/Roc, Ken	19-14	.576	1.30	37	271	146	80	39	73	98	See Players			21	144	18	.902
'48/Ken	12-13	.480	1.85	31	229	142	83	47	80	75	See Players			No record			
'49/Ken	15-10	.600	1.57	32	223	151	58	39	87	80	See Players			19	112	12	.916
'50/Ken	18-10	.643	2.96	32	243	204	108	80	114	72	See Players			8	117	9	.933
'51/Ken	5-9	.357	3.90	18	127	109	64	55	52	41	See Players			15	57	2	.973
'52/BC	2-5	.286	3.24	9	50	49	27	18	16	21	See Players			No record			
'53/Mus	1-0	1.000	5.40	1	5	7	4	3	2	1	See Players			No record			
'54/Roc	4-4	.500	5.02	10	52	51	41	29	38	24	See Players			8	19	3	.900
Car (8 yrs)	76-65	.539	2.32	170	1200	859	465	310	462	412	See Players			71	449	44	.922
Play (3 yrs)	1-2	.333	3.01	3	24	16	12	8	16	8	3	0	.000	0	0	0	1.000

Clapp, Louise (Hometown: Harrod, OH, P)

Pitching **Hitting** **Fielding**

YEAR/TEAM	W-L	PCT.	ERA	G	IP	H	R	ER	BB	SO	AB	H	BA	PO	A	E	PA
'54/GR, SB	—	—	—	3	5	—	—	—	—	—	No record			No record			

Coben, Muriel (Hometown: Saskatoon, SK, Canada; Died: Date Unknown, TR, BR, P)

Pitching **Hitting** **Fielding**

YEAR/TEAM	W-L	PCT.	ERA	G	IP	H	R	ER	BB	SO	AB	H	BA	PO	A	E	PA
'43/SB, Roc	4-16	.200	4.71	37	193	218	150	102	55	43	70	10	.143	21	46	10	.932

Cook, Clara "Babe" (Born: 6/19/21, Pine City, NY., Died 7/23/96, TL, BL, 5'2", 130, P)

Pitching **Hitting** **Fielding**

YEAR/TEAM	W-L	PCT.	ERA	G	IP	H	R	ER	BB	SO	AB	H	BA	PO	A	E	PA
'43/Roc, Ken	6-17	.261	4.42	30	203	213	177	100	52	26	80	14	.175	15	45	5	.923

Pitching											Hitting			Fielding			
YEAR/TEAM	W-L	PCT.	ERA	G	IP	H	R	ER	BB	SO	AB	H	BA	PO	A	E	PA
'44/Ken, Mil	2-2	.500	3.40	9	45	42	24	17	16	7	22	2	.091	No record			
Car (2 yrs)	8-19	.296	4.25	39	248	255	201	117	68	33	102	16	.157	15	45	5	.923
Play (1 yr)	0-0	.000	0.00	1	1	1	1	0	0	0	0	0	.000	0	1	0	1.000

Cook, Donna "Cookie" (Born: 5/24/28, Muskegon, MI, TL, BR, 5'2", 121, P, OF)

see Players

Pitching											Hitting			Fielding			
YEAR/TEAM	W-L	PCT.	ERA	G	IP	H	R	ER	BB	SO	AB	H	BA	PO	A	E	PA
'47/Mus	14-8	.636	1.42	25	178	101	49	28	58	54	See Players			17	50	8	.893
'48/Chic, Mus, FW	4-9	.308	4.03	20	116	84	64	54	107	67	See Players			No record			
'49/FW	9-9	.500	1.94	22	153	111	55	33	99	75	67	13	.194	14	47	8	.884
'50/GR	0-2	.000	10.00	4	18	24	25	20	20	9	19	4	.211	No record			
'51/BC	1-7	.125	4.38	17	78	71	53	38	66	33	See Players			No record			
'53/SB	0-2	.000	12.99	7	16	24	35	23	33	5	See Players			No record			
'54/Roc	—	—	—	4	7	—	—	—	—	—	See Players			No record			
Car (7 yrs)	28-37	.431	3.17	99	556	415	317	196	383	243	86	17	.198	31	97	16	.890
Play (3 yrs)	1-1	.666	2.53	4	25	11	8	7	31	13	8	1	0	1	4	1	.800

Cook, Doris "Little Cookie" (Born: 6/23/31, Muskegon, MI, TR, BR, 5'1", 130, P, OF)

see Players

Pitching											Hitting			Fielding			
YEAR/TEAM	W-L	PCT.	ERA	G	IP	H	R	ER	BB	SO	AB	H	BA	PO	A	E	PA
'50/Spr	6-11	.353	—	18	—	—	—	—	—	—	73	10	.137	No record			
'51/Kal	0-1	.000	5.74	8	22	19	16	14	19	5	See Players			No record			
'52/Kal, SB	0-2	.000	8.41	9	30	36	34	28	36	3	See Players			No record			
Career—3 yrs)	6-14	.300	7.27	35	52	55	50	42	55	13	See Players			No record			

Cordes (Elliott), Gloria "Cordie" (Born: 9/21/31, Staten Island, NY, TR, BR, 5'8", 138, P, 1B)

Pitching											Hitting			Fielding			
YEAR/TEAM	W-L	PCT.	ERA	G	IP	H	R	ER	BB	SO	AB	H	BA	PO	A	E	PA
'50/Rac, Kal	5-10	.333	3.63	25	119	122	77	48	76	23	45	1	.022	4	20	6	.800
'51/Kal, BC	3-15	.167	3.52	26	179	168	110	70	96	70	61	8	.131	14	66	8	.909
'52/Kal	16-8	.667	1.44	24	213	156	68	34	52	84	79	16	.203	12	72	3	.966
'53/Kal	13-11	.542	1.98	29	218	165	78	48	74	106	76	9	.118	9	84	3	.969
'54/Kal	12-7	.632	4.59	24	145	139	89	74	63	86	62	8	.129	8	47	2	.965
Car (5 yrs)	49-51	.490	2.82	128	874	750	422	274	361	369	323	42	.130	47	289	22	.939
Play (2 yrs)	1-4	.200	4.15	7	39	37	24	18	10	7	6	0	.000	1	4	0	1.000

Cornett, Betty Jane "Curly" (Born: 11/24/32, Pittsburgh, PA, TR, BR, 5'5", 125, P, 3B)

see Players

Pitching											Hitting			Fielding			
YEAR/TEAM	W-L	PCT.	ERA	G	IP	H	R	ER	BB	SO	AB	H	BA	PO	A	E	PA
'51/BC	0-1	.000	11.26	2	8	12	15	10	12	4	See Players			No record			

Corrigan, Rita (P)

Pitching											Hitting			Fielding			
YEAR/TEAM	W-L	PCT.	ERA	G	IP	H	R	ER	BB	SO	AB	H	BA	PO	A	E	PA
'43/Rac	Pitched in less than 10 games																

Dailey, Mary (Hometown: Lexington, MA; Died: Date Unknown, P)

see Players

Pitching											Hitting			Fielding			
YEAR/TEAM	W-L	PCT.	ERA	G	IP	H	R	ER	BB	SO	AB	H	BA	PO	A	E	PA
'51/Peo	1-0	1.000	6.02	3	15	18	12	10	10	5	See Players			No record			

Dancer, Faye "Fanny" (Born: 4/24/25, Santa Monica, CA, TR, BR, 5'6", 145, P, OF, 1B)
see Players

YEAR/TEAM	W–L	PCT.	ERA	G	IP	H	R	ER	BB	SO	AB	H	BA	PO	A	E	PA
											Hitting			Fielding			
'46/FW	10-9	.526	1.93	21	148	111	67	32	59	38	See Players			19	69	12	.880
'47/Peo	1-2	.333	4.17	4	26	22	15	12	11	5	See Players			No record			
Car (2 yrs)	11-11	.500	2.28	25	174	133	82	44	70	43	See Players			19	69	12	.880

Dapkus (Wolf), Eleanor "Slugger" (Born: 12/5/23, Chicago, IL, TR, BR, 5'6" 160, P, OF)
see Players

YEAR/TEAM	W–L	PCT.	ERA	G	IP	H	R	ER	BB	SO	AB	H	BA	PO	A	E	PA
											Hitting			Fielding			
'47/Rac	0-3	.000	2.45	5	55	32	17	15	27	23	See Players			No record			
'48/Rac	24-9	.727	1.55	39	172	75	51	32	104	191	See Players			No record			
'49/Rac	12-11	.522	2.25	27	208	162	75	52	74	71	See Players			9	57	2	.971
'50/Rac	17-11	.607	1.81	31	229	162	65	46	63	112	See Players			23	67	4	.957
Car (4 yrs)	53-34	.609	1.97	102	664	431	208	145	268	397	See Players			32	124	6	.963
Play (2 yrs)	1-1	.500	2.15	3	21	15	6	5	5	13	See Players			0	6	1	.857

DeCambra, Alice "Moose" (Born: 8/18/21, Somerset, MA; Died: 6/19/88, TR, BR, 5'3", 126, P, SS, 2B)
see Players

YEAR/TEAM	W–L	PCT.	ERA	G	IP	H	R	ER	BB	SO	AB	H	BA	PO	A	E	PA
											Hitting			Fielding			
'46/FW	7-5	.583	2.81	16	93	87	40	29	17	9	See Players			7	29	0	1.000
'47/FW, Peo	4-3	.571	4.24	14	70	67	41	33	19	17	See Players			7	32	1	.975
'50/Peo	—	—	—	1	2	—	—	—	—	—	See Players			No record			
Car (3 yrs)	11-8	.579	3.38	31	165	154	81	62	36	26	See Players			14	61	1	.987

Deegan, Mildred "Millie" (Born: 12/11/19, Brooklyn, NY, TR, BR, 5'7", 155, P, OF, 2B)
see Players

YEAR/TEAM	W–L	PCT.	ERA	G	IP	H	R	ER	BB	SO	AB	H	BA	PO	A	E	PA
											Hitting			Fielding			
'46/Roc	10-5	.667	2.46	21	139	78	67	38	55	47	See Players			6	76	10	.891
'47/Roc, Ken	8-9	.471	2.30	21	133	103	61	34	63	61	See Players			10	47	6	.905
'48/Ken, Spr	12-15	.444	2.13	29	237	152	91	56	89	115	See Players			No record			
'49/FW	16-11	.593	1.77	28	234	153	73	46	87	82	90	15	.167	25	82	3	.973
'50/FW	16-9	.640	2.17	29	220	161	80	53	134	75	94	29	.309	16	61	6	.928
'51/FW, Peo	4-9	.308	3.44	17	110	102	69	42	81	29	53	9	.170	5	39	7	.863
'52/Roc	0-1	.000	3.38	1	8	6	3	2	5	3	No record			No record			
Car (7 yrs)	66-59	.528	2.26	146	1081	755	444	271	514	412	237	53	.224	62	305	32	.920
Play (3 yrs)	6-4	.600	2.88	12	75	38	26	24	27	17	30	6	.200	10	23	1	.971

Degner, Betty (Hometown: Amboy, IL, TR, BR, P)

YEAR/TEAM	W–L	PCT.	ERA	G	IP	H	R	ER	BB	SO	AB	H	BA	PO	A	E	PA
											Hitting			Fielding			
'49/Mus	No record										5	1	.200	No record			
'49/Chic/Spr	No record																

Denton, Mona (Hometown: Denver, CO, TR, BR, P)

YEAR/TEAM	W–L	PCT.	ERA	G	IP	H	R	ER	BB	SO	AB	H	BA	PO	A	E	PA
											Hitting			Fielding			
'46/SB	0-1	.000	—	3	13	15	15	—	4	2	5	11	.200	No record			
'47/Ken	1-10	.091	3.54	23	112	108	75	44	35	20	51	10	.196	10	46	5	.918
Car (2 yrs)	1-11	.083	3.54	26	125	123	90	44	39	22	56	11	.196	10	46	5	.918

Descombes (Lesko), Jeanie "Lefty" (Born: 3/28/35, Lakeview, OH, TL, BL, 5'5", 135, P)

YEAR/TEAM	W-L	PCT.	ERA	G	IP	H	R	ER	BB	SO	AB	H	BA	PO	A	E	PA
Pitching											Hitting			Fielding			
'53/GR	0-1	.000	7.45	7	17	21	22	14	24	5	No record			No record			
'54/GR	10-8	.556	5.00	22	117	119	72	65	70	63	39	7	.179	8	32	8	.884
Car (2 yrs)	10-9	.526	5.31	29	134	140	94	79	94	68	39	7	.179	8	32	8	.884

Earp, Mildred (Born: 10/7/25, West Fork, AR, TR, BR, 5'6", 135, P)

YEAR/TEAM	W-L	PCT.	ERA	G	IP	H	R	ER	BB	SO	AB	H	BA	PO	A	E	PA
Pitching											Hitting			Fielding			
'47/GR	20-8	.714	.068	35	280	172	30	21	32	192	89	13	.146	24	76	6	.943
'48/GR	15-14	.517	1.31	34	282	180	70	41	60	166	94	11	.117	No record			
'49/GR	14-10	.583	1.83	27	216	162	61	44	48	143	74	13	.176	12	80	2	.979
'50/GR	5-6	.455	2.52	12	82	62	34	23	25	33	21	1	.048	5	31	1	.973
Car (4 yrs)	54-38	.587	1.35	108	860	576	195	129	175	534	278	38	.137	41	187	9	.962
Play (4 yrs)	7-5	.500	1.95	13	111	74	34	24	26	57	38	5	.132	7	30	2	.949

Eisen, Thelma "Tiby" (Born: 5/11/22, Los Angeles, CA, TR, BR, 5'4", 130, P, OF)
see Players

YEAR/TEAM	W-L	PCT.	ERA	G	IP	H	R	ER	BB	SO	AB	H	BA	PO	A	E	PA
Pitching											Hitting			Fielding			
'48/FW	0-0	.000	5.15	1	7	5	4	4	6	1	See Players			No record			

Emry, Betty (Born: 1/20/23; Died: 4/18/95, Manistique, MI, TR, BR, 5'4", 130, P, SS)
see Players

YEAR/TEAM	W-L	PCT.	ERA	G	IP	H	R	ER	BB	SO	AB	H	BA	PO	A	E	PA
Pitching											Hitting			Fielding			
'46/Rac	7-4	.636	2.15	15	91	65	39	22	24	16	See Players			2	18	7	.682
Play (1 yr)	0-0	.000	0.00	1	4	3	3	0	2	0	6	0	.000	0	0	0	1.000

Erickson, Louise "Lou" (Sauer) (Born: 6/2/29, Arcadia, WI, TR, BR, 5'9", 162, P)

YEAR/TEAM	W-L	PCT.	ERA	G	IP	H	R	ER	BB	SO	AB	H	BA	PO	A	E	PA
Pitching											Hitting			Fielding			
'48/Rac	1-0	1.000	5.74	3	11	11	7	7	4	3	3	1	.333	No record			
'49/Roc	17-6	.739	1.54	25	216	145	44	37	61	39	76	13	.171	6	54	3	.952
'50/Roc	16-10	.615	2.52	27	221	187	82	62	57	88	88	21	.239	21	75	6	.941
Car (3 yrs)	34-16	.680	2.13	55	448	343	133	106	122	130	167	35	.210	27	129	9	.946
Play (2 yr)	4-1	.800	2.60	5	45	26	14	13	14	7	17	2	.118	7	8	0	1.000

Faralla, Lillian "Lil" (Born: 6/29/24, Brooklyn, NY, TR, BR, 5'6", 160, P, 2B, OF)
see Players

YEAR/TEAM	W-L	PCT.	ERA	G	IP	H	R	ER	BB	SO	AB	H	BA	PO	A	E	PA
Pitching											Hitting			Fielding			
'46/Peo	0-1	.000	—	2	4	7	8	—	6	2	See Players			No record			
'47/FW	3-12	.200	1.98	22	123	87	53	27	56	26	See Players			16	44	2	.968
'48/SB	10-20	.333	1.99	34	267	170	86	59	86	75	See Players			No record			
'49/SB	19-9	.679	1.36	34	245	148	48	37	107	40	90	20	.222	24	118	5	.966
'50/GR, Kal	8-10	.444	3.12	32	170	164	82	59	82	40	85	17	.200	8	71	5	.940
'51/SB	15-4	.789	1.85	22	170	130	53	35	61	57	57	8	.140	16	81	0	1.000
Car (6 yrs)	55-56	.495	2.00	146	979	706	330	217	398	240	232	45	.194	64	314	12	.969
Play (3 yrs)	1-2	.333	1.91	5	33	18	11	7	6	10	13	2	.154	2	12	0	1.000

Farrow (Rapp), Elizabeth (Born: 8/10/26, Peoria, IL, TR, BR, 5'7", 130, P)

YEAR/TEAM	W-L	PCT.	ERA	G	IP	H	R	ER	BB	SO	AB	H	BA	PO	A	E	PA
Pitching											Hitting			Fielding			
'44/Roc, Mpls	1-12	.077	5.64	19	99	72	93	62	85	16	36	6	.167	12	33	6	.882

Faut (Winsch, Eastman), Jean (Born: 11/17/25, Greenville, PA, TR, BR, 5'4", 137, P, 3B, OF)

see Players

												Hitting			Fielding			
YEAR/TEAM	W–L	PCT.	ERA	G	IP	H	R	ER	BB	SO		AB	H	BA	PO	A	E	PA
'46/SB	8-3	.727	1.32	12	81	53	20	12	21	21	See Players				3	44	4	.922
'47/SB	19-13	.594	1.15	44	298	179	56	38	67	97		123	29	.236	24	133	11	.935
'48/SB	16-11	.593	1.44	34	250	156	68	40	113	165		104	24	.231	No record			
'49/SB	24-8	.750	1.10	34	261	136	47	32	118	120		117	34	.291	33	99	7	.950
'50/SB	21-9	.700	1.12	36	290	175	64	36	104	118	See Players				33	142	3	.983
'51/SB	15-7	.682	1.33	23	190	121	43	28	65	135	See Players				20	77	7	.933
'52/SB	20-2	.909	0.93	23	184	111	31	19	42	114	See Players				11	80	4	.958
'53/SB	17-11	.607	1.51	29	226	162	74	38	59	143	See Players				19	108	5	.962
Car (8 yrs)	140-64	.686	1.23	235	1780	1093	403	243	589	913		344	87	.253	143	683	41	.953
Play (6 yrs)	9-7	.563	1.43	19	170	87	37	27	35	80		37	3	.081	11	60	4	.947

Ferguson (Key), Dorothy "Dottie" (Born: 2/17/23, Winnipeg, MN, Canada, TR, BR, 5'6", 125, P, 2B, 3B, OF)

see Players

												Hitting			Fielding			
YEAR/TEAM	W–L	PCT.	ERA	G	IP	H	R	ER	BB	SO		AB	H	BA	PO	A	E	PA
'50/Roc	—	—	—	11	—	—	—	—	—	—	See Players				No record			
'51/Roc	0-2	.000	10.00	2	9	11	14	10	14	3	See Players				No record			
'52/Roc	—	—	—	1	2	—	—	—	—	—	See Players				No record			
Car (3 yrs)	0-2	.000	10.00	4	12	11	14	10	14	3	See Players				No record			

Ferguson, Fern TR, BR, P

												Hitting			Fielding			
YEAR/TEAM	W–L	PCT.	ERA	G	IP	H	R	ER	BB	SO		AB	H	BA	PO	A	E	PA
'45/Rac	0-0	—	4.90	1	11	12	10	6	9	0		4	1	.250	No record			

Fischer (Stevens), Alva Jo "Tex (Born: 8/23/26, San Antonio, TX; Died: 8/13/73, TR, BR, 5'9", 135, P, SS)

see Players

												Hitting			Fielding			
YEAR/TEAM	W–L	PCT.	ERA	G	IP	H	R	ER	BB	SO		AB	H	BA	PO	A	E	PA
'45/Roc	4-7	.364	3.77	16	98	78	52	41	73	33	See Players				8	27	3	.921
'46/Mus	11-16	.407	2.77	29	224	171	106	69	131	58	See Players				16	63	10	.888
'48/Mus	9-7	.563	1.47	21	129	78	39	21	37	55	See Players				No record			
'49/Mus	10-7	.588	1.78	25	157	92	42	31	55	82	See Players				11	78	5	.809
Car (4 yrs)	34-37	.479	2.40	91	608	419	239	162	296	228	See Players				35	168	18	.863
Play (3 yrs)	1-1	.500	1.20	7	30	17	6	4	12	21	See Players				0	1	0	1.000

Fisher, Lorraine (Born: 7/5/28, Detroit, MI, TR, BR, 5'6", 120, P, OF)

see Players

												Hitting			Fielding			
YEAR/TEAM	W–L	PCT.	ERA	G	IP	H	R	ER	BB	SO		AB	H	BA	PO	A	E	PA
'47/Roc	4-4	.500	2.35	13	69	44	22	18	20	24	See Players				5	21	2	.929
'48/GR	16-11	.593	2.82	32	230	177	97	72	138	61	See Players				No record			
'49/GR	13-11	.542	2.18	25	161	110	68	39	92	42	See Players				13	64	6	.928
Car (3 yrs)	33-26	.559	2.52	70	460	231	187	129	250	127	See Players				18	85	8	.911
Play (2 yrs)	0-1	.000	4.50	4	18	17	14	9	10	5		8	2	.250	1	3	0	1.000

Fitzgerald, Meryle (Hometown: Rapid City, SD, P)

											Hitting			Fielding			
Pitching																	
YEAR/TEAM	*W–L*	*PCT.*	*ERA*	*G*	*IP*	*H*	*R*	*ER*	*BB*	*SO*	*AB*	*H*	*BA*	*PO*	*A*	*E*	*PA*
'46/FW	—	—	—	2	—	—	—	—	—	—	—	—	—	—	—	—	—

Florreich, Lois "Flash" (Born: 4/29/27, Webster Grove, MO; Died: 9/11/91, TR, BR, 5'5", 140, P, OF, 3B)
see Players

											Hitting			Fielding			
Pitching																	
YEAR/TEAM	*W–L*	*PCT.*	*ERA*	*G*	*IP*	*H*	*R*	*ER*	*BB*	*SO*	*AB*	*H*	*BA*	*PO*	*A*	*E*	*PA*
'46/Ken	9-16	.360	2.40	33	244	171	124	65	101	72	See Players			30	133	20	.891
'47/Roc	13-19	.406	1.68	35	257	132	70	48	102	90	153	29	.190	24	136	7	.958
'48/Roc	22-10	.688	1.18	36	282_¾	157	60	37	87	231	106	15	.094	No record			
'49/Roc	22-7	.759	0.67	29	269	104	33	20	94	210	95	8	.084	27	81	9	.929
'50/Roc	20-8	.714	1.18	32	252	144	56	33	65	171	114	28	.246	29	81	5	.957
Car (5 yrs)	86-60	.589	1.40	165	1304	708	343	203	449	774	468	80	.171	110	441	41	.931
Play (3 yrs)	5-3	.571	1.43	8	63	23	17	10	26	38	24	1	.042	4	5	1	.900

Folder (Powell), Rose "Rosie" (Born: 5/12/26, Auburn, IL, TR, BR, 5'6", 140, P, OF)

											Hitting			Fielding			
Pitching																	
YEAR/TEAM	*W–L*	*PCT.*	*ERA*	*G*	*IP*	*H*	*R*	*ER*	*BB*	*SO*	*AB*	*H*	*BA*	*PO*	*A*	*E*	*PA*
'44/Ken	2-7	.222	5.67	14	73	75	67	46	49	15	207	54	.261	2	31	3	.917
Play (1 yr)	—	—	—	—	—	—	—	—	—	—	1	0	.000	—	—	—	—

Foss, Anita "Nita" (Born: 8/5/21, Providence, RI, TR, BR, 5'2", 118, P, U)
see Players

											Hitting			Fielding			
Pitching																	
YEAR/TEAM	*W–L*	*PCT.*	*ERA*	*G*	*IP*	*H*	*R*	*ER*	*BB*	*SO*	*AB*	*H*	*BA*	*PO*	*A*	*E*	*PA*
'49/Roc, Mus	—	—	—	3	6	—	—	—	—	—	See Players			No record			

Foss (Weaver), Betty (Born: 5/10/29, Metropolis, IL; Died: 2/8/98; TR, BB, 5'10", 180, P, 1B, OF)
see Players

											Hitting			Fielding			
Pitching																	
YEAR/TEAM	*W–L*	*PCT.*	*ERA*	*G*	*IP*	*H*	*R*	*ER*	*BB*	*SO*	*AB*	*H*	*BA*	*PO*	*A*	*E*	*PA*
'50/FW	0-1	.000	54.05	2	1	2	7	6	5	1	See Players			No record			

Froning (O'Meara), Mary (Born: 8/26/34, Minster, OH, TR, BR, 5'3", 118, P, OF)
see Players

											Hitting			Fielding			
Pitching																	
YEAR/TEAM	*W–L*	*PCT.*	*ERA*	*G*	*IP*	*H*	*R*	*ER*	*BB*	*SO*	*AB*	*H*	*BA*	*PO*	*A*	*E*	*PA*
'51/SB	—	—	—	1	1	—	—	—	—	—	See Players			No record			
'54/SB	1-2	.333	6.02	5	12	10	14	8	16	4	See Players			No record			
Car (2 yrs)	1-2	.333	6.02	6	13	10	14	8	16	4	See Players			No record			

Gacioch, Rose "Rosie" (Born: 8/31/15, Wheeling, WV, TR, BR, 5'6", 160, P, OF, 1B, 2B, 3B)
see Players

											Hitting			Fielding			
Pitching																	
YEAR/TEAM	*W–L*	*PCT.*	*ERA*	*G*	*IP*	*H*	*R*	*ER*	*BB*	*SO*	*AB*	*H*	*BA*	*PO*	*A*	*E*	*PA*
'46/Roc	2-2	.500	—	4	34	35	26	—	20	12	See Players			No record			
'47/Roc	—	—	—	1	4	—	—	—	—	—	See Players			No record			
'48/Roc	14-5	.737	2.21	21	175	121	59	43	52	64	See Players			No record			
'49/Roc	9-2	.818	1.68	14	91	63	26	17	33	23	See Players			6	27	1	.971
'50/Roc, GR	7-9	.438	3.56	23	162	152	74	64	92	38	See Players			19	58	5	.939

Pitching										Hitting			Fielding				
YEAR/TEAM	W-L	PCT.	ERA	G	IP	H	R	ER	BB	SO	AB	H	BA	PO	A	E	PA
'51/Roc	20-7	.741	1.68	29	231	153	59	43	63	48	109	32	.294	15	92	4	.964
'52/Roc	20-10	.667	1.88	31	259	200	82	54	40	48	121	26	.215	16	120	7	.951
'53/Roc	15-12	.556	2.67	29	229	208	106	68	69	48	See Players			19	93	4	.966
'54/Roc	7-15	.318	4.68	22	152	186	113	79	43	45	See Players			6	53	5	.922
Car (9 yrs)	94-62	.603	2.48	174	1337	1118	545	368	412	326	230	58	.252	81	443	26	.953
Play (6 yrs)	5-3	.714	2.51	11	86	57	33	24	37	22	See Players			4	26	4	1.000

Gallegos, Luisa (Hometown: Havana, Cuba, P)

Pitching										Hitting			Fielding				
YEAR/TEAM	W-L	PCT.	ERA	G	IP	H	R	ER	BB	SO	AB	H	BA	PO	A	E	PA
'48/Peo, SB	2-6	.250	5.79	16	73	46	55	47	76	37	36	3	.083	No record			

Ganote (Weise), Gertrude "Lefty" (Born: 2/17/20, Louisville, KY, TL, BL, 5'4", 130, P, 1B, OF)
see Players

Pitching										Hitting			Fielding				
YEAR/TEAM	W-L	PCT.	ERA	G	IP	H	R	ER	BB	SO	AB	H	BA	PO	A	E	PA
'44/Ken	4-6	.400	3.26	12	91	76	45	33	48	13	See Players			12	23	5	.875
'45/SB	2-2	.500	4.42	10	53	47	31	26	32	7	See Players			3	20	1	.958
Car (2 yrs)	6-8	.429	3.69	22	144	123	76	59	80	20	See Players			15	43	6	.906

Gates, Barbara (Hometown: Downers Grove, IL, P)

Pitching										Hitting			Fielding				
YEAR/TEAM	W-L	PCT.	ERA	G	IP	H	R	ER	BB	SO	AB	H	BA	PO	A	E	PA
'53/GB, SB	1-3	.250	6.71	16	55	51	54	41	59	19	19	2	105	6	15	1	.952
'54/FW	0-1	.000	18.00	3	2	2	8	6	10	1	No record			No record			
Car (2 yrs)	1-4	.200	7.42	19	57	53	62	47	69	20	19	2	.105	6	15	1	.952

Geissinger (Harding), Jean Louise "Dutch" (Born: 6/25/34, Huntingdon, PA, TR, BR, 5'6", 120, RP, 2B, SS, OF)
see Players

Pitching										Hitting			Fielding				
YEAR/TEAM	W-L	PCT.	ERA	G	IP	H	R	ER	BB	SO	AB	H	BA	PO	A	E	PA
'54/FW	—	—	—	5	10	—	—	—	—	—	See Players			No record			

Georges, Beulah Ann (Born: 5/10/23, Columbus, OH, TR, BR, 5'5", 129, P)

Pitching										Hitting			Fielding				
YEAR/TEAM	W-L	PCT.	ERA	G	IP	H	R	ER	BB	SO	AB	H	BA	PO	A	E	PA
'48/Chic, FW	0-4	.000	5.63	10	48	57	38	30	28	5	16	2	.125	No record			

Golden, Thelma (P)

Pitching										Hitting			Fielding				
YEAR/TEAM	W-L	PCT.	ERA	G	IP	H	R	ER	BB	SO	AB	H	BA	PO	A	E	PA
'43/Roc	No record																

Goldsmith, Bethany (Born: 10/6/27, Elgin, IL, TR, BR, 5'10", 160, P)

Pitching										Hitting			Fielding				
YEAR/TEAM	W-L	PCT.	ERA	G	IP	H	R	ER	BB	SO	AB	H	BA	PO	A	E	PA
'48/Ken	14-14	.500	1.62	31	245	135	71	44	99	117	82	9	.110	No record			
'49/Ken	8-11	.421	3.09	29	179	113	79	63	110	49	60	11	.183	10	67	8	.906

Pitching												Hitting			Fielding			
YEAR/TEAM	W–L	PCT.	ERA	G	IP	H	R	ER	BB	SO	AB	H	BA	PO	A	E	PA	
'50/Ken	12-9	.571	.368	27	198	162	101	81	123	80	70	14	.200	21	65	4	.956	
Car (3 yrs)	34-34	.500	2.72	87	622	410	251	188	332	246	212	34	.160	31	132	12	.932	
Play (1 yr)	0-1	.000	9.01	2	5	6	6	5	4	3	1	0	.000	0	0	1	.000	

Graham (Douglas), Mary Lou (Born: 8/15/36, South Bend, IN, TR, BR, 5'7", 149, P)

Pitching												Hitting			Fielding			
YEAR/TEAM	W–L	PCT.	ERA	G	IP	H	R	ER	BB	SO	AB	H	BA	PO	A	E	PA	
'53/SB	—	—	—	6	8	—	—	—	—	—	No record			No record				

Habben, Carol (Born: 5/15/33, Midland Park, NJ, TR, BR, 5'5", 135, P, OF)
see Players

Pitching												Hitting			Fielding			
YEAR/TEAM	W–L	PCT.	ERA	G	IP	H	R	ER	BB	SO	AB	H	BA	PO	A	E	PA	
'54/Kal	—	—	—	2	4	—	—	—	—	—	See Player			No record				

Haine (Daniels), Audrey "Audie" "Dimples" (Born: 5/9/27, Winnipeg, MN, Canada, TR, BR, 5'9", 150, P)

Pitching												Hitting			Fielding			
YEAR/TEAM	W–L	PCT.	ERA	G	IP	H	R	ER	BB	SO	AB	H	BA	PO	A	E	PA	
'44/Mpls	8-20	.286	4.85	34	230	190	171	124	209	115	86	13	.151	21	62	14	.856	
'45/FW	16-10	.615	2.46	32	223	159	98	61	156	101	85	14	.165	26	56	11	.876	
'46/FW, GR	14-11	.560	4.02	30	208	130	120	90	236	120	79	12	.152	17	61	9	.897	
'47/GR, Peo	13-12	.520	2.89	28	199	139	96	64	82	58	69	19	.275	13	47	8	.882	
'48/Peo	17-14	.548	2.92	33	228	179	116	74	100	82	79	11	.139	No record				
'51/Roc	4-3	.571	3.82	10	66	54	37	28	52	17	28	5	.179	0	31	4	.886	
Car (6 yrs)	72-70	.507	3.48	167	1154	851	638	446	835	493	426	74	.174	77	253	46	.878	
Play (1 yr)	0-1	.000	2.25	1	8	7	3	2	5	5	4	1	.250	0	4	2	.667	

Hanna, Marjorie (Hometown: Calgary, AB, Canada, P)

Pitching												Hitting			Fielding			
YEAR/TEAM	W–L	PCT.	ERA	G	IP	H	R	ER	BB	SO	AB	H	BA	PO	A	E	PA	
'44/Ken	0-1	.000	9.00	1	3	4	8	3	8	0	No record			No record				

Harnett, Ann (Born: 8/10/20, Chicago, IL, Died: Date Unknown, TR, BR, 5'6", 139, P, 3B, C, OF)
see Players

Pitching												Hitting			Fielding			
YEAR/TEAM	W–L	PCT.	ERA	G	IP	H	R	ER	BB	SO	AB	H	BA	PO	A	E	PA	
'47/Peo	—	—	—	1	1	—	—	—	—	—	See Players			No record				

Harney, Elsie "Lee" (Born: 6/22/25, Franklin, IL; Died: Date Unknown, TR, BR, 5'9", 135, P)

Pitching												Hitting			Fielding			
YEAR/TEAM	W–L	PCT.	ERA	G	IP	H	R	ER	BB	SO	AB	H	BA	PO	A	E	PA	
'43/Ken	19-19	.500	2.93	45	304	282	167	99	104	102	116	20	.172	35	85	15	.889	
'44/Ken	18-14	.563	2.23	34	262	175	114	65	115	88	89	10	.112	26	80	11	.906	
'45/Ken	14-22	.389	2.60	43	301	201	125	87	121	91	99	12	.121	30	101	10	.929	
'46/Ken, FW	10-20	.333	2.93	33	225	219	143	83	116	61	89	16	.180	22	86	19	.850	
'47/FW	2-10	.167	3.79	17	107	114	61	45	43	24	32	0	.000	6	28	4	.895	
Car (5 yrs)	63-85	.426	2.78	172	1229	991	610	379	499	366	425	58	.136	119	380	59	.894	
Play (1 yr)	0-1	.000	4.50	1	8	6	6	4	2	0	3	0	.000	0	0	2	1.000	

Hasham, Josephine "Jo" (Hometown: Waltham, MA, TL, BR, P, OF)
see Players

| Pitching | | | | | | | | | | | Hitting | | | Fielding | | | |
YEAR/TEAM	W–L	PCT.	ERA	G	IP	H	R	ER	BB	SO	AB	H	BA	PO	A	E	PA
'48/Mus, Peo	0-6	.000	2.14	10	63	46	22	15	26	22	See Players			No record			
'49/SB	12-8	.600	2.02	23	169	134	58	38	81	45	69	11	.159	19	44	2	.969
'50/Peo	8-19	.296	3.38	32	226	213	119	85	64	88	80	8	.100	9	65	11	.871
'51/Peo	13-15	.464	3.10	30	218	220	108	75	107	43	94	24	.255	17	73	8	.918
'52/BC	12-14	.462	2.51	33	222	195	95	62	74	36	See Players			17	86	2	.981
'53/Mus	8-19	.296	3.71	31	206	224	119	85	66	22	112	27	.241	16	79	5	.950
'54/Roc, GR	5-7	417	7.05	20	60	94	54	47	22	14	43	15	.349	4	10	0	1.000
Car (7 yrs)	58-88	.397	3.15	179	1164	1126	575	407	440	270	398	85	.214	82	357	28	.940

Hatzell (Volkert), Beverly (Born: 1/19/1929, Redkey, IN, TR, BR, 5'6", 135, P)

| Pitching | | | | | | | | | | | Hitting | | | Fielding | | | |
YEAR/TEAM	W–L	PCT.	ERA	G	IP	H	R	ER	BB	SO	AB	H	BA	PO	A	E	PA
'50/Rac	4-7	.364	4.85	19	102	86	72	55	83	35	37	3	.081	3	14	1	.944
'51/BC, Peo	1-14	.067	5.66	20	105	111	103	66	97	38	35	2	.057	5	38	4	.915
Car (2 yrs)	5-21	.192	5.26	39	207	197	175	121	180	173	72	5	.069	8	52	5	.923

Haylett, Alice "Al" "Sis" (Born: 4/2/23, Coldwater, MI, TR, BR, 5'6", 155, P)

| Pitching | | | | | | | | | | | Hitting | | | Fielding | | | |
YEAR/TEAM	W–L	PCT.	ERA	G	IP	H	R	ER	BB	SO	AB	H	BA	PO	A	E	PA
'46/GR	17-21	.447	2.97	38	297	203	119	98	191	113	104	23	.221	20	86	11	.906
'47/GR	19-11	.663	1.95	31	258	169	78	56	67	92	90	17	.189	14	14	10	.764
'48/GR	25-5	.833	0.77	32	269	169	36	23	67	114	93	13	.140	No record			
'49/GR	9-10	.474	1.88	27	220	149	70	46	80	71	83	11	.133	23	65	11	.889
Car (4 yrs)	70-47	.598	1.92	128	1440	690	303	223	405	390	370	64	.173	57	165	32	.874
Play (4 yrs)	4-6	.400	1.10	12	98	65	19	12	30	44	34	4	.118	7	37	4	.917

Headin, Irene (P)

| Pitching | | | | | | | | | | | Hitting | | | Fielding | | | |
YEAR/TEAM	W–L	PCT.	ERA	G	IP	H	R	ER	BB	SO	AB	H	BA	PO	A	E	PA
'45/SB	0-0	.000	.000	1	1	—	—	—	—	—	No record			No record			

Heafner, Ruby "Rebel" (Born: 3/5/24, Gastonia, NC, TR, BR, 5'6", 140, P, C)
see Players

| Pitching | | | | | | | | | | | Hitting | | | Fielding | | | |
YEAR/TEAM	W–L	PCT.	ERA	G	IP	H	R	ER	BB	SO	AB	H	BA	PO	A	E	PA
'48/FW	0-1	.000	13.51	2	2	6	6	3	0	0	See Players			No record			

Hohlmayer (McNaughton), Alice (Born: 1/19/25, Springfield, OH, TL, BR, 5'6", 160, P, 1B)
see Players

| Pitching | | | | | | | | | | | Hitting | | | Fielding | | | |
YEAR/TEAM	W–L	PCT.	ERA	G	IP	H	R	ER	BB	SO	AB	H	BA	PO	A	E	PA
'47/Ken	7-6	.538	1.88	16	129	105	37	27	12	16	See Players			12	51	2	.969
'48/Ken	4-4	.500	2.36	13	80	70	34	21	21	23	See Players			No record			
'49/Mus	0-1	.000	1.23	7	22	22	12	9	7	7	See Players			No record			
'50/Kal, Peo	7-10	.412	4.01	24	139	152	89	62	53	34	See Players			8	48	5	.915
'51/Peo	15-11	.577	2.02	29	209	184	74	47	48	46	105	28	.267	13	58	10	.877
Car (5 yrs)	33-32	.508	2.58	89	579	533	246	166	141	126	105	28	.267	33	157	17	.918
Play (1 yr)	0-0	.000	0.00	1	7	4	1	1	2	2	2	0	.000	0	6	0	1.000

Holgerson (Silvestri), Margaret "Marge" (Born: 1/28/27, Mobile, AL; Died: 3/23/90, TR, BR, P, 1B)

see Players

YEAR/TEAM	W-L	PCT.	ERA	G	IP	H	R	ER	BB	SO	AB	H	BA	PO	A	E	PA
											Pitching			**Hitting**			**Fielding**
'46/Roc	2-2	.500	—	5	33	18	7	—	11	8	See Players			No record			
'47/Roc	9-15	.375	2.42	27	201	138	80	54	77	48	111	22	.198	14	78	8	.920
'48/Roc	16-15	.516	1.92	37	277	143	71	59	109	194	93	10	.108	No record			
'49/Roc, Mus	5-10	.333	1.70	17	132	85	39	25	47	47	41	6	.146	7	45	6	.897
'50/GR	14-12	.538	2.00	33	230	185	84	51	96	101	80	14	.175	11	96	9	.922
'51/GR	16-6	.727	1.53	25	200	125	47	34	77	123	78	14	.179	9	70	6	.929
'52/GR	14-9	.609	2.36	24	168	138	65	44	81	78	61	11	.180	11	60	1	.986
Car (7 yrs)	76-69	.524	1.94	168	1241	832	393	267	498	599	464	77	.166	52	349	30	.930
Play (5 yrs)	3-1	.750	1.64	6	44	19	8	8	27	30	19	2	.250	3	13	1	.941

Horstman, Catherine "Katie" (Born: 4/14/35, Minster, OH, TR, BR, 5'7", 150, P, C, OF, SS, 3B)

see Players

YEAR/TEAM	W-L	PCT.	ERA	G	IP	H	R	ER	BB	SO	AB	H	BA	PO	A	E	PA
											Pitching			**Hitting**			**Fielding**
'51/Ken, FW	3-0	1.000	2.35	6	23	15	10	6	14	0	See Players			No record			
'52/FW	5-2	.714	2.35	10	65	45	24	17	31	28	See Players			10	15	5	.833
'53/FW	11-5	.688	2.32	17	124	92	44	32	46	57	See Players			16	34	2	.962
'54/FW	10-4	.714	2.85	16	101	90	51	32	31	46	See Players			10	31	4	.911
Car (4 yrs)	29-11	.725	2.50	49	313	202	129	87	122	140	See Players			36	80	11	.913
Play (2 yrs)	0-2	.000	3.47	3	26	29	15	10	13	15	5	2	.400	1	2	0	1.000

Hutchinson, Anna May "Hutch" (Born: 5/1/25, Louisville, KY; Died: 1/29/98; TR, BR, 5'7", 149, P, C)

see Players

YEAR/TEAM	W-L	PCT.	ERA	G	IP	H	R	ER	BB	SO	AB	H	BA	PO	A	E	PA
											Pitching			**Hitting**			**Fielding**
'46/Rac	26-14	.650	1.62	51	288	204	89	51	69	102	144	16	.111	43	120	11	.937
'47/Rac	27-13	.675	1.38	44	360	230	77	55	72	120	123	18	.146	34	71	11	.905
'48/Rac	3-6	.333	3.67	14	76	79	41	31	37	16	21	4	.190	No record			
'49/Mus	8-12	.400	2.35	25	161	126	58	42	74	19	53	11	.208	18	58	7	.916
'51/Ken	1-2	.333	4.89	4	24	20	14	13	13	2	No record			No record			
Car (5 yrs)	65-47	.580	1.90	138	909	659	279	192	265	259	341	49	.144	95	249	29	.922
Play (3 yrs)	8-6	.571	1.17	14	115	65	22	15	28	36	33	1	.030	6	15	1	.955

Jacobs (Badini), Jane "Jake" (Born: 6/16/24, Cuyahoga Falls, OH, TR, BR, 5'4", 130, P)

YEAR/TEAM	W-L	PCT.	ERA	G	IP	H	R	ER	BB	SO	AB	H	BA	PO	A	E	PA
											Pitching			**Hitting**			**Fielding**
'44/Rac	9-16	.360	2.82	31	230	251	113	72	65	16	79	7	.089	10	65	8	.904
'45/Rac	7-9	.438	2.86	21	125	137	68	40	30	9	43	7	.163	5	29	2	.944
'46/Peo	6-12	.333	2.13	23	164	147	80	39	63	21	58	6	.103	4	60	5	.928
'47/Rac	2-6	.250	2.92	13	71	46	31	23	31	6	24	4	.167	1	16	4	.810
Car (4 yrs)	24-43	.358	2.65	88	590	581	292	174	189	52	204	24	.118	20	170	19	.909

Janssen, Frances "Big Red" "Little Red" (Born: 1/25/26, Remington, IN, TR, BR, 5'11", 155, P)

YEAR/TEAM	W-L	PCT.	ERA	G	IP	H	R	ER	BB	SO	AB	H	BA	PO	A	E	PA
											Pitching			**Hitting**			**Fielding**
'48/GR	4-4	.500	3.98	11	61	63	35	27	24	7	20	5	.250	No record			
'49/Chic/Spr	No record																
'50/Peo, Kal, FW	3-3	.500	3.87	19	93	96	63	40	51	14	33	6	.182	4	56	5	.923

											Hitting			Fielding			
YEAR/TEAM	W-L	PCT.	ERA	G	IP	H	R	ER	BB	SO	AB	H	BA	PO	A	E	PA
'51/FW,Peo, Kal,BC	6-10	.375	2.67	26	117	106	69	43	57	43	52	6	.115	3	73	4	.950
'52/BC	0-1	.000	5.00	5	18	18	11	10	11	3	No record			No record			
Car (4 yrs)	13-18	.419	3.74	61	289	283	178	120	143	67	105	17	.162	7	129	9	.938
Play (1 yr)	0-0	.000	3.01	3	12	7	4	4	2	2	5	0	.000	1	1	0	1.000

Jaykoski, Joan (Hometown: Menasha, WI, P, OF)

see Players

											Hitting			Fielding			
YEAR/TEAM	W-L	PCT.	ERA	G	IP	H	R	ER	BB	SO	AB	H	BA	PO	A	E	PA
'51/Ken	1-3	.250	7.81	10	30	32	42	26	44	4	See Players			1	6	3	.700

Jochum, Betsy "Sock'um" (Born: 2/8/21, Cincinnati, OH, TR, BR, 5'7", 140, P, OF, 1B)

see Players

											Hitting			Fielding			
YEAR/TEAM	W-L	PCT.	ERA	G	IP	H	R	ER	BB	SO	AB	H	BA	PO	A	E	PA
'48/SB	14-13	.519	1.51	29	215	154	61	36	58	103	See Players			No record			
Play (1 yr)	0-2	.000	2.82	2	12	15	5	5	2	3	See Players			1	4	0	1.000

Jogerst, Dpmma (Hometown: Freeport, IL, P)

											Hitting			Fielding			
YEAR/TEAM	W-L	PCT.	ERA	G	IP	H	R	ER	BB	SO	AB	H	BA	PO	A	E	PA
'52/Roc	—	—	—	1	1	—	—	—	—	—	No record			No record			

Jones, Marguerite "The Lady" (Davis) (Born: 11/3/17, Windthorst, SK, Canada; Died: 5/9/95, TR, BR, 5'9", P)

											Hitting			Fielding			
YEAR/TEAM	W-L	PCT.	ERA	G	IP	H	R	ER	BB	SO	AB	H	BA	PO	A	E	PA
'44/Mpls, Roc	6-12	.333	3.70	28	175	150	72	16	24	1	68	11	.162	10	71	7	.920

Jones (Doxey), Marilyn "Jonesy" (Born: 4/5/27, Providence, RI, TR, BR, 5'5", 135, P, C)

											Hitting			Fielding			
YEAR/TEAM	W-L	PCT.	ERA	G	IP	H	R	ER	BB	SO	AB	H	BA	PO	A	E	PA
'52/BC	9-7	.563	1.69	17	128	94	35	24	69	46	65	6	.092	7	37	1	.978
'53/Mus	14-11	.560	2.56	30	218	186	92	62	125	86	87	17	.195	15	61	12	.846
'54/FW	8-8	.500	4.26	22	13	135	86	62	65	59	68	13	.191	6	30	9	.800
Car (3 yrs)	31-26	.544	2.31	69	577	415	213	148	149	191	220	36	.164	28	128	22	.877
Play (1 yr)	1-1	.500	5.25	2	13	17	12	5	7	7	3	0	.000	1	2	0	1.000

Jurgensmeier (Carroll), Margaret "Jurgy" (Born: 9/2/34, Freeport, IL, TR, BR, 5'6", 130, P)

											Hitting			Fielding			
YEAR/TEAM	W-L	PCT.	ERA	G	IP	H	R	ER	BB	SO	AB	H	BA	PO	A	E	PA
'51/Roc	1-1	.500	7.96	9	26	23	31	23	37	7	No record			No record			

Kabick, Josephine (Born: 3/27/22, Detroit, MI; Died: Date Unknown, TR, BR, 5'7", 142, P)

											Hitting			Fielding			
YEAR/TEAM	W-L	PCT.	ERA	G	IP	H	R	ER	BB	SO	AB	H	BA	PO	A	E	PA
'44/Mil	26-19	.578	2.66	44	366	270	158	108	147	81	128	22	.172	31	116	28	.840
'45/GR	16-18	.471	1.85	35	292	204	91	60	113	33	99	12	.121	13	99	15	.882
'46/GR, Ken	19-19	.500	2.39	40	324	283	131	86	72	53	114	19	.167	13	116	27	.837

Pitching											Hitting			Fielding			
YEAR/TEAM	W–L	PCT.	ERA	G	IP	H	R	ER	BB	SO	AB	H	BA	PO	A	E	PA
'47/Peo	13-16	.448	2.34	31	231	191	101	60	71	78	80	10	.125	18	50	13	.840
Car (4 yrs)	74-72	.507	2.33	151	1213	948	481	314	403	245	421	63	.150	75	381	83	.846
Play (2 yrs)	0-3	.000	5.08	3	16	18	13	9	4	2	6	0	.000	2	2	1	.800

Keagle, Merle "Pat" (Born: 3/21/23, Phoenix, AZ.; Died: Date Unknown, TR, BR, 5'2", 144, P, OF)

see Players

Pitching											Hitting			Fielding			
YEAR/TEAM	W–L	PCT.	ERA	G	IP	H	R	ER	BB	SO	AB	H	BA	PO	A	E	PA
'46/GR	3-2	.600	1.94	6	51	41	13	11	15	14	See Players			No record			
'48/GR	4-3	.571	3.71	10	51	32	33	21	51	8	See Players			No record			
Car (2 yrs)	7-5	.583	2.82	16	102	73	46	32	66	22	See Players			No record			

Kelley (Savage), Jackie "Scrounge" "Babe" (Born: 11/11/26, Lansing, MI, Died: 5/12/88, TR, BR, 5'7", 140, P, U)

see Players

Pitching											Hitting			Fielding			
YEAR/TEAM	W–L	PCT.	ERA	G	IP	H	R	ER	BB	SO	AB	H	BA	PO	A	E	PA
'50/Roc	0-1	.000	9.00	7	9	9	11	9	18	8	See Players			No record			
'51/Roc	1-1	.500	2.80	6	29	18	15	9	24	8	See Players			No record			
'52/Roc	12-11	.522	2.89	27	209	178	91	67	132	73	See Players			13	72	8	.914
'53/Roc	2-5	.286	4.86	13	63	54	40	34	42	26	See Players			9	26	3	.921
Car (4 yrs)	15-18	.455	3.46	53	310	259	157	119	216	115	See Players			22	98	11	.916
Play (2 yr)	2-0	.667	1.80	3	20	13	8	4	8	5	See Players			2	3	1	.833

Keough, Lavina (Hometown: Walworth, WI, P)

Pitching											Hitting			Fielding			
YEAR/TEAM	W–L	PCT.	ERA	G	IP	H	R	ER	BB	SO	AB	H	BA	PO	A	E	PA
'45/SB	0-0	.000	—	1	1	—	—	—	—	—	No record			No record			
'46/SB	No record																

Kerrigan, Marguerite "Kerry" (Born: 7/24/31, Ridgeway, MN, TR, BR, 5'9", 150, P)

Pitching											Hitting			Fielding			
YEAR/TEAM	W–L	PCT.	ERA	G	IP	H	R	ER	BB	SO	AB	H	BA	PO	A	E	PA
'51/Roc	—	—	—	1	1	—	—	—	—	—	No record			No record			

Kidd, Sue (Born: 9/2/33, Choctaw, AR, TR, BR, 5'8", 165, P, 1B)

see Players

Pitching											Hitting			Fielding			
YEAR/TEAM	W–L	PCT.	ERA	G	IP	H	R	ER	BB	SO	AB	H	BA	PO	A	E	PA
'50/Mus, Peo, SB	1-10	.091	2.94	26	141	148	75	46	30	39	49	10	.204	6	60	8	.892
'51/BC, SB	11-7	.611	2.51	19	136	119	55	38	37	50	64	10	.156	7	40	2	.959
'52/SB	13-7	.650	2.00	23	189	—	154	42	30	64	80	15	.188	12	66	1	.987
'53/SB	13-15	.464	2.37	31	258	225	94	68	51	67	See Players			19	117	6	.958
'54/SB	9-6	600	2.91	18	133	142	64	43	37	50	See Players			9	58	3	.957
Car (5 yrs)	47-45	.511	2.49	117	857	634	353	237	185	270	193	35	.181	60	341	20	.953
Play (3 yrs)	1-2	.333	3.60	7	20	23	12	8	9	6	19	4	.211	4	7	0	1.000

Kimball (Purdham), Mary Ellen (Born: 4/1/29, Kalamazoo, MI, 5'7", 148, P, OF)

Pitching											Hitting			Fielding			
YEAR/TEAM	W–L	PCT.	ERA	G	IP	H	R	ER	BB	SO	AB	H	BA	PO	A	E	PA
'48/Rac	No record										5	0	.000				

Kline (Randall), Maxine "Max" (Born: 9/16/29, North Adams, MI, TR, BR, 5'7", 130, P)

Pitching											Hitting			Fielding			
YEAR/TEAM	W–L	PCT.	ERA	G	IP	H	R	ER	BB	SO	AB	H	BA	PO	A	E	PA
'48/FW	8-13	.381	2.58	24	164	127	70	47	41	45	56	9	.161	No record			
'49/FW	14-11	.560	1.93	28	229	141	66	49	60	57	82	19	.232	23	90	3	.974
'50/FW	23-9	.719	2.44	33	266	241	96	72	72	87	111	24	.216	23	94	2	.983
'51/FW	18-4	.818	1.95	24	194	141	67	42	56	69	79	19	.241	28	77	8	.929
'52/FW	19-7	.731	1.93	28	238	189	69	51	48	70	89	14	.157	27	97	4	.969
'53/FW	16-14	.533	2.49	31	246	225	88	68	60	76	90	14	.156	30	93	0	1.000
'54/FW	18-7	.720	3.23	28	181	180	82	65	52	91	85	16	.188	15	54	2	.972
Car (7 yrs)	116-65	.641	2.34	196	1518	1244	538	394	389	495	592	115	.194	155	505	19	.972
Play (7 yrs)	6-7	.417	2.36	19	122	92	40	32	31	31	50	8	.160	7	15	6	.786

Kobuszewski, Theresa (Born: 7/15/20, Wyandotte, MI, TR, BR, 5'4", 165, P)

Pitching											Hitting			Fielding			
YEAR/TEAM	W–L	PCT.	ERA	G	IP	H	R	ER	BB	SO	AB	H	BA	PO	A	E	PA
'46/Ken	3-9	.250	2.71	21	123	96	65	37	44	56	45	10	.222	22	46	10	.872
'47/Ken, FW	11-15	.423	2.42	30	208	158	95	56	64	47	79	20	.253	14	80	11	.895
Car (2 yrs)	14-24	.368	2.53	51	331	254	160	93	108	103	124	30	.242	26	126	21	.885

Koehn, Phyllis "Sugar" (Born: 9/15/22, Marshfield, WI, TR, BR, 5'5", 120, P, U)
see Players

Pitching											Hitting			Fielding			
YEAR/TEAM	W–L	PCT.	ERA	G	IP	H	R	ER	BB	SO	AB	H	BA	PO	A	E	PA
'45/Ken, SB	2-4	.333	1.90	7	52	32	28	11	26	6	See Players			No record			
'46/SB	22-15	.595	2.48	39	309	233	132	85	131	64	151	24	.159	13	113	14	.900
'47/SB	16-16	.500	2.17	34	265	191	98	64	76	73	128	20	.156	10	111	0	.931
'48/SB, Peo, Rac	6-8	.429	3.02	21	128	97	67	43	87	60	See Players			No record			
'49/Rac, FW	2-11	.154	3.43	22	126	78	68	48	93	31	56	9	.161	7	48	6	.902
'50/GR	0-0	—	—	1	6	—	—	—	—	—	See Players			No record			
Car (6 yrs)	48-54	.471	2.55	124	886	631	393	251	413	234	335	53	.158	30	272	29	.912
Play (2 yrs)	0-2	.000	6.94	3	13	14	16	10	9	1	5	2	.400	0	4	0	1.000

Kotowicz, Irene "Ike" (Born: 12/10/19, Chicago, IL, TR, BR, 5'5", 128, P, OF)
see Players

Pitching											Hitting			Fielding			
YEAR/TEAM	W–L	PCT.	ERA	G	IP	H	R	ER	BB	SO	AB	H	BA	PO	A	E	PA
'47/FW, Ken	8-10	.444	2.61	23	162	120	69	47	64	30	55	7	.127	11	67	15	.859
'48/Chic	18-17	.514	2.71	37	296	193	109	89	167	197	106	9	.085	No record			
'49/Rac	8-15	.348	2.32	25	190	144	74	49	109	69	61	6	.098	8	61	10	.873
'50/Rac	0-5	.000	4.67	11	54	46	47	28	73	19	21	3	.143	3	11	3	.824
Car (4 yrs)	42-47	.472	2.73	96	702	503	299	213	413	315	243	25	.103	22	139	28	.852
Play (1 yr)	1-1	.000	0.90	2	20	13	2	2	1	3	7	1	.333	0	1	0	1.000

Kramer (Hartman), Ruth "Rocky" (Born: 4/26/26, Limekiln, PA, TR, BR, 5'1", 110, RP, 2B)

Pitching											Hitting			Fielding			
YEAR/TEAM	W–L	PCT.	ERA	G	IP	H	R	ER	BB	SO	AB	H	BA	PO	A	E	PA
'46/Rac	No record																
'47/FW	No record																

Krick, Jayne "Red" (Born: 10/1/29, Auburn, IN, TR, BR, 5'11", 150, P, OF, 3B)
see Players

Pitching											Hitting			Fielding			
YEAR/TEAM	W–L	PCT.	ERA	G	IP	H	R	ER	BB	SO	AB	H	BA	PO	A	E	PA
'48/SB	2-6	.250	4.12	13	59	47	44	27	60	22	See Players			No record			

Pitching										Hitting			Fielding				
YEAR/TEAM	W-L	PCT.	ERA	G	IP	H	R	ER	BB	SO	AB	H	BA	PO	A	E	PA
'49/SB	2-1	.667	1.44	5	25	20	20	4	26	10	9	2	.222	No record			
'51/BC, Peo	2-7	.222	4.12	19	107	104	79	49	47	26	See Players			1	52	8	.869
'52/GR	2-7	.222	2.69	21	117	104	55	35	48	38	See Players			14	58	6	.923
'53/GR	0-1	.000	3.90	3	7	11	9	3	8	1	No record			No record			
Car (5 yrs)	8-22	.267	3.37	61	315	286	207	118	189	97	9	2	.222	15	110	14	.899

Kruckel, Marie "Kruck" (Born: 6/18/24, Bronx, NY, TR, BR, 5'4", 130, P, OF)
see Players

Pitching										Hitting			Fielding				
YEAR/TEAM	W-L	PCT.	ERA	G	IP	H	R	ER	BB	SO	AB	H	BA	PO	A	E	PA
'48/SB, Mus	9-4	.692	1.65	19	120	83	45	22	41	19	See Players			No record			
'49/Mus	1-7	.125	2.75	15	85	82	41	26	23	8	See Players			4	40	1	.978
Car (2 yrs)	10-11	.476	2.11	34	205	165	86	48	64	27	See Players	4	40	1			.978

Kurys, Sophie "Soph" "Flint Flash" (Born: 5/14/25, Flint, MI, TR, BR, 5'5", 115, P, 2B, OF)
see Players

Pitching										Hitting			Fielding				
YEAR/TEAM	W-L	PCT.	ERA	G	IP	H	R	ER	BB	SO	AB	H	BA	PO	A	E	PA
'50/Rac	—	—	—	1	2	—	—	—	—	—	See Players			No record			

Leduc (Alverson), Neolla "Pinky" (Born: 12/23/33, Graniteville, MA, TR, BR, 5'5", 130, P, OF)
see Players

Pitching										Hitting			Fielding				
YEAR/TEAM	W-L	PCT.	ERA	G	IP	H	R	ER	BB	SO	AB	H	BA	PO	A	E	PA
'52/BC	3-4	.429	3.11	19	81	79	37	28	24	5	See Players			6	20	2	.929
'53/Mus	3-9	.250	5.10	24	97	104	75	55	50	19	See Players			5	42	5	.904
'54/FW	9-10	.474	6.05	24	125	148	106	84	72	42	See Players			8	35	4	.941
Car (3 yrs)	15-23	.395	4.96	67	303	331	218	167	146	66	See Players			19	97	11	.913

Lee (Harmon), Annabelle "Lefty" (Born: 1/22/22, Los Angeles, CA, TL, BB, 5'2", 120, P, 1B)
see Players

Pitching										Hitting			Fielding					
YEAR/TEAM	W-L	PCT.	ERA	G	IP	H	R	ER	BB	SO	AB	H	BA	PO	A	E	PA	
'44/Mpls	11-14	.440	2.43	29	211	175	96	57	69	56	See Players	22	75	15	.866			
'45/FW	13-16	.448	1.56	31	243	162	67	42	49	54	74	7	.095	17	88	5	.955	
'46/Peo	12-23	.343	2.74	37	266	233	134	81	71	82	98	14	.143	21	93	6	.966	
'47/Peo, GR	9-11	.450	2.24	24	165	140	61	41	37	29	50	9	.180	7	62	4	.945	
'48/FW	10-14	.417	2.25	27	208	155	78	52	87	74	69	10	.145	No record				
'49/Peo	5-14	.263	2.18	21	161	152	82	39	76	58	51	5	.098	14	64	8	.907	
'50/Peo	3-4	.429	2.51	17	68	56	25	19	26	28	21	5	.238	3	27	3	.909	
Car (7 yrs)	63-96	.396	2.25	186	1322	1073	543		331	415	271	363	50	.138	84	355	41	.929
Play (3 yrs)	3-4	.428	3.34	10	62	43	27	23	22	14	23	3	.130	5	8	0	1.000	

Lee (Dries), Delores "Pickles" (Born: 4/21/35, Jersey City, NJ, TR, BR, 5'6", 130, P)
see Players

Pitching										Hitting			Fielding				
YEAR/TEAM	W-L	PCT.	ERA	G	IP	H	R	ER	BB	SO	AB	H	BA	PO	A	E	PA
'52/Roc	1-2	.333	6.94	5	26	24	12	10	12	6	No record			No record			
'53/Roc	12-10	.545	2.42	26	193	175	84	48	63	30	See Players			14	69	6	.933

Pitching											Hitting			Fielding				
YEAR/TEAM	*W–L*	*PCT.*	*ERA*	*G*	*IP*	*H*	*R*	*ER*	*BB*	*SO*	*AB*	*H*	*BA*	*PO*	*A*	*E*	*PA*	
'54/Roc	10-10	.500	3.91	22	152	141	81	66	93	94	See Players			13	71	3	.966	
Car (3 yrs)	23-22	.511	3.01	53	371	340	177	124	168	130	See Players			27	140	9	.949	
Play (1 yr)	0-1		3.00	1	9	7	4	3	3	0	3	0	0	.000	3	0	0	1.000

Lee, Laurie Ann (Born: 1/3/31, Racine, WI, TR, BR, 5'7", 131, P)

Pitching											Hitting			Fielding			
YEAR/TEAM	*W–L*	*PCT.*	*ERA*	*G*	*IP*	*H*	*R*	*ER*	*BB*	*SO*	*AB*	*H*	*BA*	*PO*	*A*	*E*	*PA*
'48/Rac	No record																

Lequia (Barker), Joan "Joanie" (Born: 3/13/38, Negaunee, MI, TR, BR, 5'2", 120, P)

Pitching											Hitting			Fielding			
YEAR/TEAM	*W–L*	*PCT.*	*ERA*	*G*	*IP*	*H*	*R*	*ER*	*BB*	*SO*	*AB*	*H*	*BA*	*PO*	*A*	*E*	*PA*
'53/GR	No record — played less than 10 games																

Little, Alta (Born: 5/21/23, Gas City, IN, TR, BR, 5'10", P, 1B)
see Players

Pitching											Hitting			Fielding			
YEAR/TEAM	*W–L*	*PCT.*	*ERA*	*G*	*IP*	*H*	*R*	*ER*	*BB*	*SO*	*AB*	*H*	*BA*	*PO*	*A*	*E*	*PA*
'47/Mus	—	—	—	1	1/3	—	—	—	—	—	10	1	.100	No record			
'48/FW	No record										See Players						

Little (Bend), Olive "Ollie" (Born: 5/7/17, Poplar Point, MN, Canada; Died: 2/2/87, TR, BR, 5'3", 135, P)

Pitching											Hitting			Fielding			
YEAR/TEAM	*W–L*	*PCT.*	*ERA*	*G*	*IP*	*H*	*R*	*ER*	*BB*	*SO*	*AB*	*H*	*BA*	*PO*	*A*	*E*	*PA*
'43/Roc	21-15	.583	2.56	44	288	201	137	82	112	151	110	16	.145	22	73	7	.931
'45/Roc	22-11	.667	1.68	34	295	182	94	55	140	142	110	18	.164	26	84	11	.909
'46/Roc	14-17	.452	2.51	34	275	167	108	69	131	88	74	9	.122	19	63	7	.921
Car (3 yrs)	57-43	.570	2.16	112	858	650	249	206	383	381	184	25	.136	67	220	35	.891
Play (2 yrs)	1-3	.250	2.93	5	40	36	15	13	11	23	12	1	.083	3	12	0	1.000

Lonetto, Sarah "Tomato" (Born: 6/9/22, Detroit, MI, TR, BB, 5'3", 120, P, U)
see Players

Pitching											Hitting			Fielding			
YEAR/TEAM	*W–L*	*PCT.*	*ERA*	*G*	*IP*	*H*	*R*	*ER*	*BB*	*SO*	*AB*	*H*	*BA*	*PO*	*A*	*E*	*PA*
'48/Mus	3-9	.250	2.78	17	97	88	48	30	57	12	See Players			No record			
'49/Mus	—	—	—	3	12	—	—	—	—	—	See Players			No record			
Car (2 yrs)	3-9	.250	2.78	20	109	88	48	30	57	12	See Players			No record			
Play (1 yr)	0-0	.000	0.00	1	6	2	0	0	1	0	2	0	.000	0	0	0	1.000

Lovell (Dowler), Jean "Grump" (Hometown: Conneaut, OH; Died: 1/1/92, P, C)
see Players

Pitching											Hitting			Fielding			
YEAR/TEAM	*W–L*	*PCT.*	*ERA*	*G*	*IP*	*H*	*R*	*ER*	*BB*	*SO*	*AB*	*H*	*BA*	*PO*	*A*	*E*	*PA*
'48/Roc	3-4	.429	4.00	9	54	54	39	24	29	9	See Players			No record			
'51/Kal, Ken	0-6	.000	5.25	8	48	49	44	28	31	8	See Players			No record			
'54/Kal	—	—	—	1	1	—	—	—	—	—	See Players			No record			
Car (3 yrs)	3-10	.231	4.18	18	113	103	83	52	60	17	See Players			No record			

Lovett, Frances P (Hometown: Racine, WI)

Pitching											Hitting			Fielding			
YEAR/TEAM	*W–L*	*PCT.*	*ERA*	*G*	*IP*	*H*	*R*	*ER*	*BB*	*SO*	*AB*	*H*	*BA*	*PO*	*A*	*E*	*PA*
'46/Peo	0-1	.000	—	1	7	13	12	—	2	0	2	0	.000	No record			

Luckey, Lillian (Born: 5/9/19, Niles, MI, TR, BR, 5', 126, P)

YEAR/TEAM	W-L	PCT.	ERA	G	IP	H	R	ER	BB	SO	AB	H	BA	PO	A	E	PA
'46/SB	2-4	.333	3.44	8	54	51	37	21	48	10	15	2	.133	No record			

Pitching — Hitting — Fielding

Luna (Hill), Betty Jean (Born: 5/1/27, Dallas, TX, TR, BR, 5'5", 133, P, OF)
see Players

YEAR/TEAM	W-L	PCT.	ERA	G	IP	H	R	ER	BB	SO	AB	H	BA	PO	A	E	PA
'44/Roc	12-13	4.80	2.61	27	207	141	93	60	85	63	72	8	.111	14	76	11	.891
'45/SB	14-15	.483	1.53	30	230	141	68	39	66	77	120	30	.250	20	79	11	.900
'46/SB	23-13	.639	2.30	41	298	199	102	76	126	93	116	24	.207	23	89	7	.941
'47/Roc	11-14	.440	1.65	29	234	142	59	43	81	75	117	24	.214	23	87	11	.909
'48/Chic	12-9	.571	1.95	25	171	97	55	37	117	98	See Players			No record			
'49/FW	2-6	.250	3.90	10	67	48	52	29	49	24	See Players			6	28	2	.944
Car (6 yrs)	74-70	.514	2.12	162	1207	768	429	284	524	430	425	87	.205	86	359	42	.926
Play (1 yr)	1-1	1.000	2.00	2	18	14	12	4	3	7	8	1	.125	0	2	1	.667

Mandella, Lenora "Smokey" (Born: 5/4/31, McKeesport, PA, TR, BR, 5'7", 145, P)

YEAR/TEAM	W-L	PCT.	ERA	G	IP	H	R	ER	BB	SO	AB	H	BA	PO	A	E	PA
'49/SB	No record																
'50/Spr	1-4	.200	—	6	—	—	—	—	—	—	146	19	.131	No record			
'51/Peo	3-4	.429	4.28	17	80	75	66	38	71	23	27	3	.111	1	26	2	.933

McCormick, Judy (P)

YEAR/TEAM	W-L	PCT.	ERA	G	IP	H	R	ER	BB	SO	AB	H	BA	PO	A	E	PA
'54/SB	—	—	—	1	4	—	—	—	—	—	No record			No record			

McFadden (Rusynyk), Betty "Mac" (Born: 10/22/24, Savanna, IL, TR, BR, 5'7", 135, P)

YEAR/TEAM	W-L	PCT.	ERA	G	IP	H	R	ER	BB	SO	AB	H	BA	PO	A	E	PA
'43/SB	No record																

Mansfield (Kelley), Marie "Boston" (Born: 11/4/31, Jamaica Plain, MA, TR, BR, 5'7", 140, P, OF)
see Players

YEAR/TEAM	W-L	PCT.	ERA	G	IP	H	R	ER	BB	SO	AB	H	BA	PO	A	E	PA
'51/Roc	16-8	.667	2.85	30	202	126	94	64	150	121	See Players			10	56	8	.892
'52/Roc, BC	3-14	.176	4.94	24	122	95	81	67	128	53	See Players			6	45	2	.962
'53/Roc	10-12	.455	2.82	24	188	135	91	59	151	143	See Players			13	64	5	.939
'54/Roc	5-8	.385	3.27	14	99	68	55	36	76	52	See Players			17	34	4	.927
Car (4 yrs)	34-42	.447	3.33	92	611	424	321	226	505	369	See Players			46	199	19	.928
Play (2 yrs)	1-2	.333	1.64	4	22	10	4	4	20	12	7	0	.000	2	11	2	1.000

Marks, Gloria (Born: 1923, San Diego, CA, TR, BR, 5'6", 130, P)

YEAR/TEAM	W-L	PCT.	ERA	G	IP	H	R	ER	BB	SO	AB	H	BA	PO	A	E	PA
'43/Rac	11-9	.550	4.03	29	166	145	123	75	117	29	68	18	.265	18	63	15	.944

Marlowe (Malanowski) , Jean "Mal" "Jeanie" (Born: 12/28/29, Scranton, PA, TR, BR, 5'6", 135, P, 2B, 1B, OF)
see Players

											Hitting			Fielding			
YEAR/TEAM	W-L	PCT.	ERA	G	IP	H	R	ER	BB	SO	AB	H	BA	PO	A	E	PA
'48/Spr	7-22	.241	3.66	31	236	212	141	96	60	42	83	9	.108	No record			
'49/Ken	7-7	.500	2.67	17	108	83	42	32	49	11	See Players			8	30	8	.826
'50/Ken	12-12	.500	2.42	25	201	160	66	54	64	51	See Players			15	95	4	.965
'51/Ken	12-15	.444	2.52	28	211	171	89	59	86	116	See Players			23	72	7	.931
'52/Kal	10-11	.476	3.24	9	50	49	27	18	60	11	See Players			9	76	0	1.000
'54/Kal	8-12	.400	4.78	23	147	165	109	78	114	43	77	12	.156	9	48	2	.966
Car (6 yrs)	56-79	.415	3.18	133	953	840	474	337	433	274	160	21	.131	64	321	21	.948
Play (1 yr)	0-1	.000	6.01	1	6	9	5	4	1	1	See Players		0	3	0		1.000

Marrero, Mirtha (Hometown: Havana, Cuba, TR, BR, P)

											Hitting			Fielding			
YEAR/TEAM	W-L	PCT.	ERA	G	IP	H	R	ER	BB	SO	AB	H	BA	PO	A	E	PA
'48/Chic	4-21	.160	3.75	29	211	178	122	88	113	49	73	17	.233	No record			
'50/Kal	7-17	.292	3.73	30	186	164	108	77	98	78	58	9	.155	16	88	10	.912
'51/FW	17-8	.680	2.24	29	213	177	90	53	94	87	76	14	.184	18	80	18	.845
'52/BC	4-14	.222	3.59	23	138	142	85	55	63	33	60	11	.183	6	54	6	.909
'53/Mus	0-2	.000	7.29	8	26	32	32	21	28	5	11	2	.182	No record			
Car (5 yrs)	32-62	.340	3.42	119	774	69	437	294	396	252	278	53	.191	40	222	34	.885

Matlack (Sagrati), Ruth "Matty" (Born: 1/13/31, Cromwells Heights, PA, TL, BL, 5'2", 127, P)

											Hitting			Fielding			
YEAR/TEAM	W-L	PCT.	ERA	G	IP	H	R	ER	BB	SO	AB	H	BA	PO	A	E	PA
'50/FW	0-4	.000	3.54	14	61	37	34	24	65	6	36	13	.361	2	11	3	.813
Play (1 yr)	No record									3	1		.333	No record			

Menheer (Zoromapal), Marie (Hometown: Kenosha, WI, TR, BR, 5'5", 142, P)

											Hitting			Fielding			
YEAR/TEAM	W-L	PCT.	ERA	G	IP	H	R	ER	BB	SO	AB	H	BA	PO	A	E	PA
'45/Ken	0-0	.000	—	1	6	—	—	—	—	—	3	0	.000	No record			

Metesch, Bernice (Born: 8/9/29, Joliet, IL, 5'6", 132, P)

											Hitting			Fielding			
YEAR/TEAM	W-L	PCT.	ERA	G	IP	H	R	ER	BB	SO	AB	H	BA	PO	A	E	PA
'48/SB, Roc	No record										3	0	.000	No record			

Meyer (Moellering), Rita "Slats" (Born: 2/12/27, Florissant, MO; Died: Date Unknown; TR, BR, 5'10", 145, P, SS)
see Players

											Hitting			Fielding			
YEAR/TEAM	W-L	PCT.	ERA	G	IP	H	R	ER	BB	SO	AB	H	BA	PO	A	E	PA
'47/Peo	3-6	.333	3.12	13	75	45	41	26	48	56	See Players			13	30	4	.915

Moon, Dorothy (Hometown: Belleville, MI, P)

											Hitting			Fielding			
YEAR/TEAM	W-L	PCT.	ERA	G	IP	H	R	ER	BB	SO	AB	H	BA	PO	A	E	PA
'46/Roc	2-6	2.50	6.89	15	63	64	66	49	64	17	30	5	.167	2	13	7	.682

Moore (Warner), Eleanor "Ellie" (Born: 11/1/33, Long Point, IL, TR, BR, 5'10", 165, P, 1B)

YEAR/TEAM	W-L	PCT.	ERA	G	IP	H	R	ER	BB	SO	AB	H	BA	PO	A	E	PA
Pitching											Hitting			Fielding			
'51/Kal, FW	6-14	.300	2.86	29	176	162	86	56	69	65	68	12	.176	4	53	4	.934
'52/FW, GR	6-12	.333	3.08	28	143	126	73	49	45	59	52	10	.192	15	44	4	.937
'53/GR	17-7	.708	2.00	30	221	169	76	49	106	119	91	21	.231	20	75	3	.969
'54/GR	14-7	.667	3.31	24	163	150	80	60	84	53	104	39	.375	16	50	2	.971
Car (4 yrs)	43-40	.518	2.74	111	703	607	315	214	304	296	315	82	.260	55	222	13	.955
Play (3 yrs)	1-1	.500	6.31	4	_d10	16	11	7	6	6	6	2	.333	0	5	1	.833

Moore, Mary (Hometown: Romeland, CA, P)

YEAR/TEAM	W-L	PCT.	ERA	G	IP	H	R	ER	BB	SO	AB	H	BA	PO	A	E	PA
Pitching											Hitting			Fielding			
'48/Roc	2-3	.400	4.00	8	45	31	23	20	40	5	18	4	.222	No record			

Moraty, Mary (Hometown: St. Charles, MO, TR, BR, P)

YEAR/TEAM	W-L	PCT.	ERA	G	IP	H	R	ER	BB	SO	AB	H	BA	PO	A	E	PA
Pitching											Hitting			Fielding			
'46/FW	0-2	.000	—	6	28	34	24	—	22	5	11	2	.182	No record			

Morris, Carolyn (Born: 9/29/25, Phoenix, AZ; Died: 2/20/96, TR, BR, 5'8", 145 P)

YEAR/TEAM	W-L	PCT.	ERA	G	IP	H	R	ER	BB	SO	AB	H	BA	PO	A	E	PA
Pitching											Hitting			Fielding			
'44/Roc	23-18	.561	2.15	44	343	189	116	82	133	112	126	18	.143	28	106	15	.899
'45/Roc	28-12	.700	1.08	42	333	163	68	40	55	119	118	17	.144	21	83	8	.929
'46/Roc	29-13	.690	1.42	48	356	204	82	56	98	240	122	23	.189	34	62	15	.865
Car (3 yrs)	80-43	.650	1.55	134	1032	556	266	178	286	471	366	58	.158	83	251	38	.898
Play (2 yrs)	8-4	.666	1.10	13	98	47	13	12	21	50	37	8	.216	7	18	4	.862

Morrison (Gamberdella), Esther "Schmattze" (Born: 5/26/31, Chicago, IL, TR, BR, 5'1", 125, P, OF, C)

see Players

YEAR/TEAM	W-L	PCT.	ERA	G	IP	H	R	ER	BB	SO	AB	H	BA	PO	A	E	PA
Pitching											Hitting			Fielding			
'50/Spr	No record										See Players						

Mueller (Bajda), Dolores "Champ" (Born: 5/31/31, Chicago, IL, TR, BR, 5'3", 155, P)

YEAR/TEAM	W-L	PCT.	ERA	G	IP	H	R	ER	BB	SO	AB	H	BA	PO	A	E	PA
Pitching											Hitting			Fielding			
'49/SB	No record																

Mueller, Dorothy "Sporty" "Dottie" (Born: 12/25/25, Cheviot, OH; Died: 6/2/85, TR, BR, 5'11", 160, P, 1B)

see Players

YEAR/TEAM	W-L	PCT.	ERA	G	IP	H	R	ER	BB	SO	AB	H	BA	PO	A	E	PA
Pitching											Hitting			Fielding			
'47/Peo	21-13	.618	1.41	48	312	187	88	49	75	112	122	22	.180	46	166	9	.959
'48/Peo	21-9	.700	1.11	32	267	140	61	33	79	181	102	18	.176	No record			
'49/Peo	7-16	.304	1.89	26	219	146	73	46	53	114	90	16	.178	16	92	9	.923
'50/SB	16-9	.640	2.48	27	221	185	82	61	53	90	80	16	.200	10	78	4	.957
'51/SB	10-2	.833	1.56	13	104	89	21	18	19	40	See Players			6	2	34	.952
'52/SB	5-7	.417	1.82	12	104	85	39	21	25	38	See Players			8	30	3	.927
'53/SB	12-7	.632	2.67	28	182	142	71	54	62	82	81	17	.210	12	77	2	.978

Pitching **Hitting** **Fielding**

YEAR/TEAM	W–L	PCT.	ERA	G	IP	H	R	ER	BB	SO	AB	H	BA	PO	A	E	PA
Car (7 yrs)	92-63	.594	1.80	186	1409	974	435	282	366	657	475	89	.187	98	477	29	.952
Play (2 yrs)	1-2	.500	2.79	3	29	26	11	9	9	2	10	1	.100	0	3	0	1.000

Naum (Parker), Dorothy "Dottie" (Born:1/5/28, Dearborn, MI, TR, BR, 5'4", 112, P, C, 2B, SS)
see Players

Pitching **Hitting** **Fielding**

YEAR/TEAM	W–L	PCT.	ERA	G	IP	H	R	ER	BB	SO	AB	H	BA	PO	A	E	PA
'50/Ken	6-4	.600	2.39	19	94	59	37	25	40	38	See Players			7	39	3	.939
'51/Ken	5-4	.556	1.14	12	79	44	16	10	38	27	See Players			8	33	1	.976
'52/Kal	2-4	.333	1.99	8	68	—	33	15	17	20	See Players			No record			
'53/Kal	14-7	.667	2.18	25	198	171	69	48	54	75	See Players			8	66	3	.961
Car (4 yrs)	27-19	.587	2.01	64	439	274	155	98	149	160	See Players			23	138	7	.958
Play (2 yrs)	1-1	.500	1.96	3	23	22	8	5	9	7	8	1	.125	1	2	0	1.000

Nearing (Buntrock), Merna "Toddy" (Born: 6/13/43, Eland, WI, TR, BR, 5'4", 125, P)

Pitching **Hitting** **Fielding**

YEAR/TEAM	W–L	PCT.	ERA	G	IP	H	R	ER	BB	SO	AB	H	BA	PO	A	E	PA
'43/Ken	0-1	.000	7.40	5	19	31	22	15	13	0	8	0	.000	2	8	1	.909

Nesbitt (Crews, Wisham), Mary "Choo-Choo" (Born: 2/1/25, Greenville, SC, TL, BL, 5'8", 155, P, 1B, OF)
see Players

Pitching **Hitting** **Fielding**

YEAR/TEAM	W–L	PCT.	ERA	G	IP	H	R	ER	BB	SO	AB	H	BA	PO	A	E	PA
'43/Rac	26-13	.667	2.63	47	308	220	132	90	97	85	See Players			44	111	9	.945
'44/Rac	23-17	.575	2.73	45	343	225	137	104	190	106	188	37	.220	55	176	12	.951
'45/Rac	16-19	.457	1.87	37	284	208	111	59	101	58	135	43	.319	32	163	18	.915
Car (3 yrs)	65-49	.570	2.44	129	935	633	380	253	388	249	323	80	.248	131	450	39	.937
Play (2 yrs)	2-2	.500	5.26	5	24	31	17	14	14	4	20	7	.259	22	4	3	.897

Nicol (Fox), Helen "Nicki" (Born: 5/9/20, Ardley, AB, Canada, TR, BR, 5'3", 120, P)

Pitching **Hitting** **Fielding**

YEAR/TEAM	W–L	PCT.	ERA	G	IP	H	R	ER	BB	SO	AB	H	BA	PO	A	E	PA
'43/Ken	31-8	.795	1.81	47	348	219	115	70	108	220	154	34	.221	53	60	8	.934
'44/Ken	17-11	.607	0.93	32	243	119	57	25	83	136	96	13	.135	42	61	6	.945
'45/Ken	24-19	.558	1.34	46	357	203	98	53	145	220	126	10	.079	56	56	9	.930
'46/Ken	15-17	.469	2.09	33	231	147	79	54	147	137	100	20	.200	32	71	3	.972
'47/Ken, Roc	6-16	.273	2.62	26	175	135	74	51	99	90	56	7	.125	13	26	2	.950
'48/Roc	17-13	.567	2.61	32	252	204	107	73	81	52	88	11	.125	No record			
'49/Roc	13-8	.619	.098	26	212	101	35	23	65	70	69	14	.203	10	67	7	.917
'50/Roc	14-12	.538	1.98	28	218	158	78	48	67	60	77	12	.156	11	69	8	.909
'51/Roc	18-7	.720	2.57	28	214	174	79	61	69	67	83	12	.145	10	67	6	.928
'52/Roc	8-7	.533	2.80	15	132	119	56	41	31	24	43	4	.093	4	45	4	.925
Car (10 yrs)	163-118	.580	1.89	313	2382	1579	778	499	895	1076	892	137	.154	231	522	53	.934
Play (6 yrs)	13-7	.650	1.83	20	162	127	50	33	56	49	59	13	.220	21	28	2	.961

Nordquist, Helen "Nordie" (Born: 3/23/32, Maiden, MA, BR, TR, 5'6", 160, P, OF)
see Players

Pitching **Hitting** **Fielding**

YEAR/TEAM	W–L	PCT.	ERA	G	IP	H	R	ER	BB	SO	AB	H	BA	PO	A	E	PA
'52/Roc	3-7	.300	4.50	17	86	77	68	43	80	20	38	4	.105	7	25	4	.889
'53/Roc	1-4	.200	3.91	12	46	40	40	20	55	20	43	5	.116	2	18	3	.870

Pitching										Hitting			Fielding				
YEAR/TEAM	W–L	PCT.	ERA	G	IP	H	R	ER	BB	SO	AB	H	BA	PO	A	E	PA
'54/SB	2-9	182	7.36	15	77	105	89	63	54	17	See Players			7	26	6	.846
Car (3 yrs)	6-20	.231	5.43	44	209	222	197	126	189	57	81	9	.111	16	69	13	.867

O'Hara, Janice "Jenny" (Born: 11/30/18, Beardstown, IL, BR, TR, 5'6", 122, P, U)
see Players

Pitching										Hitting			Fielding				
YEAR/TEAM	W–L	PCT.	ERA	G	IP	H	R	ER	BB	SO	AB	H	BA	PO	A	E	PA
'43/Ken	1-0	1.000	3.21	3	14	11	7	5	6	0	See Players			No record			
'44/Ken	0-0	.000	0.00	4	—	—	—	—	—	—	See Players			No record			
'47/Ken	6-8	.429	3.51	21	118	108	75	44	33	20	See Players			8	47	1	.982
'48/Ken	4-6	.400	3.20	20	104	80	51	37	62	38	47	5	.106	No record			
'49/Ken	2-3	.400	4.65	11	60	57	36	31	39	23	37	3	.081	11	20	1	.969
Car (5 yrs)	13-17	.433	3.56	56	296	256	169	117	140	81	84	8	.095	19	67	2	.977
Play (1 yr)	0-0	.000	0.00	1	6	3	0	0	0	1	2	0	.000	1	2	1	.750

Oraveta, Pauline (Hometown: Warren, OH, P)

Pitching										Hitting			Fielding				
YEAR/TEAM	W–L	PCT.	ERA	G	IP	H	R	ER	BB	SO	AB	H	BA	PO	A	E	PA
'43/Roc	No record																

Ortman (Klupping), Dorothy (Hometown: Maywood, IL; Died: Date Unknown, TR, BR, P)

Pitching										Hitting			Fielding				
YEAR/TEAM	W–L	PCT.	ERA	G	IP	H	R	ER	BB	SO	AB	H	BA	PO	A	E	PA
'44/Rac	6-8	.429	3.38	15	99	94	53	37	47	5	34	2	.059	7	38	1	976

Paire (Davis), Lavonne "Pepper" (Born: 5/29/24, Los Angeles, CA TR, BR, 5'4", 138, P, C, SS, 3B)
see Players

Pitching										Hitting			Fielding				
YEAR/TEAM	W–L	PCT.	ERA	G	IP	H	R	ER	BB	SO	AB	H	BA	PO	A	E	PA
'50/GR	—	—	—	1	7	—	—	—	—	—	See Players			No record			
'52/FW	—	—	—	3	3	—	—	—	—	—	See Players			No record			
'53/FW	1-0	1.000	1.29	3	11	17	4	3	7	2	See Players			No record			
Car (3 yrs)	1-0	1.000	1.29	7	21	17	4	3	7	2	See Players			No record			

Parsons (Zipay), Susan (Born: 4/1/34, Medford, MA, TR, BR, 5'3", 115, P, U)
see Players

Pitching										Hitting			Fielding				
YEAR/TEAM	W–L	PCT.	ERA	G	IP	H	R	ER	BB	SO	AB	H	BA	PO	A	E	PA
'53/Roc	—	—	—	1	1	—	—	—	—	—	See Players			No record			
'54/Roc	0-2	.000	5.78	17	52	58	45	34	68	7	See Players			2	12	2	.875
Car (2 yrs)	0-2	.000	5.78	18	53	58	45	34	68	7	See Players			2	12	2	.875

Payne, Barbara "Bobbie" (Born: 9/18/32, Shreveport, LA, TR, BR, 5'7", 118, P, U)
see Players

Pitching										Hitting			Fielding				
YEAR/TEAM	W–L	PCT.	ERA	G	IP	H	R	ER	BB	SO	AB	H	BA	PO	A	E	PA
'51/Kal	—	—	—	1	2	—	—	—	—	—	See Players			No record			

Pearson (Tesseine), Dolly "Buttons" (Born: 9/6/32, Pittsburgh, PA, TR, BR, 5'5", 125, P, OF, SS)
see Players

| | | | | | | | | | | | Hitting | | | Fielding | | | |
| Pitching | | | | | | | | | | | | | | | | | |
YEAR/TEAM	W–L	PCT.	ERA	G	IP	H	R	ER	BB	SO	AB	H	BA	PO	A	E	PA
'53/SB	0-2	.000	9.02	5	11	14	14	11	11	1	See Players			No record			

Peppas, June (Born: 6/16/29, Kansas City, MO, TL, BL, 5'5", 145, P, OF, 1B)
see Players

| Pitching | | | | | | | | | | | Hitting | | | Fielding | | | |
YEAR/TEAM	W–L	PCT.	ERA	G	IP	H	R	ER	BB	SO	AB	H	BA	PO	A	E	PA
'48/FW	4-12	.250	4.62	16	113	107	70	58	91	39	53	14	.264	No record			
'49/FW, Rac	3-4	.429	2.25	12	68	45	29	17	35	10	See Players			6	19	3	.893
'50/Rac	4-4	.500	4.57	11	67	53	41	34	41	21	See Players			4	21	1	.962
'51/BC, Kal	1-7	.125	4.58	11	57	63	44	29	31	20	See Players			1	9	3	.769
'54/Kal	6-4	.600	3.32	13	65	62	38	24	44	28	See Players			3	17	2	.909
Car (5 yrs)	18-31	.367	3.94	63	370	340	222	162	242	118	53	14	.264	14	66	9	.899
Play (1 yr)	2-0	1.000	2.82	2	16	12	12	5	15	12	See Players			0	2	0	1.000

Perez (Jinright), Migdalia "Mickey" (Hometown: Havana, Cuba; Died: Date Unknown, P)

| Pitching | | | | | | | | | | | Hitting | | | Fielding | | | |
YEAR/TEAM	W–L	PCT.	ERA	G	IP	H	R	ER	BB	SO	AB	H	BA	PO	A	E	PA
'48/Chic	10-17	.370	2.55	32	240	220	111	68	62	22	82	6	.073	No record			
'50/Spr	10-8	.555	—	18	—	—	—	—	—	—	95	19	.200	No record			
'51/BC	13-16	.448	3.00	32	237	241	118	79	50	25	92	8	.087	—	102	3	.974
'52/BC, Roc	11-12	.478	2.34	33	208	214	78	54	41	25	66	14	.212	11	86	2	.980
'53/Roc	12-14	.462	2.25	34	220	204	101	55	42	15	71	5	.070	12	77	13	.873
'54/Roc	11-11	.500	3.73	24	164	197	98	68	51	29	56	10	.179	9	58	1	.985
Car (5 yrs)	57-70	.449	2.73	155	1069	1076	506	324	122	116	367	43	.117	41	323	19	.950
Play (2 yrs)	1-3	.500	3.00	5	36	39	17	12	8	4	11	0	.000	3	12	1	.938

Peters, Marjorie "Pete" (Born: 9/11/18, West Allis, WI, TR, BR, 5'2", 112, P)

| Pitching | | | | | | | | | | | Hitting | | | Fielding | | | |
YEAR/TEAM	W–L	PCT.	ERA	G	IP	H	R	ER	BB	SO	AB	H	BA	PO	A	E	PA
'43/Roc	12-19	.387	3.10	39	270	272	101	93	58	27	125	25	.200	21	53	4	.949
'44/Roc	1-5	.167	3.34	9	70	75	42	26	12	8	23	6	.261	No record			
Car (2 yrs)	13-24	.351	3.15	48	340	347	203	119	70	35	148	31	.209	21	53	4	.949

Pieper, Marjorie "Peeps" (Born: 8/2/22, Clinton, MI, TR, BR, 5'7", 140, P, U)
see Players

| Pitching | | | | | | | | | | | Hitting | | | Fielding | | | |
YEAR/TEAM	W–L	PCT.	ERA	G	IP	H	R	ER	BB	SO	AB	H	BA	PO	A	E	PA
'48/Chic	0-1	.000	2.41	4	15	7	12	4	10	10	See Players			No record			
'51/Peo	1-1	.500	11.81	3	13	18	21	17	18	4	See Players			No record			
'53/Mus	—	—	—	1	5	—	—	—	—	—	See Players			No record			
Car (3 yrs)	1-2	.333	6.75	8	33	25	33	21	28	14	See Players			No record			

Pirok, Pauline "Pinky" (Born: 10/18/26, Chicago, IL, TR, BR, 5'2", 132, P, SS, 3B)
see Players

| Pitching | | | | | | | | | | | Hitting | | | Fielding | | | |
YEAR/TEAM	W–L	PCT.	ERA	G	IP	H	R	ER	BB	SO	AB	H	BA	PO	A	E	PA
'47/SB	—	—	—	3	8	—	—	—	—	—	See Players			No record			

Podolski, Bertha (P)

YEAR/TEAM	W–L	PCT.	ERA	G	IP	H	R	ER	BB	SO	AB	H	BA	PO	A	E	PA
												Hitting		Fielding			
'46/FW	1-1	.500	—	2	17	12	5	—	13	1	9	2	.222	No record			

Pratt, Mary "Prattie" (Born: 11/30/18, Bridgeport, CN, TL, BL, 5'1", 125, P)

YEAR/TEAM	W–L	PCT.	ERA	G	IP	H	R	ER	BB	SO	AB	H	BA	PO	A	E	PA
'43/Roc	5-11	.312	3.93	24	150	157	97	68	38	8	51	12	.235	11	46	7	.891
'44/Roc, Ken	21-15	.583	2.50	41	303	207	133	84	90	26	103	13	.126	18	108	4	.971
'45/Ken	1-16	.059	3.99	27	158	131	95	70	66	14	46	8	.174	24	67	5	.948
'46/Roc	1-7	.125	4.83	14	69	79	48	37	38	6	19	0	.000	6	29	4	.897
'4K7/Roc	0-2	.000	6.33	4	27	28	23	19	8	1	10	0	.000	No record			
Car (5 yrs)	28-51	.354	3.53	110	709	530	396	278	240	55	219	33	.151	59	250	20	.939
Play (1 yr)	1-1	.500	1.16	2	31	13	10	4	4	2	11	1	.091	0	12	1	.923

Price, LaVerne "Ferne" (Hometown: Terre Haute, IN, P)

YEAR/TEAM	W–L	PCT.	ERA	G	IP	H	R	ER	BB	SO	AB	H	BA	PO	A	E	PA
'44/Mil	No record									2	0	.000	No record				

Reynolds, Mary "Windy" (Born: 4/27/21, Gastonia, NC; Died: Date Unknown, TR, BR, P, 3B, OF)

see Players

YEAR/TEAM	W–L	PCT.	ERA	G	IP	H	R	ER	BB	SO	AB	H	BA	PO	A	E	PA
'46/Peo	3-9	.250	2.37	13	91	68	38	24	29	21	See Players			9	63	2	.973
'47/Peo	0-3	.000	2.66	3	17	16	7	5	6	2	See Players			No record			
'48/Peo	9-6	.600	2.27	18	135	97	50	34	45	44	See Players			No record			
'49/Peo	6-6	.500	2.90	12	93	79	40	30	29	21	See Players			5	42	2	.959
'50/Peo	12-14	.462	2.85	33	221	194	91	70	53	106	103	24	.233	18	66	0	1.000
Car (5 yrs)	30-38	.441	2.63	79	557	454	226	163	162	194	103	24	.233	41	171	4	.981

Richard, Ruth "Richie" (Born: 9/20/28, Argus, PA, TR, BL, 5'4", 134, P, C, OF)

see Players

YEAR/TEAM	W–L	PCT.	ERA	G	IP	H	R	ER	BB	SO	AB	H	BA	PO	A	E	PA
'47/GR	—	—	—	3	7	—	—	—	—	—	See Players			No record			

Ries (Zillmer), Ruth "Boots" (Born: 3/20/33, Walworth, WI, TR, BR, 5'6", 130, P)

YEAR/TEAM	W–L	PCT.	ERA	G	IP	H	R	ER	BB	SO	AB	H	BA	PO	A	E	PA
'52/Roc	0-1	.000	25.00	3	4	7	14	11	9	1	No record			No record			

Rini, Mary (Born: 3/5/25, Detroit, MI, TR, BR, 5'6", 145, P)

YEAR/TEAM	W–L	PCT.	ERA	G	IP	H	R	ER	BB	SO	AB	H	BA	PO	A	E	PA
'45/Ken	2-12	.143	3.62	23	112	103	76	45	48	15	39	0	.000	8	35	7	.860
'46/Mus	—	—	—	—	—	—	—	—	—	—	2	0	.000	No record			
Car (2 yrs)	2-12	.143	3.62	23	112	103	76	45	48	15	41	0	.000	8	35	7	.860

Risinger, Earlene "Beans" (Born: 3/20/27, Hess, OK, TR, BR, 6'2", 137, P)

Pitching											Hitting			Fielding			
YEAR/TEAM	W-L	PCT.	ERA	G	IP	H	R	ER	BB	SO	AB	H	BA	PO	A	E	PA
'48/Spr	3-8	.273	3.35	22	129	91	68	48	62	69	36	2	.056	No record			
'49/GR	15-12	.556	2.35	30	234	146	90	61	143	116	82	10	.122	16	67	4	.954
'50/GR	14-13	.519	2.38	31	231	201	76	61	87	90	88	21	.239	16	82	6	.942
'51/GR	9-9	.500	2.14	24	177	153	65	45	57	62	63	10	.159	17	71	7	.926
'52/GR	10-15	.400	2.34	27	1921	_ä50	72	50	97	82	66	10	.152	13	66	6	.919
'53/GR	15-10	.600	1.75	30	231	162	66	45	95	121	79	16	.203	19	66	4	.955
'54/GR	7-13	.350	4.06	23	153	170	87	69	58	38	53	11	.208	8	53	8	.884
Car (7 yrs)	73-80	.477	2.53	187	1347	1073	524	379	599	578	466	80	.172	89	405	35	.934
Play (5 yrs)	4-2	.667	1.93	7	42	32	14	9	27	22	16	5	.313	1	14	0	1.000

Roth, Elaine "E" (Born: 1/17/29, Michigan City, IN, TR, BR, 5'2", 123, P, OF)

Pitching											Hitting			Fielding			
YEAR/TEAM	W-L	PCT.	ERA	G	IP	H	R	ER	BB	SO	AB	H	BA	PO	A	E	PA
'48/Peo	18-15	.545	2.38	39	291	225	113	77	60	81	104	16	.154	No record			
'49/Peo	4-12	.250	2.92	24	151	146	77	49	29	15	58	5	.086	8	56	10	.865
'50/SB	7-13	.350	3.28	23	151	140	80	55	39	47	50	5	.100	7	38	7	.865
'51/Kal	5-9	.357	4.01	30	137	136	84	61	54	43	54	6	.111	4	43	6	.887
'52/Kal	2-6	.250	2.83	19	70	68	40	22	18	9	24	3	.125	3	22	2	.926
'53/Kal	4-2	.667	2.30	25	82	76	32	21	20	14	26	5	.192	4	31		01.000
'54/Kal	5-12	.294	3.14	24	146	153	75	51	40	29	54	12	.222	12	48	4	.938
Car (7 yrs)	45-69	.395	2.94	184	1028	944	501	336	260	238	370	52	.141	38	238	29	.905
Play (2 yrs)	1-2	.500	4.69	3	25	20	18	13	6	2	10	1	.100	1	2	0	1.000

Rotvig, Barbara (Hometown: Duluth, MN; Died: 12/64, TR, BR, P)

Pitching											Hitting			Fielding			
YEAR/TEAM	W-L	PCT.	ERA	G	IP	H	R	ER	BB	SO	AB	H	BA	PO	A	E	PA
'48/Ken	11-16	.407	2.84	30	209	159	99	66	96	99	72	8	.111	No record			
'49/Ken	11-15	.423	2.33	32	209	137	86	54	117	97	58	3	.052	7	81	13	.871
'51/Ken	6-10	.375	2.57	20	133	79	57	38	93	93	64	17	.266	4	52	4	.933
Car (3 yrs)	28-41	.406	2.58	82	551	375	242	158	206	289	194	28	.144	11	133	17	.895
Play (2 yr)	0-2	.000	5.63	2	8	9	6	5	7	4	3	0	.000	0	0	0	1.000

Rumsey, Janet (Born: 10/16/31, Moores Hill, IN, TR, BR, 5'8", 135, P)

Pitching											Hitting			Fielding			
YEAR/TEAM	W-L	PCT.	ERA	G	IP	H	R	ER	BB	SO	AB	H	BA	PO	A	E	PA
'51/SB, BC	4-8	.333	2.52	19	107	92	55	30	48	45	34	3	.088	5	45	3	.943
'52/SB	9-10	.474	2.22	26	178	157	62	44	47	65	51	6	.118	15	77	5	.949
'53/SB	11-19	.367	2.42	35	249	205	97	67	102	86	86	12	.145	28	110	6	.958
'54/SB	15-6	.714	2.18	25	169	131	55	41	65	89	75	20	.267	13	60	7	.910
Car (4 yrs)	39-43	.476	2.33	105	703	585	269	182	262	259	246	41	.167	60	294	21	.944
Play (3 yrs)	2-1	.666	2.74	4	23	24	10	7	10	14	6	0	.000	0	9	0	1.000

Sams, Doris "Sammy" (Born: 2/2/27, Knoxville, TN, TR, BR, 5'9", 145, P, OF)
see Players

Pitching											Hitting			Fielding			
YEAR/TEAM	W-L	PCT.	ERA	G	IP	H	R	ER	BB	SO	AB	H	BA	PO	A	E	PA
'46/Mus	8-9	.471	3.78	25	169	148	109	71	109	53	See Players			19	71	6	.938
'47/Mus	11-4	.733	0.98	19	138	81	26	15	28	34	See Players			19	65	2	.988
'48/Mus	8-10	.643	1.54	32	268	159	64	46	97	117	See Players			No record			
'49/Mus	15-10	.600	1.58	28	211	121	59	37	90	81	See Players			31	97	2	.985
'50/Kal	12-13	.480	2.60	29	218	197	87	63	83	109	See Players			22	81	9	.920
'52/Kal	0-1	.000	30.03	1	3	13	11	10	1	2	See Players			No record			
Car (6 yrs)	64-47	.577	2.16	134	1001	719	356	242	408	396	See Players			91	314	18	.958
Play (3 yrs)	1-5	.200	2.94	6	49	29	27	16	29	12	See Players			0	7	0	1.000

Satterfield, Doris (Hometown: North Belmont, NC; Died: Date Unknown, P)
see Players

Pitching											**Hitting**			**Fielding**			
YEAR/TEAM	W-L	PCT.	ERA	G	IP	H	R	ER	BB	SO	AB	H	BA	PO	A	E	PA
'47/GR	—	—	—	1	2	—	—	—	—	—	21	1	.048	No record			

Scheer, Edna "Bunny" (Born: 11/4/26, Cedarburg, WI, TR, BR, 5'5", 104, P)

Pitching											**Hitting**			**Fielding**			
YEAR/TEAM	W-L	PCT.	ERA	G	IP	H	R	ER	BB	SO	AB	H	BA	PO	A	E	PA
'50/Roc	3-1	.750	5.58	18	71	63	52	44	66	21	28	8	.286	2	15	3	.842

Schmidt (Weitzman), Violet "Vi" (Born: 5/6/27, Fort Wayne, IN, TR, BR, 5'1", 118, P)

Pitching											**Hitting**			**Fielding**			
YEAR/TEAM	W-L	PCT.	ERA	G	IP	H	R	ER	BB	SO	AB	H	BA	PO	A	E	PA
'46/Roc	No record																
'47/FW	0-0	.000	—	4	—	—	—	—	—	—	3	1	.333	No record			

Schofield, June "Moneybags" (Hometown: Toronto, ON, Canada, TR, BR, P)
see Players

Pitching											**Hitting**			**Fielding**			
YEAR/TEAM	W-L	PCT.	ERA	G	IP	H	R	ER	BB	SO	AB	H	BA	PO	A	E	PA
'48/Spr	0-1	.000	36.36	1	1	1	4	4	8	1	See Players			No record			

Schroeder, Dorothy "Dottie" (Born: 4/11/28, Champaign, IL, TR, BR, 5'7", 150, P, SS)
see Players

Pitching											**Hitting**			**Fielding**			
YEAR/TEAM	W-L	PCT.	ERA	G	IP	H	R	ER	BB	SO	AB	H	BA	PO	A	E	PA
'48/FW	0-2	.000	3.19	2	17	14	11	6	6	7	See Players			No record			
'50/FW	—	—	—	1	1	—	—	—	—	—	See Players			No record			
Car (2 yrs)	0-2	.000	3.19	3	18	14	11	6	6	7	See Players			No record			

Schweigerdt, Gloria "Tippy" (Born: 6/10/34, Chicago, IL, TR, BR, 5'4", 120, P)

Pitching											**Hitting**			**Fielding**			
YEAR/TEAM	W-L	PCT.	ERA	G	IP	H	R	ER	BB	SO	AB	H	BA	PO	A	E	PA
'50/Chic	8-7	.533	—	18	—	—	—	—	—	—	69	14	.203	No record			
'51/GR, BC	3-4	.400	2.72	14	76	63	39	23	13	36	23	6	.261	6	20	5	.839
'52/BC	10-10	.500	2.95	28	180	167	75	59	82	44	64	5	.078	6	51	1	.983
Car (2 yrs)	13-14	.481	2.88	42	256	230	114	82	95	80	87	11	.126	12	71	6	.913

Scott, Patricia A. "Pat" (Born: 7/24/29, Covington, KY, TR, BR, 5'7", 155, P, OF)

Pitching											**Hitting**			**Fielding**			
YEAR/TEAM	W-L	PCT.	ERA	G	IP	H	R	ER	BB	SO	AB	H	BA	PO	A	E	PA
'48/Spr	No record																
'51/FW	15-7	.682	2.13	26	190	153	65	45	57	62	84	12	.143	9	64	3	.961
'52/FW	17-7	.708	2.05	26	202	—	65	46	50	60	79	19	.241	18	80	1	.990
'53/FW	16-12	.571	3.06	32	238	224	102	81	67	65	98	26	.265	18	80	1	.990
Car (4 yrs)	48-26	.649	2.46	84	630	377	232	172	174	187	261	57	.218	41	209	6	.977
Play (3 yrs)	4-3	.571	1.87	8	53	30	13	11	15	24	23	2	.087	3	15	0	1.000

Skokan, Josephine (P)

Pitching											**Hitting**			**Fielding**			
YEAR/TEAM	W-L	PCT.	ERA	G	IP	H	R	ER	BB	SO	AB	H	BA	PO	A	E	PA
'43/Roc	No record																

Sloan, Frances "Sliver" (Hometown, Miami, FL; Died 6/24/86, P)

											Pitching			Hitting			Fielding		
YEAR/TEAM	W–L	PCT.	ERA	G	IP	H	R	ER	BB	SO	AB	H	BA	PO	A	E	PA		
'46/GR	—	—	—	3	—	—	—	—	—	—	No record			No record					

Smith, Jean (Born: 5/9/28, Ann Arbor, MI, BR, TR, 5'6", 128, P, OF)

see Players

											Pitching			Hitting			Fielding		
YEAR/TEAM	W–L	PCT.	ERA	G	IP	H	R	ER	BB	SO	AB	H	BA	PO	A	E	PA		
'49/FW	0-1	.000	3.38	3	8	5	3	3	3	2	See Players			No record					
'50/Peo	2-0	1.000	1.80	4	5	7	3	1	6	0	See Players			No record					
'51/Peo	7-7	.500	2.92	18	111	75	48	36	91	28	See Players			6	36	3	.930		
'52/GR	1-2	.333	5.44	14	48	50	38	29	29	15	See Players			1	15	2	.889		
Car (4 yrs)	10-10	.500	3.61	39	172	137	92	69	129	45	See Players			7	51	5	.921		

Starck, Mae (Hometown: Hamilton, ON, Canada, P)

											Pitching			Hitting			Fielding		
YEAR/TEAM	W–L	PCT.	ERA	G	IP	H	R	ER	BB	SO	AB	H	BA	PO	A	E	PA		
'47/Roc	No record																		

Stephens, Ruby (Born: 10/2/24, Clearwater, FL, TR, BR, 5'4", 115, P)

											Pitching			Hitting			Fielding		
YEAR/TEAM	W–L	PCT.	ERA	G	IP	H	R	ER	BB	SO	AB	H	BA	PO	A	E	PA		
'46/Rac	2-1	.667	—	7	34	27	30	—	21	6	16	0	.000	No record					
'47/SB	9-15	.375	2.88	31	194	162	86	62	70	25	61	11	.180	9	74	13	.865		
'48/Spr, Ken	20-11	.645	1.85	36	241	159	79	50	68	114	80	14	.175	No record					
'49/Ken	13-9	.591	1.38	32	195	131	51	30	55	51	65	9	.138	9	63	5	.935		
'50/Ken	15-9	.625	2.73	29	211	170	78	64	93	70	72	16	.222	7	55	1	.984		
'51/Ken	3-8	.273	3.77	15	86	78	56	36	31	39	31	3	.097	4	19	1	.958		
Car (6 yrs)	62-53	.539	2.35	150	961	727	380	242	338	305	325	53	.163	29	211	20	.923		
Play (3 yrs)	1-1	.500	2.12	4	17	17	10	4	0	1	4	0	.000	0	6	1	.833		

Studnicka (Brazauskas, Caden), Mary Lou "ML" (Born: 7/19/31, Chicago, IL, TR, BR, 5'5", 162, P)

											Pitching			Hitting			Fielding		
YEAR/TEAM	W–L	PCT.	ERA	G	IP	H	R	ER	BB	SO	AB	H	BA	PO	A	E	PA		
'51/GR	15-5	.750	2.33	23	164	120	72	43	72	72	63	8	.127	10	45	3	.948		
'52/GR	11-12	.478	2.53	28	185	177	81	52	70	70	62	18	.290	14	54	5	.932		
'53/GR	12-13	.480	2.56	27	176	150	79	50	84	54	64	8	.125	12	43	4	.932		
Car (3 yrs)	38-30	.559	2.49	78	525	447	232	145	226	196	189	34	.180	36	142	12	.937		
Play (1 yr)	1-0	1.000	3.01	2	12	13	7	4	6	9	4	0	.000	2	2	0	1.000		

Tetro (Atkinson), Barbara (Hometown: Grand Rapids, MI, RP, U)

											Pitching			Hitting			Fielding		
YEAR/TEAM	W–L	PCT.	ERA	G	IP	H	R	ER	BB	SO	AB	H	BA	PO	A	E	PA		
'48/GR	—	—	—	1	—	—	—	—	—	—	No record			No record					

Tezak (Papesh), Virginia May Rita "Ginny" (Born: 5/22/28, Joliet, IL 5'6", 145, P, OF, 1B)

											Pitching			Hitting			Fielding		
YEAR/TEAM	W–L	PCT.	ERA	G	IP	H	R	ER	BB	SO	AB	H	BA	PO	A	E	PA		
'48/Rac	No record									7	0	.000	No record						

Thompson, Annabelle (Hometown: Edmonton, AB, Canada, TR, BR, P)

											Pitching			Hitting			Fielding		
YEAR/TEAM	W–L	PCT.	ERA	G	IP	H	R	ER	BB	SO	AB	H	BA	PO	A	E	PA		
'43/Rac	11-15	4.23	3.51	32	223	237	159	86	64	28	85	13	.153	11	78	10	.900		

Thompson (Griffin), Viola "Tommy" (Born: 1/2/22, Greenville, SC, TL, BL, 5'5", 120, P)

Pitching											Hitting			Fielding			
YEAR/TEAM	W-L	PCT.	ERA	G	IP	H	R	ER	BB	SO	AB	H	BA	PO	A	E	PA
'44/Mil	15-12	.555	2.88	33	222	217	120	71	73	27	67	8	.119	9	60	15	.821
'45/GR	11-19	.367	1.90	34	260	209	91	55	101	58	77	8	.104	9	78	6	.935
'46/SB	15-6	.714	2.90	31	202	195	104	65	62	14	66	4	.061	10	46	9	.862
'47/SB	—	—	—	1	1	—	—	—	—	—	1	0	.000	No record			
Car (4 yrs)	41-37	.526	2.51	99	685	621	315	191	236	99	211	20	.095	28	184	30	.876
Play (1 yr)	0-0	.000	3.00	2	9	0	3	3	0	0	1	0	.000	0	1	0	1.000

Tipton, Gloria (Hometown: Dayton, OH, TL, BL, P)

Pitching											Hitting			Fielding			
YEAR/TEAM	W-L	PCT.	ERA	G	IP	H	R	ER	BB	SO	AB	H	BA	PO	A	E	PA
'46/Ken	No record																

Tucker, Elizabeth "Betty" (Born: 11/28/24, Detroit, MI, TR, BR, 5'4", 123, P)

Pitching											Hitting			Fielding			
YEAR/TEAM	W-L	PCT.	ERA	G	IP	H	R	ER	BB	SO	AB	H	BA	PO	A	E	PA
'46/Peo	1-12	.077	3.38	22	125	105	85	47	64	20	48	10	.208	5	49	10	.844
'47/FW, Roc, GR	0-12	.000	3.72	16	92	88	63	38	36	18	28	2	.071	6	37	6	.878
'48/Chic	11-17	.393	2.68	33	238	162	106	71	112	90	86	18	.209	No record			
'49/Peo	4-8	.333	2.67	16	118	108	51	35	35	25	37	7	.189	6	40	3	.939
Car (4 yrs)	16-49	.246	3.00	187	573	463	305	191	247	153	199	37	.186	17	126	19	.883
Play (1 yr)	0-0	.000	0.00	1	2	0	0	0	2	0	0	0	.000	0	0	0	1.000

Tysver (Chiancola), Joan (Born: 1931, Glouchester, MA; Died 12/20/92, P)

Pitching											Hitting			Fielding			
YEAR/TEAM	W-L	PCT.	ERA	G	IP	H	R	ER	BB	SO	AB	H	BA	PO	A	E	PA
'50/GR	0-1	.000	10.14	1	8	11	10	9	11	3	No record			No record			
'51/Roc	0-2	9.28	9.28	9	32	40	42	33	37	4	No record			No record			
Car (2 yrs)	0-3	.000	9.46	10	40	51	52	42	48	7	No record			No record			

Vanderlip (Ozburn), Dollie "Lippy" (Born: 6/4/37, Charlotte, NC, TR, BR, 5'8", 140, P)

Pitching											Hitting			Fielding			
YEAR/TEAM	W-L	PCT.	ERA	G	IP	H	R	ER	BB	SO	AB	H	BA	PO	A	E	PA
'52/FW	0-4	.000	3.93	10	39	25	26	17	35	11	14	1	.071	0	19	3	.864
'53/FW	2-2	.500	2.88	14	50	40	25	16	32	14	12	0	.000	8	21	2	.935
'54/SB	11-6	.647	2.40	19	120	122	53	32	65	39	43	8	.186	8	56	4	.941
Car (3 yrs)	13-12	.520	2.80	43	209	187	104	65	132	64	69	9	.130	16	96	9	.926
Play (1 yr)	0-0	.000	3.00	2	9	5	3	3	4	2	3	0	.000	1	0	0	1.000

Vincent (Mooney), Georgette "Jette" (Born: 7/5/28, Fall River, MA; Died: Date Unknown, TR, BR, 5'3", 130, P)

Pitching											Hitting			Fielding			
YEAR/TEAM	W-L	PCT.	ERA	G	IP	H	R	ER	BB	SO	AB	H	BA	PO	A	E	PA
'47/Rac	No record									7	4		.000	No record			
'48/Rac	5-2	.714	3.66	15	59	41	34	24	59	28	36	4	.111	1	1	0	1.000
'49/SB	3-2	.600	3.50	11	36	20	18	14	34	13	15	0	.000	5	14	3	.864
'50/SB	8-12	.400	3.12	21	153	125	82	53	105	72	107	20	.187	12	57	5	.932
'51/SB	13-9	.591	2.42	23	171	113	55	46	88	113	58	9	.155	22	54	5	.938
'52/SB	8-8	.500	2.36	24	160	140	69	42	68	65	71	12	.169	11	59	4	.946
'54/SB	1-1	.500	5.58	3	21	18	18	13	20	8	No record			No record			
Car (7 yrs)	38-34	.527	2.88	97	600	457	276	192	374	299	294	45	.153	51	185	17	.933
Play (3 yrs)	1-2	.333	4.69	3	25	27	17	13	3	8	34	6	.176	15	9	2	.944

Voyce, Inez "Lefty" "Hook" (Born: 8/16/24, Rathbun, IA, TL, BL, 5'6", 148, P, 1B)
see Players

YEAR/TEAM	W-L	PCT.	ERA	G	IP	H	R	ER	BB	SO	AB	H	BA	PO	A	E	PA
											Hitting			Fielding			
'48/GR	1-1	.500	3.43	4	21	20	8	8	5	0	See Players			No record			

Vukovich, Francis "Be Bop" (Born: 8/30/30, Smithdale, PA, TL, BL, 5'7", 140, P)

YEAR/TEAM	W-L	PCT.	ERA	G	IP	H	R	ER	BB	SO	AB	H	BA	PO	A	E	PA
											Hitting			Fielding			
'50/Chic	9-9	.500	—	20	—	—	—	—	—	—	67	19	.284	No record			
'51/BC	0-3	.000	5.08	5	16	8	18	9	16	3	No record			No record			

Waggott (P)

YEAR/TEAM	W-L	PCT.	ERA	G	IP	H	R	ER	BB	SO	AB	H	BA	PO	A	E	PA
											Hitting			Fielding			
'52/BC	—	—	—	1	1	—	—	—	—	—	No record			No record			

Wagner, Audrey (Born: 12/27/27, Bensenville, IL; Died: Date Unknown, TR, BR, 5'7", 145, P, OF)
see Players

YEAR/TEAM	W-L	PCT.	ERA	G	IP	H	R	ER	BB	SO	AB	H	BA	PO	A	E	PA
											Hitting			Fielding			
'43/Ken	1-2	.333	3.66	5	30	36	23	11	7	5	See Players			No record			
'47/Ken	—	—	—	2	5	—	—	—	—	—	See Players			No record			
Car (2 yrs)	1-2	.333	3.66	7	35	36	23	11	7	5	See Players			No record			

Wagoner, Betty "Waggy" (Born: 6/15/30, Lebanon, MO, TR, BR, 5'1", 110, P, OF)
see Players

YEAR/TEAM	W-L	PCT.	ERA	G	IP	H	R	ER	BB	SO	AB	H	BA	PO	A	E	PA
											Hitting			Fielding			
'50/SB	0-3	.000	4.14	4	24	22	12	11	18	9	No record			No record			
'51/SB	—	—	—	1	1	—	—	—	—	—	See Players			No record			
'52/SB	5-2	.714	4.25	9	55	53	31	26	31	15	See Players			No record			
'53/SB	4-13	.235	3.02	19	149	150	84	50	106	60	See Players			21	61	12	.872
'54/SB	4-4	.500	4.66	9	58	59	42	30	38	34	See Players			No record			
Car (5 yrs)	13-22	.371	3.68	42	287	284	169	117	193	118	See Players			21	61	12	.872
Play (1 yr)	0-0	.000	3.00	1	9	6	5	3	6	7	See Players			No record			

Walker, Martha (P)

YEAR/TEAM	W-L	PCT.	ERA	G	IP	H	R	ER	BB	SO	AB	H	BA	PO	A	E	PA
											Hitting			Fielding			
'43/Rac	No record — played less than 10 games																

Walulik (Kiely), Helen "Hensky" (Born: 5/3/29, Plainfield, NJ, TR, BR, 5'8", 121, P, OF, 2B)
see Players

YEAR/TEAM	W-L	PCT.	ERA	G	IP	H	R	ER	BB	SO	AB	H	BA	PO	A	E	PA
											Hitting			Fielding			
'48/Mus, FW	2-6	.250	3.07	17	91	71	42	31	44	29	25	3	.120	No record			
'50/Kal	1-2	.333	3.63	15	57	56	40	23	44	17	See Players			6	14	3	.870
Car (2 yrs)	3-8	.273	3.28	32	148	127	82	54	88	46	25	3	.120	6	14	3	.870

Warfel, Betty (Born: 5/15/26, Enola, PA; Died: 9/23/90, 5'8", 125, P)
see Players

Pitching											Hitting			Fielding			
YEAR/TEAM	W-L	PCT.	ERA	G	IP	H	R	ER	BB	SO	AB	H	BA	PO	A	E	PA
'48/Roc	1-0	1.000	1.06	6	17	7	6	2	11	5	See Players			No record			
'49/Roc	5-5	.500	2.96	14	79	50	30	26	37	13	58	4	.069	4	34	3	.927
Car (2 yrs)	6-5	.545	2.63	20	96	57	32	28	48	18	58	4	.069	4	34	3	.927

Warren, Nancy "Hank" (Born: 6/13/21, Springfield, OH, TR, BR, 5'5", 130, P)
see Players

Pitching											Hitting			Fielding			
YEAR/TEAM	W-L	PCT.	ERA	G	IP	H	R	ER	BB	SO	AB	H	BA	PO	A	E	PA
'46/Mus	4-6	.400	2.12	11	85	60	33	20	25	40	See Players			3	35	0	1.000
'47/Mus	17-11	.607	1.13	31	223	142	54	28	25	93	81	16	.198	21	75	8	.923
'48/Mus	12-5	.706	1.45	23	161	103	47	26	52	86	62	11	.177	No record			
'49/Peo	10-16	.385	3.00	27	192	135	92	64	63	79	61	8	.131	16	74	2	.978
'50/Peo	13-13	.500	2.37	32	228	198	82	60	53	86	81	10	.123	9	91	5	.952
'51/Peo, FW	10-10	.500	2.20	27	188	146	67	46	63	79	64	10	.156	6	69	10	.882
'52/FW	17-7	.708	2.14	27	219	189	87	52	53	91	82	18	.220	7	97	5	.954
'53/Mus	6-17	.261	2.70	28	200	195	107	60	71	100	66	5	.076	6	70	5	.938
'54/Kal	12-9	.571	4.65	26	151	155	98	78	70	63	56	8	.143	5	49	0	1.000
Car (9 yrs)	101-94	.518	2.37	232	1647	323	667	434	475	717	553	86	.156	73	560	35	.948
Play (4 yrs)	2-2	.500	2.20	8	41	33	16	10	18	14	13	1	.077	2	9	1	.917

Watson (Stanton), Marion (Born: 7/2/23, Chatham, ON, Canada; Died: 7/15/97, TL, BR, 5'10", 185, P)

Pitching											Hitting			Fielding			
YEAR/TEAM	W-L	PCT.	ERA	G	IP	H	R	ER	BB	SO	AB	H	BA	PO	A	E	PA
'46/Peo	No record																
'47/Mus	0-0	.000	—	8	—	—	—	—	—	—	11	0	.000	No record			

Weaver, Jean (Born: 8/28/33, Metropolis, IL, TR, BR, 5'8", 138, P, 3B, OF)
see Players

Pitching											Hitting			Fielding			
YEAR/TEAM	W-L	PCT.	ERA	G	IP	H	R	ER	BB	SO	AB	H	BA	PO	A	E	PA
'52/FW	0-2	.000	12.90	5	14	24	31	20	2410	_ö	See Players			No record			
'53/FW	7-1	.875	2.64	20	92	60	43	27	76	41	48	15	.313	10	37	4	.922
Car (2 yrs)	7-3	.700	3.99	25	106	84	74	47	100	51	48	15	.313	10	37	4	.922

Weaver, Joanne "The Little" (Hometown: Metropolis, IL , BR, TR, 5'11", 142, P, OF)

Pitching											Hitting			Fielding			
YEAR/TEAM	W-L	PCT.	ERA	G	IP	H	R	ER	BB	SO	AB	H	BA	PO	A	E	PA
'50/FW	—	—	—	1	1	—	—	—	—	—	See Players			No record			
'51/FW	—	—	—	1	2	—	—	—	—	—	See Players			No record			
'52/FW	—	—	—	1	1	—	—	—	—	—	See Players			No record			
Car (3 yrs)	—	—	—	3	4	—	—	—	—	—	See Players			No record			

Weddle (Hines), Mary "Giggles" (Born: 4/26/34, Woodsfield, OH, TR, BR, 5'3", 118, P, 3B, OF)
see Players

Pitching											Hitting			Fielding			
YEAR/TEAM	W-L	PCT.	ERA	G	IP	H	R	ER	BB	SO	AB	H	BA	PO	A	E	PA
'54/FW	3-1	.750	3.83	15	47	23	30	20	60	21	See Players			1	10	1	.889

Wegman, Marie "Blackie" (Born: 4/30/25, Cincinnati, OH, TR, BR, 5'7", 130, P, 3B, 2B, OF)

see Players

Pitching											Hitting			Fielding			
YEAR/TEAM	W–L	PCT.	ERA	G	IP	H	R	ER	BB	SO	AB	H	BA	PO	A	E	PA
'48/FW	0-0	.000	6.56	3	11	13	11	8	9	5	See Players			No record			

Wiley (Sears), Janet "Pee Wee" (Born: 10/12/33, South Bend, IN, TR, BR, 5'4", 112 P, 1B)

see Players

Pitching											Hitting			Fielding			
YEAR/TEAM	W–L	PCT.	ERA	G	IP	H	R	ER	BB	SO	AB	H	BA	PO	A	E	PA
'53/Roc	—	—	—	1	1	—	—	—	—	—	See Players			No record			

Williams (Heverly), Ruth (Born: 2/12/26, Nescopeck, PA, TR, BR, 5'4", 130, P)

Pitching											Hitting			Fielding			
YEAR/TEAM	W–L	PCT.	ERA	G	IP	H	R	ER	BB	SO	AB	H	BA	PO	A	E	PA
'46/FW	No record									5	0	.000		No record			
'47/SB	12-8	.600	1.70	25	180	115	51	34	50	48	59	8	.136	17	58	4	.949
'48/SB	10-10	.500	2.25	23	160	126	53	40	66	55	55	7	.127	No record			
'49/SB	10-6	.625	1.64	25	170	119	48	31	60	41	48	8	.167	16	66	2	.976
'50/SB, Peo, Kal	5-10	.333	3.47	19	121	122	68	48	59	40	34	4	.118	5	43	2	.960
'51/Kal	10-11	.476	1.96	25	156	117	47	34	45	59	45	6	.133	9	56	7	.903
'52/Kal	10-12	.455	2.48	23	174	156	71	48	52	41	52	8	.154	9	76	4	.955
'53/Kal	8-12	.400	2.12	22	153	124	65	36	63	31	40	3	.075	8	57	5	.929
Car (8 yrs)	65-69	.485	2.19	162	1114	879	403	271	395	315	333	44	.132	64	356	24	.946
Play (3 yrs)	1-2	.000	2.17	4	29	19	7	7	7	6	7	0	.000	1	4	0	1.000

Wiltse (Collins), Dorothy "Dottie" (Born: 9/23/23, Inglewood, CA, TR, BR, 5'7", 125, P)

Pitching											Hitting			Fielding			
YEAR/TEAM	W–L	PCT.	ERA	G	IP	H	R	ER	BB	SO	AB	H	BA	PO	A	E	PA
'44/Mpls	20-16	.556	1.88	38	297	156	107	62	130	205	107	13	.121	21	89	10	.917
'45/FW	29-10	.744	0.83	46	345	132	58	32	111	293	113	12	.106	30	55	8	.914
'46/FW	22-20	.524	2.32	49	298	199	102	76	126	93	113	12	.106	27	91	5	.959
'47/FW	20-14	.588	1.33	40	292	156	57	43	88	244	85	16	.024	29	54	3	.965
'48/FW	13-8	.619	2.01	24	175	121	60	39	62	101	48	5	.104	No record			
'50/FW	13-8	.619	3.46	26	169	132	86	65	95	68	57	8	.140	8	38	6	.885
Car (6 yrs)	117-76	.606	1.81	223	1576	896	470	317	612	1004	410	54	.106	115	327	32	.933
Play (2 yrs)	6-2	.750	1.89	10	67	42	18	14	28	41	27	2	.074	2	11	0	1.000

Winter, Joanne "Jo" (Born: 11/24/24, Chicago, IL; Died: 9/22/96, TR, BR, 5'8", 138, P)

Pitching											Hitting			Fielding			
YEAR/TEAM	W–L	PCT.	ERA	G	IP	H	R	ER	BB	SO	AB	H	BA	PO	A	E	PA
'43/Rac	11-11	.500	2.57	29	200	201	121	57	47	13	83	21	.253	12	74	4	.956
'44/Rac	15-23	.395	2.96	40	310	276	172	102	133	52	127	21	.165	31	114	12	.924
'45/Rac	7-22	.241	2.53	34	256	209	125	72	77	35	118	14	.119	26	115	8	.946
'46/Rac	33-10	.767	1.19	46	349	199	82	46	132	183	115	25	.217	26	108	9	.937
'47/Rac	22-13	.629	2.06	38	297	222	93	68	122	121	105	17	.162	22	91	7	.942
'48/Rac	25-12	.676	1.18	38	329	49	67	43	86	248	100	12	.120	No record			
'49/Rac	11-13	.458	2.17	32	228	156	84	55	95	72	66	6	.091	17	71	6	.936
'50/Rac	9-11	.450	2.46	30	190	158	78	52	67	46	76	17	.224	5	47	2	.963
Car (8 yrs)	133-115	.536	2.06	287	2159	1470	822	495	759	770	790	133	.168	139	620	48	.941
Play (5 yrs)	8-3	.727	2.01	13	103	65	33	23	44	25	31	4	.129	3	25	1	.966

Wisniewski, Connie "Iron Woman" "Polish Rifle" (Born: 2/18/22, Detroit, MI; Died: 5/4/95, TR, BL, 5'8", 147, P, OF)

see Players

Pitching											Hitting			Fielding			
YEAR/TEAM	W-L	PCT.	ERA	G	IP	H	R	ER	BB	SO	AB	H	BA	PO	A	E	PA
'44/Mil	23-10	.697	2.23	36	291	200	88	72	47	49	111	17	.153	31	132	5	.970
'45/GR	32-11	.744	0.81	46	391	206	64	35	61	82	138	27	.196	15	172	20	.903
'46/GR	33-9	.786	0.96	48	366	235	71	39	59	79	136	34	.250	23	159	5	.973
'47/GR	16-14	.533	2.15	32	264	223	82	63	49	44	See Players			17	93	6	.948
'48/GR	3-4	.429	2.47	8	62	60	31	17	29	12	See Players			No record			
Car (5 yrs)	107-48	.690	1.48	170	1374	924	336	226	245	266	385	78	.203	86	556	36	.947
Play (4 yrs)	8-6	.571	1.06	16	119	71	21	14	18	16	32	6	.171	3	51	3	.947

Wood, Loita (Hometown: Lima, OH, TR, BR, P)

Pitching											Hitting			Fielding			
YEAR/TEAM	W-L	PCT.	ERA	G	IP	H	R	ER	BB	SO	AB	H	BA	PO	A	E	PA
'50/FW	—	—	—	2	1	—	—	—	—	—	No record			No record			
'51/Ken	3-16	.158	4.75	24	165	166	116	87	37	72	10	.139			63	1	.985
Car (2 yrs)	3-16	.158	4.73	26	166	166	116	87	37	72	10	.139			63	1	.985

Wronski (Straka), Sylvia "Roni" (Born: 12/2/24, Milwaukee, WI; Died: 11/28/97, TR, BR, 5'2", 140, P)

Pitching											Hitting			Fielding			
YEAR/TEAM	W-L	PCT.	ERA	G	IP	H	R	ER	BB	SO	AB	H	BA	PO	A	E	PA
'44/Mil	4-2	.667	3.06	13	53	44	33	18	30	2	20	1	.050	8	23	7	.816
'45/GR	0-0	.000	0.00	4	11	—	—	—	—	—	No record			No record			
Car (2 yrs)	4-2	.667	2.54	17	64	44	33	18	30	2	20	1	.050	8	23	7	.816

Young, Janet (P)

Pitching											Hitting			Fielding			
YEAR/TEAM	W-L	PCT.	ERA	G	IP	H	R	ER	BB	SO	AB	H	BA	PO	A	E	PA
'51/BC	—	—	—	2	3	—	—	—	—	—	No record			No record			

Youngberg, Renae "Ray" (Born: 4/3/33, Waukegan, IL, TR, BR, 5'6", 150, P, 3B)

see Players

Pitching											Hitting			Fielding			
YEAR/TEAM	W-L	PCT.	ERA	G	IP	H	R	ER	BB	SO	AB	H	BA	PO	A	E	PA
'54/SB	—	—	—	1	4	—	—	—	—	—	See Players			No record			

Ziegler, Alma "Gabby" "Ziggy" (Born: 1/9/21, Chicago, IL TR, BR, 5'3", 125, P, SS, 2B)

see Players

Pitching											Hitting			Fielding			
YEAR/TEAM	W-L	PCT.	ERA	G	IP	H	R	ER	BB	SO	AB	H	BA	PO	A	E	PA
'48/GR	9-6	.600	1.21	18	119	76	21	16	24	49	See Players			No record			
'49/GR	2-1	.667	1.16	5	31	26	7	4	8	4	See Players			No record			
'50/GR	19-7	.731	1.38	35	235	173	49	36	33	84	See Players			21	112	7	.950
'51/GR	14-8	.636	1.26	22	171	112	38	24	65	62	See Players			15	76	4	.958
'52/GR	3-4	.429	2.50	12	72	77	34	20	9	7	See Players			4	22	4	.867
'53/GR	8-4	.667	3.03	17	116	98	43	39	28	28	See Players			5	58	1	.984
'54/GR	5-4	.556	3.98	17	95	115	58	42	36	16	See Players			6	25	1	.969
Car (7 yrs)	60-34	.638	1.94	126	839	677	250	181	203	250	See Players			51	293	17	.953
Play (5 yrs)	3-6	.333	2.28	9	83	68	31	21	23	26	See Players			8	33	2	.953

Ziemak, Frances P (Hometown: Jamaica, NY)

Pitching											Hitting			Fielding			
YEAR/TEAM	*W–L*	*PCT.*	*ERA*	*G*	*IP*	*H*	*R*	*ER*	*BB*	*SO*	*AB*	*H*	*BA*	*PO*	*A*	*E*	*PA*
'51/Peo	0-1	.000	6.00	2	9	10	7	6	9	2	No record			No record			

Zurkowski (Holmes), Agnes "Aggie" (Born: 2/21/20, Regina, SK, Canada, P)

Pitching											Hitting			Fielding			
YEAR/TEAM	*W–L*	*PCT.*	*ERA*	*G*	*IP*	*H*	*R*	*ER*	*BB*	*SO*	*AB*	*H*	*BA*	*PO*	*A*	*E*	*PA*
'45/Rac, FW	0-1	.000	5.89	4	12	26	19	17	9	2	No record			No record			

VII

Other League Personnel

MANAGERS

Many of the league managers were former Major League players, including Hall of Famers Max Carey and Jimmie Foxx. A few of the players also managed teams, some as a result of suspensions. Bonnie Baker was the only full-time female manager in the league, running the Kalamazoo Lassies in 1950.

Following is a list of the managers, but years they served is unknown because the league failed to keep accurate records.

• **Ainsmitte, Eddie**: Rockford Peaches and Fort Wayne Daisies. Ainsmitte played in the major leagues from 1910 to 1924 for five different clubs: Washington Senators, Detroit Tigers, St. Louis Cardinals, Brooklyn Dodgers and New York Giants. The catcher was a career .232 hitter and appeared in 1,078 games.

• **Allington, Bill**: Rockford Peaches and Fort Wayne Daisies. After the league folded in 1954, Allington formed a traveling team of former players and barnstormed the country for three more years. He was the winningest manager in the AAGPBL.

• **Baker, Bonnie**: Kalamazoo Lassies. The Canadian was the only player and woman ever hired full time to manage a women's team. The All-Star catcher played

a total of nine years in the league and managed for one season.

• **Bancroft, Dave**: South Bend Blue Sox. Bancroft was a shortstop in the majors from 1925 to 1930, playing for the Philadelphia Phillies, New York Giants and Brooklyn Dodgers. The adept fielder twice led the league in fielding percentage. He played in 1,913 games and hit .279.

• **Bass, Dick**: Fort Wayne Daisies. Bass had a cup of coffee in the majors, pitching one game in 1939 with the Washington Senators. Bass fell in love with one of his players and was inexperienced with female players, which led to his dismissal before his first season was up.

• **Bigbee, Carson**: Springfield Sallies. Bigbee lasted 11 years in the majors with the

Pittsburgh Pirates. The outfielder hit .287 lifetime. His best season came in 1922 when he hit .350 for the year.

• **Billings, Josh**: Kenosha Comets. A pitcher in the majors for three seasons with the Detroit Tigers, Billings was 10-15 lifetime with a 5.03 ERA.

• **Boyle, Ralph**: Muskegon Lassies. "Buzz" Boyle played five seasons in the majors for the Boston Braves and Brooklyn Dodgers. The outfielder hit .290 lifetime.

• **Bush, Guy**: "The Mississippi Mudcat" hurled 17 years in the majors with the Chicago Cubs, Pittsburgh Pirates, Boston Braves, St. Louis Cardinals and Cincinnati Reds. He twice played in the World Series with the Cubs. His best season in the majors was with the Cubs in 1933 when he was 20–12. He had a lifetime 3.86 ERA.

• **Carey, Max**: Milwaukee Chicks, Fort Wayne Daisies. Carey was an outstanding outfielder for two decades in the majors and was named to the National Baseball Hall of Fame in 1961. He led the National League in stolen bases for ten years and putouts for nine years, which led to him being nicknamed "Scoops." After his playing career he managed minor and major league teams before coming to the AAGPBL, where he managed and was president of the league for a spell.

• **Cooper, Joseph**.

• **Cruthers, Press**: Kenosha Comets. Cruthers had a brief stint in the majors as a second baseman for the Philadelphia Athletics.

• **Derringer, Norm**: Racine Belles. "Nummy" was a shortstop phenom in softball and was selected as MVP in the National Softball Tournament in 1934. He was also twice named as an All-Star in the National Fastpitch League.

• **Edwards, Bill**: Rockford Peaches.

• **English, Woody**: Grand Rapids Chicks. English played for a decade with the Chicago Cubs and Brooklyn Dodgers. The shortstop appeared in the first All-Star Game in 1933. He twice helped lead the Cubs to the World Series. He once led the league in fielding and was a .286 lifetime hitter.

• **Foxx, Jimmie**: Fort Wayne Daisies. "Double XX" was named to the National Baseball Hall of Fame before managing in the AAGPBL. Foxx had a stellar 20-year career in the majors with the Philadelphia Athletics and Phillies, Boston Red Sox and Chicago Cubs. He played on nine All-Star Teams and three World Series squads. The home-run hitter led the league four times in that department on his way to 534 lifetime round-trippers. Foxx's drinking problems shortened his stay in the league as a manager in 1952.

• **Gottselig, Johnny**: Racine Belles and Peoria Red Wings. He led the Belles to the first championship in 1943. Born in Russia, he was brought up in Canada before coming to the United States. He was a hockey player with the Chicago Blackhawks and played baseball.

• **Grant, Chet**: South Bend Blue Sox and Kenosha Comets.

• **Griener, Harold**: Fort Wayne Daisies.

• **Johnson, George**: Fort Wayne Daisies.

• **Jonnard, Bubber**: Minneapolis Millerettes. Jonnard was a part-time catcher in the big leagues for six seasons with the Chicago White Sox, Pittsburgh Pirates, Philadelphia Phillies and St. Louis Cardinals.

• **Kloza, Nap**: Rockford Peaches. Kloza had a brief stint in the majors as an outfielder.

• **McManus, Marty**: Kenosha Comets and South Bend Blue Sox. McManus played for 15 seasons in the majors with the St. Louis Browns, Detroit Tigers, Boston Red

Sox and Braves. He once led the league in doubles, stolen bases and fielding at third base.

• **Meyer, Benny**: Grand Rapids Chicks. The outfielder played a couple of seasons in the majors for the Brooklyn Dodgers and Philadelphia Phillies and a season for Baltimore in the Federal League.

• **Murphy, Leo**: Racine Belles. Murphy was a catcher for one summer with the Pittsburgh Pirates.

• **Niehoff, Bert**: South Bend Blue Sox. Niehoff was an infielder for six seasons in the majors with the Cincinnati Reds, Philadelphia Phillies, St. Louis Cardinals and New York Giants. He led the National League in doubles in 1916 and was a .240 career hitter.

• **Rawlings, Johnny**: Grand Rapids Chicks. "Red" played professionally for 12 years, including two seasons with Kansas City of the Federal League. The infielder also had stints with the Cincinnati Reds, Boston Braves, Philadelphia Phillies, New York Giants and Pittsburgh Pirates. He helped lead the Braves to the World Series once.

• **Rogers, Bill**: Peoria Red Wings.

• **Rohrer, William**: Fort Wayne Daisies.

• **Schrall, Leo**: Peoria Red Wings.

• **Shinners, Ralph**: Kenosha Comets. The outfielder played three seasons in the majors with the New York Giants and St. Louis Cardinals.

• **Skupien, Mitch**: Kalamazoo Lassies.

• **Stis, Charles**: Racine Belles. Managed for half a season in 1945.

• **Stumph, Eddie**: Rockford Peaches and Kenosha Comets. One of the original managers of the league with the 1943 Rockford Peaches.

• **Wambsganss, Bill**: Fort Wayne Daisies and Muskegon Lassies. "Wamby" played in the majors from 1914 to 1926 with the Cleveland Indians, Boston Red Sox and Philadelphia Athletics. The infielder played in one World Series and was a .259 lifetime hitter.

• **Winsch, Karl**: South Bend Blue Sox. Winsch pitched in the minor leagues. He married South Bend Blue Sox pitcher Jean Faut before he managed the team to a championship.

• **Zintak, Lennie**

CHAPERONES

The league incorporated chaperones to manage the players off the field. The chaperone was responsible for everything from bandaging bruises to approving players' living quarters. They made sure the players lived up to the standards the league set for them. Some chaperones later became players. In later years, some teams did away with the chaperone as a cost saving measure and had one of the players take on the role.

Anderson, Marie: Racine Belles
Baker, Hilda
Baker, Mary
Baker, Mildred: Peoria Redwings
Behrens, Catherine: Kenosha Comets
Carrigg, Virginia: Racine Belles
Christensen, Edna
Deegan, Mildred: Rockford Peaches
Gerring, Betty: Peoria Redwings

Green, Dottie: Rockford Peaches
Hannah, Helen: Muskegon Lassies
Hagemann, Jo: Kenosha Comets
Harrington, Helen
Hohlmayer, Alice: Peoria Redwings
Hunter, Dottie: Milwaukee/Grand Rapids Chicks
Ives, Irene: Peoria Redwings
Kensler, Eunice

Liebrick, Barbara: Kalamazoo Lassies
Lundahl, Mildred: Rockford Peaches
McCutchen, Lex: Kenosha Comets
Moore, E.E.: South Bend Blue Sox
Moore, Helen: South Bend Blue Sox
Moore, Lucile: South Bend Blue Sox
Peterson, Ruth: Racine Belles
Rauner, Helen: Fort Wayne Daisies
Rieber, Geraldine
Rudis, Mary
Ryan, Ada: Kenosha Comets, Minneapolis
 Millerettes

Stancevic, Marian: Fort Wayne Daisies
Stefanie, Marge: South Bend Blue Sox
Strovroff, Shirley: South Bend Blue Sox
Tetzlaff, Doris: Fort Wayne Daisies
Timm, Marie: Rockford Peaches
Waca, Ruth: Peoria Redwings
Wagoner, Irene: South Bend Blue Sox
Way, Rose Virginia: South Bend Blue Sox
Wilson, Mildred: Racine Belles

UMPIRES

The league employed professional umpires, but it did not keep any records of umpires. Umpires were paid and many came from local recreation departments. Here is a partial list of umpires, many of whom called playoff and championship games.

Anderson
Barowski
Bartel
Batwinski
Bender, Dave
Block
Braden, Lewis
Ceccanese, Joe
Chapman, Al
Cromwell
Dewey, Llewellyn
Fuhst, Milton
Gembler, Al
Giacinti, Remo
Gradeless
Green, Bill
Hostetler
Hughes

Johnson
Kober
Koehnlein, Al
Kott
Kowalweski
Lewis, Braden
Llewellyn, Dewey
Loew
Meredith
Papich
Passage
Piet
Porter, "Knotty"
Pratt
Ringenberg
Rumser
Rymkus, Lou
Schalk, Ray

Schulte, Fred
Sears
Sinter
Spurgeon
Stover, Al
Tielker
Touns, James
Ullenberg, Charles
VanEennenaam
Vanportfleit
Ward, Norris
Webster
Wierzbicki
Woudstra
Zeagranti
Zoss, Barney

VIII

Playing Schedule

The All-American Girls Professional Baseball League worked on a much shorter schedule than Major League Baseball. Spring training usually did not get underway until late April or early May. The season usually started in late May or early June. The season wrapped up in early September, followed by the playoffs.

Spring Training

Like the majors, the league traveled south for spring training after the war ended. In 1946, the women trained in Pascagoula, Mississippi. The following season, the league made a historic trip to Havana, Cuba, which was an adventure. "There was a revolution for two days and we couldn't leave the hotel," recalled player Thelda Marshall. "We had to lower buckets so they could send us up Cokes."

Cartha Doyle became ill from the food in Cuba. "They called it steak, but it didn't taste very good," she explained.

Upon returning from Cuba, the league played an exhibition game in Fort Custer. "They still had German soldiers there with 'PW' on their backs," Vivian Kellogg said.

The following season, the league returned to practicing in the South. "When we went to Opa-Locka [Florida], that was paradise," remembered Len Surkowski, a Canadian player.

The league stopped training all the teams in one place in later years and left training locations up to individual teams. Some teams still traveled south, while others stayed in the Midwest. Dottie Schroeder remembered her Fort Wayne Daisies going to Newport, North Carolina, in 1952. She remembered her team playing some men's teams, like the House of David, a famed barnstorming team.

Doubleheaders

Unlike the majors and most minor leagues, the women's league scheduled double-headers. The inaugural season scheduled single games every day of the week with double-headers on Sunday. In the following season, doubleheaders were put on other days. If many rainouts occurred, it put a real strain on the schedule, resulting in back-to-back double-headers later in the season. If games did not matter in the standings late in the season, they were not made up. Also, tied games were not suspended or made up and would not count in the standings:

The AAGPBL scheduled 108 regular-season games in the first season. This number steadily increased and the season became longer as the league grew. The schedule peaked in 1948 with 128 games each scheduled for the ten teams. However, the decline of the league after that resulted in fewer games each season until the last year when only 98 games were scheduled.

Most games were played at night to take advantage of better attendance. However, day games were sometimes necessary at parks shared with other teams.

1944 Playing Schedule

Date	Games	Date	Games
May 27	Rockford at Minneapolis South Bend at Milwaukee (D) Kenosha at Racine	May 27	Rockford at Minneapolis South Bend at Milwaukee Kenosha at Racine
May 28	Rockford at Minneapolis (2) South Bend at Milwaukee (2) Kenosha at Racine (2)	May 28	Rockford at Minneapolis South Bend at Milwaukee Kenosha at Racine
May 29	Rockford at Minneapolis South Bend at Milwaukee (2) Kenosha at Racine	May 29	Rockford at Minneapolis South Bend at Milwaukee Kenosha at Racine
May 30	Minneapolis at Kenosha (2) Milwaukee at Rockford (2) Racine at South Bend (2)	May 30	Minneapolis at Kenosha Milwaukee at Rockford Racine at South Bend
May 31	Minneapolis at Kenosha Milwaukee at Rockford Racine at South Bend	May 31	Minneapolis at Kenosha Milwaukee at Rockford Racine at South Bend
June 1	Minneapolis at Kenosha Milwaukee at Rockford Racine at South Bend	June 1	Minneapolis at Kenosha Milwaukee at Rockford Racine at South Bend
June 2	Racine at Kenosha Minneapolis at Rockford Milwaukee at South Bend	June 2	Racine at Kenosha Minneapolis at Rockford Milwaukee at South Bend
June 3	Racine at Kenosha Minneapolis at Rockford Milwaukee at South Bend	June 3	Racine at Kenosha Minneapolis at Rockford Milwaukee at South Bend
June 4	Racine at Kenosha (2) Minneapolis at Rockford (2) Milwaukee at South Bend (2)	June 4	Racine at Kenosha Minneapolis at Rockford Milwaukee at South Bend

Date	Games	Date	Games
June 5	Rockford at Kenosha Minneapolis at South Bend	June 23	Kenosha at Minneapolis Racine (D) at Milwaukee South Bend at Rockford
June 6	Milwaukee at Racine Rockford at Kenosha Minneapolis at South Bend	June 24	Kenosha at Minneapolis Racine at Milwaukee South Bend at Rockford
June 7	Minneapolis at Racine Milwaukee at Rockford Kenosha at South Bend	June 25	South Bend (2) at Minneapolis Kenosha (2) at Milwaukee Racine (2) at Rockford
June 8	Minneapolis at Racine Milwaukee at Rockford Kenosha at South Bend	June 26	South Bend at Minneapolis Kenosha at Milwaukee Racine at Rockford
June 9	Rockford at Racine Milwaukee at Kenosha Minneapolis at South Bend	June 27	South Bend at Racine Rockford at Kenosha
June 10	Rockford at Racine Milwaukee at Kenosha Minneapolis at South Bend	June 28	Rockford at Minneapolis South Bend at Milwaukee Kenosha at Racine
June 11	Rockford at Racine Milwaukee at Kenosha Minneapolis at South Bend	June 29	Rockford at Minneapolis South Bend at Milwaukee Racine at Kenosha
June 12	Minneapolis at Racine Kenosha at Rockford Milwaukee at South Bend	June 30	Rockford at Minneapolis Racine (D) at Milwaukee Kenosha at South Bend
June 13	Minneapolis at Racine Kenosha at Rockford Milwaukee at South Bend	July 1	Rockford at Minneapolis Racine at Milwaukee Kenosha at South Bend
June 14	Milwaukee at Racine Minneapolis at Kenosha Rockford at South Bend	July 2	Minneapolis (2) at Milwaukee Rockford (2) at Racine Kenosha (2) at South Bend
June 15	Milwaukee at Racine Minneapolis at Kenosha Rockford at South Bend	July 3	Minneapolis at Milwaukee
June 16	Racine at Minneapolis Rockford at Milwaukee South Bend at Kenosha	July 4	Minneapolis (2) at Milwaukee Kenosha (aft.) at Racine Racine (Night) at Kenosha Rockford (2) at South Bend
June 17	Racine at Minneapolis Rockford (D) at Milwaukee South Bend at Kenosha	July 5	Racine at Minneapolis Milwaukee at Kenosha Rockford at South Bend
June 18	Racine (2) at Minneapolis Rockford (2) at Milwaukee South Bend (2) at Kenosha	July 6	Racine at Minneapolis Milwaukee at Kenosha Rockford at South Bend
June 19	South Bend at Minneapolis Kenosha at Milwaukee Racine at Rockford	July 7	Racine at Minneapolis South Bend at Kenosha Milwaukee at Rockford
June 20	South Bend at Minneapolis Kenosha (D) at Milwaukee Racine at Rockford	July 8	Racine at Minneapolis South Bend at Kenosha Milwaukee at Rockford
June 21	South Bend at Minneapolis Kenosha at Milwaukee Racine at Rockford	July 9	Kenosha (2) at Minneapolis Milwaukee (2) at Racine South Bend (2) at Rockford
June 22	Kenosha at Minneapolis Racine (2) at Milwaukee South Bend at Rockford	July 10	Kenosha at Minneapolis Milwaukee at Racine South Bend at Rockford

Date	Games	Date	Games
July 11	Milwaukee at Minneapolis Rockford at Kenosha Racine at South Bend	July 31	Rockford at Racine Milwaukee at Kenosha Minneapolis at South Bend
July 12	Milwaukee (2) at Minneapolis Rockford at Kenosha Racine at South Bend	August 1	Rockford at Racine Milwaukee at Kenosha Minneapolis at South Bend
July 13	Milwaukee at Minneapolis South Bend at Racine Rockford at Kenosha	August 2	Milwaukee at Racine Kenosha (2) at Rockford Minneapolis at South Bend
July 14	Milwaukee at Minneapolis South Bend at Racine Kenosha at Rockford	August 3	Milwaukee at Racine Kenosha at Rockford Minneapolis at South Bend
July 15	South Bend at Racine Kenosha at Rockford	August 4	Minneapolis at Kenosha Milwaukee at Rockford Racine at South Bend
July 16	Milwaukee (2) at Minneapolis South Bend (2) at Racine Kenosha (2) at Rockford	August 5	Minneapolis at Kenosha Milwaukee at Rockford Racine at South Bend
July 19	Minneapolis at Milwaukee Racine at Kenosha Rockford at South Bend	August 6	Minneapolis (2) at Kenosha Milwaukee (2) at Rockford Racine (2) at South Bend
July 20	Minneapolis at Milwaukee Racine at Kenosha Rockford at South Bend	August 7	Milwaukee at Kenosha Minneapolis at Rockford Racine at South Bend
July 21	Minneapolis (D) at Milwaukee Kenosha at Racine Rockford at South Bend	August 8	Milwaukee at Kenosha Minneapolis at Rockford Racine at South Bend
July 22	Minneapolis at Milwaukee Kenosha at Racine Rockford at South Bend	August 9	Kenosha at Racine Minneapolis at Rockford Milwaukee (2) at South Bend
July 23	Rockford (2) at Milwaukee Minneapolis (2) at Racine Kenosha (2) at South Bend	August 10	Kenosha at Racine Minneapolis at Rockford Milwaukee at South Bend
July 24	Rockford at Milwaukee Minneapolis at Racine Kenosha at South Bend	August 11	Kenosha at Minncapolis South Bend (D) at Milwaukee Racine at Rockford
July 25	Rockford (D) at Milwaukee Minneapolis at Racine Kenosha at South Bend	August 12	Kenosha at Minneapolis South Bend (D) at Milwaukee Racine at Rockford
July 26	Racine at Milwaukee South Bend at Kenosha Minneapolis at Rockford	August 13	Kenosha (2) at Minneapolis South Bend (2) at Milwaukee Racine (2) at Rockford
July 27	Racine (D) at Milwaukee South Bend at Kenosha Minneapolis at Rockford	August 14	Rockford at Minneapolis Kenosha at Milwaukee South Bend at Racine
July 28	Milwaukee at Racine Minneapolis at Kenosha South Bend at Rockford	August 15	Rockford (2) at Minneapolis Kenosha (D) at Milwaukee South Bend at Racine
July 29	Milwaukee at Racine Minneapolis at Kenosha South Bend at Rockford	August 16	Rockford at Minneapolis Kenosha (D) at Milwaukee South Bend at Racine
July 30	Rockford (2) at Racine Milwaukee (2) at Kenosha Minneapolis (2) at South Bend		

Date	Games	Date	Games
August 17	Racine at Minneapolis Rockford at Milwaukee South Bend (2) at Kenosha		Racine (2) at Kenosha Rockford at South Bend
August 18	Racine (2) at Minneapolis Rockford (2) at Milwaukee South Bend at Kenosha	August 28	Minneapolis at Racine Rockford at Kenosha Milwaukee at South Bend
August 19	Racine at Minneapolis Rockford at Milwaukee South Bend at Kenosha	August 29	Minneapolis at Racine Rockford at Kenosha Milwaukee at South Bend
August 20	South Bend (2) at Minneapolis Racine (2) at Milwaukee Rockford (2) at Kenosha	August 30	Minneapolis (2) at Racine Rockford at Kenosha Milwaukee at South Bend
August 21	South Bend at Minneapolis Racine at Milwaukee Rockford at Kenosha	August 31	Racine at Rockford Kenosha at South Bend
August 22	South Bend at Minneapolis Racine at Milwaukee Kenosha at Rockford	September 1	Minneapolis at Milwaukee Racine at Rockford Kenosha at South Bend
August 23	South Bend at Minneapolis Milwaukee at Racine Kenosha at Rockford	September 2	Kenosha at Milwaukee South Bend at Racine
August 24	South Bend at Minneapolis Milwaukee at Racine Kenosha at Rockford	September 3	Kenosha (2) at Milwaukee South Bend (2) at Racine Minneapolis (2) at Rockford
August 25	Kenosha at Minneapolis South Bend at Milwaukee Rockford at Racine	September 4	Milwaukee (2) at Minneapolis Kenosha (aft.) at Racine Racine (Night). at Kenosha South Bend (2) at Rockford
August 26	Kenosha at Minneapolis South Bend at Milwaukee Rockford at Racine	September 5	Milwaukee at Minneapolis Racine at Kenosha South Bend at Rockford
August 27	Minneapolis (2) at Milwaukee	September 6	Milwaukee (2) at Minneapolis Kenosha at Racine South Bend at Rockford

1950 PLAYING SCHEDULE OF THE TOURING TEAMS
CHICAGO COLLEENS VS. SPRINGFIELD SALLIES

Date	Place	Date	Place
June 3-4	LaSalle, Illinois	July 2	Fayetteville, North Carolina
June 5-6	Princeton, Illinois	July 3	Gastonia, North Carolina
June 7-8	Kewanee, Illinois	July 4-5	Knoxville, Tennessee
June 9	Morris, Illinois	July 6	Hazard, Kentucky
June 10-11	Lima, Ohio	July 7	Bluefields, West Virigina
June 12-13	Charleston, West Virigina	July 8-9	Hagerstown, Maryland
June 14-15	Lynchburg, Virginia	July 10-11	Jamacia, New York
June 16-17	Roanoke, Virginia	July 12-13	South Orange, New Jersey
June 18-19	Greensboro, North Carolina	July 14-15	Lodi, New Jersey
June 20	Bluefield, West Virginia	July 16-17	Scranton, Pennsylvania
June 21	Asheville, North Carolina	July 18-19	Staten Island, New York
June 22-23	Spartanburg, South Carolina	July 20-21	Union City, New Jersey
June 24-25	Columbia, South Carolina	July 22-23	Newark, New Jersey
June 26-27	Macon, Georgia	July 24-25	York, Pennsylvania
June 28-29	Columbus, Georgia	July 26	Seaford, Delaware
June 30-July 1	Charlotte, North Carolina	July 27	Salisbury, Maryland

Date	*Place*
July 28	Cambridge, Maryland
July 29-30	Newport News, Virginia
July 31-Aug. 1	Portsmouth, Virginia
Aug. 2-3	Richmond, Virigina
Aug. 4-5	Washington D.C.
Aug. 6	Alexandria, Virginia
Aug. 7-8	Jamaica, New York
Aug. 9-10	Springfield, Massachusetts
Aug. 11	Yankee Stadium
Aug. 12-13	Hartford, Connecticut
Aug. 14-15	Portland, Maine
Aug. 16	Bangor, Maine
Aug. 17	Nashua, New Hampshire
Aug. 18	Waterville, Maine
Aug. 19	Sherbrooke, Quebec, Canada

Date	*Place*
Aug. 20	Plattsburgh, New York
Aug. 20	Malone, New York
Aug. 21	Montreal, Quebec, Canada
Aug. 22	Burlington, Vermont
Aug. 23	Syracuse, New York
Aug. 24	Lockport, New York
Aug. 25-26	New Castle, Pennsylvania
Aug. 27	Erie, Pennsylvania
Aug. 28	Oil City, Pennsylvania
Aug. 29	Rochester, New York
Aug. 30-31	Jamestown, New York
Sept. 1-2	Youngstown, Ohio
Sept. 3-4	Cleveland, Ohio

The Colleens won the season series, 38-37.

Index

Abbott, Velma 34, 35, 36, 42, 110, 112, 173
Acker, Freeda 241
Adams, E. 33, 34, 173
Ahrndt, Ellen 173
Ainsmitte, Eddie 277
Albright, Eileen 51, 173, 241
Alderfer, Gertrude 174
All-Star Teams 3, 5
Allard, Beatrice 57, 241
Allen, Agnes 72, 73, 78, 79, 83, 135, 174, 241
Allen, D. 56
Allington, Bill 100, 120, 133, 164, 165, 277
Alspaugh, Melba 47, 50, 55, 57, 120, 123, 133, 139, 141, 174
Alvarez, Isabel 70, 73, 75, 83, 88, 89, 162, 163, 174, 241
Anderson 154, 157, 280
Anderson, Janet 35, 174, 242
Anderson, Marie 96, 279
Anderson, Vivian 22, 174
Applegren, Amy 24, 27, 31, 35, 36, 39, 44, 48, 53, 55, 57, 61, 70, 77, 84, 100, 104, 106, 115, 116, 120, 125, 126, 140, 141, 142, 147, 149, 152, 155, 158, 171, 174, 242
Arbour, Beatrice 175
Armato, Angie 83, 162, 175
Armstrong, Charlotte 14, 23, 26, 29, 31, 242
Arnold, Lenna 34, 49, 59, 242
Arnold, Louise 69, 75, 77, 138, 152, 153, 154, 158, 242
Arnold, Norene 242

Baker, Hilda 279
Baker, Mary (Bonnie) 5, 18, 20, 23, 29, 30, 33, 36, 40, 43, 49, 54, 59, 63, 65, 78, 85, 88, 108, 114, 125, 138, 168, 169, 170, 175, 277, 279
Baker, Mildred 279
Baker, Phyllis 242
Ballingall, C. 84, 89, 90, 165, 167, 168, 169, 175
Bancroft, Dave 277
Barbaze, Barbara 51, 175
Barker, Lois 62, 175
Barnes, Joyce 243
Barnett, Charlene 39, 50, 54, 61, 113, 115, 120, 139, 141, 142, 144, 145, 147, 175
Barney, Edith 176
Barowski 280
Barr, Doris 14, 18, 19, 20, 21, 23, 28, 29, 31, 32, 38, 39, 44, 51, 52, 57, 65, 101, 102, 107, 108, 116, 117, 118, 119, 136, 137, 243
Barringer, Patricia 176
Bartel 144, 148, 154, 157, 280
Barwinski 115, 116, 129
Bass, Dick 277
Batikis, Annastasia 176
Battaglia, Fern 73, 176
Batwinski 107, 116, 120, 166, 280
Baumgartner, Mary (Wimp) 58, 63, 65, 68, 77, 84, 88, 154, 156, 158, 167, 175
Bayse, Betty 176
Beare, Kathryn 34, 176
Beck, Lottie 239
Becker, Donna 72, 243
Behrens, Catherine 279
Bell, Virginia 52, 243
Bellman, Lois 176
Bender, Dave 148, 150, 151, 280
Bennett, Catherine 13, 18, 19, 21, 23, 26, 243

Berger, Barbara 64, 177
Berger, Joan 6, 70, 77, 83, 86, 90, 91, 155, 158, 160, 177, 243
Berger, Margaret 18, 20, 21, 23, 26, 243
Berger, Norma 149, 152, 244
Bergmann, Erma 35, 37, 38, 39, 52, 57, 60, 64, 73, 75, 244
Beschorner, M. 55, 64, 140, 177
Bevis, Muriel 62, 145, 177, 244
Bigbee, Carson 277
Billings, Josh 278
Bird, Nelda 14, 29, 244
Bittner, Jaynne 40, 48, 55, 63, 69, 75, 76, 78, 82, 86, 89, 140, 154, 155, 162, 244
Blair, Maybelle 244
Blaski, Alice 81, 82, 87, 91, 162, 177
Bleiler, Audrey 77, 151, 153, 177
Block 148, 156, 160, 280
Blok 163
Blumetta, Catherine 22, 25, 28, 36, 37, 41, 42, 44, 50, 56, 60, 61, 62, 67, 72, 78, 83, 86, 89, 125, 126, 127, 130, 131, 162, 178, 245
Bookout, Phyllis 239
Borg, Lorraine 25, 178
Born, Ruth 18, 20, 245
Boyce, Ethel 178
Boyle, Ralph 278
Braden, Lewis 280
Briggs, Rita 15, 40, 47, 51, 53, 54, 70, 79, 82, 87, 162, 165, 171, 178
Briggs, W. 50, 56, 59, 61, 66, 69, 76, 80, 82, 85, 86, 88, 90, 91, 127, 128, 131, 134, 135, 138, 143, 147, 155, 162, 167, 178
Brody, Leola 178
Brown, Patricia 73, 245

287